SHAKER VISION

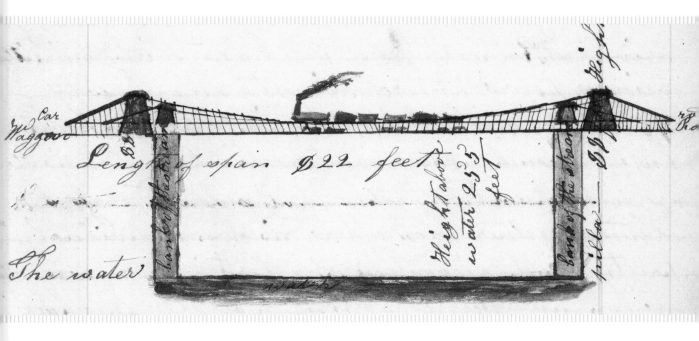

The water Length of span 822 feet Height about water 255 feet

SHAKER VISION
SEEING BEAUTY IN EARLY AMERICA
JOSEPH MANCA

University of Massachusetts Press
AMHERST & BOSTON

ISBN 978-1-62534-468-7 (paper)

Designed by Kristina Kachele Design, llc
Set in Alegreya HT Pro, Titular Alt Thin (display)
Printed and bound by Sheridan Books, Inc.

Cover design by Kristina Kachele Design, llc
Cover art: (top) Frederic Edwin Church, *Niagara*, 1857,
National Gallery of Art, Corcoran Collection. Photo:
NGA; (middle) Joshua Bussell, *View of the Church Family, Alfred, Maine*,
ca. 1880 (?), New York, American Folk Art Museum.
Photo: American Folk Art Museum/Art Resource, New
York; (bottom) Unidentified artist variant after David H.
Strother, *Meditation by the Sea*, ca. 1861–65, Boston,
Museum of Fine Arts, www.mfa.org. Photo: MFA.

Library of Congress Cataloging-in-Publication Data

Names: Manca, Joseph, 1956–author.
Title: Shaker vision : seeing beauty in early America / Joseph Manca.
Description: Amherst ; Boston : University of Massachusetts, [2019] |
 Includes bibliographical references and index.
Identifiers: LCCN 2019019888 | ISBN 9781625344687 (pbk.)
Subjects: LCSH: Aesthetics—Religious aspects—Shakers. | Aesthetics,
 American.
Classification: LCC BX9789.A47 M36 2019 | DDC 289/.8—dc23
LC record available at https://lccn.loc.gov/2019019888

British Library Cataloguing-in-Publication Data
A catalog record for this book is available from the British Library

Frontispiece: Hiram Rude, drawing of the Niagara Falls Suspension Bridge, mid-July 1856,
pen and ink and watercolor on paper. (Cleveland, Ohio, Western Reserve Historical Society,
Shaker Manuscripts, Series V, B-161, 135. *Photo:* WRHS.)

CONTENTS

FOREWORD AND ACKNOWLEDGMENTS

Despite the dour and ascetic reputation of the Shakers, a study of their early writings and material culture reveals a different picture. In many ways, Shakers lived sensuously: they ate well, they swam (in season) regularly in their ponds and lakes and in the ocean, and they danced and sang ecstatically. The Shakers also lived rich visual lives. They watched sunsets, pretty rains, rainbows, comets, northern lights, and the sun dancing on the water. Shakers enjoyed the sight of green fields, snow-covered ground, and the colors and shapes of fruit on vines and limbs. They could not grow a flower solely for its beauty, but they picked wildflowers and enjoyed springtime blossoms on apple trees. Shakers built their echo of heaven in orderly, clean, and well-designed villages and buildings. They established outdoor churches on their hilltop Holy Mounts and endowed those sites with verdant lawns, decorative fences, marble slabs with inscriptions, and fountains. They wore beautiful, fine clothing on Sundays. Believers also loved to look at each other, appreciating the charming faces of children, the moral beauty of elders, and the nimble bodies of dancing girls. Shakers eventually produced works of two-dimensional art, inspired in form and creative in content, and their ecstatic visions and song lyrics were also replete with images of vivid and sometimes intense beauty. When traveling, they enjoyed prospects from mountaintops; the beauty of forests, hillsides, and streams; and views of romantic and sublime waterfalls, cliffs, caves, and surging ocean waves. Shakers often praised

the elegant architecture they saw in early America, including the fancy mansions and fine public buildings of the world's cities, urban public fountains, naval architecture, and private and public gardens of the world's people. Shakers were naturally drawn to the beauty of planned, regular, and clean cities and towns across the United States, and they liked the bridges, aqueducts, and factories they saw in industrial America. When done with their travels, they happily returned to the sight of their green and welcoming villages. For many of these visual joys, Shaker feelings were often intensified by their religious outlook.

Every attempt has been made here to utilize and interpret, within the context of their time and worldview, a selection of original texts of Shakers. Believers were often quite verbal and articulate, and there is a great deal of surviving written evidence about their ideas and attitudes. A subtitle of this book might have been: "The Shakers in Their Own Words." We will also look to some extent at what non-Shakers (whom the believers called "the world's people") saw in the material culture of the Shakers. Similarly, we will study what former Shakers thought. These apostates are useful in that they were finally able to express their opinions freely, and they often recorded ideas they held or sentiments they felt while they were still Shakers. All of these period texts are vital for understanding how the Shakers engaged with the visual world. This book is principally a study of writings. Earlier authors have skillfully and extensively studied Shaker design and craftsmanship, especially furniture, architecture, and inspired, spiritual art. Although this book does not attempt to offer a survey of those forms, I hope that the footnotes and bibliography here will provide readers with suggestions for where to explore further the previous scholarship on Shaker visual culture.

The chronology covered here extends only into the 1870s or so. After that time, the group was in ever more serious decline in total members, despite the rapid rise in the U.S. population; the number of villages was shrinking, and the communities were becoming unbalanced in age and gender, with the average age rising and women beginning to greatly outnumber men. Moreover, by the 1870s and later, the relative economic decline of the Shakers continued. Shaker laws and expectations about the visual world became watered down by the later nineteenth century, and, although styles acceptable to them were still relatively simple compared to the rest of American society, Shakers came to accept a broader range of adornment, architectural forms, and clothing styles than before. In addition, by the last quarter of the century and beyond, there was a great diminution of episodes of visionary ecstasy and spiritual drawing.

We will look at early Shaker culture and writings, in the century or so before 1880, when they were at their height and were most distinctive.

I have been fortunate to have people and resources at a number of institutions help me advance my work. I particularly wish to thank the staff members of the following libraries and museums for their direct assistance or for making available their institution's material: the Shaker Library at Sabbathday Lake Shaker Village (New Gloucester), Maine; the library at Hancock Shaker Village, Massachusetts; Hamilton College Library, Hamilton, New York; the New-York Historical Society; the Metropolitan Museum of Art, New York; the Emma B. King Research Library of the Shaker Museum/Mount Lebanon, Old Chatham, New York; the Rare Book and Manuscripts Room of the New York Public Library; the New York State Library, Albany; the Enfield Shaker Museum, New Hampshire; the Western Reserve Historical Society, Cleveland, Ohio; the Philadelphia Museum of Art; the Bayou Bend Collection and Gardens, the Museum of Fine Arts, Houston; the Brown Fine Arts Library and Fondren Library, Rice University, Houston; and the Library of Congress, Washington, D.C. Among the staff members of these institution, I especially wish to thank Maribeth Cellana, Lesley Herzberg, Magda Gabor-Hotchkiss, and Rosana Longenbaker of Hancock Shaker Village as well as Jerry Grant of the Emma B. King Research Library in Old Chatham. Much of my research on primary and secondary sources took place at the Winterthur Museum, Garden, and Library, Wilmington, Delaware, including time as a research fellow there in the summer of 2016 and a period as a visiting scholar in 2017 and 2018. For their help, I particularly want to thank Winterthur staff members Jeanne Solensky and Laura Parrish; I am also indebted to Winterthur's Thomas Guiler, Emily Guthrie, Charles F. Hummel, Chase Markee, Richard McKinstry, and Catherine Dann Roeber. At Rice University, I was fortunate to have the diligent help of research assistants Caitlin Masterson and Claire Spadafora, both doctoral candidates in Rice's Department of Art History, and in particular to Claire Spadafora for her help in compiling the index. The department's Chelsey Denny and Kelley Vernon helped with the imagery and illustrations that appear in the book. Sandra Marcatili, an architect and alumna of Rice University, produced the map of Shaker communities (fig. appendix 1). Funding from the Department of Art History and the office of the Dean of Humanities at Rice University supported my travels and provided help for acquiring many of the illustrations that appear in the book. As for the University of Massachusetts Press, I have benefited from the support and suggestions of executive editor Matt Becker, from the help of the press's

Rachael DeShano and Sally Nichols, and from the advice of two anonymous referees. I also wish to thank Annette Wenda for her skillful editing of the manuscript. Finally, but not least, I wish to thank Christine Waller Manca, senior editor at the Museum of Fine Arts, Houston, for editing and otherwise improving the text.

SHAKER VISION

INTRODUCTION

The Shaker story has been told many times, but a few words about their origins and history might be useful here. Much of the early written information about the Shakers comes from the testimonies, recollections, and narratives they recorded or composed in the nineteenth century. That information is often suspect, but it is useful to learn what the Shakers themselves thought, just as, for any religious group, it is telling to know what miracles, prophecies, and histories the members believed in or held dear. The Shakers, who were deemed by some of the "world's people" (non-Shakers) to be peculiar upstarts, wanted to link their sect's history to a longer and deeper historical past. By their own account, Shakerism began in seventeenth-century France among a group of Huguenot "prophets" who received holy visions, shook with ecstasy, and danced with religious fervor.[1] The Shakers claimed that these French prophets were forced to move to Protestant-friendly England and that their kind of ecstasy was revived in 1747 in Manchester by a tailor, James Wardley, as well as his wife, Jane, and others in that city. Among the Wardley followers was an illiterate and poor young woman named Ann Lee (1736–84), who joined in 1758.[2] Court records do indicate that a small number of English men and women, based in Manchester, began to break away from established churches—including but not confined to Quakerism—and ran afoul of the law for making noise with their religious celebrations and for disturbing the peace during the services of others sects. Ann Lee, along with her

working-class father, was arrested and imprisoned in 1772 for a "breach of the Sabbath," and she was arrested again in July 1773, along with fellow believers, for disrupting the service at Christ Church in Manchester.[3] Perhaps because of a lack of following, and faced with arrest, physical abuse, and other persecutions, eight members of the group left for America, arriving in Manhattan on 6 August 1774. Often called Shaking Quakers in these early years, they eventually took on the official name of the United Society of Believers, or sometimes the United Society of Believers in Christ's Second Appearing, but also regularly called themselves Shakers, and that easy and vivid name has become standard.

Those immigrant Shakers, all English, were considered the founding fathers and mothers of the sect in America, and they were long revered by later Shakers. According to the sect's later histories, the first Shakers in America included Ann Lee and her husband, Abraham Stanley (or "Standerin" in some documents), as well as Lee's younger brother William Lee (1740–84), her niece Nancy Lee, Mary Partington (1755–1833), John Hocknell (1722–99), James Shepherd, and James Whittaker (1751–87). Shaker accounts report that these founders at first resided and worked at odd jobs in various locations, including near Albany and in the city of New York; in the latter place, Ann Lee worked at menial positions for others. Shepherd and Stanley, Ann's husband, did not stay with the group for long. The motley group of believers might have struggled further but for the help of Hocknell, the one affluent member of the new sect. In 1775 he acquired land for the group near Albany, a place called Niskayuna (the location of the Shaker society later called Watervliet). Hocknell shortly returned to England and brought his own family to Niskayuna, and the husband and children of Mary Partington came over as well.[4] The Shakers quietly worked, lived, and prayed in their adopted land for several years.

The Shakers arrived and lived for a decade during revolutionary times in America, and they were not welcome in the time and place of their arrival. New York and the Hudson Valley, the area of their settlement, was a place of conflict, dislocation, anxiety, and anomie. The Shakers entered that turbulent environment, and it is hardly surprising that they were poorly received. They spoke with English accents, did not back the Revolution, and told people to lay down their arms and live in peace, advice that, if followed, would have sustained the status quo of British rule. The Shakers raised the suspicions of authorities. The outspoken Ann Lee, who had come to be recognized as the leader of the group, was imprisoned for a while in the summer of 1780 along with other believers, but she was soon released.

These earliest Shakers had not developed the range of theological attitudes that Shaker believers in the nineteenth century would establish and articulate in copious writings, but certain central aspects of their beliefs were consistent from the beginning.[5] One firm tenet of the first Shakers centered on the importance of celibacy and the suppression of carnal desires. Modern writers often point to the evidence that Ann Lee, during her marital years in England, had lost four children to early death, and one has assumed that it caused her to develop Shaker dogma against the flesh. But the discouragement of sexual intercourse was hardly unique to the Shakers. Others devoted to their gods and faith had set aside the flesh. Celibacy was, for example, a well-established practice for Roman Catholic clergy. Similarly, notions about original sin as sexual intercourse were of long-standing acceptance by many Christians, and lust was one of the traditional seven deadly sins. At any rate, celibacy became a key aspect of Shakerism. Concomitantly, they discouraged desire for other pleasures, including the quest to acquire worldly luxuries and fashion. These beliefs would all come to shape Shaker life and the visual culture to be discussed in this book. The early Shakers also put great store in their "gifts" or messages or inspiration from the divine realm, as known to them from intuition, dreams, premonitions, and visions. Among other early Shaker beliefs was that Christ's millennial rule, the thousand-year period on earth before the Last Judgment as espoused by premillennialists, was not some event of the future. Early Shakers, at what date is unknown, concluded that their rise and presence on earth, ushered in by Ann Lee, marked the beginning of the Millennium described in Revelation 20:1–6.

The Shakers languished in numbers through the end of the 1770s. After that point, some radical Baptists and other millenarians who had been expecting the Second Coming came to visit Ann Lee and desired to join their group. The Shakers traditionally set the moment of the opening of their gospel to 19 May 1780, which coincided with the time, regarded by many as portentous and as a religion omen, that the sun remained darkened all day, probably because of the smoke from a large fire that burned many miles away. The Shakers gained from the anxieties of that one day and, more generally, from the troubled and uncertain social conditions fostered by the war. In an even broader sense, the Shakers benefited and sprang from the legacy of the Great Awakening of the eighteenth century. Ann Lee herself, in her youth, had heard the electrifying George Whitefield (1714–70) preach in England, and the followers she gained in America had been the same sort of Christians: they rejected the authorities and hierarchies of their time and turned to a more exuberant form of worship

in preparation for the imminent kingdom of God on earth. Isaac Newton Youngs (1793–1865), writing in 1856, acknowledged that Shakers received many converts who were tired of old religions: in 1780 he wrote, "Mother and the Elders sounded the gospel trumpet," and "many, being sick of the old forms of religion, & desiring something better, were ready to receive it."[6] Not relying on local converts, Ann and a few of her followers set out in 1781 on a grueling and dangerous tour of preaching through New England that lasted more than two years, during which time the Shakers established a cluster of multiple communities of believers. Local unbelievers feared, among other things, that Shakers wanted converts to break up their families, and opposition to the Shakers was strong during the years of preaching in New England. Still, the Shakers gained adherents and increased their ranks.

It was widely acknowledged, even by enemies, that Ann Lee was a persuasive proponent of her cause. Apostate Hervey Elkins (1823–95), resident with the believers at Enfield, New Hampshire, from 1837 to early 1852, had talked to early Shakers and concluded that "there can be no dispute but that she possessed a tremendous psychological and clairvoyant power; and was a lady of great mental and physical talent."[7] The "physical talent" included her abilities to use her body (hands, eyes, voice) to achieve her ends and lead those before her into conversion. The skills of persuasion of the Shakers are well documented, especially by early apostates, who offer reports that, even if we take into account their prejudices and their determination to oppose Shaker thought and practice, are useful to consider.[8] One early apostate text is by Valentine Rathbun (ca. 1724–1814), who first encountered Ann Lee and the Shakers in Niskayuna. Rathbun published his account in 1781 and signed it 5 December 1780, putting him right near the beginning of the proselytizing of the cult.[9] Rathbun's account is not verifiable, but seems, if anything, understated, and it rings true: "When any person goes to see them, they all meet him with many smiles, and seeming great gladness." Then, "they bid him welcome, and directly tell him they knew of his coming yesterday." Rathbun noted that their uncanny prescience "sets the person a wondering at their knowledge," and, in this state of awe, the visitor is then given some "victuals." Before any verbal proselytizing begins, the Shakers "sit down and have a spell of singing; they sing odd tunes, and British marches, sometimes without words, and sometimes with a mixture of words, known and unknown." This kind of speaking in tongues was to remain an aspect of Shaker experience well into the nineteenth century. Rathbun continued: "After singing, they fall to shaking their heads in a very extraordinary manner, with their eyes shut and face

up; then a woman about forty years old sits and makes a sort of prayer, chiefly in an unknown tongue (if I may so call it) then one of the men comes to the person, and pretends to interpret the woman's prayer." All of this, including the prescience, speaking in tongues, and the ecstatic jerking, twitching, and dancing motions (sometimes called "operations" by early believers), must have been effective in convincing outsiders of the special nature of the Shakers. We will see that the salience of the visual presentation of the Shaker body during times of worship and religious inspiration perdured through the nineteenth century. Receiving inspiration, in this case via foreknowledge of events and through speaking an "unknown tongue," would continue in the sect and, in the visual realm, erupt in a creative production of inspired spirit drawings in the second quarter of the nineteenth century.

Ann Lee stood in high esteem by the first Shakers, who regarded her as their leader. Over the course of early Shaker history, certainly by the early nineteenth century, many of the faithful proclaimed that Ann Lee—the illiterate daughter of a blacksmith—was at some level a second appearance or incarnation of Christ, his female equivalent. The Christ spirit, it was argued, had come the first time in the male form of Jesus of Nazareth and, to fulfill prophecy, returned again, the second time in female form through Ann Lee. As English-born New Lebanon elder Frederick William Evans (1808–93) summarized in 1889: "The Shakers claim that Christ did appear at the time he was expected, in the second, as in his first, advent; and that Ann Lee was the medium or prepared vessel in the second, as Jesus was in the first appearing, founding the 'first heaven.'" Evans referred succinctly to Ann as "the second appearing of Christ. Now the kingdom is established." Harvard Shaker Eunice Bathrick (1793–1883) said that "I have never doubted that Christ made his appearance in the person of Ann Lee."[10] Similarly, David Darrow (1750–1825), John Meacham (1770–1854), and Benjamin Seth Youngs (1774–1855) wrote in 1808 that Jesus of Nazareth, a man, was the first manifestation of Christ, and then "behold, the *humble Saviour* was manifested in the form and likeness of *a woman*, and assumed the appearance of *an handmaid*."[11] Ann Lee, wrote an early religious reformer who had heard about Shaker beliefs, was the "Second Incarnation of the Messiah in the person of a woman."[12] (All of this reflected the Shaker belief in gendered dualities: the godhead of God the Father and Holy Mother Wisdom, then Jesus and Ann Lee, not a trinity of God the Father, the Son, and the Holy Spirit.)[13] Over the centuries, each Shaker seems to have had a slightly different interpretation of Ann Lee's theological relationship to the spirit of Christ.[14] Many surely felt that Ann Lee, as the second coming of Christ, was at

least an equivalent and coequal and a kind of successor to Jesus of Nazareth, that is, Jesus Christ. Other Shakers have softened such a view and put forth no more than the idea that the spirit of Christ dwelled in Ann Lee and that she was a Christlike model for other believers; that is the predominant sentiment of twentieth- and twenty-first-century Shakers. For our purposes here, it is enough to recognize the central role and spiritual elevation of Ann Lee within Shakerism.

Ann Lee died unexpectedly at the age of forty-seven in 1784, and her successor and recognized head of the church, James Whittaker, passed away in 1787. Their successors were Joseph Meacham (1742–96) and Lucy Wright (1760–1821); they and others, especially during the lengthy leadership of Wright, established the rules and order that we associate with the structure of Shaker society and its daily-life restrictions on members.[15] Under the guidance of Wright, who brought a more genteel approach to the sect, the Shakers encouraged quiet and controlled personal behavior, and during the early nineteenth century religious practice became, while still raucous by the world's standards, more restrained and ritualistic than it had previously been.

By the early nineteenth century, building on the attitudes and beliefs of the first generations of believers, the Shakers established the essential characteristics, way of life, and organizational aspects of the sect. They never had a formal and definitive set of theological tenets or enforced orthodoxies, but one can glean from various Shaker texts, some published and others in manuscript form and circulated in various copies from village to village, the ideas generally shared by Shaker believers. Practice and way of life, known to us from many sources, also help us define the nature of Shakerism. First, again, was absolute celibacy, including not only complete avoidance of sexual intercourse, but also proscriptions against feeling lust at all, having tender feelings toward the opposite sex, or spilling of seed.[16] Second, continuing an eighteenth-century practice, was the confession of sins to the authorities. Shakers did not have formal and regularized sacraments, such as baptism or the sharing of a Eucharist, but their episodes of confession come the closest to Christian sacramental tradition. Third was the belief in the special role and status of Ann Lee, amounting to a kind of saintly worship of her. A fourth feature was the dwelling together in village communities, places that were rural and agrarian in large part and separated from the world. Fifth was pacifism and the abjuring of political involvement, including a lack of civic participation in governing bodies in the American republic. There were no Shaker soldiers, nor Shaker congressmen, governors, or county official, and

leadership skills stayed within the sect. Sixth was a set of laws and guidelines that regulated many aspects of daily life, including the encouragement to avoid worldly fashion and tastes. Seventh was a proclivity toward gender equality, unexpected for America of that era but flowing from the time of Ann Lee's leadership and the belief in her importance and owing as well to Lucy Wright's successful guiding of the faithful.[17] An eighth feature of Shaker life was the general separation of the sexes. Men and women spoke to each other in controlled circumstances, but otherwise lived and usually worked separately from each other and, as much as possible, entered separate doors for dining and worship. Children lived by gender and generally remained separate from adults, except for the watchful presence of their caretakers. Finally, a distinct feature of Shaker life was the hierarchy of leadership and other social arrangements at the various villages. Eventually, there were over twenty Shaker communities in eleven states, although the total number of members never included more than five thousand or so. The main centers were in New England and New York, plus important villages in Ohio and Kentucky (see the appendix for a list of Shaker communities, and fig. appendix 1).[18] All of these components, especially the separation from the world and the written guidelines about how to live, helped form the social conditions that gave rise to Shaker material culture.

The hierarchy of the community organization of the Shakers formed a pervasive aspect of Shaker life. There were variations and shifts of terminology over time, but the following expresses the predominant framework for Shakerdom and its organization. At the top was the Ministry of New Lebanon, sometimes later called the Lead Ministry or, usefully, also called the Central Ministry, which provided rules, guidance, and spiritual inspiration for the Shakers. The various communities were under the umbrella of various bishoprics, with a ministry for each bishopric. There were typically two men and two women in each ministry. In each village there was a hierarchy of what were called families or orders, groups living together in community and in near residence with each other. The provisional members or novitiates lived in the Gathering Order, while the most established, esteemed, or committed of believers there lived in the First Order or First Family or Church Family or Center Family. A Second Order or Second Family was a spiritual step below that, and there might be a Third Family as well. Elders and eldresses offered guidance or direction for each family and were resident with the others in that order. Again, elders and eldresses shared authority with each other, the Shaker system giving more influence to women than was usual in early

America.[19] As for practical matters and spheres of production and business, there were trustees and deacons and deaconesses who oversaw pragmatic issues and economic dealings internally and with "the world." At the bottom, below the rank-and-file Shakers, were those provisional members who had not yet signed the formal covenant (or Church Covenant), that is, the official agreement to join the sect. Some Shakers, even those over the age of twenty-one, lived for years at the communities before signing the covenant, but it was normal to sign upon adulthood or within a limited time after entering as a novitiate. Upon accepting the covenant, the signer committed his or her property to the sect, and the signer ceded one's rights to payment for labors rendered. Those who left the sect received a small severance payment and, we can well imagine, some verbal remonstrance, but an adult could leave freely anytime. Finally, beyond the holy villages were the great unwashed masses, the wicked "world's people," enjoying the fruits of the flesh and failing to recognize that the Millennium had begun, ushered in by the Shakers.

Even this quick review of Shaker religion and organization suggests commonalities with other religious sects. The celibacy, gathering into communities separate from society as a whole, agricultural and other economic production, and aspects of the separation of the sexes have parallels in the long-standing monastic life of Roman Catholicism.[20] The leadership apparatus, like the practice of confession, has similarities to Catholicism but also to the systems of bishops and parishes in Anglican and Presbyterian Churches. On the other hand, the aggressively antiestablishment aspects of Shakerism recall dissenting sectarian trends such as those found in Puritanism and Quakerism. Many of the first converts to Shakerism came from the New Light circles of Protestantism. Even in a broader European and American context, parallels were present. Perhaps the most striking are the similarities between Shakers and Rappites, followers of German-born Johann Georg Rapp (1757–1847). The Rappites, also called Harmonites, were dissenting religionists from the Old World who expanded in America, dwelling in Pennsylvania and Indiana, and practiced communal life and sharing of property, maintained a preference for celibacy, and fostered a conscious simplicity of lifestyle.[21] The Oneida Perfectionists, founded by John Humphrey Noyes (1811–86), differed from Shakers on sexual practice, but carried out communal living and shared property and prized cleanliness, order, and moral perfectionism.[22] The communities of the Moravian Church in early America were successful in agricultural and light industrial production and served as forerunners for the kind of utopian community-based economic output of the Shakers.[23] Other utopian

societies in America, both religious and secular, provide an abundance of similarities with the Shakers, although no other society shared the particular set of features characteristic of the Shakers.[24]

Apart from the many parallels between the Shakers and other sects and religions, many differences remain, and two distinctions stand out. The first is the peculiar theological place of Ann Lee and the extraordinary claim that she was the second coming of the Christ spirit on earth. That made her more than just another strong leader or cult figure. The second distinction, of signal importance for the study here, is the visual world and material culture created by the Shakers for their own use. Even the Quakers and the Rappites, for example, did not create a style of chair, oval box, or meetinghouse that was identifiable as springing from them. Their material culture and style were products of Shaker organization, leadership, and communal life, and we must always be aware of how Shaker society was composed and how rules or guidelines passed down to its members.

The structure and practices of daily life greatly fascinated the rest of the world, both then and now. Part of the system were the various "Millennial Laws" that were promulgated by the Central Ministry and elders of New Lebanon in 1821 (soon after the death of leader Lucy Wright), 1845 (at the peak of an ecstatic and mystical period of Shakerism, as we will see), and in shorter form in 1860. We will discuss many aspects of these in the third chapter, but it is worth noting that these were guidelines to be adapted or ignored by the leadership in various communities. They were also limited in scope and did not, for example, prevent any Shaker from enjoying a spectacular waterfall or sunset or a pleasing view of ships in New York Harbor. These rules or guidelines are of interest to students of Shaker life, for they are noteworthy in including many references to material culture and to how things ought to look, but the Millennial Laws were only one small part of the decades of Shaker life and their system of authority. Making smaller decisions and judgments daily, Shakers in the upper echelons of the moral scale had great authority and could be an invasive presence. The Millennial Laws of 1845 stated: "It is the duty of the Elders strictly to oversee the family placed under their care, and to gather the family to them, by the arm of love, and rod of correction." Those laws stated that it is the duty of elders to know the moral standing and commitment of all members, and every sin was to be confessed to them immediately, and "members may not plead and reason with the Elders, the necessity of their own way and will. . . . But they are required to yield reconciliation, and willing obedience to their word, and reverence and respect them."[25] Rank-and-file Shakers

had to knock before entering a dwelling room not their own, but elders never had to knock and could enter immediately and unannounced. Only Shaker leaders or those permitted by them, according to the laws of 1845, could read material that was forbidden even to teachers: "Those who teach school, must devote their time to teaching their scholars, and not be studying themselves, any further than is necessary to enable them to do their duty in teaching; but they should have a good understanding of all the branches they are required to teach." Only Shakers "ap[p]ointed by the Lead [the ministry], may study physic, pharmacy, surgery, anatomy, chemistry, &c."[26] In this spirit, a Shaker at New Lebanon noted in 1853 on a Saturday: "We attend meeting this evening with the first Order a strong testimo[n]y against a worl[d]ly sense, against studdying the arts and sciences that could be of no use to believers."[27]

It was this tyranny over the community, and specifically the power of the leaders, that many Americans found most galling. Other Americans practiced religious celibacy, or shared property in utopian communes, or avoided worldly luxuries, but it was the pervasive control of everyday life by Shaker leadership that somehow passed the bounds of acceptability to some Americans. One anonymous writer complained in 1832 that "there is something arbitrary and unrepublican in the mode of appointing ministers and elders," but acknowledged that the leaders at least had to be acceptable to the local members.[28] Some outside observers were disturbed to see, within a larger democratic republic and a society with various freedoms, a community of believers where a few had the religious authority of a pope and his cardinals and economic control over property and the application of labor. Apostate David Rich Lamson's (1806–86) account provides a lengthy and searing description of the dominance of a few Shaker leaders over their followers. In his negative portrait of the leadership of the Shaker communities, he wrote in his *Two Years' Experience Among the Shakers* of 1848:

> The government is a perfect despotism. The supreme authority being vested in one individual [head minister at New Lebanon]. It is a very curious anomaly, that a despotism should exist in the midst of a republic. But so it is. . . . [Their government] is like Catholicism and Mormonism. Its miracle, visions, revelation, superstitions, and confession of sins, by which the elders obtain unlimited sway over the minds of their subjects. . . . The head minister who resides at new Lebanon, appoints his successor, and the ministry, or bishops, in the societies throughout the denomination. . . . [H]is authority

is supreme. . . . The elders and deacons have authority in the family over which they are appointed, limited only by their superiors in office. . . . Every family elder is a petty despot, and a very implicit and servile obedience to him is required of all the members of the family. Every elder in the ministry is a bigger despot, as all the family elders, even, must humble themselves in perfect obedience to him.[29]

Lamson learned that one should "obey and follow your lead [the leaders]. Keep your union with the elders and you will do well enough. Obedience to them is obedience to God. . . . All is nothing without simple, childlike, and unreserved obedience to the elders."[30] Lamson was an enemy of the Shakers, and we must see his assessment in that light. Moreover, some Shakers saw equality, not tyranny, in their arrangements. Here is what Calvin Green (1780–1868) and Seth Youngs Wells (1767–1847) wrote in 1823, calling attention to their sharing of property rather than to the question of community rule making:

The great inequality of rights and privileges which prevails so extensively throughout the world, is a striking evidence of the importance of a reformation of some kind. Who can view the unequal state of human society, the overgrown wealth of the few and the abject poverty of the many, and not be convinced of this? Surely it is too obvious to escape the notice of any rational mind. To see the luxurious state of the pampered rich, the oppression and destitution of the poor, who are perishing by thousand, year, hundreds of thousand, for the want of the necessaries of life and the consequent bitter animosities and increasing collision between the rich and the poor, must suggest to every benevolent mind the indispensable necessity of some system of operation among men, that will confer a much greater equality of rights and privileges, both in person and property, than any which now prevails, in order to prevent mankind from rushing on to utter ruin.[31]

Whatever one's assessment of Shaker stratification and authority, it is inarguable that the very dictates and authority of Shaker society over its members led to a visual world that is recognizable to us as it was, reassuringly, to believers. Shaker material culture is a product of their system of community control and persuasion and their devoted striving toward union, moderation,

and disregard for worldly fashion and taste. In a more general sense, the strict organization of Shaker life led to a primacy of vision in the communities. Shakers looked intensely at people and things. During confession the confessor did not sit behind a screen or curtain: he or she stood or kneeled before elders, and one could scrutinize the subject's face for signs of submission and remorse. Not having a system of curfews and chaperones as the world did, Shakers looked carefully at their young people during daily life for subtle signs of affection between them. When Shakers traveled, it is apparent that they were expected to keep journals of what they did and saw; these journals will be of great use for us in studying the Shaker eye on the road. Shaker leaders made sure that paint colors on buildings and objects brought unity and equality to their village residents. How many religious sects have developed their own consistent and enduring styles of furniture? All of this is the fruit of Shaker social organization.

We will study some instances of Shaker visual aversion and moral repugnance at the world's material culture, but much of this book deals with the question of beauty. Perhaps because of the structure of Shaker society, the cautionary phrasing of some of the Millennial Laws, and the quest for humility, plainness, and conformity, it is often said that Shakers were not interested in the beautiful. Lending credence to this belief is a proclamation that Shaker leader and prolific writer Frederick W. Evans is quoted by Charles Nordhoff (1830–1901) as saying in December 1874: "The beautiful, as you call it, is absurd and abnormal. It has no business with us."[32] But, on the contrary, a review of actual Shaker texts indicates that they often wrote of objects and persons as being beautiful, handsome, pretty, romantic, picturesque, and so forth. As we will see in the chapters that follow, they found beauty in the neat and plain as well as in order, which they felt reflected heavenly order. They could find beauty in a person, as long as the feelings were not of desire. Believers could enjoy seeing the Crystal Palace in Manhattan, as long as they did not try to build such a thing themselves. And landscape, both natural and shaped by man, was open ground for visual pleasure, and there were no apparent limits on the colors, forms, and movement that nature could take that were not permitted for Shakers. The same can be said of their spiritual art, drawings and watercolors mostly, of the 1830s to the 1850s; if it was a "gift" or inspiration from heaven, believers could represent it on paper in the vivid way it came to them. If Shakers shared values or forms with the world, it was not because they tried to do so. On the contrary, they attempted in their rhetoric, theological statements, community laws, and social pressures to separate themselves

from the ideas, values, and even daily contact with the world at large. Still, one theme that will run through these pages is that the Shakers, in practice, did not differ as much from American society as is often supposed.

While this book is not a broad study of early American attitudes to visual culture, we can note here that, even in their railings against luxury, Shakers had much in common with attitudes expressed in Britain and America in the eighteenth and nineteenth centuries. On the secular side, the idea became widely accepted in British and American society in the eighteenth and early nineteenth centuries that luxury corrupts and that excessiveness in the arts (precious materials, gaudy ornament, profane subject matter, and so forth) would lead to social degeneration, as it had for the ancient Romans. A belief in the moral decay caused by desire for fancy goods was deeply ingrained in the influential writings of Scottish Enlightenment thinkers Adam Smith (1723–90), William Robertson (1721–93), and Henry Home (Lord Kames [1696–1782]), all of whom wrote about the possible corrosive effect of luxury and ostentation. Mankind, they suggested, moved from an early hunting stage to a pastoral one and then to an agricultural state. The fourth, and capstone, phase—commercial society—represented a great advance in many ways, but carried the danger that wealth would produce a thirst for luxury, weakening the moral fabric of civilization.[33] English clergyman John Brown (1715–66), describing the stages of society that peaked with the mercantile and commercial stage, wrote in 1757 how "Trade and Wealth" in Britain was leading to vanity and effeminacy among men and that a "false Delicacy" was weakening the "national Capacity."[34] Similarly, American founding fathers, including Benjamin Franklin (1706–90), George Washington (1732–99), and John Adams (1735–1826), expressed suspicion of luxuries and how they might corrupt the people in the new republic.[35] In early-nineteenth-century America, the notable series of paintings by Thomas Cole (1801–48), *The Course of Empire* (1836), centered around the corruption brought about by wealth, luxury, and ornateness in art and architecture.[36] In his widely admired *Walden* (1854), Henry David Thoreau (1817–62) called for simplicity in furniture design; he decried dusty and cluttered households. He asked, echoing the Scottish philosophers, about the nature of luxury that "enervates and destroys nations," and he called for readers to live a "simple and meagre" life and not be lured by "luxuries and comforts."[37] There was, in short, a long-standing strain of American life and thought that was in harmony with the Shaker desire for spare and functional material goods.

In the religious sphere, there were long-standing calls for the elimination of ornament and for a turn to simplicity. The Shakers often compared

themselves to the Early Christians, and one can regard the Shakers as part of a long group of sects that, beginning with the Reformation and Counter-Reformation, sought to reduce pomposity in their rituals and ornateness in their material culture. There were, of course, frequent imprecations by British and colonial American preachers against fancy goods and fashion; where sumptuary laws failed, preachers thundered that there was an innate goodness and godliness in moderation in material culture and that one should prefer the simple, well constructed, unpretentious, and functional. Closest to home, a modesty and self-imposed restraint often informed some aspects of the visual culture of the Quakers well before the Shakers came on the scene as something of an offshoot of the sect.[38]

In short, the Shakers were not the only people in Britain or America who esteemed the simple, plain, and functional. Although they seemed to enjoy fine materials, bright colors, and good design, as we will see, it was recognized at the time, and is apparent now, that a high level of restraint characterized their material culture. Some simplicity and utilitarianism were, from the time that the ancient Greek philosopher Diogenes of Sinope (d. 323 B.C.) threw away his superfluous drinking cup, a goal of many a philosopher, social theorist, or religionist, but such ideals were often disregarded in practice, making us wonder how the Shakers succeeded when other groups failed to rein in their impulses toward luxury, ornament, and fancy goods. Certainly, the community controls (laws, expectations, and the system of inspection and review by the sect's leaders) played the largest role in this regard. The Shakers had not just a philosophic or religious longing for the neat and plain, but also a community organization that helped them root out any luxuries that entered. Along with that was the isolation of the communities from the rest of the world and the establishment of their communities in rural places, away from the populous cities. Finally, the economic system lent itself to restraint and control: sect members held their goods in common, and individuals did not have incomes to spend. Rank-and-file Shakers had no money to buy luxuries and faced difficult access to places where such things were sold, and if they did have any fine goods, their elders would have spotted them and called out the possessors. In their own peculiar way, and as a result of their community organization, the Shakers managed to achieve the long-standing Western ideal of the rural community that lived uncorrupted by fancy goods, luxury imports, and other material temptations.

The documents in this book will, at least indirectly or silently, raise the timeless question about the dividing line between religion and secular life.

To be sure, the Shakers were not the first religious people about whom one can detect worldly tastes and behavior, despite their avowals to the contrary. This book is not the place to answer the questions that have long been asked about human nature and the border, or lack of one, between a religious and a secular kind of thought. Still, this study does, if anything, suggest the pervasive presence of shared aspects of human nature, including similar tastes for visual and other pleasures, that unite the human race, apart from differences in religious belief. Shakers liked to eat fruit pies, go swimming, look at landscapes, enjoy pretty faces and bodies, marvel at freaks of nature, and admire well-made and colorful buildings, sharing those interests with many other people. That commonality was true even of the most fervent believers, the ones who wrote most of the travel accounts and journals cited here. Other less powerful and less literate Shakers demonstrated their worldly sense and unity with broader human inclinations even more forcibly: by leaving the societies, and they did so in large numbers throughout the nineteenth century. Overall, the records indicate a conclusion new and unexpected: that Shakers were in many ways not so different from other people. When Ohio Shaker William Reynolds (1815–81), visiting at Canterbury, New Hampshire, got into a bathtub for the first time in 1854, his reaction was just as secular and hedonistic as what we might expect from other mortals: "About 5. Oclock P. M. we were invited to take a bath. This is one of the great luxuries we have been blest with since we left home. It is truly a blessing to be introduced to a bath of 10. inches deep and the vessel spacious enough to be lie down your whole length, fed by a teemcock [steam-cock] at the foot of the bath, and warm water enough to make it pleasant to the feel."[39] Other Shakers, as we will see, took similar delight in looking at the northern lights or at anchored ships afloat in a harbor.

Apart from the pleasures that humans typically enjoy, such as the joys of a hot bath or the sight of a waterfall, Shakers also shared ideas, cultural tastes, and critical language with the contemporary American populations of their times. Shakers had frequent contact with the outside world during travels or by speaking to visitors to their villages; believers did not live cloistered lives. Some received visits or letters from relatives in the outside world. Many Shakers grew up in the world and joined the communities only as adults. Those serving as elders or in the ministry had some access to worldly and secular literature. Some probationary Shakers did not stay long, but they brought their values and ideas with them and could have exposed them to others. There was a revolving list of residents of each community, with ongoing additions

from the outside and frequent departures from the societies. Even at their height of population in the second quarter of the nineteenth century, perhaps only one person out of four thousand in the United States was a Shaker. Believers dwelled in their own villages, but they lived in a sea of non-Shakers and shared a common national culture with them.[40] Still, despite all of the similarities and overlaps of ideas and actions between Shakers and others, the believers spent much effort carving out and affirming their own identity, and they crafted a material culture to reflect it. That the self-conscious Shakers were a peculiar and special people, or at least fervently wished to be, is also an important leading theme of this book.

Finally, in assessing the mass of Shaker documents, one can sense a remarkable unity of thought among Shakers. The structure of their communities and the radiating influences deriving from the Central Ministry and elders at New Lebanon led to a consistency of belief. Still, there were some shifts of thought over time, as we will see, and some subtle differences between men and women. One aspect of the documents should be noted before we begin our look: while there is some variety and heterogeneity in the record of Shaker documents, they are preponderantly the product of the more elite or literate men and women of the societies. That is who tended to travel and write journals, to author the Shaker histories and tracts, and to create the sect's laws and dictates. As is true of nearly all societies in the world's history, those on the top in power or education leave more writings than those at the bottom. At any rate, we have a rich record of Shaker thought, but we need to remember that it was largely written by those with the most influence, who were most committed to the faith, and who had the freedom and access to knowledge that not all Shakers shared. Given the Shaker system of organization, those in New Lebanon left more laws, ideas, and observations than did other believers, and there are more surviving records from eastern Shakers compared to western. Keeping all of this in mind, we can proceed to explore Shaker attitudes to the visual world mostly as known through their writings, a fascinating record full of frequent surprises.

THE SHAKERS AND THE HUMAN BODY
Beauty, Curiosity, and Spectacle

1

One rarely associates Shaker aesthetics with the human body, yet believers had a great deal to say about the human form, whether in its beautiful, unpleasant, or merely curious varieties. As it turns out, the Shakers shared with the broader American public many attitudes about human beauty. As many religious sect members have done over the centuries, Shakers described their founders, including Ann Lee, as beautiful, handsome, or physically strong. Shaker men noticed the presence and appearance of pretty girls. Shakers also enhanced the beauty of the human form through fine costume. In presenting themselves to each other and to the world, Shakers dressed well on Sundays and on special occasions, wearing such finery as beautiful bonnets and fur trim on their clothing. And like non-Shaker society, believers prized the movement of the human body in dance and enjoyed the rhythms, bodily attitudes, and dress of their dancers. In short, the Shakers found their own ways to admire and enjoy the sight of the human body. It was not all about beauty, however. The Shakers also had a quick eye for various human types, and they noticed the variety and occasional oddity of appearance or even ugliness of a range of people.

We might start with early accounts of the appearance of Ann Lee herself. There are no likenesses of Ann Lee that one can confirm as accurate. Mother Ann would likely never have sat for a portraitist, and no printmaker or contemporary painter who met her, if any, seems to have captured her likeness

The zeal [among Shakers at meeting] was uncommon & the countenances were lovely[;] they looked more like angels than human Beings. And I can verily say it was the most lovely sight I ever beheld.
—Kentucky Shaker Milton Robinson, visiting at New Lebanon, New York, 12 June 1831

Figure 1.1.
Attributed to
a certain "Milleson,"
Alleged Portrait of Ann Lee,
1871, engraving, about 3 x 2
inches, published in Samuel
R. Wells, "Mother Ann Lee,
the Shaker," in *Illustrated
Annuals of Phrenology and
Physiognomy for the Years
1865–6–7–8–9–70–1–2 &3*
(New York: Samuel R.
Wells, 1872), 39.

from observation. One nineteenth-century image purports to be based on an early portrait, but there is no convincing evidence that it records Ann Lee's likeness (fig. 1.1).[1]

We have to rely on written accounts and the assessments found there. These changed over time. The earliest documents stated that she was, at best, plain in appearance, but estimations of her beauty and even her height rose as time went on.

Shaker children who met her were entranced with Ann Lee's appearance. One early believer, an adoring child remembering Ann from about 1781 and reporting her thoughts some years later, grouped her, along with Shaker elders, as among the "lovely" leaders of the sect. Young Thankful E. Goodrich (1771–1858) was with the blessed Mother Ann and some Shaker elders at Niskayuna, New York, and she remembered later how "in days of my Youth the first time I see them, I was ten years Old; they then looked more lovely, to me, than any thing that I had ever seen in this World; Their soft words and beautiful Countiance fild [filled] my soul with reverance, and fear. . . . Mother Call[e]d me her Child, and said, that I might love and embrace her, I did so, and her smel[l] seamed pure[,] heavenly and angelic." Another Shaker who met Ann Lee in his youth was Timothy Hubbard (1742–1814). As recorded in the *Testimonies* of 1816 by Rufus Bishop (1774–1852), and Seth Youngs Wells, Hubbard said, "She stood erect on the floor, for the space of an hour. Her countenance was angelic, and she seemed to notice nothing of the things of time." Ann Lee is described in the *Testimonies* of 1816 by early adherent Thankful Barce (1759–1839), later at New Lebanon's community, who as a young woman met Ann at Hancock, Massachusetts, in 1780. Barce recalled the beauty of Ann Lee when she appeared before followers in a private home: "Mother was under great power of God; her soul seemed filled with joy and her countenance shone with beauty."[2]

Thankful Barce's son, Calvin Green, a historian, leader, and theologian of the sect, and educator Seth Youngs Wells, writing with Green in 1823, were more nuanced and less glowing about Ann's appearance and stature. They did call attention to her sober bearing and pensive nature: "In her childhood she discovered a very bright and active genius, was remarkably sagacious, but

serious and thoughtful."[3] As for her physical constitution, Green and Wells added: "Mother Ann Lee, in her personal appearance, was a woman rather below the common stature of women; thick set, but straight and otherwise well proportioned and regular in form and feature. Her complexion was light and fair, and her eyes were blue, but keen and penetrating." A generation later, a widely read author of the world, Benson John Lossing (1813–91), repeated Green's description: "At maturity she was rather below the common stature of women, rather thick set, but well proportioned. Her complexion was light and fair, and her eyes blue and penetrating."[4] For his part, Shaker leader Frederick W. Evans, writing in 1859, echoed Green and Wells to some extent, but improved Ann's appearance in several ways: he made Ann Lee taller (average height rather than being on the shorter side), added a soft Victorian touch about her "light ches[t]nut brown hair," wrote more than Green did about Ann's inspiring countenance, and passed along to us the judgment of a broad range of people who deemed her to be beautiful: "In appearance, Ann Lee was about the common stature of women. She was thick-set, but straight, well-proportioned, and regular in form and features. Her complexion was light and fair, blue eyes, and light ches[t]nut brown hair. Her countenance was mild and expressive, but grave and solemn. Her glance was keen and penetrating; her countenance inspired confidence and respect. Many called her beautiful."[5] It took some time, but the Shakers, like the Roman Catholics before them, had their beautiful virgin female leader.

We will discuss Shaker visions again in the final chapter, but it is worth noting here that mystical visions and dreams of Ann Lee in the nineteenth century continued to emphasize her beauty, glory, and goodness. These elevated descriptions came from those who had never met her. One vision of 1840 at New Lebanon conveyed that "the Daughter of Zion (your spiritual Mother) is adorned with glory and arrayed in heavenly beauty."[6] In recounting a vision, Grove B. Blanchard (1797–1880), of the Harvard, Massachusetts, community, on 1 March 1843 referred to "our Beautiful Mother Ann."[7] Rebecca Cox Jackson (1795–1871), an African American preacher and visionary, was visiting Watervliet from Philadelphia in January 1843 and had a vision of "blessed Mother." Associated with the Methodist Church, Jackson was transitioning toward a life with the Shakers, and she would help establish an extended Shaker society in Philadelphia in the 1850s. Likely influenced by similar visions that the established Shakers had experienced during the ongoing ecstatic Era of Manifestations, Jackson experienced a vision at Watervliet of the glory of either Ann Lee or Holy Mother Wisdom:

At night we went to meeting and while they were worshiping God, I saw the head and wings of their blessed Mother in the center of the ceiling over their heads. She appeared in a glorious color. Her face was round like a full moon, with the glory of the sun reflecting from her head, formed itself into a round circle with glorious lights reflecting from it in streams which formed a glorious crown. And her face [was] in the midst. And she was beautiful to look upon. Her wings was gold. She being in the center, she extended her golden wings across the room over the children [Shaker worshipers] with her face toward me. . . . I understood by one of the discerners that there was sixteen angels in the room that night. I only saw our Blessed Mother, and that was as much as I was able to bear.[8]

Anti-Shakers also had much to say, most of it negative, about Ann Lee's appearance and behavior. Like believers, apostates were biased, and their statements were not always based on firsthand viewings, but their accounts, many of them early in date and springing from personal acquaintance or contemporary hearsay, tell us something about early attitudes to Ann Lee and the Shakers. Apostate Thomas Brown (1766–?) described her in 1812: "Ann Lee was a woman rather short and corpulent. Her countenance was fair and pleasant, but often assumed a commanding, severe look." Addressing the visual appearance of the behavior of the Shaker leader, New York State resident Samuel Jones, an anti-Shaker but not an apostate, denounced Ann in 1825: "In the time of the Revolution, I commanded a company when we were troubled with these European Toreys." Jones stated of Ann Lee: "Her conduct was disgusting in the highest degree, she was drunk even to puking, her language profane and Indecent."[9] Apostates, like nonbelievers, sometimes called attention to the unpleasant aspects of Lee's personality and actions. David R. Lamson, who spent two years with the Shakers, was scathing:

Her followers of course must believe that she was all she pretended to be. But in the world she has the reputation of being, and there is much testimony to show that she was, an immoral woman. Intemperate, licentious, and passionate. It is testified by some who were intimate with her that she has been seen to strike the elders in anger, &c. It was testified by some of the most respectable people who lived near the Shakers in her day, that they had frequently seen her intoxicated. And on one occasion she was seen vomiting from

drunkenness. An explanation was afterwards given by one of her followers. It was, that "she was drunk, not with liquor, but with the sins of the people; which she was vomiting up."[10]

Shakers sometimes called attention to the comely qualities of the founding fathers of the sect, the equivalent of their early saints. We heard of the soft beauty that ten-year-old Thankful E. Goodrich saw in Ann Lee upon meeting her. As for Father James Whittaker, the eleven-year-old Goodrich saw him as sober, fair, and heavenly in appearance, and he spoke kindly to young Thankful: "One day he sit down and called me to him, I kneeld before him, and his countenance was solemn[,] Heavenly and sublime, and the smeel of his garments was like sweet insence, [and] he gave me some Shugar." Thomas Brown said of Whittaker that he was "majestic, commanding; authoritative look at the same time pleasant and complacent. He was of a fair complexion."[11] Writing in 1827 about early Shaker leader Joseph Meacham, Calvin Green characterized his body as well proportioned and graceful, and he noted that Meacham was graced with other fine physical features:

> Father Joseph was in person about six feet high; middling well proportioned though rather slim, his limbs rather long; was very straight and graceful in his carriage and walk; he was, also, very active and endowed with uncommon strength. His countenance was open and dignified; his eyes a bluish grey, clear and quick, and very penetrating; his hair, a dark chestnut brown; rather dark complexion: comprising altogether, an appearance that inspired confidence and united respect, and struck the beholders with a reverential awe . . . and his eyes appeared like flames of fire; so that it seemed as though they would penetrate the inmost recesses of the heart, and the stoutest hearted man would tremble in his presence.[12]

Apostate Lamson passed along the tradition that William Lee, brother of Ann, was "represented as a man of great personal beauty, and great personal strength. And while in England, as well skilled and practiced in the pugilistic art" and "rough in his manners." Frederick W. Evans added in 1859 that William Lee had a "melodious and powerful voice, and was a musical and beautiful singer."[13]

For her part, early leader Lucy Wright received positive notices about her countenance and emotional bearing. Shaker Seth Youngs Wells recorded the

appearance and mental state of Lucy Wright at Watervliet just before her death in 1821: "The next day (Sabbath) she again attended our meeting, and appeared still very cheerful & comfortable."[14] Calvin Green, who also knew Lucy, left a lengthy and worshipful description of her physical and moral appearance. He began by reporting that her husband, Elizur Goodrich (1751–1812), had said, in a statement with which some non-Shakers might not sympathize, that his nineteen-year-old bride "Lucy was so beautiful & amiable that he could not bear to spoil her with the flesh, hence they lived uncommonly continent." Green then offered his own recollection of her fine appearance:

> Mother Lucy was slightly above the medium height of women—strait, well proportioned & as complete in symetry as any person I ever saw. She had no deformity whatever. Her well formed shoulders appeared as if built for solid strength & endurance; & her solid arms, as if they were fitted for labor & accustomed thereunto. Head & neck suitably proportioned—Hair dark brown & but little gray at her decease—Face neither round nor long, but fair & symetrical. Forehead rather bold or full, indicated deep penetration & under standing—Eyes were called black—clear & penetrating, but mild & placid. Her open & serene countenance bore the impress of sincere Integrity & affability, with candor and calm consideration. Her step was elastic & firm, & all her movements were modest, graceful & becoming. No coquetry or ostentation was ever manifested in any of her words or ways. Yet her Countenance ever wore a pleasant smile, & when she smiled from effect, it was the most pleasant & beautiful smile I ever beheld on mortal face. . . . She was called handsome by the children of the world, & it cannot be denied that she was naturally handsome.

Green added the bonus that, in addition to her exterior, Lucy housed a more significant "Celestial Beauty" within her.[15]

Shaker interest in the face and body of Ann Lee and other early leaders extended to a consideration of the visual aspects of their death and also of the marks made on them from the torture by Shaker opponents. The story of the punishment of the bodies of the early Shakers runs throughout the histories of the sect. There is much in common between these Shaker accounts and those of other Christian groups, especially Roman Catholics, in that Shakers also mourned the harm done to believers and celebrated their saints' heroic submission to punishment.

Figure 1.2. Written on back: "Ann Lee's House (Shaker)," American, ca. 1920–40, postcard (black-and-white photography on cardboard), 3½ x 5½ inches, the view showing the Square House (built 1769), where Ann Lee and close followers resided from June 1781 until January 1782. (Clinton, New York, Hamilton College Library. *Photo:* Hamilton College.)

Even before coming to America, Ann Lee, according to an early Shaker history, "became like a skeleton" in Manchester because of the sufferings and tribulations she felt during her time of "conversion" to what would be Shakerism.[16] We have a number of vivid verbal accounts of early Shaker bodily suffering in America, much of which happened during the Revolutionary War and when early leaders traveled to New England, where, while proselytizing, they met with opposition from officials and angry crowds, as they did during an extended stay in Harvard, Massachusetts, in 1781 and 1782 (fig. 1.2). During these years, the Shakers were insulted and sometimes beaten and dragged about, and an 1888 revision of the *Testimonies* provided gruesome details of the early suffering, as at Shirley, Massachusetts, in June 1783:

> [The mob] then seized Elder James, tied him to the limb of a tree, near the road, cut some sticks, from the bushes, and Isaac Whitney, being chosen for one of the whippers, began the cruel work, and continued beating and scourging till his back was all in a gore of blood, and the flesh bruised to a jelly. They then untied him, and seized Father William Lee; but he chose to kneel down and be whipped, therefore

they did not tie him; but began to whip him as he stood on his knees. Notwithstanding the severity of the scourging which Elder James had already received, he immediately leaped upon Father William's back, [and] Bethiah Willard, who had followed from Jeremiah's, leaped upon Elder James' back; others, who came with Bethiah, followed the same example. But, such marks of genuine christianity only tended the more to enrage these savage persecutors, and those who attempted to manifest their love and charity in this manner, were inhumanly beaten without mercy.[17]

Some later Shakers went in reverence to the place where Father James Whittaker was whipped by a crowd. Deborah Robinson (1801–92) was passing through Harvard in 1850 and wrote of the "sympathetick feelings" evoked after seeing the place of Shaker suffering: "We went to the place where our dear Father James was tied to the limb of a tree and cruelly whip[p]ed by the wicked. . . . [W]e each placed a stone upon the pile, and reluctantly left the place." In 1854 western Shakers William Reynolds and Nancy Elam Moore (1807–89) and other believers visited and reported, "We all stood in solemn contemplative silence as we looked at the stone pile which covered the spot on which once grew the tree to which our worthy Fathers were tied."[18] The site at Harvard where James Whittaker was tied and tortured and Father William beaten is even now marked by an inscription on the "Whipping Stone" and memorial stones put there by sympathizers.

In the 1830s the Shakers at Watervliet exhumed the remains of Ann Lee, William Lee, and William Bigsley, and they were gratified to find that the bodies were in a fair shape of preservation, and the account of the inspection of their remains continues with hagiographical accounts of discovering the wounds of martyrdom. New Lebanon Shaker Rufus Bishop and a companion saw the bodies, and Bishop described it in detail in 1835:

We found them in a better state of preperation than was expected, notwithstanding they had lain in the sand more than half a century. Even the bones of the fingers & toes were in pretty good shape. . . . The Brethren prepared a small & decent coffin for each. During which preparation the society had free access to view the bones of these venerable messengers of peace and salvation. . . . Some marks of their sufferings were yet visible—On the left side of Mother's scull could be seen a fracture, said to be made when she was dr[a]gged

down stairs feet foremost by her persecutors, when at Petersham [Massachusetts].

In addition, there was a fracture on the skull of William Lee: "Also a fracture of an inch & half was plainly seen above Father William's left temple, which according to his own account when living with us, was made by some of the persecutors who gave him a severe blow with a fire-poker while in England."[19]

Having to rely on secondhand accounts, Shakers sometimes put words in the mouths of their founders to evoke images of early Shaker suffering. An inspired vision of 1843 claims to be testimony of early Shaker Richard Hocknell, son of Shaker benefactor John Hocknell. Richard was said to be remembering the early days in America for the tiny group of believers. The vision makes clear that he was loyal to Ann Lee and protected her from others, and for that, he said, "I have been many times been severely beaten. I have been struck to the earth, and have been left for dead; and when I had recovered my senses, I have more than once found that the remains of my garments and the ground beneath me, were wet with the blood that flowed from the wounds I received from the hands of our enraged persecutors."[20] Richard was a youthful martyr in this vision, his alleged suffering expressed in gory language.

Ann Lee's grave at Watervliet became a regular visiting point for nineteenth-century Shakers. For example, New Lebanon Shaker and pharmacist Alonzo Giles Hollister (1830–1911) wrote in 1857: "I visit Mother Ann's grave." Shakers did not believe in the corporeal resurrection, only that of the soul. As Benjamin S. Youngs and Seth Youngs Wells put it: "It is the soul of man alone, that is the proper subject of the Resurrection."[21] Still, the state of the body after death was of some concern, and, in the beginning, at least some Shakers believed that Ann Lee, who passed away in 1784, would not actually die. The Marquis de Lafayette (Gilbert du Motier [1757–1834]) happened to visit Watervliet soon after Ann's demise, along with François Barbé-Marbois (later the Marquis de Barbé-Marbois [1745–1837]), the secretary of the French legation to the United States. The visitors learned that Ann's death surprised and embarrassed her followers, who had believed her to be immortal.[22] Other Shakers in Canterbury, New Hampshire, expressed the opinion in 1783 to visitor William Plumer that Ann Lee and some of her closest followers would "never be subject to death" and that they would be transformed into pure spirit at the time of the Millennium and thus would never be subject to bodily rot.[23] We have seen in Rufus Bishop's account that the Shakers were pleased at the state of preservation of the bodies of Ann and William Lee and William Bigsley. Similarly, the

desire that Shaker leaders would remain relatively uncorrupt even in death extended also to the body of Lucy Wright. On 9 May 1835, Rufus Bishop noted, "This forenoon the brethren opened Mother Lucy's grave & Coffin, & moved the latter into a strait range with other's [sic]—The body had retained its shape pretty much, but the coffin was very rotten—yet so as to bear moving."[24]

While retaining their powerful interest in Ann Lee, the Shakers became more interested in her male counterpart, Jesus Christ, as the nineteenth century progressed. The shifting focus toward Christ included an interest in the purported beauty of Jesus, whose appearance is not mentioned in the Bible. In one Shaker account, Ann Lee imagined herself with Jesus as a lover. In the *Testimonies* of 1816, Ebenezer Cooley (1737–1817) stated that Ann Lee said at Hancock, Massachusetts: "When I first gained the victory over a carnal nature, I was brought into great clearness of sight. I saw the Lord Jesus and met with him, as a lover, and walked with him side by side."[25] The Shakers did not ignore the beauty of Jesus; while they did not keep paintings showing his beautiful appearance, they could put their ideas about his fine appearance in writing. In a "Book of Visions: Revelations. And Prophecies. Received at various times," by "witness Calvin Green" of the North Family at New Lebanon, in an account dated to 3 May 1828, it is written, "In my vision I appeared to be standing on a pleasant green level and beautiful situated westward of the Church at New Lebanon." The account continued: "It was a vision of the night, if called a dream," revealing like a prophecy of Old Testament times, and "whether asleep or awake my soul was continually absorbed in the same spiritual views and prophetic interpretations." Green offered a significant assessment of the beauty of Jesus Christ: "Such a beautiful, lovely, and benign countenance I never saw before." Green later inserted into the manuscript on a later page, supplementing the description earlier, as follows: "His hair was of a beautiful bright chestnut color, it was very smooth on his head not thick but it perfectly covered his head, and appeared to be cut perfectly true in a semicircle on his forehead not high up but in a handsome medium—His eyes were a deep blue color exceedingly bright[,] beautiful[,] and pleasant—He was clothed with garments of such color as I never saw, for the color appeared as if all colors were mixed together, yet each color was shown."[26]

Similarly, an appreciation of the beauty of Christ appeared in an anonymous and undated broadside, bearing the fanciful title "A Description of the Person and Character of Jesus Christ, As it was found in an ancient manuscript, sent by PUBLIUS LUTULUS, President of Judea, to the Senate of Rome."

This description of Jesus, which appears, judging from the decorated border, to date from the 1850s or so, states:

His person is tall and elegantly shaped; his aspect amiable and reverend; his hair flows in those beautiful shades which no united colors can match, falling into graceful curls below his ears, agreeably couching on his shoulders, and parting on the crown of his head like the head dress of the sect of Nazarites; his forehead is smooth and large, his cheeks without spot, save that of a lively red; his nose and mouth are formed with exquisite symmetry; his beard is thick, and suitable to the hair of his head, reaching a little below his chin, and parted in the middle like a fork; his eyes are bright, and serene. . . . [H]e seems at present, a man, for excellent beauty, and divine perfections, every way surpassing the children of men.[27]

Looking beyond Shakers' views of the appearance of the sect's founders, and Jesus Christ himself, the Shakers saw beauty and visual interest in the external personhoods of each other. They regularly referred to each other as "pretty" or "lovely." When Shakers saw beauty in each other during everyday moments, their assessments were often linked to the moral quality of those seen. Prudence Morrell (1794–1855), coming from New Lebanon with Eliza Sharp (1797–1881), also from that community, and visiting Union Village, Ohio, where both had lived earlier, wrote on 4 June 1847 of their visit to about thirty "believers in joint interest with the gathering order," remarking, "We visited the sisters in the forenoon and after dinner we saw the brethren. Some very pretty among both sexes."[28] Western Shaker Deborah Robinson, on 25 September 1850, was at Chosen Vale (in Enfield, the Shaker village sometimes called New Enfield, New Hampshire), where she and others enjoyed "a feast of Mellons, raised by our good Brother Joseph Dyre. And prepared in the nicest and sweetest manner by the pretty sisters in the Office. Here we each did our part without hesitation." Robinson was also at Enfield on 24 September 1850 and wrote, giving us a nice sense of the rhythm of daily speech among the Shakers, "Here we met many pleasant faces. Who made us wellcome, welcome, Kindly welcome here." And they enjoyed "a most delicious dinner." Milton Robinson (1807–32), who arrived from Kentucky and was at New Lebanon, wrote on 12 June 1831 of the events that he saw at a meeting of the First Order: "The zeal was uncommon & the countenances were lovely[;] they looked more

like angels than human Beings. And I can verily say it was the most lovely sight I ever beheld." Elizabeth Lovegrove (1791–1844), at the North Family's dwelling house in New Lebanon, noted on 2 April 1837 that it was a "pleasing sight" to view "Elder Ebenizar" on the afternoon meeting. On another occasion, on 10 April 1837, Lovegrove complained in her journal that the weather was inclement, "so that we are deprived of the plesant sight of the Brethren in the dooryards at the wood piles." Finding fault with the appearance of the world's people, and seeing beauty instead in her fellow believers, Shaker Susan C. Liddell (1824–1900 or later), of North Union, Ohio, visited Clinton Valley in 1857. At a Catholic girls' school, she compared the schoolgirls there unfavorably to the graceful and lovely Shakers: at a "large noble looking house," with a "neat parlor," she met with girls, "however I was not myself so much enamourd with their beauty—a exquisit grace and lovliness that some of our company were."[29]

Apostate Hervey Elkins, formerly at Enfield, New Hampshire, wrote about his days as a Shaker and the time he asked to visit the dwelling of the Senior Order there, where he marveled at the charming human presence as well as the architectural beauty:

> I had listened to the choir of musicians who, in that beautiful mansion almost every evening, aided, with the heavenly euphonies of their strains, to entrance the many who, like spirits, danced before them. But now, when the beautiful granite walls and blue roofs appeared more distinctly, and in the evening, when I saw the twinkling light emerging from hundreds of windows, and caught, by the radiation of the chandeliers of the sanctuary, the glympse of human forms, gliding like shadows, or sprites of an angelic nature in divine service, I sighed to go thither and learn the mysteries of that devotion which drew from the inferior Orders so much deference, and strife for imitation.[30]

In 1850 Rufus Bishop wrote of the trim physique of a fellow Shaker, comparing her body to that of a teenager: "Our good Sister Anna Cole [1769–1861] being 81 years old this day, made us a visit at our work shop: She looks as strait & trim as some girls are at 16 years of age." Sister Anna White (1831–1910) of New Lebanon wrote in 1857 of a recently deceased Sister Eunice: "Never shall we behold her pleasant visage or be partakers of the good she imparted from temporal labors." Shakers saw each other as physically and morally beautiful. In another instance of Shakers looking with admiration at other

Shakers, Charles Hodgdon visited Enfield, New Hampshire, from his base in Canterbury, and noted that "the doors and windows seemed to be crowded with people viewing us as we passed, as though we were some Royalists from some renowned city."[31]

Accounts by Shakers appreciating the appearance of other Shakers usually received cursory expression in print. But an apostate like Hervey Elkins, looking back on his Shaker days, could write with the freedom of one from the world, and he left a rapturous description of the beauty of a young woman at Enfield, New Hampshire. The passage, according to Hervey, was written by his then Shaker friend "Urbino," describing his beloved, but the account is rather suspiciously close to Harvey's own style of writing. At any rate, Hervey wrote:

> Her hair was of a light auburn. Her eyes, somewhat large and expanding as they turned upward in contemplation, were of a color, variable, like the undulations of the wave, absorbing or reflecting the luminous rays of day. Long eye-brows, dark, and turned upward, like the tenor of her thoughts, gave her the aspect of intelligence. . . . Her teeth were white, like ivory set in the roseate statuary of carnation. She blushed, or grew pale very suddenly,—an emblem of the quick sensibility of thought. Her hands, small, delicate and flexible, were most exquisitely moulded. Her chest, wide for her height, which was hardly middling, was healthfully and gracefully formed. The whole figure was one of grace, elegance and ease, and the very incarnation of beauty. Her grave, yet lustrous beauty, gave her the impress of a celestial being, and taught me that there was something which moulded, vivified, and influenced that heavenly statue of purity and love, which was not of earth.[32]

Accounts of Shakers looking at Shakers were not always about beauty. In the following passage, Elkins described the intensity of Shaker bodies in disaster, the passage comprising a verbal romantic picture of women putting out a fire in the village. The account recalls a painting by John Martin (1789–1854), or other scenes of pandemonium from the time, such as *The Destruction of Empire* in *The Course of Empire* (New-York Historical Society, 1836), by Thomas Cole. Elkins wrote: "Oh! the convulsive throbs, the bitter anguish, felt by every inhabitant of that beautiful, earthly palace! Think of those two hundred females, comprising all in every Order of that virgin community, with many of their female neighbors and friends, whose magnanimity brought them, not as spectators, but as

active auxiliaries, some standing to the knees in water, and dipping with all their force, others running with water amidst the eddying flames and smoke, and others yet, mounted upon the fences, and handing pails of water higher than their heads, to men upon the roofs above!" Watervliet Shaker Freegift Wells (1785–1871) went west in 1836 to join the ministry in Union Village, Ohio, and left a description of distorted Shaker bodies and faces he saw at a Sabbath meeting at South Union, Kentucky: the leader of the meeting "call'd on all the sisters that hated the flesh, & were determined to forsake it forever to come out & show themselves. The sisters rushed forward with a good deal of nerve in their limbs, & vengeance in their countenances, & manifested their detestation of the filthy beast, by a powerful gift of leaping, &c."[33]

Shakers took special delight in the beauty and charm of children in their charge, especially when the young people were singing or dancing. There was frequent opportunity to observe the young when Shakers visited other communities of believers, and the visitors wrote down their observations and reactions. Deborah Robinson was enchanted at the dancing of young believers at Canterbury, New Hampshire, on 2 October 1850. She was presented to some Shaker girls, who recited and sang. "After this they sung melodiously, and danced in different manners, so limber and hansome, that it appeared almost perfection." After the dance the girls "thanked us with so much freedom and grace. That it made them look very beautiful." A ministry visit from New Lebanon to Shirley, Massachusetts, wrote that it was "a pretty sight indeed" to see the girls there recite and sing. David R. Lamson noted the handsome movements of a teenage girl who was experiencing "beautiful visions." Of sixteen-year-old Shaker Ellen Wier, Lamson wrote in 1848: "In the gift of turning, there was no sister who could turn more handsomely, and rapidly, than she. And she had been subject to some 'beautiful visions,' her visions were sometimes refer[r]ed to by the Shakers as wonderful."[34] Young boys attracted the eyes of Shakers, especially when they were dancing or singing and when they were well dressed and behaved. At Canterbury, on 14 July 1850, the New Lebanon Ministry visited "little boys in their habitation 22 in number, a beautiful sight of well drest likely boys."[35] Similarly, at Canterbury, New Hampshire, in 1850, according to Thomas Damon (1819–80), who was at the time with the ministry at Hancock, the boys in their retiring room danced and sang, and "all their exercises were simple & beautiful."[36] Two western Shakers, Elder William Reynolds and Eldress Nancy E. Moore, were at the Second Family at Canterbury on 16 September 1854 and saw "a good looking com-

pany of youth [*sic*] boys."[37] Then, a day later at the boys' residence, the youths were sitting neatly in a row, rose up, and sang two songs, and "then they sung four more songs and labored them in a new way which looked pretty[.] They were certainly a nice well behaved set of boys I saw."[38] Traveling outside their communities, the Shakers also looked at the charms of the world's children. In 1836 young Hannah Agnew (1820–1905) was at Lake Erie on the way from Ohio to her new home in New Lebanon and enjoyed seeing a young boy on shore before boarding the boat: "The Captain's little Son, about 4 years of age, was in our company; his infant heart, was as light & gay as a new born butter fly, & as such, he flew from flower to flower, snip[p]ing with his tiny fingers, those best suiting his taste, & presented them to the home sick; looking as if he understood the heart was sad, & he would fain cheer it with the beauties of God[']s Creation."[39] Agnew found charm in the little boy and, at the same time, recognized the flowers as beauties from the hand of God.

Shakers sometimes thought about, and allegedly exhibited, the most fundamental form of the human figure, namely, the nude body, and sometimes did so in motion, and even ecstatically.[40] The earlier Shakers aroused the ire of many people, in part, it seems, because of allegations of public and private nudity, and Shaker leaders vowed to rein in excesses. Anti-Shaker Valentine Rathbun described some of the extreme behavior of the Shakers: "They meet in the night, and have been heard two miles by people, in the dead of the night; sometimes a company of them will run away to some [stranger's] house, get into it, raise a bedlam, wake up all in the house, and the neighbours round about for mile; They run about in the woods and elsewhere, hooting and tooting like owls; some of them have stripped naked in the woods, and thought they were angels, and invisible, and could go about among men and not be seen, and have lost their cloaths, and never found them again."[41] James Thacher (1754–1844), in the account of his time as physician during the American Revolution, reported in his narrative for 1778 that the Shakers danced "nearly divested of clothing," basing his account on hearsay, and he poured moral opprobrium on the Shakers for a range of delicts: "They spend whole nights in their revels, and exhibit the most unbecoming scenes, violating all rules of propriety and decency. Both sexes, nearly divested of clothing, fall to dancing in extravagant postures, and frequently whirl themselves round on one leg with inconceivable rapidity, till they fall apparently lifeless on the floor."[42] There had been a long association with nudity and purity (Adam and Eve were naked before the Fall, but covered later), and it is not impossible that some

Shakers imitated this Edenic purity in the paroxysms of their early revelries, but the world's people detected only moral corruption behind the ecstatic movements.

There was some acknowledgment among the Shakers that early excesses, including nude display, took place. Shaker enemy Thomas Brown, in his *An Account of the People called Shakers* of 1812, repeatedly claimed that Shakers danced naked, in the woods and out of the view of the world, for some purpose of demonstrating an avoidance of desires. Brown asked a Shaker if Ann Lee and followers danced naked to somehow mortify the flesh: "1803 . . . I was at Lebanon. . . . with Elder Hezekiah. . . . , Now, said I, Elder Hezekiah, I know the old believers, or church brethren and sisters, have danced naked repeatedly, under an idea, or with intention, to mortify the fleshly nature, and you have danced so with them. He replied—'Yea, once,'" but Hezekiah stated that there is no such behavior now among the Shakers.[43] Brown noted elsewhere of the Shakers: "Several things which took place, for the sake of modesty, are here omitted. . . . But . . . [Shakers] stripped themselves and danced naked, when the gift or order came from Mother Ann so to do." Early Shakers danced naked, or were ordered to do so as a "gift" or idea of one in authority, and Brown stated that those who objected or left the room were themselves denounced as "fleshly creatures—full of the flesh." The Shakers felt that they could assert that these nude dancers were not actually naked, as they were "clothed with righteousness" (2 Chron. 6:41) or "clothed with salvation" (Psalm 132:9). Daniel Rathbun (b. 1724) offered similar accounts, also putting some of the blame on orders from Shaker authority. Writing in 1785, the earliest published anti-Shaker account by an apostate, Rathbun decried the action of Elder James Whittaker, writing, "Again men and women, parents and children, dancing stark naked together; as also, men and women, parents and children going into the creek and swimming together." And Rathbun wrote later, addressing James Whittaker: "And I suppose that for you to order men and women to strip naked and dance, and go swim together, is la[s]civiousness."[44] Rathbun complained that men and women spanked each others' bare bottoms:

> Certainly they were accused of riot, and of being very unruly, for they will many of them drink hard, sing and dance all night, strip naked and spank one anothers arses, and make as much noise as they can among themselves, and to those that are opposed to them, they will judge and condemn, and sentence to hell with the most dreadful

oaths & curses; calling them boogers, devils and Sodomites; besides pushing, hunching, pulling hair, striking, biting, and spitting in their faces—see the widow Goodrich in particular, and the others almost as bad, in the most angry, venemous manner I think that ever I see any where in any case. Mark I don't mean that this is the case at all times; for there is at sometimes the greatest appearance of love and meekness.[45]

All of this seems to have been a way not toward overt sexual excitement but to test oneself and conquer the flesh. Along these lines, sometimes Shakers wrote of nudity as something to ignore and thus conquer morally. In an undated document emanating from Enfield, Connecticut, and purporting to record events of 1783, the anonymous documents seem to imply the conquest of sexual excitement or interest on the part of Father James Whittaker: "I heard Father James of Enfield Speaking to the Believers of that Purity & Redemption From Original Sin [that] was Attainable in this Life. In Obedience to the Gospel. Then went on and Said if I should now see Every Woman on the Globe as Naked as they were born into this world. I would not alter my frame and feeling in the least."[46] Shakers were capable of avoiding feelings of lust, and naked revelry and display helped them prove it to themselves.

Apostates never accepted the Shaker displays of the body, and nonbelievers interpreted such action as morally objectionable. A perhaps far-fetched account by Daniel Rathbun, either being (if true) a description of striking Shaker behavior or (if false) serving as anti-Shaker propaganda concerning what Shakers thought and did with bodies and private parts, is as follows:

And also under the mother's ministry, children do dishonor their parents I know, for I saw a young man of your company order his father to strip in the midst of a large room full of people both men and women, then seizing him by his private members, hauling him this way and that by them, chastizing him aloud for his old heavens and lust, and then taking him up and setting him upon his head and shoulders, heels upwards, then by force wrenching his naked thighs apart and taking him again by his members, and handling them in the view of all present, every way exposing his father to the utmost shame. Was not this dishonoring his parent, elder James, and breaking the command of God? the mother being present and the mover of it.[47]

Aspects of the nude body of Ann Lee would seem to be alien to Shaker thought, but they did incorporate one facet of that question into their hagiography. In a not implausible account found in early Shaker testimonies, Ann Lee herself is said to have had her genitals inspected by anti-Shakers who wanted to verify that she was a woman. While in New England during her proselytizing trip with Shaker fellows, Lee went from town to town, and either officials or self-appointed mobs would meet the Shakers and warn them out of town or confront them. Shaker histories aver that she was sometimes physically abused. At Ashfield, Massachusetts, in 1783, a mob "concluded that Mother's pretentions were an imposition [imposture] upon the people, and strongly suspected her to be a British [male] emissary, dressed in women's habit, for seditious purposes."[48] They could not believe that a woman might be a successful ringleader, and they suspected that this "Ann Lee" was actually a man. They seized her, and she was rudely and intimately inspected by two local women, who confirmed that she was indeed no male.

Apart from their own actions, and controversies about them, the Shakers did mention nudity in their writings as not just something that could excite lust, but as a state of innocence and purity. Since, again, Adam and Eve were nude before the fall from God's grace, nudity can mean purity in the Judeo-Christian tradition. Referring to those who are innocent of desire, in "Words of the Little Book. Father James' Word to the Elders, brethren and sisters of the Church. Written by his own hand for them. March 1st 1851," the instrument (writer), Miranda Barber (1819–71), saw in her vision in New Lebanon that "they are strip[p]ed of all earthly covering, naked and innocent—before God and his wittnesses, and their appearance is clear as crystal. Their countenances shine with beauty; still they are not exalted in feeling[,] neither do they know any shame for they have overcome the nature of sin in themselves."[49] In another Shaker visionary account of 1850, by a female Shaker at Harvard, Massachusetts, there is a suggestion of purity among the Native Americans who were said to have lived, as in the Garden of Eden, in a state of goodness, nudity, and fine weather. This is a remarkable imaginary account of an aboriginal person who lived with his people completely naked and who supposedly spoke at a visionist Shaker meeting: "My name is Potymus, I belong to a race called Omnipotymus, nicknamed Sectrilegurs. We lived fifteen thousand years ago: one thousand years is a century with us. We lived on this very Continent called 'America,' we had no houses; but we lived in the beautiful groves of Woonhoons. . . . We never sin[n]ed, for we never had a law,—we

were never tired, for we never worked,—we had no clothing, for our climate required none."[50]

The nudity of children and the sight of it were carefully controlled by the Shakers in a variety of contexts. It was not only the adults who might be gratified by the sight of nude children: young ones themselves were prevented from letting their perceived filthy natures lead to temptation and sin. In "A General Statement of the Holy Laws of Zion" of 1840, Shaker adults were admonished to lead children away from "various natural[,] filthy and wicked dispositions, (to which all are prone, and their strength and power over the soul is increased just in proportion as they have been gratified and indulged, from time to time)." While adults were helping children bathe, they were to monitor the young ones carefully, lest the young ones indulge themselves in sinful actions. In the "Gospel Monitor" of 1841, Shaker adults in charge of children were told to wash the young bodies completely at least once a week "but leave them not alone at such times, lest they tempt each other in some way." If children did go astray in any way and ignore orders given to them, as stated in "Mother Lucy['s] address to the Children," in "A Book of Orders, Given for the Children by Mother Lucy," 21 August 1840, they were warned: "Yea if you slight these orders, and refuse to obey, awful will be your hell."[51]

The bodies of children were sometimes subjected to corporal punishment. Later Shaker assertions, followed by modern scholarship, claiming that the sect did not use corporal punishment, are not credible.[52] It seems that young children, especially boys under twelve years of age, were regularly punished with the rod or by other means, that older children were punished when recalcitrant, and that abuses happened in isolated cases, sometimes with elements of passion, including perhaps sexual passion, involved. Still, discouragement of corporal punishment was part of the publicity of the sect, which wished to increase their population by receiving whole families and orphan children and in frank recognition by the Shakers that children were isolated and unprotected by parents, uncles, and other family members, and thus were vulnerable to abuse.

Hervey Elkins, a Shaker schoolteacher at Enfield, New Hampshire, was humane and kindly disposed toward his charges, but he acknowledged that Shaker rules allowed the striking of boys under the age of twelve with a small stick, and Elkins himself did punish boys through corporal punishment. Shaker rules did permit some corporal punishment, and even more freely than Elkins suggests. According to some rules of 1840, girls under twelve and

boys under fourteen could be punished with sticks if the teacher first got permission from superiors: with children "under the age of twelve or fourteen, who are given to lying and stealing, and who rise in open disobedience to your word and teaching . . . after having the matter fairly & truly opened to his own Elders, to make use of small rods for the correction of such children. But all kicking, pounding or striking is forbidden, saith the Law Giver in Zion." Above all, if children made "light of divine, spiritual and sacred things," then "let that child feel the severity of your spirit against all such like indulgences." But sometimes "reason and greatness of spirit" on the art of caretakers was not present, and there was arousal of sexual feelings of the punisher or other feelings of unspecified "passion." Shakers admitted this, and Elkins wrote, although he himself had not witnessed abuse of children: "Without doubt, passion sometimes induces some teachers there, as elsewhere, to pass beyond the bounds of prudence and their own judgment." Verbal admonitions against having passions aroused by children were necessary, both for the sake of the adult and to preserve the child against memory of the actions against them: a rule of 1840, "written by the hand of God Himself," stated that no one "should ever suffer themselves to meddle with a child, in any way whatever, when under the influence of madness or passion; for if you do, you will be guilty of a great sin; and I shall hold you accountable for the wicked impressions made upon that childs mind, while in a fit of your passion."[53]

All of this ties in with the question of Shaker nudity and the presence in their villages of the nude body, which was especially an issue in the earlier years. Thomas Brown, apostate, stated that in the early days, "Several [Shakers] were whipped, and some were ordered to whip themselves, as a mortification to the flesh."[54] In one sensational report, Brown asserted that in 1793, three girls were found watching flies procreate. They were forced to strip naked and whip each other as punishment for their sins. Brown wrote that

> the last instance of stripping naked and of corporeal [sic] punishment, was at Niskeuna about the year 1793: two young women, by name Abigail Lemmons, Saviah Spires and another who has since left the people and had rather her name should not be publickly mentioned, amused themselves by attending to the amour of two flies in the window: they were told by Eldress Hannah Matterson for thus gratifying their carnal inclinations, and as a mortification of the same, they must strip themselves naked and take whips she had provided and whip themselves, and then whip each other; two

happened at once to strike the third, when she cried *murder*! they were then ordered to stop, and to plunge into a brook nearby; all of this was done in the presence and under the approbation of Elder Timothy Hubbard, and Jonathan Slosson[,] one of the brethren.[55]

Similarly, claiming that Shakers in general were early on "whipped as a mortification to the flesh," Thomas Brown, in an undated incident, noted that "a young woman by the name of Elizabeth Cook, was whipped naked by [former sea captain] Noah Wheaton [1744–1834] for having desires towards a young man." There was a hearing in court, brought by the girl's father, and the girl's sister, Hannah, not wishing to condemn the Shakers, testified that her sister was not naked, since she was wearing a fillet in her hair![56] By most accounts, such public displays of the nude figure, either in nighttime ecstasy at meetings, or while swimming in groups, or during punishment, ceased or largely ended by the early years of the nineteenth century.

We have so far considered Shaker bodies. Believers also viewed and commented on outsiders, the world's people, and often judged them negatively or as curiosities. It was all but unknown for an active Shaker to write that he saw an attractive girl or a handsome man from the world, but Shakers did comment on issues of physical size, race, and other such bodily matters. Certainly, the Shakers had a dark view of the outside world and its people. The references in the Millennial Law of 1845, for example, casually refer to the world's people as "the wicked."[57] This kind of language of non-Shakers as filthy and unclean of spirit, and sometimes of body, was widespread in Shaker documents. On the other hand, Shaker travelers sometimes noted, seemingly to their surprise—presumably because they were told to expect otherwise—how well appearing and behaving were the world's people in their carriages or in train stations. Still, they spiced their (shared) journal accounts with notices of odd nonbelievers they met along the way.

We would expect that with their hard work and restrictions on overindulgence in foods, obesity would be rare among the Shakers, and that is supported by the images of their members that appear in early prints and drawings and in the earliest photographs. Not surprisingly, some Shakers commented on people who were not trim. In a meeting at her dwelling house in New Lebanon, Jane D. Knight (ca. 1804–80) in 1838 took the trouble to note the presence of what was undoubtedly a stout, middle-aged, rustic fellow: "We have meeting at home—a few French Canadians & a sort of John Bull looking personage are our Spectators."[58] In a striking passage in his journal, Isaac

Newton Youngs described at length a greatly obese child he saw in 1834 during a trip from New Lebanon to the Shaker communities in Ohio and Kentucky. He was 125 miles from Cleveland, on the water route:

> Here I saw a sight, full as remarkable as any that I have seen, viz: a boy 7 years old next Sept.—He weighs 135 lbs.! is about 4 feet tall. His name is Luke Medcalf. He was on board the boat Utica which we met. I stepped aboard to get sight of him; he sat in the gang-way so that I could not well see him. I took some sugar plums & hold out to him, he said he could not reach them! I told him he could get up & come to me. So he got up and waddled along, so that I had a chance to view him!!! A real squaddy heap![59]

Fifteen years later, Sarah Ann Lewis (1813–77), traveling in Maine from New Lebanon, where she served as trustee, saw a pleasant boy ("a likely looking lad") who, although only thirteen, weighed 226 pounds. Much slimmer, but still garnering Shaker comment and an exclaiming underline of a word, was a boy seen by the New Lebanon Ministry in or just outside a tavern some miles from Alfred, Maine, in July 1850: "a boy 14 last March he weighed 144 pounds, about 5 feet and 7 or 8 inches high a <u>monster</u>." Along similar lines, referring in 1823 to Jeremiah Mason (1768–1848), a politician in New Hampshire, New York Shaker Seth Youngs Wells wrote: "He is the tallest man, I think, I ever saw, and well proportioned in form. they say he is not far from 6 ½ feet high and weighs 300 [pounds]."[60]

Shakers sometimes expressed surprise at the nice appearance and good behavior of non-Shakers. Abigail Crossman (1807–89), traveling from New Lebanon with fellow Shakers and also with some of the world's people, was struck by the appearance of some Roman Catholics that she saw on a boat in the Hudson Valley in 1846 near Rhinebeck. Compatible with her Shaker attitudes, Crossman respected them for their quiet and reserved appearance: "We observed a singular looking people, 1 male & 2 females sitting among the shrowds, all over dress'd in black, even their caps & veils. And their appearance caused considerable excitement among the passengers. . . . One of the females said they were Nuns, but styled themselves Sisters of Charity. Their deportment was moddest & much reserved."[61]

Like other nineteenth-century Americans, who were happy to pay for and attend circus displays or other exhibits of unusual physical types of people, Shakers were interested in the sight of odd, different, or disabled bodies,

whether Shakers or not.[62] They did not always comment with sympathy toward the individuals in question. At New Lebanon, Elder Rufus Bishop recorded in 1835: "A piece of a man from Albany attended public meeting to day, & called at the Office afterwards—It was said that he was born without feet. He had knee joint & short stumps below—He professed to be a Ventriloquist." Sarah Ann Lewis, visiting from New Lebanon, was in 1849 at Enfield, Connecticut, at the West Family, and met a "Portigue" (Portuguese) man who was "always a laughing." She also sketched a verbal caricature of another participant and even mocked his religious feelings: "And another man, who sung with his mouth very much twisted, & his eyes turn'd to things above." At Harvard, Massachusetts, on 14 August 1846, Abigail Crossman, before going to see the spot where Father James was whipped, took the trouble to record another body; she saw a girl "about 16 years of age, an entire fool—She could do nothing but grunt & howl, the spittle running from both corners of her mouth. This was caused by fits."[63]

The Shakers often commented negatively on the moral qualities as well as the appearance and customs of non-Shakers. Isaac Newton Youngs, from New Lebanon, passed through Louisville, Kentucky, on 15 September 1834 and thought the city fine in appearance, but believed that "its prosperity is fettered by the bands of slavery." The pacifist Shakers disliked the military establishment and armaments and sometimes disapproved of the appearance and behavior of soldiers themselves. Thomas Damon was returning to Hancock in 1848, during a time of war, and complained of the soldiers he saw: "Returned to Hancock. We passed in the Albany train of cars some 4 or 500 of the Massachusetts volunteers who were returning from Mexico to Boston. A more disgusting, dirty set of human beings I never saw. Such is the condition to which war reduces its votaries."[64] On a lighter note, Irish immigrant and New Lebanon Shaker John M. Brown (1824–75) did include himself in a negative but mirthful account of the appearance of swimmers in July 1866, comprising non-Shakers as well, in a dip at Coney Island; he enjoyed the "gentle rolling waves" and the "beautiful Sea breeze, & its reviving waters," but "six of us went in, three of each sex; we made a grotesque appearance."[65]

Another moral conclusion about the bodies and movements of the world's people appeared in Hervey Elkins's scathing account, written soon after he had left the community of believers, of upper-class New England women; he viewed them with the eye and sympathetic moral sensibility of a Shaker: "I entered . . . your palaces. . . . Genteel women—the goddesses of these mansion, bedecked with jewelry and dressed in satin—glided slowly

from one apartment to another, suffering for a portion of that labor, which, required of others in excess, destroyed their health and life." Elkins believed that the luxury of the rich produced or fed upon poverty, and, in addition to corrupting the rich, excess by the rich weakened the bodies and destroyed the lives of the poor in America. Elkins was more reassured about the moral world in the universities and scientific locations, and he approved of the life purpose, outward appearance, and unpretentious clothing of the students and professors: "I entered your collegiate halls, your laboratories, and your observatories. I there found intelligent and plainly dressed men searching for the recondite treasures of knowledge, which would never fade away;— universal and infinite truths! This was noble."[66]

Shakers sometimes encountered and described black people. As early as 1790, Congressman William Loughton Smith (1758–1812) of South Carolina visited New Lebanon and saw "two negroes among the dancers; one of them was the best dancer there."[67] Over time, in addition to a small number of black Shakers in various communities, there arose in the second half of the nineteenth century a small community of Shakers, mostly African American women, who resided in Philadelphia; that urban group, with adherents living in different residence in the city, seemed to have endured through the first decade of the twentieth century. Shakers were also solidly abolitionist, an attitude not uncommon in New York and New England. But, despite their willingness to be inclusive, egalitarian reputations, and abolitionist leanings, Shakers sometimes poked fun at blacks and held at least some prejudices similar to those harbored by other Americans. One writer in 1847, among a "load [group] of Shakers" visiting Massachusetts from Watervliet, wrote the following, with a physical description of an African American "with very fat lips," and the account includes a slight of the "rubbish" of whites present:

I must not forget to mention that the only case of persecution we met with, while we were gone, was this, at a Tavern where we stopped for refreshment, &c[.] while sitting in the front room, an old brother Affrican, with very fat lips, got into the stoop, & began to talk and dance Shaker and act out many curious tricks, as he thought, in derision of the Shakers, which excited some carnal mirth & laughter from the by-standers round the door & in the street—indeed we could hardly keep our own sober faces on, however we soon left them behind with the rest of the rubbish, & it did no particular or serious injury, as we know of.

The Shaker writer showed some sympathy with the world's people by noting that the group of believers was generally treated well the whole time, "with the exception of the above mentioned case, of the poor old Affrican."[68] In addition to the racial issues involved, the account gives some insight into how non-Shakers caricatured the sect, the parody performed by one person but enjoyed by a small audience beyond that.

Viewings by Shakers of African Americans occurred frequently in Kentucky, but less often in New England or upstate New York, and rare enough there for a vivid comment by Canterbury Shaker Henry Clay Blinn (1824–1905) in 1853. Traveling at Williamstown, Massachusetts, Elder Blinn saw "a family of the colored race," the first he had seen since traveling: "They were as black as midnight." The blacks, for their part, were apparently amused, to the amusement of Blinn, at the sight of the Shakers ("really we appeared to excite their mirth"), and Blinn, writing for the entertainment of the Shakers back home, speculated that the blacks perhaps felt themselves "a grade higher in the scale."[69] Similarly, also in a pejorative attitude, Watervliet Shaker Freegift Wells thought it mirthful that black men would be dressed in fine fashion, for he wrote on 13 September 1861, having enjoyed food at a dining establishment in Manhattan on the way back home to Watervliet, that he had had a "first rate breakfast which was served up entirely by darkies dressed like gentlemen." Sympathy between races was also possible, however. In 1856 Philip Burlingame (1794–1866), of Enfield, Connecticut, and other Shakers went to the worldly "Cahoosie Village" (Cohoes) near Watervliet. Children and adults sang to them, and the believers seemed to have gone out of their way to meet the black children among them: "They sung very beautifully to us[.] There were two colored boys among them[;] we had a very good visit with them, also with their caretaker Alexander Youngs."[70]

The abolitionist Shakers also criticized whites as well, harsh words coming particularly from northeastern Shakers traveling in slaveholding areas. Prudence Morrell, on the way to Pleasant Hill, Kentucky, on 17 August 1847, took careful note of the people she saw along the way, including their race relations: "There is nothing scarcely to be seen on this road but stones and rocks, hills and hollows, ticks and giggers, cabins and dogs, black children and hogs, horses and mules, slaves and slaveholders, and the like." Finer for the scenery and condition of the roadway was Morrell's trip on 19 August 1847, but she had a low assessment of the languorous white people. On the road to Pleasant Hill from South Union, she wrote that "this afternoon we passed thro a very handsome country on the turnpike. We went thro Harrodsburg, some

very elegant buildings and a great many lazy whites." She had a few days earlier, traveling from South Union to Pleasant Hill, complained of "the coloured people at work, but the lazy whites sitting [a]round."[71]

Shakers took the opportunity to describe their encounters with Native Americans, and they were struck by their appearance. Most of these accounts come from eastern Shakers traveling in Ohio, where the population of Native Americans was larger than that in New York and New England and the Native peoples closer to their early traditions in dress and manner of living. In Ohio three Shaker leaders were pleased at the plain and decent garb of a tribe's "Prophet," or holy man, in 1807: "He was divested of all his tinkling ornaments but a round tire on his breast, that fastened his garments. His dress was plain & decent, his countenance grave & solemn, his person a common size, rather slender & of no great appearance." Shakers often had ecstatic visions of ethnic and racial types and a variety of people, and we will see some of that in the last chapter. Sometimes, the line is blurred between fact and fiction. The following improbable account, which includes mention of blacks and Native Americans, might seem to some modern viewers to be based on real events, but Shaker readers would have understood it as the fictional narrative it is. On 4 October 1850, at Canterbury, New Hampshire, returning from the feast grounds, Hancock Shaker Thomas Damon visited an "Indian Wigwam for further entertainment[.] Here a real pow wow commenced—all sorts of antics were performed in honor of the 'shiny whitys['] who had made them a visit. Garlands of creeping vines and wild wood flowers were wound around & entwined about our hats & bonnets." Then, they enjoyed fiddling at the nearby "blacks quarters." Next, the groups of blacks and Indians were said to have begun fighting with each other.[72] This fantasy account of racial conflict and mayhem formed a kind of low entertainment for Shaker readers.

We might turn at this point to questions concerning the Shaker body in motion and appearance in daily life, including control of it by Shaker authorities. Shaker life and control of each other had much to do with intensely viewing the human body and face. One of the pillars of the sect's belief was in confession and reconciliation with the group, and Shaker authorities looked for signs of submission, guilt, pride, obstinacy, obedience, and lust. They watched each other dancing and marching (they often called the same actions "exercises" or "laboring"), and during weekly union meetings (periodic conversations across a room between small numbers of males and females) a Shaker in authority looked for signs of interest or flirtation between the sexes. In short, sight was used for control as well as admiration, and there was a persistent

suspicion that sins were hidden from view of those in authority. In a statement from the leadership of New Lebanon in 1859, it is written: "O ye children of my Zion, saith the Lord, and ye who inhabit the dwellings that have been consecrated to the Lord your God; My spirit is grieved with the crooked and deceitful workings of souls, in striving to cover from mine eyes, and hide from my chosen witnesses [that is, Shaker leaders], secret abominations and willful transgressions of my Holy and sacred laws." The always useful Hervey Elkins described the anti-amorous spies employed during occasional union meetings, in which the different sexes (each "six, eight, or ten in number") faced each other, seated, for conversation: "An hour passes away very agreeably and even rapturously with those who there chance to meet with an especial favorite; succeeded soon however, when soft words, and kind, concentrated looks, become obvious to the jealous eye of a female espionage, by the agonies of a separation."[73]

Apart from glances and intentions, Shakers studied and monitored the bodily movements of other Shakers. They liked orderly and uniform bodily movement, just as they liked well-maintained, clean villages and tidy gardens, and enforced various rules in this regard. Calvin Green, conveying the thoughts of Lucy Wright, wrote her admonition: "It was very unbecoming for the people of God, to sit awkwardly, crooked, & lounging in the chairs, especially where Brethren and Sisters were present. They ought to sit strait & modest. . . . [Y]ou ought not to lean your chairs against the wall ceiling [sic], beds or any other furniture, but sit up decently." Some of the regulations bringing about such uniformity and control were quite detailed and even petty, such as the rules about folding the hands: according to the Millennial Laws of 1845, under "Miscellanious Rules & Counsels," "When we clasp our hands, our right thumb and fingers should be above our left, as uniformity is comely."[74] There is no religious or other symbolic reason for this given, and it is stated, as was a widespread Shaker belief, that comeliness would result from that restrained and uniform action. The Millennial Laws of 1845 included antiblinking injunctions to the list of rules, probably to keep members of different sexes from sending messages to each other: "When brethren and sisters come together to support union, their conversation should be open and general; and no whispering nor blinking may be done at such times; and blinking should never be practiced, it is not becoming for Believers."[75] Elkins also noted that blinking was forbidden during prayer at table. Of course, cleanliness was demanded at appropriate times; the Millennial Laws of 1845 required that, in going to meeting, all should be clean in body and mind: "All are required to present

themselves to worship, with clean hands, and a pure heart, and a justified conscience."[76]

Silence and controlled movements were required while going through Shaker interior spaces. According to the Millennial Laws of 1845: "Believers are required by the orders of God, to retire to their rooms in silence, for the space of half an hour, and labor for a sense of the gospel, before attending meeting," and "All should go into meeting in the fear of God, walking upon their toes, two abreast, if the passway be sufficiently wide to admit of it, keeping step together; and none should have any talking[,] laughing, or hanging on the railing, while going to, or coming from meeting." Further in the 1845 laws, it demands, "There must be no unnecessary conversation after evening meetings, and none at all in bed, unless absolutely necessary."[77] And for good measure, Shakers rules insisted one had to "lie straight" and "be still and peacible" at night in bed, presumably with legs distended and parallel, and "No one should talk while eating, and no one present should talk to a person that is eating unless it be very necessary."[78] That silence was a Shaker habit from the earliest time is suggested by a non-Shaker, reformer and journalist William Goodell (1792–1878), who was born in 1792 in Chenango County, New York. His father lived in New Lebanon, New York, and came across the Shakers early on, and the story passed down in the family that the Shakers "at supper . . . sat a long time in silence, interrupted only by unearthly groans with sudden twitchings of the limbs and grim contortions of countenance. At length, they brightened up and began to eat, bidding him a renewed welcome, and relapsing again into silence."[79]

Shakers found a quiet and beautiful poetry and godliness in the silent, orderly, and symmetrical movement of groups of people through space, as when leaving the dining hall: marching in line divided by genders, turning corners at right angles, passing through in silence and single file, walking softly and closing doors quietly. But apostates offered objections to these controls of the body to make them "comely" to other Shakers. Apostate David R. Lamson offered what he believed to be the Shaker reason for these admonitions to silence: "All heavy walking or loud talking in the halls of the house, is strictly forbidden. And it is alledged as a reason, that such things displease the invisible Spirits which are constantly present." He concluded, harshly, that "Shakerism is therefore nothing more nor less than a system of slavery, carried on by cunning and fraud." Apostate and Shaker opponent John McBride, writing in 1834, reported that all of the ordering of movement, including the kneeling, the orderly sleeping, the silence, the low voices, circular marching,

and so forth, was suspect on theological grounds, but he acknowledged in a numbered list that "all" would agree, especially the Shakers, that these quiet rituals were beautiful: "16. Now I suppose it will be granted by all that those orders were beautiful; but why is it that Jesus Christ never taught the people such orders as these. It is obvious, for the Jews had enough of such outward beauty. 17. So that Jesus had to remind them of the necessity of making clean the inside of the cup and platter; shewing them that in making the inside clean[,] the outside would be clean also."[80]

The Shaker human body was clad in ways that corresponded to their ideas of uniformity, simplicity, and beauty in restraint. Shakers banned or otherwise discouraged ornate or fancy clothing, but they wore clothing finer than one might think, as we will see. Shakers were mostly interested in avoiding fashion, that is, they refused to follow the world and update their styles to keep up with current trends. They were also desirous of having some uniformity of dress among those of different ages and genders so as to create a sense of harmony both in a village and in the sect in general across geography. The Millennial Laws of 1845 stated, "All should be dressed in uniform, as near as consistant, when assembled to worship God, especially on the Sabbath."[81] Similarly, an injunction of 1841 stated, "Do not look upon that which the world bring among you with a pleasing eye" and prefer instead "that uniformity, which is the adorning of God's people." Shakers should ask themselves this question: "How can you think that cloth made among the world, is <u>prittier</u> than that made by your own hands?" The advice continued: "Peace, harmony, and Heavenly Order, surrounded by neatness and uniformity, form a kingdom of beauty; which is a heavenly Paradise upon earth."[82] And, on paper at least, the rules often suggested a restricted appearance of Shaker clothing, and Shakers in daily life wore much brownish drab, grays, and umber garments, often with coarse cloth. Along these restrictive lines, a remark recorded in 1840 but said to be by Lucy Wright (who died in 1821) expressed a negative thought about green veils, about which Mother Lucy said, "They look very homely on my children." This same kind of advice appears in "A General Statement of the Holy Laws of Zion" of 7 May 1840, said to be written by an angel and "by the hand of God Himself," and given to two anointed ones at New Lebanon to pass on to other Shakers: all Shakers should "clothe their persons alike" and not "break the uniformity," and "all adorning of your persons in any way, for look's sake, beyond the standard given, is forbidden."[83]

Adults were charged with controlling the dress of children. The New Lebanon "Gospel Monitor" of 1841 advised the adults in charge to provide

education but "without fables, news prints, novels, picture books, primers and such like which are injurious studies for Mother[']s little ones." The "Gospel Monitor" added an injunction, including a worry that an outside family would send in anything too fancy to the child in the Shaker village: dress little ones "neat & comely, but put no superfluous garments upon them. Dress none, over ten years old, in calico of any kind or in garments of gay colors," and send back any "fine and gay articles & garments" to the family outside. A writer from the world, Benson John Lossing found at New Lebanon serenity, placidity, and peace and thought that the children looked dressed like little proper adults: "As I walked into the village, serenity and peace seemed to pervade the very air! Placidity dwelt upon every face I met. And there were children, too, with cheerful faces peering out from their broad hats and deep bonnets, for they were all dressed like old men and women."[84]

There were three general types of Shaker clothing or ideas about them. First was everyday work clothing, which tended toward the drab or mundane. Second, there was finer clothing to be worn on the Sabbath, or at meetings at the Feast Grounds, or potentially other occasions (fig. 1.3). Official suggestions for clothes to wear and documents about Shaker garb point to a kind of elegant, restrained beauty for the best Shaker clothes. Finally, there were fantasies about clothing to wear; we will explore Shaker visions and fantasies in the fifth chapter, but we might note one example of this here. In "A Little Book containing a short word from Holy Mother Wisdom," dated to 1842 and apparently originating from New Lebanon, it states that Mother Ann and Father William had prepared for Shakers on earth various holy and symbolic garments. Men could wear a "jacket of a sky blue color, also with gold buttons thereon, and on these buttons are wrought in fine needle work, many elegant and pretty flowers, of different colors." For women, it was stated that they could wear a "gown of heavenly brightness, even like that of the Brethrens Coats, which have twelve very beautiful colors and do shine exceedingly, these are emblems of holiness, virtue, and purity. . . . A Bonnet of silver color, trim[m]ed with white ribbon, also a pair of blue silk Gloves."[85] A document such as this, even if inspirational and mystical, indicates at least an aspiration toward luxury, color, and fine materials, the kind of sentiment that did lead to some finery for actual garments for the Sabbath and other special days or occasions.

The insistence on uniformity and fashionlessness did not preclude the wearing of nice clothing made with fine materials. Of course, during the week, the Shakers were working hard and needed simple clothing of hardy materials

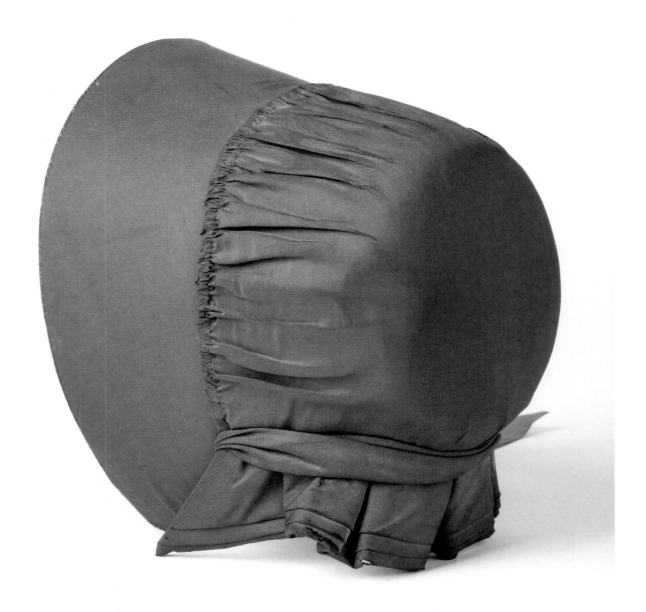

Figure 1.3. Unknown maker, Shaker Community, *Bonnet, Female*, 1800–30, silk, paperboard, cotton, and linen, 10 x 7¾ inches. (Winterthur, Delaware, Winterthur Museum, Garden and Library. Gift of Davison B. Hawthorne, 2012.24.189. *Photo:* Winterthur.)

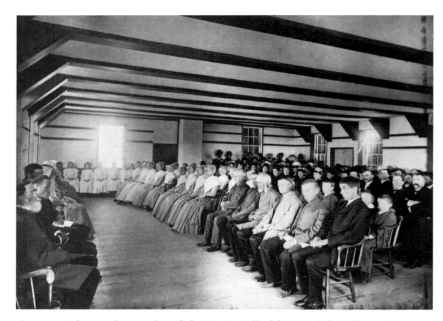

Figure 1.4. Unknown photographer, *Shaker Meeting, Sabbathday Lake Shaker Village*, 20 September 1885, glass-plate negative, 5 x 7 inches. (Sabbathday Lake, New Gloucester, Maine, Collection of the United Society of Shakers. *Photo*: United Society of Shakers.)

was true of laboring non-Shakers in America. On Sundays the clothing could be finer, and attire was often noted for its style, materials, and, of course, cleanliness and good condition (fig. 1.4).[86] Shaker sense of style was good enough for the world, and in the late nineteenth century Shakers produced a line of clothing, adapted from their own styles, that sold widely. Benson John Lossing described in 1857 Shaker women's shoes that were "made of prunella, of a brilliant ultramarine blue."[87] Rufus Bishop noted in his daybook in 1847 his work on good-quality cloth for making coats: "I finished a fine broad cloth coat which I lately cut for John Meacham." And in 1851 Bishop wrote, "This day I finished a fine Broadcloth coat which I lately cut for Charles Bracket[t]." For his part, Kentucky Shaker Milton Robinson, who was allowed to travel across the nation because of his declining health from consumption, was no Shaker authority leader or theologian and had a less guarded attitude toward pleasure than, say, a Shaker elder or eldress, and Robinson was happy to acknowledge openly that he got "genteel" clothing as a gift from Shakers in 1831 in New Lebanon, an unusual use of that word by a Shaker. He referred to the work of

Sally Smith (or Sarah Smith [1803–69]), who was a hat and bonnet maker at the New Lebanon community: "Also this evening I received from the Sisters by the hands of Sally Smith (acting Deaconess) a neat & pleasant Summer hat & also a genteel & handsome frock for to wear to meetings at home & Sabbath evenings." An admonition of 26 April 1842 concerns how young Shaker women should not indulge a fancy for garments, but some of the content of the document actually points to a persistent Shaker taste for finery. The statement was written at New Lebanon, supposedly by Olive Spencer (1778–1834), who had died eight years before. The conceit of the document is that Spencer was at that time actually in heaven and able to pass along to living Shakers the concerns of Mother Ann Lee. The statement asks that girls avoid "fine[,] nice and costly clothing, which the young mind is so constantly craving." The documents suggests that "new fine gloves" and "fine cotton stockings" not be given to girls under the age of twenty, implying that they could be and were supplied to those twenty and older.[88]

The informative Hervey Elkins, who wrote as both an apostate and a recent Shaker, more than once offers insight into the pleasing aspects of Shaker life, and here is what he says about Shaker clothing. Elkins, at Enfield, New Hampshire, wrote of how his friend Urbino described to him the attractive dress of his Shaker beloved: "She was clad with a dress of dark, pressed worsted, which dazzled and rustled by the slightest movement. Her cap, vandyke and scarf were of the purest white, plated, ruffled and starched in minute conformity to Shaker rules. The scarf thrown over her shoulders, formed a perfect isosocles over her bust, and another upon the back, extending below the scapulas to the natural waist." This does not sound like asceticism in dress. Elsewhere, Elkins called attention to Shaker rules, but the description suggests that Shaker clothing was endowed with color, variety, and touches of fur:

> The costume in every bishoprick, in every order, and by all classes, is subjected to the following rules. Hats drab, crown four and a half inches high, rim from four to five inches in width according to the wearer's breadth of shoulders—the best are of beaver, but the fur of the Russia rabbit is mostly used. All woolen garments for winter use, with the exception of pantaloons, shall be of a brownish drab; pantaloons of a reddish brown or claret. Summer vests of a light blue; pantaloons, striped blue and white. Females' winter dress, wine colored alapacca, druggett or worsted; capuchins drab; riding cloaks deep blue; caps white muslin, and bordered with lace, not crimpled,

but smooth and starched stiff; vandyke of the same material; scarf white muslin, or white silk; palm bonnets, of a cylindrical ungula shape, lined with white silk, and furnished with a veil of white lace; shoes, high heeled, similar to those worn by females half a century ago. Summer dress white muslin or very light striped.

Again, this is in line with country dress in early America, and the emphasis as usual is with avoiding fashion and sometimes retaining a style that the world would consider to be old-fashioned ("similar to those worn by females half a century ago"). Elkins also described the beautiful texture of a Shaker hat: "Four [boys] reserved for braiding palm hats, besides braiding twenty of these, (some of beautiful texture) cleft the wood for two hundred fires." Similarly, Prudence Morrell, at Union Village, Ohio, on 28 July 1847, noted the sisters of the Second Order making "handsome" handkerchiefs: "Saw the sisters weaving silk hand-kercheifs; they were white plain cloth with a twill'd border, they are very handsome, and better than any they can buy to wear to meeting." The Millennial Laws of 1845 insist, "Silk hat bands may not be worn, except on fur hats, for nice use." Shaker Charles Hodgdon, visiting in Enfield, New Hampshire, from his home in Canterbury, had a sense of the "beautiful" clothing on the persons of the Shakers, especially garments for special occasions, an opinion that he wrote down after he became an apostate. Like other Americans, Shakers had their Sunday finery (fig. 1.5): "Their clothing is of a drab colour among the men, and their Sabbath clothes are very fine and nice, and changed immediately after meeting.—The men have from three to four suits. The women generally wear what is called oil-nut colour, but they have different kinds of wearing apparel. The men wear wide rimmed hats, made of furs principally. They [sic] women wear caps, which are kept very white and clean, without any ruffles. They wear a fine linen handkerchief about their neck, of a beautiful check of blue and white."[89]

Even though fine materials like silk and fur and rich reds and blues were commonplace, many Shakers pushed even beyond that for individual fashion. One such person, Ransom Parks, was called to account by the elders at Watervliet in 1845 after having repeated verbal conflicts with those in authority in the community. After much discussion and after a period of time for reflection, by mutual agreement the troublemaker left the Shakers. It was noted incidentally in the records that the elders knew of "a pair of fine Boots, then in making for Ransom, with deep red Morocco tops, turned down about three inches, extravigantly stiched with lining upon the back, part of the pale

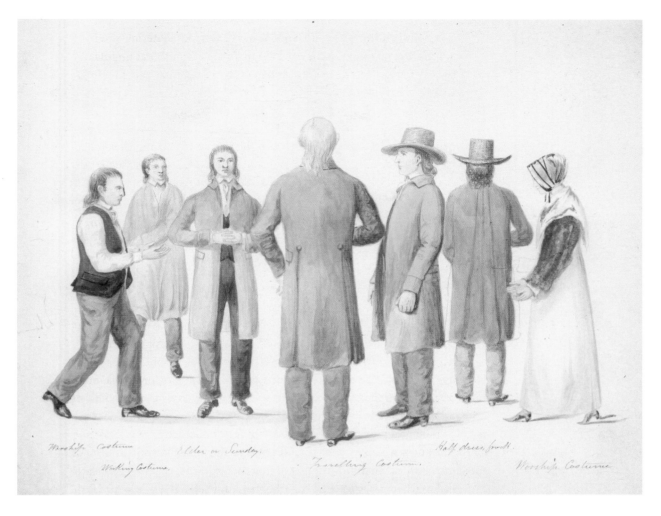

Worship Costume Elder on Sunday. Half dress frock.

Working Costume. Travelling Costume. Worship Costume

Figure 1.5. Benson John Lossing, *Shaker Costume [New Lebanon]*, undated (ca. 1856?), watercolor on paper, 5 x 8 inches. (San Marino, California, Huntington Library. *Photo:* Huntington Library.)

red d[itt]o.—which thing or fashion was no wise allowable in our Society, as he was very well aware." Parks had a taste for fine boots that had not been suppressed by Shaker expectations of him.[90]

A telling early document suggests that the Shakers themselves thought their varied dress not economical, despite any laws about excess of forms and materials. In the 1866 "Circular Concerning the Dress of Believers," signed by the "Ministry, Mount Lebanon, N.Y." and attributed to Giles Bushnell Avery (1815–90), appointed to the ministry in 1859, we read that uniformity of dress and so forth contributes to "unanimity of feeling" and "peace and union in spirit." Similarly, dress codes make "Zion's children feel like Brethren and Sisters when meeting each other, either at *home* or *abroad*, from appearance." But, he

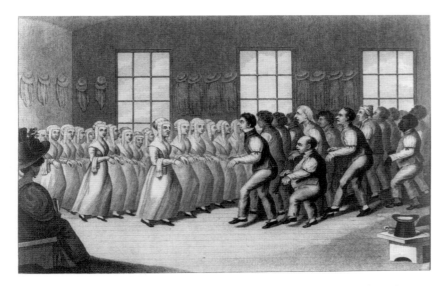

Figure 1.6. Unknown artist, "Shakers near Lebanon state of N York. their mode of Worship. Drawn from Life," ca. 1829–30, stipple line engraving, 15¾ x 13¼ inches. (Washington, D.C., Library of Congress, Prints and Photographs Division. *Photo:* Library of Congress.)

laments, "few people on earth, in proportion to their numbers, spend so much for dress, as do the Shakers," in part because there is "such a variety of clothing on hand at once."[91] The injunction returns to the chief Shaker theme of avoiding "Fashion" and calls for uniformity as an aspect of beauty: "*Mere Fashion* is a cruel tyrant, but, consistency is [a] jewel; and constancy in consistency, is a diadem of beauty." So this document points to another aspect of Shaker clothing: despite whatever uniformity or stepping away from the dictates of fashion, it was still possible to achieve a kind of indulgence through the number of outfits owned by each Shaker. Already in 1856, Isaac Newton Youngs lamented that the variety and quality of Shaker dress "is a great expense to us," even with some attempts at achieving "uniformity and Economy."[92]

We have discussed the Shaker face and body and Shaker clothing; we might turn now to the Shaker marching and dancing, those exercises (or "laboring") that were so striking for visitors to watch. The Shakers are rare for an American religious sect for being widely known via their unofficial title by the motion of their bodies. Their early shaking and spasms received almost universal scorn from the world, but by the early nineteenth century they had solidified their pattern of synchronized marching and dancing into motions

that were beautiful to Shakers (fig. 1.6).[93] We have seen some positive references to beautiful twirling by young Shakers. In the sphere of marching, Rufus Bishop extolled the controlled steps executed at a religious ceremony on the Holy Mount on 16 June 1850 at New Lebanon, and he suggested that the world's people enjoyed it as well: "It was indeed a beautiful sight to see so many virgin followers of the Lamb[,] say about 400 of both sexes, beating the heavenly marches up and down the mountain, 4 a breast a distance of nearly 2 miles; 2 males on the right and 2 females on the left hand. There were many of the children of this world that followed us to the Sacred ground with their horses and carriages, and they generally remained till they were dismissed." He noted earlier, on 24 September 1837, how a Sabbath service served as visual path to confirming faith, where some doubted the mystical aspect of the visions and trances at first, but now "they must believe their own eyes." Later that year, on 24 December 1837, in an event filled with trances, believers lying down as if dead, and other movements and postures, the actions also included "beautiful" movements of the body in turning: "They formed 3 circles, 2 a breast in each. The first & third turned to the left, & the 2nd to the right, & it was a beautiful sight."[94]

Motions of the body and spontaneous worship of the earliest Shakers bore little resemblance to the orderly steps and marches that developed over time. Again, early Shaker opponent Valentine Rathbun is a useful guide. Although various religious sects before had behaved in ecstatic ways, from the point of view of an American in 1780, it was a new form of worship:

> The manner and form of their worship is entirely new, and different from all others: it differs but little on the Sabbath, from any other day: They begin by sitting down, and shaking their heads, in a violent manner, turning their heads half round, so that their face looks over each shoulder, their eyes being shut; while they are thus shaking, one will begin to sing some odd tune, without words or rule; after a while another will strike in; and then another; and after a while they all fall in, and make a strange charm:—Some singing without words, and some with an unknown tongue or muster, and some with a mixture of English: The mother so called, minds to strike such notes as makes a concord, and so form the charm.

Then, they break off as individuals:

Every one acts for himself, and almost every one different from the other; one will stand with his arms extended, acting over odd postures, which they call a sign; another will be dancing, and sometimes hopping on one leg about the floor; another will fall to turning round, so swift that if it be a woman, her cloaths will be so filled with the wind, as though they were kept out by a hoop; another will prostrate on the floor, another will be talking with somebody; and some sitting by, smoking their pipe; groaning most dismally; some trembling extremely; other acting as though all their nerves were convuls'd; others swinging their arms, with all vigor, as though they were turning a wheel, &c.

They also shook their heads and prayed during meals, and Rathbun emphasizes that their Sabbath meetings differed little from this kind of ecstatic dancing, shaking, speaking in tongues, and falling down. Rathbun summarizes by giving his assessment of the power of the message to him at that time. He recognized that they worked hard to keep their visitors enthralled and invented details for "their adherents, as they are ever studying new things, to keep up the dependence, and admiration of their disciples." He concludes: "There is a very extraordinary and uncommon power attends their instructions. . . . A strange power begins to come on, and takes place in the body. . . . I can compare it to nothing nearer in its feelings, than the operation of an electerising machine; the person believes it is the power of God, and therefore dare not resist, but wholly gives way to it."[95] The movements and attitudes clearly did not please Rathbun.

Soon, the Shakers turned more to controlled dance than spontaneous ecstasy. Shaker dance, like their other art forms, comprised the sensuous (motion of the body, exertion, and sweating) with the restrained, the latter brought about by geometric and restricted patterns of motion and lack of touch between the sexes. The useful Isaac Newton Youngs, writing a history of Shakers at New Lebanon in 1856, noted that for 1787 and later, "F'r[.] Joseph [Meacham] introduced a regular form of exercise, in the worship, in which the assembly exercised in rank and file, in what was called the square order shuffle." For other orderly steps, the Shakers introduced, two years later, "the Square Step" and after that "the skipping Manner," the "Back Manner," and, during the time of the Era of Manifestations, the more freewheeling "Whirling Gift."[96] Shakers liked to dance, march, and labor and to see each other do so. In a letter of 28 November 1826 to his father, recent convert William S. Byrd

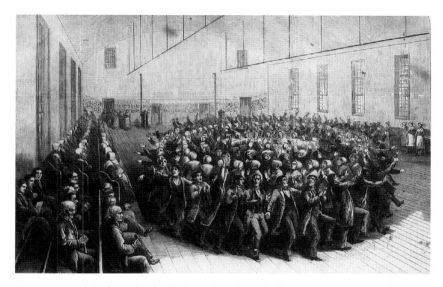

Figure 1.7. Joseph Becker ("sketched by"), *New York State. The Shakers of New Lebanon. Religious Exercises in the Meeting-House*, in *Frank Leslie's Illustrated Newspaper*, 1 November 1873, 124, accompanying the unsigned article on page 127, "Dancing Religious Exercises of the Shakers, New Lebanon," wood engraving, 9¼ x 14 inches.

(1806–29) remarked on the beauty of newly introduced Shaker dancing forms, and he compared them favorably to previous dancing that the father would have known at the Pleasant Hill community: "The Society [at Pleasant Hill, Kentucky] have gotten several new modes of worshipping in the dance from the Eastward, which are very beautifull, far more so than any that was practised while you were here."[97]

Dancing was a highly visible way to display the Shaker body, and believers did so most often at Sabbath services, or on the occasional celebrations on the Holy Mounts, except during moments in the Era of Manifestations when some Shaker sacred gatherings were closed to outsiders. It is clear from visitor accounts that the world's people highly prized their chance to see Shakers dancing. The Shakers, in turn, were glad to know that non-Shakers were attending their services. At New Lebanon in 1848, Sally Bushnell (ca. 1796–1865) wrote that at a meeting, there was "a pretty good number of Spectators." Two years later, she was again happy that there was "an uncommon large concourse of spectators at public meeting to day." For her part, Asenath Clark (1780–1857) was pleased that on 28 August 1836 at New Lebanon there was "a

great concourse of spectators, who filled the meeting house nearly half full."[98] Rufus Bishop noted with apparent satisfaction in 1851 at New Lebanon that some "worldlings" who had come some distance wept when told there would be no public Sabbath meeting. Bishop himself lamented that, perhaps because of the cold weather, on 15 February 1852, there were "not many spectators at the public meeting to day."[99]

Although they were happy to see the dancing, some of the witnesses of the world's people described the dancing as unpleasant to view because of the jerking motions of some of the participants or because of the music (fig. 1.7). Congressman William Loughton Smith was at New Lebanon on 29 August 1790; he thought the place "well cultivated, and their buildings are very neat, but he wrote of the "horrible clatter and shuffling on the floor" of the dancing at meeting. Similarly, a visitor to Pleasant Hill in 1825 thought of the meetinghouse there that everything was in the "neatest conceivable style" and the clothing sober, "resembling that of the old Quakers," but the dancing reached a frightful climax: "The motions which were before violent, became furious, and the noise, before stunning, was appalling." In a remarkable early visitation to the Shakers in 1810, a visiting Scotsman, J. B. Dunlop, wrote, describing the still formative patterns of dance and singing among the Shakers, "There was nothing rude or overstretched in their gestures. . . . The whole proceedings are regular, but hideous to any being who feels for the dignity of his race. The music is grating." He called the dancing and singing "ridiculous work." Charles Dickens (1812–70), judging from a print of Shakers dancing, wrote that he guessed that the dancing "must be infinitely grotesque."[100] Horace Greeley (1811–72) complained about the dancing when it went from orderly to "wild, discordant frenzy," ending with whirling, in which each dancer looked like a "decapitated hen." Nathaniel Hawthorne (1804–64) liked the Shaker villages and orderly lives, but in 1831 alluded at least in part to their dancing when he denounced their "ridiculous ceremonies."[101] For the Shakers, the dancing was a chance to offer some order to the sect's original chaotic steps and also allow a release from bodily, sexual, and other tensions: as a Shaker song went: "Come, life, Shaker life, come, life eternal, shake, shake out of me all that is carnal." Thus, they regarded the shaking and movement of the body as expelling carnal feelings. Another song begins "I'll spend and be spent in the cause of my God," implying an expenditure of feelings through travail and action.[102] Every day of the week, the Shakers had to work hard and could fully throw themselves into "God's work" and not face the consequences of their

carnal feelings. The shuffling, labored dancing was one antidote to sexual feelings, and, as we have seen, they regarded their dancing as beautiful.

Despite criticisms of dance, it was attractive or curious enough to the world that some borrowed the outward form of it (without the Shaker theological feelings) and made money by performing in public, having learned the skills as Shakers. Christian Goodwillie noted, "During the 1840s, troupes of Shaker apostates travelled throughout the eastern and Midwestern United States performing the songs and dances of their former communities. . . . Where once they [the Shakers] had been a viewed as a threat to the republic, they were now a bizarre novelty marketed to the public as entertainment."[103] The implication is that, at some level, there was for the world an aesthetic interest in the music and dancing of the Shakers, even if for different reasons from those of the faithful. Many of the world's observers liked the Shaker dancing on aesthetic grounds, and they saw it as appropriate for the Shaker believers. According to Benson John Lossing:

> Their movements in the dance or march, whether natural or studied, are all graceful and appropriate; and as I gazed upon that congregation of four or five hundred worshipers marching and countermarching in perfect time, I felt certain that, were it seen upon a stage as a theatrical exhibition, the involuntary exclamation of even the hypercritical would be "How beautiful!" The women, clad in white, and moving gracefully, appeared ethereal; and among them were a few very beautiful faces. All appeared happy, and upon each face rested the light of dignified serenity, which always gives power to the features of woman.[104]

In another account, a Shaker observed that the world's people enjoyed viewing a Feast Day gathering at Watervliet in 1844 on a Sabbath day:

> There were 4 in a rank, 2 males and 2 females. . . . In this order our procession moved, to the time of a slow march, to the feast ground, where we formed in a large circle around the Fountain. The Singers were then requested to form an inner circle around the Fountain. . . . This is the first time that all of the Society have assembled at the Feast Ground, or Holy Mother's Fountain, and it is also the first time that the children of the world have ventered to approach the sacred

spot at any time of worship, but, at this time there were between 30 & 40 of men[,] wommen and children that gathered, around the outside of the fence, and appeared to be very much entertained with our proceedings.[105]

Shakers often smiled and danced joyously, but few views of them by "the world" captured such states of being. The image of the Shaker as captured by the world is largely outside of the scope of this book, but by way of summary, we can emphasize that a view of the Shakers as stiff and emotionless appeared regularly in accounts from the world. When Charles Dickens wrote his widely circulated *American Notes*, he painted a picture of a grim, wooden people:

> As we rode along, we passed a party of Shakers, who were at work upon the road; who wore the broadest of all broad-brimmed hats; and were in all visible respects such very wooden men, that I felt about as much sympathy for them, and as much interest in them, as if they had been so many figure-heads of ships. Presently we came to the beginning of the village, and alighting at the door of a house where the Shaker manufactures are sold, and which is the headquarters of the elders, requested permission to see the Shaker worship. Pending the conveyance of this request to some person in authority, we walked into a grim room, where several grim hats were hanging on grim pegs, and the time was grimly told by a grim clock which uttered every tick with a kind of struggle, as if it broke the grim silence reluctantly, and under protest. Ranged against the wall were six or eight stiff, high-backed chairs, and they partook so strongly of the general grimness that one would much rather have sat on the floor than incurred the smallest obligation to any of them. Presently, there stalked into this apartment, a grim old Shaker, with eyes as hard, and dull, and cold, as the great round metal buttons on his coat and waistcoat; a sort of calm goblin.[106]

This verbal description does not reflect Shaker behavior and movement when they were with each other, speaking with "freedom," smiling, dancing, or swimming. The grim quality of Dickens's description is echoed in another widely seen publication, Benson John Lossing's *Harper's* article of 1857, where we can see a telling alteration having taken place. For his illustration *Finishing Room*, comparing the watercolor of women (now at the Huntington Library)

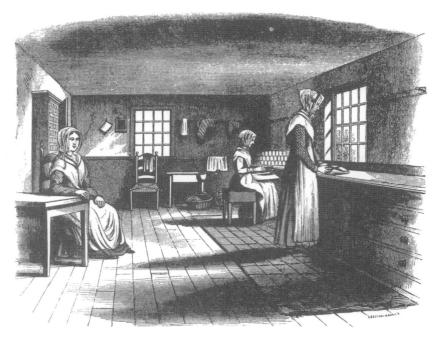

Figure 1.8. Signed "Lossing-Barritt" workshop, New York (after original watercolor of ca. 1856 by Benson John Lossing now in San Marino, Huntington Library), *Finishing Room*, wood engraving, 3¼ x 4¼ inches, published in *Harper's New Monthly Magazine*, July 1857, 174.

with Lossing's published print of the same view, the engraving is darker and casts bold, ominous shadows of the figures, and the shading makes the interior look dark and prison-like and the outside world bright and more desirable (fig. 1.8).[107] All of the Shakers in Lossing's widely seen article of 1857 are without humor and exist in a setting of dark shadow. A paradigm was set for interpretation of the Shakers as melancholy and still figures who occupied cool, geometric architectural settings, a dismal view failing to convey to us the emotions, both sacred and secular, that they experienced in everyday life. In the next chapter, we will see the Shakers enjoying landscape at home and while traveling and get a different image of their emotional state than we did in the passage by Dickens or the engravings published by Lossing.

"SAW A VERU PLEASING SIGHT TO DAU"
Viewing Landscape and Nature

2

Shaker communities consisted of rural villages surrounded by their agri-cultural fields and woodlands, so the Shakers enjoyed an intimate and daily relationship with nature.[1] And on their way to visit other communities of believers, Shakers had a chance to view and take delight in the vast and varied American landscape. Like the broader American public, Shakers enjoyed see-ing pretty farms, trees, flowers, and animals; watching the change of seasons and striking celestial phenomena; and viewing the unfolding panorama of beautiful and sublime landscape during their travels. The Shakers flourished in the decades before 1870, during the rise and popularity of landscape paint-ing in America, most famously in what has come to be called the Hudson River School. Shakers did not display landscape art on their walls, but they shared the American love of real landscape, and they employed a critical aes-thetic language they shared with their national countrymen.

Only occasionally do Shaker accounts of the world beyond their own vil-lages mention God's presence in nature. Shakers were most focused on estab-lishing and reflecting on the beauty of the material culture and surrounding natural setting in their own villages, which they considered to be their Zion. The Shakers were less inclined to find holiness in the natural beauty of the land of the unsaved. Artist Thomas Cole proclaimed that, for Americans in the midst of their national scenery, "it is his own land; its beauty, its magnif-icence, its sublimity—all are his."[2] The Shakers had their lovely communities,

The brethren ar[r]ived and we got our bathing clothes, prepared and took a good duck, returned[,] took supper, after this walked on the beach and viewed the rolling waves while the bright Sun appeared as if hiding it self in the deep water. Returned home and went to bed, in fair view of the briney deep.
—Deborah Robinson, traveling with fellow Shakers at Lynn, Massachusetts, 2 September 1850

shaped by their own hands, places not meant for the defiled population as a whole in America. It is difficult to quantify, but it does seem as though the Shakers were less inclined than most Americans to suggest God's authorship of the broader natural world. They were most liable to focus not on the divine authorship but on aesthetic qualities of the American landscape, from the soft beauty of a verdant field to the romantic sentiments aroused in them by rocky cliffs and waterfalls.

Many of the observations discussed here and later chapters appear in travel journals, so a word about this kind of Shaker writing might be useful at this point. Whether the trips were for Shaker business, institutional advancement, or (in a few instances) leisure, most Shaker journeys involved, at least in part, visits to other Shaker villages. The great number of these suggests that at least one member of a group was expected to keep a detailed account of activities during the trip. Shaker diary and journal entries written at home are usually dry and workmanlike; as craftsman Isaac Newton Youngs, younger brother of Benjamin S. Youngs, wrote in the account of his daily labors: "I have nothing special to say—it is the same old round of drive drive [sic] at work."[3] But, with the novel experiences that came with travel, Shaker pens were active during their journeys across America, and the journal keepers eagerly and some-times vividly recorded and commented on what they saw.

The journals were meant to be shared with and read by other believers and perhaps to serve as travel guides for other Shakers who might journey to the same places. When Shaker leader and writer Calvin Green of New Lebanon finished his journal of a trip to New York and Philadelphia in 1828, he con-cluded with a question for the Shakers back home: "And now what do you think of this narrative—so long as if it was worth something. . . . But such as it is I give it to those who are willing to take the trouble to read."[4] Another Shaker travel journal, from 1847, ended: "Now I must bid you all Farewell.—The end."[5] Freegift Wells, from the Watervliet Shaker community, suggested, as is clear from other documents by him and some other Shakers, that the travel journal that has come down to us is an elaboration of earlier, more cursory notes and was padded later with original memories, to amuse his readers: "But notwith-standing its present condenced form, it [this journal] has been considerably lengthened from memory, while transcribing from the original notes. But it is now finished, and if it fails to amuse any other person, it will be an occasional satisfaction to the writer to examine its contents, especially desirous to call to mind some of those agreeable interviews and pleasing circumstances which so often occurred throughout the whole journey."[6] Freegift thus acknowledged

his readership and his purpose of amusement and implied that he himself could return to the journal and enjoy it in the future. In another place, Freegift omitted description of a landscape in Long Island in 1863, telling the readers that "an account therof may be found in my journal of September 1853," thus expecting that the reader could pull that older journal off the shelf for the same information.[7] For his part, John M. Brown of New Lebanon finished his autobiography, writing on 21 June 1866 that "I leave this little account, hoping it may meet the eye of some one in the future, and do some good, and no harm."[8] Such travel accounts provided entertainment and edification for at least some Shakers back home.

Shaker travel writings formed a kind of subset of American literature of the nineteenth century, being neither traditional letters nor published tales of travel nor personal journals or diaries.[9] Shaker private writings were discouraged and at various times explicitly forbidden. For example, the sisters at Harvard, Massachusetts, recorded the orders of their ministry in 1840: "No day books to be kept for individual purposes."[10] Travel journals, which were often copied so they could be shared, were literature or documentation for other Shakers, who were otherwise not reading the world's travel histories and exotic tales of faraway places. We can see in these writings a communal function: Shaker descriptions of natural sites, people, and cities expressed the views of the person writing, but the accounts were also consciously written to affirm broader Shaker values. The sharing of the writings meant that believers keeping journals perhaps had to suppress their warmer feelings about the world and its cities and artifacts; the traveler could write only what would pass critical assessment by his or her readers. Those Shakers who traveled and wrote about their experiences tended to be the more influential and literate members of the sect, and their readers were likely among the more leading members of the communities. We should also note here that the acceptance of female leadership in Shaker culture meant that a good percentage of these travel journals were written by women. In addition to the preponderance of writings by male and female leaders among the Shakers, some travel accounts were written by the less powerful and less articulate Shakers, but it is noteworthy that their critical assessments were generally similar to those held by more powerful Shakers.

Shakers wrote about the same categories of sights that struck the attention of most Americans in the nineteenth century, a list similar to what scholar John F. Sears described in his book on American tourist attractions of that time. In the realm of nature, the sites of greatest interest consisted of waterfalls, deep

caves, large trees, and other striking features of the landscape. In the sphere of the man-made, Shakers looked, as did most Americans, at fountains, mansions of the wealthy, major public buildings, public parks, and striking vernacular buildings and objects such as bridges, aqueducts, ships, and trains.[11] Also, like many Americans, Shakers were interested in the size of things, their cost, what kinds of materials were used, and how fine or elegant was the style. Again as with most American accounts, Shaker descriptions of the natural world tended to emphasize the emotional impact on the viewer, the journals indicating how the sight evoked feelings such as fear, wonder, or pleasure.

As we begin with Shaker written accounts of nature, we should remember that, as with all matters of culture, Shakers participated in landscape tourism only in their own fashion. Shakers did not share in the broader culture in America that involved reading poems about nature, buying and displaying landscape art, commissioning artworks, and associating with artists, professional writers, and fellow collectors. Nor, like the elite classes in America, did Shakers maintain rural seats, take regular trips dedicated largely to the enjoyment of the landscape, or stay in genteel leisure hotels in the countryside, such as those in the Catskills. A few fortunate Shakers had a chance on occasion to take something approaching a summer vacation, the travelers surrounded by nature's glory, but the most frequent scenario is that a believer was traveling from one Shaker village to another on business and had a chance to see the countryside along the way, perhaps making a short detour or extra effort to see something special. Still, Shakers clearly enjoyed the sights of nature, and they managed to turn their journals, which in the earliest period were dry accounts of movement from place to place, into vivid descriptions of what they saw, writings clearly for the entertainment, and sometimes edification, of their Shaker readership. And the easiest access to the natural world was on their own lands, and there the Shakers were closer to the normal American experience of enjoying the sight of nature around them in their everyday lives.

In looking at Shaker experiences of nature, we might begin with a consideration of their appreciation of the prospect, that is, an expansive view from a high vantage point. The prospect was among the mainstays of Anglo-American visual culture of the eighteenth and nineteenth centuries and formed a staple of landscape tourism. For their part, Shakers frequently mentioned good prospects and the details of what they saw from on high. Sometimes the prospect occurred en passant during a trip, but oftentimes Shakers labored to attain the grand view, and the accompanying aesthetic pleasure, by climbing hills or structures just for that purpose.

The earlier Shaker mentions of prospects were relatively dry and less effusive about beauty than the more aestheticized accounts that appeared later in the nineteenth century. Three Shaker elders going across the Appalachian Mountains noted on 23 February 1805 only that "here we have a prospect of part of North Carolina on the East & South Carolina & Georgia & Tenesee on the S East[,] a vast country presents to view, Mountain after Mountain, whose ranges lay in directions from NE to S West."[12] In 1823 Seth Youngs Wells, Shaker educator from Watervliet and New Lebanon, New York, was at Alfred, Maine, and mentioned a good prospect without detailed comment but did note that he and his companions made the effort to achieve the view: "Afternoon took a walk up the hill in company with Elder Elisha & George Palmer & the sisters from Gloucester where we had an extensive prospect of the Believers settlement & farm."[13] Nine years later, on a lovely day in June, Wells had more to say, and he liked the siting of the new eastern house of the land purchased at the Shaker settlement in Sodus, New York: "The situation of the east house is very pleasant and beautiful for a summer residence. It stands on a level spot of high land and commands a fair view of the bay."[14] On the same journey, Wells saw near Liverpool and Geddes, New York, "an extensive and beautiful prospect."[15] Lucy Ann Hammond (1797–1881), of the Harvard, Massachusetts, community and traveling to Enfield, Connecticut, and New Lebanon, stopped on the road to Pittsfield in 1830 with her group on a summit: "After we reached the top of the mountains, I stood on a rock & viewed the mountains around." She was gratified to be told that she was on the very summit, and, after being revived by the view, the company "started all in good spirits."[16] For her part, Sarah Ann Lewis, hailing from New Lebanon and traveling across the border between Vermont and New Hampshire in 1849, wrote, "The prospect on the west side of the mountain is very beautiful."[17] Sometimes the prospects came from atop buildings. Shaker educator Seth Youngs Wells, traveling in 1822 from New York to Harvard, Massachusetts, stopped in Boston and used a high point in Charles Bulfinch's (1763–1844) State House to get a "fair view" of the gathering of islands that dot the harbor. Wells and his fellow Shaker travelers "went up to the top where we had a fair view of the whole city of Boston & all the adjacent places, bays, Islands, bridges & saw Castle Island."[18]

Many Shaker accounts of prospects were aesthetically sensitive and well articulated. Sometimes the Shakers compared the prospects to pictures themselves, works otherwise forbidden in their communities, and they showed a connoisseurial appreciation of visual particulars. Shaker leader Henry C. Blinn of Canterbury, New Hampshire, was passing through the Green

Mountains on 28 June 1853 and wrote in his journal, "To look back we seemed to be on a place similar to the edge of a bowl, for we could see the deep valleys far below & beyond us, neatly covered with nature's scenery."[19] He thought the overall view of the Green Mountains to be "charming."[20] Similarly, Blinn was in the Genesee Valley in New York in 1856 and wrote, "On our way up the mountain we turn to take a view of the beauties of this world. . . . From the valley the land seemed to rise gradually, till it met the blue clouds afar off in the distant horizon. It was indeed, a most lovely picture. . . . But the thought of New Hampshire and her beautiful lakes & mountains, made us turn to our own Granite State[,] which was far dearer to the mind than all this."[21] Here, as often in other Shaker accounts, there is a comparison of place to place, in this case between the landscape in New York and that of New Hampshire, which Blinn, of Canterbury, judged (doubtless to the gratification of the Shaker readers in his village back home) to be superior.

Shakers did not have far to go for a prospect, as they had hills or elevations within their own landholdings, especially on the Holy Mounts, or Feast Grounds, outdoor worship areas that will be discussed in the next chapter. Even standing on holy ground, and looking down like the eye of God across the landscape, the Shakers tended to offer what are essentially secular descriptions, emphasizing the pleasure of their viewing. Giles B. Avery, visiting from New York and at the Feast Ground, or "Mount of Olives," at Enfield, Connecticut, on 21 April 1843, wrote, "This is a beautiful spot of ground upon a hill. . . . [F]rom this place the whole surrounding country for nearly 30 miles lies plainly in view, on 3 sides, and the other side is only veiled by adjacent woods," and also "on the south is approached by a beautifully graded rise of land to the very top."[22] Some Shakers, such as a group from Harvard, Massachusetts, visiting at Enfield, Connecticut, in the scenic month of September 1846, noted their purposeful stopping along the path up the hills to take in the scenery: "On our way [up to the "Mount of Olives"] we stopped to view the face of the country west which is beautiful and level."[23] Another Shaker group, in 1846, went up to the Holy Mount at Harvard. Apart from "reading the sacred word upon the Stone," the experience and the view offered by the high point ("after viewing the co[u]ntry around") were described in secular and contemporary terms: "It is now [after recent improvements of the site] very beautiful, & the surrounding prospects pleasant & romantic."[24] Even from a holy spot, the Shaker made no mention of God, and the account stresses instead the "romantic" quality of the view.

Some prospects on Shaker lands were outside of the Holy Mounts. Rufus Bishop commented on the beauty of a prospect on a mountain in 1839: "I went onto the South Mountain [at New Lebanon], to a place where the 2.d [Second] family were harvesting Oats above where E.[lder] Ebenezer once lived. This is high ground & a wonderful slightly place."[25] Other views were from buildings on high points of Shaker villages. Apostate Absolem H. Blackburn, in his account of Union Village, Ohio, where he resided as a Shaker during much of 1819 until 1824, was impressed with the siting of a family house and its prospect: "Now I come to speak of the south house—I cannot pass it unnoticed; it is the most beautiful site I ever saw, for you have a fair view of the whole prairia [sic], and also of the improvements of the society."[26] In 1873 Henry C. Blinn enjoyed the view at Enfield, Connecticut, from an observation point in an elevated new residence there: "The observatory which [is] of very ample dimensions, commands a beautiful prospect of the surrounding country. . . . [One has] reason to be thankful for such a beautiful residence."[27] Teacher Hervey Elkins, writing in 1853 as a recent apostate but remembering his days and actions as a Shaker, noted how, in the afternoons in good weather, he and his schoolboy charges at Enfield, New Hampshire, frequently finished their boating and fishing in beautiful Mascoma Lake and then "ascended the mountains of the back ground; where I enjoyed my favorite, prospective of the east."[28]

Turning from prospects to views in general, we might begin by noting the frequent Shaker use of the words "sublime" and "romantic," charged terms that were in broad use since the eighteenth century in the Anglo-American world. A number of Shaker descriptions of landscape are dry and factual, especially earlier on in the nineteenth century, and focused on distances or pure geographical listing of places.[29] But during the first quarter of the nineteenth century, the Shakers were excited by dramatic parts of the American landscape, and they used words widespread in American discourse about nature, including "magnificent" and "picturesque," in addition to "sublime" and "romantic."

We might start with Shaker reaction to water, including the ocean and waterfalls, both seen in most instances only during travel, as only the Alfred, Maine, location among Shaker communities was close to the sea, and substantial waterfalls were at some distances from all Shaker communities. This would include, of course, the famous Niagara Falls (fig. 2.1), which was a mainstay of American landscape tourism.[30] Shaker Naomi Legier (or Ligier) (1800–1887), from Union Village, Ohio, and visiting Shakers in New York, saw

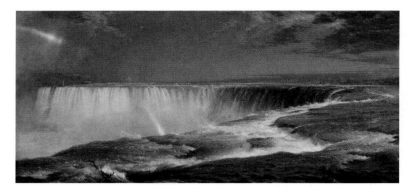

Figure 2.1. Frederic Edwin Church, *Niagara*, 1857, oil on canvas, 40 x 90½ inches. (Washington, D.C., National Gallery of Art, Corcoran Collection. *Photo:* NGA.)

the impressive falls in 1842 while waiting for a train: "We had but 15 or 20 minutes to run down & look at the wounderful & far-famed Cataract of Niagara; & we dare[d] not occupy all the time that we might in safety, in beholding the magnificent scene, for fear that the Carrs would start out & leave us."[31] Also in the upstate region were the impressive High Falls of the Genesee River at Rochester, New York (fig. 2.2), which Amos Stewart (1802–84), a Shaker leader in the ministry at New Lebanon, saw in 1852; he marveled that "water falling 90 feet or more made most a tremendous noise. . . . [and mist] appeared like fine rain."[32] Isaac Newton Youngs of New Lebanon wrote of the crossing of the Erie Canal and the Genesee River: "On each side of the canal there is a broad walk of stone, guarded by an iron railing, where one may look over & view the foaming stream, rushing over the rocks 20 or 30 feet down. There are several large mills of various kinds, close by the canal. . . . [T]he sense is almost bewildered with the bustling scenery." Similarly, Youngs saw the Upper Cascade into Akron, Ohio, on 24 June 1834, and he referred to the "mighty descent" of the water and called it "a romantic place."[33]

Seth Youngs Wells, who had lived in Watervliet and New Lebanon, was a fine writer among Shaker travelers, and he made an effort to entertain his Shaker readers back home. On a boat on the Mohawk River and Erie Canal, he passed Danube, near Mannheim, and left a remarkable and vivid description of the rough scene, an account worthy of the brush of a Salvator Rosa (1615–53) or the sublime style of a romantic-period painter:

[We] passed 4 locks in succession, with the most astonishing & very romantic views on each side of us—on the left, close beside

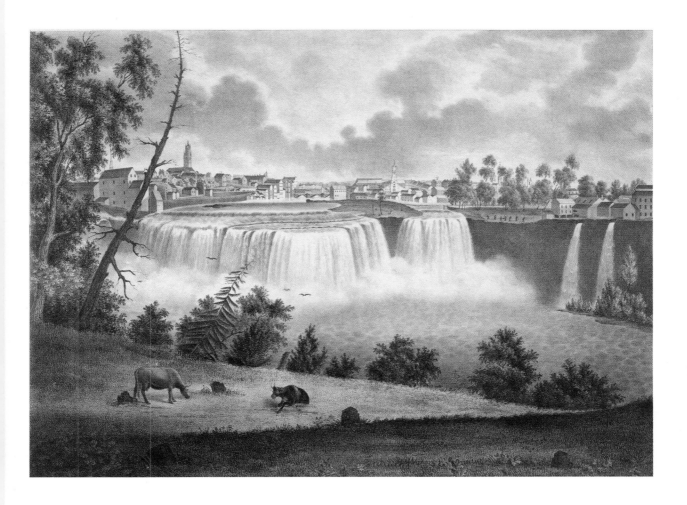

the canal, being a high ledge of perpendicular rocks, resembling a very high artificial wall which had been cut down to form the canal & tow path—on the right appeared the dark and gloomy depth of the Mohawk waters, rushing along down a succession of awful cataracts, dashing down the rocks with a tremendous, roaring noise, which for a night scene appeared awfully sublime & terrific. In looking down from the deck of the boat upon this deep and awful gulf, close by our side, into the dark abyss below, the only object we could discern was the white spray of the foaming waters, as they rushed over the rocks—all else seemed dark & gloomy as the bottomless pit, and the roaring of the waters beneath rendered the scene still more awful.

Figure 2.2. John T. Young (design), John Henry Bufford (lithography and printing), published by C. and M. Morse (Rochester, N.Y.), *The Upper Falls of the Genesee at Rochester N.Y. from the East*, 1836–37, lithograph, 15¼ x 20¼ inches. (Miriam and Ira D. Wallach Division of Art, Prints, and Photographs, New York Public Library. *Photo:* NYPL.)

This account is an embellished version of Wells's earlier notes taken on the spot; here, he raises up the language to a more vivid and flowery level for his Shaker readers.[34]

Seth Youngs Wells and other Shakers often used the word "sublime." Their usage stands as an example of how the Shakers were aware of and shared the world's aesthetic language. Rooted in the Latin word "sublimis," the English word "sublime" had been used since the sixteenth century, carrying from the beginning various connotations of something lofty, grand, or elevated and referring to people, literary style, or ideas.[35] In *A Philosophical Enquiry into the Origin of Our Ideas of the Sublime and Beautiful* (1757), Edmund Burke (1729–97) gave the word a special stamp by identifying it above all with pain and with the passions of the mind often otherwise described as fear or anxiety, and he associated it with human reactions to natural occurrences as well as to literature and works of art. Burke's analysis sometimes retained established understandings of the word, as he associated the sublime also with feelings about that which is infinite, vast, or magnificent.[36] His ideas had obvious applications to human experience of nature and artistic renderings of it, but it was other British writers, such as William Gilpin (1724–1804), Richard Payne Knight (1750–1824), and Uvedale Price (1747–1829), who applied the word, along with concepts of the picturesque, even more explicitly and extensively to real and painted landscapes.[37] Burke and these other writers contrasted the sublime with the beautiful, the latter relating to feelings of tenderness, love, and pleasure. By the mid-nineteenth century, the idea of the sublime was well established in Anglo-American aesthetics, referring, in the visual realm, to sights in art or nature that brought on feelings of fear, gloominess, awe, or marvel and grandeur. The Shakers consistently used the word in that general sense in their travel accounts in the nineteenth century. For his part, in the passage just cited, Wells was clearly aware of the Burkean sublime as something related to apprehension of danger, as his account described the "awful gulf" and "dark abyss," and he must have assumed that his Shaker readers understood the word "sublime" in the same way.

Freegift Wells, like his older brother Seth Youngs Wells, was a superb writer, and he paid attention to details of natural phenomena. Contemporary Americans were also keenly interested in the particulars of nature, such as the appearance of water in motion, and art critics remarked in detail, for example, about the exact nature of the flow of water in Frederic Church's (1826–1900) paintings of waterfalls.[38] For his part, Freegift offered an extensive and

incisive description of water falling down and catching on rocks at Bellows Falls, Vermont, in 1851:

> The River [is] very narrow, seemingly not more than 25 or 30 feet wide. The bed and Banks of the River is solid rock of the roughest kind, & being very de[s]cending the water made foaming work in passing thro', and the curve gave a whirling motion to the water, which in various places where a stone chanced to be lodged on a level spot, or shelf, projecting out from either side of the River, it was set to whirling by the current, & in this way wore holes in the solid Rock called potholes, from the resemblance they bore to the inside of a pot. The River being low at the time, there were many shelves with their potholes bare—they were of various sizes in caliber & depth— capable as I imagine of containing from one quart, to two hogsheads of water—with the stone, or stones inside which continue to grind away & enlarge the dimentions of the orifice when ever the water is high enough to have the current act upon them.

In addition, there were "two Bridges across this Chasm" that "afforded beautiful situations for viewing the scenery below which rendered my delay, an interesting season which will not soon be forgotten."[39]

The ocean, a novel sight for most Shakers, was a frequent source of sublime and romantic feelings for traveling Shakers. As contemporary Herman Melville (1819–91) noted in the first chapter of *Moby-Dick* (1851), Americans were fascinated by the ocean. Melville wrote: "Look at the crowds of water-gazers there [at the Battery, on the southern tip of Manhattan]. Circumambulate the city of a dreamy Sabbath afternoon. Go from Corlears Hook to Coenties Slip, and from thence, by Whitehall, northward. What do you see?—Posted like silent sentinels all around the town, stand thousands upon thousands of mortal men fixed in ocean reveries."[40] In his essay "Scenery and Mind," Elias Lyman Magoon (1810–86) wrote in 1852 that "the infinite is palpably impressed upon the boundless deep," and, like mountains, oceans had a strong influence on the American "national mind."[41] Shakers, too, were drawn to the sea and the waves. With the exception of the community at Alfred, Maine, most Shakers lived distant from the shore, and they enjoyed the novel sight when they saw the ocean. Nancy E. Moore, from faraway South Union, Kentucky, and on the beach at Lynn, Massachusetts, in September 1854, was struck by the sight of

the rolling and crashing waves: "Well we did have a fine time with our good Elders at the Beach, we shall never forget the grandeur and sublimity of the waves of the Ocean, the long parallel lines which reached farther than our vision could see which came rolling one after another lashing out on the Beach then retreating to give place to another was a scene which the eye could not tire to look upon, but the sweetest enjoyment of all was the love and sociability of the good Ministry the [i.e., that] we were privileged to be with."[42] Hancock Shaker Deborah Robinson at nearby Nahant, Massachusetts, in 1854, sat on the rocks and noted that "the heavy waves roll'd and beat against them, throwing up the white spray continually."[43] On 30 August 1849, Sarah Ann Lewis was overwhelmed by the vast and turgid Atlantic Ocean at Hampton Beach, New Hampshire: "After some conversation we retired to rest—but was so amazed with the rolling of this mighty Ocean almost to our door steps that we could not sleep much." The next day was spent looking across the waters: "Here we discovered 3 vessels at a distance thro' a glass also the Isle of shoals."[44] The Great Lakes, ocean-like in scale, could evoke the same kinds of reaction. Rufus Bishop was on a boat on Lake Erie, going from Buffalo to Cleveland in 1852, and the continuer of his journal (Amos Stewart) described the lake surface near Erie, Pennsylvania: "When day-light appeared so that we could see[,] the lake looked most wonderful rough."[45] The sight of the ocean was compared by Freegift Wells to hills he saw in Kentucky on the way to Pleasant Hill in 1836: "These hills may be discribed to those who have travelled the ocean, by mighty waves, whose towering tops exclude from each others sight the ships & crews of which are only divided by one of them."[46]

We have focused on water so far in considering Shaker expressions of the sublime and romantic, but other aspects of nature, such as cliffs, rocks, and great heights, could elicit strong emotional and aesthetic feelings. Even a man-ravaged forest could be sublime. As early as 1807, New York Shaker Benjamin S. Youngs noted in Ohio of land stripped of its timber: "The aspect of the country appeared awfully sublime, many hundreds of acres round the garrison was entirely stripped of timber & afforded a very extensive & level prospect."[47] William Leonard (1803–77), a Harvard Shaker when writing but describing his spiritual and actual journeys before becoming a believer, included in his spiritual autobiography an appreciation of romantic landscape in the United States and Canada. He wrote of his travels in New Brunswick, Canada, on land along the St. John's River, "It was one of the most wild, romantic scenes, that ever met my vision. As far as the eye could reach, up and down that river might be seen, hundreds of overgrown shade trees,

strongly rooted over that extensive interval co[u]ntry, and the tide running in circles among the branches." The next morning, he described the scene: "The sun was up; the sparkling waters, rapid currants, and forrests of the tree tops glittered in the sun beams."[48] Elsewhere in his journeys, Leonard further acknowledged his pleasure at looking at rough landscape. On the wild route toward Bangor, Maine, on the Penobscot River, he wrote that "I amused myself, at viewing the rough scenery that extends sixty miles down that broke water course . . . Islands, ledges, rips, and waterfalls." Near Orono Island, "the water of this river is quite clear. I have stood and looked on it, when the sun beams played upon it, and could see the bottom fifteen feet down. This renders it amusing, to witness the immense crowd of alewives, shade, salmon, herring &c. that rush up the river to spawn during the greatest run."[49]

As for romantic and sublime cliffs, some Harvard Shakers in 1846 traveling from Westfield, Massachusetts, to Blandford Plains saw mountains above and a "steep gulf" down to the river below: "We stop and get out to look out into the gulf below and stre[t]ch our eyes to the top of the precipice above us[.] Nature is here seen in a wild[,] grand and romantic aspect calculated to fill the beholder with wonder and solemnity." The writer for the same group appreciated tamer nature, as well, such as at Tyringham, Massachusetts, on 23 September 1846: "We ride thro their magnificent maple orchard again which is at once grand and delighting." But they were back again in rough terrain the next day, on the way from Tyringham to Hancock, Massachusetts: "The mountains on either hand are in the rudest most fantastic forms that can be well imageined."[50] For his part, Seth Youngs Wells wrote along similar lines of his 1822 journey between Alfred, Maine, and Harvard, Massachusetts: "The road to Portsmouth thro' Wells and York lies along the seacoast where we had a fine view of the Ocean for some miles from Wells to York. . . . [T]he ledges of Rock on our right for some distance were astonishing. . . . But some part of the day was thick & rainy, which obstructed our prospect."[51] Because of the location of their home villages, Shakers often passed through the Hudson Valley and, like many Americans as well as foreign visitors, were struck by the scenic and varied views along the rivers.[52] Abigail Crossman, returning home with a group of Shakers to New Lebanon in 1846, had been heading north up the Hudson River from New York City and looking at the famous Palisades. She stated, "On our right is a beautiful landscape—& along our left is a cliff of rocks many miles, extending 100 feet perpendicular," referring to the imposing Palisades (fig. 2.3).[53] The Palisades, on the west bank of the Hudson spanning New Jersey and New York State, are much higher in elevation than she stated (actually in

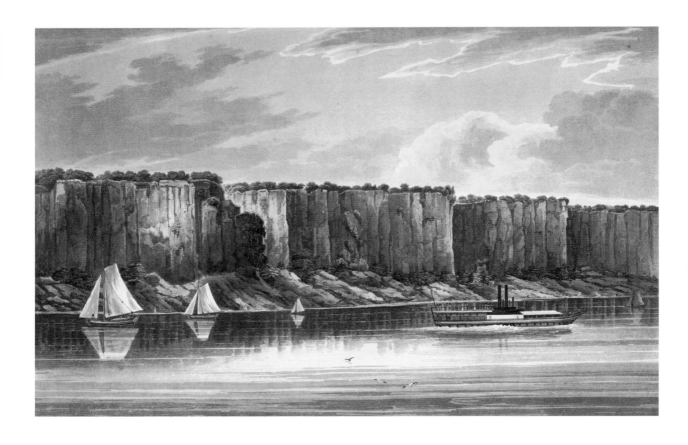

Figure 2.3. John Hill after original artist William Guy, *Palisades*, 1823, aquatint hand-colored, 14.4 x 21.3 inches. (Miriam and Ira D. Wallach Division of Art, Prints, and Photographs, New York Public Library. *Photo:* NYPL.)

the 400- to 550-foot range for long stretches), although she might have been referring only to the treeless and rather vertical upper sections of the cliffs. Crossman, traveling with a group of Shakers in 1846, was entranced with the scenery from West Point in August 1846: "Now comes a most romantic scenery. Rocks, Mountains, small Islands, beautiful Co[u]ntry seats, situated upon points of land."[54] Also sensing the romantic quality of landscape was Thomas Hammond Jr. (1791–1880), of the Church Family of the Harvard community and traveling with a small group of fellow Shakers; he was on the road to Tyringham in 1846 and wrote: "Rocks, streams, & sawmills, mountains & hills, abound much. Some of the way very romantic."[55]

Later in the century, Shakers became ever more likely to feel and describe a romantic reaction to nature. One western Shaker, visiting with a group of believers in 1869, rode out near Lebanon Springs, New York, in June and

saw "a most magnificent & picturesque scenery on the side of a mountain, where the works of nature & art are most profusely intermixed, producing a grand & romantic appearance," with a view of the whole valley producing a "grand & sublime appearance."[56] As for the whole region around Enfield, New Hampshire, the Shaker stated: "This is a romantic region."[57] Similarly, the journal keeper wrote of Maine: "There is a beautiful[,] mountainous & picturesque scenery all around this Poland-Hill."[58] Earlier, the group of Kentucky Shakers had enjoyed "wild mountain scenery" going into Virginia in 11 June 1869, and "Daylight found us on the waters of the Potomack, which we crossed at Harpers Ferry, where there is a gap in the Blue Ridge through which it passes, presenting one of the most romantic views of picturesque scenery our eyes ever beheld."[59] On a train going from Baltimore to Philadelphia on 11 June 1869, they "passed through a beautiful country, generally level."[60] Then, on a trip by steamboat up the Hudson River on 14 June 1869, they traveled on "one of the most beautiful Rivers, with its mountain scenery"; they took note of Sunnyside, home of Washington Irving in Tarrytown, and noted the location of Poughkeepsie and Mother Ann's imprisonment there.[61] For his part, Giles B. Avery was on the way to Pittsburgh from New York in 1862 and thought it to be the "prettiest region of country I ever saw[,] universally beautiful and sublime in scenery." Avery combined the two Burkean notions of beautiful and sublime to indicate the variety of scenery.[62] Nancy E. Moore looked out her window on a train in New York State near Newburgh in 1854 and described how she passed "thro' a diversified and beautiful country of fine land, mountain heights and romantic scenery."[63]

At times, romantic feelings from nature arose from association of the land with a human presence. Nineteenth-century Americans often thought of Native Americans as being somehow part of nature itself, and their essential departure from the wilder lands of America in the eastern states could elicit some contemplation of something lost. One Shaker group near Harvard had some sentimental thoughts along these lines and added some others when visiting a flowering bush that bloomed in the days of Ann Lee. Abigail Crossman and her Shaker fellows were at Harvard, Massachusetts, on 11 August 1846, when Crossman "plucked a bough from an ancient Lilack bush, which bloomed in days of our Mother." Further along on the visit, the little group, in the company of their hosts at Harvard, took a walk that filled them with romantic sensations and sentimental identification with Native peoples who had lived on the land. They strolled a half mile east away from the

structures at Harvard and "passed thro' gardens, Orchards, meadow, & entered a beautiful grove of young forest trees." They found a large rock where, their guide told them, "Red men of the forest used to keep their Tobbacco." Then,

> a little below this, was the most romantic scene my eyes ever beheld. Rocks of immense size, hanging over frightful precipices, others with large cavit[i]es, formed by the hand of nature, situated upon a summit seemingly too steep for man or beast to ascend without the aid of shrubbery to help them along; and below, on our left, were large ravines, well fitted for the wild I[n]dian to build his wigwams. With much difficulty we de(s)cended from the lofty pin[n]acle into the valley, sat down upon a rock over grown with moss, & sung several native songs, in remembrance of those who once inhabited the forest. We were filled with reflection, yet pleasant & cheerful.[64]

This remarkable scene, with an envisioning of Native Americans in a romantic, "frightful" nature, recalls contemporary paintings by Thomas Cole in the representation of Native Americans in rocky natural settings (fig. 2.4), and the little mossy resting spot described at the end of the account evokes the intimate forest views in the canvases of Asher Brown Durand (1796–1886). Only the reference to Ann Lee distinguishes this description from that of a typical American of the time.

Apart from the usual grand features of the American landscape, such as cliffs and great waterfalls, Shakers kept their eyes open for natural oddities, and mention of these found their way into their travel accounts. In 1807 a trio of Shaker brothers traveling through Ohio saw many miles of "wild meadows, between us & the river; very antient & extensive to the eye."[65] Isaac Newton Youngs marveled in 1834 not at how God the artist had created wonderful nature, but how "it would seem" that "Providence" cut a path through a rocky mountain: "At about ½ past 7 ock we came to Little falls 22 miles from Utica. Here opens to view a most wonderful and interesting scene. It would seem as if Providence had designed to form the rocks to admit the canal thro the mountain." As for the cutting of rocks by the power of man for the canal itself, "It would seem as tho nature & art had here vied with each other to display gigantic powers."[66] In another viewing later in the century of man's intervention in nature, Freegift Wells, traveling from Detroit to Marshall, Michigan, in 1855, saw "thousands of beautiful saw logs" floating in the water.[67]

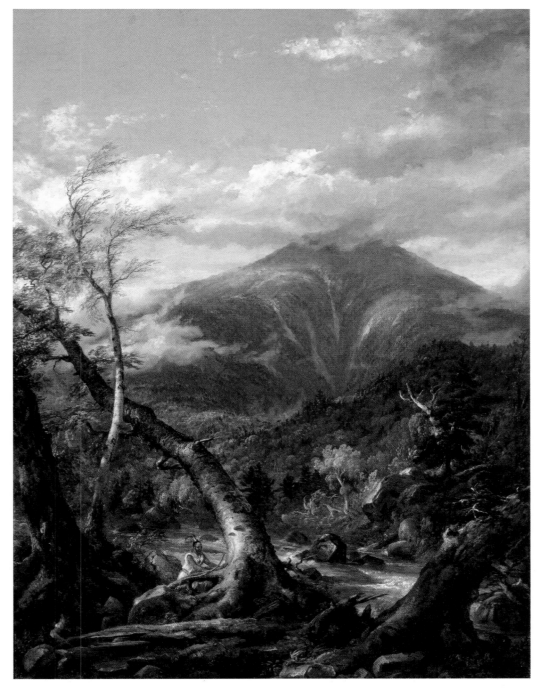

Figure 2.4. Thomas Cole, *Indian Pass*, 1847, oil on canvas, 40 1/16 x 29 3/4 inches. (The Museum of Fine Arts, Houston, The Agnes Cullen Arnold Endowment Fund. *Photo:* MFAH.)

Shakers were, it seems, particularly drawn to caves and often took the opportunity to visit them in their travels to Ohio and Kentucky. On 13 August 1847, near South Union, Kentucky, Prudence Morrell of New Lebanon visited a picturesque cave: "About a mile south of the buildings, we went down into it on a ladder, it is about 14 feet deep. Over head is solid rock & under foot a living stream of pure water. On one side of the cave is the water & on the other it is quite passable."[68] For his part, Freegift Wells on 29 September 1836 humorously applied the Shaker notion of the inspirational "gift " to getting out of the gloomy place that lacked a "solid & permanent appearance," and he noted Sister Sally's (probably wise) reluctance to descend below ground level. The site, which he visited with three other Shakers, was near South Union, Kentucky, the water said to form a source of the Gasper River:

> Very pleasant after dinner[.] Eldress Betsy, Sister Sally, Harvey & myself took a walk to the Cave, we crawled down into it but Sally. But we found it to be a gloomy looking place yet there is a beautiful stream of water runs through the bottom winding its way among the rocks & stones. Immediately at the bottom of the avenue through which we de[s]cended appeared a small Cateract, whose foaming w[h]ite [?] spray, among the huge rocks caused a perpetual sound nearly sufficient to drown all conversation. I stooped down & took a drink of the water, which was clear & good. But as the rocks, over head & about did not exhibit that solid & permanent appearance which I had expected, I felt more gift in crawling out again, than I did to continue.[69]

Similarly, Isaac Newton Youngs, on 8 September 1834, near South Union, went to see "the Cave," writing, "It is a curious and entertaining sight."[70] Hancock Shaker William Deming (1779–1849), on 1 August 1810, after leaving Lexington, Kentucky, and before fording the Barren River, on the way toward South Union, Kentucky, wrote: "We went into two Caves—went into one of them about Ten Rods and it was a beautiful Sight." Continuing his appreciation of nature, on 2 August 1810, at the head of a fork of the Gasper River, he exclaimed that Clear Fork is a "large beautiful Spring."[71] Then, sixteen miles from Gasper, Kentucky, on 4 August 1810, he went into another cave: "Rob.t Briant informed me of a Cave 16 miles from here at which he had been—That it was 50 feet Deep—the inside was in the Common form of Mounds above Ground i.e. the Cave was Small at the top & grew larger & larger to the bot-

tom[.] And in it 50 feet below the Surface of the Earth were great & Small human bones, without number."[72]

Large, ancient trees caught the attention of Shakers. Isaac Newton Youngs of New Lebanon took the time to record his sight of a massive tree near Sodus, New York: he viewed "the big white wood tree!" that was "20 feet round," or "6 ½ feet diameter" and, without further comment on the earth's age and natural history, noted that "we stopped a while to view the shells in the rocks near the mills."[73] Freegift Wells, at Sodus, New York, in 1834, also "went out into the woods, saw a large white-wood tree which measured 20 feet 6 inches in circumference 3 feet from the ground."[74] William Deming transcribed into his travel journal a published account of a great tree in Ohio; the description could then later be enjoyed by his Shaker colleagues at home. The article described a "Sycamore tree which measures on the Inside 21 feet in Diametre & more than 60 in Circumference," and with a "Spacious Cavity" inside. It was to be found on the land of Abraham Miller in the township of Seal and county of Scioto.[75] Similarly, in Kentucky, Deming was struck by the size of a great maple tree that he himself did see: "Saw a very Pleasing Sight to Day[,] a mound that had been uncovered—it was arched all over with Stone and among the trees growing on it was a Maple tree about 2½ feet over & we thought it must be at least 200 years old."[76]

Shakers did not always like what they saw in nature, and they sometimes were displeased with rough or desolate landscape. Rough terrain was early on seen as threatening and harsh, and the old preromantic distaste or even fear of the "howling wilderness" sometimes appears in Shaker accounts, although, as we have seen, rocky or desolate nature became appreciated for its picturesque or even sublime qualities.

Somewhat different from other Shaker accounts in being a poem, there is a remarkable verse description by Issachar Bates Sr. (1758–1837) of harsh landscape, indicating both his fear of it and a fascination with its visual qualities and its dangers. The poem, set to music by Bates, was much copied by other Shakers and presumably widely admired by them.[77] Bates and Benjamin S. Youngs passed through Ohio and Indiana in the winter of 1808–9 to help establish Shakerism in the West.[78] Bates was skilled with words as a preacher, writer, and song lyricist and composer, and he described the frightening winter weather and landscape that almost took his life:[79]

The sixteenth day of January,
Through stormey winds, through ice and snow

From Turtle Creek we took our journey

. .

A howling wilderness before us,
A thousand Furlongs in extent.

The way blocked up with floods of water,
The land with ice was over laid;
On broken ice for miles we travel,
And through chilling water wade.
On the third day, though cold and stormey
It thundered[,] lightn'd[,] and it rained,
Till by a foaming branch of Lockryd [Laughery],
One day and night we were detained.

Bates's description of landscape continued in stanza 13:

Tho' walnut[,] oak[,] and chestnut timber
On every side the forest lin'd

. .

Thus over hills and creeks and vallies
We marched o'er through the desert-land.[80]

Bates nearly lost his life in the icy landscape, so that experience shaped his description. Even without such a threat, other early Shakers indicated their distaste for desolate landscape. In the "Diary of Three Brethren Going South," we read of John Meacham, Issachar Bates Sr., and Benjamin S. Youngs going from New Lebanon on a mission trip south and west. On 25 February 1805, the journal entry called the Cumberland Gap "a dreary looking place in a rocky & high Mountain."[81] Similarly, Youngs, traveling with the small group in January 1805, lamented the desolate rocks and trails along the way in Ohio (including Poland and Georgetown) as "dreary" and "desolate" places.[82] Giles B. Avery liked the town of Enfield, New Hampshire, but was also put off by the sight of the surrounding countryside, comparing the attractive town to the unpleasant rocks of the surrounding landscape in 1843: "Enfield is a pretty Township,—but there is some of the roughest & most ragged & rocky[,] high, bold and picturesque scenery I ever saw, in my life."[83] Prudence Morrell of New Lebanon, on the way to Pleasant Hill, Kentucky, on 17 August 1847, showed a

predilection for clean landscape and tidy dwellings and people, but was disappointed: "There is nothing scarcely to be seen on this road but stones and rocks, hills and hollows, ticks and giggers, cabins and dogs, black children and hogs, horses and mules, slaves and slaveholders, and the like." Better for scenery was Prudence's trip on 19 August 1847; on the road to Pleasant Hill from South Union, Kentucky, she wrote that "this afternoon we passed thro a very handsome country on the turnpike."[84] New Lebanon believer Abigail Crossman, with a group of Shakers going via train in 1846 from Pittsfield toward Springfield, Massachusetts, also contrasted the rough terrain with the more pleasant: "We have now passed the rock and mountains. Before us lies a beautiful country."[85]

Crossman suggested a preference for the beautiful rather than the rough, and, beyond her, most widespread in Shaker accounts was a predilection for soft, beautiful, green nature. The word "beautiful" is not as particular in aesthetics as the sublime, and it is less certain that the Shakers were as aware of the Burkean sense of the word as they were of his notion of the sublime. Still, like others in the Anglo-American context, Shakers had a general sense of a beautiful landscape as one that is verdant, cursive, soft, and lovely. The pleasing, green, and ideal landscapes of French painter Claude Lorrain (ca. 1600–1682) were regarded in aesthetics as the epitome of a kind of beautiful landscape. For their part, Shakers consistently praised green valleys and gentle, leafy landscapes. Some of the earlier appreciations of verdant, rich, or pleasantly undulating landscape came in the assessment of land purchased or available for settlement. Already in 1810, a Shaker was describing the beauty of such terrain. William Deming, of Hancock, Massachusetts, was in Kentucky seeing newly purchased Shaker land near Harrodsburg for what would be the Pleasant Hill village and wrote that "it is a very beautiful Rich level tract of Land and hansomly Situated & well timberd."[86] For the practical Shakers, it was good if the landscape was also useful, as suggested by Calvin Green in assessing lands near Germantown in 1828: "This is a beautiful valley consisting of levels and rises, just enough to be handsome and convenient."[87]

Many of the Shaker comments about the charms of everyday scenery came from traveling. An early appreciation of nature appeared while Shaker Daniel Moseley (or Mosely) (1760–1852) was on the road in May 1812, leaving work in the West and crossing Pennsylvania and New Jersey on the way home to New Lebanon: "Jefferson and Levenston. these towns stand on the center of the most delightful plaine I ever saw." And when he passed through Bethlehem, Pennsylvania, he got to "cross a butiful mill creek on the edge of town."[88]

Rhoda Blake (1808–95) remembered decades later how on 23 May 1819 she was arriving at New Lebanon for the first time: "Vegetation was rapidly growing & covering the earth with its mantle of green—the hills and mountains that surround Mount Lebanon and the vallies below, were an attractive appearance. The Fruit trees were in bloom, and as we came down the Taghanic [Taconic mountain] range, new beauties continually opened out before us. The beauties of nature so animated our feelings while on our way that all sorrows we had past thru, were gone."[89] Thomas Hammond Jr., of Harvard, Massachusetts, traveled in New Hampshire in 1851 and gained "much satisfaction in viewing the falls" at Manchester.[90] Charles Hodgdon, who would become an apostate but writing of an event while still a Shaker, had a chance with three others in June 1823 to visit the Shaker village at Enfield, New Hampshire. He enjoyed a visually rapturous day: he and his companions rode in a "beautiful wagon" and "while on our way every thing around seemed beautiful; the air fresh and fragrant, and the fields adorned with fruit and flowers of various kinds."[91] Henry C. Blinn had a similar experience a half century later, riding to Concord, New Hampshire, from Canterbury: "The ride to Concord was very pleasant as every surrounding conspired to make it congenial to the mind."[92] Shakers enjoyed the quiet sights on the ocean shore, as well, when they had an opportunity to visit or while passing through. Near or at Cutchogue, Long Island, in 1853, Freegift Wells, who had grown up in that charming area, said that "I saw nothing in all this region which I coveted as much as I did the beautiful white sand."[93] Using even more flowery language, Wells was at the shore one evening on Long Island in 1861, writing, "This evening is very pleasant, wind all gone down, moon a little past south & shines very clear, causing the water of the Bay under it, to appear like silver."[94]

Shakers liked meadows and woods framing farmlands. Isaac Newton Youngs of New Lebanon and traveling along the Erie Canal in 1834 saw "the most beautiful meadows & rich, fertile lots of land."[95] This assessment of the region was echoed by one prominent contemporary writer from the non-Shaker world, author James Fenimore Cooper (1789–1851), who thought that the landscape, farms, and villages in New York State seen along the Erie Canal and the nearby railroad line comprised views of "sublimity and grace."[96] Similarly, in a tour with Rufus Bishop to Ohio and Kentucky, Isaac Newton Youngs wrote on 6 June 1834, forty-eight miles from Schenectady, New York: "And it is a delightful prospect on the side of the mohawk, while the verdant fields stretch forward wide in view with here and there a village and smaller habitations of man enlivening the scenes."[97] Traveling near Sodus, New York,

in 1832, Seth Youngs Wells saw "beautiful farms & meadows" near Phelps, New York, with an "enchanting prospect. Extensive and beautiful fields of wheat, corn, oats, & flax lay along on our left—large green meadows & pastures extended for miles on our right, in the midst of which ran a beautiful stream of water."[98]

Apart from their experiences of the aquatic sublime, Shakers left frequent accounts of their enjoying pleasant views of water. In 1836 sixteen-year-old Hannah Agnew enjoyed a picnic of sorts with fellow believers and had an epicurean time enjoying the view and the Shaker baked goods. On the way from Ohio to New Lebanon, Agnew stopped in 1836 with a group of Shakers by the side of a stream for a springtime idyll on a beautiful day in May: "About noon, by the side of a beautiful stream, upon the green turf, and the early spring flowers, the humming of bees, and the singing of birds in the wilderness bowers, we regaled up on a good Shaker cake, with a little cracker and cheese, & a cooling draught from the flowing rill."[99] Prudence Morrell wrote about upstate New York on the way home to New Lebanon by train on 1 October 1847: "At day break we landed[,] took breakfast & then set out in the cars for Schenectady, past the town of Canandaigua & and a beautiful lake of same name. . . . [T]he water was very clear and beautiful, & [at] a little distance there was a bridge for common travelling one mile long, this was a delightful view."[100] Joanna Mitchell, writing on 7 August 1835, and going from New Lebanon to Union Village, Ohio, went first by steamboat and "then took the rail road 35 miles, this is beautiful travelling."[101] An unidentified Shaker from Harvard, Massachusetts, going to Watervliet sailed up the river to Albany, seeing "a great variety of scenery to behold" and on the way in to New York City from the Long Island Sound had "viewed the scenery of land, vessels, Islands, &c."[102]

Shakers sometimes compared one beautiful spot to another, showing a connoisseurial sense of exercising critical judgment. A group of Shakers from the West were traveling outside of Albany, New York, on 18 June 1869, the journal keeper writing, "I viewed one of the most beautiful districts of country, kept in the neatest style & under the highest state of cultivation that my eyes ever beheld." There the "beauty and loveliness of nature & art [are] combined." The writer especially liked the Albany Cemetery for the similar reason of art and nature, for the site "presents a most romantic scenery of hills ravines & plains, combining the beauties of art & nature, vastly more extensive & picturesque than that of Lexington in Kentucky."[103]

The level of interest and appreciation of Shakers for landscape is indicated by their frequent efforts to go out and attain the best views, sometimes walking to

a different point of land to achieve it, at other times riding out into the country-side for the pleasure of it. As Hannah Agnew reported in 1836, on a boat in Ohio with some Shakers, on the way to New York: "Last evening about sunset, we all went on deck, seated ourselves, & commenced viewing the landscape, & con-versed on passing events."[104] In a ministry journal from Watervliet on 8 May 1851, documenting a trip to Groveland, New York, two miles north of Mount Morris, Livingston County, New York, the land purchased "about the best, and the handsomest that our eyes ever beheld." Similarly, on 15 May 1851, during a journey from Watervliet to Groveland, the journal states, "We remained on deck the most of the way from Groveland to Rochester, for the scenery was so inchant-ing that it was difficult for us to deny ourselves of the pleasure of seeing these beautiful intervals."[105] In Alfred, Maine, on 14 September 1850, Thomas Damon (probable author of the account), along with three other Shakers, "rode out 7 or 8 miles to view the brethren's meadows. . . . Had a fine ride." In addition to seeing the countryside en passant while going to a destination, Shakers sometimes went out riding for pleasure and to enjoy the sights.[106] Anna White, journeying from her Mount Lebanon (New Lebanon, renamed in 1861), noted on 14 July 1873 at the Shaker community at Alfred, Maine: "El[der] John took us out riding around the [Massabesic] pond* [written on the bottom of the page: "*MASSA-be sick pond. an Indian name"] just back of the house—a beautiful sheet of water it is. This is the roughest country I ever saw. Rock, rocks on every side, fields of granite stone yielding nothing else[,] still the scenery is enchanting almost as beautiful as my own dear mountain home."[107] Similarly, on 25 August 1821 at New Lebanon, according to the diary of William Trip (or Tripp), who later (in June 1827) apostatized: "Benjamin[,] William[,] Sarah[,] Joanna and Sally Thomas ride out for pleasure" beginning at seven in the morning.[108] South Union, Kentucky, Shaker Milton Robinson, who was suffering from consump-tion (tuberculosis), was in New Lebanon, and on 17 June 1831, with three Shakers (two females and one other male), they used a carriage "to take a ride for recre-ation & health," going to Hancock, Pittsfield, and other places. Robinson stated in his journal that "there are few days of my life when I took so much real com-fort and satisfaction as I have taken to day[.] the day was uncommon pleasant[,] the roads good & the company agreeable & interesting."[109]

So far, we have seen Shakers on the road viewing and enjoying nature. Of course, Shakers spent most days of the year on their own community lands and recorded their thoughts about the natural world around them with entries in daybooks and narrative accounts of life, some of the latter having been writ-ten by apostates. The most fundamental and frequent aesthetic experience of

a Shaker was of the villages and farms that they created, with neat buildings in orderly arrangement and about them pleasing fields, meadows, woods, and various kinds of bodies of water, enjoyed best, it would seem, in springtime or fine weather. Nature in the Shaker communities was viewed in the organized gardens and growing beds closer to the residences, broader fields, orchards, meadows, and undeveloped woodlands more on the perimeters. Believers considered all of this to be part of their Zion, and their comments often mix together the various natural and improved aspects of the rural sites. Of course, the Shakers were not alone in the love of pretty farms and villages. The idea of the *ferme ornée*, or "adorned" farm, was of long standing in England and America. In the Hameau de la Reine (Queen's Hamlet) at Versailles, Marie Antoinette (1755–93) enjoyed a pretty, scenic farm constructed just for her. The Shakers had a special interest in theirs, however, as they intensely believed that their lands were God's realm and that they were ordering and prettifying it for him and to serve as a counterpart to the neatness and beauty of heaven.

True, there were limitations on what kind of natural beauty they could create at home. For example, although the nineteenth century was the great age of the expansion of the greenhouse in America, the Shakers avoided the exotic, pleasurable, and unnatural aspects of greenhouses, and according to the Millennial Laws of 1845, "Believers may not spend their time cultivating fruits and plants, not adapted to the climate in which they live." Similarly, "Different kinds of trees or plants, may not be engrafted nor budded upon each other, as apples upon pears," and so forth.[110] Still, they loved fruit naturally grown on their properties. Shakers could enjoy the sight of anything growing wild, and of anything growing for consumption or for medicine or other use, but they could not purposely grow something solely for beauty or keep what they found as a personal object. As Marcia Bullard (b. 1822) ([Lower] Canaan, New York, and, later, Harvard, Massachusetts), writing of her memories of being a Shaker in the 1860s, put it: "The rose bushes were planted along the sides of the road which ran through the village, and were greatly admired by the passersby, but it was strongly impressed on us that a rose was useful, not ornamental. It was not intended to please us by its color or its odor, its mission was to be made into rose-water, and if we thought of it in any other way we were making an idol of it and thereby imperiling our souls." Indeed, she stated, "In those days no sick person was allowed to have a fresh flower to cheer him.[111] Still, Shakers found plenty to enjoy visually both at home and while traveling, and the insistence on practicality hardly presented great limitations on people surrounded by wildflowers, flowering trees, pretty bushes, and trees.

Figure 2.5. After William Rickarby Miller, *Shaker Village at Canterbury N.H.*, late-twentieth-century postcard, 3½ x 5½ inches, based on a 1853 wood engraving ("Sketches among the Shakers," in *Illustrated News* [New York: H. E. and A. E. Beach], 29 October 1853, 245). (Clinton, New York, Hamilton College Library. *Photo:* Hamilton College.)

Shakers frequently commented on the natural beauty found in and around their villages. Hervey Elkins noted that the Shaker village at Canterbury, New Hampshire, is "located upon a beautiful swell," a placement conveyed by a number of artists over the years, who often exaggerated the extent of the sweep up the hill (fig. 2.5). Elkins, writing himself but claiming to be quoting from a letter from a friend named Urbino, who had just left the Shakers, painted a verbal picture of one morning in the Shaker village at Enfield, New Hampshire: "It was a morning in summer, when nature appeared bedecked with gems. The sun had risen, and pendent from every blade of grass, were glittering diamonds of liquid formation. The fragrance exhaled from the floras of surrounding nature, perfumed the atmosphere I inhaled."[112] In the Shaker villages, one found beautiful nature, fair to see and bountiful in harvest. At Alfred, Maine, in the "Testimony of Elisha Pote," written in 1843 for the edification of "good believing young people and children" in Shaker villages, it stated, "Here you find yourselves provided for, in everything for your comfort in temporal things; good comfortable houses, and every conveniense, comfortable food, and raiment, look around you, and you will find yourselves surrounded with every temporal blessing; behold your beautiful cultivate[d] fields, your beautiful gardens, and pleasant orchard's yielding pleasant and

delight[ful] fruit. . . . You have all which you could reasonably desire."[113] A group of Kentucky Shakers were pleased in June 1869 at the tout ensemble of the Shaker village at Watervliet: "Every thing shines with cleanliness, & the yards & premises are beutifully [*sic*] clothed with a green mantle, & every thing wears the appearance of neatness & loveliness & beauty."[114] Even an apostate like Absolem H. Blackburn gave a rapturous description of Union Village, Ohio, a western outpost of the Shakers, as he praised the plantings and layout:

> I cannot pass without speaking of their gardens which are managed commonly by the special direction of the Elders. They are divided by a large walk through the middle into two parts; these are again subdivided by lesser walks, crossing each other at right angles; at the farthest end of the walk and garden there are pleasant summer houses, arbours, &c. which are delightful to people of taste and fancy. In these gardens are a pleasing diversity of flowers of various kinds. Herbs, fruit, roots, greens, and all kinds of vegetables that a garden can produce. It is here worthy of remark that the vegetables, flowers, &c. opposite each other on the right and left of the main walk, are exactly alike, or of the same kind, size, position, &c. thus by examining one side of the gardens you can see what is the regulation of the other.[115]

Shakers sometimes offered a dreamy and romantic assessment of the beauty of nature found in their communities. In "A Play Day in Whitewater Enjoyed by Hannah Ann Agnew with her old play mates," dated 27 June 1856, Agnew, now a deaconess at New Lebanon, wrote of her girlhood home village in Ohio: "As the carriage wheels roll away over the hills Hannah turns her eyes for the last time to wards the beautiful wood land[,] the lovely playground of her child hood and youth, and with a deep sigh, calmly whispers: Adieu! thou favorite spot, Adieu forever!"[116] Hervey Elkins offered an especially idyllic description of the beauty of Enfield, New Hampshire, where he lived:

> By the mountain's suddenly receding and a plain's advancing upon the waters, a scene, unrivalled for novelty and rural beauty any where in New England, is rapidly disclosed. Level, fertile fields of great extent, with marginal trees; gardens of six, eight and ten acres' surface laid out along the shores and containing every variety of esculent herbage that the soil and climate will permit; avenues long

and splendid, of the sugar maple and butternut, reaching across the plain and extending far up the mountain side; orchards of ingrafted fruit; innumerable trelisses supporting vines; fences with granite posts; barns which, from the rich exterior and size, resemble more the market houses of our cities; beautiful edifices of capacious dimensions for houses, some of stone, others of brick, others yet of thoroughly painted wood and roofed with the slate of Wales;—every thing which substantial utility could suggest and modest plainness approve, apprize the visitor that he has entered an area of singular charm and occult signification. The lake itself clean, sweet, chrystal-like and noble in its outlines, heightens immeasurably the fascination of the spot.[117]

For her part, Deborah Robinson, on 28 August 1850, at Shirley, Massachusetts, wrote that a "beautiful place" is formed by the vineyard and fruit orchard behind the Square House and that "it reminded us of the garden of Eden."[118] Sarah Ann Lewis, on 12 September 1849, toured the grounds at Canterbury, New Hampshire, and sat on 15 September 1849 in the garden amid the late-summer grapevines, "a very delightful place." Shakers liked to compare their sites and were gratified to see beauty appear in all Shaker villages. Lewis was at Enfield, New Hampshire, on 20 September 1849: "Here presents another handsome situation of believers—a beautiful pond laying north and east of their buildings."[119]

Hervey Elkins described his feelings experienced as a Shaker and the idyllic beauty of the lake at Enfield, New Hampshire, as he would drift in boats and angle for fish with his charges from school. The appearance of Mascoma Lake, with the enduring preservation of the green surroundings, is still idyllic and offers some sense of Elkins's situation:

Sometimes we would enter our boats, lying in a creek below our garden, and rowing half way to the opposite shore of the lake, would then drift in obedience to the impulse of the rippling waves; I, seated in the stern, basking in that soft repose which sound health, unannoyed conscience, easy circumstances, and a warm and luminous atmosphere, combine to afford; intoxicated with the voluptious undulations of the boat, produced by the action and reaction of the water; and contemplating the radiance, beauty and splendor of the

sun, the sky, the distant mountains, almost hid in the soft purple light of September air, and the clean verdant shores, rising in terrace like form, to the orchards, the groves, the gardens, and to the pleasant estrade fronting the family mansion.[120]

Shakers often moved around the grounds and sought out aesthetically pleasing sights of nature. That Shakers could not walk about their lands on the Sabbath rather indicates that it was a pleasurable act. According to the Millennial Laws of 1821 (and reiterated in 1845), "No one is allowed to walk out on the sabbath day for recreation; but if any have duties to do, they may go out and do them in justification."[121] Numerous documents indicate that the Shakers regarded it as a pleasure and a temptation to walk in the fields, gardens, and orchards. Giles B. Avery, at Canterbury, New Hampshire, on 15 May 1843 wrote that this evening we "all went out into the meadow north of the buildings & sowed & watered it[.] here was one of the prettiest sights I ever saw, a great privilege. Came back into the door yard, and had a joyful dance." And there he also saw on 21 May 1843 "a beautiful rolling meadow."[122] Shakers going to other villages of believers toured gardens. As noted in the "Journal of Seth Wells' tour among eastern believers to organize their schools" on 18 August 1823, in Alfred, Maine, he visited the Second Family, then "after tarrying a while, walking in the garden," he returned for supper.[123] On 20 September 1850, Thomas Damon and those fellow Shakers disposed to join him "took a tramp over a delightful tract of meadow" at Poland Hill, Maine.[124] Not just walking for functional purposes, Prudence Morrell and her Shaker companions walked apparently for the pleasure of viewing at Union Village, Ohio, on 2 June 1847: "We took a walk thro the orchards & woods down to the square house and tanyard and the like."[125] Shakers placed seats in their gardens and orchards for enjoying the natural beauty of the villages, and as noted by Henry C. Blinn of Canterbury, New Hampshire, on 10 July 1856, when at New Lebanon, "We walk to the pear orchard & are provided with nice seats under the shadow of a beautiful grape vine."[126] Hannah Agnew, on the way back from Ohio, wrote a kind of journal in verse concerning a trip to New York (including Groveland and Rochester) in July 1856, the account titled "Joyful Meeting and Wonderful Expedition of the Five Churches." In one part, she stated: "Some went out to view the landscape, / Others went upstairs to bed!" On another evening during the same stay, she enjoyed the idyllic evening:

Calm and pleasant was the evening,
Fields and forest spread their charms;
And the moon as fair as "Eden."[127]

For Shaker praise of the beauty of nature, but restrictions on use of and access to flowers, one can read in a visionary statement from New Lebanon in 1841, referring to the spiritual city of Shakerdom on earth: "The glorious gates and beautiful towers of this holy City, are adorned with everlasting strength! <u>Order</u>, <u>meekness</u> and <u>love</u> ornament the heavenward travellers who inhabit her peaceful abodes. The trees of Eternal Life grow in this pleasant valley, unfolding their leaves and spreading wide their branches. . . . Beauty and order reign triumphant in this Holy Sanctuary. . . . Remember ye, that order, is Heaven's <u>first law</u>!" But the document goes on to discourage believers from culling "flowers by the way," and asks, "Why is it that ye still seek to please the lust of the eye, and the pride of life (instead of devoting your time and talents, in doing the will of God, and his chosen people?)."[128] Despite this visionary admonition, and while it is true that Shakers could not plant flowers for pleasure in the communities, they could enjoy them when they grew in the wild, and they often picked wildflowers. For example, when she arrived in Watervliet, on the way from White Water (or Whitewater or White-Water), Ohio, to New Lebanon, sixteen-year-old Hannah Agnew wrote, "After a short & sweet refreshment, we visit a little among the Sisters; Paulina Bates [1806–84] (deaconess of said [Second] Family) & myself, take a short ramble in the pine woods & gather wild honey suckles & cc."[129] Agnew, homesick all the years she had been away since the age of sixteen, had a chance to return to White Water in 1856 at the age of thirty-six, and she gave a rapturous description of the landscape there: "Heaven sheds her blessing of peace & prosperity, upon the blooming hills & dales, the fragrant woodlands, & spring groves, of your ever beautiful, & flourishing home. 'Fair White-Water.'"[130]

Some nature at the villages was wild, and at the periphery, but much of it was part of the controlled arrangement of rectangular growing beds, tidy orchards, and well-appointed fields of plantings. Along their roads, Shakers planted trees in a row and liked the effect. That traditional arrangement of evenly spaced trees in a line pleased the orderly Shakers. Thomas Hammond Jr., of Harvard, Massachusetts, on 22 September 1846 wrote of Tyringham, Massachusetts, after passing the North Family: "Came to where are beautiful, lofty & very stately rock maple trees on each side of the road, & a beautiful watering place on the right as we go."[131] Canterbury Shaker Henry C. Blinn

arrived at Hancock on 8 July 1856 and wrote that the "beautiful maples are arranged on each side of the road, the entire length of the street, the foliage of which, in the summer season renders it a most delightful place."[132]

The change of seasons was a significant part of the visual world of the Shakers and was mentioned with great frequency in Shaker daybooks. No travel was needed for this. The advent of spring was an especially welcome event in Shaker villages, many of which were in northern locations and chillier still by being away from the seacoasts. Shakers also found much beauty in summer and some in snowfalls. Fall was the harbinger of a long winter and perhaps dreary for the village dwellers, and Shaker accounts are not so enthusiastic about autumn foliage, which was otherwise widely represented in nineteenth-century American landscape paintings and discussed in literature. The onset of winter and the appearance of a November shower of hail displeased Ann Buckingham (1804–92), a diarist at Watervliet, New York: "A very homely day it hails all day."[133]

Describing the beauties of spring, Philemon Stewart (1804–75) wrote on 16 April 1836 at his home village of New Lebanon: "Peach trees now are all but ready to expand their beautiful blossoms."[134] An anonymous Shaker account includes a collection of verses and other writing, including a little piece called "Spring:" "Spring has just made its appearance, clothed in beauty. The earth has arrayed herself in a garment of green." The "bright sun" has returned, and "his rays, which make so many beautiful colors are shining with more brilliancy. . . . Winter with its sublime mountains of ice and snow has disappeared. . . . The tall trees in the sylvan groves bow their heads as if inviting us to enter and enjoy the fragrant blossoms and the pleasures of their cooling shade."[135] For Sally Bushnell, in New Lebanon and writing on 4 May 1848, it was "a beautiful Spring day."[136] Anna White wrote on 1 January 1871: "Winter, Spring, Summer, Autumn and again Winter. The Spring was delightful, never more enjoyable. Can the beauties of the spirit land exceed the enchanting splendor of a Spring morning at Mt[.] Lebanon? Who can tell? echo answers, who? Summer equally beautiful with abundance of small fruit."[137]

Rufus Bishop, of New Lebanon, kept a detailed journal of his activities and events on the villages where he resided or visited as part of his duties in the Central Ministry. He never mentioned the beauty of furniture or interior design, but he often commented on the beauty of nature and natural events. In his lengthy daybook kept of events at New Lebanon, Bishop found visual pleasure in springtime fields on 18 April 1831: "Warm & clear vegetation puts forth rapidly—yards, meadows & pastures are clad with a beautiful green."

After much rain on 21 May 1836, Rufus delighted in the appearance of the farms: "Scarce ever saw so great a change in the face of creation in one day. The Earth is very suddenly clad with a beautiful green." And he was delighted on 3 March 1832 that "Blue birds & Phee bees [sic] sing this morning for the first time this Spring." He took pleasure in the sight of the blooming of trees on 12 May 1833: "Apple trees in full bloom—scarce a tree which does not resemble a large Pink-posy." On 23 May 1836, he wrote, "Fine warm growing season—our Orchards blossom out remarkably. I think they are about in full bloom." Bishop recorded, in addition to visual pleasures, a note about the attractive sound of birds on 19 March 1833: "This day seems like Spring in good earnest—warm & fair. Robbins & other birds sing pleasantly."[138]

Apart from the seasons themselves, the Shakers took note of the visual and pleasurable aspects of the change in weather. Shakers frequently found beauty in rain and snow and in clear weather. Rufus Bishop often noted when there was fine weather, as the "Beautiful weather" on 21 and 16 July 1843."[139] Eunice Esther Bennet (1780–1848), a Groveland eldress visiting at Watervliet, New York, wrote on 26 June 1844: "We spend the Day with the Ministre. This after noon we have a b[ea]utiful Shower."[140] An anonymous diarist at Harvard, Massachusetts, wrote in 1847: "It has been a very clear bea[u]tiful still day."[141] In a journal entry, Daniel Miller (ca. 1797–1873) wrote at Union Village, Ohio, on 7 June 1849: "A delightful shower of rain fell to day."[142] Ann Buckingham wrote of a day at Watervliet, New York, in April 1840 that "this afternoon and evening we have a beautiful april shower."[143] Rufus Bishop mentioned on 13 July 1847 a "beautiful shower of rain" and on 22 June 1840 noted that there was "a beautiful shower this afternoon."[144] Bishop even thought of a storm that "we had a beautiful thunder Shower this afternoon while in meeting." Like other Shakers, he liked white snow, as on 18 December 1830: "Snows a little so as to whiten the ground," and on 19 January 1836 he noted the "handsome winter weather." Similarly, on 6 January 1836, Bishop witnessed that "a pretty little snow fell last evening, which lays still." In another typical note for him, he wrote on 21 January 1841 of "a beautiful smow [sic] storm this morning."[145] He cheerfully saw the pleasant weather and good work in the same light, as on 15 October 1836, when he noted, "We have a beautiful pleasant day for business [that is, work]," and he wrote on 28 May 1837 of "fair & cool, beautiful weather & beautiful meetings to day." Again, on 23 October 1833, it was a "beautiful morning & good day for business, only the ground is very full of water."[146]

Again almost always without seeing divine reference or meaning, the Shakers saw beauty in the sky in various ways, from the northern lights to

sunsets to moon and starlight. They were building heaven on earth in themselves and their localities, and the sky to them was a curious, distant, and at times beautiful thing. Sally Bushnell marveled in February 1848 there was "a very curious appearance in the sky this evening, the color resembling that of fire."[147] Among some Shakers on the evening of 5 August 1846, on a train leaving Worcester, Massachusetts, one wrote, "The Moon gives us li[g]ht; and the big stars glowed with resplendent beauty."[148] Hancock Shaker Thomas Damon, setting out from Alfred, Maine, in 1850, wrote, "The stars shine brightly & everything indicates a fine day."[149] Rebecca Cox Jackson noted in her autobiography how she was struck by a "view of the Natural Atmosphere." Viewing the crisp, midwinter sky of Watervliet, she wrote in 1850 that the air is like the sea: "It is always calm and serene between its face and the starry heavens." She added, "The sight, to me, was beautiful."[150] Also without divine reference or moralizing is an interest in coloration among planets that appears in "Notes on Comets" (1853–63), by an anonymous Shaker at Union Village, Ohio. The writer laments that ideas about planets are "chiefly founded on conjecture" and in "Notes on Planets" stated that Venus is distinguished by "brilliancy and whiteness" and in "Notes on Mars" that Mars has a "dusky red color."[151] To be sure, Shakers had a keen interest in the nature and visual appeal of celestial phenomena.

In his youth, Issachar Bates Sr. noted that he saw the northern lights and comets as portentous and "frightful signs" from God before the "opening of the [Shaker] gospel" in New England, but, for his part, Rufus Bishop's mentions were visual and without religious inflection.[152] On 5 September 1830, Bishop marveled at "remarkable Northern lights this evening," and again on 12 December 1830 he witnessed "remarkable Northern lights through the whole of last night"; on the next night he enjoyed more and compared the experience to the previous evening's display, saying that he saw "Northern lights all last night, but not so wonderful as the preceeding night." Elsewhere, on 25 January 1837, he recorded another aurora borealis in vivid terms: "This evening there was the most remarkable Northern lights that was ever behild. The sky was cloudless, but a large portion was of a deep crimson." He was smitten with another aurora borealis on 3 September 1839, when the "remarkable northern lights" covered the "whole horizon," and "sometimes the sky, in many places, resembled blood, and at other times bright flames which would flash in a terrible manner. Some times the bright streaks would center about at our zenith." Remarking on another celestial event, on 24 December 1833 he recorded a "remarkable phenomanon on the 13:th of last month," apparently

witnessed in the Shaker villages in Ohio and Kentucky, namely, "the Stars or Met[e]ors seemed to shoot by thousands at a time" over the course of several hours, and it must have been a "wonderful sight."[153] Bishop exclaimed on 21 March 1843, "This evening I saw the tail of the Comet for the fir[s]t time, a wonderful phenomenon."[154] In another unusual celestial occurrence that he saw in the sky, Bishop saw, after rain on 6 May 1844, "some remarkable appearances about the Sun, such as 2 Circles & a bright Sun Dog," the latter being colored patches of light to the right or left of the sun.[155] Bishop had a sharp eye even for subtle aspects of celestial nature: on Christmas Eve 1836, he recorded that "in the evening there was an uncommon large circle around the Moon."[156] Bishop was not alone in his fascination with the northern lights. Ann Buckingham, recording at Watervliet, New York, in 1837, wrote, implying that she was not alone in her viewing, "This evening we see very remarkable northern lights."[157]

Turning from the sky back to earthly sights, engagement with nature among Shakers occurred while swimming, and those outings frequently involved the aesthetic appreciation of the natural setting. Shakers swam often, a practice encouraged by some sense of the widely held belief that a cool dip, with the vigorous exercise of swimming, helped to suppress sexual desires. Educator Seth Youngs Wells traveled in New England with other Shakers and took a dip at a beautiful spot in 1823 in the sea while headed toward Kennebunk, Maine. He and Shaker fellows "travelled over a level & beautiful road for 7 or 10 miles to Kenanbunk." When they got to the ocean, they enjoyed themselves in a secular way: "There we stopped & spent 2 or 3 hours—went into the water & bathed—It was a very pleasant beach of hard sand. . . . At the place where we stopped was a reef of rocks, which made a fine stopping place." Further on in the trip, moving through Maine, the group traveled along the coast and prized the ocean vistas from the road on 13 August 1823: "From Portland we proceeded through a fine country of excellent farms 15 miles to Saco falls having the sea in view a great part of the way."[158]

Deborah Robinson left a rapturous account of walking and swimming on the beach. She was at the Atlantic Ocean with a group of male and female Shakers on Lynn, Massachusetts, in the late summer of 1850: "After getting our things a little adjusted, took a walk on the Beach, returned to the house, the brethren ar[r]ived and we got our bathing clothes, prepared and took a good duck, returned[,] took supper, after this walked on the beach and viewed the rolling waves while the bright Sun appeared as if hiding it self in the deep water. Returned home and went to bed, in fair view of the briney deep."[159] Along on the same trip, Thomas Damon, in his own journal of the trip, stressed

the beauty of the beach scenery at Nahant: "We looked around among the wild scenery & rugged rocks."[160] Still at Lynn on 2 September 1850, Deborah Robinson took "a fine bathe in the great Pond" near the boardinghouse. All of this swimming pleasure occurred in the context of Shaker meetings and visitations, as with the spirit of joy on 8 September 1850: "Had a lovely good meeting. The spirit of freedom, life and love prevailed. We sung, danced, blowed our trumpets. Shook, whirled, bowed and bent[.] Appearantly all partook of the resurrection power of life." After arriving in Maine from Massachusetts, Robinson, on 18 September 1850, walked with sisters and brethren at "Sabbathday Pond."[161] Thomas Damon, in the same group as Robinson, told his side of things; he went swimming, likely skinny-dipping, after waiting for the Shaker sisters to depart: "In the afternoon went with a good company of sisters & brethren down to Sabba day pond a beautiful place—waited til the Sisters were gone when I plunged into its waters—a fine time."[162] A few years earlier, also enjoying Lynn, Massachusetts, a Shaker from Watervliet wrote on 8 June 1847 at "Lin": "We tarried here two nights, & one day & ½[;] viewed the curiosities all about, bathed in the Salt water, some of us were much benifited by it."[163] When the weather was warm and Seth Youngs Wells was at Sodus, New York, he and other Shakers swam where the creek entered the bay at Lake Erie, and "the water was pleasant and agreeable."[164] Freegift Wells, at the town of Southold, New York (Long Island), with brothers and sisters on 6 September 1853 brought along his "duds," meaning some bathing clothes, and on the beach went to "the little house, where we changed our clothes, & had a fine time for bathing, I believe to the satisfaction of all our company," then put on dry clothes and took a scenic walk on the beach.[165] Freegift, in 1861, swam on Long Island in the same area: "Between 2 & 3 Oclock I walked over to Landon's Creek & went into the water[,] had a beautiful place & time." On the same trip, Freegift felt obliged to emphasize, in addition to all of the secular leisure, "things in a temporal line" on the trip, that religion is "a subject which I think should not be wholly neglected."[166]

As for appreciation and knowledge of trees, nineteenth-century Americans were keenly aware of the size, nature, and identification of trees, and Shakers were no different. We have seen how some believers commented on oversize and ancient trees; they also noted regular and more modestly scaled trees and were most likely to discuss trees when away from their home regions. They also were not hesitant to point out the beauty of fruit trees, especially in bloom or abundant with fruit. Freegift Wells, in 1836, en route from Philadelphia to Lancaster, wrote, "I have distinguished some walnut, white oak, ash & locust,

but seldom an ever green of any kind, except occasionly some dwarf Cedar."[167] Elsewhere, Freegift saw from the Erie Canal in June 1834 a "thickly set grove of sycamore trees, or what we call button wood, about 25 or 30 feet high, which make a beautiful appearance."[168] Shakers enjoyed trees at the own villages. At the Shaker village at New Lebanon in 1856, Philip Burlingame walked from the school to the pond: "It was a very beautiful square pond surrounded by willow trees set out by Elder Issachar." This awareness of Issachar Bates Sr., as designer of the landscape, shows a rare instance of known Shaker authorship of a landscape element.[169] For his part, Thomas Damon, at Enfield, Connecticut, in August 1850, noticed the beauty of trees and fruit: "There were a number of the Bartlett pear in full bearing and a beautiful sight it was[.] the large splendid fruit bending the branches nearly to the ground." The plums there also had a "magnificent appearance."[170] Even large fruit caught the attention of Shakers. Giles B. Avery was impressed by fruit at South Union on 31 July 1862: "Such a sight I never saw before," enormous fields of blackberries some "as large as a doves egg."[171]

Shakers had long been disposed to recognize the beauty of the "vegetable creation," and in the 1810s *Testimonies* it affirmed of the natural world created by God that "every thing was beautiful after its kind, and in its times and seasons."[172] Shaker travel documents bear out this appreciation. The diversion that Seth Youngs Wells sometimes gained enjoying trees and nature, even on a business trip, was impressive. While one of his Shaker traveling companions was taking care of some matters, Wells, in Lyons, New York, in June 1832, looked for an hour or more of the gardens of Myron Holly, "formerly one of the canal commissioners & Judge of the county court."[173] He was accompanied by Holly and his family, all of whom, though non-Shakers, were "very friendly" to Wells. Holly and his family "took us in their garden, which was extensive and beautiful . . . containing flowers, of almost every description, a great variety of fruit trees [including cherry, peach, pear, and plum], loaded with fruit. . . . [after an] hour or more, very agreeably, we proceeded on our journey."[174] There is no indication that Wells entered the house, or, if he did, he did not bother to report that to his Shaker readers back home. Abigail Crossman, on 11 August 1846, was with a group at Harvard and one day "returned to the Office; take dinner & our next move is a walk in the gardens, Orchards, Vineyards &c with Elders, Brothers, &c," and found "numerous kinds of fruit trees. Peach, pear, Apple[,] Quince & plum. The trees were heavily laden with choice fruit not yet ripe." The next day they had "a pleasant ride on the pond[.] the boats were

rowed by Br. John & Elder Br. sing, play. I have quit[e] an interest in that as we glide along over the water in our little barks."[175]

We started this chapter noting that the divine and moral component of consideration of nature and landscape was not prevalent in Shaker writings. We might record here, though, some instances of such thought and expression in Shaker literature. Beyond the Shakers, the idea of God's authorship of natural beauty was an idea widely espoused in Western civilization, the notion rooted in the book of Genesis and sanctioned by later theological thought. His handiwork was seen most clearly in untouched nature, and many American poets, artists, and travelers in the nineteenth century readily felt God's presence especially in the splendid, raw nature to be seen across the American states and territories. Painter Thomas Cole, writing at the heart of the period of Shaker travel accounts, stated the idea in a number of nuanced ways in his influential "Essay on American Scenery," published in 1836. Cole wrote that when one is "gazing on the pure creations of the Almighty, he feels a calm religious tone steal through his mind." In the wilderness, especially, which was still to be found in America but had all but disappeared from Europe, one feels God's presence: "Amid them the consequent associations are of God the creator—they are his undefiled works, and the mind is cast into the contemplation of eternal things." He exclaimed, "How congenial to religious musings are the pathless solitudes." Cole asks the reader to follow the admonition of Scottish poet John Wilson (1785–1854), who wrote, "Learn The laws by which the Eternal doth sublime And sanctify his works, that we may see The hidden glory veiled from vulgar eyes."[176] Nature is God's masterpiece, given for our use and enjoyment, and we inhabit it daily.[177] In his essay "Scenery and Mind" (1851), American clergyman Elias Lyman Magoon (1810–86) wrote that "the book of nature . . . is the art of God," and in "viewing magnificent scenes, the soul expanded and sublimed, is imbued with a spirit of divinity, and appears, as it were, associated with the Deity himself."[178] The Shakers had their own ideas about what godly landscape looked like, and it was their tidy villages, well-kept farmlands and meadows, and the woods that enframed the scene. Niagara Falls was a splendid sight to see, and Shakers gawked along with other American tourists, but, for believers, the presence of God was felt most keenly in their community's landscape and buildings.

While Shakers were happy to look at nature aesthetically, a few did mention it as God's work, and, in addition, there were some generalized Shaker moral interpretations of landscape, these last on various topics and not with

so much of a consistent theme. As for Shakers who proclaimed the grandeur or beauty of the world as the product of God as artist, one was Giles B. Avery, in 1862, in Kentucky, and seems to refer to the natural surroundings of the locality: "South Union is a pretty locality, and God deserves praise for his workmanship."[179] Similarly, Susan C. Liddell, near Union Village, Ohio, in 1857, found a beautiful landscape that inspired religious thoughts: "Here was the strong grape vine climbing the tall oak and again bending its head downwards seemingly to accommodate. . . . Here was the extended hazel thickets with frequently a blackberry vine entwining seemingly for support and occasionly a delicate flower to waste its fragrance in the gale. And what could be lacking to impress the mind with the infinite goodness and greatness of God our Author and maker."[180] For his part, John M. Brown, writing in 1866 of a trip down the Hudson River, thought that God produced a beautiful landscape for the "comfort" of mankind. He stated that "the scenery on either bank of the Hudson was pleasing to look upon; The variegated forms of landscape gave scope for enlargement & appreciation of our good Creator, who has furnished so much, & such a variety for the Comfort of his creature man."[181]

New Lebanon Shaker Hiram Rude (1802–73), writing in 1856, indicated his sense that the beauty and the fullness of the landscape were divine, but was disturbed that the Shakers did not possess all of this God-sent and beautiful American landscape. Writing sometime in June 1856, Rude was on the way to Union Village in Ohio, coming from White Water in that state, when he commented morally on the landscape; he also suggested that he and the group repeatedly took in broad views of the countryside during their travels: "Again we take a retrospective view of the country, which is about the best I ever saw, too good for sinful man to possess, it ought to belong to the people of God [Shakers]. It is written the earth is the Lords and the fullness thereoff. I should be glad he would begin to manifest his claim in earnest."[182] Thus, Rude shows some frustration that Shakerism had not swept the nation. Sally Bushnell, in New Lebanon, made at least a mention of the earth as God's creation (on the Sabbath, 2 November 1851): "This PM the Clouds disperse and the Sun ushers forth its bril[l]iant rays and cheers the face of creation."[183]

Sometimes the moralizing was essentially secular, and rather mild in effect, with aspects of nature being called "noble." Calvin Green, visiting Philadelphia in 1828, said of the Delaware River: "This is a noble and beautiful river."[184] Isaac Newton Youngs expressed a moral tone at Union Village, Ohio, on 18 July 1834, writing that "the pond is a noble one."[185] The ocean could be "noble" as well. On the shore north of Boston, Abigail Crossman enjoyed the waters, but she

was not too impressed with one kind of local delicacy: "What a dish is Lobster! An animal cooked with all its contents. Too much for my stomach." But she enjoyed a boat ride on the Atlantic and saw "3 mast ships, proudly riding upon her noble waves. The interprizing farmer beautifying the land with his industry."[186] Note also Crossman's characteristically Shaker interjection of the praise of industry and beautification of the land through the hand of the farmer. Calm seas and lakes were a widespread and long-standing symbol of the calm of the human soul, and Rhoda Blake, in June 1868, was at Enfield, Connecticut, and used such a metaphor: the gospel was taught by an elder and eldress at the South Family, with their "imparting the gospel of peace, like a calm bosomed lake."[187]

On a smaller scale in Shaker writings, flowers could be moralized, as they commonly are in all cultures, not least in nineteenth-century America. Hannah Agnew, a good writer, noted several moral aspects of imaginary flowers, including a sign of God's creation, and a child's use of them to cheer the homesickness of others. She wrote in 1836, in a passage we saw earlier, that "the captain's little Son, about 4 years of age, was in our company. his infant heart was so light & gay as a new born butter fly, & as such he flew from flower to flower, snip[p]ing with his tiny fingers those best suiting his taste, & presented them to the homesick, looking as if he understood the heart was sad, & he would fain cheer it with the beauties of God's creation." Similarly, Agnew wrote in a poem of a flower on 17 May 1836, giving it moral qualities. Homesick for her home in White Water, she envied a woodland flower for never having to leave its home, being able to remain there in its colorful beauty:

Little tiny wood-land flower
Parting scenes were never thine!
Brilliant rays, & balmy showers
Round thy petals, daily twine

. .
Thou hast bloom'd & lived in pleasure,
Handsome form, & radiant dye.[188]

The opposite of the flowery landscape was wild and thorny nature, such as briars, wild growth, and stony terrain, which in one Shaker account appear as symbolic of suffering in the sect's founding years. While at Harvard in 1822, New York Shaker Seth Youngs Wells painted an intimate landscape picture

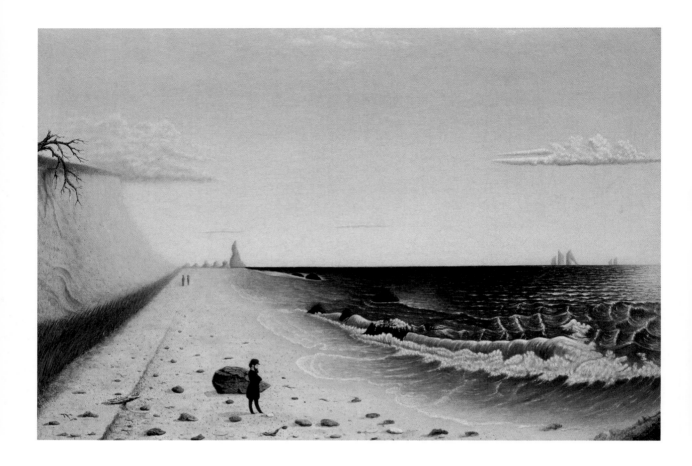

Figure 2.6. Unidentified artist, American, variant after David H. Strother, *Meditation by the Sea*, ca. 1861–65, oil on canvas, 13⅝ x 19⅝ inches. (Boston, Museum of Fine Arts, Gift of Maxim Karolik for the M. and M. Karolik Collection of American Paintings, 1815–65. Photograph © 2019 Museum of Fine Arts, Boston.)

by making the place of Shaker sacrifice a wild place. Wells went to the "stump of the tree to which they tyed Father James and also the valley after the mob left them—The sight of this place brought a very solemn feeling upon us—The place where the stump stood was a dismal looking place—rough & stoney— full of briars & wild stuff."[189] Wells offers a picturesque and moral description of how wild nature echoes the evil act performed at the dismal spot.

In a pictorializing and moralizing passage, written at a dark and bloody time in the Civil War, Freegift Wells described crashing waves in a way that recalls Civil War–era landscapes by Frederic Church and others, the conflicts and drama of nature echoing the martial times. Martin Johnson Heade (*Approaching Storm: Beach Near Newport*, ca. 1861–62; Boston, Museum of Fine Arts) and an anonymous artist (fig. 2.6) both found the contemplation of the sea to be fraught with moral feelings and made references to the ongoing Civil

War. For his part, watching with "inexpressible admiration," Wells described the "rolling surf dashing against the beautiful white sand shore," and then, seeing the waves on the beach pound against the rocks, he wrote of them: "In their apparent madness & determination to break down the barrier which stayed their progress, their battle was incessant, & their rage indescribable, & in this conflict they did not tire, nor show any abatement of their hostility."[190] More subtly, nature, with references to North and South, appears in a Shaker poem from the early 1860s as something of beauty, with a "wealth of hidden gems" even in a troubled world:

> The wintry clouds that shade the north
> And the glorious southern blue
> A land where orange-blossoms fall
> Like snow-flakes on the earth
> .
> A land of vines and singing birds
> Of sunshine and sweet dells
> .
> A wealth of hidden gems that dwell
> Unpolished in her breast.[191]

Believers equated Shaker villages with "Zion," their holy place on earth, the heavenly mount of the Old Testament, and the place where the saved would be gathering. In another document concerning moral issues and Shaker sentiment about landscape, one document from 1843 refers to the beauty of the Shaker fields in the context of keeping out the filthy hired hands from those places, with reference to the natural beauty of the Shaker villages. The Shakers were clean and blessed by God, and one owed him thanks for blessing the fields and pastures of Shakerdom: "O Zion! O Zion! I would that thy inhabitants were closely gathered within thy strong walls of protection, and that the feet of the filthy and unclean [that is, the world's people] were no more seen passing thro' thy pleasant groves and beautiful fields, nor that their hands were employed to work among you." The document continues: "Zion is indeed beautiful in my sight and she is the glory of the earth, but she would be still more beautiful, were her children more withdrawn from the wicked and unclean, were her dwellings no more defiled with their walking among them, or the work of their hand labor hired among you." So, gather together for thankfulness, and "I will bless your green fields and pretty pastures, yea

the land shall become fat because of my never ending blessing."[192] The document suggests that Shakers lands are beautiful and blessed with fruitfulness, and not meant for the use or enjoyment of the unclean.

We have seen how the Shakers enjoyed the beauty of the seasons and the skies. At times, the sight of those phenomena also evoked moral thoughts and elicited the implication, widespread in American and nineteenth-century thought, that nature experienced human feelings and emotions. As usual, the earlier Shaker manuscripts are dry and not embellished with moralizing sentiments.[193] Moralizing references increase in number during the course of the nineteenth century. One anonymous diarist at Pleasant Hill wrote frequently with flowery passages about nature and its feeling and intentions, such as when a drought ensued in 1854 when "the scortching sun continued to shoot forth its burning beams with unmidigated fury."[194] Some passages are merely visual and anthropomorphic rather than religious, as on 12 April 1846: "This morning it is cool and raining slowly. The peach, pear, plumb, cherry trees, and even the little barbary [barberry] bush are in bloom, the scene is most delightful." The journal comprises several moralizing descriptions of the changing face of the natural world. On 15 April 1850,

> The earth clothed in a mantle of snow, an inch and a half deep. The slender twigs of fruit trees bending with the frigid load, the green foliage of early shoots and the peach blossoms blushing with surprise at the incivility of the white robe that has unceremoniously enveloped them in its folds, present a scene that would be picturesque and beautiful indeed, were it not associated with the melancholy reflection, that the eye has played the truant and unmercifully monopolized all creation, and left the palate to pine in distress, & perish for want of sustenance[.] But the tender hearted maid of the month, hearing its plaintive moan, has once more come to its timely relief.

Further on in the extensive journal, on 2 September 1856: "It is quite seasonable for this time of year, and the earth is clothed in a green mantle of brilliant lively hue, vegetation displaying a luxuriant growth presenting an appearance of lively spring, a striking contrast to the dreary appearance of the Earth's burning surface a months past." The next spring, on 8 April 1857: "Old Dame Nature seems to be somewhat capricious this Spring, dressing herself in white and green alternately and that too at the expense of the palates of her

dear children, not much to their fancy." With winter waning at the onset of spring, we read on 11 April 1858: "The Winter king seemed to have withdrawn his forces. . . . [T]he whole premises around presented the appearance of one vast flower garden, beautiful and fair as the bloom of glowing Eden." Even a writer not normally sentimental would inject an anthropomorphized view of nature. Henry C. Blinn mentioned on 7 July 1856, while setting out from Canterbury, New Hampshire, "The sun seemingly smiled upon us in pleasing approbation of our contemplated journey."[195]

Romantic, moral, and anthropocentric battles in nature at New Lebanon are described in the daybooks of Sister Anna White, who focused on the moral qualities of weather. On 13 January 1855, she wrote: "Cold icy winds with drifting snows have been our constant attendants since last Christmas. To day the elements appear to be engaged in a severe contest, snow, hail, rain, and wind all seem to be striving to obtain the victory."[196] Nature at the village is seen as landscape painting, with human striving as a model. On Tuesday, 18 March 1856, White wrote, "Very beautiful day, and some encouragement is felt that we shall soon have Spring weather." Anna White again wrote in her daybook on 30 May 1858:

> Spring May 30th. Beautiful is the unfolding of Nature. Lovely is Creation adorned with rich blessings descending from an All Wise Parent—in sweet harmony let me join in Praise and Thanksgiving for all creative thing's appear to dwell in gratitude to their Maker. then let me not be stupid or void of feeling but unite in simplicity with the little birds of the field, and sing songs of praise and with the frisking lambs innocent in their merry sports dancing joyously— with the trees of the wood with every flower and shrub bursting in gratitude and gladness, into new life, this is what I want new life like as the Spring.

Similarly, on the first day of January in 1860, she wrote:

> Swiftly do the wheels of time roll onward and still onward, producing various changes both in the civil and religious world—yet does the sun keep its unerring course, giving lights and warmth, shimmering on the just and on the unjust. . . . The moon and all the planetary orbs, the season of seed time and harvest, the flowing and ebbing of the tide all move in order and harmony, and showing forth

the power & wisdom of an Almighty Eternal God. . . . Would that the human race could see the order and beauty of heaven, manifest as it is through his witnesses, could see wherein they were lost from God, what a paradise this earth would be. It would be filled with Angels, cultivating and adorning it with beautiful flowers of peace, of love and union, with spreading works of strength and beauty.

Jane D. Knight offered some florid passages about weather and the seasons and weather. The exact date of Knight's birth is uncertain, but she seems to have been in her later twenties when she came to the Shakers in 1832, bringing some sensibility of the "world" with her, manifesting itself in her romanticized, anthropomorphizing, and sentimental thoughts about nature and remarks on the moral quality of landscape and weather. For example, on 20 April 1834, she jotted down that "the weather is <u>somewhat</u> dull & hazy and I feel in <u>somewhat</u> of a sober contemplative mood." She continued: "This is the season we call Spring, we see the leaves beginning to shoot out & the fields begin to shew their rich verdure. . . . Even the little warbling songsters are seen & heard in all directions and add greatly to the interest of the scene with their sweet melody." She notes that she draws a "moral therefrom" and sees heaven's hand at work.[197] Fall brings a battle of forces in nature in October 1834: "This is a genuine stormy day, rain, hail, snow & wind seem all striving for the supremacy."[198] Knight prefers the "beauties of Summer" to winter on 22 February 1835: "I think I shall rejoice once more to see the green herbiage & hear the singing of the birds.—I love the comforts of Winter, but I love & long for the beauties of Summer."[199] Spring brings more moralizing, and recognition of God's hand in creation on 9 May 1835: "Without [that is, outside] are happifying sights & sounds—the pleasant groves, lovely vales[,] gales[,] waters[,] & songsters. . . . [I]n them we perceive the hand of an All-wise Being—let the enjoyment of the beauties lead us to look at the state of our own hearts—is the work of proper cultivation and beautifying attended to—& is there a place for the rejoicing spirit to abide—if what the natural sight may behold is so much noticed, how infinitely more should the culture of proper training of the immortal part occupy the attention. We may look thro Nature up to Nature's God."[200] Finally, Knight gains inspiration in blossoming and animating nature on 31 May 1835: "The country looks flourishing—blossoms in abundance—animating to the sight, but not to my pen. What shall I do to procure a little more zeal in everything—mend your pen and manners."[201]

Figure 2.7. Edward Lear, *Hedgehog*, ca. 1831–36, watercolor over graphite drawing on brown paper, 24 x 16 inches. (Cambridge, Mass., Harvard University, Houghton Library. *Photo:* Harvard University.)

In addition to their interest in inanimate nature, Shakers were also curious about the appearance of animals. There were moral and institutional headwinds against Shakers who were interested in mere creatures apart from utilitarian reasons. Ann Lee herself warned against playing with dogs and cats and specifically mentioned that a child can catch "evil spirits" from dogs, and later Shakers frowned on the luxury and pleasures of pet ownership.[202] In dictates throughout most of the nineteenth century, Shaker rules opposed the owning of pets by believers, that is, animals owned for their beauty, curiosity, or companionship, and giving of human names to farm animals was also discouraged. In the Millennial Laws of 1845, it was stated in the section "Order Concerning Dumb Beasts," "No Believer is allowed to play with cats and dogs,

Figure 2.8. John James Audubon, *Carolina Parakeets* (Conuropsis Carolinensis), ca. 1825, watercolor, graphite, pastel, gouache, and black ink with scraping and selective glazing on paper, laid on card, (sheet) 29¾ x 21¼ inches. (New-York Historical Society Museum and Library. *Photo:* © New-York Historical Society.)

nor make unnecessary freedom with any of the beasts of the field, nor with any kind of fowl, or bird."[203] Still, Shakers did comment on animals in their daybooks and travel journals. They most often commented on faunal oddities. On 2 July 1823, Seth Youngs Wells wrote that someone "invited me to go & see a hedge hog [see fig. 2.7] which he had just killed—Having never seen one I went out, to see it & examined its quills—It is a very singular animal; in form it resembles a woodchuck, but rather larger—Its quills are dangerous things unless carefully handled."[204] Nancy E. Moore, traveling by train in New York State on 28 September 1854, "saw two Paraketes in a cage in the cars owned by a Californian," exotic birds celebrated in art by John James Audubon (fig. 2.8).[205] Freegift Wells passed through the Fulton Market in Lower Manhattan on 6 September 1853 and visited the colorful section where merchants offered fish and other seafood (fig. 2.9). The market had become, and long remained, something of a tourist attraction. He saw the "Fish Market, which to me was a beautiful exhibition of the fin[n]ey tribes, including Sea Tortois[e] & Lobsters."[206] As for living creatures of the water, traveling by steamboat from

Figure 2.9. Stanley Fox ("sketched by"), *Fish Stands in Fulton Market, New York*, 1869, wood engraving on paper, 14 x 9 inches, published in *Harper's Weekly: A Journal of Civilization*, 3 April 1869, 213.

Figure 2.10. Robert Havell Jr., *View of the Hudson River near Sing Sing*, ca. 1850, oil on canvas, 36 x 50 inches. (New-York Historical Society Museum and Library. *Photo:* © New-York Historical Society.)

Albany to New York City on 24 July 1856, Henry C. Blinn noted, "The trip down the Hudson was one of pleasure [see fig. 2.10]. The scenery was beautiful & everyone seemed to enjoy it. . . . During our passage a school of dolphins pass by sporting with each other to the great amusement of all our passengers, who were favored with the sight."[207]

Freegift Wells had much to write about shells and living creatures as well, and, here as elsewhere in his journals, we especially get a sense that he was writing for the entertainment of his Shaker readers. On 16 September 1853, on a boat near the town of Greenport, New York, going toward Mattituck, he "saw a large number of Porpoises who showed themselves to good advantage." On the same day, he described "a very beautiful evening[,] the Sun set handsomely beyond the water & gave a touch of splendor to all around us." Freegift,

at Cutchogue, Long Island (a hamlet in the town of Southold), on 8 September 1853, used a literary device to have his Shaker readers imagine visual pleasures: "It would be quite too much of an undertaking to discribe the multitude of pretty shells & stones which the Sisters picked up on the beach. I shall here dismiss the subject, & let the readers draw their own inferences, which experienced ones may do with considerable accuracy & satisfaction." Freegift felt compelled to write further about pretty shells on 9 September 1853 while near Cutchogue and New Suffolk, New York: "Spent about two hours in walking the Beach, viewing the beautiful white sand, and rolling Surf, which sent its foaming spray for several rods on the rising Beach—& in picking up a few shells, which we found to be very scarce."[208] Similarly, in another year, on 3 August 1863, in the same area, Freegift marveled at "beautiful Sea Shells, . . . beautiful beyond description," in "a very large collection" amassed by a sea captain and seen by Wells in a private home, that of Ira Brewster Tuthill Jr. (1836–98).[209] Freegift had an eye for other animal life, as in 1837 he noted that he and his companions, on the way to North Union, Ohio, near Washington, Ohio, "passed a Crane City being according to estimate 500 crane nests in the Sycamore tops; occupied & improved by their several owners." Freegift was on the canal boat, but not told about it until after the boat passed, and he was annoyed that he missed what his Shaker companion told him was an "extraordinary and remarkable sight."[210]

As with shells, Shakers found beauty or simple curiosity by looking at animal remains. William Deming was at Turtle Creek, in the area of Lebanon, Ohio, in 1810 when he met a man, Robert Gill, who had come from Busro (West Union, Indiana), and told Deming of the Big Bone Lick: "Informed me of the Big bone Lick. He saw one Tooth which weighed Nine pounds & was Dug out of the earth 18 feet below the Surface."[211] An odd and amusing document about Shakers finding the remains of a cat that looked like a man with a "dandy" hairstyle appears in Calvin Green's journal of a trip to Pennsylvania, somewhere in a rural area near the Schuylkill on 16 May 1828: "Here we see, absolutely the greatest natural curiosity that any of us ever saw—a Cat skin upon which nature had in the hair—made a complete profile of a human head—face, nose, mouth—chin double, eyes, ears tho' not as complete as the rest, hair and foretop is complete dandy, style [dandy style], there is no desception in this, you never saw so complete a profile drawn by the pencil of man."[212] It is noteworthy that he compares this favorably to a two-dimensional, conscious drawing of a man, a rare reference by a Shaker to the art of design.

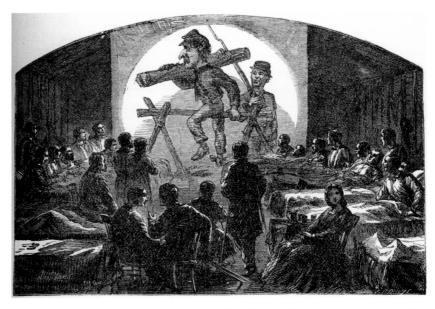

Figure 2.11. John Parker Davis, after a design by Alfred Rudolph Waud, *The Magic Lantern in the Hospital*, 1862, engraving, 3¼ x 4¾ inches, from Charles Carleton Coffin, *The Boys of '61; or, Four Years of Fighting* (Boston: Estes and Lauriat, 1884), opposite 174.

Shakers had regulations about naming, nicknaming, or becoming friendly with animals, but they did sometimes find beauty or interest in the appearance even of common farm animals. As early as 1805, Benjamin S. Youngs, in his travel diary, saw a handsome horse, which he called a "pretty likely brown horse."[213] In 1856 Henry C. Blinn referred to "the same, beautiful, black horses that we saw yesterday."[214] Prudence Morrell, visiting Union Village, Ohio, on 18 June 1847, faulted the appearance of some horns on Durham cattle, also called shorthorn cattle; she saw sixty cattle "all of the Durham breed; their horns are very homely, but they are as fat as meadow moles."[215]

Later Shakers detected beauty in scientific study of animals. In Shaker communal viewing experience, at Chosen Vale (Enfield, New Hampshire), on Monday, 30 September 1850, Deborah Robinson wrote, "After dinner, went to the Second family in company with the Ministry, and Elders of the Church, to see the shadows of animals brought to view by Microscope glasses. A great curiosity. A common house fly being placed in the glas[s]es, his body measured five feet through and the whole length form his head to the end of his wings 15 feet. After viewing these wonders, and visiting some, returned and

Figure 2.12. Unknown artist, *Various Forms of Diatoms* (Verschillende vormen Diatomeën), 1886, engraving, 3 x 3 inches, from Camille Flammarion, *De Wereld vóór de Schepping van den Mensch*, edited by B. C. Goudsmit, revised by P. M. Keer, 3rd ed. (Zutphen, Netherlands: W. J. Thieme & Cie, n.d.; originally published in 1886), 91, fig. 46. A translation into Dutch of Flammarion's *Le monde avant la création de l'homme* (Paris: C. Marpon and E. Flammarion, 1886).

went to the pond, a beautiful place." This seems to have been some kind of makeshift, single-lens projection, a cruder version of a more sophisticated magic-lantern display, a kind of entertainment known since the seventeenth century that was reaching something of a peak of popularity in the nineteenth century after the introduction of better ways of illumination (see fig. 2.11).[216] Having used another kind of lens—one in a microscope—an anonymous Shaker female, writing in her diary in the late 1870s, wrote about "Curious Discoveries"; her viewing into a microscope was focused on diatoms, a form of algae, which seemed beautiful to her. "This was one of the simplest forms of plant-life known—only a single cell in a crystal cube. These diatoms [fig. 2.12], as they were called, though almost invisible, were shown by the microscope to be covered with beautiful sculpture, in regular and symmetrical forms."[217]

This chapter has focused on nature and on the natural phenomena seen while traveling and at the villages. The following chapter will study what the Shakers thought of the visual aspects of their communities, including architecture, interiors, and village planning.

CRAFTING ZION
Refinement and Restraint in Shaker Villages

3

This chapter explores Shaker communities and the buildings and man-made objects within them. Believers designed their villages in orderly fashion, insisting on a simplicity and restraint in the overall layout, architectural design, and appearance of the interiors and furnishings.[1] The orderliness for which the Shakers are famous in their individual and communal lives is apparent and well documented, and they equated it with heavenliness, finding moral beauty in simplicity. The *Testimony* of 1810, comprising some of the earliest published Shaker statements of belief, includes several instances of the phrase "beautiful simplicity."[2] But while the Shakers wanted order, cleanliness, and restraint in their communities, the story does not end there, for Shakers sometimes used fine materials, built in impressively large scale, often applied bright colors to their furniture and interior walls, and embraced fine craftsmanship that itself constituted a kind of refinement. We will look here at the visual world the Shakers created, and also look at the various community restrictions they used to help achieve the appearance of what they considered to be their Zion and an echo of heaven.

One pervasive aspect of Shaker design is broad similarity of form over time and place: clothing, schedules of daily life, forms of worship, furniture design, and other aspects of Shaker life were intended to be not identical, but rather similar across the various communities and endure over the years. Union was

Floating along the mountain sides, were vapors fast dissolving in the sun, as they advanced. I was crossing, diagonally, the level and beautiful court—the intervening ground between the public sanctuary of worship and the large stone mansion. The sun, reflected from the windows and from the innumerable specks of mica which enter the composition of the granite, gave this mansion the appearance of a crystal palace. The slated roof without the angle of reflection, bore a dark, indigo hue, beautifully contrasted with the crystal facade. The jut or eave and end projections were of a deep, rich green. —Hervey Elkins, *Fifteen Years in the Senior Order of Shakers* (1853), writing about the place of his former residence, the Shaker village at Enfield, New Hampshire

an important concept for Shakers and is an outgrowth of the spiritual bond between members that they sought to establish. The preface to the Millennial Laws of 1845 proclaims, referring to uniformity of dress, styles, behavior, rules, and so forth, "Believers in Christ's second appearing; who are united in one body, possess one united and consecrated interest; and therefore must, in all things, and under all circumstances, be influenced, led and governed by one spirit, which is the spirit of God; and be subject to one general law, which is the law of Christ, in this day of his second appearing."[3] Union was also the goal in the layout of Shaker villages. Of course, different geographies, varying arrangements of public roads, a somewhat diverse economic output of each village, and a different numbers of families or orders and overall population all worked against any thorough uniformity, but a general similarity of appearance was a goal, and the broad similarities between villages are easily recognizable. Charles Hodgdon, writing in 1838 as an apostate but reflecting on earlier times, noted when he visited another Shaker village and was pleased to find it "so much like that of my own that I had left."[4]

One way to achieve order and consistency was to establish guidelines about geometric layout and insist on right angles and an avoidance of curves. The Millennial Laws of 1821 state, "It is considered good order to lay out and fence all kinds of lots, fields and gardens in a square form where it is practicable, but the proportion, as to length and width may be left to the discretion of those who direct the work."[5] Within that framework, buildings were made in a form that was simple and, over time, increasingly retrospective. A Shaker building from 1850 looked like a spare version of a typical rural building built decades earlier. And ideas traveled from place to place rather than springing up only by local design traditions: eastern Shaker William Deming helped designed the meetinghouse at Turtle Creek, Ohio, in 1810: "Drew a draught of the meetinghouse and the next day helped the brethren lay the Sills on the wall of the new house."[6] Other individual types of buildings, such as the meetinghouses, often derived from the same template, as with the multiple versions from 1785 and onward by Shaker Moses Johnson (1752–1842) (figs. 3.1 and 3.2).[7] Shakers were adamant about not following fashion, and they wanted to achieve a kind of approximate uniformity from village to village as a way to bring harmony to peoples across the societies, but there were variations of design from place to place. Shakers who visited each other's villages noticed and appreciated, as we will see, the various distinctions of design that they saw. They took note not just to enjoy delightful nuances of design, but to get ideas that might be applied to arrangements or construction in their own communities.

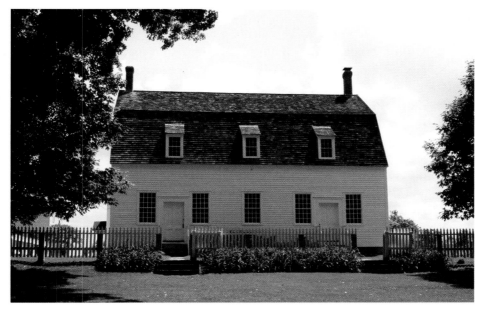

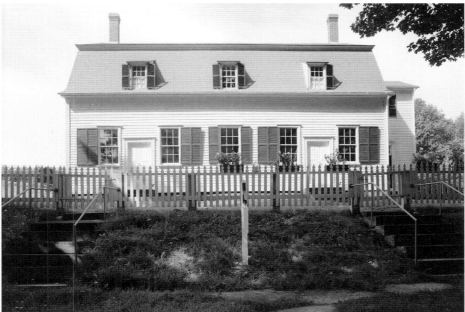

Figure 3.1. Moses Johnson, Shaker meetinghouse, 1792. Canterbury, New Hampshire. (*Photo:* by the author.)

Figure 3.2. Moses Johnson, Shaker meetinghouse (with alterations), 1794. Sabbathday Lake (New Gloucester), Maine, photograph by Gerda Peterich, 1962. (*Photo:* Library of Congress.)

A principal visual and aesthetic experience of a Shaker was the overall layout and aspect of their villages and the surroundings lands, and it is clear that Shakers thought highly of their villages, calling them beautiful, handsome, and heavenly. In 1850 Shaker Deborah Robinson said of Poland Hill, Maine, "It is a beautiful place." Robinson referred to Enfield, New Hampshire, as a "beautiful City Chosen Vale."[8] The following year, a Shaker from Watervliet, Freegift Wells, called Poland Hill "a handsome little place, & [it] affords a great prospect of the surrounding country."[9] John Kaime (or Kaim [1843–77]), of Canterbury, visited Enfield, Connecticut, in 1847, and referred to the "beautiful station" of the site.[10] Henry C. Blinn, on 7 July 1856, wrote before a journey that "we left our beautiful home in Canterbury."[11] Kentucky Shaker Nancy E. Moore and Ohioan William Reynolds, approaching Canterbury, were enchanted (fig. 3.3): "Canterbury is like a city set upon a hill which cannot be hid," and the journal writer praised its "imposing appearance," yet, fearing that their description might be painting too magnificent a picture, made sure to state that "there is nothing but might be endorsed by plain Shakers. But Order Order and neatness is met everywhere."[12] Shakers could sense the difference between, and superiority of, their clean and orderly world and the realm of the nonbelievers. In 1847, leaving their Zion at Watervliet on the way to Massachusetts, a group of Shakers looked around, "observing nothing very remarkable, excepting that we had got out of the Shaker atmosphere, and the scenery around us, appeared very much like the <u>world</u>, or the Old creation."[13] Believers used symbolic language, as well, to express the moral and visual loveliness of the Shaker villages, as in an inspired writing from Watervliet in 1844, the document itself written in florid handwriting: "Yea, bow low, all yea inhabitants of this lovely Vineyard."[14] Another Watervliet document from 1844 asks, "Supposing ye were called as overseers in the framing and building of an extensive edifice, say for instance, like the Temple of Solomon, where the requirement was to bring all things to perfection in order, beauty and harmony; Would it not be necessary for the master workmen and Overseers to be united in their feelings and in their goings?"[15] Similarly, in the "General Statement of the Holy Laws of Zion" of 1840, the text proclaimed that "the time has come for Zion to be again reestablished in her order, her beauty and glory."[16]

An important part of the look of the villages was cleanliness and neatness, and both aspects frequently received comments by Shakers themselves and worldly visitors. Praise of cleanliness as a part of order appears in great regularity in Shaker writings, and there is no doubt about their sense of things: heaven is clean and orderly, and earthly arrangements should reflect divine

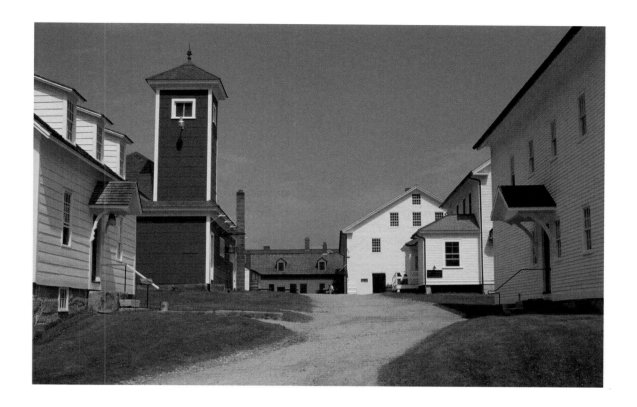

Figure 3.3. View of central buildings, Canterbury Shaker Village, New Hampshire, founded 1792. (*Photo:* by the author.)

order and purity. A pristine Shaker village was, in their eyes, good, beautiful, and godly.[17] Shakers were insistent cleaners, stating that cleaning a room was like cleaning your soul and making it like heaven. That which they cleaned was to be in good condition and functional. Shakers documents often refer to the cleaning of their buildings and surroundings, and laws insisted on cleanliness. The *Testimonies* of 1816 mention the sweeping of floor of a piazza (porch) at Watervliet in 1784, during the last days of Mother Ann, who suggested that the act was symbolic of cleaning the "floor of the heart."[18] The earliest version of the Millennial Laws (1821) insisted, "No kind of filthy substance may be left or remain around the dwelling houses nor shops, nor in the door yards; nor in the street in front of the dwelling houses and shops."[19] Some 1821 laws stipulated, "Every saturday nig[h]t and monday morning the street opposite the meeting house, and against the dwelling houses must be cleared of hay, straw and hung &c. And the outward yard of the meeting house must be cleaned every monday morning from of all such filthiness."[20] This was all part of

general order and tidiness, such as that "doors and gates must not be left swinging, but either shut or fastened open."[21]

Irish-born Shaker John M. Brown wrote of the "Sweeping Gift" that had been practiced on the date for several years at New Lebanon, an extra autumnal cleaning for the village. He opined that "I always found enough to do with both heart & hands, & many times have realized heavenly blessings for being faithful and industrious, improving my spare moments to beautify and adorn the external order, & thereby represent the internal moving spring towards the God of Order, beauty, & harmony. Yea truly, Order is represented as 'Heaven's first Law.'" Brown concludes with a remarkable statement that order in a spiritual sense "seems lame unless it has expression in temporal arrangements." Thus, he suggested that mere spiritual order is not convincing or moving unless expressed in worldly order.[22] Other Shakers, looking at New Lebanon from some distance (fig. 3.4), stated in 1869 in positive moral fashion that we "beheld a delightful village with a beautiful & imposing exterior indicative of the purity of the interior." At the First Order, they praised the sisters' shop, "which is kept as neat as a palace."[23] The opposite of cleanliness and order, such as peeling paint, was deemed ugly. A New Lebanon Shaker wrote in 1854, "Peter Long [1816–85] and A. L. the writer undertook to get the paint off of the door at the south end of the Porch, it was much blistered and looked ecseeding bad, we had a tegious [tedious] job."[24]

Even after they left the sect, the various apostates who later reminisced about their days as Shakers could still remember their feelings from earlier times, and despite any personal or theological differences with the sect they appreciated the visual and material aspects of the communities. Order, peace, and cleanliness at Hancock were described by David R. Lamson: "The people are strict utilitarians. In all they do the first inquiry is, 'will it be useful?' every thing therefore about their building, fences, &c., is plain. Their buildings were made capacious with a view to receive the world when they shall be converted to shakerism. Although every thing is plain, there is about the whole village an air of plenty, neatness and comfort which gives it the appearance of a little paradise as it were." Lamson first saw this "little earthly paradise" at Hancock in March 1843. He did doubt some aspects of Shakerism, but, after visiting, wrote, "Here I found every thing to all human appearance, neat, plentiful, orderly, peaceful, devout and beautiful," all reflected by what he saw of the Shakers themselves, who "appeared to be temperate, frugal, industrious, honest and simple hearted."[25] Lamson described the day of purification of the villages on certain days in the 1840s during his two-year stay. One would sing

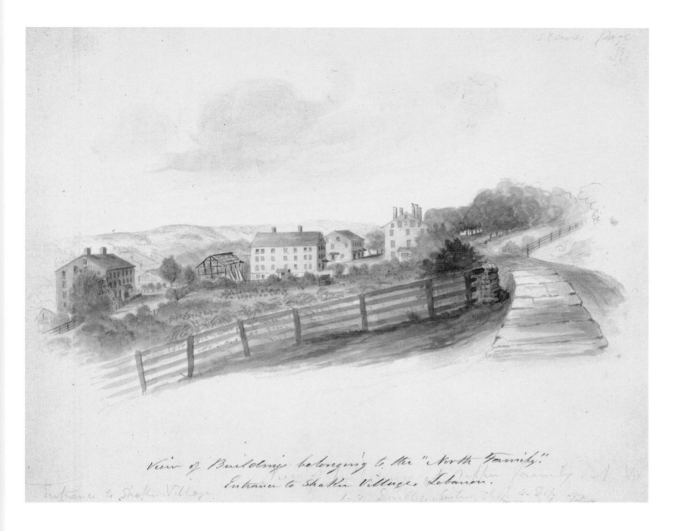

View of Buildings belonging to the "North Family." Entrance to Shaker Village. Lebanon.

the words to the hymn "Purify your hearts o my children, cleanse your sanctuary clean, clean your dwellings and prepare for holy Mother to meet with you." Then, the "eldresses and singing sisters go through all the rooms occupied by the sisters singing as they go," and the brethren did the same, while "the rest of the brethren and sisters must be in their several rooms during the performance. Thus ends the day. The employment of all the brethren and sisters, save the elders and singers, is, cleansing every dirty or filthy place on the premises, mending broken windows, putting things in place, &c."[26] Charles Hodgdon, who had lived among the Shakers, noted in 1838, recalling his assessment of the village at Canterbury after he first arrived in December

Figure 3.4. Benson John Lossing, *View of Buildings belonging to the "North Family,"* undated (ca. 1856?), watercolor on paper, 5¾ x 9 inches. (San Marino, California, Huntington Library. *Photo:* Huntington Library.)

1821, that he was impressed with the buildings and the impressive siting of the village on a hill (cf. figs. 2.5 and 3.3): "When I arrived at the village, which was on a large and beautiful summit, with houses, barns, work-shops, &c. I asked who lived in such a house, and such a house. He said those all belong to the Shakers—nearly 200 buildings in all. Their houses are all painted yellow and generally from two to three stories high. I thought that they were a rather poor, degraded set of people, till I viewed their buildings and their beautiful situations."[27] Nathaniel Hawthorne experienced similar pleasure at the scale and coloration of the buildings at Canterbury in 1831, when he saw the "streets of great houses painted yellow and tipt with red."[28]

Hervey Elkins, an apostate who had recently left the sect, reflected on how the believers at Enfield, New Hampshire, worked together to clean and purify for a special day. He was writing for the world's people and gave them insight into how the Shakers achieved the order and neatness that visitors could see in the villages:

It was announced that Jehovah—Power and Wisdom—the dual God, would visit the inhabitants of Zion, and bestow a blessing upon each individual as their works should merit. A time was given for us to prepare for His coming. Every building, every apartment, every lane, field, orchard and pasture, must be cleansed of all rubbish and needless encumbrance; so that even a Shaker village, so notorious for neatness, wore an aspect fifty per cent more tidy than usual. To sweep our buildings, regulate our stores, pick up and draw to a circular wood-saw old bits of boards, stakes, and poles that were fit for nought but fuel, and collect into piles to be burned upon the spot, all such as were unfit for that, was the order of the day. Even the sisters, debouched by scores to help improve the appearance of the farm and lake shores, on which were quantities of drift wood. Thus was passed a fortnight of pleasant autumnal weather. As the evenings approached, we set fire to the piles of old wood, which burnt, the flames shooting upwards in a serene evening, like the innumerable bonfires which announce the ingress of a regal visitant to monarchical countries. Viewed from the plain below, in the grey, dim twilight of soft and serene atmosphere, when all nature was wrapped in the unique and beautiful solemnity of an unusually prorogued autumn, these fires, emerging in the blue distance, from the vast amphitheatre of hills, were picturesque in the highest degree. How neat!

how fascinating! and how much like our conceptions of heaven the whole vale appeared. And then to regard this work of cleansing and beautifying the domains of Mount Zion, as that preparatory to the visitation of the Most High, is something which speaks to the heart and says: "Dost though appear as beautiful, as clean, and as comely in the sight of God, as dost these elements of an unthinking world? Is thine heart also prepared to be searched with the candles of Him from whom no unclean thing is hidden?"[29]

This remarkable passage captures the sense of cleanliness, order, beauty, and the "conceptions of heaven" that the Shakers held, embodied by their neat, orderly villages and surrounding lands.

The world's people, although not sharing Shaker theological beliefs, often found the design and cleanliness of Shaker villages to be appealing. Benson John Lossing wrote in 1857 about approaching New Lebanon: "In a few moments, new emotions were excited, for on the right, stretching along upon a noble mountain terrace, half way between the deep green valley and the bending sky, lay the Shaker village, surrounded by slopes enriched by the most perfect culture. A portion of it was half hidden by trees and a vail [sic] of blue smoke, while the polished metal roof of the house of worship sparkled in the rays of the sun like a cluster of stars."[30] The *tout ensemble* of the Shaker villages often pleased visitors and passers-by, in part because the Shakers arranged the buildings with some consideration for how they looked from the public roads that ran alongside or up to the main buildings of their communities. True, Hervey believed that Shaker streets were made parallel to public roads to give "greater seclusions from the passers by."[31] But Shaker buildings, especially offices for business, related to the public roads, and open spacing between buildings allowed viewing by visitors of the campus-like arrangement of structures. Some villages sat on a nice rise of land, such as at New Lebanon or Canterbury, New Hampshire, and that siting encouraged broad admiration, and contemporary prints celebrated those views. The Shakers sometimes started their beautification at the roads themselves, as at Hancock, Massachusetts, where spaced trees lined the public road, the arrangement prettifying the place and uniting the two sides of the community. Robert P. Emlen has collected the views by the world of the Shaker sites, and a pattern emerges of a beauty meant by the Shakers to be enjoyed by the outside world as well as by Shakers, with the beauty meant to impress the world and also attract outsiders to the sect.[32]

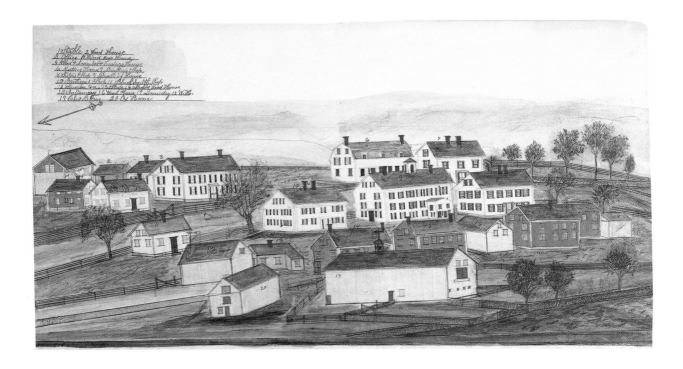

Figure 3.5. Joshua Bussell, *View of the Church Family, Alfred, Maine,* ca. 1880 (?), pencil, ink, and watercolor on paper, 17½ x 27¾ inches. (New York, American Folk Art Museum. Gift of Ralph Esmerian. *Photo:* American Folk Art Museum/ Art Resource, New York.)

Shakers occasionally created drawings or watercolors of their villages, and they consistently conveyed a sense of order, cleanliness, abundance, and calm. Shaker artist Joshua Bussell (1816–1900), of Alfred, Maine, otherwise also skilled as a cobbler and woodworker, created some watercolors of the villages at Alfred (fig. 3.5), Sabbathday Lake, and Poland Hill (fig. 3.6) in Maine and of Canterbury, New Hampshire.[33] He presaged later published interpretations of the Shakers by including few people or animals and concentrating on the simplicity of the arrangements of buildings and the orderly appearance of the whole. His compositions were not a reflection of exact appearance, and his different renderings even of the same place contain significant differences. He was evoking an ideal realm. In one view, he included two figures in dialogue, these world's people clearly shown, as the believers would wish them to be, intrigued by the Shaker places. In speech balloons in the view of Poland Hill (fig. 3.6), one well-dressed gentleman on the road asks another, "What Village is this?" and the other replies, "Poland Village."[34]

The matter of Shaker presentation to the world continued into the age of photography. Judith Ann Livingston has argued that the later-nineteenth-

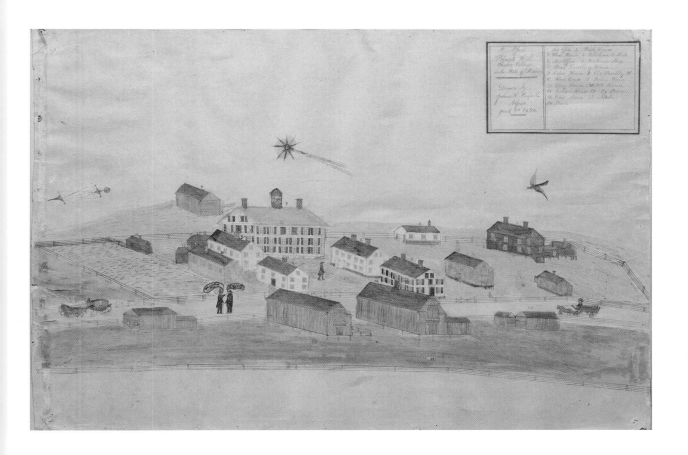

Figure 3.6. Joshua Bussell, *A View of the Shaker Community at Poland Hill, Maine*, ca. 1880 (?), pencil, ink, and watercolor on paper, 25 x 36 inches. (Sabbathday Lake, New Gloucester, Maine, Collection of the United Society of Shakers. *Photo:* United Society of Shakers.)

century Shakers "engineered and designed" the subject matter of the stereographs taken of their communities and sold in their shops. The views, produced by professional, non-Shaker photographers, showed the Shaker communities as productive, clean, and well kept and the Shakers as successful, educated, and healthy (fig. 3.7). The Shakers hoped to use the views to impress the world and to attract new converts.[35] These Victorian-era stereographs, meant for sale, never showed meetings or dances in progress, and they tended to represent Shakers not as portraits of individuals but in groups or as part of larger agricultural or manufacturing enterprises, emphasizing the communal living and economic success. Many of the stereographs showed sweeping views of the whole village or focused on the most impressive buildings, such as the meetinghouse or the larger dwelling structures.

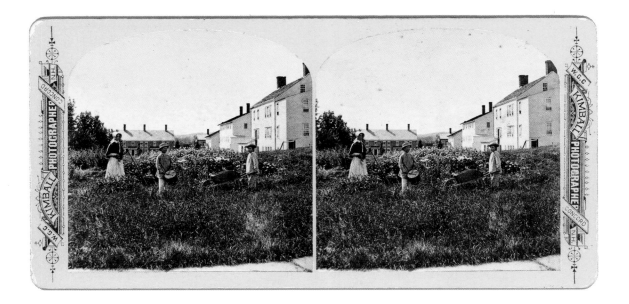

Figure 3.7. W. G. C. Kimball, *Flower Garden at Canterbury Shaker Village*, third quarter, nineteenth century, stereograph, 3½ x 7⅓ inches. (Hamilton College Library. *Photo:* Hamilton College.)

In their writings, Shakers had a good deal to say about their individual buildings, many of which have survived and are well maintained and researched or are known from early views or photographs.[36] They looked carefully at the buildings when they visited each other's villages, and they often wrote down their thoughts in their travel journals. Shakers often praised simplicity of design. Americans in general, like the Shakers, embraced the idea of the appeal of neat, simple dwellings, whether in the simplicity of Greek Revival design, the cult of the log cabin, or the fascination with the simplicity of Thoreau's cabin at Walden Pond. Thomas Jefferson (1743–1826) had earlier indicated the moral excellence of a plainer style when he stated his preference for architecture that was "chaste" and without "barbarous ornaments."[37] Thomas Cole, in his influential "Essay on American Scenery," wrote of the American nation that possessed "no gorgeous temple to speak of ostentation," in a country where one knew instead that "neat dwellings, unpretending to magnificence, are the abodes of plenty, virtue, and refinement." For the Shakers, the restraint in building design sprang from their moral beliefs. Calvin Green, in a description of the life of Lucy Wright, who was so important in setting out the rule and expectations for Shaker life, wrote, "She was Frugal in a preeminent degree, & temperate in whatever she partook or used—unwilling to be extravagant in food or raimaent or anything else. Was averse

to superfluous & useless decorations in buildings, dress, workmanship, or equipage of any kind. Nor would she ever adopt any thing not useful because it was fashionable in the world."[38] The Shaker visual world derived from their ideals of holy frugality and the avoidance of the fashions of the world.

As with American design in general, restraint was not the sole design principle for Shakers. In their own ways, believers included much refinement in their building and had a taste for fine design, dignity of effect, and quality construction, and they attempted to achieve a recognizable beauty, as their documents attest. They did so using fine stone on exteriors, vivid coloration, and thoughtful harmonies of design as well as building on a consciously impressive scale. The Shakers did not build using classical architectural orders, stylish ornament drawn from pattern books, artfully high or low rooflines, or conscious references to other cultures or places. Still, their buildings were impressive in their own way and pleasing to the Shakers, who described in their written accounts good or even fine materials, skillful construction, appealing siting, sheer size and grandeur, usefulness, "convenience," and overall neatness, among other qualities. Shaker design was not only about admonitions and avoidance, or heavenly purity and order.

Shakers were not hesitant to lavish praise on the appearance of their buildings and often used the words "beauty," "beautiful," "pretty," or "fine," often without elaboration, to describe their buildings. Deborah Robinson said in 1850 of the ministry's shop at Shirley, Massachusetts: "A pretty little building it is." Robinson, like other Shakers, was drawn to the building materials for its value or rareness or novelty. In Canterbury, New Hampshire, on 7 October 1850, Robinson anticipated that fellow believers there would use the finest stone for dwellings. Watching quarrying of gray granite, she stated that they "will doubtless save the most perfect stone for that purpose," of building a fine dwelling and not just a barn.[39] The Ministry of New Lebanon was at Poland Hill in the summer of 1850, and one of them keeping a journal noted that at the quarry "the stone are of a light grannite verry beautiful."[40] At Poland Hill on 20 September 1850, Robinson noted that they were building a stone dwelling house: "They have already the cellar dug, and, and [sic] most of the wall laid, it is a very hansome, and to all appearance a firm and durible wall."[41] Shakers often looked for and praised fine workmanship, as did a group from Harvard visiting at New Lebanon in 1846 commenting on the meetinghouse and new stone barn, calling the former "the noblest and most beautiful place of worship that I ever set my feet into." As for the new (stone) barn at New Lebanon (fig. 3.8), "I was pleased and surprised with the workmanship and

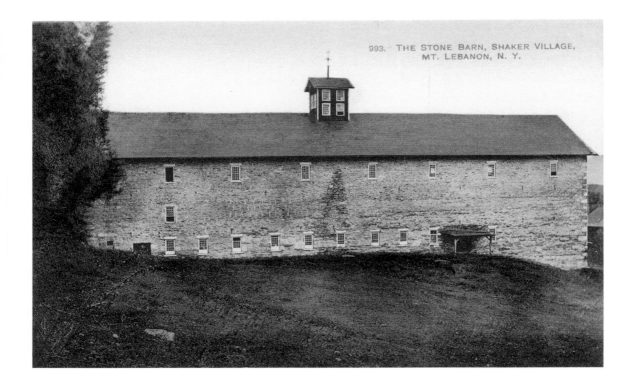

993. THE STONE BARN, SHAKER VILLAGE, MT. LEBANON, N. Y.

Figure 3.8. The Great Stone Barn, built 1859 (damaged by fire in 1972), Shaker Village, Mount Lebanon, New York, postcard (H. M. Gillet, publisher), ca. 1910–20, color lithograph, 3½ x 5½ inches. (Clinton, New York, Hamilton College Library. *Photo:* Hamilton College.)

ingenuity of this structure and went out pronouncing it a first rate barn and worth going a great ways to see."[42] Henry C. Blinn noted the fame of another great barn of the Shakers, the 1826 Round Stone Barn at Hancock (4 July 1853; fig. 3.9): he went to "see the far famed, circular, stone barn."[43] The Shakers did not favor natural, or undressed stone, as was becoming something in vogue in nineteenth-century America, but liked it worked down. That is borne out by the working of extant stone exteriors and a comment like that of the Shaker at New Lebanon in 1859, when he saw a path with stones and steps by the Sisters' Shop in which the Shakers "did considerable at dressing the stone in order to make it more perfect."[44]

The great stone dwelling at Enfield, New Hampshire, built in 1837–41, received much attention from Shakers residents there and from admiring Shaker visitors (fig. 3.10). It was large and made of fine material, the workmanship was applied at a high level, and the engineering was impressive for a people used to building smaller residences. Nancy E. Moore wrote in 1854, "It is confessed by all that it is the most convenient & elegant house we have yet seen among believers. The house stands facing the south[.] Is 100 feet

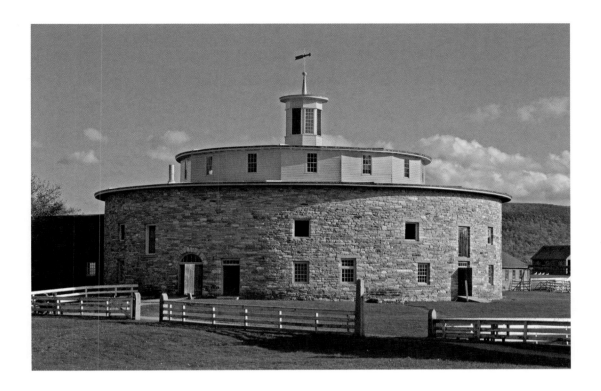

Figure 3.9. The Round Stone Barn, 1826. (Pittsfield, Massachusetts, Hancock Shaker Village. *Photo:* HSV.)

long, by 58 feet wide. Four stories besides the cellar. . . . It is covered with Slate. They have a portico at the East end of the house which is supported by six granite pillars. Is floored with mica slate, and has steps of Granite about fourteen feet long." Inside (cf. fig. 3.11) it is "well furnished with drawers and cupboards," with eight hundred drawers total, and "the outside walls are built of the native Granite, and like Solomons Temple the pieces were all fitted to their place and carded [*sic*] up before the house was commenced to be built."[45] Elder Giles B. Avery of New Lebanon was visiting at Enfield, New Hampshire, in 1843 and wrote, "After breakfast we visit the Ministry and Elders a while and then go about some, and see the place. A beautiful situation truly, but O' what a stone palace. 100 feet in length & 58 in width 4 stories high without the cellar semiloft—one of the most stately, magnificent, and solid buildings I ever saw."[46] At Enfield, New Hampshire, on 21 September 1849, Susan Ann Lewis wrote, praising the building and the view from it, that we "arise in the morning and from our east windows view'd their most magnificient stone house[.] It is 4 story above the cellar 100 feet by 80 feet—30 windows in each end—and 40 in front as many in the rear."[47] There on 25 September 1850,

Figure 3.10. The Great Stone Dwelling House, 1837–41. (Enfield, New Hampshire, the Enfield Shaker Museum. *Photo:* by the author.)

Thomas Damon, of Hancock, glowed about this "stone dwelling house. . . . It is capacious being being [*sic*] 100 f.[eet] long 58 f.[eet] wide and 4 stories high— the meeting room is 54 by 32—The entire building is finished & furnished in the best manner."[48] At Enfield, New Hampshire, the visiting ministry from Pleasant Hill pointed out of the First Order, "Their dwelling is of Granite, a large 4 story house of solid masonry."[49] William Charles Brackett, on 30 May 1862, at Enfield, New Hampshire, "Visited in the First Order, [and] admired the Noble Granite Dwelling 100 ft Long by 64 Broad."[50] Similarly, "A journal of the Ministrys Eastern Visit," of 5 July 1850, praised the "fine appearance" and impressive length of one hundred feet of the stone dwelling house at Enfield, New Hampshire, and took a thorough tour of the interior and inspected the details, which was typical in Shaker visits ("we went pretty much all around the house").[51]

Figure 3.11. Detail of a residential room ("Room 16") on the second floor of the Brick Dwelling, 1830–31. (Pittsfield, Massachusetts, Hancock Shaker Village. *Photo:* HSV.)

For his part, offering a description of the stone dwelling at Enfield, Hervey Elkins purported to be quoting a former Shaker friend, Urbino, who wrote of the day he lost his loved one, a girl taken away because Urbino's love interest was discovered by the Shaker superiors:

> It was a morning in summer, when nature appeared bedecked with gems. The sun had risen, and pendent from every blade of grass, were glittering diamonds of liquid formation. The fragrance exhaled from the floras of surrounding nature, perfumed the atmosphere I inhaled. Horizontally, floating along the mountain sides, were vapors fast dissolving in the sun, as they advanced. I was crossing, diagonally, the level and beautiful court—the intervening ground between the public sanctuary of worship and the large stone mansion. The sun, reflected from the windows and from the innumerable specks of mica which enter the composition of the granite, gave this mansion the appearance of a crystal palace. The slated roof without the angle of reflection, bore a dark, indigo hue, beautifully contrasted with the crystal facade. The jut or eave and end projections were of a deep, rich green.[52]

Even allowing for some exaggeration, for Elkins's playing to the worldly readership, and the authorship by an apostate, the passage is accurate in its description of coloration and place and bears the ring of truth in reflecting the feelings of a Shaker who was present and had enjoyed the building during his time as a believer. Elkins also conveyed the sense of hierarchy as well as physical beauty of this granite dwelling of the Senior Order at Enfield. He asked to be able to visit, and he marveled at the location and the building: "When the trees were [earlier] covered with verdure, I had beheld the graceful symmetry of the cupola towering high above every other object of the plain, whose majestic crown was a large sphere, with a segment deduced and resting upon a chapiter of splendid mouldings, and this resting upon eight columns, whose foundation, rising from the roof, was a plinth of ten feet square. . . . I ate for the first in a dining hall which to my juvenile eye, seemed almost illimitable, though it was less than one hundred feet in length." Elsewhere, Elkins called the dwelling "the beautiful stone mansion," and he characterized the whole community as "that beautiful village."[53]

The Shakers, who consistently liked marble and granite, were pleased to see fine stone when used as underpinning, trim, or other adornment on

Figure 3.12. Unknown photographer, *Meetinghouse of the Shakers, Exterior,* ca. 1912 (structure built 1824), photograph, 3¼ x 4 inches. (Albany, New York State Archives, New York State Education Department. *Photo:* NYSA.)

architectural surfaces. One large and stately structure that received widespread attention and praise by the Shakers themselves was the meetinghouse at New Lebanon, which still stands (fig. 3.12). Henry C. Blinn, visiting from Canterbury, New Hampshire, wrote, "It is a noble building 80 x 65 feet. The posts are not far from 25 ft and arched about 12 ft." He further added praise for the application of fine stone, remarking, "The underpinning of the building & the steps are of white marble, which presents a fine appearance."[54] The idea that counterplacing of granite with other materials so that it would create a "handsome underpinning" was noted by a ministry journal writer looking at the burial ground at Sabbathday Lake, Maine, in 1850: "the better part of which is built of beautiful blocks of Granite & with a little pointing would make a handsome underpinning for a building."[55]

Henry C. Blinn liked the way the brick, which was painted bright red, contrasted with the marble trimming at the great brick dwelling at Hancock (fig. 3.13). He wrote in 1856, "Their large, brick, family dwelling is the best in the place. Its trimmings of white marble are in pleasant contrast with that of the fire red brick."[56] The red paint that Blinn saw has worn away, but the brick is of a deep red anyway and still nicely contrasts with marble elements, such as the elegant, thin horizontal string courses. Blinn never saw the original brick, but he assumed that it was of poor quality; it is actually of average quality, and the decision by the Shakers to paint it was surely motivated in large part by aesthetics and the desire for a bright, uniform red surface. The designer and builder, William Deming, wrote a letter in 1832 to Benjamin S. Youngs describing the beauty of the exterior: "The outside of the house is painted with four coats of a beautiful red."[57]

Figure 3.13. William Deming (designer and construction supervisor), the Brick Dwelling, 1830–31. (Pittsfield, Massachusetts, Hancock Shaker Village. *Photo:* HSV.)

Despite his pleasure in 1856 at the contrast of the red and white colors, earlier (1853), Blinn had not accepted the falsification that made it look an even bright red rather than unpainted, and had thus been more critical of the painting of the dwelling house, but he still called attention to effect of the counterplacing of red and white: "This building is 3 stories high, but the brick being of poor quality, as most are in this section, they were under the necessity of painting it red. But it still continues to be a handsome house. The underpinning & step stones, window sills and caps are all of white marble. There is a layer of marble slabs 4 inches thick extending around the entire building, over each loft of windows. This contrasting with the red brick makes it very unornamental." And below ground level, he noted the "nice cool cellar, the floor being laid with blocks of sawn marble."[58] The marble flooring in the basement is extant and is still impressive. By "unornamental," he probably intended to

say that the contrast highlights the structure of the building and is not merely pretty. Much later (1873) than Blinn's first visits, but with a continued favorable opinion, he wrote of the same building at Hancock: "The dwelling house at this place is built of brick & painted red. The underpinning stories, door steps, window sills & window cups are of white marble. . . . The cellar is paved with blocks of marble." He wrote further of the community, with less enthusiasm, "The other buildings are of wood."[59] Blinn echoes his own sentiments about the stylistic details at Hancock in his praise of the world's architecture in 1873: "Philadelphia is really a City of bricks. In some cases white marble is used for the underpinning, window cills, & step stones, which in contrast to the brick of the house, makes rather a delicate appearance." Blinn also seemed to like the straight and clean streets of Philadelphia.[60] For his part, the designer of the great brick dwelling at Hancock, Elder William Deming, noted in a letter of 1832 the speed of construction, and, like Blinn, he thought highly of the style and the quality of materials: he boasted that the building was "neatly laid up" and "The work is all well done. There is none to exede it in this country [that is, in that region]. And the same can be said of the joiner work, the stuff is very clear[;] there is scarcely a knot to be seen in all the work."[61]

Shakers also commented favorably on the use of tin, as well as employment of slate. David R. Lamson, an apostate but recalling his time as a Shaker, found neatness and perfection of form in the appearance of the villages and wrote of the dwelling house of the church family at Hancock that it was "roofed with tin, and finished outside and inside in the most perfect though plain manner."[62] Similarly, Prudence Morrell, at the Gathering Order at South Union, Kentucky, in 1847, wrote, "They are building a dwelling house of brick & have just begun covering it with tin."[63] As for slate, Hiram Rude, in addition to noting how systematically he toured the site at Union Village, Ohio, wrote, "I finish the day in walking around the buildings, and look at the new house from celer to the top of the building, out on the rough [roof] which is made of slate and a very good roof it is, and a very convenient house, the largest I have seen among believers."[64] Writing with interest and some pride at a novel introduction of roofing material, Henry C. Blinn, describing the trustee's house in Canterbury, noted in 1830 that "the roof will be slated. Till this date only shingles have been used, and a new roof covered with slate is a thing unknown in this part of the country."[65] For his part, Thomas Damon took the trouble to mention the slated roof of the Office at Enfield, New Hampshire (27 September 1850).[66] And the sharp-eyed Prudence Morrell, writing of the First Order at Union Village, Ohio, on 26 May 1847 described how "we visited in the

first order, and went to see the new house, and a very handsome house it is; it is built of brick and covered with slate, a very durable, plain and handsome house."[67]

Shakers used words such as "grand," "noble," and "substantial" to describe some of their buildings, conveying their sense of the power of the impressive effect, which reflected the moral stature, importance, and economic vitality of their villages. At Enfield, New Hampshire, the Second Family, the New Lebanon Ministry that was visiting reported about the "stone Office, which is a noble building."[68] On 18 September 1846, at Enfield, Connecticut, the journal entry by the writer from the group from Harvard stated:

> The church and this family [North Family] appears more like the palaces of princes than the habitations of the humble children of hated and abused but blessed Mother Ann. Thier buildings like the Church are beautiful[,] substantial and commodious[,] supplied with every comfort and convenience that could be desired to soften the toil and lessen the trials of ter[r]estrial life. Thier beautiful stone walks which you found your feet upon which ever way you went from building to building . . . thier green pleasant dooryard luxurient with grass all give tokens of high prosperity and much industry on the part of the inhabitants to adorn Zion and make her an admiration to the passers by.[69]

The Shakers were aware of hierarchy of fineness within a village. Hervey Elkins, at Enfield, New Hampshire, wrote, "In every society there is a physician, and in each family an infirmary located on a beautiful site, and unsurpassed by any buildings except the great mansions in convenience and neatness, and several nurses who occupy it."[70]

That the Shakers were erecting finer and more elaborate building as the century progressed was recognized, and decried, by Henry C. Blinn. Visiting at Hancock, he praised the simplicity of the early meetinghouse there, which he thought stood in contradistinction to the "splendid and costly edifices reared in the different societies." He wrote in 1853:

> The Meeting house is the one originally built & remains in its primitive form. It is the cause of reflection, or it sometimes produces reflection, when we see such splendid & costly edifices reared in the different societies for our personal accommodation, while the

Figure 3.14. William F. Winter Jr., *Shaker Meetinghouse, Hancock, Berkshire County, MA*, after 1933, photograph. (Washington, D.C., Historic American Buildings Survey, Library of Congress, Prints and Photographs Division. *Photo:* Library of Congress.)

house dedicated solely to the worship of God, is left & seemingly uncared for, through all the changes that may occur. Perhaps it will be reserved as a memorial, to the honor of the first founders and the simplicity of architecture, or because it is a building seldom used & therefore made to answer for the present.[71]

Perhaps forgetting what he wrote in 1853, twenty years later he was back in Hancock and noted, "The [original 1786] meeting house has recently [1871] been changed from the old style curb roof [gambrel] to the gable roof [see fig. 3.14; demolished in 1938].—It is now a beautiful two storied house with green blinds."[72] But Blinn was still willing to resist change, and he conveyed a sense of unease at the novelty in Hancock of the brethren "ornamenting their door yard with fruit trees."[73] The conflict between the older, more chaste style versus new urges for more ornament continued through the nineteenth century.

Traveling Shakers visited other believers' interiors systematically and thoroughly, and they made frequent comments in journals. In a typical note, Barnabas Hinckley (1808–61), visiting from New Lebanon, was at the Second Family new dwelling at Watervliet on 30 September 1836 and wrote that he and others "went pretty much all over it."[74] Susan Ann Lewis in 22 September 1849 was Enfield, New Hampshire, and wrote, "We took much pleasure in viewing the neatness of their dwellings." And, two days later, she saw there a dwelling house of a "rather singular shape, by the many additions to it."[75] Philip Burlingame and other Shakers visited Hancock from Enfield, Connecticut, and on 29 June 1856 after visiting the brethren and sisters "looked about the house a little, etc."[76] At New Lebanon on 3 August 1846, wrote Rufus Bishop, "The Ministry from New Hampshire came last evening soon after supper and sat with us, after viewing the interior of the Meetinghouse and all our apartments and accommodations."[77] Shakers gained satisfaction from the appearance of neatness, cleanliness, and craftsmanship of Shaker interior spaces. Elsa Parsons (b. 1800) wrote on 19 December 1843 that at the age of eleven she first came into the Shaker community with her parents at Enfield, Connecticut, and "On entering their habitations, I was as it were struck with admiration at the beauty of the places, such perfect neatness and order was manifested throughout."[78] Hancock Shaker Thomas Damon, himself endowed with skills in woodworking, liked a meeting room in a large dwelling at Enfield, New Hampshire, calling it "is a very beautiful room."[79] Kentuckians Moore and Reynolds were at the Wash House in Canterbury, New Hampshire, on 14 September 1854 and liked the neat arrangement with benches as well

as shoes, dresses, and bonnets hanging on shelves, "in good order," noting, "This is a simple arrangement to be sure, but to me it spoke more than to see a splendid hall with the richest furniture."[80] Even a humble sleeping chamber was attractive to Shakers. Hervey Elkins wrote of the bedroom of a Shaker forced to leave the village as "the beautiful chamber in which she would never more sleep."[81] At the Shaker village at Harvard in April 1843, Giles B. Avery was "disappointed" in general with the buildings, but, in giving authorship to a building and also praising the interior finish, stated, "A beautiful new & convenient office is here—plan drawn by Br[other] Jonas N.—I admire the internal arrangement and finish very much, in general, some few slight exceptions. . . . 3 stories high, with a little porch on the east."[82] He concluded that "I was never more pleased with the internal arrangements of any building than I am with this."[83] Thomas Hammond Jr., visiting the North Family in Alfred, Maine, in 1851, went "into their meeting room, a beautiful room."[84]

Shakers took note of and passed judgment on materials used in interiors, including plasterwork and paint. Seeing fine workmanship and the application of good materials gave the Shakers pleasure. Isaac Newton Youngs noted in 1856 that "some of the nicer buildings" at New Lebanon were "done with a hard coat of white finish." He did state, too, though, that chair moldings were once used there but came to be omitted because they were "needless."[85] Nancy E. Moore, traveling in 1854 with William Reynolds from Ohio, liked the interior at the large stone dwelling house at Enfield, New Hampshire: "The paint is very smooth and glossy. Elder Orville says they finished by dipping the paintbrush in the boiled oil just as the paint is drying, and brush it over[;] by this means the oil becomes a varnish which looks elegantly when dry."[86] A simple whitewashing would be enough to cause pleasure. Giles B. Avery at Enfield, New Hampshire, on 3 May 1843, was back in the "stone house," he said: "The plastering throughout is the neatest I ever saw, not the whitest, although it is sufficiently white to look well."[87] Similarly, in an anonymous female Shaker diary of 1877 at Shirley, it reads: "I bake pies & before I commence Horace takes down the stove pipe & clean it, he whitewashes the kitchen & does it thorough it looks a good deal better, tho' it makes us extra labor."[88] Deborah Robinson, on 28 September 1850 at Chosen Vale (Enfield, New Hampshire), favored a "house, which is both convenient and pretty," and its interior, for "having a nice smooth floor, with smooth Seats attached to the House."[89] Even ironwork, not usually associated by us with Shakerdom, appears to gain the approval of Rufus Bishop at New Lebanon in 1833: "I help the Brethren put up the first iron railing ever used in the church, at the South end of the First Order's house."[90]

One Shaker made note of the appearance of an interior lit by candlelight and the celebratory meaning involved: John McBride, who had left the sect but who had signed the covenant at Pleasant Hill in 1814 and 1830, wrote of his time at the Shaker village: "Now, this brings to mind a very great and extraordinary surrender we did make at a certain time. It was a celebration of the birth-day of MOTHER ANN LEE. 12. It was an exceeding large fire; very early in the morning before every day, every house was enlightened with two special large, candles, representing Jesus Christ and mother Ann Lee."[91] Hervey Elkins liked the plastering and space at the cleanly school building at Enfield, New Hampshire: "The schoolroom was large, high, well ventilated, beautifully plastered and painted, and kept in minute cleanliness. Over the entrance was inscribed in large letters, 'Walk softly, open and shut doors gently.'"[92]

Just as Elkins and others described the exterior beauty of the granite dwelling at Enfield, New Hampshire, he offered a favorable description of the interior and its details:

> The stone edifice, occupied for the family mansion, is one hundred feet in length, fifty-eight feet in width, and four stories high, above the basement. The summit of the cupola is one hundred feet from the ground. The interior of the edifice is finished with beautiful white pine, and not a knot, blemish, or nail head was any where visible, *before painting*, from the cupola to the cellar. The finish is painted white, and varnished, and shines with the brilliancy of reflected light.... This cellar is flagged with irregular polygons of argillaceous slate, geometrically fitted together, forming a smooth, elegant, and expensive bottom. The portico, extending across the eastern end and supported by six massive granite pillars, is also flagged with the same material. The construction of the whole house, for convenience and pleasantness, is unsurpassed. . . . [In the kitchen] the walls are pure white and the inside of the cupboards and closets of a sky blue. . . . [The] hall of worship is immediately above the dining hall in the centre of the house. It is fifty-eight by forty feet, and is lighted by twelve large windows. Not a post, or support of any kind, interrupts, in this place, the felicity of space. . . . Three flights of stairs, richly fortified by beautiful balustrades and rails, lead to the cupola. The balustrades, from the attic to the ground loft, are of black cherry wood, and are connected by a continuous curvature railing near one hundred feet in length.[93]

Shaker writings about their buildings are often fraught with suggestions of moral goodness and the fitness of the structures for their place at the Shakers' Zion. As Elkins summarized it, "Order is heaven's first law," and that was true for internal arrangements, as we have seen.[94] Prudence Morrell, at South Union, Kentucky, on 10 August 1847, wrote: "We went thro' the Office and it is neat & plain, just such a house as Mother [Ann Lee] could own, it is brick and very convenient. The buildings here are chiefly brick and very plain."[95] One Shaker from 1869 wrote of New Lebanon: "a delightful village with a most beautiful & imposing exterior indicative of the purity of the interior."[96] Hervey Elkins, of his recent home at Enfield, New Hampshire, called attention to the beauty of the buildings and degrees of difference in cost, refinement, and location:

> The great mansion lifts itself up, two entire lofts, roofs and cupola above every every [sic] other structure of the village. The numerous deep blue roofs indicate that they are covered with a substantial and costly material. Three fourths of a mile to the south, the buildings of the Junior Order are in full view. Not so beautifully located as those of the Senior, they also exhibit less wealth, or more parsimony in their design. Those of the Novitiate are also in view, fewer in number but neat, commodious and nearly approximating those of the Senior in beauty, symmetry and refinement.[97]

As for the moral quality of Shaker architecture, Elkins wrote:

> The lovers of gaudy decorations and "small display," would perhaps deem the style of architecture, employed by the Shakers as too modest, uniform and plain. They wish embellishments to alleviate a monotony, which, though rich and commodious, is not fanciful. Those whose fancy would lead them to prefer the style of the Custom House [see fig. 4.18] and Merchant's Exchange of Boston, to the Court House of that city, would greatly differ in opinion from me in regard to architectural design. The low, dark, and heathenishly ornamented structures are not compatible with the liberal and enlightened spirit of modern times. They behoove despots and seem the concomitants of slavery and terror.[98]

Even in his freedom from the sect, Elkins maintained Shaker-like values and abjured the fancy styles, the "heathenishly ornamented structures,"

present in American cities, and he allied Shaker style with "modern times" and broader American values of antidespotism and antiluxury.

As their own interior elements became finer or more elaborate, some Shakers started to raise moral objections. In the travel journal of the ministry from Pleasant Hill, when at New Lebanon (1869) at the dwelling house of the Second Order, the officials seemed uncomfortable that "the window curtains are rolled up by little brass pulleys . . . & little white knobs or pins on the small drawers, & a few of the doors with white knobs."[99] Similarly, although Henry C. Blinn was gratified by the "beautiful prospect" of the buildings at Mount Lebanon as he rode from Hancock in 1873, he was not so taken with the ornament he found there and complained that "beautifully polished Italian marble" and silver-plated fixtures in a building there added to the "burden of life."[100] On another occasion, Blinn noted, not with approval, the novelty of interior elements. At Enfield, Connecticut, in 1873, looking at a residence building, he wrote, "The building is painted white & trimmed with green blinds. . . . The drawers and cupboards are built into the house;—the faces are black walnut & finished with French polish. . . . This ornamental style of painting in a Shaker house is wholly new to us. How extensively it has been used we are at present unable to tell." He noted other innovations at that village, but seemed comforted by the retention of "old fashioned" furniture: in the "meeting house in this place is a large two story building, furnished with green blinds. Everything about it is on an extensive scale. This house true to the primitive style retains the blue paint throughout the interior. They still retain the old fashioned benches, without backs, for both believers & the world."[101]

Among the most striking of the physical products of Shakerism, but one that is today known only from early views or descriptions, were the largely outdoor sacred grounds, placed on some elevation of land, and called, depending on the community, various names, including the Feast Ground, Holy Ground, Holy Mount, Chosen Ground, Holy Hill, Holy Circle, and Mount Sinai, or what Isaac Newton Youngs called, more generally, "Holy and consecrated grounds" (fig. 3.15).[102] Not part of the earliest Shaker communities, these holy places were the result of the ecstatic times of "Mother Ann's Work" of the 1830s and 1840s and corresponded to the age of revelation and mysticism of that time. Choosing a spot on an elevated place, each community shaped and adorned a sacred spot where the group would meet for sacred events and clairvoyant occurrences. Larger ceremonies typically happened in the spring and fall, marking the "Feast of the Passover," but documents indicate that visitors were often taken there throughout the year, and impromptu prayer and song by

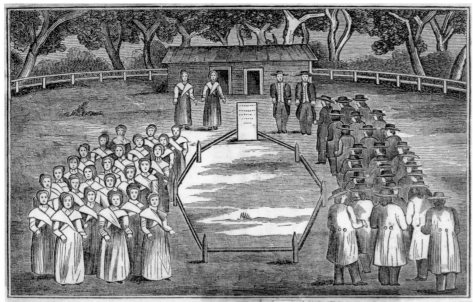

Figure 3.15. Unknown artist, *Mountain Meeting*, ca. 1848, wood engraving, 3½ x 5 inches, published in David R. Lamson, *Two Years' Experience Among the Shakers* (West Boylston, MA: published by the author, 1848), frontispiece.

MOUNTAIN MEETING.—See page 56.

small groups occurred during these sporadic visits. Each mount typically had small, decorative fencing, a marble slab (sometimes called a "fountain stone"), a spiritual fountain (dry, perforce at the elevations), and flat, grassy surfaces and bushes and trees planted about. The Shakers found these sites beautiful and inspiring, and we saw in the last chapter that they appreciated the prospects offered by the loftier Feast Grounds.[103]

Appreciation of the visual aspects of the Feast Grounds was a regular feature of Shaker travel literature. Giles B. Avery, visiting from New York and at the Feast Ground or "Mount of Olives" at Enfield, Connecticut, on 21 April 1843, wrote of the holy ground, or Mount of Olives: "This is a beautiful spot of ground upon a hill."[104] Prudence Morrell, visiting at Union Village, Ohio, on 1 June 1847, liked their chosen ground: "On our return home we went across lots to see the chosen ground. It is a beautiful square yard ten rods each way, and shaded with forest trees, Ash, Oak, and Hickory. The fountain is in the centre of the yard, just 18. feet square; and over the gate the word is as follows. Purity Holiness and Eternal Truth I do require of all who enter here to worship Me saith the Lord."[105] Morrell praised the "Holy Sinai's Plains," about a half mile from the meetinghouse in Pleasant Hill, writing that "the yard is a handsome oval round."[106] A member of the Central Ministry called the Holy

Figure 3.16. Unknown sculptor, fragment from a marble slab for a Feast Ground/Holy Mount ("Mount Horeb") at Tyringham, Massachusetts, 1843, height ca. 18 inches. (Winterthur, Delaware, Winterthur Museum, Garden, and Library, Edward Deming Andrews Memorial Shaker Collection, SA 1294. *Photo:* Winterthur.)

Hill at Alfred, Maine, "a verry beautiful place" on 23 July 1850.[107] In 1850 Deborah Robinson wrote of the "Holy Hill" or "feast ground" at Harvard that "it is a beautiful place indeed."[108] For her part, Nancy E. Moore, on 18 September 1854, in Canterbury, New Hampshire, wrote of the hill and was impressed by the cost: "The Feast Ground is in a beautiful grove of Hemlock and Oaks. It is surrounded by a row of beautiful Fir trees—has a spiritual fountain and a Marble Slab about 4 feet high elegantly finished and lettered in a masterly style by brother Henry C. Blinn one of the Ministry." We learn that the Feast Ground cost $1,000.[109] Another Shaker, on 4 June 1847, was at Shirley and "went into the gardens, & round among the buildings—went to their great Barn, which is by far the best constructed Barn that we have ever seen— then went up to their Holy Hill, saw a beautiful Fountain—the Brethren & sisters that went with us, sung some beautiful songs, we marched round the Fountain, had a good & joyful time."[110]

Fine stone, especially marble, was usually used at Holy Mounts, with nicely executed inscriptions. A fragment of such stone survives, from the Feast Ground/Holy Mount at Tyringham, Massachusetts (fig. 3.16). Dating to 1843, the slab is carved with skill.[111] The acquiring of a marble slab and the undertaking of its carving were notable events that found their way into Shaker diaries, such as that of Mary Dryer at Groveland, New York, in 1843: on 13 May two men "went to Mr. Morris[;] brot home a marble stone to be placed at the fountain," and on 18 May 1843, it was recorded, "The marble containing the word of the Lord taken to the fountain and set up in its place."[112] That some effort was made to build these Feast Grounds is noted by Susan Ann Lewis in 1849: the "feast ground some [lacuna] rods east of the dwellings" at Alfred, Maine, forms "a butiful square—prepared with some exertion."[113] Similarly, Isaac Newton Youngs noted that in 1842, "a great amount of time was occupied & labor expended this year [in New Lebanon] at the Holy Feast Ground, &

in connection therewith; in visiting the place, preparing the ground, erecting a fence, setting out trees, &c. &c. Also, there were many meetings there, much attention was turned there by the whole society."[114] In addition to the layout, the Holy Mounts were well maintained, and an event like the erection of the holy stone was noted with pride by diarists.[115] David R. Lamson pointed out the neat appearance of the sites prepare for the ecstatic Feast Ground meetings in the 1840s:

> The place pointed out for our society was about a mile and a half from our village upon the top of a mountain, and is named Mount Sinai. . . . The brethren went to work and removed the trees and their roots, the stones, and other rubbish, smoothed and prepared the ground. It is now covered with a green-sward, and surrounded with a plain strip-fence painted white. It is in the form of a square and contains I should judge about 3–8ths of an acre. Near the centre is a little spot, enclosed with a fence of a string strip about fifteen inches high, in form a hexagon. It is called "the Fountain." At the north end of the fountain is erected a marble slab 3½ or 4 feet high.

He notes the words inscribed on the slabs and states that, beyond that, "there is also, a building erected at the north side of the ground with two apartments, or sitting rooms, one for the sisters, and the other for the brethren. But the fountain claims our particular notice. It is a fountain not of literal waters, but of the water of life and is exceedingly productive of spiritual gifts. It serves also, as a centre, around which they march, and dance, and sing, and play." So the Shakers chose a special and elevated place, with a prospect to the distance, and prepared it with a green lawn, white fences, and special geometries and the iconography of the spiritual "fountain." Within this space, the participants wore their Sunday clothing and put on a fine show for themselves and, sometimes, outside visitors, who sometimes came to watch even when not invited or welcomed: "Imagine yourself a Seer, beholding this army of Shakers, glittering in the full splendor of this glorious uniform, winding up the mountain. Is not it a most brilliant sight to behold?"[116] On this spot, beautiful and fantasy visions unfolded, such as Martha V. and a little white box with gold leaf: "Brother Robert's gift was also a beautiful white box, and within it a gold leaf, on which was written something (which I do not recollect). In addition to this, he [spiritually] received a beautiful garment, and a trumpet."[117]

The great range of Shaker visuality is indicated further by a remarkable document showing believers entertaining each other with a variation on the camera obscura. The New Lebanon Ministry was visiting at Enfield, New Hampshire, and on 9 July 1850 saw a clever demonstration:

> This afternoon we were invited to see an invention which the young Brethren had got up to show the small insicts which are hardly disernable by the naked eye. The rays of the Sun was let in thro' a magnifying glass at the west end of a carriage house chamber, before which a small speck of the rind of Cheese, say as small as ½ of a wheat corn, was pierced with the point of a cap-pin. When the sun warmed the cheese[,] the little mites would begin to move. The little bit of cheese would cast a shade on a white sheet at the opposite end of the building about as large as a Corn fan, and when the mites came onto the edge of the bit of cheese, we could see the mites running on the Canvass, about the size of rats! chasing each other about from place to place with great activity, and we were told that they had been seen fighting together. Can it be possible that we daily eat scores of such hedious looking animals?[118]

This projected image was not exactly a work of art, but did involve vision, optics, light, and narrative (fighting mites), all on a canvas sheet for entertainment. It was hardly a solitary event, as the performance was organized by a group of young Shaker men and projected in a large public space before an audience. We saw in the last chapter, in a related kind of projection, Shakers looking at flies enlarged in a manner like a magic lantern show. In another kind of visual experience, in a real event and not a work of art, we can see that even in looking at disaster, Shakers could find beauty. Hervey Elkins noted that in putting out a fire at Enfield, New Hampshire, the splashing of the masses of water, created by ingenuity and applied by the teamwork of the Shakers, formed a kind of lovely sight: "Water was baled until the middle of the relics [remainders] could be reached, where the gate of a large aqueduct was hoisted, and a beautiful fountain, urged by the hard pressure of a forty feet fall, boiled upwards ten or twelve feet, and ran hissing over the charred and smoky mass, forming a beautiful and imposing sight."[119]

Turning to furniture made by believers, we might offer a brief summary of its forms and appearance. Shaker style was affected by specific Shaker laws but had resulted from various non-Shaker traditions and tendencies. Their

furniture was rooted in earlier designs and stood as simplified variants on the earlier American types, especially rural styles. Shaker types were based on the world's furniture: tripod tables, blanket chests, oval boxes, work tables, and woven baskets were, as articulated by the Shakers, abstracted from American works of ca. 1800–1820 or even earlier. The retrospective quality of Shaker furniture is evident, for example, in their chairs, in which the ladderbacks continue long-standing forms, and the occasional inclusion of mushroom pommels, those rounded handgrips, are a throwback to a manner that was widespread for centuries in American style (fig. 3.17). In 1873 Henry C. Blinn wrote, proudly, that chairs being produced by Shakers were "old fashioned" and characteristic of styles from "one hundred years ago."[120] While Shaker furniture differed greatly in level of ornament from fancy pieces made for American urban centers, in their own way (through, for example, bright paint colors, colored cloth on seats, and fine workmanship), Shakers endowed their works with high quality, and they made it appeal to the eye while still conveying the idea that the simple and plain are beautiful and heavenly.

In design, Shakers kept ornament on furniture to a minimum; finials, for example, that might have been turned to look more like acorns in furniture of "the world" became more spare and ended up like vertical ovals (fig. 3.18). Chair turnings are reduced in appearance, and where a piece by the world's people might have comprised a ball-and-ring turning in a stretcher, a Shaker work will have a pure cylinder or only a slight swelling to the stretcher. Shakers avoided fancy materials (ebony and mahogany, for example) and veneers. Yet it was not all about reduction and absence. Shakers did not adorn their works with paint in "fancy" patterns, but they did sometimes apply pigment in thin applications or use staining, both applications allowing the pattern of the figuring of the wood to show through and offer a kind of surface articulation. The use of colored wool webbing on seats, often resulting in herringbone or checkered patterns, formed another sort of decoration and could be carried out in a number of colors, and the coloring became greater in extent as the nineteenth century progressed and as chairs became more and more intended for "the world" through commercial sales (see, for example, fig. 3.19). Other Americans made oval boxes, but not always with the swallow-tailed joins or fine staining or washes of paint used by the Shakers.

Shaker furniture shared similarities with a number of different kinds of American furniture, but it arose under its own specific religious context.[121] Still, both the forms and the moral context had certain parallels in traditional American beliefs about material culture, for there had for centuries in America

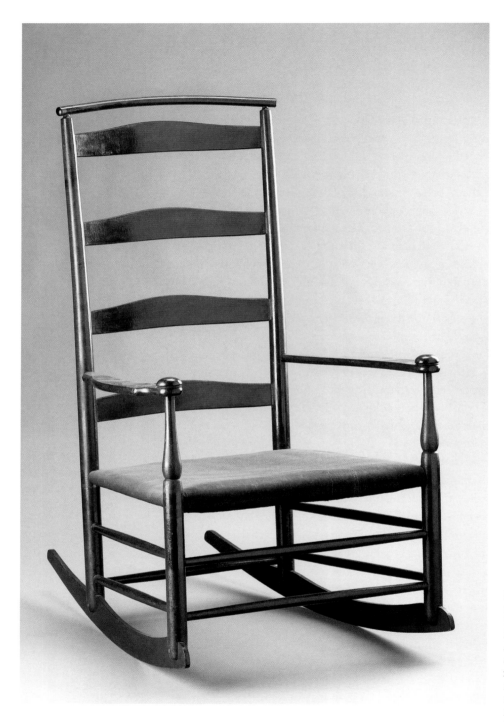

Figure 3.17. Unknown maker, Mount Lebanon community, *Rocking Chair (No. 7), Shaker*, 1875–99, maple and ash, 41⅛ x 25¼ x 31 inches. (Boston, Museum of Fine Arts. Photograph © 2019 Museum of Fine Arts, Boston.)

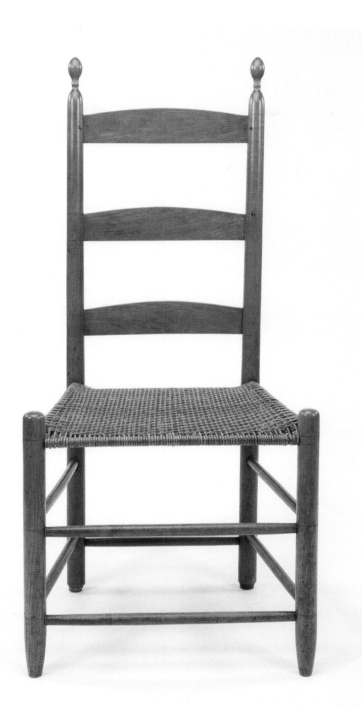

Figure 3.18. Unknown maker, Shaker Community, *Side Chair*, ca. 1830–60, maple, 40¾ (height) x 18½ (width) x 14¼ (depth). (Winterthur, Delaware, Winterthur Museum, Garden, and Library. Gift of Dr. and Mrs. Robert Booth. *Photo:* Winterthur.)

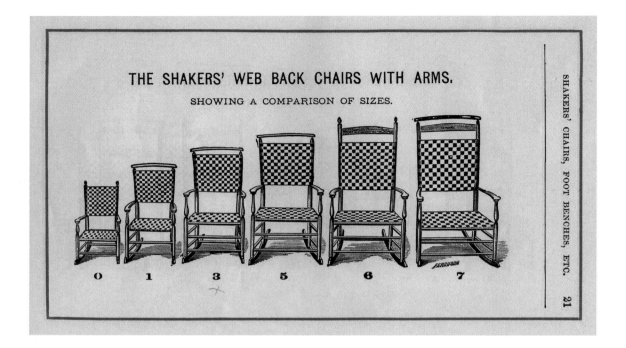

SHAKERS' CHAIRS, FOOT BENCHES, ETC.

21

Figure 3.19. Signed "[Hiram] Ferguson," *The Shakers' Web Back Chairs with Arms,* woodblock print, 3 x 6 inches, showing chairs made in Mount Lebanon, New York, from the *Centennial Illustrated Catalogue and Price List of the Shakers' Chairs, Foot Benches, Floor Mats, etc.,* no author listed, but noting, "Manufactured and sold by the Shakers at Mt. Lebanon, Columbia Co., N.Y." (Albany, NY: Weed, Parsons, 1876), 21. (Winterthur, Delaware, Winterthur Museum, Garden, and Library, Edward Deming Andrews Memorial Shaker Collection, ASC 343. *Photo:* Winterthur.)

been calls for various kinds of material restraint. As long expounded from the pulpit, there were shame and potential moral danger in luxury and the ornate. The Quakers in American leaned toward honest construction and, sometimes, simplicity of design.[122] The widely read and admired Benjamin Franklin wrote in his autobiography about his plain tastes earlier in his marriage: "We kept no idle servants, our table was plain and simple, our furniture of the cheapest. For instance, my breakfast was a long time bread and milk (no tea), and I ate it out of a twopenny earthen porringer, with a pewter spoon. But mark how luxury will enter families, and make a progress, in spite of principle: being call'd one morning to breakfast, I found it in a China bowl, with a spoon of silver! They had been bought for me without my knowledge by my wife."[123] A taste existed in America throughout the eighteenth century and into the nineteenth century for a plain and neat style for furniture rather than for the more ornate styles that were available. Others have pointed out that Shaker furniture is consistent with some of the ideals of restraint found in neoclassical thinking and that Shaker furniture was a simple and spare version of Federal-period style.[124] Getting closer to the time of Shaker design in the arts, Thomas Jefferson's "Monticello joinery" and his famous "Jefferson cup" in silver embodied a spare

style that is not so distant from the spirit of the Shakers, with little or no ornamentation. Sumpter Priddy has emphasized the difference between Shaker design and "Fancy" pieces of American painted furniture.[125]

As for purely formal parallels with Shaker works, although Baltimore designer Samuel Gragg applied surface painting on his works, his sinuous and simple elastic chairs also represent minimal design in America in the first half of the nineteenth century.[126] In the years when the Shakers flourished (ca. 1810–60), the Grecian style was becoming widely diffused, and, especially toward 1840 and later, some Grecian furniture became spare of ornament. Finally, there was also a growing market in America for Asian furniture; even the bed in Henry David Thoreau's cabin at Walden Pond started life as a Chinese chair, altered by him to its later purpose. A remarkable similarity of appearance exists between Shaker furniture and Japanese and Chinese furniture of the second quarter of the nineteenth century; an influence of the East on the Shakers is improbable, but it is noteworthy that the Shaker taste for well-crafted and spare furniture happened to have been shared by a segment of the American public.[127] In 1846 Shaker Abigail Crossman came across some Chinese furniture in a private home in Nahant, Massachusetts, and it caught her eye.[128] We will see in the next chapter how other Shakers sometimes commented favorably on the world's furnishings.

While there were precedents in American design for Shaker products, many American works differed greatly from Shaker pieces. The more luxurious furniture in the United States was endowed with grain painting, gilding, brass and ormolu elements on feet and elsewhere, marble columns and mirrors on pier tables, and other elements fundamentally opposed to Shaker principles. Unlike admired American works, Shaker pieces rarely included imported or fine wood, such as mahogany. Shaker furniture was always useful, never created for display on its own or meant to show off fine decorative arts such as plateware; Shakers designed no étagères or sideboards with galleries. Believers also suppressed knowledge of authorship, as Shaker makers were discouraged by local dictates or custom from signing or dating their pieces. It is possible to identify the makers of some Shaker furniture, as Jerry V. Grant and Douglas R. Allen did, and as set out in the scholarship of Timothy D. Rieman and Jean M. Burks, all using various kinds of evidence, such as (rare) signatures or oral tradition, but prideful individual authorship was not a morally acceptable goal for Shaker craftsmen.[129] The Millennial Laws of 1845 stated that "no one should write or print his name on any article of manufacture that others may hereafter know the work of his hands."[130]

Even though they sought to suppress worldly passions and sensations, and while some of their objects were colored in more muted fashion, Shakers were hardly averse to bright colors. Some of the colors have faded over time, or been stripped away by modern restoration, but research has indicated that Shakers used vivid coloration on furniture and other interior elements. Timothy D. Rieman, who has restored and carefully studied Shaker furniture from the classic period, referred to the "almost lavish use of color as the primary factor" in Shaker design.[131] He noted that colors have thinned and muted over time and that the "use of painted furniture such as this [bright butter yellow] blanket chest [from New Lebanon] may have made the early nineteenth century Shaker residences much more colorful than most of our twenty-first century homes."[132] A Shaker pine blanket chest from the mid-nineteenth century is still endowed, despite much loss of paint, with a charming blue color (fig. 3.20).[133] The Shakers achieved further pleasing results by the use of darker pulls set off against lighter paint surfaces or a contrast of larger planes of color, as in the blue body and salmon-orange top of an early counter from Canterbury (fig. 3.21).[134] The original bright coloring of some Shaker furniture corresponds to the coloring of Shaker moldings and other elements in their interior. Recent analysis and restoration of a second-floor room in the Brick Dwelling at the Hancock Shaker Village has brought back the original kind of bright, buttery yellow coloring on the doors and woodworking.[135] Designer and builder William Deming boasted of the interiors in a letter to Benjamin S. Youngs in 1832 that "the drawers are faced with butternut & handsomely stained," and the whole building "is finished from the top to the bottom, handsomely stained in a bright Orange color."[136] Susan L. Buck, looking broadly at Shaker paint colors on furniture and interiors, has written of the "intense red color," vibrant chrome yellow, and otherwise "surprising variations" in Shaker paint applications.[137] The Shaker world was replete with lively, even bold, colors, and, as William Deming's testimony indicates, Shakers found the vivid coloring to be handsome and aesthetically pleasing.

Shaker dictates stated that unnecessary adornment should be omitted from furniture, but we should not take that too literally, as arm- and side chairs are often endowed with finials, which served a decorative role and were hardly functional in any real sense in their shapes. Case pieces often have feet that are shaped like reduced versions of the French feet on the furniture of the "world's people"; although spare in form, these feet are attractive and embellish the piece where a straight leg would have done as well or better for function (see fig. 3.20). Visible scoring on chairs, showing where the

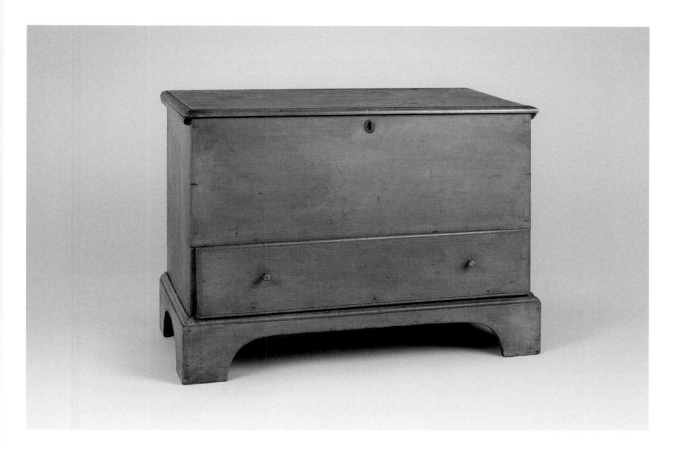

stiles are joined by ladderback horizontals or seat rails, creates visual inter-
est. The ladders on the backs of chairs were usually arched, as in the world's
traditions, entailing extra working to create an aesthetic effect. Also artful
and not merely functional are the graduated drawers on many movable and
built-in case pieces. The famous swallow-tailed binding found on Shaker oval
boxes is also more delicate and refined than is needed for function, and the
little nails form their own aesthetic pattern (fig. 3.22). Pommels on armchairs,
swelling of turnings, and the tapering of stiles and stretchers are other exam-
ples of fine details that go beyond mere usefulness. The graceful way that legs
on Shaker tripod tables arch and then swell out farther while reaching to the
ground can be called an aesthetic embellishment.[138]

Modern analysis of Shaker furniture forms a vast literature.[139] Our focus in
this book is on what Shakers thought and wrote. Apart from their laws and

Figure 3.20. Unknown maker, *Blanket Chest*, ca. 1835–75, pine, with blue paint, 29 ⅛ x 38 ¾ x 19 inches. (New York, Metropoli-tan Museum of Art. Friends of the American Wing Fund, 1966. Image copyright © The Metro-politan Museum of Art. Image source: Art Resource, NY.)

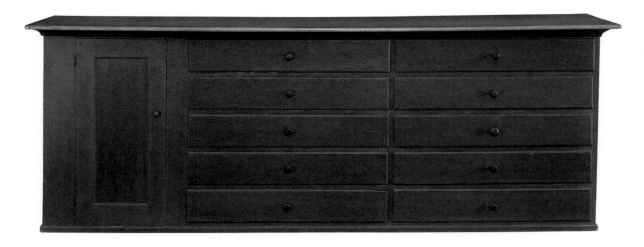

Figure 3.21. Unknown maker, *Tailor's Counter from the Eldresses' Room*, ca. 1815, pine, cherry knobs, glue sized under paint, case painted blue, top and inside of cupboard painted orange, top finished with varnish, 39 x 104 x 25½. (Mount Lebanon, New York, Shaker Museum/Mount Lebanon. *Photo:* Michael Fredericks/ Shaker Museum.)

regulations, to be reviewed later in the chapter, Shakers had little to say about their furniture, and there has been an understandable temptation to fill that gap by speaking for the Shakers and providing an aesthetic assessment of their works. There has been a good deal of casual comparison of Shaker furniture with modernism in general, the Bauhaus, the International Style, and so forth. American painter and photographer Charles Sheeler (1883–1965) and other modern artists took an interest in the Shakers and their visual world. Some Shaker pieces please modern viewers by a certain elegant elongation, a truth to material of construction, and an apparent less-is-more attitude. Recent scholars have come to criticize the claim that protomodernism is a fundamental aspect of Shaker furniture and other design, and some have stressed how the art market and modern collectionism are behind the twentieth-century obsession with Shaker furniture.[140] While comparisons between Shakers and the modern world are unhistorical, they are not solely to be lamented: if the modernist eye has taken an interest in the Shakers and this has led to a desire to study, collect, preserve, and exhibit their material culture, that is, in the long run, a positive development. But a better way to see the Shakers is through their context. They were rural dwellers who fought fashion, so they froze in time the style of furniture acceptable to them and looked to types and forms current in the countryside. They sought a heav-

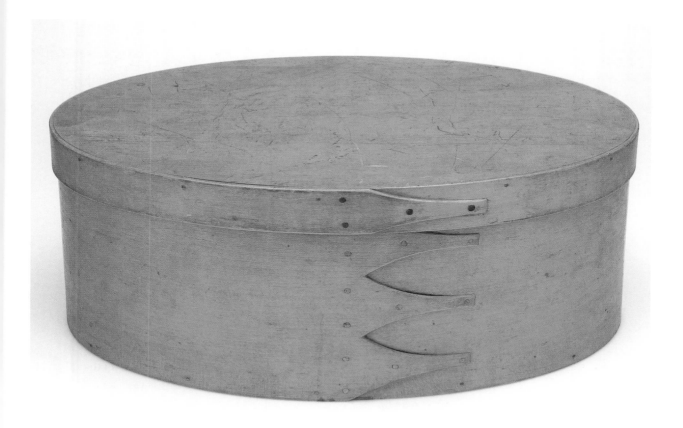

Figure 3.22. Unknown artist, Sabbathday Lake community, *Covered Oval Box, Shaker,* 1850–1900, birch, pine, painted yellow, 5 x 9¼ x 13¼ inches. (Boston, Museum of Fine Arts, Gift of Richmond G. Wight. Photograph © 2019 Museum of Fine Arts, Boston.)

enly purity, and order and moderation in all things, and their furniture tends to be geometric (rectangular and with circles, mostly), of modest materials, and unadorned compared to that of the world's people. Their diligence and devotion to detail led them to produce furniture that is fine and well crafted, including being well joined and planed. And Shaker exuberance and energetic religiosity perhaps stand behind their acceptance of a lively coloration on the furniture. As for modernism, it implies novelty, difference, and an aesthetic focus, while Shaker material culture is based on stasis, conservatism, usefulness, and economy.

Most people in any society do not write about the quotidian objects that surround them, and it is perhaps expected that there is little overt evidence indicating that the Shakers highly prized their furniture. Perhaps we should not weigh the lack of verbal evidence too heavily, as there might have been deep

satisfaction or feelings that never made it onto the printed or written page. We can at least safely conclude that the surviving documents fail to record the kinds of aesthetic experiences enjoyed by many modern viewers. Shakers repeatedly discounted the importance of material objects and, if anything, tried to suppress interest in them. We have to suppose that the craftsmen themselves took a special interest in their products, but, otherwise, there is little evidence that rank-and-file Shakers or their leaders were keenly interested in details of furniture style or construction. Jerry V. Grant and Douglas R. Allen called attention to an early letter (1807) in which the New Lebanon Ministry state that they were pleased to have just had crafted for them a "very nice table" of black-walnut boards.[141] Even such brief and generalized comments on furniture were rare. The analysis of Rieman and Burks has usefully set out the differences between the styles that arose in various Shaker communities, and these variations appeal to our modern eyes and tastes, but, while it may have existed, there is no evidence that there was local pride in community style or any aesthetic, connoisseurial judgments rendered by Shakers traveling from one place to another and comparing local furniture styles to each other.[142]

Shakers in their home villages were less likely to comment on their surrounding pieces than believers who were traveling and seeing new things, and travel journals yield some Shaker critical notices about material and furnishing. Probably referring to the evenness of the rounding up of a headstone, Hiram Rude wrote in 1856 of a Shaker tombstone in Ohio that "the grave[-stone] [is] nicely rounded up."[143] Henry C. Blinn seemed to like that headstones at Hancock, Massachusetts, were made of marble rather than a lesser stone. He wrote in 1853, "The grave stone were of marble & about 20 inches high, on which were engraven the initials only."[144] As for wooden pieces, western Shaker Nancy E. Moore commented positively in 1854 on some chairs in Canterbury, New Hampshire, but it was more the usage than the appearance that caught her eye: "Also they have in the sick room two splendid Rocking Chairs of exquisite arrangement; In one of these you can lie down, or sit up as you feel to."[145] The Shakers had a preference for the clean and shiny. An unidentified female Shaker at wrote in 1875, "I have given Bessie Joseph's Chair[.] I have fixed the Chushion & the Chair has been varnished so it look's well & they both seems pleased with it."[146]

There was some change among Shakers over the nineteenth century toward acceptance of more genteel objects. In 1805 some Shakers traveling from New York to the South objected to a table set "in fashion." They complained, "We sat down with a number of Students &c[.] to a Table prepared in fashion. To

have Eat[en] a crust of Bread in a Cottage with plain and decent People would have been abundantly more our faith and feelings."[147] By midcentury other Shakers were not averse to seeing a shiny table and a nice cruet and glass dishes: in 1854 at Canterbury, New Hampshire, one saw on a table, along with an impressive array of foods, including "rye Indian bread, Mutton, Irish potatoes, Corn, Apple pie, Cranberry tarts & turnovers, pound cake, White bread. The center of the table was garnished with two glass dishes filled with preserves and a crewet stand which contained the spices." The table was cleaned and varnished, "the surface of which might serve as a mirror."[148] Also on the more ornate side of things, and offering us a rare Shaker drawing of an actual decorative work, is a design after a brush by Curtis Cramer (1812–86) of North Union, Ohio (fig. 3.23); in 1854 Nancy E. Moore illustrated in a pen drawing a "North Union [Ohio] Pea Fowl Brush [made] by Brother Curtice Cramer," and she called these ornate items "pretty brushes."[149] Clearly, she appreciated the exotic brush adorned with the "pretty" feathers of a pea fowl. Hervey Elkins offered his sense of adornment with objects, referring to the school at Enfield, New Hampshire, where "the books were choice; and globes, celestial and terrestial [sic], maps and diagrams adorned the apartment."[150]

Shaker furniture was akin to that of the world, and there is some compatibility between works by the Shakers and those of the world. Most Shaker historic sites or period rooms in museums showcase only Shaker furniture, but, in reality, believers bought furniture from the world or brought it with them when they joined Shaker communities. For example, on 2 September 1830, Rufus Bishop "had a new table yesterday which Frederic got made in Albany for the use of our Shop—E. Ruth paid $3.00 for for [sic] it."[151] By commissioning a piece from the world, the Shakers could control the style and coloring, if any, as well as any practical matters of size and form. Young William S. Byrd, in a letter (28 November 1826) to his father, Charles Willing Byrd (1770–1828), mentioned a handsome case piece procured for him by Francis Voris, trustee at the Pleasant Hill Shaker community. William was not yet a full member of the Shaker society and was paying out of pocket for some of his own provisions and furniture: "Frances procured for me a buroe, to keep my cloathes, and other things in. It was not quite finished when he bought it, although it had been made some time before. I suppose alltogether it will not cost me more than eleven dollars. It is a very handsome one, and I understand from him that if it had been bought out of town, it would have come to about twenty two."[152] The letter is ambiguous, but it appears that the bureau was made locally and then sold by Voris to Byrd and was then perhaps

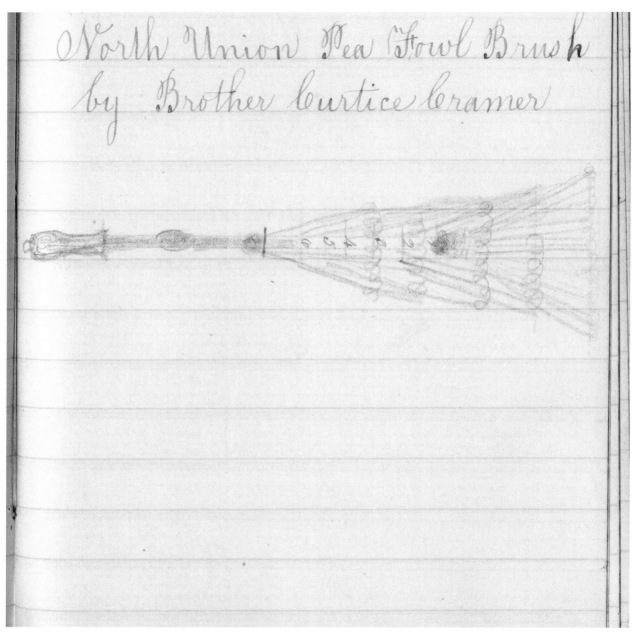

Figure 3.23. Nancy E. Moore, *Curtis Cramer's Plan for Making Pea Fowl Brushes*, in a "Journal of a visit by the ministries of Union Village [Ohio] and South Union [Kentucky] to eastern communities," 11 October 1854, pen and ink on paper. (Cleveland, Ohio, Western Reserve Historical Society, Shaker Manuscripts, Series V, B-250, 149. *Photo:* WRHS.)

to be finished under the auspices of the Shakers at Pleasant Hill. At any rate, although the letter was from a provisional Shaker to his non-Shaker father, it shows that those entering the community were bringing their previous attitudes to the decorative arts, as he commented on the costliness of the piece, its handsome appearance, and how it was apparently turned into a finished piece for his use. Shakers had a sense of "good, better, and best" with furniture, as Byrd suggests. Along similar lines, Hervey Elkins acknowledged a hierarchy of furniture (likely meant in the broad sense of furnishings) at Enfield, New Hampshire: "These rooms [for boys] were furnished in a manner similar to those in the stone mansion, devoted for the residence of those over sixteen. The furniture was of course not quite so nice."[153]

Some characterizations of Shaker furniture appear in printed sales catalogs of the 1870s and later. Some uncertainty arises about whether the descriptions are reflective of Shaker feelings or whether the wording is crafted to boost sales among the world's people. At any rate, the verbiage is not effusive, but enough is there to get a sense that the Shakers were most focused on the craftsmanship, usefulness, and low cost, but also sense a prettiness to the pieces they produced. The 1876 centennial catalog of works from the Shaker factory in New Lebanon was most concerned with making sure that "imitation or spurious chairs which may bear the name of Shaker chair" not be confused with the real product.[154] Otherwise, the catalog notes, with the text set out as believers writing in the first-person plural, that Shakers "do not sell any of the cheap quality of chairs" and sell "very comfortable" chairs with web backs, with all of their pieces offering "advantages of durability, simplicity, and lightness." One chair, they claim, "is a great favorite with the ladies. It is broad on the seat, and very easy." They enticed buyers by noting that their cushions include "all of the most desirable and pretty colors. In one remarkable passage, the Shakers muse about the earliest Shaker chairs, made in "revolutionary times," and that a "contrast between those and our present production is quite amusing." The catalog does not stress beauty or niceties of proportion, but one section, apparently composed by the exhibition organizers and characterizing the sect's members in the third person, notes that Shaker pieces had by then gained "an extensive reputation for comfort and beauty."[155]

We can turn now to the notable issue of Shaker restrictions or laws concerning their material world and productions, and we can begin with a consideration of buildings. Shakers, as we have seen, felt that their buildings sometimes had grandeur, a high quality of craftsmanship, impressive size,

use of fine materials, and aesthetic features such as a pleasing counterplacing of marble and brick; any records of restrictions have to be seen in light of the evidence that Shakers believed that they built fine and impressive buildings. Also, some of the laws that seem to us to impose limits were meant not necessarily to suppress the pleasure of looking, but to achieve an ease of identification and a union between the communities. For example, one purpose of making meetinghouses white on the outside, with blue coloration on the interiors, or having a darker color for barns or other "lower" buildings, all as dictated in the Millennial Laws of 1845, was to establish uniformity and achieve common unity across the sect's various villages. It should also be noted, as stated in the Millennial Laws, that the "laws" themselves were guidelines and could be applied or adapted as deemed fit by elders in charge of each place.

Restrictions on the design and articulation of exteriors and interiors appeared in Shaker Millennial Laws, originating from the Central Ministry and elders in New Lebanon, and most common were warnings against ornament and specific recommendations for color. Actual practice sometimes deviated from specific suggestions found in the laws, but the existence of the rules indicates a desire for uniformity, clarity, variety, and the use of color to signal architectural use. The Millennial Laws, in 1845, stated, in the section "Concerning buildings[,] cornicies[,] painting[,] and the manufacture of articles for sale":

> Beadings, mouldings, cornicings and the like, which are merely for fanciful ornament, may not be made by Believers. 2. Odd or fanciful styles of architecture, may not be used among Believers, neither should any deviate widely from the common style of building among Believers, without the union of the Lead [the ministry]. 3. The meeting house should be painted white without, and of a blueish shade within. Houses and shops should be of a nearly uniform color, but it is advisable to have the color of shops of a little darker shade than dwelling houses. 4. Floors in dwelling houses if stained at all, should be of a reddish yellow, and shop floors (if painted or stained,) should be of a yellowish red. 5. It is not advisable for wooden buildings, fronting the street, to be painted red, brown or black, but they should be of a lightish hue. 6. No buildings may be painted white excepting the meeting houses. 7. Barns and back buildings, wood-houses &c. if painted at all, should be of a dark hue, either red or brown, or led color, or something of that kind, unless they front the street, and

command a sightly view; & then they should not be of a very light color.[156]

Significant is the notion of "nice use," which implies an echo of the sense of gentility of the world's people. Significant also is the idea that a farm building might "command a sightly view" and then should be colored in a very light color. This shows a sharp awareness of the viewing points into the village and how a building, whether because it is elevated or isolated from others, could be pleasingly visible and well colored to add to the effect. Also of particular interest is number 2 above, forbidding odd styles, and an insistence that the manner of expression be consistent with the "common styles of building among Believers."

The laws called for order and simplicity in the layout of the villages. The Millennial Laws of 1845, in the section "Concerning door yards, farms and so forth," are explicit about the heavenly order to inform Shaker village design: "In the spring of the year, the fences about the farm should be mended; for Zion is called to be a pattern of good order & economy in all things." The Shakers avoided curves and diagonals, preferring right angles. The Millennial Laws of 1845 include admonitions to order and avoidance of pedestrians creating desire paths: "It is not good order to have the door yards cut up into little crosspaths and by-roads, but when consistant, every one should keep on the walk."[157] Similarly, the squarish mind-set of the Shakers appeared earlier in the notion in the 1821 Millennial Laws that "it is considered good order, to lay out, and fence all kinds of lots, fields, and gardens, in a square form, where it is practicable."[158] Their villages were, indeed, set up in this fashion, avoiding curves (including circles and ovals, so much in vogue in America otherwise), all with the usual Shaker combination of aesthetic simplicity, economy, and drive toward heavenly order and cleanliness (fig. 3.24).

In considering strictures against architectural practice, we should note one omission for building practice, not mentioned in the laws themselves but clearly discouraged or locally forbidden at some level: a look at surviving architecture, early views, and verbal records indicates that the Shakers did not build broad porticoes useful for seating and social gathering, as was done enthusiastically in America at the time. The nineteenth century in America was the age of what was variously called a veranda, piazza, porch, or portico, an idea widely adopted by "the world."[159] Clearly, they were associated with pleasure and a genteel lifestyle, as Henry David Thoreau noted in *The Maine Woods*, in which he imagined seeing endless rows of porches, columns, and

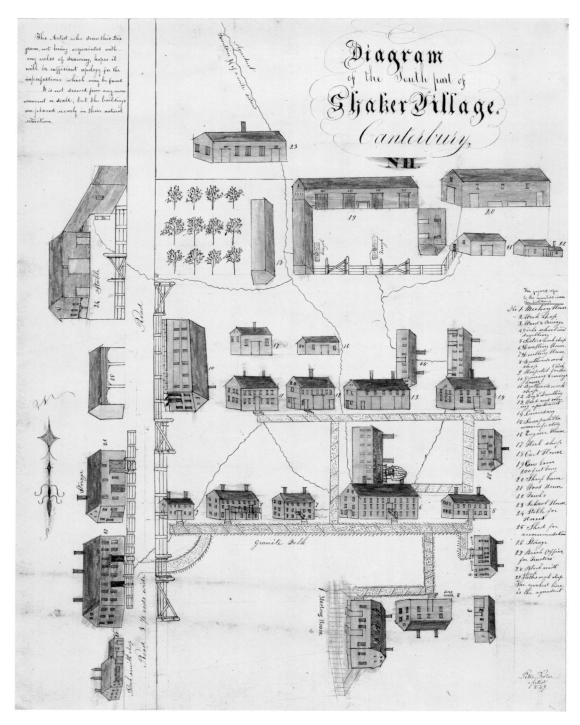

Figure 3.24. Peter Foster, *Diagram of the South Part of Shaker Village, Canterbury, NH* (detail), 1849, pen and ink and watercolor on paper, 16½ x 12½ inches. (Washington, D.C., Library of Congress, Geography and Map Division. *Photo*: Library of Congress.)

verandas, and he thought of the "nobility" that must dwell behind them.[160] Apart from the pleasure of sitting on a porch, the Shakers could have used porches for the practical purposes of work or to keep rain and snow away from the doorways, but they chose not to do so, perhaps because porticoes had become associated with genteel society. A porch also exposed one to the views of passers-by both among believers and from the public passing along a road. The Shakers also tended to look retrospectively and build in ways that conformed to earlier trends, and in that regard the portico was not as widespread in domestic architecture in 1800 as it was in 1840. The Shakers built some smaller porch-like additions for practical purposes, often at the short end of the building, but in the period of our focus (the 1870s and earlier), they did not participate in the American trend of porch building. To keep rain away from the portal, they used small unornamented coverings that Isaac Newton Youngs called "door Caps."[161]

In their building and furnishings, Shakers were most concerned, as was their custom, with not following fashion. Of course, they were not alone in that regard in America. Thomas Cole, in his "Essay on American Scenery," also railed against the "gaudy frivolities of fashion."[162] Shaker restrictions helped to achieve several goals: first, they wanted to avoid making themselves slaves to the shifting customs of the world. As Hervey Elkins put it, "They tremble at adopting the *customs* of the world."[163] The Shakers avoided glass at table for that reason. Elkins explained that that was not because it is so expensive, but because use of glass was a widespread material in common use. When a new Shaker brought a mahogany piece into the community, they often painted over it. This was not the most economical thing to do, as leaving it as it would have cost the least amount of money, but it allowed them to put their own plain stamp of work on fine wood that was prized in the United States in general. Second, related to the first idea, Shakers avoided ornament so as not to feed the "pride and vanity" of the user, who was going beyond what was useful. Millennial Laws of 1821: the members of the church of God are "forbid making any thing for believers that will have a tendency to feed to the pride and vanity of a fallen nature, or making anything for the world that cannot be justified among ourselves, or purchasing any of their manufactures to sell with ours for the sake of temporal gain."[164] Again, as Elkins put it, "An arbitrary inhibition rests upon statuary, paintings, watches, jewelry of all kinds, knives of more than two blades, sofas, divans, musical instruments, and whatever gorgeous appendage would serve to feed vanity and pride, more than subserve the practical utility of civilized life."[165] Third, and on the positive side, Shakers

found godliness in simplicity, as we have seen. Thus, the restrictions could help the Shakers be closer to God, avoid the vagaries of worldly custom, and not distract and corrupt themselves as individuals with superfluities. Finally, keeping things simple made it easier to achieve uniformity, which led to cohesive union between individuals and between villages and which the Shakers found to be beautiful. Even if the laws differed somewhat over time and were not necessarily always followed, and some leeway written into them through calls for adaptation by the different villages, Shaker laws provided guidelines for the appearance and furnishing of their interiors. In the Millennial Laws of 1845, in section 10, "Concerning furniture in Retiring rooms," several suggestions for restraint and uniformity appear:

> 2. Bedsteads should be painted green. Comfortables should be of a modest color, not checked, striped nor flowered. Blankets or comfortables for outside spreads should be blue and white, but not checked nor striped. Other kinds now in use may be worn out. 3. One rocking chair in a room is sufficient, except where the aged live. One table, one or two stands; A lamp stand may be attached to the woodwork if desired. One good looking glass, which ought not to exceed eighteen inches in length, and twelve inches in width, with a plain frame. A looking glass larger than this, ought never to be purchased by believers. If necessary, a small glass may be hung in the closet, & a very small one may be kept in the public cupboard of the room. 4. Window curtains should be white, or of a blue or green shade, or some very modest color, and not red, checked, striped nor flowered. 5. The carpets in one room should be as near alike as can consistently be provided, and these the Deaconesses should provide . . . 7. No maps, charts, pictures nor paintings, shall ever be hung up in your dwelling rooms, shops, nor office. And no paintings nor pictures of any kind, set in frames with glass before them, shall ever be among you. But modest advertisements, may be put up in the Trustees Office, when necessary . . . 10. If any person or persons mar, break or destroy any article or articles of furniture in the retiring room, it is the duty of such, to acknowledge the same to the Deacons or Deaconesses, as the case may be, and if possible, to repair the injury.[166]

Again, various laws were supported by spiritual commands, which often came from the leadership of the New Lebanon community, but were claimed to be dictates from beyond by a deceased Shaker. "An Extract from The Holy Orders of the Church: Written by Father Joseph, To the Elders of the Church At New Lebanon, and copied agreeable to Father Joseph's word: February 18th 1841," includes many specifics, and calls for "Suitable Furniture for Retireing Rooms." The document demands, "Bed steads, painted green; Comforters, of a brownish shade; Blankets for outside spreads, blue and white, but not checked nor striped. Plain splint, bark, list, or tape bottomed chairs, are preferable to any other kind." As for curtains: "Window curtains white, or of a blue or green shade, but not checked nor striped."[167]

The effect of the rules for interiors is summarized by the always useful Hervey Elkins, who noted:

> The dwelling rooms are strictly furnished according to the following rules: plain chairs, bottomed with rattan or rush, and light so as to be easily portable; one rocking chair is admissible in each room, but such a luxury is unencouraged; one or two writing tables or desks; one looking glass, not exceeding eighteen inches in length, set in a plain mahogany frame; an elegant but plain stove; two lamps; one candle-stick, and a smoker or tin funnel to convey to the chimney the smoke and gas evolved from the lights; bedsteads painted green; coverlets of a mixed color, blue and white; carpets manufactured by themselves, and each containing but three colors; two or three bibles and all the religious works edited by the Society, a concordance, grammar, dictionary, etc. These are all the books they tolerate in the mansion where they retire from labor and worldly pursuits. No image or portrait of anything upon the earth, or under the earth, is suffered in the holy place. Consequently clocks and such articles, purchased of the world, go through the process of having all their superficial decorations erased from their surfaces. None shall go thither only for the purposes of eating, sleeping, retiring for evening worship, and spending the Sabbath, unless for short errands.[168]

Elkins did note the use of mahogany, as long as it was "plain," by which he must have meant with no carving, gesso, gilding, or inlay. He notably stated that, although it would have been more economical of time and use of tools,

"superficial decorations," probably meaning paint and gilding, were removed from items purchased (and brought in, we can suppose) from the world.

Another item of note in the account by Elkins of Shaker rules for interiors is the restriction on the number of rocking chairs per room. Rocking chairs are sometimes associated by us with health and an old-fashioned lifestyle and are widely seen as a simple piece of furniture, but they were thought by Shakers to be an indulgence except for the infirm and could be restricted in number per room or even banned from villages except for the ill. At Harvard in 1840, in a "journal" that was kept by some sisters, some Shaker sisters noted a rule that came down from the authorities: "Rocking chairs were put aside, except for the sick & aged."[169] In 1854 Thomas Damon noted, "Eld[er] Grove & Elder Wm. came over to Hancock from New Lebanon—The Rocking Chair is condemned except for the sick and the small chair admitted with some modifications."[170] This was a restriction not on the visual form of the chair, but on the comfort it provided.

During the third quarter of the nineteenth century, there was a desire by some Shakers to expand the limits of what ornament was acceptable for believers. The desire for more decoration or introduction of finer materials led to tensions with Shaker authorities. For example, Elder Rufus Bishop, writing at New Lebanon in 1830, reported of a request, and a denial, for glass furniture pulls: "Justus Harwood here this A.M. to see if glass buttons would be allowed of to put on the Cupboard doors & drawers of their new house, but he got no approbation from us."[171] Canterbury leader Henry C. Blinn, traveling to Pleasant Hill in Kentucky on 4 June 1873, noted sarcastically of one house:

> The Brethren's rooms in this dwelling were quite plain & neat. The sisters had taken a little more care for the ornamental. A beautifully framed chromo of flowers, and a small framed picture of birds hung from the walls. In one room the table was filled with fancy articles, trinkets & pictures that we were strongly impressed to regard it as a show case. Really we think this is a good way to make an exhibition of this order of treasures. Believers are noted for the large number which they possess and a free exhibition gives all the pleasure of seeing the many beautiful useless things that we hold in possession.[172]

As Blinn suggests, over the course of the later nineteenth century, the earlier dictates against ornament were often disregarded. Whereas the Millennial Laws of 1845 said that architectural and furniture additions "merely for fan-

ciful ornament" should not be made by Shakers, various kinds of moldings and turnings began to enter Shaker design and production, just as they began more and more to purchase goods from the world that included fancy adornment formerly proscribed for Shaker acquisition.[173]

Shakers had a particular predilection against artworks, and they never exhibited sculpture in their spaces or hung paintings or prints on their walls. Elkins stated, as we saw, "No image or portrait of anything upon the earth, or under the earth, is suffered in this holy place," meaning (somewhat tongue in cheek in this context) in the Shaker villages.[174] In the aforementioned 1841 "The Holy Orders of the Church written by Father Joseph to the elders of the church at New Lebanon," it demands that "no paintings, shall ever be hung up in your dwelling rooms, shops or Office." In the same document, even for two-dimensional works in books, they kept a close eye on things: "Almanacks shall be inspected by the Elders when first bo't; and if they contain any thing unsuitable to be in the house, it shall be cut out, before they are placed in the rooms and before any one has seen [them]."[175] Indeed, the suppression of access to imagery began in schools, as stated in the Millennial Laws of 1845: "Picture books with large showy and extravigant pictures, in them, may not be introduced into our schools, nor used by Believers."[176] For adults, there were also injunctions against the overdecoration of books. One could write on plain paper, but not use "superfluously marbled books, or paper," presumably referring to any amount of marbling. The opposition to anything superfluous is shown by the injunction against writing a date with more than two figures (not "1834," for example, as one should write "34," which could not mean anything but 1834), and it was strictly forbidden to "embe[l]lish any mark." The 1845 Millennial Laws state: "2. Blue and white thread should generally be used for marking garments. 3. It is considered unnecessary to put more than two figures for a date, on our clothse [sic] or tools; and it is strictly forbidden, needlessly to embe[l]lish any mark."[177] A similar spirit informs the rules about marking and signatures, with avoidance recommended for coloring, gilding, and ornament: according to the 1845 rules, one could not write with red ink for ornament, and even for purposes of identification the use of red for marking could not occur with permission from those higher up: "6. No writing with red ink may be done for ornament, and none at all without liberty from the Elders. 7. No gilding nor lettering may be put upon books manufactured among Believers, excepting printed books."[178]

It was not just wall paintings that were forbidden in the rules of 1845, but painting of common items as well, including tools. While there is some

recognition of "nice use" and of items that the world would see, such as carriages or sleighs, the prejudice is against adornment, and varnish is largely, it seems, for protection rather than to apply a fine and pleasing surface: "8. It is not considered prudent and is therefore not allowable, to paint or oil such articles as the following, viz. Cart and lumber waggon boxes, ox waggons, sleds and sleigh boxes, except those kept at the office for journeying. But Wheel barrows, hand-cart bodies, and sleds for rough use, hoe-handles, rake stales[,] fork stales, broom or mop handles for home use, plough beams, milking stools and all such like articles as are exposed to rough use and ready ware, whether for in door or out, should not be painted." Similarly, "9. The following articles may be painted. All kinds of cart or waggon wheels &gearing; all kinds of carriages and sleighs for nice use, wheel barrows, hand sleds and hand carts kept exclusively for nice use; oxyokes, and snow shovels, may be stained or oiled. The frames of cart or waggon bodies, and also gates, may be jointed together with paint, not painted." And Shakers thinking of using varnish might have considered the following: "10. Varnish, if used in dwelling houses, may be applied only to the movables therein, such as the following. Tables, stands, bureaus, or cases of drawers, writing desks or boxes, faces of drawers, chests, chairs, &c. Carriages kept exclusively for riding or nice use, may be varnished. But no ceilings, casings or mouldings, may be varnished. Oval, or any nice boxes may be stained reddish or yellow, but not varnished. Balusters or hand rails for dwelling houses may be varnished."[179] The issue of varnishing was but one way to maintain condition of pieces made of wood; the 1845 laws also ask that believers not rest their feet on stretchers ("rounds") of chairs or lean their chairs back against walls.[180]

The rooting out of superfluity extended even to pens and pencils, and other small items, as stated in great specificity in the 1845 laws:

[1.] Fancy articles of any kind or articles which are superfluously finished, trimmed or ornamented, are not suitable for Believers, and may not be purchased nor used. Among which are the following; also some other articles which are deemed improper to be in the Church, and may not be brought in, except by special liberty from the Lead. 2. Silver pencils, silver tooth picks, gold pencils or pens, silver spoons, silver thimbles, (but thimbles may be lined with silver) gold or silver watches, brass knobs or brass handles of any size or kind, three bladed knives, knife handles with writing or picturing on

them, bone or horn handled knives, except for pocket knives; bone or horn spools, superfluous whips, marbled tin ware, superfluous paper boxes of any kind, gay silk handkerchiefs [lacuna] checked handkerchiefs made by the world, may not be bought for sisters use. Lace cap borders, Superfluous suspenders of any kind. Writing desks may not be used by common members, unless they have much public writing to do. But writing desks may be used as far as it is thought proper by the Lead.

3. The following articles are also deemed improper; superfluously finished, or flowery painted clocks, bureaus, and looking glasses. Also, superfluously painted or fancy shaped sleighs or carriages. Superfluously trimmed harness; and many other articles, too numerous to mention.

4. The forementioned things, are, at present, utterly forbidden; but, if the Lead see fit to bring in any among the forementioned articles, which are not superfluously wrought, the order prohibiting the use of such articles or articles is thereby repealed.

5. Believers may not, in any case or circumstance, manufacture for sale, any article which is superfluously wrought, and which may have a tendency to feed the pride and vanity of man, or such as would not be admissible to use among themselves, on account of their superfluity."[181]

The 1845 rules, assuming the elders would abide by the dictates, make it clear that deacons and trustees of the communities also must not purchase or receive as a gift any item that was superfluous or otherwise lacking in "gospel plainness."[182]

The Millennial Laws of 1860 were shorter in length than those of 1845, but they reinstated the main strictures such as we have seen, concerning superfluous adornment, collection and display of artworks, and the like. For example, the updated laws of 1860, with emphatic underlining, state succinctly: "No Maps, Charts, Pictures or Paintings, should ever be hung up in retire Rooms; and no pictures, paintings, or likenesses, as Daugurrotypes &c. set in frames, or otherwise, should ever be kept by Believers." Similarly, the 1860 rules state: "The furniture of dwelling rooms, among Believers, should be plain in style and unembellished by stamps, flowers, paintings, or gildings, of any kind. And Looking Glasses, ought not to be purchased by Believers, exceeding about 12

A Card of love and notice from the Holy Saviour, to Philemon Stewart January 25th 1843.

I am Jesus the Holy Saviour, even the Son of God. I am love, peace and comfort; and whosoever shall follow me; I will lead them o'er foaming billows, and thro' raging and tempestuous storms. Yea, I will lead them thro' valleys of sorrow and deep tribulation, beyond which they shall find peace and everlasting comfort, and dwell with me their loving Saviour in the celestial Paradise of Heaven, and sing triumphant songs of joy and gladness, before the Lord their God, thro' the endless ages of Eternity.

Figure 3.25. Unknown author, probably from New Lebanon, "A Card of love and notice from the Holy Saviour, to Philemon Stewart," dated 25 January 1843, pen and ink on paper. (Cleveland, Ohio, Western Reserve Historical Society, Shaker Manuscripts, Series VIII, C-5, loose sheet. *Photo:* WRHS.)

by 20 inches." The strictures against adorned books was maintained in the laws as well: "Very superfluously marbled, or gilt Books, or Papers, should not be used among Believers."[183]

We have seen some strictures against the superfluous and against fancy pens and pencils in form, and on unnecessary writing on objects, but the Shakers seem not to have had rules against calligraphy. Even the Shakers did not go so far as to regulate the form of handwriting, and that slight opening allowed the fully practical device of lettering to take florid and elaborate forms. Clearly going beyond the bounds of what was needed, the flourishes stand as Shaker design that can be called elaborate and "fancy" by American standards of the time. Such calligraphic handwriting tended to be internal (so "the world" would not see the level of decoration) and was aimed at others who would read, such as elders or trustees, or more literate recipients of letters. The average farming Shaker did not oversee the account books or the travel journals of Shakers. So this was an elite form of artmaking, just as were the travel journals describing buildings, bridges, and landscapes across the nation. At any rate, the large number of such examples indicate that Shakers

liked to write in calligraphy, with decorative flourishes appearing often in their documents, as in an inspirational "Card of love" of 1843 (fig. 3.25).[184] The documents themselves were sometimes dry lists or financial records and did not especially call for a calligraphic titling. For example, the "Records of the Church at Watervliet" (fig. 3.26) includes a nice flourish on the *T* in "Tuesday." Calligraphy gives an official, clerkish air to the documents in question but also serves as decoration and breaks with the usual Shaker strictures against superfluity and curvilinearity. It should be noted, though, that Shaker writing is usually clear. It is impossible to quantify and demonstrate, but one gets the overall sense that everyday Shaker handwriting was plainer and more legible than the average American hand of the time.

The Shakers discouraged the collection or gathering of objects, whether these were made by the world or by believers. The laws earlier were restated in 1860 in slightly altered form: "All should remember that these are not the true heirs of the Kingdom of Heaven, who multiply to themselves, needless treasures of this world's goods." Similarly, an admonition of 26 April 1842, mostly concerning clothing, mentions other art forms and addresses this issue.

Figure 3.26. Unknown author, Watervliet, title page of "Records of the Church at Watervliet," 1852, pen and ink on paper. (Cleveland, Ohio, Western Reserve Historical Society, Shaker Manuscripts, Series V, B-338, 6 January 1852. Photo: WRHS.)

The document was written at New Lebanon, supposedly by Olive Spencer, who had actually died eight years before, and who was said to be channeling ideas of Mother Ann. "Olive" gave the statement from Mother Ann "that writing, printing and pictures on your knife handles does not beautify them," implying that some Shaker girls and young women were doing that. The document then asked that young women not use baskets to hold items, but to use boxes instead. It stated, "Yea, boxes of your own make, [are] much prettier, than those defiled by the hands of the wicked," meaning, non-Shakers.[185] We see an admonition here, but also get a sense that Shaker boxes, such as the famous oval form (see fig. 3.22), were seen by them as pretty and as "collectibles." While not referring to any specific piece or defined form, this document is a rare example of addressing real-life behavior and the question of crafted pieces and beauty. The Shakers were against collectionism, what was becoming something of an American pastime among the genteel classes. Despite the admonitions against it, we read of many Shakers, to the distress of Shaker officials, keeping small objects of beauty. In the 1842 "Short Roll from Mother Ann and Father William," we read, "Dearly beloved Elders . . . O Says Mother, how many times have I been in & around your dwellings & have seen the young brethren & sisters, standing over their chests & drawers, viewing their vain Idols, and placing their affections upon them—O how it has grieved me!"[186] Shaker leaders exercised constant pressure on rank-and-file Shakers to avoid gathering and enjoying pretty objects, especially those items held in private in drawers.

We have seen that, in addition to documents like the Millennial Laws, some dictates about material objects came down from visionary documents. A record of this kind, significant for its length and specificity, is "A General Statement of the Holy Laws of Zion," penned by two anonymous Shakers but said to be "Written by the hand of God Himself" and also "Written by the Angel Vikalen" and "Approved by the Ministry and Elders at N.[ew] Lebanon," and dated to 7 May 1840. The inspired writer has much to say about the material culture, beauty, and restraint. It is advised of fellow Shakers that when one went to sell anything in the "public markets," let it be "plain and simple and of that good and substantial qaulity [sic] which becomes your calling and profession unembellished by any superfluities which add nothing to its goodness or durability. This my gospel does forbid." To the trustees, "God Himself" gave particular instructions along these same lines: let "nothing pass through this door, in the way of coming into my sanctuary [the village], but what is plain,

modest, and becoming my holy people."[187] The Holy Laws of 1840 also forbade artworks and adornment in the Shaker villages in spaces of worship:

> And my holy law doth furthermore strictly forbid that there should be any engravings, sculptures, pictures or images, or likenesses, either of man, beasts, birds, or any living thing, or the likeness of flowers or inanimate things either upon iron, brass, wood or stone or any other kind of metal be brought into my holy sanctuary, where ye assemble to offer up praises unto me in sacred devotion. But I require that every thing that is attached either to the inside or the outside of such buildings and places, should be perfect and plain, free from all unnecessary embellishments; for in this my last display of grace to man, I leave no room for half way work, either in things inward or outward.[188]

The "Holy Laws of Zion" of 1840 call also for modesty of building design: "Do not be expensive and extravagant in your buildings, but modest and neat. For a lowly cottage, in order and cleanliness, is far more beautiful than a grand dwelling, made and inhabited by that which is unclean. Was it not the pattern that was set by your first Parents & those who have gone before you & laid the foundation for you to build upon, to be tidy & snug in temporary things?" The same laws demanded that orderliness be kept during construction: "It does not beautify Zion to have a great deal of lumber about, and a building began and left and another begun."[189]

A striking set of rules governing, in part, the visual world and arts of the believers can be found in the manuscript titled "The Solemn and Sacred Word or Holy and Eternal Law of God Almighty," deriving, most likely, from leaders of New Lebanon and commenced 20 February 1841. Many of the precepts involve the dwellings and the meetinghouse. The world's people themselves, with whom the Shakers did business, are called "the vain, the wicked, the filthy and ungodly," and they are not to be let into the dwellings of the "Holy Chosen." Meanwhile, "the House of the Lord," apparently referring to Shaker habitations, should be restrained in articulation: "My Holy Law doth forbid, saith God, that in the dwellings of my Holy Chosen, there be any high or superfluous paintings or colors of this kind, even in their possessions either on the ceiling, the floor or on articles of any kind whatever." Ceilings were to have a blue cast, floors a light yellow.[190] The document opposes the use of varnish by

Shakers: "Let all the necessary articles of wood together with the chairs, be plain, and simply wrought by the hands of your own people using no extra liquids to set a peculiar gloss upon them." Similarly, adornment of any kind for material objects is discouraged from on high:

> And O my Chosen Ones, provide not for yourselves, neither handle or keep in your possessions tools, or articles of any kind, either Iron, wood, bone, glass or earthen, or whatever, that has been the object of idle curiosity in the hands of those that formed them, either by the picturing, printing, and flouring, figuring or gilding with any colored wash for the increase of its beauty in any manner whatever. But provide the perfect, plain and heavenly article such as resemble the vessels used in my mansions above, and by my Chosen there: and beautiful they are in my sight saith the Lord, but the embellishments of human and natural arts, are not for you, my Chosen, and beautify not your dwellings, saith the God of Order. And again, let the outside coverings of your beds, on which you rest your bodies, and often receive the blessings which I your Father in Heaven pour freely upon you, be plain, of a changeable, mixed or blue color, and neither striped, checked, speckled or spotted: and after the same form prepare ye your floor coverings and chair mats or cushions without stripes but plain work, all being prepared by the hands of my undefiled people. Let there be nothing of fashion or fancy set upon the table my Holy Chosen saith the Lord. But let it be furnished with the vessels like unto those in my mansions above, which are of the pure lily white and these are the vessels of my choice; but those of a bluish cast, and still of one color and plain, my Holy Order does not forbid, or if only an edge of blue. But let images and pictures go from whence they came, unto those that serve the Gods of their own folly.[191]

The edicts extended to the realm of literature, in particular that there was to be no "perusing of morals or fables of any description or kind written or printed by the hands of the ungodly." For the Shakers, the Lord commanded, "Let the necessary and convenient articles of your hand labor be plain and of a simple form, comely and beautiful, not ornamented by ingenious improvements of fashion or colour." And the injunctions in this regard conclude: "Finally, I would saith God, so far as is possible that my Chosen Anointed

on earth throughout my Zion should suffer not a thing and by no means a superfluous or vain thing, or an unnecessary thing of any kind formed and defiled by the hands of the sinner (for they are in my sight filthy and abominable) to be in their possessions or in any wise kept or used in your retiring apartments."[192] Further admonitions appear about fashion and materials. In addition to the usual ("L[e]t your dress be plain," to avoid that which is "wholly or mostly formed of gold and silver: or even washed with the same merely for ornament"),[193] superfluous adornment is ungodly, while God smiles on the pure, plain form that is without ornament or anything superfluous. Simplicity is the style for angels and is pleasing and comely in God's sight and is used in heavenly mansions, and it is to be applied on earth only for that which is necessary and convenient, not merely for show.

With all of the admonitions in place, it is hardly surprising that Shakers sold off and ordered to be sold in advance any aesthetic object that they did not want to enter their communities. We might say that at times they engaged in mild forms of iconoclasm. Thomas Brown, apostate, reported in 1812 that the earliest Shakers destroyed fine things: "Their superfluous furniture, such as ornamented looking glasses &c. in a number of instances, were dashed upon the floor and stamped to pieces; ear and fingerrings were bitten with all the symptoms of rage and then sold for old metal."[194] We have read Hervey mention that "no image or portrait of anything upon the earth, or under the earth, is suffered in the holy place. Consequently clocks and such articles, purchased of the world, go through the process of having all their superficial decorations erased from their surface."[195] One can imagine the Shakers scraping off flowers from tinware or painted borders from mirror frames. When one entered a community, one had to leave behind objects of aesthetic worth and beauty, such as silver buckles, and Shakers would break off églomisé panels and replace them with plain, clear glass. Rejecting vanities, new Shakers left behind objects of aesthetic value or of beauty. Stephen J. Stein called attention to how new converts in Kentucky pounded with their fists objects of furniture that they had previously cherished.[196] Sally M. Promey discussed a document of 1838 describing the opposition of the Shakers to superfluities and the question of iconoclasm. "Mother desires we would search and see if we have not gathered that which is superfluous . . . everything wherein *fancy* is inclined to bear rule, instead of that modest, decent plainness which becomes the people of God, let it be put away."[197] In another document from ca. 1840, we read the admonition, "Little idols, Mother says, will become great ones if they are not purged out. But bestow upon those who are needy and destitute, and

in this way you will fulfill the order of your calling." One document, dated 12 March 1840, stated of horse whips used for travel that Shakers should ask if these objects were of the "most grand and expensive class." If so, those fancy whips should be "purged out, and such as becomes God's people used in their stead."[198] Believers discarded fancy items or gave them or the money they made of the sale of them away to the worldly poor who could use them.

The destruction of photographic portraits appears in an official circular from the ministry at New Lebanon of November 1, 1873. The circular, usefully for us, also summarizes the Shaker attitude toward portraiture. Intended to deal with the spread of photography and the ease with which images of Shakers could be made, the circular dictated that photographic images of Shakers be included only as incidental to larger views of village life. Over time, the battle was lost, and photographs of individual Shakers became widespread in the late nineteenth and twentieth centuries.[199] The ministry appeared to have been frustrated that "some persons in our societies appear not to appreciate the propriety or necessity of this prohibition." The opposition to portraits is clear:

> As pictures are ordinarily used, it is an eminent species of idolatry, a kind of civilized (so called,) Fetichisin, belonging to a low state of human development in the spiritual scale of progress, even far below that attained unto by some people whom so called Christians, sometimes denominate as heathen, who sacrifise all that tends to install the love of, and devotion to self, as arbiter of human destiny instead of God. 2. The tendency of their use, in multitudes of cases is to foster a worldly affection, vanity, pride, and even worldly lusts, by persons of both sexes, who have a fondness for each other, attaining each other's pictures, and carrying them about their person, fondling them and kissing them as they would wish to do the person of whom the picture is taken, until their spirits are quite corrupted by worldly affections & lusts.

The circular is even concerned that some Shakers would wish "to procure the pictures of the (so called) great men and women of our day." The circular asks of Shakers that they immediately destroy "all Photographs, Daugerrotypes, Ferrotypes, or sum pictures of any name or description, or person, in an individual capacity, or in groups, unconnected with general landscape or village scenery at large."[200] It was hardly an object of beauty,

but Thomas Damon noted in 1854 having in his possession a daguerreotype of a young woman who was appearing in public as a Shaker: "Returned to Hancock . . . I found in waiting a letter and a Daguerreotype likeness of a Shaker imposter who has been playing her pranks in Baltimore, New York &c. under the name of Elizabeth Bushnell." (Elizabeth Parker was her real name, and she "once lived a short time at Tyringham," a Shaker community.)[201] The piece was transferred and seen by the Shakers in this instance not as an object of beauty but as evidence of perfidy against them.

Shaker dictates and restrictions suggest control over the form, color, and finish of Shaker-made products and control over what was brought into the communities from the world or purchased from the world. The documents also suggest, though, that the Shakers found beauty in objects. Moreover, the Shakers incorporated a certain ornateness in materials of building (granite and marble), fine craftsmanship, and bright colors on walls and furnishings, and from early on there was a desire, especially by younger and rank-and-file Shakers, for fine objects that they doted over and kept in drawers. This desire for the more ornate found a greater expression, as we will see in the next two chapters, in Shaker viewing of the world's cities and buildings and even more so in visionary moments and ecstatic drawings, explored in the last chapter.

JOURNEYS TO THE OUTSIDE
Seeing the Art and Architecture of the World's People

4

[Central Park in New York] is the most beautiful specimen of nature & art combined probably to be found any where in America. Smoothe gravel roads, Several large fountains with jets or perpendicular spouts and spreys in them. Large ponds or lakes with vessels to ride about in. Buildings in the hill sides for resting, playing, or eating in. Stone steps to ascend the hills. All kinds of ever green & other trees, the grassy plats, lawns & hills kept low, smoothe[,] and green, a delightful & picturesque scenery.
—Betsy Smith, journal entry of Shaker ministers traveling from Pleasant Hill and South Union, Kentucky, to visit eastern Shaker societies, 13 June 1869

When Shakers traveled, they often enjoyed the appearance of the monuments, public spaces, and architecture of the world at large. Many believers accepted more ornate styles than what they saw at home, but others resisted what they considered to be the follies of this world found in the material culture outside the Shaker communities. For those who looked with favor on the world's creations, we can conclude that the Shaker experience and attitude prepared believers for a positive reception of many aspects of the American scene. For example, Shakers generally seemed comfortable with the plain and weighty Greek Revival style in architecture. Reflecting the mechanical innovativeness of Shaker life, they were attracted to the sight of bridges, aqueducts, waterworks, and fountains in America. In the layout and appearance of towns and cities, Shakers preferred straight streets, cleanliness, and greenery in parks and city squares, all consonant with their experiences and tastes.

Shakers were not just like the world's people, and there were some limits to Shaker interests and places visited when they were outside their communities. For example, they did not visit retail stores or other commercial emporia to amuse themselves or to pass time. The Central Ministry periodically provided rules for the societies to follow, and it seems that each community received a copy for its edification. According to the Millennial Laws of 1821, "No one is allowed, for the sake of curiosity, to go into the world's meeting houses, prisons or towers, or to go on board of vessels, nor to see shows, or

any such things as are calculated to attract the mind and lead it away from the love and fear of God."[1] The 1845 laws and 1860 rules and orders added museums and caravans to the list. In 1845 it reads, "11. It is forbidden for Believers to go into museums, theaters, or to attend caravans or shows, to gratify curiosity; and none should go on board of vessels, ships or steam boats, nor into prisons or jails, unless duty requires it."[2] The "Holy Orders of the Church" of 1841 included a slightly different and expanded list of forbidden spots, beyond museums and prisons: "Ye shall not go to see Museums, nor shows, Jails[,] prisons, poor houses, Assylums, factories, glass works, navy yards nor anything of the kind, to gratify your curiosity."[3] Still, despite any edicts against it, Shakers sometimes bent or broke these rules, and, in any case, the official restrictions covered only some kinds of viewing and visiting, and the circle of visited places expanded over the course of the nineteenth century. Still, Shaker touring was generally of public places such as government buildings or parks and quite often seen from the outside only. We will see that when Shakers saw the world's paintings or sculptures, they often abreacted for one reason or another. Yet despite any restrictions on places to visit or occasional discomfort with individual artworks, it is remarkable to read accounts of the range of places and kinds of buildings and objects that Shakers viewed and enjoyed. That it was a bit of a guilty pleasure is indicated by the remark of John M. Brown in 1866, reporting to Shaker readers in his autobiography that he "wanted a releasement, to have a ramble and see the 'Sights' in 'Gotham.' Thinking perhaps it was 'best not to be righteous overmuch.'" Elsewhere in his account, he expressed guilt about touring in Manhattan and Brooklyn and not spreading the gospel where and when he could.[4]

Shakers entered their travels with a predisposition to look closely and render thoughtful judgment. They regularly toured each other's villages, as we saw in the third chapter, and they were used to making comparisons between places. They had carefully crafted their visual surroundings at home and were eager to see what the world had created with its aspirations for visual beauty. The Shakers had an especially keen eye for architecture, and one small encouragement for each other is worth adducing in this context: although it did not appear in the Millennial Laws of 1821, nor in the shortened rules and orders of 1860, the Millennial Laws of 1845 asked of Shaker educators that young people be taught in the schools "a small portion of Geography, and history, especially that of our own country, also the principles of architecture may be added," although the suggestion continues with the admonition that "but too much time should not be devoted to these branches."[5] The Shakers embraced their

own architectural traditions and principles, but they were capable of study and appreciation of a wider range of building styles. In sum, Shaker travelers were, perhaps unexpectedly for us, accepting and appreciative of a broad range of the material culture of the world: cities, buildings, gardens, and fountains found favor in their eyes, although Shakers on the move were often quick to point out when something crossed a line morally.

We might start with consideration of the largest cities—New York, Philadelphia, and Boston—all teeming with people, traffic, and commerce, the opposite of the quiet and secluded Shaker communities loved and preferred by Shakers. These cities were not necessarily final destinations, but often served as travel points for Shakers passing through them. Still, it is clear that Shakers made the effort to tour these metropolises and specific sites within them.

New York City was within easy boat and, later, train access from the Shaker villages of New Lebanon and Watervliet and often served as a gateway to and from New England as well. Opinions were not always favorable. One unidentified Shaker traveling with fellow members from the community at Harvard, Massachusetts, on the way to Watervliet said succinctly and sarcastically of New York on 12 August 1845: "This is a wonderful city. Pray deliver me from such a sink of corruption." Coming back from Watervliet, they stopped again in Manhattan briefly on 21 August 1845 and went about the city during the day while awaiting passage home, but "found nothing tempting, for all that they had could not save the soul, or supply it with any thing for its support or relief in the solem[n] hour of judgment, therefore we gladly left the wicked City at 5 Oclock PM for our nation land, and our Dear relations in the pure gospel," and the writer then reminded his or her Shaker readers that Mother Ann had fled that very "Wicked City" and moved to the "wilds."[6] Shaker Nancy E. Moore, from the quiet setting of South Union, Kentucky, concluded the same in 1854: "New York is an awful place full of swindlers & smugglers," and she described the perhaps all too familiar "ill bred" drivers there who took no mercy on pedestrians. But, like many a tourist, she had to acknowledge the city's visual charms. On a boat heading north, she described what she saw and painted with her pen a picturesque, dusky harborscape graced with undulating waves: "Here lay spread out before the vision, the world renowned harbour of New york, and besides the dark looking hulls and masts of two French frigates in the distance, the water was made to look alive with the unnumbered craft that floated upon its bosom." There were smaller craft as well, and "the wind was blowing a fresh breeze which gave a zest to the sight, and a lively motion to the

Figure 4.1. Unknown artist, *View of Broadway, Opposite Fulton Street, New York*, 1860, wood engraving, published in *Harper's Weekly: A Journal of Civilization,* Saturday, 18 February 1860, 104–5.

little craft. It was a rich sight for me to see the little things careen in the water and again rise buoyantly on the passing wave."[7]

Other Shakers found a mixture of chaos and beauty in New York. Hiram Rude and Hannah Agnew, both based in the New Lebanon Shaker community but on their way to see Shakers in the West, were visiting Manhattan after decades of a steep rise in the growth and industrialization of the island, with a population at the time of about seven hundred thousand inhabitants. Rude seems to have been author of the account, because he refers to Agnew in the third person. On 29 May 1856, in New York City on the way west, Rude recorded that "people, coaches, hacks and other cariages make a very interesting spectacle, while the surrounding places, mansions, and water fountains and public squares, add to the georgeous appearance." Still, the chaos of people and everything else (cf. fig. 4.1) makes an "awful s[c]ene of confusion," and Rude concluded, echoing the sentiment of many rural visitors to New York City through the decades, "upon the whole I feel thankful my lot is not cast in a citty."[8]

Similarly, Abigail Crossman felt "alone among thousands" in New York City (22 August 1846) and was glad to be home at New Lebanon on 25 August 1846: "Thro' many dirty Cities.—But now at home I'm found."[9] Despite all of the wonders of the large cities, Shakers often expressed the desire to be home again in their clean, idyllic, and holy villages. Shakers seemed to love nothing more than their beautiful, well-kept communities, and returning to one after a trip away was a great pleasure and relief for them. Calvin Green had seen much in the great and small cities of America, but he was gratified to return home from New York City and Philadelphia to New Lebanon (29 May 1828), back to his green and regular village and its moral inhabitants: "I think of all the places I have seen this is the most beautiful of all—the beauty and glory I have seen in all places—the glory of [New] Lebanon excels them all—it looks like the 'field that the Lord hath blessed' and its inhabitants like plants which the Lord hath planted."[10] Another traveling Shaker, Joanna Mitchell of New Lebanon, wrote in 1835 that "nothing, lacking but a heart that could delight in things of time, I have seen the greatest wonders of nature and human art that I ever conceived"; it all left her cold, and she missed being home in her Shaker village at New Lebanon, her "good home."[11]

Elder Freegift Wells, otherwise based far up the Hudson River at Watervliet, toured New York and found much to like in the city, including the view from the Battery at the southern tip of Manhattan on 5 September 1853: "After supper, Br. Chauncey Miller [1814–1907] (who accompanied us to N. York on business,) took a walk in the City with the Sisters, & Jessie & I took a walk from the foot of Courtland Street, to the foot of Fulton Street. In this circuit we passed an abundance of Shipping, & also the whole extent of the Battery, the scenery of which, was very beautiful." The next morning, 6 September, even before breakfast, Wells and Miller went "to see the fountain in the Park," probably meaning not the spectacular fountain far north in Union Square Park, but likely the more modest and nearby circular fountain in Bowling Green Park on Broadway just north of the Battery; an altered fountain, surrounded by a surviving colonial-period iron fence, is extant on the spot.[12] Then Wells passed through the "fish market," that is, at the Fulton Market, located on the street of that name where it meets the East River, a shopping and tourist destination that had opened in 1822.[13] Here, as elsewhere in Shaker accounts, we can see that believers were drawn to fountains. They did not purchase or craft ornamental fountains for their communities, but, as we saw in the third chapter, they built dry but spiritually potent "fountains" on their Holy Mounts. The world's real-life fountains were deemed beautiful by the Shakers and

Figure 4.2. John Bachmann, *Bird's-Eye View of the New York Crystal Palace and Environs*, 1853, lithograph printed in colors, with hand coloring, 21 x 31 inches. (Museum of the City of New York, J. Clarence Davies Collection. *Photo:* MCNY.)

had reverberations with their religious life and writings, in which they often evoked the idea of a sacred fountain. And unlike galleries or retail shops, for example, fountains were out-of-doors, clean, and free of charge and did not offend iconographically. For Wells, the Bowling Green fountain was a destination in itself, a characteristic choice of sites for a Shaker traveler in the world's cities.

Henry C. Blinn, a Shaker from Canterbury, New Hampshire, was a skilled writer, mostly of theological literature, and he also left some vivid travel accounts.[14] He had been an elder and then minister since the previous year and was traveling in 1853 as part of his Shaker leadership in the ministry. He called the Crystal Palace "one of the wonders of the day."[15] Blinn saw the Crystal Palace two years before it was destroyed by fire (fig. 4.2; see also fig. 4.4). Designed by Georg Carstensen (1812–57) and Charles (Karl) Gildemeister (1820–69) and built in 1853 on what is now Bryant Park on Forty-Second Street in Manhattan, the great iron and glass structure was inspired by the Crystal

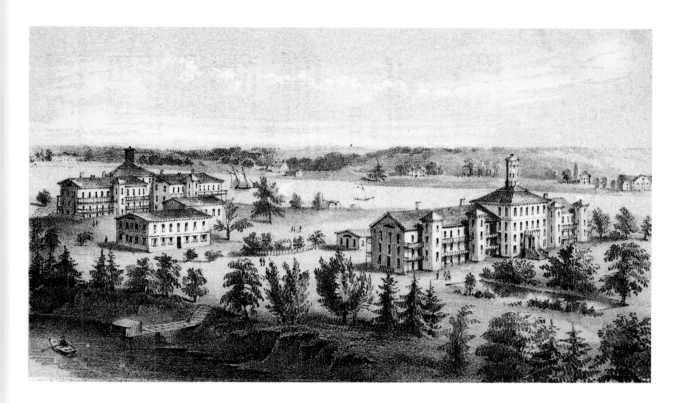

Figure 4.3. George Hayward, *Alms House Buildings. Blackwells Island*, 1853, two-color lithograph, 3½ x 6⅛ inches, "for D. T. Valentine's Manual, 1853" (*Manual of the Corporation of the City of New York for 1853* [New York: D. T. Valentine, printed by McSpedon & Baker, 1853], opposite 54).

Palace in London's Hyde Park. This marvel of New York architecture was in the neo-Gothic style, informed with a modern spirit through its materials, abstract and simple areas of glass and metal, and purpose as an exhibition and meeting hall.[16] Shakers liked a broad range of styles, but they seemed particularly drawn to architecture that was technologically advanced, useful to a broad range of the public, and looked good without being overly ornate. Shakers avoided viewing exhibitions of art or of fancy items for display or commercial sale, and there is no evidence that Blinn entered the glass palace itself.

On their trip to New York, the above-mentioned Kentucky Shakers William Reynolds and Nancy E. Moore described passing Blackwell's Island in 1854 and mentioned seeing "the State Prison, the Lunatic Asylum, and the Almshouse," while "on Long Island shore is to be seen rich country residences."[17] For his part, Henry C. Blinn visited Manhattan (again) in 1856, and on his tour of the teeming city, Blinn saw on 25 July 1856 the Blackwell's Island prison complex,

"12 large buildings with beautiful grounds around them, which appeared more like the residences of wealthy people, rather than of criminals."[18] Blackwell's Island, now called Roosevelt Island, comprised a prison (built in 1832 in a stony and crenellated-castle style), an 1853 view of which offers a glimpse of the almshouse and "beautiful grounds" mentioned by Blinn (fig. 4.3). Again, a Shaker was drawn to a planned, orderly combination of fine architecture and verdant grounds with trees, a kind of secular parallel to a Shaker village. Blinn might not have known or recognized where the prison complex ended, and nearby or adjacent were other distinguished buildings, including one by Alexander Jackson Davis (1803–92) (a "lunatic" asylum of 1839) and a small-pox hospital by James Renwick Jr. (1818–95), opened in 1856, the year of Blinn's visit. At any rate, it took extra effort (then, as now) to get to the island, and Blinn either did so or took the time to see it from Manhattan across the narrow stretch of river. Shakers usually favored society's underdogs, but Blinn seems to show some resentment of the prisoners, implying that the fine architecture, suited more for wealthy people, is too good for "criminals."

Freegift Wells, in New York in 1853 with some other Shakers, notably heard that a Sister Clarrissa and others among their group wanted them all to stay for another day to see the Croton Waterworks (Croton Distributing Reservoir), on the current site of the New York Public Library at Forty-Second Street and Fifth Avenue (fig. 4.4; also partially visible on the right in fig. 4.2). It is a rare document that records the process of Shakers working out sightseeing plans, and it is striking to see the Shakers putting off their return home for a full day merely to undertake some extra touring. They were about to leave on 18 September 1853, Wells reported in his journal, but, he wrote, with some sense of mirth, "Clarrissa had advised to have us go & see the Croton waterworks &c. Now I could not really believe that Clarrissa's counsel was the original cause of this anxiety to stay another day, but as that was brought up in support of the proposition; and finding also that there was a very strong under current running that way, it seemed almost dangerous to undertake to stop its course—I therefore concluded that it would be the most expedient to unite with the general feeling." So, on Monday, 19 September 1853, they went to see it, "on the East side of the Crystal Pallace. This is the most stupendeous piece of Mason work that I ever saw—a description of which I shall not undertake" because, Wells claimed, it would take too long to write. The reservoir, first receiving water in 1842 and dismantled in 1897, had massive granite walls fifty feet high that were capped with a bold cornice, all done in an Egyptianizing style. Freegift used here a literary device he employed elsewhere in his journals, writing

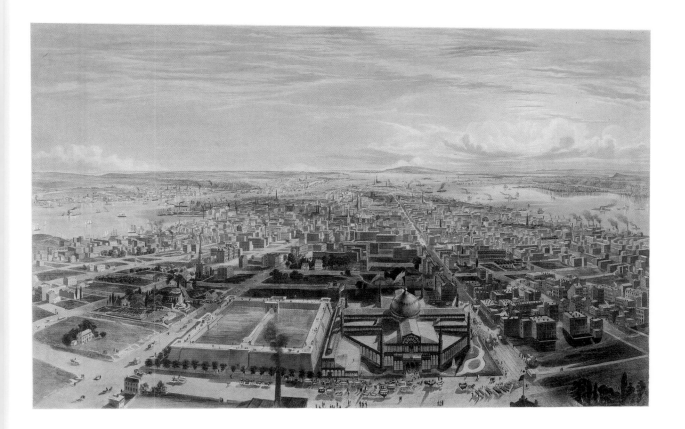

that he could not or would not describe something, leaving it instead to the readers' imaginations. A remarkable colored engraving by William Wellstood (1819–1900) shows a bird's-eye and conveys the impressive appearance of the reservoir (fig. 4.4). Wells noted that "after a thorough view of this and other adjacent curiosities," presumably including the adjacent Crystal Palace, they returned to the station for their train home.[19] One does not associate Shakers with monumental building, but, as we have seen, they built huge stone barns, such as the ones at New Lebanon and Hancock, and their dwellings were large by the standards of their region and achieved the scale of the world's institutional buildings. The believers were eager to see the massive Croton Reservoir, which was large, massively proportioned, designed in an ancient historical style, and functional.

Somewhat advanced in time in the nineteenth century, and edging into ever-greater sensibility of pleasure, was the report of a ministerial visit to New

Figure 4.4. William Wellstood, engraver, after Benjamin F. Smith Jr., publisher Smith, Fern & Company, *New York, 1855, from the Latting Observatory*, 1855, engraving with hand coloring, 29¼ x 46 inches. (New York Public Library, Miriam and Ira D. Wallach Division of Art, Prints, and Photographs. *Photo:* NYPL.)

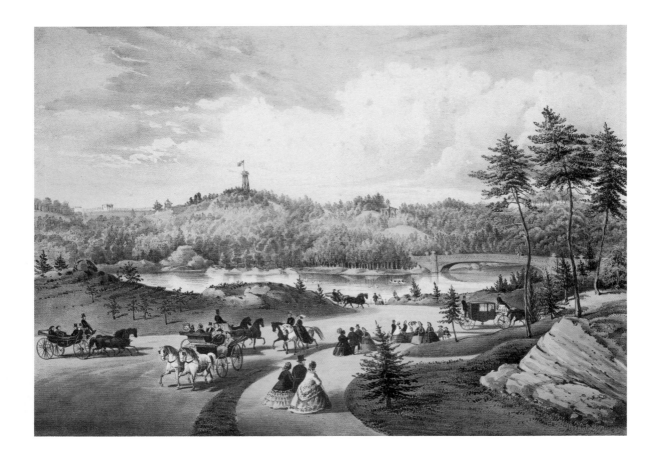

Figure 4.5. Nathaniel Currier and James Merritt Ives, *Central Park: The Lake*, 1862, lithograph, colored by hand, 15¾ x 19½ inches. (New York Public Library, Miriam and Ira D. Wallach Division of Art, Prints and Photographs. *Photo:* NYPL.)

York and elsewhere in 1869. The group of Shaker leaders included Kentucky Shakers Harvey (or Hervey) Lauderdale Eads (or Eades), Betsy Smith (the probable author of the account), and James Rankin as well as New Lebanon Shaker Paulina Bates. The journal included an appreciative reflection on Central Park in New York on 13 June 1869, where they "chartered a carriage" for the tour, although there was a disagreement about the cost, and it is uncertain whether they rode or ended up walking: "[Central Park in New York] is the most beautiful specimen of nature & art combined probably to be found any where in America. Smoothe gravel roads, Several large fountains with jets or perpendicular spouts and spreys in them. Large ponds or lakes with vessels to ride about in. Buildings in the hill sides for resting, playing, or eating in. Stone steps to ascend the hills. All kind of ever green & other trees, the grassy plats, lawns & hills kept low, smoothe[,] & green, a delightful & picturesque

scenery."[20] Central Park encompassed more grassy and open space at that time compared to now and attracted large numbers of genteel users (cf. fig. 4.5). Designed in 1858 by Frederick Law Olmsted (1827–1903) and Calvert Vaux (1824–95), the park was a broadly recognized masterpiece of nature and art, including the recently finished pond and scenically medievalizing Belvedere Castle, perhaps one of the "buildings in the hills sides" seen by the Shakers (fig. 4.6).[21]

Figure 4.6. Calvert Vaux and Jacob Wrey Mould, Belvedere Castle, 1865–69, New York, Central Park. (*Photo:* Tony Hisgett, CC BY 2.0.)

John M. Brown, of New Lebanon, visiting New York City with other Shakers in July 1866, liked Central Park and took the opportunity in his autobiographical notes to put his enjoyment in the context of Shaker theological thought. He stated that our first duty is to "beautify our souls by having the image of Christ formed in us, is our first duty, then to have all external things in Order, and beauty, as appendages, to the useful, the true & the good." He could justify

"merely gratifying the eye" by touring Central Park and "seeking pleasure on the natural plane" because the park offered another specimen of order and beauty in the world, although it was on a lesser plane than spiritual order: "The Central park is a pleasant promenade, and may serve as recreation for the Natural man, and a Substitute for what we experience on the Spiritual basis, but a poor apology." Noting the "small beautiful lake" and other features, Brown stated that:

> they have certainly shown great taste in beautifying that place, and it seems quite justifiable as a rendezvous for the pent up weary citizen, where they can relax, & recuperate. It is admirable to see Order, & System everywhere, and glad would I be to have more feeling of that sort amongst us, & thereby declaring to the world, that the God of Order, & Beauty, is indeed manifest among this His people; and that by our fruits we are known, as the living embodiment of all that is heavenly, pure, & angelic, on the earth. We love to see pretty places, they exert a good influence on the mind & feelings.[22]

Brown suggests that Shakers, the "zion travellers," see better than the world's people; the former do not merely have the "eye of the body gratified," but instead see the order and the beauty of a place like Central Park as at least a "poor substitute" for the "Spiritual basis" of their religion.[23]

Calvin Green, whose travels to New York have been briefly mentioned, was a traditional Shaker, among the first born into the faith, and he grew up during its formative years. Green lived in several Shaker communities, including, for the longest duration, New Lebanon. He wrote detailed and useful travel accounts during his life as a Shaker leader, writer, and proselytizer, including a journal of 1828 recording a visit to New York, Philadelphia, and elsewhere.[24] Green found much to be wanting in the city plan of Lower Manhattan (fig. 4.7), where the population at the time was concentrated. Shakers consistently liked orderly and planned towns and cities, with straight streets, a lot of greenery, cleanliness, and well-kept buildings, echoing aspects of their own villages. In that regard, his criticism is very much in the mainstream of Shaker thought. Yet it is also consistent with comments made by a broad range of visitors to American cities: it is remarkable how nineteenth-century travelers and diarists, whether American or foreign visitors, complained about American cities with tangled and narrow streets and liked those cities or areas of them with streets that were straight and preferably broad and tree lined.[25] For his part,

Green chimed in with that broadly held opinion, disliking the older streets, and favoring the "new part," certainly meaning the then more northern area near city hall, Broadway, and St. Paul's Chapel:

> The old part of the City [New York] is quite irregular being built by the range of Cowpaths—streets too narrow and buildings rather mean—not seeing only this part, much before I went to Philadelphia—I much preferred the latter—but after I came back and went over the new part saw its broad Streets and spacious squares and in many places rows, and even groves of trees, and well as splendid buildings—I confess upon the whole I was rather

Figure 4.7. John Bachmann (artist), Adam Weingartner (printer), and L. W. Schmidt (publisher), *The Empire City, Birdseye View of New-York and Environs,* 1855, lithograph printed in colors with hand coloring, 26¼ x 35¾ inches. (New York Public Library, Miriam and Ira D. Wallach Division of Art, Prints, and Photographs. *Photo:* NYPL.)

inclined to give the preference to NY—but the streets not running in straight lines with the cardinal points—will ever remain—blemish and inconvenience[.] Pha. [Philadelphia] is laid out in nearly regular squares . . . and all the streets run in nearly straight lines which add to its beauty [fig. 4.8].[26]

Green was not merely echoing secular preference for a classical order and enlightenment breadth and regularity: squared and orderly cities were more like Shaker villages and the holy order established there.

Like Green, other Shakers passed through Philadelphia, and there were many sights to see. Milton Robinson, a young Shaker from South Union, Kentucky, was unusual in that he was not on official business, such as helping establish or maintain other Shaker communities: he was inflicted with consumption (tuberculosis), and as an act of mercy and hoping for his recovery, the Shakers let him travel widely at sea and then on land. Sadly, he died on 19 October 1832 at the age of twenty-five. Not being a Shaker elite or theologian, he was perhaps less guarded than some Shaker journal keepers. It is illuminating to see him revel, in touristic fashion, in the world's beautiful and famous buildings and monuments. Robinson saw a large number of sites in Philadelphia, accompanied by a non-Shaker (Jonathan Swain), and he focused in his written account, as usual for a Shaker, on public monuments and places, avoiding visits to retail stores, interiors, galleries, and the like: "Jonathan Swain (Son of Sophia Swain) walked with me through the City showing me the Publick buildings of different kinds Such as the [lacuna] United States Bank[,] Independence Hall[,] Several splendid Churches[,] the Water Works" on the Schuylkill, and many other sites in his days in Philadelphia, including Benjamin Franklin's grave. Robinson must have meant the Second Bank of the United States (fig. 4.9), built after designs by William Strickland (1788–1854) in 1818–24 in a stark Greek Revival style, a building likely pleasing to a Shaker because of its lack of ornament; the bank is located near Independence Hall, which he also noted seeing.[27]

Tombstone and burial-ground tourism was not a significant part of Shaker visuality during travels, except for the site of Ann Lee's burial at Watervliet. Robinson's visit to the grave site of Benjamin Franklin was an unusual visit, or a rare acknowledgment of one, by a Shaker to the tomb site of one of the unsaved. Shakers sometimes visited the cemeteries of their own, as when Hiram Rude, from New Lebanon, saw in June 1856 a tombstone in White Water, Ohio, of Rufus Bishop and was pleased to see "Elder Rufuses grave

Figure 4.8. John Norman, *A Plan of the City of Philadelphia*, ca. 1777, woodcut, 7 x 6¾ inches, from *The Philadelphia almanack for the year 1778: Calculated for Pensylvania [sic] and the neighbouring parts: To which is added some useful tables* (Philadelphia, 1777), frontispiece. (Washington, D.C., Library of Congress, Geography and Map Division. *Photo:* Library of Congress.)

Figure 4.9. William Strickland, Second Bank of the United States, 1818–24, Philadelphia. (*Photo:* by the author.)

chiseled up with a nice stone at the head, and his name cut on it, and the grave[stone] nicely rounded up."[28] We saw in the first chapter that the grave site of Ann Lee was a frequent visiting site for Shakers, but they rarely mention seeing cemeteries in general or particular tombs of people of the world. The burial place for Franklin was no extravagance (fig. 4.10), however, marked by a simple slab on the ground at Christ Church and bearing only a minimal inscription (the names of Franklin and his wife, Deborah), all according well enough with Shaker values, as were Franklin's scientific interests; Milton Robinson could without shame mention his visit there in a journal meant to be read by other Shakers back home.

On that same day, 13 May, Robinson also enjoyed Philadelphia's "many beautiful squares ornamented with shade trees." There was a pattern of Shakers, who were coming from verdant, planned country villages, appreciating parks, green squares, and other integration of nature and art in American towns and cities. In another kind of visit, on 16 May 1831, Robinson went in Philadelphia to the navy yard, and "there I saw the Largest ship in the World called the

Pennsylvanian." Although the pacifist Shakers sometimes shook their heads at armies and forts, Robinson had no problem with the massive 140-gun USS *Pennsylvania* (fig. 4.11). The ship was laid down (commenced) in 1821, launched in 1837, and was largely constructed at the time of Robinson's visit. Elsewhere in the city, he admired the "Marine Hospital built of marble."[29] This was the Naval Asylum, designed by William Strickland and built 1826–33, a fireproof structure erected as a home for retired American navy sailors. The building was repurposed as a private residence at the end of the last millennium and still retains the Pennsylvania marble noticed by Robinson, another admiring mention by a Shaker of the extensive use of fine stone.[30]

We saw Hiram Rude and Hannah Agnew in New York City, starting from their home in New Lebanon, and they soon continued on to Philadelphia on their way to western Shaker communities. One day Rude went about the city with Brother William Reynolds of a western ministry (South Union, Kentucky). Rude and Reynolds on 30 May 1856 stood at the wharf on the Delaware River "with a fine view of the bay and other ship[p]ing." Next that

Figure 4.10. Unknown artist, *Franklin's Grave at Philadelphia*, ca. 1875, wood engraving, 4⁴⁄₁₀ x 5½ inches, from Edmund Ollier, *Cassell's Illustrated History of the United States of America* (London: Cassell, Petter, Galpin, 1874–77), 2:517.

U. S. SHIP OF THE LINE PENNSYLVANIA, 140 Guns.

LITH. & PUB. BY N.CURRIER, Entered according to Act of Congress in the year 1846 by N.Currier, in the Clerks Office of the District Court of the Southern District of N.Y. 152 NASSAU ST. COR. OF SPRUCE N.Y.
Tonnage 3100 – Length from Figurehead to Stern gallery 247 ft – Extreme breadth 85 ft – Height from bottom of Keel to top of rail amidships 54 ft – Total height from water line to main truck 239 ft – Draught of water 25 ft
404.

Figure 4.11. Nathaniel Currier (lithography and publisher), *U.S. Ship of the Line Pennsylvania, 140 Guns*, 1846 (published in New York), lithograph, and colored by hand, 14 x 10 inches. (Washington, D.C., Library of Congress, Prints and Photographs Division. *Photo:* Library of Congress.)

day was a trip to "Jeyards Colladge, and viewed the whole establishment," namely, Girard College, finished by 1848, a masterwork of Thomas Ustick Walter (1804–87) in the Greek Revival style and built with an abundance of costly Pennsylvania marble and other fine stone (fig. 4.12).[31] Girard College, a school for poor boys, was a couple of miles outside the city center, and the two Shakers made the commitment of time and effort to see it. Despite the eleemosynary purpose and humble clientele of the institution, the campus of five principal buildings was famed for its great expense (the staggering cost of $2 million), fundamentally Greek architectural style on the exteriors, and fine carved details, all funded by the bequest of merchant Stephen Girard (1750–1831), who at his death was perhaps the richest man in the United States. Despite being surrounded by splendor, Rude took the trouble to notice "old

Figure 4.12. Thomas Ustick Walter, Girard College, Founder's Hall, completed 1848, Philadelphia. (*Photo:* by the author.)

Figure 4.13. J. W. Hill and Benjamin F. Smith Jr.; lithography by Benjamin F. Smith Jr., printed in tints by F. Michelin, *Philadelphia from Girard College, 1850,* crayon lithograph, tinted with two stones, 23¼ x 39 inches. (Washington, D.C., Library of Congress, Prints and Photographs Division. *Photo:* Library of Congress.)

Figure 4.14. J. C. Armytage, engraver, after design of W. H. Bartlett, *Schuylkill Water Works*, 1839, steel engraving, with colors, 8 x 10 inches. (Washington, D.C., Library of Congress Prints and Photographs Division. *Photo:* Library of Congress.)

plates of earthen[ware]" and the flatware used for meals there, a rare mention in any Shaker document of actual tableware in use. After a thorough look inside, Rude and Reynolds "went out on the roof where we could overlook the city." This was a famous and well-visited prospect from the roof of Founder's Hall, with a distant but what Rude accurately called a "very extensive" view of the city of Philadelphia.[32] A lithograph from 1850 by Benjamin F. Smith shows visitors, like our Shakers, standing on the roof and looking toward the center of Philadelphia, the skyline punctuated by the steeples and smokestacks of Philadelphia (fig. 4.13).

Quite a few traveling Shakers took the trouble to see, and praise, the Fairmount Water Works. It had the right kind of combination of aspects for the Shakers: it was useful for the whole community of Philadelphia; it was a marvel of technology, with pumps and machinery inside on view to visitors; the riverfront buildings were in a chaste classical style (cf. fig. 4.14); and there was a large fountain in the South Garden, surrounded by greenery and formed of two marble basins and spectacular spouts, that caught the eye of more than one Shaker (fig. 4.15).[33] This fountain has been reconstructed in modern times very close to the original appearance and still serves as a focal point for the South Garden of the riverfront complex. Again, the combination of greenery and fine architecture in a clean setting was a winning combination for Shaker

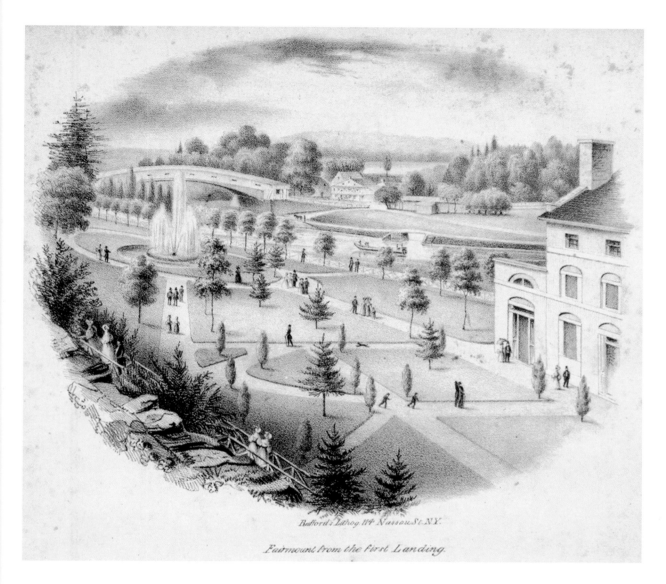

Bufford's Lithog. 114 Nassau St. N.Y.

Fairmount from the First Landing.

approval. Notable also is that the large fountain was purely ornamental and rimmed with fine stone; the Shakers liked it anyway.

These waterworks were mentioned only in passing by young Milton Robinson, as we saw, but other Shakers give more extensive accounts. The complex, first designed in 1812 and expanded in phases over the course of much of the nineteenth century, had several aspects that made it ideal for Shaker tourism: it comprised attractive buildings in a spare classical style; it

Figure 4.15. John Henry Bufford, *Fairmount from the First Landing*, 1836, lithograph, ca. 5 x 6 inches, top of the title page of John H. Hewitt, *The Fairmount Quadrilles, Selected and Arranged for the Pianoforte* (Philadelphia: John F. Nunns, 1836).

was free of charge and large parts were out-of-doors; it comprised viewable and admirable technology, set forth in an important early phase by engineer Frederick Graff (1775–1847), of carrying water up the hill to the reservoir (present-day site of the Philadelphia Museum of Art); it included a fountain and yard, the jets produced by water released from the reservoir overhead; and it was useful for the citizens of the city. Calvin Green was a leading figure in the Shaker society at New Lebanon, and he had praised the waterworks of Philadelphia on 12 May 1828: "Got to see the water works at the Schuylkill River, this is a wonderful work of art," and he liked its wholesomeness and usefulness for the local inhabitants.[34] Isaac Newton Youngs, traveling with Rufus Bishop in 1834, liked the waterworks and offered his own description, the best of them by a Shaker from the early nineteenth century, written for the edification of his Shaker readers back home. His account is enthusiastic and indicates his attention to detail:

> Here is an admirable display of neatness and elegance and mechanical performance enough to astonish the beholder. I saw wonders in plenty, the first is a beautiful fence enclosing a beautiful green, in the center of which is a large reservoir of water built circular of white marble, perhaps 50 feet [in] diameter just rising above ground[;] within this is another perhaps 3 feet high and long 25 feet diameter having a neat rim like [a] dish [?] and in this ther[e] are five pipes projecting above the water[;] these are spouters by which water is thrown up when they please many feet in the air to divert spectators and water the green & handsome shrubbery is growing round.

He did not call attention to the elegant female figure there, omitting any mention to his Shaker readers of William Rush's (1756–1833) wooden *Allegory of the Schuylkill (Nymph and Bittern)* that had been placed in 1829 at the center of the fountain.[35] Instead, he was enthusiastic about the engineering of the larger site, and he went on to describe at length the "astonishing" machinery underground at the works.[36] Youngs recognized the larger category of "beholders" and "spectators," grouping himself with them. Not stopping there in his tour of the city, Youngs saw the Mint on Chestnut and Juniper Street, where they "make money on a large scale and in fine style," the building itself being impressive, "150 square of elegant stone."[37] Thus, Young appreciated the "fine style" of the coins (a rare bit of praise by a Shaker for such a worldly and venal object) and the elegance of the building itself (under way by 1829 and

Figure 4.16. Unknown photographer, *The Old United States Mint* (Chestnut Street, Philadelphia), photograph, ca. 1900, from Moses King, *Philadelphia and Notable Philadelphians* (New York: Moses King, 1902), 260. (Mint designed by William Strickland, built 1829–33 and demolished 1902.)

standing until 1902), which was designed by William Strickland and sported a great hexastyle portico in the Ionic order (fig. 4.16).

Third in population among the great American cities, and along the way to and from some of the New England Shaker communities, Boston received a good number of Shaker visits, and one travel journal in particular by William Reynolds and Nancy E. Moore offered a number of instances of aesthetic appreciation of the city. Moore complained on 26 September 1854 that in Boston, "the streets run every point of the compass, in short they are <u>narrow crooked & irregular</u>."[38] That next morning, 27 September 1854, Moore went to the beach at Lynn, and some brethren, including Reynolds, it seems,

> went to see Bunker hill monument [fig. 4.17] which is situated on the top of the hill and is [number left blank] feet high, they went up to the top by a set of winding stairs which number 295 steps; Had a fine view of the city proper and also the environs. There we [*sic*;

Figure 4.17. Unknown photographer, *Bunker Hill Monument, Bunker Hill Day*, ca. 1890–1901, photograph, 8 x 10 inches (Detroit Publishing Company). (Washington, D.C., Library of Congress, Prints and Photographs Division. *Photo*: Library of Congress.)

meaning "they," "the men"] saw two of the four cannon which con-stituted all of the ordinance of the colonies at the commencement of the Revolution. These cannon are both styled the Hancock. One of them was bursted or had a piece broken out of it. We [from both groups] were all very tired when we returned to the Tavern.[39]

Significant here is that there was no antiwar sentiment in discussing the American Revolution, the battle site, or the armaments.

After lunch they both toured the city of Boston and were gratified with what they saw. Again for a Shaker on tour, a Greek Revival building, Ammi Burnham Young's (1798–1874) Custom House (fig. 4.18), was a standout, with

Figure 4.18. Unknown photographer, a view of India Street and Ammi Burnham Young's Custom House, Boston, ca. 1850, photograph, 9½ x 12 inches. Custom House built in 1837–49. (Boston, Museum of Fine Arts. Photograph © 2019 Museum of Fine Arts, Boston.)

porticoes and a highly visible dome (completed by 1849, now altered), and stacks of coins that the Shakers, perhaps unexpectedly for us, found fascinating: "Next went to the custom house. It is built of Granite and is a stupenduous structure. [We] were conducted thro' the different apartments one after another. Then was shown the vault where was stored four and three quarter millions of dollars [of] gold. It was all arranged in quantities of from one thousand, to fifty thousand dollars." These Shakers seemed less impressed with older buildings, including Charles Bulfinch's state capitol and the Georgian-style house of John Hancock (1737–93): "Went to the top of the State house. It is an old building. There is a very high dome." The Shakers then enjoyed a prospect of the city from above.[40] They showed a sense of architectural history and progress when looking to the left of the state capitol building: "John Hancocks house is close by the State house. It is rather a humble building at the present day, but was in the days of the first proprieter considered a first class house. It is now occupied for Store house and is two stories, & built the old fashioned hip roof."[41]

Thomas Damon, of the Hancock Ministry, traveling with a group of Shakers from Enfield, Connecticut, enjoyed his trip to Boston. They began at the area around Faneuil Hall, and he mentioned two Greek Revival masterworks: the extant and still popular destination of the Quincy Market (1824–26), designed by Alexander Parris (1780–1852), and Young's custom house again: "We strolled about the City through the New Market [Quincy Market][,] the Custom House[,] which cost over a Million [dollars] down to the wharf where we had a fine view of the shipping, Castle Island, &c." Then he described the "Common [fig. 4.19][,] which is very tastefully laid out & in the middle is a beautiful pond kept up by a fountain." Next was the statehouse of Bulfinch (visible in fig. 4.19), where he climbed up for a "fine view" and saw the granite reservoir nearby. At the statehouse, "In the basement room we were politely shown Audobon's magnificent work on American Birds. The Secretary of the Board of Education—[lacuna in the original] Sears was very courtious," a rare instance of Shakers viewing and noting their having seen two-dimensional art on their travels.[42] The Shaker strictures against visiting a museum were obviated by the location being a public building and not a gallery of art, and that he said they were "politely" shown John James Audubon's works suggests that the unnamed tour leader proposed the viewing and the Shakers went along with it. For her part, Susan Ann Lewis walked around the Boston Common in 1849 and was impressed by the size: "Walked around some—saw

the Boston common, 40 acres square a complete place for all the shakers on earth to have a meeting."[43]

A group of Shakers from Watervliet visited Boston in 1847. Unlike some official missions by elders or a ministry, this was a group selected as a kind of special occasion: "There was liberty from the Ministry for a load of Brethren & Sisters from the Second Family [at Watervliet] to visit some of the Eastern Believers, consequently, six of us were selected."[44] While their primary goal was to study other Shaker societies and visit with other believers, they took the opportunity, as was usual in Shaker travels, to tour and see curious or interesting sites of the world, and they were happy and honored to be able to travel. On 9 June 1847, they were at Bunker Hill (fig. 4.17):

Went up on Bunker Hill, saw the great Monument, a beautiful & splended peice of workmanship, in commemoration of the perilous times that 'tried men's souls.' I will here give a brief description of this wonderful work of art. It is built on a high spot of ground upwards of 60 feet above the level of the sea & sloping off handsomely in every

Figure 4.19. Edwin Whitefield (design), John Henry Bufford (lithography), published by P. R. Stewart and Company, *View of the Public Garden & Boston Common. From Arlington St.*, 1865, three-color lithograph, 21¾ x 33¹¹⁄₁₆ inches. (New Haven, Connecticut, Yale University Art Gallery, Mabel Brady Garvan Collection. *Photo:* Yale University Art Gallery.)

direction.—The first corner stone was laid on the 17th of June 1825, by our dearly beloved Brother La Fayette. . . . this monument is built of hewn granite stone, it is about 30 feet square at the base, or bottom, and 15 feet square at the top, rising into the air 22 feet. . . . In the inside there is a flight of stairs where people can go up to the top, by paying 12 ½ cents, where can be had a very extensive view of the surrounding country, & the Ocean, but we did not go up, any of us. It is surrounded by a beautiful white picket fence, enclosing several acres of land, green grass, adorned with handsome gravel walks, in various directions. On the whole it is a beautiful sight.[45]

This passage has a number of notable elements. One is the apparent sympathy with the American Revolution and the calling of the Marquis de Lafayette "dearly beloved." It seems that the spirit of the place had an unexpectedly patriotic effect on these Shakers. It is noteworthy that the writer went out of his or her way to say, "we did not go up, any of us," lest the elders and others reading would think they had wasted their money in entering something like a ticketed museum site, even though they had only good things to say about the idea of a distant prospect. At any rate, this was again an ideal combination of elements for Shaker appreciation: simple, abstract, and geometric style of the great obelisk (finished just five years before the Shaker visit); the centerpiece well laid out with the hill and fence defining it; and the monument providing a superb, distant view.

We have looked so far at Shakers in New York, Philadelphia, and Boston, but they traveled far across America and left opinions about material culture in towns and cities across the nation. Remarkably, the Shakers rarely passed through a town without liking it. They complained at times of tangles of streets or unclean conditions, but it is striking how much they enjoyed seeing the towns and cities of America and the buildings, squares, and parks there. They favored regularity and greenery, and these were easier to achieve in the smaller towns or newer cities away from the Eastern Seaboard. Sarah Ann Lewis, coming from New Lebanon in 1848 and visiting seven Shaker communities, thought that Westfield, Massachusetts, was "a butiful place."[46] Thomas Damon wrote in 1850 that "Standish [Maine] is a handsome thriving place."[47] Freegift Wells liked the town of Salina, then near Syracuse and now incorporated into it: "The road is level & handsome, on this road is an elegant Court house & a jail. The village of Celina [Salina] is handsomely built, Houses spacious & grand."[48] Prudence Morrell and Eliza Sharp trav-

Figure 4.20. W. H. Morse (design) and John Douglas Woodward (engraving), "Main Street, Buffalo, from St. Paul's Church," 1872, steel engraving, 9 x 6⅛ inches, published in *Picturesque America; or, The Land We Live In*, 2 vols., edited by William Cullen Bryant (New York: D. Appleton, 1872–74), vol. 1 (1872), opposite 512.

eled from New Lebanon to the western societies, and Morrell, keeper of the journal, opined in 1847 that Harrodsburg, Kentucky, had "some very elegant buildings."[49] In 1856 Hiram Rude praised Buffalo (fig. 4.20), "with its long warfs, and splended buildings, and tow[er]ing steeples."[50] Henry C. Blinn

of Canterbury, New Hampshire, thought that Bellows Falls, Vermont, was "a beautiful little village."[51] Calvin Green looked carefully when traveling and rendered terse judgment in 1828: Burlington, New Jersey, although it was "handsomely situated on rising ground," contained "not very noble buildings," while Washington, New Jersey, was a "small dirty village with only a few mean Buildings," and Bristol, Pennsylvania, was "a pretty large handsome village."[52] Seth Youngs Wells thought Liverpool, New York, in 1832 to be a "handsome village."[53] Hannah Agnew, on the way east toward New Lebanon in 1836, wrote on the Erie Canal that we "are passing Utica, a very splendid City."[54] For his part, Thomas Hammond Jr. praised Manchester, New Hampshire, on 9 June 1851, saying "Manchester is a very pretty place," and another Shaker traveler, Deborah Robinson, called it a "magnificent place grown up in the short space of 12 years."[55] Prudence Morrell wrote that "Cleveland [Ohio] is a handsome place but sandy soil."[56] Henry C. Blinn praised the "beautiful" and "handsome" dwellings in Albany, noting also that some buildings were old and decayed, but he left aside the usual criticism of the old step-gabled Dutch buildings that one typically found even in curt summaries of Albany's architecture in travel accounts by the world.[57]

The Shakers liked to compare one place to another, indicating a kind of connoisseurial sense of things, as we saw with comparison of New York and Philadelphia. Seth Youngs Wells, visiting Portsmouth, New Hampshire, on 20 August 1822, wrote: "The town of Portsmouth is large and beautiful, well built and clean, far exceeding that of Portland [Maine] or any other town that I have seen yet. . . . We made some stop at Haverhill on the Merrimack—which is a considerable village, in which are some very elegant houses & many stores." As part of the same journey, Wells (30 September 1822) was in Leicester, Massachusetts, "a fine town on the top of a hill."[58] New Lebanon Shaker Hiram Rude thought Cincinnati in July 1856 not as large as Philadelphia, but "the streets of Cincinnati are much more regular than any of our eastern cityes Philadelphia not excepted." As usual for the Shakers, Rude went to the roof of a tallish building for a prospect and was happy that he had a good view across the river of Newport, Kentucky, as well. Rude also compared Dayton, Ohio, favorably to other towns in America: "We soon arr[i]ve at Dayton. Now I must own that, if there is any beauty attached to a wicked city, it is at Dayton. We make but a short stay here: only enough to see the order and neetness of the place. The streets are kept very clean & they run at right a[n]gles with each other[.] the buildings were very nice, for the reason that there is no need to build in a three corner form as is common in the country, where the streets

run in any direction." He had similar ideas about Cleveland, where his time on 10 July was "mainly spent" looking at the arrangement of streets and order of the city. He compared it to Dayton and eastern cities, saying that "the streets and order of the city, which is built in the same manner of Dayton[,] the streets broad and ru[n]ning at right angles and kept quite neet and clean. Which makes them far excell our cities in the east."[59] Rude also liked the upscale outskirts of the city of Cleveland (cf. fig. 4.21): "We come in to the subberbs [of Cleveland] where the road is richly spread along with what is called jentleman's country seats with beautiful shade trees and other nice fixtures about them; in the whole it is a grand place."[60] There were still more high marks for Cleveland from Freegift Wells, who referred to the "handsome & thriving village, or City of Cleveland."[61]

A trip on the Erie Canal was a naturally scenic and extended opportunity for viewing New York State's villages and the landscape between, and a good deal of American artmaking captured the beauty of the canal and the townscapes and geographies through which it passed.[62] Freegift Wells, a Shaker from

Figure 4.21. A. C. Warren (design), Robert Hinshelwood (engraving), *City of Cleveland from Reservoir Walk*, 1872, steel engraving, 5¼ x 9 inches, published in *Picturesque America; or, The Land We Live In*, 2 vols., edited by William Cullen Bryant (New York: D. Appleton, 1872–74), vol. 1 (1872), opposite 529.

Figure 4.22. Edward Lamson Henry, *Before the Days of Rapid Transit (a Packet Boat on the Erie Canal)*, ca. 1900, pencil and watercolor on paper, 13¾ x 34¾ inches. (Albany Institute of History and Art. *Photo:* Albany Institute of History and Art.)

Watervliet, traveled on the Erie Canal on the way to Sodus, New York, which is on Lake Ontario. In one day, 17 June 1834, as if creating a slowly unscrolling panoramic painting, Wells maintained a remarkable and sustained account of what he saw, keeping a constant written account of his surroundings, while turning left and right, forward and back. He described himself to his Shaker readers as holding an umbrella over his head as he wrote: "It has just commenced raining & I am standing on the upper [deck] holding my pencil & umbrella with one hand & arm & my book in the other hand." He stated that he was reluctant to leave the open air. These were live shots, as it were, written en plein air and from life, not from memory. A nostalgic watercolor painting by Edward Lamson Henry (1841–1919), *Before the Days of Rapid Transit (a Packet Boat on the Erie Canal)*, ca. 1900, suggests how a viewing point on a boat on the Erie Canal might have looked for Wells (fig. 4.22).[63]

In addition to other specificities, Freegift interspersed his account with frequent notices of the time of day, and he provided a record of the miles traveled, giving an exact sense to the reader of the intervals of time and space. He liked and described the landscape, but he especially kept his eyes open for towns and buildings, and he made useful and critical comments. Of Frankfort Village in New York, he wrote, "Frankfort Village, of a considerable size but not compact. There is one handsome Meeting House and a considerable number of handsome new buildings." Wells seems not to have appreciated urban sprawl, and he felt a contrast with the tightly arranged Shaker villages. He was accepting of new styles, accepting of the architecture of that non-Shaker

church. Then, "3 miles from Utica we pass York Ville[,] a small but handsome village," and as the boat floated on even closer to Yorkville: "We are now in full view of the village, & it looks elegantly, the buildings being all painted white, &c." This last comment is unexpected, since the Shakers generally painted their village buildings different colors or kept some utilitarian buildings natural wood. Then, still on the same voyage and the same manuscript pages, they went on to "Whitesborough, nothing grand or inviting here except a fountain of watter brought in an aqueduct where the Boats stop & take in their supply, a fountain like this looks well in any place." Wells was sometimes sorry for his readers when he was floating between villages or farms and apologized at one point that "we have just been passing a dreary woods, having a steep hill on the left & de[s]cending on the right, here there is neither buildings nor fields to be seen," and finding near Oriskany, New York, "handsome farms on the left & dismal woods on the right." All of this and much more forms just a part of his account for the seventeenth of June, with Wells jotting away and creating his vivid and time-based picture as if he were the narrator or "delineator" of a moving panorama, which were so popular in the period.[64]

So far, we have seen largely positive responses by Shakers to the visual appearance of American cities and towns. Like others, though, Shakers lamented the appearance of cities besmirched by smoke that came from the burning of coal. As we saw earlier, in shaping and maintaining their communities, Shakers despised dust, dirt, and other filth. Out in the world, Freegift Wells wrote on 23 April 1836 of the negative appearance of smog and darkness of surface from coal in Pittsburgh and elsewhere where large-scale burning of it was the practice: "It is wonderful to see the blackness & darkness that pervades these Cities & Villages, whose only fuel for their fires are coal dug out the big hills. I think I never saw the smoke of tar or fat pine equal it in density. And such a blackness, issuing from every chimney in the village & setling down upon all the buildings & on every thing that is not enclosed in buildings, causes a very disagreeable appearance as well as smell. . . . I shall number Pittsburg & Wheeling with those places in which I have no desire to live."[65] Similarly, on the way west toward Pittsburgh in June 1862, Giles B. Avery saw "luxuriant crops" and "the prettiest region of country I ever saw universally beautiful and sublime in scenery," but Pittsburgh did not fare as well in his opinion. Although it is surrounded by "romantic scenery" and "novelties" for the eye, he wrote of it, "Pittsburg, the smutty city, where every person and every house, and even white paint, is black." Still, Avery went up to a tall building for a "birds eye view."[66] Shakers Wells and Avery were echoing the poor

critical response that Pittsburgh received from American travelers in general. For example, Captain Willard Glazier (1841–1905), from New York State, noted in 1886 that "in truth, Pittsburg is a smoky, dismal city, at her best. At her worst, nothing darker, dingier, or more dispiriting can be imagined."[67] The Shakers lived in rural villages with pure air, and the contrast was stark. They usually drew no moral conclusions about the dirt or smog of a city (for example, sooty surfaces as symbolic of sin or ethical darkness), but one document from the end of the period we are considering, an account by Henry C. Blinn on 23 May 1873, adumbrated a moral element in the culture of petroleum and coal: "Chillicothe is a beautiful city, in Ohio. . . . It is considered to be one of the finest farming regions in the United States. Petroleum wells and coal mines abound in this part of the country. From appearance they might well belong to the regions of blackness, if not to despair."[68]

We have seen some Shaker interest in individual buildings in the major cities; this kind of focus was manifested in the smaller cities and towns, as well. Again, the sites that elicited Shaker aesthetic appreciation were much broader in range, and often fancier or more luxurious in style and materials, than what we might have guessed from looking only at their own village building styles.

In an early Shaker instance of appreciation of classical style in architecture, on 26 June 1823 Seth Youngs Wells wrote of the granite statehouse (Stuart James Park, architect [1773–1859]) in Concord, New Hampshire, built 1816–19 in a rich style that, with its balustrades, superimposed orders on the temple front, tympanum sculpture, and tall cupola with golden dome could be called "showy," as he put it (fig. 4.23). Wells characterized it as an "elegant and showy building of hewn stone of the white granite kind, with an interior yard in front, between the buildings and the street, surround[ed] with a fence of cast iron, with stone posts & sills, built upon a foundation of stone. The lot on which the building stands contains about 2 acres of land enclosed as a yard & sur[r]ound[ed] by a walk on each side of white hewn stone about 5 feet high. The whole makes a showy appearance."[69] Here, already in the first quarter of the nineteenth century, is a Shaker interest in the siting of a building and the arrangement and adornment of the grounds around it. Wells seems concerned that the building is flashy and pretentious, but most Shaker criticism after 1823 became more accepting of classical buildings by the world, partly because the Greek Revival manner became comparatively sparer than this incipient specimen of it, and thus more to Shaker taste, and partly because, as we are seeing in the documents, Shakers became more appreciative over

time of the world's material culture, even when fine details, gilding, and other niceties were present.

Harvard Shaker Thomas Hammond Jr., who was a wheelwright and mechanic and interested in the techniques of building, was in Maine and went out after breakfast one day in 1839 and "walked down to Portland Exchange, a spacious stone building, of hewn stone, & round stone pillars, fluted. . . . [Inside] there is some lathing done & some plastering. . . . The large hall is very spacious. The round top [dome] they are covering with copper."[70] Hammond had seen the heavy and imposing Greek Revival Merchants' Exchange of Portland by Massachusetts architect Richard Bond (1798–1861), built ca. 1835–39. The stonework and the low-slung dome were captured in a daguerreotype of 1846, before the building was destroyed by fire in 1854 (fig. 4.24).[71] Hammond seemed impressed that copper was to be applied to the dome, another Shaker appreciation of fancy materials and surfaces, and he was interested in the progress of the lathing and plastering in the interior. Elsewhere in his journal, Hammond recorded that he visited Worcester, Massachusetts, and "saw the new courthouse and other splendid buildings as we move along."[72] Hammond seems to have seen the splendid granite courthouse of Ammi Burnham Young (built 1843–45), which is extant but altered.[73] On the road to Tyringham on 22 September 1846, Hammond stayed at a hotel, the Delevan House in Westfield,

Figure 4.23. Stuart James Park, statehouse, 1814–19. Concord, New Hampshire, unsigned engraving (2½ x 4 inches) in George Ripley and Charles A. Dana, eds., *The American Cyclopedia* (New York: D. Appleton, 1874), 5:205.

Figure 4.24. Unknown photographer, Portland Merchants' Exchange, north side of Middle Street, between Exchange and Market Streets, Portland, Maine, ca. 1846, daguerreotype, 5 x 7 inches. (Washington, D.C., Historic American Buildings Survey, Library of Congress, Prints and Photographs Division. *Photo*: Library of Congress.)

Massachusetts, "a large & elegant looking house," and the town itself he called "a large & handsome village."[74] Apart from showy buildings, Shakers also visited, and approved of, the simpler architecture of the churches of other sects. Rhoda Blake, of New Lebanon, wrote of seeing in 1854 an attractive church: "Went to North Adams, Massachusetts Saturday, and on Sunday held meeting in a Universalist meeting house. It was [a] neat, plain edifice, had a pulpit and small gallery, and was well carpeted."[75]

A Shaker traveler, Sister Naomi Legier (or Ligier) of Union Village, Ohio, touched on a number of visual issues in her account of a brief tour of Frankfort, the capital of Kentucky, including seeing a major public fountain and a prison while another Shaker went out and sold some oval boxes to the residents on

Figure 4.25. Unknown photographer, *The Arsenal, U. S. Armory, Springfield, Massachusetts*, ca. 1910–20, photograph (Detroit Publishing Company), 8 x 10 inches. (Washington, D.C., Library of Congress, Prints and Photographs Division. *Photo:* Library of Congress.)

18 April 1843: "Brother Lewis took some of his oval boxes up into the village, & sole [sold] a few. Elder Freegift & Elders Sally & the writer went up & saw the celebrated fountain in front of the State House. Also walked down & took a view of the Walls of the Penitentiary; and then returned to the boat." The old capitol building, still extant (under the aegis of the Kentucky Historical Society), is in a chaste Greek temple form. Designed by Gideon Shryock (1802–80), it opened in 1830 and was, as described, fronted by a now-lost fountain, elegant in style but modest in its height, spray, and width.

One would expect the extensive arsenal in Springfield, Massachusetts, to have been a target for Shaker pacifistic ire (fig. 4.25). In 1843 Henry Wadsworth Longfellow (1807–82) published a bitterly antiwar poem, "The

Arsenal at Springfield," after having visited and seen the "accursed instruments" of death being made there.[76] In 1873 Henry C. Blinn went there for an extended viewing of the largest arms-making factory in the United States. It was just eight years after the Civil War ended, and he had every opportunity to denounce the military institution, but instead he was dazzled by the beauty of the place, the ornament, and the technological features: "The buildings are of brick, and arranged around a fine square of 20 acres." Describing his tour, he noted:

> In another building we entered the engine room. The engineer was equally as conversant as the one we had just left. This room was kept very neat. We presume that another like this for beauty & ornament would be hard to find. . . . The rough iron work was ornamentally painted, as the wealthy only can paint. The polished iron was kept in the best manner, while the brass work shone with the bril[l]iancy of burnished gold. . . . Beautifully framed pictures hung from the walls of this room. . . . Several small cabinets of curiosities were arranged around the room. . . . [W]e stood for several minutes admiring some choice specimens of stuffed birds.[77]

Then, "leaving the building we spend a few minutes in admiring the order and neatness of the walls and gardens." He liked the whole area, writing that the Connecticut River Valley near Enfield, Connecticut, was fertile like the Garden of Eden.[78] The document falls to 1873, somewhat late for our consideration, but Blinn was born in 1824, and he thus was of an older generation of Shakers, so it is noteworthy that he enjoyed the framed and hung pictures, brass work that shone like gold, and the museological display of stuffed birds. He talked to the engineer, and the mechanical aspects of the place thus had a role in his visit. Blinn liked the decorated interior and the orderly exterior grounds; views of the complex from near and after the time of Blinn's show that the complex was a campus of regularity, with arranged buildings, lawns, and other greenery, almost guaranteed to appeal to a Shaker (fig. 4.25).

Shakers regularly liked the parks and other landscape design by non-Shakers. The subject of landscape and nature was treated in chapter 2 here, but we might mention a few of the world's private gardens that, like Central Park described above and at the start of the chapter, were shaped by the hand of man and admired by Shakers. Deborah Robinson wrote, "From here [stay-

Figure 4.26. Burial mound, Adena culture, ca. 100 B.C.–A.D. 100, formerly on Dublin Road, described as south of Upper Arlington, Ohio, photograph (2½ x 4½ inches) from the section "The Work of the Mound Builders," in the *Norwester* (November 1918), 19; the text of the 1918 article was excerpted from E. O. Randall, "The Mount Builders," in *Ohio History Sketches*, edited by F. B. Pearson and J. D. Harlor (Columbus, OH: Fred. J. Heer, 1903), 1–11.

ing near the sea at Lynn, Massachusetts, at Nahant] went to a man's house by the name of Tudor. Took a walk in his garden, where was cultivated in high style the various kinds of fruit, Flowers and herbs, with many things in a green House."[79] Thomas Damon, of the Hancock Ministry and traveling in 1850 with a group of Shakers from Enfield, Connecticut, gave a similar account for the same visit to Nahant: "Walked through Tudor's splendid Garden of choice fruit trees & flowers, various kinds of apple, pear, plum, cherry & peach trained horizontally made a fine appearance, many of which were in full bearing."[80]

Shapings of nature that fascinated the Shakers were the Indian burial mounds they saw in Ohio and Kentucky (cf. fig. 4.26). Even early on, we have detailed accounts of what Shakers saw.[81] In Ohio in March 1807, Benjamin S. Youngs of Watervliet wrote:

We passed over large upland plains on which were extensive entrenchments & all the evident marks that the country was once inhabited by a great warlike people whose name like like [*sic*] Amalek is now out of remembrance & blotted out from under heaven. In the midst of these plains were artificial mountains or hills called mounds cast up by hands—one of these was about 180 yards in circumference & 35 feet high, said to contain the bones of those who are supposed to be slain in their ward. These mounds are covered with trees as large as any in the woods around them & shew it

impossible to form any calculation when, or by whom this country was once inhabited—all these mounds & the prospects around them are great marks of antiquity & are very striking to the eye.[82]

This is written with a sense of wonder at the passage of time and the obliteration of a people, but also with a then-commonplace misconception and prejudice that these were remnants of the material culture of warlike savages (the earthen mounds were not forts but were for burial and carried other symbolic meanings).

Three years later, in 1810, William Deming reported the appearance of the mounds to his readers as they had been described to him in Gasper, Kentucky, by a William Pittillo (also spelled by Deming as "Pittello"): "He informed me that he helped Remove the Stone from one of the Mounds which are so numerous & unaccountable Throughout the Western Country—This mound was in the form of a Cole pit arched over with Stone & then Covered over with earth—The human bones found in the inside were innumerable." Deming was aware of the burial aspects of the mounds, but again stated the belief, not accepted today, that these were forts of some kind. Deming noted of the banks: "These mounds generally Stand on Some level plain & many of them are Surrounded with artificial banks and trenches of various Extent & forms which appear to have been Calculated for Defense in war. Some of the Mounds are 30 feet high & 40 or 50 rods in Cercumference at the bottom & Covered with trees which look as antient as the Rest of the woods."[83] Whatever his interpretation, Deming was clearly fascinated by the form and noticed how the ancient mounds and old trees formed a unity in the natural setting.

Some decades later (1837), the observant and mobile Freegift Wells described the earthworks in southern Ohio, near the Scioto River:

> After breakfast we 3 Brethren walked up to the old, Aboriginal Forts, to view the work of art, perform'd by men whose geneology is now lost. It appears that these prodigious works were erected for a defence against an enemy. I say prodigious, because it appears so; to see such extraordinary embankments made (as we have no reason to doubt) without carriages, or iron tools. The embankment of the Circle Fort is nearly all dug down & carried away, & a considerable part of the old Fort is now covered with a village. The Court house stands exactly in the center, & is an eight square building. The Houses of the village stand in a circle, facing the court house, per-

haps 15 or 20rods distant. This leaves a large circle of level ground, with no building thereon excepting the Court House & that in the center. Beyond the circle Fort is a square one. The bank on the east & south is mostly standing, & is grown over with vine [?] & briars it is about 30 feet wide at the base, & 8 feet high.

Wells included two sketches, a circle, saying, "This fort appears to be 50 or 60 rods in Diameter," and in the square an inscription, "This is a sketch of the form of the two Forts, this appears to be 50 or 60 rods square."[84] The place was near an aqueduct over the Scioto River and appears to have been a part of the Portsmouth Earthworks of the Native American Hopewell culture near the confluence of the Ohio and Scioto Rivers.

For an account of a wooden Native American structure, there is a remarkable, early, and extensive Shaker description of an Indian "meetinghouse." After describing mounds in the area in 1807, as we just saw, Benjamin S. Youngs met with the Miami Indians, near Lebanon, Ohio. Youngs was traveling with David Darrow and Richard McNemar Sr. to advance Shaker communities in the West. He did complain, as might be expected for a Shaker, about gaudy American Indian body ornament: "We saw many heathenish & superstitious practices among them such as shaving part of their heads, painting their heads & faces with diverse colours—wearing feathers on the top of their heads—wearing tinkling ornaments of silver on their heads & garments, earrings & nose jewels & many other costly ornaments & idle practices of superstition—but not withstanding, such was truly the work of the spirit of God among them that these things were no obstruction to our feeling it."[85] As for the structure, a Shawnee house that was not normally shown to "white people" because "they would mock" it, Youngs wrote glowingly:

> We went in & viewed it & could not have felt more solemn in viewing throughout the temple of Solomon with all its magnificence & glory. It was 160 feet in length from East to West & 34 in bredth—this immense building was raised upon three rows of large hew'd posts set in the ground—the middle row contained ten posts elevated to a proper height to form the roof—large hew'd beams extending from post to post supporting the rafters which were also hew'd & neatly covered with lath & clapboards & the whole stockade round with split & hew'd plank set in the ground & extending upwards to the foot of the rafters—even the weight poles on the roof were neatly hew'd &

everything looked new & white—There were four doors to the house one at the middle of each end & one at the middle of each side & on each side of the house within were hew'd logs for seats from end to end—There was no floor laid in the house, but the ground was beaten hard & level as the floor of an house & every thing was very neat and clean & in good order. . . .

The whole order & appearance of things, but particularly the spirit we felt there, brought on our minds a very striking & solemn sence of what God was doing in the earth & the world knew it not—& although both ministers & people would come & see & hear yet they can neither discern nor comprehend it—but are all of them by these poor Shawneese both discerned and comprehended. . . . We now felt at liberty & beyond our expectations were fully satisfied in finding such a real work of God among a noble, likely & resolute people.[86]

This description contains a number of elements reflecting Shaker interests: a fascination with and acceptance of the style and the technical aspects of construction, as well as a reflection on the morality of the makers.

We have so far seen Shaker attitudes to town and cityscapes, individual buildings, and shaped landscape. They also had a visual interest in the very means of transport that took them across the nation, including trains, bridges, ships, and other transportation. Shakers liked machines and technology, and they found a certain beauty in the practical.

The speed of trains disturbed one's viewing, and at least a couple of Shakers, in addition to being struck by the visual qualities of locomotives, were displeased, as were many Americans, at how trains curtailed the viewing pleasure of travelers. James Fenimore Cooper noted that beautiful scenery when seen from a speeding railroad "will long be hopelessly looked for by him who flies through these scenes, which, like a picture placed in a false light, no longer reflects the genius and skill of the artist."[87] New Lebanon's Daniel Boler (1804–92), traveling with fellow Shakers to the western societies of believers, wrote in 1852, on a train from Albany to Rochester, New York, "[We] Speed our way with the firey horse (or Engine) at a furious rate thro' whirling fields, and forests (or seemingly so) passing thro' towns and Villages, with but a short glimpse of people, houses, bridges, canals, rivers, & lakes."[88] Similarly, the velocity and sound of trains were fearsome for Hiram Rude and disturbed his inspection of the Hudson Valley townscapes. Aboard on the way from Albany to New York, he wrote, "We hear the harsh sound of the whissle, while we go

fleeting along, and pass by 34 flourishing towns, and villages, of which I cannot give any account owing to our quick speed."[89]

Without being a passenger, a schoolteacher, Oliver Hampton, had a more positive attitude concerning the "sublime" appearance of a train in motion, which was the finest sight he had ever seen. Hampton, caretaker of the boys in the "centre or First Family" of Union Village, Ohio, took his charges on a field trip in October 1845: "Boys had a ride [in a cart] out to the Cincinnati & Lenia Railroad, where for the first time I ever saw a locomotive in operation propelling cars by steam and it seem'd to me to exhibit the most powerful[,] sublime & interesting spectacle of Human achievement & ingenuity, that my eyes ever beheld! indeed far surpassing any thing of the kind I had ever concieved of." After strolling, swimming, and seeing two more locomotives, the group of teacher and pupils walked a "considerable way" along the Little Miami River "to witness the 3 oclock train under a full headway with which we were at length gratified."[90]

A railroad bridge itself won the approval of Hiram Rude while on the way back from his trip to the western societies. He first started with his appreciation of Niagara Falls: "We are soon in the midst of stupenduous wonders[,] the gigantic streem passing over the huge rocks," which "pours over with one solid sheet with such tremendious force that the foundation of the earth trembles beneath the concussion." He then had a chance to view the famous Niagara Suspension Bridge: "the suspension bridge[,] the most stupendious piece of architector there is in this world[,] a wire bridge stretched across a gulf." Rude included in his account a clearly rendered drawing (fig. 4.27), perhaps influenced in design by some print he had seen.[91] The Niagara Falls Suspension Bridge project was initiated by Charles Ellet Jr. (1810–62) and the work completed in 1855, just before Rude's visit, following the design of engineer and builder John Augustus Roebling (1806–69), who would later design the Brooklyn Bridge.[92] The Niagara Falls Suspension Bridge, which spanned 825 feet, was demolished in 1897. Newly created at the time of Rude's visit, it was widely photographed, visited, and represented in artworks of the period, including a scenic and charming view by Currier and Ives (fig. 4.28). The bridge contained a level for trains (rare for the time) and another level for regular roadway and pedestrian traffic, suspended 240 feet above the level of Niagara River. It is extraordinary that Shaker Rude saw this as the most stupendous piece of architecture in the world; it seemed to put his humble village architecture in the shade, and it was rare for a Shaker to be moved (and able) to make a drawing of anything seen along the way on a journey. That the

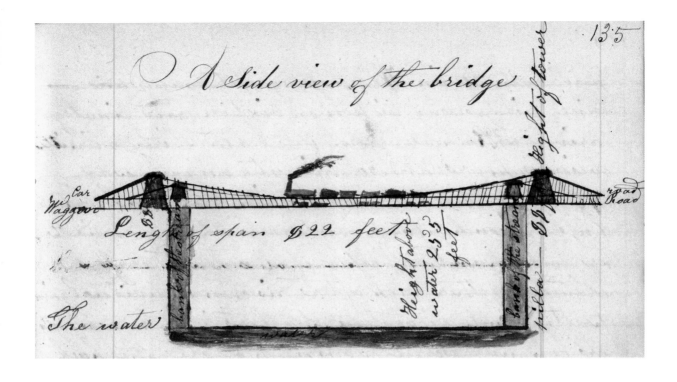

Figure 4.27. Hiram Rude, drawing of the Niagara Falls Suspension Bridge, mid-July 1856, pen and ink and watercolor on paper. (Cleveland, Ohio, Western Reserve Historical Society, Shaker Manuscripts, Series V, B-161, 135. *Photo:* WRHS.)

bridge was useful and clever in design is something that would have appealed to a Shaker, and the beauty, which also comes across in his drawing, formed but part of his interest.

Other Shakers wrote approvingly of the appearance of bridges, tunnels, and similar structures. On 19 November 1851, Freegift Wells saw a "handsome Bridge" near Bellows Falls, Vermont.[93] Some years earlier, Freegift Wells liked the architecture of tunnel nine hundred feet long in heading toward Johnstown, comparing it to high-style building facades in Albany for comparison with his Shaker readers in Watervliet and making a subtle distinction in the color of the stone: "Each end of this tunnel is built up in elegant stile, resembling in workmanship, some of the marble fronts in Albany, only the stone is rather more yellow." Later on during the trip, Wells described the "beautiful structure" of an aqueduct crossing the Conemaugh River with the same kind of yellowish stone he had mentioned earlier at the tunnel (26 April 1836).[94] Wells was a worker in wood (furniture and carpentry) and had a natural affinity for substances, style, materials, and coloration. Similar attitudes to the practical and beneficiary among building projects come

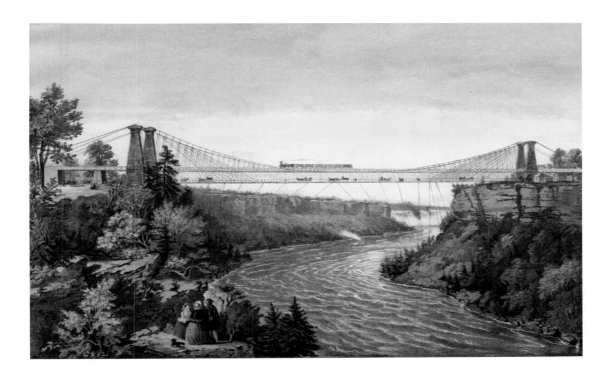

across in the account of Daniel Boler, in Rochester on 9 June 1852: "We saw much of the work of mens hands that was virtuous and good & a benifet to the public good."[95] He did not say what "work" he meant, but he was probably writing about roads, aqueducts, and bridges, and the complex of mills and other buildings near Genesee Falls might also have caught Boler's attention.

Shakers used sleighs regularly and had some community restrictions on how they could be adorned, but commenting on one made by the world and owned by the Shakers, Nancy E. Moore had no moral qualms about a charming sleigh of the ministry seen at Enfield, New Hampshire, and she was also impressed at the cost (21 September 1854): "The Ministry have a beautiful Sleigh covered and neatly finished. cost one-hundred & thirty dollars."[96] One imaginative reference to a carriage shows the Shaker sense of visuality and play. The comment was made by Prudence Morrell while traveling in Kentucky and after she and others were forced for a stretch to walk alongside the carriage on a rocky and bumpy stretch of road near South Union, Kentucky on 12 August 1847: "It was diverting to see the carriage totling about over the stumps & stones; it put me in mind of a mouse in the paws of a cat, cuffed about like a play-ball."[97]

Figure 4.28. After Charles Parsons ("C. Pasons, Del." [sic]), published by Nathaniel Currier and James Merritt Ives, *The Railroad Suspension Bridge, near Niagara Falls*, 1856, hand-colored lithograph, from two stones, 15½ x 10 inches. (Washington, D.C., Library of Congress, Prints and Photographs Division. *Photo:* Library of Congress.)

Turning now to floating vessels, it is apparent that Shakers were regularly fascinated by the beauty and technological aspects of boats. Except for the short-lived experiment at Sodus, New York, Shaker communities were away from the coasts of the Atlantic Ocean and the Great Lakes, and they did not have to build or own large vessels of their own. Naomi Legier, of Union Village, Ohio, took what she called "the elegant Steam Boat Vermillion" on her journey from Buffalo toward Detroit (1842).[98] Abigail Crossman admired a ship in Boston Harbor: "Have a view of a bea[u]tiful Ship nearly completed called the Anglo Saxton [sic]."[99] When Freegift Wells arrived in Sodus from Watervliet in 1834, he and another Shaker looked at ships with a telescope: "Br John borrowed a spy glass & we went upon a bluff west of the Light-house where there was nothing but water to be seen. . . . One Steam Boat & a schooner excepted."[100] We have seen how Milton Robinson noted the mighty warship USS *Pennsylvania* in Philadelphia. Farther on his voyage, he passed through Louisville, Kentucky, and on 14 March 1831 wrote, "Yesterday a new Steam Boat arrived in this Port called the Louisville. To say the least about her, she is truly a splendid Boat."[101] Sometimes sheer size and number caught the Shakers' attention, as with Freegift Wells in Boston on 4 December 1851: "I spent the most of the afternoon in travelling along the Wharves & viewing the Shipping[,] which was quite numerous, & some very large—one of 1600 tons."[102]

Despite the Millennial Laws or other discouragements against the practice, Shakers did sometimes enter ships for viewing pleasure and satisfying their curiosity, and we saw earlier how the rules, dictates, or guidelines from the Shaker leadership were frequently broken or bent, even near to the time of their promulgation. Nancy E. Moore and William Reynolds, and other Shakers, were in Boston on 27 September 1854 and "went to the Navy Yard where we saw two large three decker Ships of War & by the kindness of one of the Officers were conducted thro' a sloop of war newly built." The same afternoon they took a ferry boat to East Boston and, through the intercession of an acquaintance of a Shaker they knew, got to tour the inside of an unnamed "British steamer" going the next day to Liverpool, the engine having "760 horse power."[103] Of course, Shakers often boarded smaller boats for transportation and sometimes found pleasing style there. Freegift Wells, traveling from Ohio to Buffalo, wrote on 3 July 1855, "It is an elegant Boat, furnished in first rate stile." Wells pleased himself visually on the same trip with a visit on the side to Niagara Falls.[104]

Ships, bridges, and aqueducts represented a kind of vernacular construction, but were not the only vernacular architecture favored by the Shakers trav-

Figure 4.29. James C. Sidney and James Neff (surveyors), printed by Frederick Kuhl, "Lowell Co. Mills," detail from *Plan of the City of Lowell[,] Massachusetts* (Philadelphia: S. Moody, 1850), 33.5 x 36 inches. (Boston Public Library, Norman B. Leventhal Map Center Collection. *Photo:* BPL.)

eling through America. In addition to common village and town structures mentioned by Shakers here so far, they often singled out factories (cf. fig. 4.29) and other useful structures for praise. Many Shaker buildings were essentially factories or work buildings, and the simple form favored for utilitarian factories of the world appealed to the plain and neat sensibility of a Shaker. Abigail Crossman, traveling with a Shaker group from New Lebanon, liked the "splendid Cotton factories" at Waltham, Massachusetts.[105] Harvard Shaker Thomas Hammond Jr. was in Manchester, New Hampshire, on 9 June 1851 where he found "some very Stately & elegantly built factories."[106] Other Shakers, in 1846, admired the factories in Ware Village, Massachusetts: first they passed through Worcester, which they liked ("we move moderately along the street to notice the place[,] which is handsome and flourishing"), then on the road from Ware Village they viewed "splendid new stone factories—we pass along admiring the mills."[107] Yet there was always some resistance to the chaos and dirt of newly established factory towns; unconvinced about the beauty of Manchester, New Hampshire, was Canterbury Shaker John Kaime, who wrote in verses while traveling in 1847: "First, Manchester City / We pass'd by in pity."[108]

Shakers often came across other kinds of vernacular architecture and jotted down praise for what they saw. Passing through Andover, Massachusetts, in 1822, Seth Youngs Wells noted "many elegant houses are scattered over this town," but in addition to those undoubtedly genteel homes, he was also happy to see the workers' housing being built at "Chelmsford" (now Lowell) near "the

factory which is built at the falls of Concord river in this place near its confluence with the Merrimak," where a "whole street of houses is already erected," each house for two families. "The houses are finished off in style, painted white with two green doors in the front, both covered by one cap [door cap; canopy]." Worthy of note is that Wells believed these houses, painted white with green doors and not so different from many Shaker structures, were finished off "in style."[109] We have seen the Springfield arsenal before; it was also visited by a Shaker group in 1846, who also liked the town itself and found the street to be finely ornamented by the buildings lining it: "As we came to Springfield we saw the Arsenals belonging to government. We soon come down on Springfield street[,] which is uncommonly pleasant and finely ornamented." Later, in a nonvisual reference, they heard on 21 September 1846 at Westfield, Massachusetts, the "exhilerating sounds of a Piano most admirably played by a girl 11 years old."[110]

Calvin Green, Shaker leader, writer, and theologian, made the effort in 1828 to comment on (for him) unusual, rough surfaces seen in Germantown, Pennsylvania. He was fascinated by the houses, many of them stone, but also "some plastered then coarse gravel thrown on this gives them a curious appearance. . . . [T]hey are neat, but not splendid." These he found "neat," a flexible word here probably meaning well made. He was apparently looking for buildings that were splendid, but it is not surprising that an orderly Shaker did not like an irregular, pebbledash surface with gravel thrown broadly against it for decoration.[111] We might note here that, although they liked their own barns, Shakers could also find appeal in one most likely of non-Shaker origin. In his "journal" of the Shaker community at Canaan (New York), Elder Levi Shaw (1818–1908) noted in 1841 that two Shakers went to nearby Schenectady and brought back a dismantled barn that had been built earlier in Ohio: "John [Sidle] & James [Wilson] return home [from Schenectady] with their barn, 2 tons, which we pay 6 cents a pound for it, it was raised in the State of Ohio[;] it is [a] very bright & handsome barn."[112] Sometimes, the perception of vernacular architecture could be affected by its moral context. Abigail Crossman saw some cottages along the river near the fort at West Point in 1846 and seems to have wondered whether they served to support the military purpose of the place: "Small Cottages erected on the brink of the river for the accommodation of some one, either for a good, or bad purpose."[113]

Turning now to objects, including artworks, it was not customary for a Shaker to come across and comment on what we would call art, but there were a few instances of this. Sometimes chance encounters occurred, as with the

viewing in Boston of Audubon's *Birds of America*, as we saw earlier. Thomas Damon, who was skilled in working in wood and prone to want to see a fine wooden piece, liked a fancy parade "chariot." Damon, of the Hancock Ministry, went to Hartford in 1847 and chanced on a circus caravan: "Went to Hartford, purchased a few Joiners tools, saw a procession of carriages (about 30 in number) containing wild animals, preceeded [*sic*] by a gorgeous Roman Chariot, literally covered with gold drawn by ten black horses &c." It was one thing to see something in the world and another to have it, or imagine it, in use in a Shaker community, however "gorgeous."[114] Still, it is telling that a Shaker enjoyed this secular and flashy chariot and the exotic circus animals pulled behind it.

Apart from chance encounters, Shakers sometimes went into galleries or saw art collections. We have seen that the Millennial Laws of 1845 stated that "it is forbidden for Believers to go into museums, theaters, or to attend caravans or shows to gratify curiosity," but the regulations of 1860 dropped the phrase, and opposition seems to have waned in this regard. As time progressed, Shakers were more likely to be comfortable in visiting a museum display. One Shaker wrote in 1869 from Philadelphia, "Visited the Academy of natural sciences, consisting of all varieties of animals, fish, fowls & reptiles & insects &c. being stuffed skins, frames of bones, &c."[115] In the summer of 1863, Freegift Wells seems to have seen and enjoyed the equivalent of a cabinet of curiosities in a private home on Long Island, that of Ira Brewster Tuthill Jr. The owner had some marvelous seashells collected by his father-in-law, who was a sea captain, but Wells wrote, "In addition to shells there was a great variety of other curiosities of which I shall not attempt to give a description in writing," suggesting that he might tell the Shakers about these items orally upon his return to the society in Watervliet.[116] Shakers were probably better acquainted with art and art techniques than we suppose. One Shaker in 1847 mentioned the technique of "waxwork," which was a common manner of miniature portraits, reliefs, and free-standing smaller figures made with high detail, coloring, and the textural finish possible when working in wax. Visiting the Harvard, Massachusetts, society in 1847, a Shaker from Watervliet noted the following in a travel journal, adding an epicurean food sentiment, as well: "After partaking of an excellent dinner, served up in the first rate Shaker style, we went over to the new Office, viewed every room & closet, every thing appeared as neat as waxwork and in the best order."[117]

Much of the focus of modern Shaker studies has been on their furniture. They had little to say about their own familiar furniture, as we saw in the third

chapter, but sometimes passed judgment on furniture of the world. Shakers bought, and must have approved of, some furniture from the world, as when Rufus Bishop wrote on 2 September 1830 in New Lebanon: "Had a new table yesterday which Frederic got made in Albany for the use of our Shop—E. [ldress] Ruth paid $3.00 for for [sic] it."[118] Shakers were not manufacturing or producing maps and globes, and when Hervey Elkins saw these, approvingly, as adorning the schoolrooms of the Shaker youth, he was talking about the manufacture by the world for the Shakers. Elkins wrote, as we have seen, "The books were choice; and globes, celestial and terrestial [sic], maps and diagrams adorned the apartment."[119] Apart from objects and furniture at home compatible with their own style, when out and about Shakers sometimes saw, and seemed to appreciate, fine styles of the world. Freegift Wells, whom we saw visiting Long Island in September 1853, stayed at the house of a well-to-do, "fine old man," a non-Shaker, and noted the presence of "our rooms, & the beds which were in excellent stile and sweet."[120] On another trip (1861) to the same area of Cutchogue and New Suffolk, Long Island, Wells visited the home of an elderly man who had bought Wells's boyhood home, and he wrote to his Shaker companions at home: "The man who owns it is a Scotchman & he has been organizing the interior on quite a different plan from it was formerly; he has made two beautiful parlors, furnished in high stile."[121] Like the viewing of the "gorgeous" circus chariot by Thomas Damon, Wells could appreciate the world's furniture when it was seen and kept in its own context.

Shaker furniture, as has been noted, has something in common with Asian furniture, and in early-nineteenth-century America there was also a growing market for Chinese furniture; even the bed in Henry David Thoreau's cabin at Walden Pond started life as a Chinese chair, altered by him. There is a remarkable similarity between early-nineteenth-century Japanese and Chinese furniture and Shaker works, although not because there was necessarily an influence of Asian style on the Shakers, but rather because the Shakers also liked well-crafted and spare furniture styles.[122] At least one Shaker, Abigail Crossman, came across some Chinese furniture in a private home near Boston (the house of a man "named Bates"), and it caught her eye: the home "was fitted with Chinese furniture, such a Cupboards & chairs[.] they were made of Bamboo, Willow, & Rattan."[123] She seemed more interested in the material used than in the style itself. In another Shaker notice about similar materials used in a non-Western object, Harvard Shaker Thomas Hammond, Jr., while traveling in New York State in 1846, bought some Indian woven baskets to bring back to his community; he had met "an indian, his squaw, & a

boy lived in a little one roof [sic; room?] shanty, & make baskets. We have some baskets to bring home that were made by them."[124]

We can now turn to a consideration of some moral reactions to the world's creations. A review of Shaker opinions over the decades reveals far less ethical aversion than one might expect. Some of what we have seen so far, such as objection to swindlers and ill-bred carriage drivers in Manhattan, was aimed more at the people than at the material culture of the places themselves. Still, although relatively rare in Shaker writings, there were some Shaker comments on the follies and objectionable aspects of the world. Henry C. Blinn wrote about Williamstown, Massachusetts, in 1853: "The village is not large, yet handsomely laid out in streets & having neat houses and stores. . . . We drove along looking rather indifferently at the follies of this fanciful world, comforting ourselves with the assurance that we should ultimately reap the reward of our labors."[125] Daniel Boler found the thriving city of Buffalo to be a modern Babylon, like the sinful city of the Bible, with a chaos of buildings, people, and animals (fig. 4.20): "We found Buffalo to be another Babylonish City full of buildings, men, women, boys & girls, horses & waggons, dogs & hogs," and so forth.[126]

Some of the opposition to the world sprang in part from dislike or resentment of the wealthy class of owners. We saw earlier how one Shaker liked the gentlemen's houses in the hills of Cleveland (fig. 4.20), but Daniel Boler, on 17 June 1852, had moral qualms about the attempts by the pretentious wealthy to beautify their surroundings: "Cleveland is a very thriving place & beautifully situated with the large square in the Centre of the City covered with a beautiful growth of forest trees, the whole distance of about 3 miles above the city is very handsomely intercepted or interspersed with forest trees & other varieties. . . . [That area is] mostly the resort of some 'big bugs' of the City who have done their best to build up an earthly paradise, many splendid mansions are now built up with all the splendid adornings that mortal hands could impart."[127] Boler questioned wealthy citizens for building their splendid mansions, mockingly calling them the then current slang phrase of "big bugs." Isaac Newton Youngs felt the same as Boler about the pretensions of the rich. On a tour through Ohio and Kentucky, he acknowledged on 23 August 1834 that "Bolingreen is a tolerable descent-looking place with a good many pretty nice buildings. The nicest looking town we have seen in Ky.," but he wrote on 13 September 1834 that in Louisville, Kentucky, he "saw many fine buildings and elegant stations belonging to the rich people—Nabobs of Louisville who doubtless felt mighty big & grand."[128]

Resentment of the rich and dislike of the size of their dwellings can be found early in Shaker publications. In the *Testimonies* of 1816, under the category of "Remarkable Instances of the Judgments of God upon Reprobates and Persecutors," presumably referring to an anti-Shaker at Petersham, Massachusetts: "Doctor _____ Bridge [lacuna in original] undertook to build a large house, and having got the frame up, there came a violent whirlwind, and rent it from the foundation. . . . The Doctor, soon after, became a drunkard and died in poverty."[129] Shakers often accepted class differences, for the most part, and usually did not begrudge elegant houses, as we have seen, but they made an exception if the builder opposed them, such as the doctor from Petersham. In another antigenteel comment, although Benjamin Seth Youngs, in 1805, worried during his travels that a plain house might not be a civil house, he was also disturbed to have eaten in Edmunson with some young men in a fine setting and would have preferred a lowly cottage and humbler fare. Reflecting recurrent Shaker feelings toward the wealthy elite, he opined "To have Eat[en] a crust of Bread in a cottage with plain and decent People would have been abundantly more our faith and feelings."[130] As time passed, and with perhaps less effacement of the self, and more romantic admiration of the accomplishment of individuals, there developed less concern about "big bugs" and more admiration of American heroes or leading thinkers and scientists, an attitude more consonant with mainstream nineteenth-century attitudes. We have seen Milton Robinson's visit to Benjamin Franklin's grave in Philadelphia, for example. In 1869 some Shakers sailed up the Hudson and were happy to see the homes of the famous of the world, in particular that of Washington Irving (1783–1859) (Sunnyside in Tarrytown, New York) and George Washington's headquarters and residence in Newburgh.[131] These were less comments on a fine tombstone or architectural splendor than expressions of interest in the personhoods of a scientist, leader, and writer.

Shakers often liked the genteel houses and interiors of the world and frequently praised ornate and pretentious public buildings. We might expect that a Shaker apostate like Hervey Elkins, who had lived in Enfield, New Hampshire, would come down on the side of the world and be more accepting of fashionable mores than the Shakers he abandoned. But Elkins, who when he left the Shakers immediately saw the world to satisfy his curiosity, left behind a nuanced, detailed, and morally scathing reading of the world's sites and institutions. He had a pent-up need to see the world: "I traveled through several sections of New England, with no other motive than to gratify a thirst for novelty."[132] He wrote with the sensibility of a Shaker, and his testimony is

invaluable because of its detail and his lucid writing style. He concludes that, although he has left the Shakers, he "cannot join in that cry of objurgation, and opprobrium, which many have raised against the Institution [of Shakerism]" because he had seen how "cupidity, fraud, theft, lying, and all kinds of meanness, bear down and trample upon unfortunate virtue, modesty, intelligence and grace," such as he knew as a Shaker. He was used to trim and tidy Shaker buildings, but, in the world at large, he "entered your huts, your hovels, and your dilapidated houses," and "the hideous and repulsive spectacle of poverty, or wretchedness, of filth, of haggard misery and disease, which I beheld in some of these, sent a thrill of unutterable horror through my bosom." He morally objected to the waste on gaudy artifacts sold to New England farmers. Recently a Shaker and not having been acquainted with new consumer wares that imitated better goods, he was disgusted at what he saw: "I entered your farm-houses; where industry was rewarded with competence, and where a little surplus of money was afforded the girls and boys, to buy a tinsel and cheap imitation of the costlier gew-gaws worn in the cities. One young gentleman had purchased, of a pedlar, for five dollars, a ring for a favorite lady, which of course he thought to be gold and garnished with a diamond; an article which the pedlar, afterward, averred, cost him five cents, and five cents only."[133]

Elkins felt no better in the marketplaces themselves viewing the wares of the world sold in New England:

> I entered your villages, and your nascent cities. I examined therein articles set out for the gaze of an unwary purchaser. Jenny Lind, Kossuth, Congress, German, French, Turkish, Persian and Cashmere articles, manufactured in Massachusetts, or Connecticut, were heaped in profusion on the side-walks. There were bonnets and hats, manufactured from straw, said to have been grown in India; but which were probably made from an inferior rye straw, grown on Cape Cod; colored glass, set in gilded tinsel, sold at exorbitant prices for precious gems; paste-board hats, covered with a glossily napped cotton for the genuine beavers; galvanized watches, warranted to be pure gold, for only one hundred dollars.[134]

Elkins's account reaches a moral climax in his discussion of the wealthy: "I entered there your palaces; where *atriums* of soft verdure, surrounded by railings of bronze, led up to marble steps, ornamented with statues and sculpture. . . . Plate of the precious metals, marble, bronzes, tapestry of velvet and

embroidered satin, Asiatic carpets, sofas, divans, costly wood, mirrors, statues and pictures, made them seem to me the palaces of kings. And certain it was an attempt to imitate, in a land of democracy, that feudal materialism which has abused power, trampled upon the rights of man and created a people of serfs."[135] This idea exemplifies Shaker thought, but was also a long-established secular one. John Adams and George Washington, a great number of preachers, and others in the Anglo-American world had long warned that fancy goods could undermine good morals and democracy and turn Americans into slaves in the continental European or Asiatic fashion. To that view, Elkins brought the piquancy of the antiluxury believers with whom he shared fifteen years of his life, but his attitude was shared by a number of other Americans.

Shakers had some contact with Roman Catholic churches and their style of decoration, which was typically more ornate than that usually found in Protestant churches, let alone the starker meetinghouses of the Shaker communities. The Catholic services themselves were less exciting for Shakers than their own dance- and song-filled meeting. A group of western Shakers went to a Catholic Mass in Manhattan on 13 June 1869 and were unimpressed. Some of the group went to Brooklyn for a personal visit, while "the rest of us went to a Catholic meeting. A dry concern."[136] Beyond such a terse assessment, and directly addressing the issues of decoration, Calvin Green left a lengthy account of his visit to a Roman Catholic church in Manhattan in 1828. He already came to New York with a poor assessment of the morals of the inhabitants (8 May 1828): "I land in this famed City, find this part of it, rather a dirty nasty place on out side and I am sure more so inside." He was also put off by the presence of the military forts in New York Harbor (10 May 1828), "monuments of human pride, ambition and consumate folly," but, also in looking around the harbor, he liked the house of the former governor and recent vice president: "Governor Thomkin's [Daniel D. Tompkins [1774–1825]] mansion house in plain view, it is a spacious, neat looking white house situated on high ground."[137] After conducting business in Philadelphia, Green returned to Manhattan and evidently experienced moral and visual disgust at a papist house of worship. Green visited Christ Church, on the north side of Ann Street, between Nassau and William Streets. The building, finished by 1793, had only recently been purchased by Catholics from the Episcopal Church and was dedicated by Bishop John Dubois (1764–1842) in July 1827 as a Catholic church.[138] The particular touches, such as the throne, velvet, silver cross, painting of Jesus, and "gaudy fringe" mentioned by Green, were among the Catholic touches brought to bear in the interior. The church was destroyed

in the great fire of 1835 that devastated Lower Manhattan. On Sunday, 25 May 1828, Green recorded:

[I] conclude to go to a roman Catholic meeting—go to one in Ann Street saw pomp and splendor and ceremonies enough if it will save people, they are sure to be saved but I believe there is a great deal of ignorant sincerity, their Chapel is verry splendidly decorated, the priest sat on a seat ornemented with velvet and gaudy fringe—on the right was a kind of throne covered with Black velvet and tissue fringes—this is for the Bishop when he visits them, and is to represent the chair of St Peter—on the left is the pulpit with a hidden door from the Vestry, the alter is most richly ornamented with gold and Silver tissue—with a pedestal like a steeple rising almost to the arch floor, surmounted by a picture (pretended) of Christ, holding a cross of Silver, on each side, were 4 wax tapers burning and when the mass was offered, 2 more large ones perhaps 6 feet long were bro't in and plais'd on each side before—for what purpose those were burning unless to burn up the daylight does not appear—and I am sure they burnt up the daylight of the mind, by fixing it on external light and ceremonies instead of the internal light of God and real devotional worship—they say that the splendor of the place of worship & their ceremonies are to fix upon the mind of the people who are mostly led by external appearances, and how much they ought to devote to religion—but in all this they show themselves verry destitute of the internal substance.[139]

Green's account is not far from typical Protestant reactions to Catholic decorative sensibilities, with his opposition to "external appearances," the sarcastic underlining of Saint Peter, and the dislike of elaborate ceremonies, although in his journal Green took a shot at the Presbyterians as well, for that night, he wrote for the amusement of his Shaker readers back home, beginning with a mocking of colloquial worldly speech: "O dear it rains[;] my new drab Coat will surely get Christianed [Shakers did not practice watery baptism] and I am afraid will look as spotted as a Presbyterian in fact but I dont see as it can be helped."[140]

Green objected to the ornament of the Catholics and their tendency to external showiness and at the "pretended" image of Christ, the exhibition of which was very much opposed by Shaker practice, but he was more impressed

by the priest of Christ Church. The next day, Green met an unnamed father there, perhaps speaking to Reverend Félix Varela (1788–1853), whom Green described as endowed with "french-Courtesy" (Varela was actually Cuban born), and "though ignorant of the real nature of Spiritual principles, I believe him more sincere than most protestant Preachers." Elsewhere in the city, Green had some pleasure in seeing a worldly theater destroyed in a fire ("not much matter") and concluded, as have many tourists to New York, that "I was glad I did not live in a city." On 28 May 1828, Green had hoped to get away from it all and "take a bath in the sea" in Brooklyn, but the weather was too cold, more like March, he wrote, than late May.[141]

Green's criticism of Roman Catholic interiors and decoration was echoed later in the active pen of Freegift Wells, who on Sunday, 18 September 1853, visited the Catholic church on James Street, still extant, a Greek Revival building based on a published design by Minard Lafever in 1830–32. Wells made no mention of the building as architecture, as he went for the service, but experienced unpleasant fascination, as again was not uncommon for a Protestant visitor to a Catholic church in the nineteenth century, with the gaudy form of lighting inside. Wells was disappointed that there was no preaching, "but I will just mention that they had 24 lighted candles, 6 of which seemed to be about 5 feet long, and 3 inches in diameter, & the candlesticks were about the same length, which elevated the light from them, about 10 feet. The wax of the candles appeared to be the common Spirm candles."[142]

Hervey Elkins, who also denounced historical architecture that was ornate, leveled criticism at those who worshiped images of the holy, and his remark about resurrection of the whole body and, especially, transubstantiation refers effectively to Roman Catholicism:

> But little could be required of those people, who, though they piled up proud memorials of architectural skill, sincerely prostrated themselves before images of artistic device. But little moral, or intellectual responsibility was incurred by that tactician and king who, though he entered with his army a city whose walls were deemed impregnable, conscientiously believed that images of brass and clay were deities endowed with tremendous powers of digestion. And but little more could be expected from men who sincerely believed in the doctrines of transubstantiation, election, reprobation, and the natural resurrection, as taught for sacred canons of faith, as late as the eighteenth century.[143]

Elkins stated that "two thirds [of] the crimes cognizable by the government of the United States, at the present time, are perpetrated by the ignorant, and consequently, vicious emigrants from foreign nations." A fundamental slant of Elkins's remarks appears to be opposition to Catholicism, with its emphasis on images and transubstantiation and the adherents of which formed a large part of the "vicious" foreign immigrants into America of the time. We can imagine that Elkins was thinking of Irish immigrants in particular. As for his taste in style and level of adornment, Elkins did not approve of ornate churches, and he again likely meant Roman Catholic and also more ornate Episcopalian houses of worship: "I entered some of your churches; where, from mahogany tribunes garnished with crimson and tassels, I heard most appropriate and holy discussions upon the folly, the injustice, the sin, and the vanity of man; and the fragility of all human things. I entered others, where, from wood colored pulpits, ministers preached to congregations, 'lolling on benches,' and surrounded with the filth of tobacco and mud, the necessity of a moral renovation and a new birth."[144]

Freegift Wells did not record his objection to any images of Jesus or the saints in the Roman Catholic church he visited in Manhattan, but he took particular exception elsewhere to the display during a sermon of an image of Juggernaut, a name or title for Krishna, the eighth avatar of Vishnu. On 11 September 1853, Wells went to an unnamed church, very likely the Presbyterian meetinghouse in Cutchogue, Long Island (New York), which housed a congregation that had existed since the 1730s. The preacher seemed intent on raising funds to help send missionaries across the globe to convert heathens. To that preacher, "it was a matter of the greatest importance, and as an evidence of this he exhibited the portrait of old Juggernaut, a heathen god, who is worshiped by millions of human beings, &c. It was truly a queer picture, & an odd exhibition for the Sabbath." Wells believed that the preacher wanted the congregation to "hand out their money," and, indeed, the collection basket made the rounds after the plea and the display of the image.[145] Many in the West were struck by tales of enthusiastic followers of Juggernaut killing themselves by throwing their bodies under the great cart that held a statuary image of him (the English word "juggernaut" at that time connoted most regularly the unstoppable power of a large cart, train, or truck/lorry). Saving heathens of India from this cult worship was a goal of Presbyterian missionaries at the time, and in the 1840s Presbyterian chronicles were circulated to inspire anti-Hindu sentiment and gain support for their missions abroad.[146] Shakers did not display images even of Christ, saints, or Ann Lee in their meetinghouses,

and one can understand the horror that Wells felt upon seeing a Hindu religious image, probably some lithograph or other print, held before a Christian congregation in the middle of a service.

Shakers rarely commented on individual works of art that they came across, but we have seen that—unlike with fountains, buildings, and parks or gardens—they usually showed some level of discomfort or displayed some reaction against works of art. Another example of this abreaction came in 1862 in the pen of Giles B. Avery, from New Lebanon and traveling with a group of Shakers to the West. On 21 June 1862, Avery described a symbolic interpretation or use of the statue, that of *Harmony* (*Harmonia*) for the Harmony Society in Economy (now called Old Economy Village), in (now) Ambridge, Pennsylvania (fig. 4.30). That Rappite group had some aspects in common with Shakerism, including the creation of an ideal physical community and the moral elevation of celibacy, and Avery was at their village getting a tour. Unlike the Shakers, the Rappites actively commissioned, collected, and displayed works of art. After describing a grotto that held the sculpture, carved in 1824 by William Rush, Avery noted that the "interior [is] neatly plastered and containing the inscription in golden washed letters, of the date in which the society was founded at Harmony and at Economy & the name of its founder, George Rapp." Avery continued, "There is also a carved female Statue, life size, containing a harp in one hand, to play the harmonies of life—And Br [other] or Elder Baker observed that when he took married strangers there he often pointed to the statue saying, to the husband, 'When your wife takes the <u>high</u> tone, you must take the <u>low</u> tone so that your notes may blend in harmony.'" The presence of the statue, and this interpretation by their guide, Elder Romelius Baker (1793–1868) of the Harmony Society in Economy, was of great enough interest to Avery for him to record it, but, for the sake of the Shaker readers of his journal, who would disapprove of the statue of a beautiful female, as well as its use as a harmonizer of real-life marriage, Avery felt compelled to write: "Well, all of this is outwardly fine, and worldly gay, & terrestrially pretty, but not a whit of spiritual life is ministered by the whole of it."[147] The Shakers often shared aesthetic values with other Americans, but there were limits to their appreciation of the world's artifacts, even in 1862, when some of the older Shaker restrictions were beginning to relax.

Some moral comments by a young Shaker woman about the visual world could be included in our discussion of landscape, but since they also involve an unusual Shaker mention of painting and sculpture as art forms, we can consider them here. Susan C. Liddell, a Shaker sister from Union Village, Ohio,

Figure 4.30. Variant copy (20th c.) of a lost original by William Rush, 1825, originally wood and white paint, height ca. 72 inches with base. (Old Economy Village in Ambridge, Pennsylvania, Johann Georg Rapp House Garden. *Photo*: Pennsylvania Historical & Museum Commission: Old Economy Village.)

visited a nearby Catholic academy on 2 November 1857 and called it a "large noble looking house" with a "neat parlor," but she had other illuminating ideas on the ride home through "a natural forest nearly two-miles." She writes that "here I was interested. I saw a beauty in yonder wild natural unbroken forest[,] not in the Catholic Academy—not in the art of man. No sculptor's finger prints can tell the mind so much as this[,] cannot cast a shadow of impression of the great magnitude of the power and wisdom and taste of God's works[,] not one leaf can he [the sculptor] make so nice. . . . What could be lacking to impress the mind with the infinite goodness and greatness of God our Author and maker."[148] This comment, which brings a consideration of painting and sculpture into the fray, reinforces what we saw in the second chapter, namely, that Shakers were appreciative of natural beauty, whether in raw nature or as shaped by the hand of man. The notion of God the Father as the greatest artist was a mainstay of nineteenth-century American aesthetic sentiment, but here given a piquancy by a Shaker disparagement of a "neat parlor" and of a "noble looking house."

We have seen Hervey Elkins and his opinions about architecture, interiors, and retail emporia of the world. He also had a chance to visit museums, and we might give the eloquent Elkins one more brief word in this chapter. Writing when an apostate, but with the moral sensibility of his long residence as a Shaker, he went into unnamed collections of art, saw historical objects and scientific displays, and raised objections both moral and aesthetic: "I entered your museums; and there I saw perpetuated relics of the mighty past, which teach us, without much reflection, of the 'fragility of human things.' Embalmed, yet partly decayed mummies; armors; warlike and kingly trappings; garments of ancient costume; heathen fetishes and idols,—all showed what death, and 'moth and rust' will do. I would not dwell upon isolated cases of extreme poverty, extreme vanity, extreme cupidity and extreme wealth; but my reader can bear witness that they are too common."[149] He conveys a typical romantic idea of decay and the passing of time. More characteristic of Shaker thought was his objection to "heathen fetishes and idols," the pacifistic opposition to armor and "warlike" trappings, and the denunciation of luxury in the presence of poverty, the owners of fine objects satisfying their vanity and cupidity.

Shaker John M. Brown of New Lebanon made similar moralizing comments during his trip to Manhattan in 1866. He thought the jails and courthouses he saw were evidence of a corrupt society, and Brown complained about the small luxuries owned by the daughter of a cousin. He hoped to convert her to

the Shaker religion, but the twenty-four-year-old woman, who happened to be a Methodist, would not budge, as she was "joined to her (Methodist) Idols—a way broad & easy, admitting pianos, gold watches, and many other etcetra's." He visited a large steamship docked in the harbor and proclaimed "O man! How mighty thou are become! and still going on, increasing in skill, in influence, and power, ever changing to more perfection, like unto the gods." At Greenwood Cemetery in Brooklyn, Brown met a man from Philadelphia, perhaps a Quaker, who agreed with Brown that the cemetery, with its elaborate tombstones, was of questionable morality, what Brown called "all idolatry." On the way home from New York City, Brown toured Albany, but would not visit the "Military Bereau [Bureau]," as he was a "peace man."[150] Brown raised these objections, but he kept touring widely in various cities, somehow drawn to the sight of the creations by the world's people.

In this chapter, we have seen, despite some qualms by Elkins and others, a good deal of acceptance of the current styles of art and architecture produced by the world's people. In the next chapter, this sharing of broad American taste for fine material culture will go even further when Shakers experienced colorful, ornate visions or gave each other imaginary gifts that included such luxuries as crystal vases, flowers, gold and silver vessels, and fine jewelry. Many things that Shakers could not experience in reality in their villages, or see during travels across America, they could enjoy in their holy visual imaginations.

VISIONS, VOICES, AND ART
Imagining Heaven and Earth

<div style="font-size:large">5</div>

The world of Shaker visuality comprised spiritual visions, that is, images mystically received by believers. Such visions formed an integral part of Shaker life from the eighteenth century to the third quarter of the nineteenth century, after which time they largely ceased to occur. Shakers themselves usually called these experiences "gifts," "messages," or "signs" and sometimes suggested that these were nightly dreams or daydreams; they also used the word "visions," and sometimes called receivers of them "visionists" or, most often, "instruments." The word "vision" has two principal meanings. It can pertain to the sight of something actual; the *Oxford English Dictionary* defines it as "the action of seeing with the bodily eye; the exercise of the ordinary faculty of sight, or the faculty itself." A vision can also denote a mental apparition or a part of a waking or actual dream. For this second sense, the *OED* defines it as "something which is apparently seen otherwise than by ordinary sight; *esp.* an appearance of a prophetic or mystical character, or having the nature of a revelation, supernaturally presented to the mind either in sleep or in an abnormal state."[1] We are concerned in this chapter with this second sense, of mystical visions, as well as other imaginings. Some of the visionary experiences were recorded in purely verbal fashion, while others took the form of artworks that Shakers, as instruments or mediums of the higher world, carried out in two-dimensional art. We will also see that another form of Shaker expression—namely, song lyrics—evoked images in one's mind and can in that respect be considered part of the world of Shaker visual imagination.

With this I have some pretty presents to give you. A Gold Pocket Hankerchief and a pretty white Book with gold Stars sparkling in the cover. A beautiful tree with sweet spices on it and much other kinds of fruit, fresh Tamarinds Grapes Plums Apricots and Vana[n]as.
—A spiritual communication: "A Letter from Lovicy Carey to Elder Br.[other] Amaziah Clark," 30 March 1843

Shakers were hardly alone in their religious visions and spirit possession; these were commonplace in Christianity from the beginning and played a significant part of the millennialist religious movements of the eighteenth century, the time period during which the Shakers came on the scene.[2] But while other Christians also experienced mystical visions, these were particularly important for Shakers. Among the main focal points of Shakerism were an emphasis on the special role and status of Ann Lee; confession of sins to Shaker leaders; complete, lifelong celibacy; and the importance of "gifts," including visions. In this last regard, Shakers were not interested in repeating or reliving the visions of Catholic saints or earlier Protestant mystics. They believed that Shakers marked a new order of things, and they proclaimed that they had their own connection to the divine. For Shakers, visions served as a means of communication between this world and the heavenly realm; quiet belief was well enough, but getting special access to the divine was especially important for them, and a vision was evidence of a special relationship between Shakers and the heavenly realm. As Clarke Garrett has summarized it, spirit possession for Shakers did not, as with many Christians, typically mark a moment of conversion, signaling the point of being saved or of securing a place in the next life: it was a recurring phenomenon, part of God's ongoing favor and support of the Shaker faith, and an affirmation of their holy path.[3]

The Shakers maintained a broad and semi-institutionalized recognition that some of the members were "instruments" who had special access to the other world. Mystical experiences and reception of communications from heaven were particularly prevalent from the 1830s to the 1850s, but visionary experiences started at the sect's beginning. Shakers gained early adherents with their claims of seeing what others could not, like the evil spirits that founders are said to have viewed on the shoulders of others, or the angels seen hovering in the air in a room. While the culture of visionism and spiritualism waned for a while from the 1790s to the 1820s, it never left the sect. Ann Kirschner has called attention to the importance for Shaker spiritualism of the *Testimonies* from the earlier nineteenth century, which provided published examples of early visions.[4] Shaker Isaac Newton Youngs wrote in 1856 that even in the earliest worship by the sect before 1785, there were "spiritual gifts, of tongues and signs."[5] Believers were conscious of the importance of visions for the establishment of the sect, and spiritual communications and other gifts reechoed throughout Shaker life from the beginning.

There was a remarkable regeneration of the spiritual life of Shakerdom in the couple of decades after 1837, a period sometimes called "Mother's Work" or

"Mother Ann's Work," "Mother Ann's Second Coming," or the "New Era," as it was called by Isaac N. Youngs in 1856.[6] The phrase often used in modern scholarship, and as we have been using here, is the "Era of Manifestations."[7] That era began with ecstatic visions and behavior of adolescent girls at Watervliet on 16 August 1837, described in detail by Shaker Henry C. Blinn. The children could not sleep at night, and they spoke of seeing angels and "some very pretty flowers." Their "trances continued from day to day, till many others became impressed with the same gifts. Under the direction of spirit guides they were conducted from place to place, and these guides conversed with those in the body, through the entranced persons."[8] Isaac Newton Youngs stated: "[In 1837] the windows of heaven and the avenues of the spirit world were set open, and innumerable gifts were showered down, of visions, revelations, inspiration, messages from spirits, spiritual presents and new songs in profusion." Youngs noted that, among children at meetings, "some individuals were taken under a new and singular influence, in a kind of vision or trance, unconscious of external things. Their spiritual sight was opened, beholding things invisible to those around. They had a spirit guide, who communicated to them, and conducted them here and there, in the spiritual world . . . Those under that influence were termed 'Instruments.'"[9] We can only speculate why there was a burst of spirituality in the Era of Manifestations. The society was losing more and more individual members to apostasy, and the memory of the founding members was fading. A burst of spirituality gave the sect a new impetus forward and made up for the loss of the connective, historical memory to the founders. In her analysis, Deborah E. Burns wrote that, by the 1830s, "even peaceful interaction with the world had a dangerous edge as the Society grew more prosperous and the world grew more materialistic. With worldly values of materialism and individualism infiltrating the villages, a spiritual cleansing was in order."[10] The Era of Manifestations expanded the scope of the sect, especially through the proliferation of the instruments who brought refreshing new ideas, some of them visual in what we call artworks and what they called inspiration or gifts from heaven.

The Shakers were taking a risk in recognizing these instruments. Many of the recipients were adolescents or young adults, and some accompanied their verbal reports with ecstatic dancing and uncontrolled movements; these inspired young people carried the risk of questioning normal Shaker tenets or attitudes. As one Shaker authority stated, "It requires some wisdom and caution to steer the young through those gifts without some loss to themselves or dishonor to the cause. The gift of God is always good, but when fallen nature

lays claim to the honor to it, there is danger of great loss."[11] Sally M. Promey pointed to a note of 1837 from a Shaker ministry proclaiming that "in the earlier part of their vision we were afraid that their great gift would lift them up above their protection."[12] Some Shakers felt uncomfortable, or unconvinced, that fellow Shakers were tapping into the divine, but most believers accepted the visionary experiences of their fellows, and those in charge did have a chance to reinterpret the visions for the community, or isolate the visionists if need be. We do not know how many written records of visionary experiences were destroyed early on. At any rate, the ones that survive are consistent with the overall structure and tendencies of Shaker belief. Most written, recorded visions offer us the names of the earthly instruments, whether in a written document or as inscribed in the wording on the sheet of paper with the artwork. The Shakers had little interest in artistic identity and selfhood, but the names of visionary scribes survive as evidence that the gift was received by a particular person in a particular time.

The time of "Mother Ann's Work" gave us a substantial number of "gift drawings," new dances, new songs, and a host of mystical manifestations. In addition to the religious content of the Shaker visions, there were aesthetic issues interwoven into the sacred ideas, even in the verbal material, including evocations of light and dark, coloration, and other themes of embellishment of ornament and materials. In short, religious visions give us another facet of the Shaker visuality, with aesthetics interwoven with belief. We can hypothesize that Shaker visions and visionary art served at least in part as an outlet for the kinds of beauty and embellishment that they were denied in real life. Even allowing for the purely religious purpose and context of the visions, it is not unreasonable to conclude that part of the appeal of the visions was the sensate aspects of the visions themselves. Visions, whether verbal or visual, constituted a kind of artistry, even if the Shakers did not understand them to be artworks in our modern and secular sense; what was seen, either in the imagination or on paper, was often spectacular in iconography, coloring, material, texture, and chiaroscuro. Apart from the unique Shaker context, the description of visions, or the form they took in drawings and other designs, links Shakers to a broader worldly taste for fancy coloring, gilding, marble mansions, the colors of rainbows, and many other visually stimulating phenomena. There was little that was plain and simple about Shaker visions.

In addition to the elders' initial suspicion of some Shaker visionary experiences, especially those of children, spiritual manifestations did not gain uni-

versal credibility or admiration in Shaker society. Hervey Elkins, at Enfield, New Hampshire, complained that the very definition of "infidelity" among the Shaker officials was "unbelief in the revelations of their mediums." The elders and his caretakers wanted to keep young Elkins away from the youthful farmers among the Shakers, as it was among them that disbelief in "spiritual infusions" was most widespread, and Elkins needed to be spared the "commonplace and sportive remarks made about visionary boys and girls." Elkins concluded that the physicality and freedom of their agricolan profession led to a freedom of mind, explaining why they were "extremely liable to treat subjects of the most solemn and sacred character in a facetious manner." The youths working the farms were apparently less likely than other Shakers to accept the idea of "reception" of spiritual ideas, and the authorities attempted to keep Elkins away from what he called the "liberal class" of young farmers, the very word "farmer" among the Shakers being, according to Elkins, equivalent to what the world would call "rowdies."[13]

Apostates, of course, discussed Shaker visions with great derision. For example, apostate David R. Lamson mocked Shaker visions. That fallen Shaker noted that visions "could be seen only by those whose eyes were opened to spiritual things. They were a gift from the Spiritual world. . . . And knowing that the elders, and beloved ministry will be disappointed if they do not obtain the fits, it is not strange that many of them work themselves up into the belief that they are inspired; talk gibberish for an unknown tongue; see spirits, and many wonderful things. . . . But all these fits of visions, and revelation, must be in obedience to, and union with their visible lead." Lamson suggested that the Shakers contradicted each other when reporting their visions. For example, a Martha van Valen came forward at a meeting and saw a vision that "raised upon a very tall pol[e] an ensign or banner, printed all over in large letter [sic] of various colors. She called upon the seers, to say if they beheld it. Several of them responded, yea. And they named many of the colors. . . . When they were naming the colors, one saw green another red, another blue, &c. One saw black; yea, said several others, they are black! This signified that something dreadful was approaching."[14]

The power of the meetings that comprised visionary experiences was acknowledged by skeptic and apostate Hervey Elkins. He wrote without rancor and with respect for the Shakers, finally breaking with them only after they suppressed his quest for knowledge and wider reading. Describing times in the days of the tumult of the 1830s, he writes:

Our juvenile meetings, where the boys, about twenty in number, and the caretakers, the one our spiritual, the other our temporal supervisor, met for worship, were conducted by my tutor with all the religious sincerity and fervor of devotion. The songs, the dances, the ministrations, the illapses into a visionary or abducted state, heightened immeasurably in interest and excitement by the announcement of angels and departed spirits, causing the instruments to join simultaneously in the evolutions and caroles of complicated dances and songs of immediate creation—scenes common in the family meetings which Sundays we attended, and not uncommon even among the children, exercised upon my mind a curiosity and inclination to investigate the cause, or else reason away, by the pretext of impossibility of such power being exercised over mortals. More than a score of new dances were performed with an attitude of grace and with the precision of a machine, by about twenty female clairvoyants. They *said* they learned them of seraphs before the throne of God.[15]

Apart from his subtle doubts and the sarcastic italicization of "said," Elkins conveys the power and effectiveness in the communities for the believers during the Era of Manifestations.

In looking at the primary evidence, we might first consider Shaker visions as documented in verbal records. It is intriguing that Shaker visions often comprised mention of fancy objects that believers were normally forbidden to own or enjoy seeing in real life. One visionary in 1843 explained that this occurred so that mortals can understand the divine message and suggested that the presence of fancy things should not be understood as anything but spiritual: "All the presents that I have sent, or caused to be sent forth unto you, must be used in a proper line of sensation, for they are all spiritual, whether they be of ancient or modern date. They have been sent forth in this degree of nearness and semblance of material things that do exist on earth, that you may be better able to appreciate in lively colors, and thrilling sensations, the real adornings and beauties of the spiritual world," to which "all the arts of man's invention are but a dismal, gloomy and imperfect figure."[16] Shakers could explain fancy ornaments as holy in nature, presented in a vision as a way for Shakers to understand the moral beauty of the spiritual world beyond.[17] Other religions achieved similar effects by, for example, adorning a house of God with gilded pictures and brass chandeliers. For Shakers, the

utilization of luxury in visions is especially of interest, since a central tenet of Shaker daily life was the abjuring of beautiful and costly material objects. Their visions brought them closer to the broader American experience of enjoying fine metal, stone, and other luxuries. Recorded visions along these lines were numerous and graphic in detail in describing ornaments and fancy materials, including bright colors, gold, and diamonds.

Some of the fancy items appeared as part of narratives. Many of them were spiritual, imaginary gifts from an absent or deceased person, while some of the items were "given" in person by Shaker to another, and the imaginary thing was recognized by the giver and receiver to be what earthly name the giver assigned it. Isaac Newton Youngs gives a summary of the fancy gifts that appeared during what we call the Era of Manifestations: the offerings were given "names of material things, as Gold Leaf, paper, pens, books, musical Instruments, fruits of all kinds, flowers, roses, Diamonds, numerous articles of ornament, Boxes, Baskets, Implements of hand labor, as sythes, rakes, &c—weapons of war, guns, swords, spears, &c. and sacks, full of all kinds of rich treasures."[18] Again, what the Shakers went without in real life, they received, at least in their imaginations, through such ritualistic giving of luxuries and niceties.

Among fancy items and materials in Shaker visions, we might look first at evocative images of gold. Gold, gilding, golden light, and gold-background pictures had long been associated with the divine in religious art and thought. In real life, though, golden objects and gilding were forbidden in Shaker communities. Gold and gilding appeared widely in American furniture ornament, book decoration, jewelry, and other arts; Shakers could not share in that broad taste for gold, but they could include it in their religious visions. New Lebanon Shaker Calvin Green saw gold in a night vision in 1829, an experience he described as a "visionary sleep or in a real trance."[19] In the dream or vision, he described what occurred: "Then I looked towards the south among the newly prepared timber on the green and beheld a most beautiful Dove its sym[m]etry appeared perfect in all its part, the feathers were of a most pleasing white; but around the neck was as it were a ring of purest bright gold . . . and these words of the hymn descriptive of the heavenly dove came fresh to my mind 'Her feathers are like purest gold, she is a beauty to behold.'"[20] For her part, young Ann Mariah Goff (1823–42) had a vision at New Lebanon in 1837 of the "city of Paradise," with neat rows of structures: "We then went to another house, and there I saw a room which my guide told me was the first place that Mother Ann came to after she left the earth. The walls of the room

were white and shone very bright; and there were rows of flowers of a golden color all round the room; and between the rows of flowers Mother Ann's name was written, in large gold letters, all round the room, and at the beginning and end of her name was a large golden flower."[21] In 1851 the New Lebanon "instrument" Miranda Barber had a vision of an angel in gold bearing a banner with gold letters: "Angel riding upon a white horse hastening towards us. His path was narrow and grown over with very beautiful white flowers. As he approached us I saw that he was decorated with gold and jewelry from the crown on his head to his feet, and a flag waving in his hand wheron was written in large letters of gold Liberty."[22]

Part of the Shaker "gold rush" in visionary imagery appears in descriptions of gold chains and gold coins. Even in the other restrictionary Millennial Laws of 1845, one reads, after the conclusion, in the collection of "Mother Lucy's Sayings": "To my sense, Believers are held together in union, by a golden chain. This chain is composed of the gifts and orders of God, & every order is a link in this chain; and if you break any of these orders, you break this chain, & are exposed to be led astray. But while you are careful, to keep the gifts & orders of God, you are surrounded by this golden chain, and are secure from all evil."[23] Rebecca Cox Jackson, a visionary from Pennsylvania, recorded striking gilded visions in her writings. Jackson was visiting the Shakers in Watervliet in late January 1843; they hoped to convert her to their faith, and after a particularly lively meeting, the Shakers gave her an (imaginary) gift, as was their custom: "The next morning one of the Sisters came in and brought me a present, a gold chain, put it around my neck and locked it to her [so we were joined together in the Lord,] and gave me a bunch of grapes."[24] A gold chain would otherwise be unknown in a Shaker community, and a fresh bunch of grapes, otherwise unavailable at that season, would have also been precious and prized. The use of the imaginary gold chain to "lock" two people together also shows how the Shakers used subtle psychological methods to produce converts. They called Jackson a "prophetess," and she left the community with feelings of love and continued the theme of gold and precious beauty upon her departure:

Saturday, 21st January, 1843, I bid them farewell and came away. After we got some distance I saw a large eagle before me in the road, as if it was coming directly to us. Its wings extended across the road. It was the color of gold. Its appearance was very powerful. In the same moment, there stood before me a little saint, taking hold of a gold chain that was around my neck, and showing it to me—

this chain was placed around my neck by one of the Sisters in Zion. I received it in faith, but did not see it until now—and the sweet peace that flowed to me from her heavenly presence![25]

Even the not overly mystical Rufus Bishop, of New Lebanon, who noted that he was usually in the habit of recording dreams, dreamed of golden money (1830): "Eldress B. Hastings came to see us, and gave to me large quantity of hard money, all done up in parcels, by the apparent weight I thought it must be gold. . . . Before she left the room Br.[other] Seth Wells came in and urged me to take from him a similar present. Their money was curiously packed up, some in papers, some in sea shells and others in transparent boxes."[26] A decade later, Bishop mentioned Shakers receiving a "gift" from Ann Lee and Lucy Wright: "Mother Ann and Mother Lucy gave each [Shaker present] a double Neck Chain of Gold, to which was suspended a <u>Seal</u>."[27]

Shakers' visions and dreams included not just gold but also precious stones and silver, as well as other costly and beautiful materials. The kinds of consumer goods sweeping America, and normally denied to the Shakers, could come into their imaginary possession during visionary episodes and writings. Such materials appear in a remarkable document of a "Macedonian boy," written by Hancock Shaker Elvira Curtis Hulett (1805–95) in 1843, titled by her "A Brief narative of the misery[,] sufferings and death of a poor Massadonian Boy, who starved to death when in his thirteenth year."[28] The little boy and his parents were present when the brethren of the Shakers opened the story:

> This little Boy was exceedingly pleased with the appearance of the brethren, they looked so bright he see their glitering chains and diamonds sparkling with such beauty that he could not forbear asking them to bestow some of them upon him, saying that he was a poor little beger boy and had no gold about him.
> At this request the brethren all as one began to wind Chains about his neck and place diamonds in his hands, for which he bowed in thankfulness.
> Likewise the Father of the little boy, presented a beautiful staff to each of the brethren, for the menny and the beautiful gifts which they so freely bestowed upon the little beger boy.[29]

The boy, named John, had been born in Macedonia in the reign of King Phillip and was the recipient of many fine gifts: "The greate King Philip says

that little John gets a greate menny pretty gifts. The shining brethren keeps loading him with gold chains and silver diamonds [*sic*], and they have even put a band of gold around him, and he learns very fast and can unite very pretty in the dance." The report also includes recognition of Shaker order and purity: in a "Letter of request "from the Masidonian King," dated 26 December 1842, Mother Ann Lee expressed her will from beyond: "Yea, saith the blessed Mother, go ye to the earth and behold the order and beauty of my simple children. . . . There you will find that order, that union, that purity," recalling "the power[,] wisdom and order" of the great Jehovah himself.[30] In short, Elvira's vision is dripping in luxury (gold, silver, and diamonds), but also with a recognition of the order and purity of the Shaker communities.

Diamond and crystal appear with great frequency in Shaker visionary documents, as in a "Copy of a Word Spoken by Father William and Father James[,] February 6th and 7th 1847," where on "February 6th while in our evening meeting, Father James brought a silver box of gold[,] glass[, and] diamond rings, and said that Mother Ann sent them to us."[31] Another imaginative document from that same year describes a diamond from Holy Mother Wisdom that is like an all-seeing eye, with mystical and divine connotations: "Receive my beloved, with this short communication, a Treasure Chest, containing small boxes of Gifts and Seals. . . . The seals are in [the] form of a Diamond, bearing the likeness of an allseeing Eye." The same visionary document states: "To you my beloved, I send my right-hand Angel with a beautiful Box containing a sap Vine of my love, and a sweet-scented Rose of my approbation."[32] Yet another Shaker visionary writing noted imaginatively that "this anthem was written upon a stone called Jasper, the first foundation stone in the Heavenly Jerusalem, Jan. 9th 1842."[33] Sometimes Shaker faith itself was characterized as a gem: "Osilen VE behold look and see what I behold in my hand a beautiful gem of holy faith."[34]

Shakers used the Feast Grounds/Holy Mounts twice yearly, in the spring and fall, for major communal ceremonies, but residents and visitors from various communities went there from time to time for smaller gatherings, and exotic gifts were sometimes exchanged or received during those visits, as in 1845, when at Watervliet "the Ministry from Harvard visited Holy Mothers centre Fountain," accompanied by some Shakers, including "some inspired Sisters and Singers," fifteen people total. The givers included the Virgin Mary, who was not mentioned with frequency by the Shakers: "Given from Holy Mother Wisdom to the Harvard Ministry—A Trunk of Jasper, filled with gifts and blessings for their people—A Key and Chain—A Lamp having 4 balls filled

with the oil of Wisdom and burning with the true light of revelation to the 4 quarters of the earth. . . . Three Baskets by the Virgin Mary filled with fruit cake, wine & pretty gifts to be a union feast in the churches at the Holy Mount, Wisdom's Valley and Harvard."[35] Another document, although including the gift of a "beautiful lamp" given by Mother Ann, and a "pretty robe" and diamonds, offered this moderating statement from her: "Mother says, your treasure in heaven consists not in feasting and having fine things. But, as little as you can get along with, and be comfortable, and the less you have that is unnecessary, the greater will be your treasure in heaven."[36]

In real life, Shakers ate well and abundantly, and the food was skillfully prepared. Abigail Crossman at dinner at a worldly boardinghouse in Massachusetts in 1846, served fish, steak, pork, string beans, pie, bread, and butter, complained that it was below the standards of a "Shaker supper," but that they were "bound to eat what is set before us, asking no questions for manner's sake."[37] Isaac Newton Youngs offers a summary of Shaker eating, and he made it clear that Shakers enjoyed abundant and well-prepared foods, including fruits, sauces, cakes, and meats for who those wanted. Still, he also noted that Shakers avoided "luxurious" foods.[38] Believers were usually deprived of some of the finer delicacies, such as liqueurs, exotic spices, and imported fruits, that the world might consume. Again, visions allowed a way to imaginatively consume fine foods, and such experiences also expressed the Shaker sense of the spiritual blessings shared by those of their faith. In a document from New Lebanon dating to about 1840–42, we read of "a pretty present of Encouragement, Sent from the Saviour, Mother Ann, Father William, Father James, to little James Goodwin. . . . Father William sends a pair of silver slippers lined with velvet. Father James sends a glass of candy, figs & grapes of much worth."[39] More fruit and spices are described in a spiritual communication of 1843 from Enfield, Connecticut, "A Letter from Lovicy Carey to Elder Br.[other] Amaziah Clark. It was copied by an inspired Instrument March 30[,] 1843." We read in the letter, "With this I have some pretty presents to give you. A Gold Pocket Hankerchief and a pretty white Book with gold Stars sparkling in the cover. A beautiful tree with sweet spices on it and much other kinds of fruit, fresh Tamarinds Grapes Plums Apricots and Vana[n]as."[40] We will explore some more examples of Shaker visionary artwork later in the chapter, but it is worth noting here that fruit sometimes appeared in two-dimensional examples of inspiration, as in a 1856 gift drawing of a basket with fourteen golden apples likely by Hannah Cohoon (1788–1864), of Hancock, Massachusetts (fig. 5.1), who joined the sect at the age of twenty-nine and

would have had exposure to the world's art and stylistic traditions.[41] The artist gives each apple a motley coloration, reflecting nature, but the order, regularity, separation of the fruit, and otherworldly two-dimensionality of the arrangement are characteristic of Shaker design.

Shakers were normally discouraged from drinking alcohol, except moderate amounts of hard cider, so wine would have been an exceptional experience in real life. As for mystical experiences, Isaac Newton Youngs of New Lebanon reported that, in 1838, believers who drank the merely spiritual wine during manifestations seemed to be inebriated, as the wine "carried a great evidence of its reality, by the paroxysms of intoxication that it produced; causing those who drank it to stagger and reel, like drunken people."[42] Recording a typical spiritual experience at meeting, Grove B. Blanchard, of Harvard, Massachusetts, described in 1843 how the group acknowledged a gift, one that included

Figure 5.1. Hannah Cohoon, *A Little Basket Full of Beautiful Apples*, 1856, pen and ink and watercolor on paper, 10⅛ x 8³⁄₁₆ inches. (Pittsfield, Massachusetts, Hancock Shaker Village, Andrews Collection. *Photo:* HSV.)

wine: "Mother Ann's Angel brot a store of precious fruits, of many kinds and a great supply of heavenly Bread and wine—Silver knives and forks with gold handles, so that we enjoyed a glorious feast of our Beautiful Mother Ann. We all sat on the floor and partook of these spiritual bounties."[43] Eunice Bathrick recorded a spiritual gift, among many over the years, at Harvard in 1841: "We received some oranges from our Holy Savior and some wine from blessed Mother Ann."[44]

Shakers could not own or display still-life painting, which were so popular in nineteenth-century America, nor did they prepare real-life displays of sumptuous mixed fruit, but they could enjoy the thought of spiritual still lifes, as in an 1842 document: "But to all such as are prepared, I say, come freely, fear not. Here are peaches, oranges, pine-apples[,] plumbs and berries; take freely, there is a plenty, for the feast of the Lord is very abundant."[45] At New Lebanon in 1841, an evening meeting included a holy gift of flowers and fine fruit, as well as an ornamental cage of birds, something otherwise not allowed

in Shaker communities: "In our evening meeting we received some beautiful presents of Basket of roses from Holy Mother Wisdom brought by Mother Lucy. Also some Peaches & Plumbs given to us by Mother Ann with her love[.] And a cage of birds from Elder Sister Olive."[46] When visiting Union Village, Ohio, in 1847, New Lebanon Shakers Prudence Morrell and Eliza Sharp received spiritual gifts of apples, wine, and a gold ring: "After some exercise Eliza and I received a beautiful green branch full of white apples from Eldress Betsey." Then, a couple of weeks later, Prudence wrote, "Eliza and I received a gold ring and a purple ball of love and a glass of wine from our beloved Eldress Hortense which pleased us very much."[47]

Just as visions offered Shakers a chance to imaginatively enjoy gold, diamonds, candy, and wine, they served as way to experience artworks otherwise forbidden or discouraged for them. One such spiritual experience included a design "drawn by obadiah of old." In "A Short Word of Notice from Father James to Jane Blanchard" from 1841, we read of the gifts, "a present gathered from the Heavens by Father William, namely:

> a glass band box, lined with pink parchment, on the cover Holy Mother has printed your name in letters of gold, and surrounded it with a circle of Jasper stones, set in gold diamonds, on the side of the Box is Her likeness sitting on the Eternal Throne. . . . He also sends a gold card, with the writing seen by Belshazzar, Mene Tekel Upharsin &c, on one side, and the picture of this memoriable event on the other side. This was drawn by obadiah of old and by him presented to Sennacherib and John the Revelator received it of him & took it to the Isle of Patmos . . . this was set in a gold frame by Tubil Cane, and by him presented to Father James. Father Joseph sends a silver platter. . . . A gold Urn filled with pleasant drink . . . 4 gold spoons bearing the likeness of Christ, The Ancient Kings of Judah, and Prophet Amos.[48]

Some Shaker visions seem based on earlier art. It was traditional in Christian paintings of hell to show molten gold, silver, or lead being poured down the mouths of the damned. In the *Testimonies* of 1816, Ann Lee is remembered in Watervliet as reporting to followers a vision she had of those in hell: "They are bound in the prisons of hell, and their torment appears like melted lead, poured through them in the same parts where they have taken their carnal pleasure."[49] Gilded or gold-painted chariots appeared in parades and circuses in nineteenth-century America; for their part, Shakers could enjoy

chariots in their visions. Ann Lee is said to have appeared to a Shaker in the 1840s riding in a chariot lined in purple and gold, a fancy carriage rather different from the average Shaker carts: "I have a beautiful little chariot, in that I can go as quick as thought," and then in verse:

I am coming in my beautiful car,
All lin'd with gold and purple,
Attended by my loyal tram,
I am the Princess Royal.[50]

One inspired drawing (1848), by Miranda Barber , a recognized medium at New Lebanon, illustrates, on the lower right-hand corner, a "Golden Chariot to take Mother Dana Home," referring to the recently deceased Eldress Dana Goodrich (1769–1848) of Hancock. The chariot is of fine overall design, seems to be of pure gold, and is conducted by a driver wearing a golden crown (fig. 5.2).[51] A divine revelation in New Lebanon in 1842 noted beauty in a sign: "I saw, placed on the top of the dwelling house, a beautiful sign . . . it shone with such very great brightness. It resembled the color of gold." It was six feet wide and ran the length of the house, and a voice said, "The dwellings of my people shall I cause to glow with beauty."[52]

Shakers often had visions of bright colors. These were not forbidden in Shaker communities, and one finds vivid coloration on furniture and buildings themselves, and the visions do further underscore the Shaker delight and interest in bright and beautiful colors. During the Era of Manifestations, a Jemima B. (Jemima Blanchard) stated: "I have heard Mother say she used to have visions of heavenly things, & see beautiful colors when a child—& she dreaded to have her Mother get her up in the morning for fear she would open the windows & let them out."[53] The 1816 *Testimonies* include mention of early Shaker experience of beautiful color in visions: "Hannah Kenda[l]l [1760–1816] once presented to Father William a posey of divers colours; he looked on it and said, 'I have seen all manner of colours in Heaven, much more beautiful than these.'" This shows Shaker interest in the beauty of colors, but also suggests the belittlement of a child and offers insight into their leaders' psychological interactions with rank-and-file Shakers. Similarly, also from the important *Testimonies* of 1816, Eunice Bennett (1735–1827), herself later resident at New Lebanon and Watervliet, noted of Ann Lee at Watervliet, "She [Mother] said she saw the glories of God round about her head and pillow like the colours of the rainbow."[54] Similarly, Sarah Kendall (1759–1852) reported that at the home

Figure 5.2. Miranda Barber, *Golden Chariot to take Mother Dana Home (lower right)*, 1848, pen and ink and watercolor on paper, overall image size 9¾ x 7¾ inches. (Pittsfield, Massachusetts, Hancock Shaker Village, Andrews Collection. *Photo:* HSV.)

of her father, Nathan Kendall Sr. (1723–94), in Woburn, Massachusetts, Mother Ann awoke and reported that she "saw the glory of God surround my head and pillow last night, in colors like the rain-bow."[55]

Shakers had some fine and large-scale architecture of their own, as we saw in the third chapter. Still, there were limits to the materials and ornamental level of their own buildings. But they could fantasize about fine buildings, heavenly mansions, and adornment. These visions often include a moral component, including statements about order and cleanliness such as otherwise appear regularly in Shaker visionary statements, like one from New Lebanon in 1840: "I will thoroughly sweep & purge my house, every crack & corner will have to be swept before my work is completed."[56] We learn, "My work now, is, to set in order Zions Children; to show them the order & beauty, which adorns the worship of God."[57] In Calvin Green's 1827 account of the life of Joseph Meacham, we learn that the habitations of the spiritual world resemble the natural world, with beautiful homes: "Of the spiritual world, he said it resembled the natural or visible world. There was in that state (to them who inhabit it) land[,] water, fields, trees of the field, grass of the meadows, fruits and food adapted to their taste & state . . . also they had houses or mansions where they dwelt as homes, as really as we do on earth. But the beautiful habitations, delightsome infusions and happifying scenes which would be unfolded, for souls who were faithful in the way of God to the end of their probation, were inexpressible." Moral sentiment in visionary contexts includes this injunction of 1843 about Shaker creation of their moral environment: "Devote every talent for the upbuilding, beautifying, and adorning of this my holy Zion, that it may shine forth in its full splendour, and glow like the sun at noon day. And may her children that dwell secure beneath her strong walls of protection, increase in order and beauty, and be as shining lights to the nations around."[58]

Shaker visionary documents are filled with references to beautiful and happy mansions in heaven. The Shakers were not the only Christians to make such remarks about wonderful, heavenly mansions, but Shaker visions are notable in that, in contrast to some of their written restriction on real-life building, the visionary structures were unabashedly glorious and sometimes included gilded and other adornment. In "A Short Communication from Sister Lucy Prescott [1765–1845] to Eldress Betty," dated 6 March 1846, we read, "I have visited your mansion more than once, & every time I visit it, I see some new addition to its beauty. For every good deed that any one performs, there is some rare & beautiful gem or diamond or precious pearl" that is arranged by the angels in the mansion.[59] The death of a fellow Shaker in 1857 spurred

the writer to imagine the deceased in her beautiful mansion in the beyond; in the "Diary Kept by Sister Anna White, 1855–1873," on 20 December 1857, at the death of Sister Asenath Clark, we read of her passing, "like a shock of corn fully ripe is gathered to her own beautiful mansion with redeemed and purified souls, there to dwell forever."[60] Rufus Bishop, in 1837, wrote of recent visions, with some Shakers "traversing the invisible world, at times viewing the happified state of the Saints in light" and in these visions "beholding the beauty & glory of the faithful & viewing their happy mansions."[61] In a florid vision of 1841, "A Farewell Visit to the Spiritual World," of 30 May 1841, Harriet Bullard (1824–1916; at New Lebanon in 1841), featuring messages from Ann Lee and Lucy Wright, Mother Ann said, "Go my child, and view with pleasure and comfort, the Heavenly world, and remember all thou seest. . . . So I left my Mother's house and traveled in a beautiful green road, while the Angels, flew before, that led to the mansion that I was next to view. Mother Lucy said, my child would you like to fly with the Holy angels to that beautiful Mansion"; the angels themselves had "pretty white wings" and "gold buckles." Further on, we read that the "golden streets were beautiful to walk, the buildings were transparent," and that Mother's house had "white marble steps."[62]

Orderliness was the heart of Shakerism and is the most repeated of all aesthetic categories. Nor was it merely, or even essentially, aesthetic: order is good and beautiful, because heaven itself is orderly, good, and beautiful. Shakers had dreams of luxury, finery, and feasting, but, just as often, their visions were of order. Rufus Bishop noted on 12 August 1837 how a Shaker had a vision in which the heavenly host marched in "beautiful order." Bishop noted on Christmas Eve 1837 that during services at New Lebanon, the Shakers present marched in circles, and "it was a beautiful sight."[63] The opposite of order brought on distress and confusion: in a vision, Ann Mariah Goff was taken to a place with good girls "standing in a row," but in contrast was a dark place with "the wicked in great confusion," and there were screeching and groaning.[64]

Bright light effects, or light and dark (chiaroscuro), constituted mainstays of aesthetic experience for Old Master painting, often with connotations of light signifying holiness and darkness as evil. Similarly, lighting effects, conveying moral meaning and perhaps aesthetic sensibilities, appear often in Shaker visionary statements. At one Saturday-evening meeting in 1842 in New Lebanon, an angel was said to have appeared with an odd collection of mystical attributes (including a ball of light) and practical instruments and was given permission to participate: "While marching an Angel came in and

stood in the middle of the singing ring, having four wings and four heads. On one wing he had a rod _ on the opposite a vial _ on another a ball of light _ on the other a rake. The Angel desired to march around the ring. Liberty [that is, permission] was given."[65] It is not a vision per se, but a kind of visionary proclamation, published in 1843, and said to have been written by "the Holy Prophet Elisha," proclaimed: "O my Zion, my Zion! Bow down low, exceeding low, because I have blessed thee, and have in my glory shone upon thee with great brightness and beauty."[66] In a secondhand account, Rufus Bishop, at New Lebanon, noted in 1832 that some Shaker brethren had been arrested and jailed and had a vision that included an apparition of Mother Ann, and they reported that "after singing a number of songs and speaking of the way of God, our dark prison was illuminated as bright as noon day."[67] For his part, David R. Lamson recorded a vision of 1843, infused with brilliant and heavenly light, "Received at Union Village, Warren Country, Ohio, May 14, 1843," as follows: "Then O ye children, how necessary it is, that you keep your stores full, and your souls well supplied with the beautiful gifts of God; for they will adorn the soul with heavenly beauty and glory; yea, and your light shall shine forth like the morning sun; and all who behold it shall say, Behold the light and glory of Zion! the beautiful city of god, where dwell peace and righteousness, abounding with the blessings of heaven forevermore."[68] Even on a small scale, light appears: one revelation in 1842 consisted of "words written by the hand of the Lord, upon a beautiful little Ball of brightness."[69]

We have been looking at Shaker visions of nature, light, and color; they also envisioned people themselves, often seeing them as beautiful or shining or dressed in striking or fanciful clothing. In 1845 Annie S. Colley of Canterbury, New Hampshire, had a vision of a handsome infant: "Two persons came into the room bringing a cradle, in which lay a beautiful babe. They placed it before me, and I saw its sweet face, all smiling and beautiful."[70] William Deming, of Hancock, Massachusetts, in "A Vision Seen the 24th of January.43.," included "A short and interesting account of a beautiful Temple and glorified spirits in heaven: Seen in Vision. Tuesday evening January 24th and written the 28th 1843"; he had been transported to a heavenly "place of worship," and "turning in my seat I saw a little boy who was very handsome and bright."[71] James Wilson (1794–1870), of New Lebanon, in 1843 recorded his vision, replete with moral comparisons of dirtiness versus cleanliness and white purity, in which he saw "beautifull clean white people," a "beautifull looking valley," and a "beautifull looking angel flying along over thoes in the dance & looked upon them with a smiling countenence."[72] On the other hand, a few Shaker docu-

ments record unpleasant visions of the body, as in the diary of Isaac Newton Youngs; in conversation in 1837 with Youngs, John Meacham told of a "vision Samuel Johnson Sr. [of New Lebanon] once saw many years ago," in which "he saw a basin of water set, & two men with bloody hands came & washed in it." The next day, in reality, a man died, and two men carried him off and then washed their bloody hands in a basin, like in the vision.[73] In the *Testimonies* of 1816, Mother Ann, according to Hannah Goodrich, said of a W. C., who had heard the recent opening of the Shaker gospel (1780) but who refused to join: "I saw him in the same hell with murderers, as hot as a glowing oven, for defiling his own body, and going to dumb beasts."[74]

Shaker visions often included imaginings of resplendent clothing of fine material or with gilding or fancy colors. A document from 1842, "A Little Book containing a short word from Holy Mother Wisdom, concerning the Robes and Dresses that are prepared for all such as go up to the feast of the Lord, or attend to her Holy Passover," is replete with descriptions of fanciful garments for men and women, all of it prepared in heaven for them to wear on a special occasion. The articles of clothing, all of it symbolic, are to be worn only by those on earth who are simple, honest, good, and sincere. The clothing for men included "beautiful, fine Trowsers, as white as snow; these resemble a garment of purity, with many shining stars there on," and jackets with gold buttons and "fine needle work." For women, there was a muslin cap with "many stars and Diamonds, and your names are also written thereon."[75] Similar in its evocation of fanciful clothing, a "Roll from the Angel of Peace" of 1842 included a mention of beautiful and symbolic robes:

Here a robe of lasting beauty
Your immortal soul shall wear
And your crown it shall be glorious
Which in time you did prepare.[76]

Many Shaker visions of people involved apparitions of exotic figures, including ethnic types, foreigners, and historical figures, sometimes clad in fanciful costume. Largely denied access to written ethnographic accounts of real people or unable to indulge in reading about fanciful or foreign peoples in novels, Shakers were able to include them in their visionary experiences. At one meeting at New Lebanon in 1842, some Shakers had "a visit" by Laplanders and an Indian chief, all "fantastically drest in belts, caps, blankets, kerchiefs, etc."[77] According to "A journal of the Ministrys Eastern Visit," on 16 July 1850, an

imaginary group of blacks came to dance at the Feast Ground at Canterbury, New Hampshire.[78] As for apparitions of individuals, Shakers seemed especially willing to fantasize about being visited by great men of history, including such luminaries as Isaac Newton, Alexander the Great, and Pope Leo X.[79] Such visionism corresponds to general nineteenth-century tastes for historical accounts of Great Men. Visions allowed Shakers an outlet for the same, and they came to life in vision and in dialogue. Shakers were particularly interested in George Washington, seeing him as ordained by God to establish the American republic, the place where Shakerism would flourish.[80] Shakers managed to share in the American fervor for George Washington iconography, an obsession that rose to a peak during the nineteenth century, during the time of the flourishing of the Shakers.

While not a vision per se, a visionary sense and image are conveyed by a curious remark by Rufus Bishop in 1834 concerning the American republic. "After dinner I went & held a long talk with Garret [van Hoosen] and labored to convince him that instead of the republican government's belonging to the kingdom of Christ, it is only the feet & toes of the great image."[81] Bishop was referring to the prophet Daniel's interpretation of the dream of Nebuchadnezzar, for which the ruler desperately sought the meaning, According to Daniel 2:31–44:

> Your Majesty looked, and there before you stood a large statue—an enormous, dazzling statue, awesome in appearance. The head of the statue was made of pure gold, its chest and arms of silver, its belly and thighs of bronze, its legs of iron, its feet partly of iron and partly of baked clay. . . .
> Your Majesty, you are the king of kings. The God of heaven has given you dominion and power and might and glory; in your hands he has placed all mankind and the beasts of the field and the birds in the sky. Wherever they live, he has made you ruler over them all. You are that head of gold.
> After you, another kingdom will arise, inferior to yours. Next, a third kingdom, one of bronze, will rule over the whole earth. Finally, there will be a fourth kingdom, strong as iron—for iron breaks and smashes everything—and as iron breaks things to pieces, so it will crush and break all the others. Just as you saw that the feet and toes were partly of baked clay and partly of iron, so this will be a divided kingdom; yet it will have some of the strength of iron in it, even as

you saw iron mixed with clay. As the toes were partly iron and partly clay, so this kingdom will be partly strong and partly brittle. And just as you saw the iron mixed with baked clay, so the people will be a mixture and will not remain united, any more than iron mixes with clay. In the time of those kings, the God of heaven will set up a kingdom that will never be destroyed, nor will it be left to another people. It will crush all those kingdoms and bring them to an end, but it will itself endure forever.

Thus, Bishop, with great imagination, saw that the expansive and (to him) unwieldy and weak American republic was only a last stage before the kingdom of God (Shakerism), the national government of the United States being only the crumbling feet and toes of the "great image."[82] The patriotic sense shared by most Americans, the admiration for their own moral excellence, and their sense of geopolitical destiny were far from the minds of Shakers. Believers saw the American republic, and its religious freedoms, as a convenient place for Shakerism to flourish, but it was their holy societies, not some democratic and secular republic, that had God's blessing and stood at the highest rung of human institutions.

Among the more peculiar manifestations of this time among the Shakers was the haunting presence of the spirits of Native Americans. The Shakers were frequently moved by and aware of the former presence of Native peoples, and they were in frequent communications with their ghosts or spiritual presence. The fascination with local "Indians" is among the most purely American of Shaker traits. Shakers, with their rural life and habitation near woods and meadows, were haunted, like other Americans, by the presence of displaced peoples and had a longing to unite with them, partly in what we would call fantasies of reconciliation. The Shaker co-opted Native peoples into their religious sect by offering them advice and participation in Shaker activities. The visionary sighting of American Indians allowed a kind of multicultural experience for the Shakers, forming a romanticized aspect of their lives.

The original Shaker settlement in Niskayuna, New York, was near Native American populations; like most communities in New England and New York in the early period, the settlers had contact with local tribes. These very first Shakers had little to say about the Indians, and from the time of Ann Lee there were no reported "Indian spirits" from beyond working to advance Shakerism. This changed in the nineteenth century and reached a peak during the spiritual upheavals of the 1830s–1850s. Even in mundane aspects of daily life, the

Shakers believed the Native peoples intervened with their actions. Hervey Elkins reported that a Shaker young man was convinced that "Indian spirits" were obstructing his work, and he attacked them, flailing at the air:

> One of my comrades, a year younger than myself, but much larger in size, worked in vain, half a day, in attempting to get two logs down from those horizontal obliquities and abrupt slopes. He loaded a dozen times, and as often upset. Imagining at last that the Indians spirits, which the visionists had declared would accompany us, were striving to defeat his attempts, he seized a lever and ran at them, uttering sinister phrases, and aiming his prodigious blow, with a gross weapon, upon the subtle, etherial backs, shoulders and heads, which modern psychologists have given to the souls of the departed. It was a ludicrous sight for the rest of us to behold.[83]

Elsewhere, Elkins noted, "At times I was asked by the elders if I could not unite and take upon me an Indian, a Norwegian or an Arabian spirit? I would then strive to be impressed with their feelings, and act in conformity thereto."[84]

The Native spirits were not always hostile, and we can imagine the outsider Shakers having a proclivity for comradeship with aboriginal Americans. The regularity and shared belief in Indians' spirits is demonstrated by their friendly arrival at a meeting, depositing invisible but effective machines for aiding in spiritual conquest of the material world: "On one occasion, when the spirits of some [of] the aboriginal inhabitants of America were said to be present, in worship, they deposited in the center of the sanctuary, the clairvoyants declared, a pile of spiritual machines made for the purpose of 'grinding to pieces' (metaphorically speaking) 'old nature,' as the Shakers term the evil, sensual principles in man. Each was requested to get one of these invisible engines and metaphorically try them, to see how they would work."[85] In 1843 a Shaker document seemingly (to us) evinced real interest in Indian canoes, but the document records a spiritual gift. Giles B. Avery, on April 1843, while at meeting at Enfield, Connecticut, wrote, "Rec'd from the natives two canoes, filled with love, in which to sail over the billowy seas of time.—The natives all sailed in them, sitting flat upon the floor, and paddeling with both hands—truly a pretty sight, no spectators."[86] While Avery seems to have been having a vision and receiving a "gift," he indicated an aesthetic appreciation of the imagined sight.

Moving on from Shaker visions of people, we can note that, not surprisingly, many of the Shaker visions comprised images of natural beauty, usually bound up with some moral and religious idea. Even before arriving in America, a Shaker had a vision of a beautiful and prophetic tree. In the *Testimonies* of 1816, we read in the recollections of an Eliphalet Comstock (1748–1828) of a story heard at the home or property of Nathan Kendall Sr. from Middlesex County, Massachusetts:

> At Nathan Kendal[l]'s, in Woburn [Massachusetts], Elder James related the following vision, which he had in England. "When we were in England, (said he,) some of us had to go twenty miles to meeting; and we travelled anights on account of persecution. One saturday night, while on our journey, we sat down by the side, to eat some victuals. . . . While I was sitting there, I saw a vision of America, and I saw a large tree, and every leaf thereof shone with such brightness, as made it appear like a burning torch, representing the church of Christ, which will yet be established in this land. After my company had refreshed themselves, they travelled on and led me a considerable distance before my vision ceased.[87]

Similarly, the "words written by the hand of the Lord" of 1842 included a number of visual features we have seen so far, including attire and mansions, but also references to heavenly nature as found at the Shaker Zion. In "Words written by the hand of the Lord, upon a beautiful little Ball of brightness," New Lebanon, 1 March 1842, the document refers to an imaginary Holy Mount: "I have placed a beautiful Orchard" there on the east side, and one can eat the fruit, and "upon the West side is a Garden of beautiful roses, and sweet smelling flowers," while "upon the North side I have placed a beautiful vine." One is bidden to take off one's old clothes and mourning clothes and instead "in beautiful and rich attire let them be clad."[88] Similarly, in "Mother's Pretty Garden of the first half of the 1840s, we read that "here is a beautiful garden, set with lovely plants and flowers. . . . [S]he hath employed us to cultivate and prune her lovely plants that the odors thereof may ascend to the throne of our heavenly Father."[89] The document suggests that, in real life, Shaker agricultural work consisted of pruning and keeping order in a lovely garden.

Moral equivalencies between Shakerdom and nature come across in Hannah Agnew's poem of July 1856, in which she wrote of the elect at White Water, Ohio, her former home that she was visiting:

We view you as the lilly fair & like the Sharon rose
Yea all who Mother's likeness bear & beauty outshine those
The rainbow in its splendid hue[.] The evening landscape fine
In glory can[']t compare with you[,] their tint but dimly shine.[90]

The inspirational "Holy and Divine Roll," written by "the Holy Prophet Elisha" and dated to 1842, paints a picture of the rolling ocean that turns calm and beautiful under divine direction: "Judgments shall roll and roll; yea, like the tide of the rolling deep, they shall ebb and flow, flow and ebb, until in my infinite wisdom I shall cause, for a season, the waters to be calm and beautiful."[91] Finally, a purported Anna Vines of the "English Ministry" is said to have composed a "roll" in 1842 in which she referred to the "branches of the beautiful Union Tree, which over shadow me," and she painted a lovely picture beyond that set in the community at Shirley: "There is a beautiful golden Table in the middle of this lovely bower. . . . Precious fruits are gathered and placed in golden fruit dishes. . . . You must not be astonished if I often digress and wander from my subject; for I am [so] captivated with the surrounding scenery that I do not know how to fix my mind upon any thing else."[92]

One extended verbal account merits our consideration in this look at Shaker visions of nature. Tinged with some moral sentiment, but largely of a secular feel, are the passages by the aforementioned Hannah Agnew of the first return trip, two decades later, to her girlhood home in White Water, Ohio, which she left at the age of sixteen before she moved to New Lebanon. In her writing, she imagines enjoying the out-of-doors in White Water, as she did in her youth. Agnew painted a perhaps imaginary but believable picture of leisure time among believers, consistent with other Shaker accounts of real-life enjoyment of nature: "Here comes another company; they have been sitting by the roadside, culling flowers, singing, talking, resting, & so on & so forth. . . . Only see there! They have erected a swing on a branch of yonder towering oak." Agnew continued: "I believe the Brethren have all gone home, & left the fair sex to rule the forrest—They look as gay, as so many woodlarks. Some are swinging; some have scampered away after mulberries. . . . [There is a]beautiful Red-bud tree, & see that happy little circle seated on the green turf, as in the days of their childhood . . . Ah! They are about to dine; they have spread their snow-white tableclothes, on the green turf, beneath a majestic oak, and beautiful magnolia."[93] In another creative moment in her thoughts, Agnew mused on the passing of time:

Oft shall Autumn's yellow leaves,
Withering fall around our eaves;
While her hallowed voice will ring,
Faintly lonely echoing.

Further on, in prose: "The sun has shed his last golden rays, upon the lofty sycamore & lowering rock, which border the silver stream by which they are passing."[94] Times marches on, and Agnew painted an autumnal and dusky picture of a landscape in charming yet melancholy decline. In a similar imaginary scene, Agnew wrote an illuminating poem in 1846, composed in New Lebanon but reflecting on her arrival in New Lebanon at age sixteen in 1836: "The Churchyard (of Lebanon)," which includes the lines:

Twas on a rising spot of ground
I saw this grave-yard fair;
A gentle rivulet by its mound,
And sweetly murmured there.
The sign was pleasing in my eye,
Yet solemn in my heart;
.
The green shady bower is yet waving there.
Like the garden of Eden; delightfully fair.[95]

The Shakers, as we see here and in evidence brought forward in the second chapter, were quite enamored by the beauty of the natural world. Like mainstream Americans, the Shakers described the natural world sometimes in secular language and at other times, as in Agnew's reference to the Garden of Eden, in moral or religious terms.

Shakers did make some visionary works in two dimensions, mostly drawings, in pen and also with watercolor pigments.[96] These are fascinating because they are, in most cases, not third-person representations of visions described to a maker but illustrations of visions received directly by the artist. They are personal, vivid, and deeply felt. Shaker two-dimensional visions have received a great deal of attention, fetched high prices at auction, and found their way to museum collections and exhibitions. They have also been subject to detailed and convincing scholarly analysis in modern times.[97] These works are rooted in Shaker attitudes and Shaker experience and relate to the verbal visions we have been studying. Shakers would have considered these to be

messages or gifts, not creative art or expressions of their individuality, but for convenience we can refer to these as artworks, always with the caveat that they had special meaning for the believers that we might not share. At any rate, these artworks did not form a significant part of the Shaker experience. Most of them date to the Era of Manifestations, mostly to the later 1830s to about 1850; many were made by young women, including adolescent girls; and they were not displayed as art.

Where were these visionary works held, how were they used, and what did believers think about them? This volume has tried to turn, as much as possible, to primary Shaker sources, but here there is essentially a void. As Edward Deming Andrews notes, "Shaker literature is almost totally silent on the subject."[98] Sally M. Promey calls attention to a visionary map at New Lebanon in 1843 that was framed and hung for display.[99] That was, as Promey stresses, a map, not an artwork, and the Shakers would have been considered it to be something other than a picture. We have to surmise that spirit drawings were kept in drawers and were viewed on occasion by single persons and perhaps small groups. They did not form any part of religious ceremonies. Essential lack of verbal reference to them by Shakers of the time indicates that few knew about them, or knew enough to comment, or thought the subject not important. Andrews concludes that "few Believers who were alive during the period in question knew of the existence, to say nothing of the prevalence, of such forms of expression," and he surmises that community authorities disposed of many of them, or kept them from the eyes of other Shakers.[100] France Morin, on the other hand, stresses that some gift drawings, composed by "inspired instruments" (authors) but mentioning the names of other Shakers in the community, likely made it into the hands of some rank-and-file believers beyond the leadership.[101]

The subject matter of Shaker artworks is related to their theological beliefs and recalls the nature of Shaker written visions. As for style, there were certain tendencies. Edward Deming Andrews was hesitant to make a claim for a Shaker style per se and insisted that he was not claiming the art to be "representative of a school of native folk art."[102] Still, even though there were a number of hands applying their art over time, and coming from different communities, there were recognizable patterns and trends. Shaker art has much in common with "folk" or "naive" art in America, with similarities, for example, with Pennsylvania German design of the nineteenth century in the symmetries, simplifications, clarity of layout and coloring, and linear articulations (cf. figs. 5.3 and 5.4). The abstractions, geometries, and stylizations of natural

Figure 5.3. Francis Portzline, *Birth and Baptismal Certificate*, ca. 1840–55 (made in Snyder County, Pennsylvania), watercolor wash, pigments in gum medium, and ink on wove paper, 12¹³/₁₆ x 15⁹/₁₆ inches. (Philadelphia Museum of Art, gift of J. Stogdell Stokes, 1928–10–90. *Photo*: PMA.)

elements in Shaker design also recall American works such as painted tin decoration (sometimes called "toleware"), clock faces and clocks, checkerboards (not otherwise permitted), borders of painted mirrors, schoolgirl samplers, needlework of various kinds, and compass points in maps.[103]

The American folk or naive style, we can sense in retrospect, was ideal for Shaker needs, and their version was often stark, being ordered in composition, and rarely sensuous in surface treatment. There is little perspective in Shaker style, and any represented depth is minimal and does not appear to

Figure 5.4. Attributed to Sarah Bates, *From Holy Mother Wisdom to Hannah Ann Treadway (Shaker Inspirational Drawing)*, 1845, blue and red ink, pen and wash, colored paint, on white paper, 15 x 20¾ inches. (Philadelphia Museum of Art, gift of Mr. and Mrs. Julius Zieget, 1963–160–2. Photo: PMA.)

be studied or academic (cf. fig. 5.5); in this inspirational work from midcentury by Sarah Bates (1792–1881) of New Lebanon, the design elements mostly run parallel to the picture plane. Here, as in most other Shaker works, objects and creatures are usually separated from each other and mostly do not touch each other. Among the more difficult achievements in the academic tradition is to represent overlapping elements in an artful and continuous fashion, and Shakers, even skillful ones, rarely attempted it to any great extent (cf. fig. 5.6). Shaker coloring is sometimes bright, but usually simple in articulation, with little modeling or gradation of hue. There are no cast shadows in Shaker art, one of the mainstays of Western art since the fifteenth century, a device that shows an object or figure in real space and light. No outside source of light ever appears in Shaker artmaking. Illumination might be present from a sun

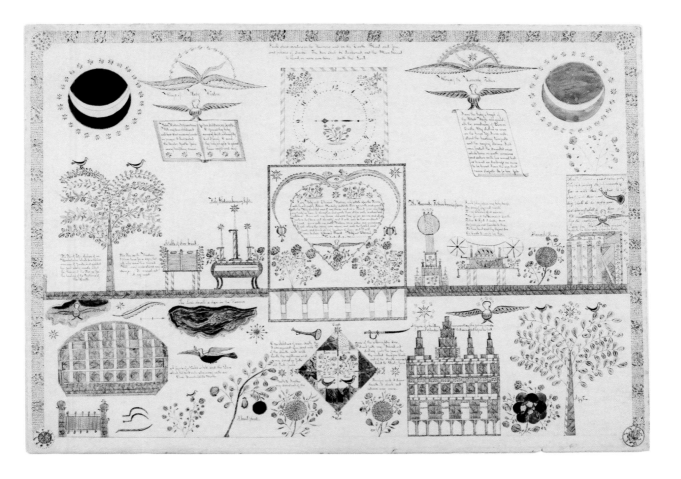

Figure 5.5. Sarah Bates, *Wings of Holy Wisdom, Wings of the Heavenly Father*, Mount Lebanon, New York Church Family, First Order (sacred roll), 1843–58, blue ink, with red and blue watercolor on white paper, 19½ x 27½ inches. (Philadelphia Museum of Art, gift of Mr. and Mrs. Julius Zieget, 1963–160–1. Photo: PMA.)

or some obvious internal and literal source, but those internal elements do not supply the source for modeling or shadowing within the work. There is no atmospheric, or aerial, perspective, with distance or atmosphere causing a change in color or clarity to objects. On the contrary, all of the air is clear and neutral. Very rarely do Shakers use chiaroscuro or shadows to model form in three dimensions. There is a fairly insistent emphasis on ordering and compartmentalization. Geometric shapes often appear, and objects within the works often get geometricized. There is a great deal of profilism, as in representing birds in profile, as occurs in much abstract art (fig. 5.7; see also fig. 5.6). Along these same lines, bird tails are nearly always tipped up and lie flat on the picture plane rather than receding back in space and foreshortened. All of this simplicity and starkness worked perfectly for Shakers, who sought to

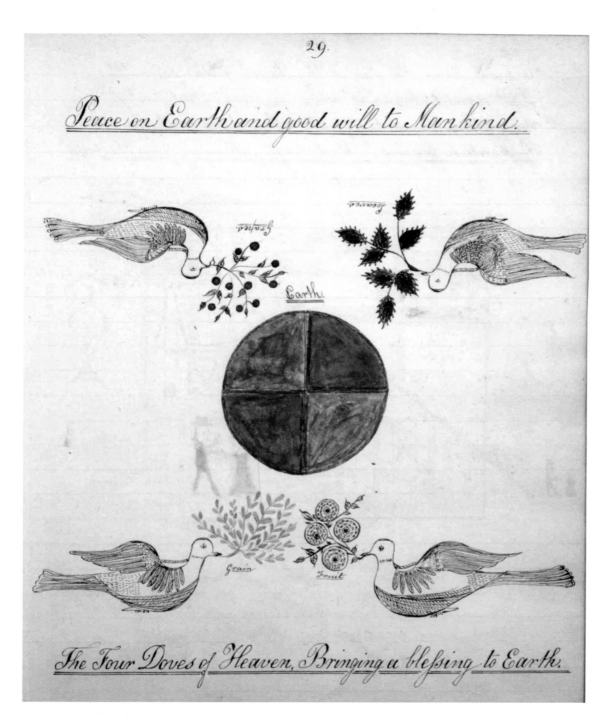

Figure 5.6. Miranda Barber, *Peace on Earth and good will to Mankind*, 1843, pen and ink and watercolor on paper, 8½ x 6¹³⁄₁₆ inches, in "A volume of Inspired Writings." (Cleveland, Ohio, Western Reserve Historical Society, Shaker Manuscripts, Series VIII: C-1, 29. *Photo:* WRHS.)

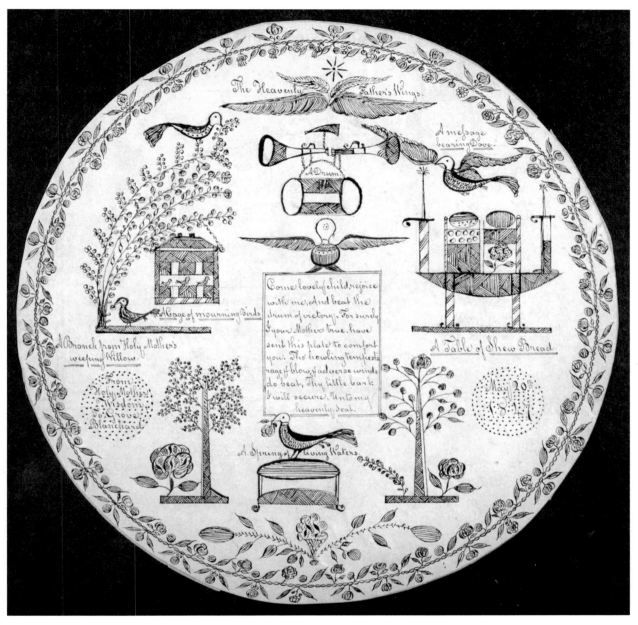

The Heavenly Father's Wings.

A message bearing Dove.

A Drum.

A Cage of mourning Birds.

A Branch from Holy Mother's weeping Willow.

From Holy Mother's Wisdom To Grove Blanchard

Come lovely child rejoice with me, And beat the drum of victory, For surely thy Mother true, have sent this plate to comfort you. Tho' howling tempest rage & blow, & adverse winds do beat, Thy little bark I will secure, Unto my heavenly seat.

A Table of Shew Bread.

May 20th 1847

A Spring of living Waters

Figure 5.7. Unknown artist, *Come lovely child, rejoice with me,* pen and ink on paper, 6⅝ inches in diameter, 20 May 1847. (Cleveland, Ohio, Western Reserve Historical Society, Shaker Manuscripts, Series VIII, C-2, loose sheet. *Photo:* WRHS.)

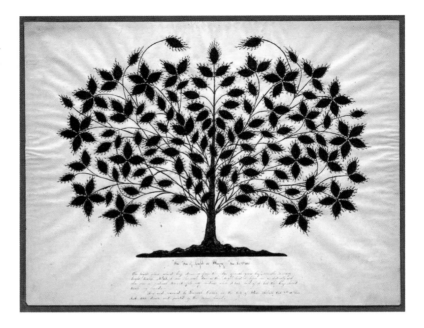

Figure 5.8. Hannah Cohoon, *The Tree of Light* or *Blazing Tree*, 1845, pen and ink and watercolor on paper, 18⅛ x 22⁹⁄₃₂ inches. (Pittsfield, Massachusetts, Hancock Shaker Village, Andrews Collection. *Photo:* HSV.)

evoke visionary and spiritual realms and also wished to avoid the niceties of sensuous style that, for their part, many of the people of the world prized. In music early Shakers omitted harmonization, counterpoint, and instrumental accompaniment; their visual styles achieved the same directness and clarity.

When Shakers did design with a more fervent and less controlled manner, that too was consonant with Shaker lived experience of visionary trances. Sometimes, one saw in Shaker art a kind of ecstatic representation of details, such as the flaming leaves in the vibrant and expressive 1845 *Tree of Light* of Hannah Cohoon (fig. 5.8), a design produced, like many of the most creative Shaker artworks, at the height of the fervor of the Era of Manifestations. Also striking is the widespread use of wording or lettering in Shaker spirit art. A large number of the Shaker visionist drawings or paintings have written text on the same design area or on the borders or even within the same design area, with the words tucked or wedged in between representational elements. We can conclude that, however grounded or rooted in other ideas and traditions, there was a recognizable Shaker art form: stark, minimal design or, conversely, ecstatic design suggestive of powerful visions; use of visionary verbiage; and Shakers' own particular iconography.

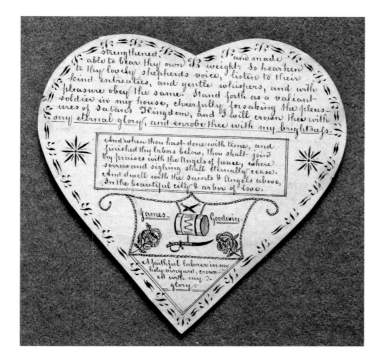

Figure 5.9. Polly Jane Reed, *Heart-Shaped Cutout, to James Goodwin: "The Word of the Holy Heavenly Father,"* 1844, pen and ink on paper, 4 x 4¹⁄₁₆ inches. (Pittsfield, Massachusetts, Hancock Shaker Village. *Photo:* HSV.)

Many of the iconographic elements characteristic of Shaker art were of long-standing tradition in America and Europe. Hearts and flaming hearts appeared regularly in Renaissance and baroque art to symbolize divine love and charity, and they appear in American folk art as well.[104] In Shaker design, some works are heart-shaped cutouts, as in a set signed by New Lebanon Shaker Polly Jane Reed (1818–81), datable to 1844 (fig. 5.9).[105] Other familiar Shaker themes are stars, the sun and moon, rivers, leaves, bowers, fruit, mansions, furniture, and birds and other animals, including both familiar farms animals and exotic beasts native to other places. Trees, in particular, were an ideal theme for Shakers, as they had these aplenty in their communities, while the motif stood at the very beginning of Judeo-Christian iconography as the Tree of Life. The considerable modern scholarship on Shaker visionary art has discussed these images in detail and has located the iconography in the context of Shaker life and imagination.[106]

The principal focus of this book is on Shaker words, and it is helpful that the Shakers wrote so much on their sheets with images, sometimes with parallel

text, sometimes with the words as captions for the visual representations. A skillful drawing from 1853, attributed to assistance from New Lebanon and Sodus Shaker Polly Lawrence (but whose life dates were 1792–1826), reads: "By Mother Dana this is given, But Polly Laurance aids in drawing. 'Tis July first, in fifty-three, This little gift is sent to thee" (fig. 5.10). The design includes a remarkable gathering of Shaker iconic images: the willowy branches and drooping leaves stand for "Submission." An apparently flowering tree stand for "Order." A leafy tree on the lower left stands for "Quietness" and suggests what Shakers thought of nature and the tree-filled villages. Finally, the "Arbor of Peace" shows a simple chair with, apparently, a checkered, tape seat, simple legs and stretchers, and vertical turned gallery below a flat rail, an unusual inclusion of seating furniture. In these images combined with verbal texts, the wording is usually well integrated into the design area as a whole, the words placed around the imagery, or sometimes written in patterns, as when following the shape of a cutout. The words are often straightforward but helpful descriptions of that which was seen by the medium, as in the text and fiery hot leaves of the aforementioned Hannah Cohoon drawing *The Tree of Light* or *Blazing Tree* (fig. 5.8). "The bright silver color'd blaze streaming from the edges of each green leaf, resembles so many bright torches. N.B. I saw the whole Tree as the Angel held it before me as distinctly as I ever saw a natural tree. I felt very cautious when I took hold of it lest the blaze should touch my hand." This was "Seen and received by Hannah Cohoon in the City of Peace Sabbath Oct. 9th 10th hour A.M. 1845, drawn and painted by the same hand."[107] One drawing contains the equivalent of a still-life painting, and the words reference Native spirits, who, as we noted earlier, often appeared in visionary experiences and writings. In "A Dish of Fruit from The Native Spirits. With their kind love" (fig. 5.11), signed on the left "Joanna Mitchell," the work shows a bowl below and the scene is topped by a bird, while the basket of fruit is accompanied above left and right by a large cup and a crown, the whole bordered with leaves and berries.[108]

Sometimes the text and image are remarkably strong, both romantic and sublime in word and image, as in a colorful book of drawings of 1843 by Miranda Barber of New Lebanon, the designs attributed by her to the inspiration of Prophet Isaiah (fig. 5.12): "And from the Stones of their Walls shall come forth a Voice; and from the beams of their timber an answer to it against them. And they will flee to the Mountains for fear of the Lord And call on the rocks to cover them[.] And showers of blood will fall from Heaven and rivers will turn to blood. And the fishes of the seas will perish; and few will come

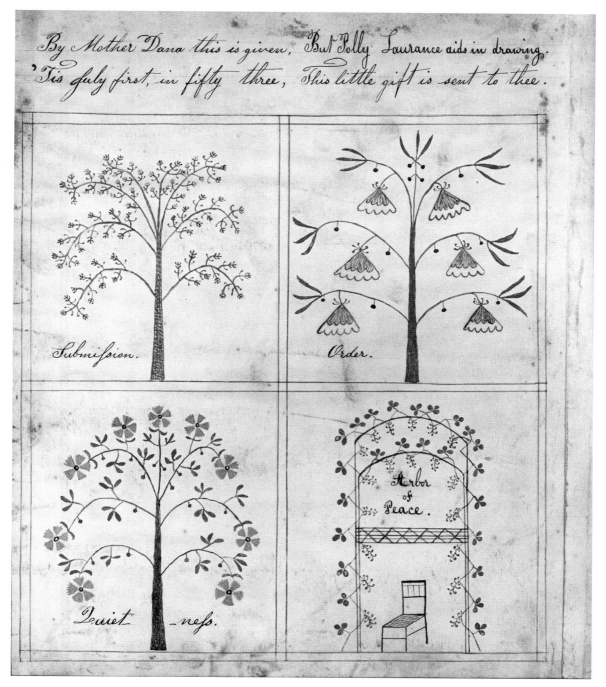

Figure 5.10. Unknown artist, *By Mother Dana this is given, But Polly Laurance aids in drawing*, 1 July 1853, pen and ink and watercolor on paper. (Washington, D.C., Library of Congress, Shaker Collection, Item 135, "Three water color paintings and a roll," loose sheet.)

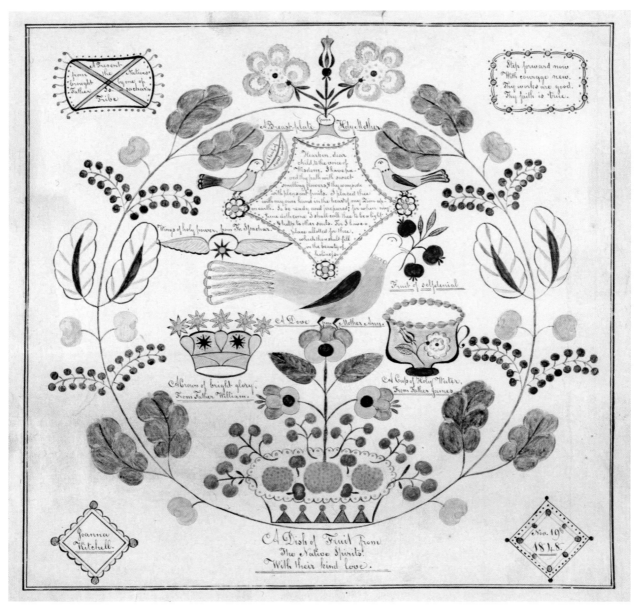

Figure 5.11. Joanna Mitchell, *A Dish of Fruit from The Native Spirits. With their kind love*, 1848, pen and ink and watercolor on paper. (Cleveland, Ohio, Western Reserve Historical Society, Shaker Manuscripts, Series VIII, C-7, loose sheet. *Photo:* WRHS.)

37

And showers of blood will fall from Heaven and rivers will turn to blood. And the fishes of the seas will perish; and fire will come up out of the midst of the deep.

Showers of Blood.

Rivers of Blood

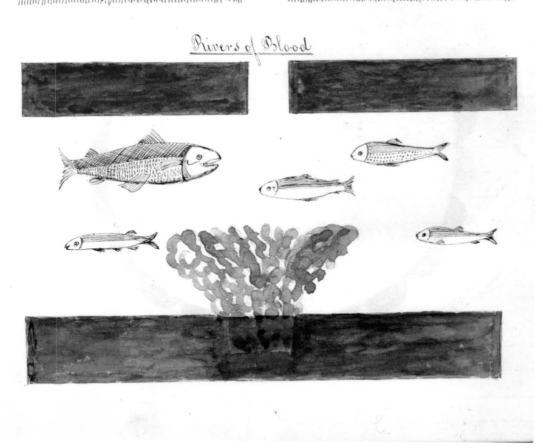

Figure 5.12. Miranda Barber, *Showers of Blood*, and *Rivers of Blood*, 1843, pen and ink and watercolor on paper, 8½ x 6¹³⁄₁₆ inches. (Cleveland, Ohio, Western Reserve Historical Society, Shaker Manuscripts, Series VIII, C-1, 36–37. *Photo: WRHS.*)

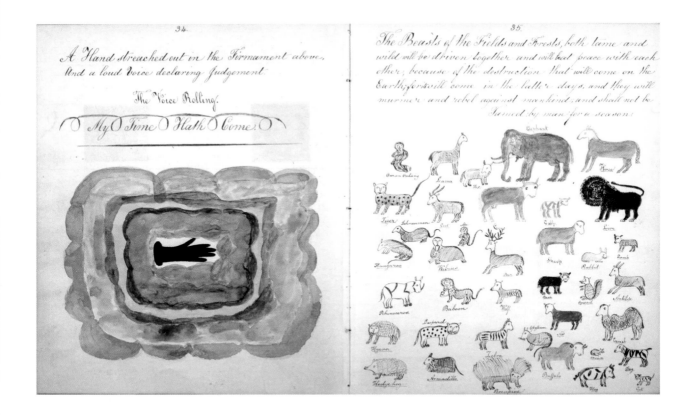

Figure 5.13. Miranda Barber, *My Time Hath Come* and *Beasts of the Fields*, 1843, pen and ink and watercolor on paper, each sheet 8½ x 6¹³⁄₁₆ inches. (Cleveland, Ohio, Western Reserve Historical Society, Shaker Manuscripts, Series VIII, C-1, 34–35. Photo: WRHS.)

up out of the midst of the deep." The piece includes a curiously ordered pair of rainfalls on either side labeled "Showers of Blood," and brightly colored, rectangular "Rivers of Blood" stand below that. The doomed fishes are swimming amid a stream of blood that, finally, breaks out of geometry and expands throughout the water. Across the book (not shown here) appears the powerful message "Wo! Wo! Wo! to the children of Men," which curves over rocks and mountains.[109] In the same book of watercolors, a painterly treatment of the "firmament" shows the hand of God and "The Voice Rolling. My time Hath Come" (fig. 5.13). On the right sheet, naive but charming representations of animals are, on the surface, more calming for the viewer, but the text tells us that the beasts, both domestic and wild, "will murmur and rebel against mankind, and shall not be Tamed by man for a season." Many of the animals are rather off the mark in verisimilitude, such as the tiger and orangutan, but the elephant is remarkably naturalistic, as is the lion, and these were likely drawn with the help of models from other artworks. This kind of work is the visual

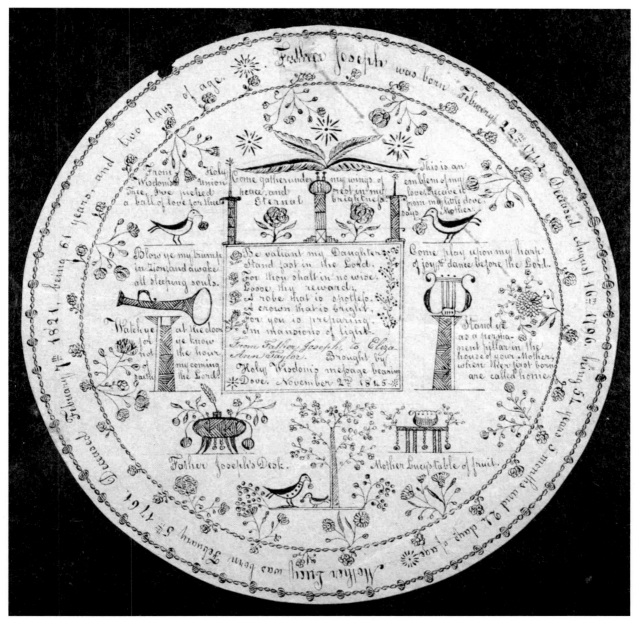

Figure 5.14. Unknown artist, New Lebanon community, *Father Joseph*, 2 November 1845, pen and ink on paper, 6 inches in diameter. (Cleveland, Ohio, Western Reserve Historical Society, Shaker Manuscripts, Series VIII, C-2, loose sheet. *Photo:* WRHS.)

equivalent of the apocalyptic visions conveyed in Shaker writings, especially from the Era of Manifestations. One such purely verbal "spirit message," to give an example, evokes strong visual, romantic imagery: Elvira C. Hulett, while in meeting in Hancock on 7 January 1844, was given a stunning vision of destruction of European cities and rulers: "O'er the valleys shall the Serpants of the great deep be hurled," and "many, many, shall be dashed beneath the ruins of their splendid cities." She proclaimed that we will see "splendid Cities, and whole vil[l]ages wrap[p]ed in flames."[110]

Despite any visionary extravagance, both verbal and visual, much of the Shaker inspirational art returns us to the calm daily life of the Shakers, with images replete with bowers, flowers, and trees, but sometimes the decorative elements recall the art of the world's people. A drawing from New Lebanon in 1845 (fig. 5.14) identifies within the circle the representations of "Father Joseph's Desk" and "Mother Lucy's table of fruit."[111] The furniture is fine but not extravagant, and the table includes a modest representation of fruit. The circular borders, stars, and inner circle decoration look like period stencil decorations or borderings on mirrors or other decorative arts. Another anonymous work from the same time, a fleshy representation of flowers on a table, is reminiscent in style of midcentury American tinware flowers, and the table also recalls period features in sophisticated furniture of the world's people (fig. 5.15). We have seen throughout this book that the Shakers were often never too far removed from worldly forms or ideas, even when they recast and translated them to their own beliefs and circumstances.

We have looked at the visual qualities of ideas spiritually received by Shakers, and to that we might add consideration of a modest sample of lyrics of songs, which generally were of religious content and would mostly be categorized as hymns or spirituals. It was not a visual art form, but Shaker songs contain words that evoke visual imagery and could serve in their own way as substitutes for the kinds of visual art not permitted to be created, framed, or hung on a Shaker wall. Unlike inspired two-dimensional art forms, which appeared largely during the Era of Manifestations and were shown under conditions, probably narrow, of which we are still uncertain, songs existed from the beginning of the Shaker sect, were vigorously shared and performed in groups in all villages, and numbered in the thousands. Like of other forms of art and beauty, Shakers often spoke of their lyrics as being received and the songwriter as a conduit from heaven to those on earth. The numerous Shaker songs that have survived supply a rich offering of texts about Shaker theological attitudes as well as aesthetics.[112] Carol Medlicott has written about the

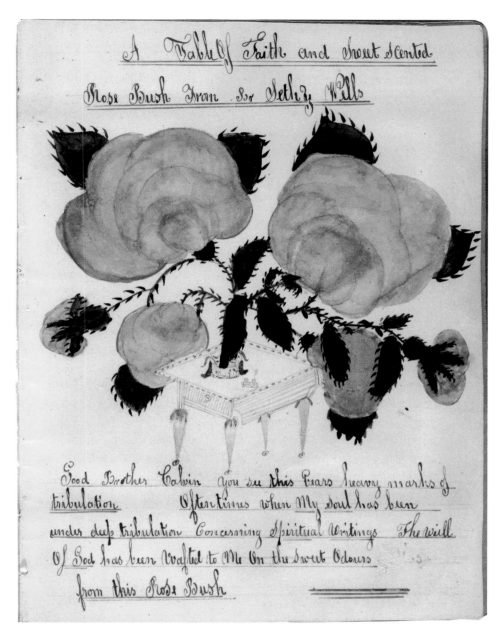

Figure 5.15. Unknown artist, *A Table of Faith and Sweet Scented Rose Bush From br[.] Seth Y[.] Wells*, ca. 1840, pen and ink and watercolor on paper, 6½ x 4⅝ inches. (Canterbury, New Hampshire, Canterbury Shaker Village. *Photo: CSV.*)

"Nature Metaphors" and tree, branch, and vine mentions in Shaker hymns.[113] For example, many Shaker songs involve descriptions of nature, sometimes with aspects of the romantic or sublime, as in the words of one song from Pleasant Hill (undated, but before 1850): "Low within the vale we lie / While raging storms are passing by." As part of the sublime, we saw in the second chapter the poem by Issachar Bates Sr. that was set to music by him, "The Sixteenth Day of January," with verses along the way used to describe crossing a river in 1809 "while the majestic current flowed / O'er all its banks so high and bold." And they passed "walnut, oak, and ches[t]nut timber / On ev'ry side the forest lin'd." The music is related to what became known as the song "Wayfaring Stranger."[114] A good deal of the pictorial sublime comes across in "The Rolling Deep," the lyrics of which date to 1826:

> The rolling deep may overturn
> The vallies sink[,] the mountains burn
> But thou my soul shall firmly stand
> Supported by [God's] righteous hand.[115]

Another aspect of the sublime, the feeling of awe and grandeur of God's universe, comes across in a Shaker song of 1845 from Canterbury, New Hampshire: "Hark, hark unto my voice, Ye lovely objects of my choice," and "O praised be God. Let his praise be resounding. Let the deserts rejoice and break forth into joy. Let the valleys arise and the high hills descend. Let every living thing in his praise be employed. Let the mountains rejoice. Let the rills skip and play. Let the rivers roll on in majesty. For the day of the Lord has come upon earth, and his saints shall be filled with his thanksgiving and mirth."[116] This is fine nature painting, carried out with words and made vivid by the musical score.

Rather than the sublime, many lyrics tended toward the soft, beautiful, and pastoral, as in "Verdant Groves" of 1846 (Enfield, New Hampshire):

> Here we walk in the verdant grove
> Where lilies fair are growing
> Here in love and sweet repose
> And gentle rivers flowing.[117]

Also in the realm of soft beauty, in the same song:

O here[']s a beautiful spreading vine
My little ones twill cover
And all who will be truly mine
Must 'neath its branches hover
And there no one shall make thee afraid
Ye little chosen number
For while you rest beneath its shade
I'll shield you from all danger.[118]

Another Shaker song mentions beautiful flowers, which Shakers could not grow for their beauty alone, and adds some jewels to the evocative description:

I have an assortment of beautiful flowers;
And now of my choicest take some.
I dwell in Mother's garden, among her green bowers.

Mother Ann sent these and other flowers and fruit, "With her love and her choicest of gems."[119] Another song for believers, "Basket of Flowers," mentions flowers, but makes it clear that they are wildflowers, which were permissible for Shakers to enjoy: "Here's a pretty little basket filled with flowers, / Which Mother sent me forth to gather this morn."[120] In a Shaker song from the mid-1840s, "Pleasant Path," we hear Mother Ann say to a believer: "I have placed before you a path that is pleasant & low."[121] In a little idyllic song, "The Nightegal," a songbird appears and lends its support to Shakerism:

Coo, coo, coo, coo
Chila cotha coo
I'll bring you Mother's love
I will bring you Mother's blessing.[122]

There is a good deal of moralization of nature in Shaker songs, as one would expect, as in "Willow Tree" from the 1840s: "I will bow and be simple. . . . like the willow tree," or a gift song perhaps from Union Village (by 1851), "O I will be free moving in simplicity / Bowing and bending like the limber willow tree."[123] Another song has implications of Shakers working hard, like a bee:

Like a little busy bee,
I'll fly around and gather honey
From every pretty flow'r
Which grows in Zion's bower.
Come, ev'ry busy bee,
Ye may freely share with me;
O it is a pretty treasure / From our holy Mother.[124]

Nature is sometimes regarded as a metaphor for Shaker religious life, as in a song from midcentury:

I've come unto my Vineyard
To prune each growing vine
That each may be producing
The choicest fruit divine.
I'll cut away the branches
That will no fruit produce
And cast them out my Vineyeard
As not of any use. . . . My Father then can glory
In such a lovely sight
And Wisdom too can view it
With joy & sweet delight.[125]

To conclude this chapter, we can say that, at every level, imagination helped to expand the realm of Shaker visual experience, whether through verbal spiritual messages, what we would call artworks, or song lyrics that evoked images of the natural world. Even at the imaginary level, the Shakers lived rich visual lives, far surpassing the restricted aesthetics that one would guess from their community laws and from a consideration of their plainest pieces of furniture.

LIST OF SHAKER COMMUNITIES

These are the organized Shaker communities in America that existed from soon after Ann Lee's death to the present, apart from the very short-lived or failed attempts to establish them. By the 1840s, Shakers often used second, spiritual, names for their villages; such an alternative name, if there was one, appears here after the place listing and the dates of duration of that community.

The map here (fig. A.1) shows the location of the Shaker communities that endured for at least two decades and reached a substantial level of population. Those same societies have received an asterisk in the list below.

CONNECTICUT:

*Enfield, Connecticut, 1792–1917; City of Union
New Canaan, Connecticut, 1810–12

FLORIDA:

Narcoossee, Florida, 1895–1924; Olive Branch

GEORGIA:

Brunswick, Georgia, 1898
White Oak, Georgia, 1898–1902

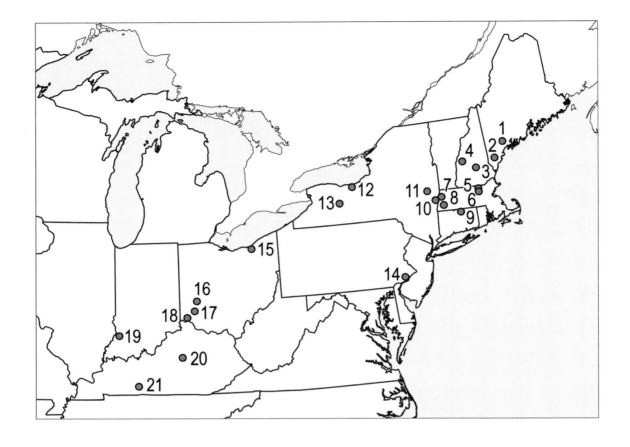

1	Sabbathday Lake (New Gloucester), Maine	11	Watervliet, New York
2	Alfred, Maine	12	Sodus, New York
3	Canterbury, New Hampshire	13	Groveland, New York
4	Enfield, New Hampshire	14	Philadelphia, Pennsylvania
5	Shirley, Massachusetts	15	North Union, Ohio
6	Harvard, Massachusetts	16	Watervliet, Ohio
7	Hancock, Massachusetts	17	Union Village, Ohio
8	Tyringham, Massachusetts	18	White Water (or Whitewater or White-Water), Ohio
9	Enfield, Connecticut	19	West Union (Busro), Indiana
10	New Lebanon (renamed Mount Lebanon in 1861), New York	20	Pleasant Hill, Kentucky
		21	South Union, Kentucky

Figure A.1. Map of long-lived and substantial Shaker communities. Created by Sandra Marcatili for the author.

INDIANA:

*West Union (Busro), Indiana, 1807–27

KENTUCKY:

*Pleasant Hill (Harrodsburg), Kentucky, 1806–1910; Pleasant Hill
*South Union, Kentucky, 1807–1922; Jasper Valley

MAINE:

*Alfred, Maine, 1793–1931; Holy Land
Gorham, Maine, 1807–19; Union Branch
Poland Hill, Maine, 1819–87 (part of the Sabbathday Lake community)
*Sabbathday Lake (New Gloucester), Maine, 1794–present; Chosen Land

MASSACHUSETTS:

*Hancock (and Pittsfield), Massachusetts, 1790–1960; City of Peace
*Harvard, Massachusetts, 1791/1792–1918; Lovely Vineyard
Savoy, Massachusetts, 1817–21
*Shirley, Massachusetts, 1793–1908; Pleasant Garden
*Tyringham, Massachusetts, 1792–1875; City of Love

NEW HAMPSHIRE:

*Canterbury, New Hampshire, 1792–1992; Holy Ground
*Enfield, New Hampshire, 1793–1923; Chosen Vale

NEW YORK:

Canaan, New York, founded 1813, formed part of the New Lebanon
 community
*Groveland, New York, 1836–92 (community relocated from Sodus in
 1836); Union Branch
*New Lebanon (renamed Mount Lebanon in 1861), New York, 1787–1947;
 Holy Mount
*Sodus, New York, 1826–36 (relocated to Groveland in 1836)
*Watervliet (Colonie), New York, 1775–1938; Wisdom's Valley

OHIO:

Darby Plains, Ohio, 1822–23 (community relocated to White Water, Ohio)
*North Union (Shaker Heights), Ohio, 1822–89; Holy Grove, or Valley of
 God's Pleasure

*Union Village (Turtlecreek Township), Ohio, 1805–1912; Wisdom's
 Paradise
*Watervliet (Kettering), Ohio, 1806–1900; Vale of Peace
*White Water (or Whitewater or White-Water) (New Haven), Ohio,
 1824–1916; Lonely Plain of Tribulation

PENNSYLVANIA:

*Philadelphia, Pennsylvania, 1858–ca. 1910? (a society of affiliated
 individuals rather than a community village)

For other published maps of Shaker sites, see Elmer R. Pearson and Julia
Neal, *The Shaker Image* (Boston: New York Graphic Society; Hancock, MA:
Shaker Community, 1974), 28; Julie Nicoletta, *The Architecture of the Shakers*,
photography by Bret Morgan (Woodstock, VT: Countryman Press, 1995), 15;
and online via the Digital Collections, Hamilton College Library: https://elib.
hamilton.edu/shaker-communities.

NOTES

ABBREVIATIONS

HSV,MillerLib, Hancock Shaker Village, Amy Bess and Lawrence K. Miller
 Library
LofC,ShakColl, Library of Congress, Shaker Collection
N-YHSML, New-York Historical Society Museum & Library
NYPL, ShakerMSColl, New York Public Library, Shaker Manuscript
 Collection
NYSL, ShakColl, New York State Library, Shaker Collection
OED, Oxford English Dictionary
OldChatKingLib, Old Chatham, Emma B. King Research Library at the
 Shaker Museum/Mount Lebanon
WilliamsCollLib, Williams College Library, Archives & Special Collections,
 Shaker Collection
WintAndrewsShakColl, Winterthur Museum, Garden and Library, Edward
 Deming Andrews Memorial Shaker Collection
WRHS, ShakerMSS, Western Reserve Historical Society, Shaker Manuscripts

INTRODUCTION

1 For early histories of the Shakers, see Benjamin Seth Youngs and Seth Youngs
 Wells, *The Testimony of Christ's Second Appearing* (Albany, NY: printed by E. and E.
 Hosford, 1810; second edition, "Corrected and Improved," "Published by Order of

the Ministry in Union with the Church"), xxi–xxxviii; and Charles Edson Robinson, *A Concise History of the United Society Believers, Called Shakers* (East Canterbury, NH: Robinson, 1893). For modern, broad histories of the Shakers, see Marguerite Fellows Melcher, *The Shaker Adventure* (Princeton, NJ: Princeton University Press, 1941; cited here from Cleveland, OH: Press of Western Reserve University, 1960); Henri Desroche, *The American Shakers: From Neo-Christianity to Presocialism*, translated from the French and edited by John K. Savacool (Amherst: University of Massachusetts Press, 1971), originally published as *Les Shakers américains: D'un néo-Christianisme a un pre-socialisme?* (Paris: Éditions de Minuit, 1955); Doris Faber, *The Perfect Life: The Shakers in America* (New York: Farrar, Straus and Giroux, 1974); John McKelvie Whitworth, *God's Blueprints: A Sociological Study of Three Utopian Sects* (London: Routledge & Kegan Paul, 1975), 13–88; Priscilla Brewer, *Shaker Communities, Shaker Lives* (Hanover, NH: University Press of New England, 1986); Flo Morse, *The Story of the Shakers* (Woodstock, VT: Countryman Press, 1986); Mick Gidley and Kate Bowles, eds., *Locating the Shakers: Cultural Origins and Legacies of an American Religious Movement* (Exeter, UK: University of Exeter Press, 1990); Stephen J. Stein, *The Shaker Experience in America: A History of the United Society of Believers* (New Haven, CT: Yale University Press, 1992); John T. Kirk, *The Shaker World: Art, Life, Belief* (New York: Harry N. Abrams, 1997); and Brian L. Bixby, "Seeking Shakers: Two Centuries of Visitors to Shaker Villages" (Ph.D. diss., University of Massachusetts–Amherst, 2010), 11–53. For essays published originally in French that interpret Shakers and Shakerism, see E. Richard McKinstry, trans., *The Shakers through French Eyes: Essays on the Shaker Religious Sect, 1799–1912* (Clinton, NY: Richard W. Couper Press, 2011).

2 Her original family name appears as Lees in some documents. For biographies of Ann Lee, see Arthur F. Joy, *The Queen of the Shakers* (Minneapolis: T. S. Denison, 1960); Nardi Reeder Campion, *Ann the Word: The Life of Mother Ann Lee, Founder of the Shakers* (Boston: Little, Brown, 1976); Marjorie Procter-Smith, "'Who do you say that I am?': Mother Ann as Christ," in *Locating the Shakers*, ed. Gidley and Bowles, 83–95; and Richard Francis, *Ann the Word: The Story of Ann Lee, Female Messiah, Mother of the Shakers, the Woman Clothed with the Sun* (London: Fourth Estate, 2001). Throughout the text here, life dates will be given at the initial mention of important names, unless one or both dates are unknown.

3 See the summary in Clarke Garrett, *Spirit Possession and Popular Religion: From the Camisards to the Shakers* (Baltimore: Johns Hopkins University Press, 1987), 150.

4 For the Shakers at Watervliet, see Dorothy M. Filley, *Recapturing Wisdom's Valley: The Watervliet Shaker Heritage, 1775–1975* (Albany, NY: Albany Institute of History and Art, 1975). *Niskayuna*, derived from Mohawk words, appears also in early documents as *Niskeyuna, Nisqueunia, Niskauna*, and other variants. The Shaker settlement was in what is now called Colonie, not the smaller adjacent city now called Watervliet, New York.

5 The literature on evolving Shaker beliefs is vast. For an important early Shaker text setting out theological beliefs, see Seth Youngs Wells and Calvin Green, *A Summary View of the Millennial Church, or United Society of Believers, (commonly called Shakers)* (Albany, NY: printed by Packard and Van Benthuysen, 1823). See also Frederick W.

Evans, *Shakers: Compendium of the Origin, History, Principles, Rules and Regulations, Government, and Doctrines of the United Society of Believers in Christ's Second Appearing* (New York: D. Appleton, 1859; reprint, New York: Lenox Hill, 1972). For some texts and modern overviews concerning Shaker theological tenets, see the texts and bibliography in Robley Edward Whitson, ed., *The Shakers: Two Centuries of Spiritual Reflection* (New York: Paulist Press, 1983); Kathleen Deignan, *Christ Spirit: The Eschatology of Shaker Christianity* (Metuchen, NJ: American Theological Library Association and Scarecrow Press, 1992); Stein, *The Shaker Experience in America*, 66–76; and Stephen C. Taysom, *Shakers, Mormons, and the Religious Worlds: Conflicting Visions, Contested Boundaries* (Bloomington: Indiana University Press, 2011).

6 Isaac Newton Youngs, "A Concise View of the Church of God and of Christ On Earth[.] Having its foundation In the faith of Christ's first and Second Appearing[.] New Lebanon 1856," 5–6, 7, Winterthur Library, Edward Deming Andrews Memorial Shaker Collection (hereafter cited as WintAndrewsShakColl), ASC 861b; transcribed also by Christian Goodwillie in Glendyne R. Wergland and Christian Goodwillie, eds., *History of the Shakers at New Lebanon by Isaac Newton Youngs, 1780–1861* (Clinton, NY: Richard W. Couper Press, 2017), 40. The title page of the manuscript includes a theologically important comma after the word *Christ*, but that comma is in a sharp pencil mark that was most likely added later. Not acknowledged on the manuscript's title page is that the last pages of the manuscript were written in 1860. For the biography of Youngs, see Jerry V. Grant and Douglas R. Allen, *Shaker Furniture Makers* (Hanover, NH: University Press of New England, published for Hancock Shaker Village, Pittsfield, MA, 1989), 35–51.

7 Hervey Elkins, *Fifteen Years in the Senior Order of Shakers: A Narration of Facts, Concerning that Singular People* (Hanover, NH: Dartmouth Press, [August] 1853), 18. James Hervey Elkins was brought by his father to live with Shakers in 1837, and he left in 1852. He signed his apostate account as Hervey Elkins. His narration is of great value in Shaker studies because of his intimate, critical, yet sympathetic view of Shaker life. He later became a Universalist minister. For his life, see John R. Eastman, *History of the Town of Andover, New Hampshire, 1751–1906* (Concord, NH: Rumford, 1910), 392.

8 A useful and extensive gathering of the writings of Shaker opponents can be found in Christian Goodwillie, *Writings of Shaker Apostates and Anti-Shakers, 1782–1850*, 3 vols. (London: Pickering & Chatto, 2013; London: Routledge, 2016). See also the discussion "Shakers and Anti-Shakers," in *Shaking the Faith: Women, Family, and Mary Marshall Dyer's Anti-Shaker Campaign, 1815–1867*, by Elizabeth A. De Wolfe (New York: Palgrave Macmillan, 2004), 1–18.

9 Valentine Rathbun, *Some Brief Hints of a Religious Scheme, Taught and Propagated, by a Number of Europeans Living in a Place Called Nisqueunia in the State of New York* (Norwich, CT: John Trumbull, 1781; several later editions published in Boston, Salem, and New York in 1782–83), 3–10 for the quotes given here. Also published by him as *An Account of the Matter, Form and Manner of a New and Strange Religion, Taught and Propagated by a Number of Europeans living in a Place called Nisqueunia in the State of New-York* (Providence, RI: printed by Bennett Wheeler, 1781). Another early account with similar revelations or claims of Shaker behavior is Amos Taylor,

A Narrative of the Strange Principles, Conduct and Character of the People Known by the Name of Shakers (Worcester, MA: printed [by Isaiah Thomas] for the author, 1782). Written somewhat later, but claiming to gather testimony from those who criticized early Shaker behavior and methods of proselytizing, is Mary [Marshall] Dyer, *A Portraiture of Shakerism* (n.p.: printed for the author, 1822).

10 Frederick W. Evans, *Who is Ann Lee? What Evidence is There That She is the Second Messiah?* (Mt. Lebanon, Columbia Co., NY: n.p., 1889), 6, 12; "Testimony of Eunice Bathrick" (Harvard, MA), 31, Western Reserve Historical Society, Shaker Manuscripts (hereafter cited as WRHS,ShakerMSS), Series VI, A-5.

11 The quote, date in 1808, and the signature of three authors appear in the preface to Youngs and Wells, *The Testimony of Christ's Second Appearing*, xii. The essentially identical passage appeared in Benjamin Seth Youngs, *The Testimony of Christ's Second Appearing Containing a General Statement of all Things Pertaining to the Faith and Practice of the Church of God in This Latter-Day* (Lebanon, OH: from the Press of John M'Clean, Office of the Western Star, 1808), 9–10. Linda A. Mercadante, *Gender, Doctrine, and God: The Shakers and Contemporary Theology* (Nashville: Abingdon Press, 1990), discusses at length Shaker beliefs concerning Ann Lee and the female element in Christ. Mercadante notes that the acceptance of Ann Lee's christological essence was not strong in the earliest Shaker thought, but developed over time in Shaker theology and became fully accepted by the early nineteenth century.

12 Winterthur Library, Joseph Downs Collection of Manuscripts and Printed Ephemera, COL. 596, William Goodell Papers, folder 1 "Autobiography," 37. The library catalog entry notes that the "date of the composition is unknown."

13 For an extended discussion of the Shaker belief in a gender-inclusive Godhead, encompassing both male and female elements, see the discussion "God Dual—Father and Mother," in *Shakers*, by Evans, 103–14. See also Mercadante, *Gender, Doctrine, and God*, esp. 74–115.

14 For a discussion for Shaker thought about Ann Lee as the Second Appearing, see Deignan, *Christ Spirit*, esp. 40–59, 94–124.

15 For concise summaries of the structure of Shaker societies, see Stein, *The Shaker Experience in America*, 87–122; and Glendyne R. Wergland, *One Shaker Life: Isaac Newton Youngs, 1793–1865* (Amherst: University of Massachusetts Press, 2006), 1–17.

16 For an analysis of Shaker celibacy, see Lawrence Foster, *Religion and Sexuality: Three American Communal Experiments of the Nineteenth Century* (New York: Oxford University Press, 1981), 21–71.

17 For questions about gender equality in Shakerdom, see Priscilla J. Brewer, "'Tho' of the Weaker Sex': A Reassessment of Gender Equality among the Shakers," in *Women in Spiritual and Communitarian Societies in the United States*, ed. Wendy E. Chmielewski, Louis J. Kern, and Marlyn Klee-Hartzell (Syracuse, NY: Syracuse University Press, 1993), 133–49.

18 Useful chronologies of the Shakers, including the opening and closing of various villages, appear in Edward Deming Andrews, *The People Called Shakers: A Search for the Perfect Society* (New York: Oxford University Press, 1953; reprint, New York: Dover, 1963), 290–92; Priscilla J. Brewer, "The Shakers of Mother Ann Lee," in *America's Communal Utopias*, ed. Donald E. Pitzer (Chapel Hill: University of North

Carolina Press, 1997), 50–52; and Holley Gene Duffield, *Historical Dictionary of the Shakers* (Lanham, MD: Scarecrow Press, 2000), xi–xiv.

19 See, for example, Marjorie Procter-Smith, *Women in Shaker Community and Worship: A Feminist Analysis of the Uses of Religious Symbolism* (Lewiston, NY: Edwin Mellen Press, 1985); Marjorie Procter-Smith, *Shakerism and Feminism: Reflections on Women's Religion and the Early Shakers* (Old Chatham, NY: Shaker Museum and Library, 1991); Jean M. Humez, ed., *Mother's First-Born Daughters: Early Shaker Writings on Women and Religion* (Bloomington: Indiana University Press, 1993); and Glendyne R. Wergland, *Sisters in the Faith: Shaker Women and Equality of the Sexes* (Amherst: University of Massachusetts Press, 2011). See also Louis Kern, *An Ordered Love: Sex Roles and Sexuality in Victorian Utopias: The Shakers, the Mormons, and the Oneida Community* (Chapel Hill: University of North Carolina Press, 1981).

20 Andrews notes that the "student of monasticism may notice in how many instances the [Shaker] Laws prescribe practices similar to those enjoined centuries earlier in the famous Rule of St. Benedict." Andrews, *The People Called Shakers*, 248.

21 See George Rapp, *Thoughts on the Destiny of Man, Particularly with Reference to the Present Times* (New Harmony, IN: Harmony Society, printed by Johann Christoph Müller, 1824 [actually printed in 1825]); and Karl J. R. Arndt, *George Rapp's Harmony Society, 1785–1847* (Philadelphia: University of Pennsylvania Press, 1965). See also Anne Taylor, *Visions of Harmony: A Study of Nineteenth-Century Millenarianism* (Oxford: Clarendon Press, 1987); and Robert P. Sutton, *Heartland Utopias* (DeKalb: Northern Illinois University Press, 2009), 13–37, for the Shakers and the Harmonists.

22 See John McKelvie Whitworth, *God's Blueprints: A Sociological Study of Three Utopian Sects* (London: Routledge & Kegan Paul, 1975), 89–119; Robert David Thomas, *The Man Who Would Be Perfect: John Humphrey Noyes and the Utopian Impulse* (Philadelphia: University of Pennsylvania Press, 1977); Lawrence Foster, *Religion and Sexuality: Three American Communal Experiments of the Nineteenth Century* (New York: Oxford University Press, 1981), 72–122; Spencer Klaw, *Without Sin: The Life and Death of the Oneida Community* (New York: Allen Lane, 1993); and Robert P. Sutton, *Communal Utopias and the American Experience: Religious Communities, 1732–2000* (Westport, CT: Praeger, 2003), 67–86.

23 See Gillian Lindt Gollin, *Moravians in Two World* (New York: Columbia University Press, 1967); and, for a broader look at Moravians and other religious communities in early America, Donald F. Durnburgh, "Communitarian Societies in Colonial America," in *America's Communal Utopias*, ed. Pitzer, 14–36.

24 For comparison of Shakers with other religious communities, see Sutton, *Communal Utopias and the American Experience*, 17–35, for a focus on the Shakers; and Sutton, *Heartland Utopias*.

25 "Millennial Laws, or Gospel Statutes and Ordinances Adapted to the Day of Christ[']s Second Appearing[.] Given & established in the Church for the protection thereof, by Father Joseph Meacham, and Mother Lucy Wright, The Presiding Ministry, And by their Successors, the Ministry & Elders, Recorded at New Lebanon, August 7th 1821. Revised and Re-established by the Ministry & Elders.

October 1845" (short title to be used hereafter in these notes), Part I, Section III, nos. 3 and 9, 32 and 35–36, Library of Congress, Shaker Collection, item 100 (hereafter cited as LofC,ShakColl); the Millennial Laws of 1845 transcribed here were affirmed (p. 243) on 20 March 1846 by Ruth Landon (1775–1850), Asenath Clark, Ebenezer Bishop (1768–1849), and Rufus Bishop, all of the Central Ministry. See also a transcription in Andrews, *The People Called Shakers*, 256–57.

26 "Millennial Laws, or Gospel Statutes and Ordinances," October 1845 (revised from the laws of August 1821), Part II, Section XVI, nos. 4 and 5, 156–57, LofC,ShakColl, item 100. See also a transcription in Andrews, *The People Called Shakers*, 277.

27 Rufus Bishop, "A Daily Journal of Passing Events; begun January the 1st, 1830. By Rufus Bishop, in the 56th year of his age" (in three volumes; vol. 3 covers from 2 January 1850 until Bishop's death in August 1852, then continued by other hands until 19 October 1859), vol. 3, 14 May 1853, 109, New York Public Library, Shaker Manuscript Collection (hereafter cited as NYPL,ShakerMSColl), no. 3. Bishop had died in the previous year; this entry was a continuation of his journal of events at New Lebanon, the continuation written by several hands over time.

28 *Peculiarities of the Shakers Described in a Series of Letters from Lebanon Springs, in the Year 1832 . . . by a Visiter* (New York: J. K. Porter, 1832), 39.

29 David R. Lamson, *Two Years' Experience Among the Shakers* (West Boylston, MA: published by the author, 1848), 27–29.

30 Ibid., 30–31.

31 Green and Wells, *A Summary View of the Millennial Church*, 2.

32 Charles Nordhoff, *The Communistic Societies of the United States; From Personal Visit and Observation* (New York: Harper & Brothers, 1875), 164–65.

33 See especially Henry Home, *Sketches of the History of Man*, 4 vols. (Dublin: printed for James Williams, 1774–75). For a summary of eighteenth-century Scottish thought about economic progress and luxury, see David Spadafora, *Idea of Progress in Eighteenth-Century Britain* (New Haven, CT: Yale University Press, 1990), 253–320.

34 John Brown, *Estimate of the Manners and Principles of the Times* (London: printed for L. Davis and C. Reymers, 1757), 73. See the extended discussion of Brown's thesis in Spadafora, *Idea of Progress in Eighteenth-Century Britain*, 213–23.

35 See John Bigelow, ed., *Autobiography of Benjamin Franklin* (Philadelphia: J. B. Lippincott, 1868), 210; and Joseph Manca, *George Washington's Eye: Landscape, Design, and Architecture at Mount Vernon* (Baltimore: Johns Hopkins University Press, 2012), 184–211.

36 For a consideration of Cole's series, with an emphasis on its moral meaning and relationship with Anglo-American ideas about luxury, see Alan Wallach, "Luxury and Downfall of Civilization in Thomas Cole's *Course of Empire*," in *Global Trade and Visual Arts in Federal New England*, ed. Patricia Johnston and Caroline Frank (Durham: University of New Hampshire Press; Hanover, NH: University Press of New England, 2014), 304–18.

37 Henry D. Thoreau, *Walden; or, Life in the Woods* (Boston: Ticknor and Fields, 1854), 17, 18, 40.

38 See Marcia Pointon, "Quakerism and Visual Culture, 1650–1800," *Art History* 20,

no. 3 (1997): 397–431, with an emphasis on restrained dress and wigs. Still, Quakers, unlike Shakers, never developed detailed and broadly applicable sets of guidelines about material culture.

39 "Journal of a visit by the ministers of Union Village [Ohio] and South Union [Kentucky] to eastern communities." Early part written by William Reynolds of Union Village, Ohio, and the later part by Nancy E. Moore, of South Union, Kentucky, 13 September 1854, 24. WRHS,ShakerMSS, Series V, B-250, 1854. (The demarcation line of authorship is not clear. The manuscript is written by one hand, and it is likely that either Moore or Reynolds took the notes that the other had written and wrote them cleanly at a later time and made one account manuscript of it all.)

40 For the decline of the sect in population, see Priscilla J. Brewer, "The Demographic Features of Shaker Decline, 1787–1900," *Journal of Interdisciplinary History* 15, no. 1 (1984): 31–52. For the decline of the society in the late nineteenth and early twentieth centuries, see Stein, *The Shaker Experience in America*, 337–53.

CHAPTER 1: THE SHAKERS AND THE HUMAN BODY

1 Michael Horsham referred to the engraving as a "rare portrait" of Ann Lee, lamenting that it "reveals little of her fabled charisma or alleged beauty." Horsham, *The Art of the Shakers* (Secaucus, NJ: Chartwell Books, 1989), 18–19. However, the story and source information behind the publication of the engraving serve rather to discourage our acceptance of its validity. George A. Lomas, editor of the *Shaker*, noted in a letter of 9 May 1871 to Samuel R. Wells that a picture he was sending to Wells, who had it engraved, was itself a "copy from a crayon" that was "purported to be psychometrically drawn by one Milleson, of New York." Lomas reported that a "test medium" and psychological expert, when presented with it, judged the picture to be not the portrait of a member of "some of the nobility of England," as had been thought, but that of Ann Lee. Lomas expressed his belief that the picture differed from most verbal descriptions of the appearance of Lee, although he acknowledged that some Shakers accepted the image as a true likeness. For the letter and a discussion of Lee and her appearance, see the article, unsigned but presumably by Samuel R. Wells, "Mother Ann Lee, The Shaker," in *Annual of Phrenology and Physiognomy for 1872*, published as part of Samuel R. Wells, *The Illustrated Annuals of Phrenology and Physiognomy for the Years 1865–6–7–8–9–70–1–2 & 3* (New York: Samuel R. Wells, 1872), 38–41.

2 "[Experience of] Thankful E. Goodrich. Born 1771. October 9," 1816, first page (no page numbers), New York Public Library, Shaker Manuscript Collection (hereafter cited as NYPL,ShakerMSColl), #14 (the witness sometimes appears as Eunice Thankful Goodrich in documents); Rufus Bishop and Seth Youngs Wells, *Testimonies of the Life, Character, Revelations and Doctrines of Our Ever Blessed Mother Ann Lee, and the Elders with Her* (Hancock, MA: printed by J. Tallcott & J. Deming, Junrs., 1816), 209; Bishop and Wells, *Testimonies* (1816), 212. For Barce's life, see Peter H. Van Demark, *The Journals of New Lebanon Shaker Elder Rufus Bishop*, vol. 2, *1840–1852* (Clinton, NY: Richard W. Couper Press, 2018), 393.

3 Calvin Green and Seth Youngs Wells, *A Summary View of the Millennial Church, or*

United Society of Believers, (commonly called Shakers) (Albany, NY: printed by Packard & Van Benthuysen, 1823), 6. That she was Green's mother, see his comment in the "Biographic Memoir of the Life and Experience of Calvin Green," 1861, 3 ("My Mother's name was Thankful Barce from Connecticut"), Western Reserve Historical Society, Shaker Manuscripts (hereafter cited as WRHS,ShakerMSS), Series VI, B-28. For another transcription of Green's memoir of 1861, and useful biographical information on Green's life and extensive editorial notes, see Glendyne R. Wergland and Christian Goodwillie, eds., *Shaker Autobiographies, Biographies and Testimonies, 1806–1907*, 3 vols. (London: Pickering & Chatto, 2014; London: Routledge, 2016), vols. 2–3. For Green, see also Van Demark, *Journals of Rufus Bishop*, 2:443; and Stephen J. Paterwic, *Historical Dictionary of the Shakers* (Lanham, MD: Scarecrow Press, 2008), also published as *The A to Z of the Shakers* (Lanham, MD: Scarecrow Press, 2009), 91–93.

4 Green and Wells, *A Summary View* (1823), 25; Benson John Lossing, "The Shakers," in *Harper's New Monthly Magazine* 15, no. 86 (1857): 177. See also Don Gifford, ed., *An Early View of the Shakers: Benson John Lossing and the "Harper's" Article of July 1857. With Reproductions of the Original Sketches and Watercolors* (Hanover, NH: University Press of New England, 1989; published for Hancock Shaker Village), 56.

5 Frederick W. Evans, *Shakers: Compendium of the Origin, History, Principles, Rules and Regulations, Government, and Doctrines of the United Society of Believers in Christ's Second Appearing* (New York: D. Appleton, 1859; reprint, New York: Lenox Hill, 1972), 121.

6 "The following Communication was given by Inspiration in the Meeting of the Church, at the Meeting-House in New Lebanon, Sabbath Afternoon, November 22: 1840, chiefly from the Prophet Daniel, by the request of Mother Ann, and written the next Day, by Inspiration from Father James, principally for the two Brethren, James Darrow and Stephen Euston, to carry to their beloved Ministry, at Union Village, in Ohio," 2, NYPL,ShakerMSColl, #94.

7 Grove B. Blanchard, "Daily Journal" (Harvard, MA), 1 March 1840, 181, WRHS,ShakerMSS, Series V, B-46.

8 See Jean McMahon Humez, ed., *Gifts of Power: The Writings of Rebecca Jackson, Black Visionary, Shaker Eldress* (Amherst: University of Massachusetts Press, 1981), 168. For her life, see also Richard E. Williams, *Called and Chosen: The Story of Mother Rebecca Jackson and the Philadelphia Shakers*, ed. Cheryl Dorschner (Metuchen, NJ: Scarecrow Press and American Theological Library Association, 1981). For an overview of women in Shaker society, see Glendyne R. Wergland, *Sisters in the Faith: Shaker Women and Equality of the Sexes* (Amherst: University of Massachusetts Press, 2011), with mention also of Jackson (46). See also Suzanne R. Thurman, *"O Sisters Ain't You Happy?": Gender, Family, and Community among the Harvard and Shirley Shakers, 1781–1918* (Syracuse, NY: Syracuse University Press, 2002).

9 Thomas Brown, *An Account of the People called Shakers* (Troy, NY: printed by Parker and Bliss, 1812), 330; Samuel Jones, "Statements against the Shakers, Samuel Jones, State of New York," 30 May 1825, the sheet marked on the top as a copy, Winterthur Library, Edward Deming Andrews Memorial Shaker Collection (hereafter cited as WintAndrewsShakColl), ASC 835.

10 David R. Lamson, *Two Years' Experience Among the Shakers* (West Boylston, MA: published by the author, 1848), 203.

11 "[Experience of] Thankful E. Goodrich. Born 1771. October 9," n.p., NYPL,ShakerMSColl, #14; T. Brown, *An Account of the People called Shakers*, 311.

12 "Biographical account of the Life, Character, and Ministry of Father Joseph Meacham, the Primary Leader in establishing the united order of the Millennial Church. Collected from eye and ear witness, and personal observation; by Calvin Green. New Lebanon N.Y. A. D. 1827. Copied from the original by Elisha D. Blakeman[,] May 1859," 37–38, NYPL,ShakerMSColl, #110.

13 Lamson, *Two Years' Experience Among the Shakers*, 12; Evans, *Shakers*, 159.

14 "Account of Mother Lucy Wright's last visit to Watervliet," January 10–February 7, 1821, 8, WRHS,ShakerMSS, Series V, A-11, described as another copy of A-10 with the same title.

15 Calvin Green, "Biographic Memoir of Mother Lucy Wright by Calvin Green [1861], as copied by Alonzo Hollister," 73–74, WRHS,ShakerMSS, Series VI, B-27.

16 Benjamin Seth Youngs and Seth Youngs Wells, *The Testimony of Christ's Second Appearing* (Albany, NY: printed by E. and E. Hosford, 1810; 2nd ed., "Corrected and Improved," "Published by Order of the Ministry in Union with the Church"), xxvii.

17 Rufus Bishop, Seth Youngs Wells, and Giles Bushnell Avery, *Testimonies of the Life, Character, Revelations and Doctrines of Mother Ann Lee, and the Elders with Her*, 2nd edition (Albany, NY: Weed, Parsons, 1888), 119–20. Bethiah Prescott Willard, of the Harvard community, lived from 1758 to 1832.

18 Deborah Robinson, "A Short Sketch of our Journey to the East," 30 August 1850, 16–17, WintAndrewsShakColl, ASC 829; "Journal of a visit by the ministers of Union Village [Ohio] and South Union [Kentucky] to eastern communities," early part written by William Reynolds of Union Village, Ohio, and the later part by Nancy E. Moore, of South Union, Kentucky, 12 September 1854, 11, WRHS,ShakerMSS, Series VI, B-27. Moore had become ministry eldress in 1850. Van Demark, *Journals of Rufus Bishop*, 2:476. Reynolds was later made first in the ministry (in 1875).

19 Rufus Bishop, "A Daily Journal of Passing Events; begun January the 1st, 1830. By Rufus Bishop, in the 56th year of his age" (in 3 vols.; vol. 1 covers 1 January 1830 to 18 May 1839), vol. 1, 11 May 1835, NYPL,ShakerMSColl, #1. Bishop died on 2 August 1852, but his journal was continued by various hands at New Lebanon until 1859. Another transcription of the journal, and information on Bishop's life, can be found in Van Demark, *Journals of Rufus Bishop*. For Bishop's life, see also Paterwic, *Historical Dictionary of the Shakers*, also published as *The A to Z of the Shakers*, 17–18.

The question of Shakers' bodies and relics, including this exhumation in 1835, is discussed in Salley M. Promey, *Spiritual Spectacles: Vision and Image in Mid-Nineteenth-Century Shakerism* (Bloomington: Indiana University Press, 1993), 119–20.

Information similar to Rufus Bishop's is recorded in Asenath Clark, "Diary. 1834–1836," 11 May 1835, WintAndrewsShakColl, ASC 1237. A photocopy of the journal can be found at Hancock Shaker Village, the Amy Bess and Lawrence K. Miller Library (hereafter cited as HSV,MillerLib), call #9758 C592, ID #1480, Asenath Clark, "Ministerial Journal, New Lebanon–Watervliet, N.Y., 1834–1836."

20 "A Little Book, Containing Scetches, of the Life and Gospel Travel of Elder John Hocknell. Given by Inspiration in The Church at Harvard. Commencing March 25th:1843," 25–26, WRHS,ShakerMSS, Series VIII, B-99.

21 "Account written by Alonzo G. Hollister of a visit to Watervliet and Groveland by Benjamin Lyon and others in August [1857]," 24 August 1857, WRHS,ShakerMSS, Series V, B-162; Youngs and Wells, *The Testimony of Christ's Second Appearing* (1810), 589.

22 See Eugene Parker Chase, ed. and trans., *Our Revolutionary Forefathers: The Letters of François, Marquis de Barbé-Marbois during his Residence in the United States as Secretary of the French Legation, 1779–1785* (New York: Duffield, 1929), 180–81.

23 Clarke Garrett, *Spirit Possession and Popular Religion: From the Camisards to the Shakers* (Baltimore: Johns Hopkins University Press, 1987), 181–82.

24 Bishop, "Daily Journal of Passing Events," vol. 1, 9 May 1835, NYPL,ShakerMSColl, #1.

25 Bishop and Wells, *Testimonies* (1816), 208; testimony by "E. C." (Ebenezer Cooley). For information of Cooley's later Shaker life, see Garrett, *Spirit Possession and Popular Religion*, 185–90; and Van Demark, *Journals of Rufus Bishop*, 2:419.

26 Written ca. 1849 by "witness Calvin Green" and titled "Book of Visions: Revelations. And Prophecies. Received at various times," 3 May 1828, 2, 10, 4, 12, HSV,-MillerLib, call #9758 G795, #3661.

27 "A Description of the Person and Character of Jesus Christ, As it was found in an ancient manuscript, sent by PUBLIUS LUTULUS, President of Judea, to the Senate of Rome," ca. 1850s, 1 page, printed, LofC,ShakColl, Item 166.

28 Prudence Morrell, "This little Book contains an account of a journey taken by Prudence Morrell & Eliza Sharp, to the West, in the year 1847," 4 June 1847, WRHS,ShakerMSS, Series V, B-141. Morrell's name is sometimes misspelled "Morrill" in some documents. She was sometimes known as Polly. Manuscripts of this travel account exist in a number of variant versions. The manuscript B-142 at the Western Reserve Historical Society is a copy of 1868 made by Eunice Bathrick. Another manuscript version, nearly identical to B-141 at the Western Reserve Historical Society, is at the Emma B. King Research Library at the Shaker Museum/ Mount Lebanon, Old Chatham (hereafter cited as OldChatKingLib), "A journey to the West in the year 1847," the exact title being "This little book contains an account of a journey, taken by Prudence Morrill & Eliza Sharp, to the West, in the year 1847." A photocopy of the Old Chatham manuscript is at HSV,MillerLib, call #9779, M874 ms. Xc., ID #2024. An early variant copy of the journal is at WintAndrewsShakColl, ASC 836, "Copy of a journal of a visit to The Western Societies by Prudence Morrell in 1847." A published transcription of the journal, based on a manuscript in the Shaker Library at Sabbathday Lake Shaker Village, is in Theodore E. Johnson, "Prudence Morrell's Account of a Journey to the West in the Year 1847," pts. 1–2, *Shaker Quarterly* 8, no. 2 (1968): 37–60; no. 3 (1968): 82–96.

For a discussion of the trip by Prudence Morrell and Eliza Sharp, including a map and a discussion of their accompaniment on the trip by fellow villager Robert White (1792–1856), see Sandra A. Soule, *Seeking Robert White: Quaker, Shaker Husband, Father* (Clinton, NY: Richard W. Couper Press, 2016), 161–84. For more on White,

see Sandra A. Soule, *Robert White Jr.: "Spreading the Light of the Gospel"* (Clinton, NY: Richard W. Couper Press, 2009).

29 Deborah Robinson (likely author), "A Short Sketch of our Journey to the East. 1850," 24 September 1850, 58, WintAndrewsShakColl, ASC 829; Milton Robinson, "Journal, 1830–1831" (described on a title page as "Written by Milton, of South Union, KY, was declining with consumption—took a sea voyage for the improvement of his health, & past Spirit Land Oct. 19, 1832, aged 25, here in New Lebanon. The rest of the story he relates himself"), 12 June 1831, LofC,ShakColl, Item 37 (a photocopy of the manuscript is available at HSV,MillerLib, call #9758, R663 Ms. Xc, ID #4379); "Journal kept by Elizabeth Lovegrove," 2 April and 10 April 1837, 4, 5, WintAndrewsShakColl, ASC 1221; Susan C. Liddell, "Journal kept by Susan C. Liddil on a visit to Clinton Valley [Ohio], October 31 to November 2 [1857]," 2 November 1857, WRHS,ShakerMSS, Series V, B-253. Her name is given as Susanna in some documents and usually as Liddel, not Liddil. She was alive in 1900, and the year of her death is unknown.

30 Hervey Elkins, *Fifteen Years in the Senior Order of Shakers: A Narration of Facts, Concerning that Singular People* (Hanover, NH: Dartmouth Press, [August] 1853), 38.

31 Bishop, "Daily Journal of Passing Events" (vol. 3 covers from 2 January 1850 until Bishop's death in August 1852, then continued by other hands until 19 October 1859), vol. 3, 28 August 1850, 16, NYPL,ShakerMSColl, #3; "Diary Kept by Sister Anna White, 1855–1873," 1 December 1857, NYPL,ShakerMSColl, #11; Charles Hodgdon, *Just Published, Hodgdon's Life and Manner of Living among the Shakers: Founded on Truth* (Concord, NH: published by the author, 1838). For information on Hodgon himself, see Christian Goodwillie, *Writings of Shaker Apostates and Anti-Shakers, 1782–1850*, 3 vols. (London: Pickering & Chatto, 2013; London: Routledge, 2016), 3:77 (quote), 73–74.

32 Elkins, *Fifteen Years in the Senior Order of Shakers*, 105–6.

33 Ibid., 99; Freegift Wells, "Ministry journal from Aug. 22, 1836 to May 1, 1837 including trips to Pleasant Hill & South Union, Ky. and North Union, Watervliet & Whitewater, O.[hio]," Sabbath meeting, 16 October 1836, WRHS,ShakerMSS, Series V, B-239. Freegift returned to Watervliet in 1836 and remained there. For biographical information on Wells, see Jerry V. Grant and Douglas R. Allen, *Shaker Furniture Makers* (Hanover, NH: University Press of New England, published for Hancock Shaker Village, Pittsfield, MA, 1989), 22–33. For information on his life, see also Paterwic, *Historical Dictionary of the Shakers*, also published as *The A to Z of the Shakers*, 231–33.

34 D. Robinson, "Short Sketch of our Journey," 2 October 1850, 87, 88, WintAndrewsShakColl, ASC 829; "A journal of the Ministrys Eastern Visit," commenced 19 June 1850, visit on 7 July 1850, 18, WRHS,ShakerMSS, Series V, B-147; Lamson, *Two Years' Experience Among the Shakers*, 91.

35 "A Journey and D. [to] the Eastern Societies of Believers, by the Ministry of the Holy Mount. Commenced June 19th 1850," 14 July 1850, WSHS,ShakerMSS, Series V, B-148. (Another manuscript, Series V, B-147, bears a similar title and is a journal of the same trip, but offers a different account and is written in another hand.)

36 Thomas Damon, "Journal of a trip from Enfield, Connecticut to Shaker communities

in Maine, New Hampshire, and Massachusetts. 1850," 6 October 1850, WintAndrewsShakColl, ASC 833. For the life of Damon, see Grant and Allen, *Shaker Furniture Makers*, 132–35.

37 "Journal of a visit by the ministers of Union Village [Ohio] and South Union [Kentucky] to eastern communities," early part written by Reynolds and the later part by Moore, 16 September 1854, 32, WRHS,ShakerMSS, Series V, B-250. For information on Damon's life, see Stephen J. Paterwic, *Historical Dictionary of the Shakers*, also published as *The A to Z of the Shakers*, 50–52.

38 "Journal of a visit by the ministers of Union Village [Ohio] and South Union [Kentucky] to eastern communities," early part written by Reynolds and the later part by Moore, 17 September 1854, 34, WRHS,ShakerMSS, Series V, B-250.

39 Hannah Agnew, "Journal of a Memorable Journey from White Water, Ohio. to New Lebanon. N.Y. Taken by Hannah R. Agnew when 16 years of age. In the Year 1836," 17 May 1836, 16, LofC,ShakColl, Item 50. Agnew is sometimes referred to in documents as Hannah Ann Agnew or Hannah R. Agnew. For information on Agnew, see Van Demark, *Journals of Rufus Bishop*, 2:386.

40 For Shaker writings about the body, including the nude body, see Etta M. Madden, *Bodies of Life: Shaker Literature and Literacies* (Westport, CT: Greenwood Press, 1998), 71–92.

41 Valentine Rathbun, *An Account of the Matter, Form, and Manner of a New and Strange Religion, Taught and Propagated by a Number of Europeans living in a Place called Nisqueunia, in the State of New-York* (Providence, RI: printed by Bennett Wheeler, 1781), 13. Rathbun gave his title as "Minister of the Gospel" to establish his credentials for his readers.

42 James Thacher, *A Military Journal during the American Revolutionary War, from 1775 to 1783* (Boston: Richardson and Lord, 1823), 169–70. For some outsider views of the Shaker dancing and its appearance, see discussion and illustrations in Robert P. Emlen, *Picturing the Shakers in the Era of Manifestations* (Clinton, NY: Richard W. Couper Press, 2015).

43 See T. Brown, *An Account of the People called Shakers*, 173. See also the discussion in John Symonds, *Thomas Brown and the Angels: A Study in Enthusiasm* (London: Hutchinson, 1961), 115.

44 T. Brown, *An Account of the People called Shakers*, 322; Daniel Rathbun, *A Letter from Daniel Rathbun of Richmond in the County of Berkshire, to James Whittacor* (Springfield, MA, 1785), 19, 93–94.

45 D. Rathbun, *A Letter from Daniel Rathbun*, 36.

46 "Mother Ann's Journey to Harvard, etc.," WRHS,ShakerMSS. The manuscript is a creative account of what Mother Ann said to a Shaker (unsigned document), and the quote is from A-5 (continuation of A-4), "My Journal Continued of Mother and the Two Elders," 1783.

47 D. Rathbun, *A Letter from Daniel Rathbun*, 30.

48 Bishop and Wells, *Testimonies* (1816), 140.

49 "Words of the Little Book. Father James' Word to the Elders, brethren and sisters of the Church. Written by his own hand for them. March 1st 1851," 75, WRHS,Shak-

erMSS, Series VIII, C-1. For some information on Barber, see Van Demark, *Journals of Rufus Bishop*, 2:393.

50 From *Extract from an Unpublished Manuscript on Shaker History* (Boston, MA: E. K Allen, 1850), cited in Goodwillie, *Writings of Shaker Apostates and Anti-Shakers*, 3:204. According to Goodwillie, it was written "by an anonymous female member of the South Family of the Harvard, Massachusetts, Shaker community" (189).

51 "A General Statement of the Holy Laws of Zion[.] Introduction by Father James[.] New Lebanon Thursday morning May 7th 1840" ["written by the hand of God Himself, and given to his two Anointed Ones to establish on earth"], 73, NYPL,ShakerMSColl, #10; "The Gospel Monitor[,] or A little Book of Mother Ann's Word To those who are placed to instruct children. Written by Mother Lucy, and brought by her to the Elders of the First Order, on the Holy Mount [New Lebanon]. March 1st, 1841. Copied by inspiration by Mother Ann's desire, March 2nd, 1842," 31, NYPL,ShakerMSColl, #9; "A Book of Rolls, Letters, Messages, & Communications to the Ministry and Elders, and individual members, Given by Divine Inspiration at New Lebanon, Not Recorded in Public Record Transcribed 1842;" 21 August 1840, 71, OldChatKingLib, cat. 12,306.

52 A balanced analysis of the subject appears in Stephen Stein, *The Shaker Experience in America: A History of the United Society of Believers* (New Haven, CT: Yale University Press, 1992), 160, who noted that Shakers avoided meting out corporal punishment but that it did sometimes occur in their communities.

53 Elkins, *Fifteen Years in the Senior Order of Shakers*, 30–31; "A General Statement of the Holy Laws of Zion[.] Introduction by Father James[.] New Lebanon Thursday morning May 7th 1840" ["written by the hand of God Himself, and given to his two Anointed Ones to establish on earth"], 76–78, NYPL,ShakerMSColl, #10; Elkins, *Fifteen Years in the Senior Order of Shakers*, 31; "A General Statement of the Holy Laws of Zion[.] Introduction by Father James[.] New Lebanon Thursday morning May 7th 1840" ["written by the hand of God Himself, and given to his two Anointed Ones to establish on earth"], 72–73, NYPL,ShakerMSColl, #10.

54 See T. Brown, *An Account of the People called Shakers*, 322.

55 See ibid., 335. The incident is discussed also in Glendyne R. Wergland, *One Shaker Life: Isaac Newton Youngs, 1793–1865* (Amherst: University of Massachusetts Press, 2006), 45. Slosson lived from 1759 to 1845 and dwelled at New Lebanon and Watervliet.

56 See T. Brown, *An Account of the People Called Shakers*, 322–23.

57 "Millennial Laws, or Gospel Statutes and Ordinances," October 1845 (revised from the laws of August 1821), Part I, Section IV, no. 11, 43, LofC,ShakColl, Item 100. See also a transcription in Edward Deming Andrews, *The People Called Shakers: A Search for the Perfect Society* (New York: Oxford University Press, 1953; reprint, New York: Dover, 1963), 258.

58 Jane D. Knight, "Journal," 1833–1836, 1838, New Lebanon, October 1834, 49, Old-ChatKingLib, #32, 10,362.

59 Isaac N. Youngs, "Tour thro the states of Ohio and Kentucky, 1834," vol. 1, 25 June 1834, 37–38, OldChatKingLib, 12,751 (vol. 1) and 12,752 (vol. 2).

60 Sarah Ann Lewis (called in some documents as Susan Ann Lewis), "A Small Memorandum Kept while on a Journey to the East" (recording a trip from New Lebanon to seven Shaker communities), 6 September 1849, 45, OldChatKingLib, 10,483; "A journal of the Ministrys Eastern Visit," commenced 19 June 1850, 24 July 1850, 44–45, WRHS,ShakerMSS, Series V, B-147; "Journal kept by Seth Y. Wells of a tour to the eastern Believers' schools," 11 June 1823, WRHS,ShakerMSS, Series V, B-302.

61 "Items of a Journey to Harvard, Shirley, Lynn, New York, etc.," trip taken by Aaron Bells, George Curtis (1806–73), and Abigail Crossman, journal likely written by Abigail Crossman (sometimes spelled "Crosman"), 24 August 1846, WRHS,ShakerMSS, Series V, B-140.

62 See the chapter on human oddities in R. W. G. Vail, *Random Notes on the History of the Early American Circus* (Barre, MA: Barre Gazette, 1956), 57–68. For a focus on periods somewhat later in time, see Janet M. Davis, *Culture & Society under the American Big Top* (Chapel Hill: University of North Carolina Press, 2002), esp. 82–206.

63 Bishop, "Daily Journal of Passing Events," vol. 1, 1 February 1835, NYPL,ShakerMSColl, #1; Sarah Ann Lewis (called in some documents Susan Ann Lewis), "A Small Memorandum Kept while on a Journey to the East" [recording a trip from New Lebanon to seven Shaker communities], 18 August 1849, 8, OldChatKingLib, 10,483; "Items of a Journey to Harvard, Shirley, Lynn, New York, etc.," trip taken by Aaron Bells, George Curtis, and Abigail Crossman, journal doubtless written by Abigail Crossman, 14 August 1846, WRHS,ShakerMSS, Series V, B-140.

64 Isaac N. Youngs, "Tour thro the states of Ohio and Kentucky, 1834," vol. 2, 15 September 1834, 48, OldChatKingLib, 12,751 (vol. 1) and 12,752 (vol. 2); Thomas Damon, "Memoranda, &c. mostly of Events and Things which have transpired since the first of Jan. 1846" (the journal actually begins 3 November 1845), 19 July 1848, 46–47, OldChatKingLib, #5, 13,357; photocopy available at HSV,MillerLib, call #9758, Da ms. xc., ID #342. Damon, coming from Enfield, Connecticut, had joined the Hancock Ministry on 1 January 1846.

65 John M. Brown, "Notes by the Way," written in 1866–71, the passage here written 5 August 1866, recording events from 18 to 21 July 1866, 39, WRHS,ShakerMSS, Series VII, B-127.

66 Elkins, *Fifteen Years in the Senior Order of Shakers*, 135.

67 Visit of 29 August 1790, recorded in William Loughton Smith, "Journal of William Loughton Smith, 1790–1791," *Proceedings of the Massachusetts Historical Society* 51 (October 1917): 50.

68 "A Journal, or an Account of a load of Brethren & Sisters at Second Family, Watervliet, N. York, Visiting Harvard & Shirley, Mass. June 1847," travelers listed as David Train Jr., Joel Smith, Eleanor Vedder, Polly Bacon, Thankful Copley (1782–1859), and Lucinda Harwood, from Watervliet, 1847; as written at the end of the (unpaginated) manuscript, for a journey that ended 19 June 1847, WRHS,ShakerMSS, Series V, B-332.

69 Henry C. Blinn, "Diary of a Journey from Canterbury, N.H. to Enfield & on to New Lebanon, N.Y. & to Hancock, Mass. in a Carriage," 30 June 1853, 95, OldChatKingLib, 12,792. For Shakers and their attitudes to blacks and to abolition, see Anita

Sanchez, *Mr. Lincoln's Chair: The Shakers and their Quest for Peace* (Granville, OH: McDonald & Woodward, 2009), 82–87. For Blinn's life, see Grant and Allen, *Shaker Furniture Makers*, 146–53.

70 Freegift Wells, "Diary of a trip from Watervliet, N.Y. to Cutchogue, Long Island" [journal entries from 1861 and 1863], 13 September 1861, 65, WRHS,ShakerMSS, Series V, B-344; "Journey" to Mount Lebanon, Watervliet, Hancock, & Tyringham, from Enfield, Connecticut, by Philip Burlingame, et al., 23 June 1856, WRHS,ShakerMSS, Series V, B-19.

71 Prudence Morrell, "This little Book contains an account of a journey taken by Prudence Morrell & Eliza Sharp, to the West, in the year 1847," 16, 17, 19 August 1847, WRHS,ShakerMSS, Series V, B-141.

72 Benjamin S. Youngs, "Diary of Three Brethren Going South" (John Meacham, Issachar Bates Sr., and Benjamin S. Youngs, going from New Lebanon to the southeast, beginning 1 January 1805), 23 March 1807, 216, this section called "A Journey to the Indians[,] Miami Near Lebanon Ohio. 3rd Month 1807," OldChatKingLib, 15,220; Thomas Damon, "Journal of a trip from Enfield, Connecticut to Shaker communities in Maine, New Hampshire, and Massachusetts. 1850," 4 October 1850, WintAndrewsShakColl, ASC 833.

73 "Divine Judgment's Law to the Children of the New Creation of God In every branch of His Zion on the Earth," 11 December 1859, 13, NYPL,ShakerMSColl, #109; Elkins, *Fifteen Years in the Senior Order of Shakers*, 26.

74 "Biographic Memoir of Mother Lucy Wright by Calvin Green [1861], as copied by Alonzo Hollister," 118, WRHS,ShakerMSS, Series VI, B-27; "Millennial Laws, or Gospel Statutes and Ordinances," October 1845 (revised from the laws of August 1821), Millennial Laws, Part IV, no. 17, 216, LofC,ShakColl, Item 100; see also a transcription in Andrews, *People Called Shakers*, 287.

75 "Millennial Laws, or Gospel Statutes and Ordinances," October 1845 (revised from the laws of August 1821), Millennial Laws, 1845, Part II, Section V, no. 18, 99, LofC,ShakColl, Item 100; see also a transcription in Andrews, *People Called Shakers*, 267.

76 Elkins, *Fifteen Years in the Senior Order of Shakers*, 24; "Millennial Laws, or Gospel Statutes and Ordinances," October 1845 (revised from the laws of August 1821), Part II, Section II, no. 3, 78, LofC,ShakColl, Item 100; see also a transcription in Andrews, *People Called Shakers*, 263.

77 "Millennial Laws, or Gospel Statutes and Ordinances," October 1845 (revised from the laws of August 1821), Part II, Section II, no. 1, 77; Part II, Section II, no. 4, 78, LofC,ShakColl, Item 100; and Part II, Section VII, no. 4, 113–14; see also a transcription in Andrews, *People Called Shakers*, 263, 269.

78 "Millennial Laws, or Gospel Statutes and Ordinances," October 1845 (revised from the laws of August 1821), Part II, Section VII, no. 8, 114–15, LofC,ShakColl, Item 100; and Part II, Section VIII, no. 15, 120; see also a transcription in Andrews, *People Called Shakers*, 270–71.

79 Winterthur Library, Joseph Downs Collection of Manuscripts and Printed Ephemera, COL. 596, William Goodell, "Papers," Folder 1—"Autobiography," 36. The library catalog entry notes that the "date of the composition is unknown."

80 Lamson, *Two Years' Experience Among the Shakers*, 166, 171; Goodwillie, *Writings of Shaker Apostates and Anti-Shakers*, 3:66–67. Original in John McBride, *An Account of the Doctrines, Government, Manners, and Customs of the Shakers. With Remarks on the Confessions of Catholic Priests and Shaker Elders* (Cincinnati, 1834).

81 "Millennial Laws, or Gospel Statutes and Ordinances," October 1845 (revised from the laws of August 1821), Millennial Laws, 1845, Part IV, no. 24, 218, LofC,ShakColl, Item 100; see also a transcription in Andrews, *People Called Shakers*, 288.

82 "A Communication Written by Father James[,] in union with the Ministry and by the request of our Heavenly Parents. . . . For the order of Young Believers in this the Zion of God upon Earth. New Lebanon. March 9[?], 1841." From "Part 2^nd: A Mother's Farewell Address!!," NYPL,ShakerMSColl, #17.

83 "A Journal or Day Book Containing some of the most important transactions of the Church [Family] of Harvard" and kept by the Sisters by order of the Ministry and Elders, 1840 [no particular date given], 1, WSHS,ShakerMSS, Series V, B-50; Shaker Library, Sabbathday Lake (New Gloucester), ME, "A General Statement of the Holy Laws of Zion," cat. no. 10-CL-020, New Lebanon, 7 May 1840, 86. A similar manuscript is "A General Statement of the Holy Laws of Zion[.] Introduction by Father James[.] New Lebanon Thursday morning May 7^th 1840" ["written by the hand of God Himself, and given to his two Anointed Ones to establish on earth"], NYPL,ShakerMSColl, #10.

84 "Gospel Monitor," 27, 29–30, NYPL,ShakerMSColl, #9; Lossing, "The Shakers," 166. See also Gifford, *An Early View of the Shakers*, 31.

85 "For the Ministry of the City of Peace" (Hancock, MA), "A Little Book containing a short word from Holy Mother Wisdom, concerning the Robes and Dresses that are prepared for all such as go up to the feast of the Lord, or attend to her Holy Passover, Copied July 20^th. 1842," no pages, LofC,ShakColl, Item 140. Another manuscript copy of the "Little Book," LofC,ShakColl, Item 141, also dated 20 July 1842, is signed A. C., J. J., C. P., and M. R.

86 For an analysis of Shaker clothing in the context of their beliefs and social structure, see Ulla Gohl-Völker, *Die Kleidung der Shakerschwestern im 19. Jahrhundert: Die Repräsentanz kategorialer Ordnungsbegriffe* (Münster: Waxmann, 2002).

87 Lossing, "The Shakers," 168. See also Gifford, *An Early View of the Shakers*, 36. Some extant Shaker shoes from the nineteenth century are of fine quality and support Benson's account. See Mario S. De Pillis and Christian Goodwillie, *Gather Up the Fragments: The Andrews Shaker Collection* (Hancock Shaker Village, MA, distributed New Haven, CT: Yale University Press, 2008), 259, the shoe illustrated there dating from ca. 1840 (Hancock Shaker Village 1963.304). See also 251–89 for a broader range of fine and often colorful clothing and other textiles.

88 Bishop, "Daily Journal of Passing Events" (vol. 2 covers from 19 May 1839 until 1 January 1850), vol. 2, 9 March 1847, 288, NYPL,ShakerMSColl, #2; vol. 3, 24 January 1851, 28, NYPL,ShakerMSColl, #3; Milton Robinson, "Journal, 1830–1831" (described on a title page as "Written by Milton, of South Union, KY, was declining with consumption—took a sea voyage for the improvement of his health, & past Spirit Land Oct. 19, 1832, aged 25, here in New Lebanon. The rest of the story he relates himself"), 9 June 1831, LofC,ShakColl, Item 37; signed "Ollive Spencer,"

statement dated 26 April 1840, following a list of "Wearing apparel for females" that is given on p. 1, quotes here from pp. 3–4, WintAndrewsShakColl, ASC 797.

89 Elkins, *Fifteen Years in the Senior Order of Shakers*, 105, 29–30, 79; Prudence Morrell, "This little Book contains an account of a journey taken by Prudence Morrell & Eliza Sharp, to the West, in the year 1847," 28 July 1847, WRHS,ShakerMSS, Series V, B-141; "Millennial Laws, or Gospel Statutes and Ordinances," October 1845 (revised from the laws of August 1821), Part III, section III, no. 4, 184, LofC,ShakColl, Item 100; see also a transcription in Andrews, *People Called Shakers*, 282; Hodgdon, *Just Published, Hodgdon's Life and Manner of Living*, cited from Goodwillie, *Writings of Shaker Apostates and Anti-Shakers*, 3:80.

90 "Journal concerning charges of disorderly conduct against Ransom Parks of Watervliet, N.Y.," 5 March 1845, 1–2, WRHS,ShakerMSS, Series V, A-14.

91 "Circular Concerning the Dress of Believers," 1866, signed by the "Ministry, Mount Lebanon, N.Y." and attributed to Giles B. Avery, 1 and 2, WintAndrewsShakColl, ASC 35. For the biography of Avery, see Grant and Allen, *Shaker Furniture Makers*, 112–15; Paterwic, *Historical Dictionary of the Shakers*, also published as *The A to Z of the Shakers*, 8–9; and Van Demark, *Journals of Rufus Bishop*, 2:390.

92 "Circular Concerning the Dress of Believers," 1866, signed by the "Ministry, Mount Lebanon, N.Y.," 9, WintAndrewsShakColl, ASC 35 (emphasis in the original); Isaac Newton Youngs, "A Concise View of the Church of God and of Christ On Earth[.] Having its foundation In the faith of Christ's first and Second Appearing[.] New Lebanon 1856," 334, WintAndrewsShakColl, ASC 861b; transcribed also by Christian Goodwillie, in Glendyne R. Wergland and Christian Goodwillie, eds., *History of the Shakers at New Lebanon by Isaac Newton Youngs, 1780–1861* (Clinton, NY: Richard W. Couper Press, 2017), 121.

93 A discussion of Shaker dancing and the patterns of their steps appears in Edward Deming Andrews, *The Gift to be Simple: Songs, Dances and Rituals of the American Shakers* (New York: J. J. Augustin, 1940), 143–57. As for figure 1.6, there were a number of variants on this popular composition, including this early version. For a discussion of these prints, see Robert P. Emlen, "The Shaker Dance Prints," *Imprint: Journal of the American Historical Print Collectors Society* 17, no. 2 (1992): 14–26. Emlen called this composition "wildly popular" and "the first image of Shaker life ever published" (14).

94 Bishop, "Daily Journal of Passing Events," vol. 3, 16 June 1850, 13, NYPL,ShakerMSColl, #3; vol. 1, 24 September and 24 December 1837, NYPL,ShakerMSColl, #1.

95 V. Rathbun, *An Account of the Matter, Form, and Manner of a New and Strange Religion*, 7, 10.

96 Isaac Newton Youngs, "A Concise View of the Church of God and of Christ On Earth[.] Having its foundation In the faith of Christ's first and Second Appearing[.] New Lebanon 1856," 74, WintAndrewsShakColl, ASC 861b; transcribed also by Christian Goodwillie, from Wergland and Goodwillie, *History of the Shakers*, 50. For a discussion of specific Shaker steps, such as the "square order shuffle," see Andrews, *The Gift to be Simple*, 146–55.

97 Stephen J. Stein, ed., *Letters from a Young Shaker: William S. Byrd at Pleasant Hill* (Lexington: University Press of Kentucky, 1985), 58.

98 Sally Bushnell, "A journal commenced January 1st, 1848" and goes through 1858, vol. 1, 17 September 1848, 42 (in three volumes: vol. 1, 10,347; vol. 2, 10,347-A; and vol. 3, 10,347-B), OldChatKingLib, 10,347; vol. 2, 11 August 1850, 5, OldChatKingLib, 10,347-A; Asenath Clark, "Diary. 1834–1836," 28 August 1836, WintAndrewsShak-Coll, ASC 1237. A photocopy of the journal can be found at HSV, MillerLib, call #9758 C592, ID #1480, Asenath Clark, "Ministerial Journal, New Lebanon–Watervliet, N.Y.,1834–1836."

99 Bishop, "Daily Journal of Passing Events," vol. 3, 17 August 1851 and 15 February 1852, 65, NYPL,ShakerMSColl, #3.

100 W. L. Smith, "Journal of William Loughton Smith," 49–50; Earl Gregg Swem, ed., *Letters on the Condition of Kentucky in 1825* (New York: Charles F. Heartman, 1916), 57–60; J. B. Dunlop, "Diary," 1810–1811, Sunday, 8 September 1810, New-York Historical Society Museum & Library, Patricia D. Klingenstein Library, Shaker Collection, 1822–79; Charles Dickens, *American Notes* 2 vols. (London: Chapman and Hall, 1842), 2:217. We do not know the print source for Dickens's critical opinion. For discussion of figure 1.7, see Robert P. Emlen, "Picturing the Shakers in the Popular Illustrated Press: Daily Life at Mount Lebanon in the Winter of 1869–70," *Winterthur Portfolio: A Journal of American Material Culture* 50, no. 4 (2016): 249–87.

101 Horace Greeley, "A Sabbath with the Shakers," *The Knickerbocker; or New York Monthly Magazine* 11, no. 6 (1838): 537. For Hawthorne's visit to Canterbury, New Hampshire, in 1831, see Hyatt Howe Waggoner, *Hawthorne: A Critical Study* (Cambridge, MA: Belknap Press of Harvard University, 1963), 40. See also the transcription in Flo Morse, *The Shakers and the World's People* (Hanover, NH: University Press of New England, 1987; first published New York: Dodd, Mead, 1980), 192. For Hawthorne's less favorable opinion of the sect in 1849, when he called them "the most singular and bedevilled set of people that ever existed in a civilized land," see his notebook entry from August 8 of that year in Nathaniel Hawthorne, *The American Notebooks by Nathaniel Hawthorne*, ed. Randall Stewart (New Haven, CT: Yale University Press, 1932), 229–30. For the broader question of visitors to Shaker communities, see Brian L. Bixby, "Seeking Shakers: Two Centuries of Visitors to Shaker Villages" (Ph.D. diss., University of Massachusetts–Amherst, 2010).

102 Daniel W. Patterson, *The Shaker Spiritual* (Princeton, NJ: Princeton University Press, 1979), 254, 393.

103 Goodwillie, *Writings of Shaker Apostates and Anti-Shakers*, 3:165.

104 Lossing, "The Shakers," 169. See also Gifford, *An Early View of the Shakers*, 40.

105 "Church meeting journal kept by request of the elders," 1844–46, 13 October 1844, 117, 121, WRHS,ShakerMSS, Series V, B-327.

106 Dickens, *American Notes*, 2:214–15.

107 Lossing, "The Shakers," 174. For the watercolors as a point of comparison, see Gifford, *An Early View of the Shakers*, figs. 14b and 14c, 3, 23, 50–51.

1 For some broader ideas about the Shakers and the theology of the world of nature, see Carl Benton Straub, *An Honorable Harvest: Shakers and the Natural World* (New Gloucester, ME: United Society of Shakers, 2009).

2 Thomas Cole, "Essay on American Scenery," *American Monthly Magazine* 1 (January 1836): 1.

3 Isaac Newton Youngs, "Journal kept by Isaac N. Youngs," 1 January 1856, Western Reserve Historical Society, Shaker Manuscripts (hereafter cited as WRHS,ShakerMSS), Series V, B-134.

4 Calvin Green, "Journal Kept by Calvin Green on a trip to Philadelphia and vicinity," 29 May 1828, WRHS,ShakerMSS, Series V, B-98. (Manuscript difficult to read; cited here from the typescript prepared by the WRHS, B-98A; title there given as "Journal, of a Journey to Philadelphia and its Vicinity—May, 1828: Kept by Calvin Green.") For a short biographical entry on Green, see Stephen J. Paterwic, *Historical Dictionary of the Shakers* (Lanham, MD: Scarecrow Press, 2008), also published as *The A to Z of the Shakers* (Lanham, MD: Scarecrow Press, 2009), 91–93. A similar account of Green's trip of May 1828 is included in his "Biographic Memoir of the Life and Experience of Calvin Green" (1861), 211–30, WRHS,ShakerMSS, Series VI, B-28, transcribed in Glendyne R. Wergland and Christian Goodwillie, eds., *Shaker Autobiographies, Biographies and Testimonies, 1806–1907*, 3 vols. (London: Pickering & Chatto, 2014; London: Routledge, 2016), vol. 2, esp. 213–31.

5 "A Journal, or an Account of a load of Brethren & Sisters at Second Family, Watervliet, N. York, Visiting Harvard & Shirley, Mass. June 1847," WRHS,ShakerMSS, Series V, B-332. The names of the travelers are listed as David Train Jr. (1777–1858), Joel Smith (1790–1870), Eleanor Vedder (1789–1883), Polly Bacon (1788–1861), Thankful Copley (1782–1859), and Lucinda Harwood (1796–1885), as written at the end of the (unpaginated) manuscript, for a journey that ended 19 June 1847.

6 Freegift Wells, "Freegift Wells set out on a journey to New Gloucester, by way of New Enfield—Canterbury–Alfred &c," 31–32, written after his return from the trip on 13 March 1852; journal begun 19 November 1851, WRHS,ShakerMSS, Series V, B-337.

7 Freegift Wells, "Diary of a trip from Watervliet, N.Y. to Cutchogue, Long Island" [journal entries from 1861 and 1863], 3 September 1861, 4, WRHS,ShakerMSS, Series V, B-344.

8 John M. Brown, "Notes by the Way," written in 1866–1871, the passage here written 5 August 1866, recording events from 18–21 July 1866, 51, WRHS,ShakerMSS, Series VII, B-127.

9 For a useful review of Shaker forms of literary expression, including travel journals, see Etta M. Madden, *Bodies of Life: Shaker Literature and Literacies* (Westport, CT: Greenwood Press, 1998), esp. 11–32, 113–23. For a substantial gathering of texts of another kind of Shaker literature, namely, autobiographies and testimonies, see Wergland and Goodwillie, *Shaker Autobiographies, Biographies and Testimonies*, esp. vol. 1 and the introduction to that Shaker genre, xi–xxxi.

10 "A Journal or Day Book Containing some of the most important transactions of the Church [Family] of Harvard" and kept by the Sisters by order of the Ministry and Elders, 1840 [no particular date given], 1, WRHS,ShakerMSS, Series V, B-50.

11 John F. Sears, *Sacred Places: American Tourist Attractions in the Nineteenth Century* (New York: Oxford University Press, 1989).

12 Benjamin S. Youngs, "Diary of Three Brethren Going South" (John Meacham, Issachar Bates, Sr., and Benjamin S. Youngs, going from New Lebanon to the Southeast, beginning 1 January 1805), 23 February 1805, 26–27, Old Chatham, Emma B. King Research Library at the Shaker Museum/Mount Lebanon (hereafter cited as OldChatKingLib), 15,220.

13 Seth Youngs Wells, "Journal of Seth Wells' tour among eastern believers to organize their schools," 18 August 1823, WRHS,ShakerMSS, Series V, B-3.

14 Seth Youngs Wells, "Journal of a Tour in the summer of 1832 to Sodus and Port Bay," 19 June 1832, 15, WRHS,ShakerMSS, Series V, B-103. The same journey is recounted in three variant manuscripts by Wells, the last being the most lively in language: B-101, B-102, and B-103, the first two given the title of "Journal kept by Seth Y. Wells of a visit to Port Bay [Sodus]"; B-101 is titled on the top of the first page "Bro. Seth's Visit to Believers at Sodus Bay."

15 Seth Youngs Wells, "Journal kept by Seth Y. Wells of a visit to Port Bay (Sodus)," mid-June 1832, 8, WRHS,ShakerMSS, Series V, B-101.

16 "Journal kept by Lucy Ann Hammond," from Hancock, Massachusetts, traveling to New Lebanon, Hancock, and Enfield, Connecticut, 16 October 1830, WRHS,ShakerMSS, Series V, B-39.

17 Sarah Ann Lewis (called in some documents Susan Ann Lewis), "A Small Memorandum Kept while on a Journey to the East" (recording a trip from New Lebanon to seven Shaker communities), 27 September 1849, 92, OldChatKingLib, 10,483.

18 Seth Youngs Wells, "Record of a journey from Alfred to Harvard to visit the schools," 25 September 1822, WRHS,ShakerMSS, Series V, B-1.

19 Henry C. Blinn, "Diary of a Journey from Canterbury, New Hampshire to Enfield & on to New Lebanon, New York & to Hancock, Mass. in a Carriage," 28 June 1853, 90, OldChatKingLib, 12,792.

20 Henry C. Blinn, "Diary of a Journey from Canterbury, N.H. to Enfield & on to New Lebanon, N.Y. & to Hancock, Mass. in a Carriage," 29 June 1853, 93, OldChatKingLib, 12,792.

21 Henry C. Blinn, "Diary of the Ministry's Journey to New Lebanon and Groveland," 21 July 1856, 52–53, OldChatKingLib, 12,792.

22 Giles Bushnell Avery, "Journal of a Trip to the Eastern Societies," 21 April 1843, 7 and 9, OldChatKingLib, 12,744.

23 "Journal of a visit to five societies of believers viz Enfield, Conn.[,] Tyringham and Hancock Mass.[,] New Lebanon and Waterviliet [sic] New York" by a company from Harvard, including Thomas Hammond Jr., Daniel Myrick (1814–68), Lucy Mackintosh (or McIntosh, or Sarah) (1781–1872), Rosalana (Roxalana) Grosvenor (1813–95), Olive Hatch Sr. (1774–1858), and Leonora Blanchard (b. 1810), 18 September 1846, 11, Williams College Library, Archives & Special Collections, Shaker Collection (hereafter cited as WilliamsCollLib), 21, J82 ("Anonymous journal of a

visit by a company from Harvard to five societies of believers: Enfield, Tyringham, Hancock, New Lebanon and Watervliet, 1846"). Photocopy also at Hancock Shaker Village, Amy Bess and Lawrence K. Miller Library, call no. 9758, Har ms. xc., ID #343 and 343a.

24 "Items of a Journey to Harvard, Shirley, Lynn, New York, etc.," trip taken by Aaron Bells, George Curtis, and Abigail Crossman, journal likely written by Abigail Crossman, 12 August 1846, WRHS,ShakerMSS, Series V, B-140.

25 Rufus Bishop, "A Daily Journal of Passing Events; begun January the 1st, 1830. By Rufus Bishop, in the 56th year of his age" (in 3 vols.; vol. 2 covers from 19 May 1839 until 1 January 1850), vol. 2, 6 September 1839, 24, New York Public Library, Shaker Manuscript Collection (hereafter cited as NYPL,ShakerMSColl), #2.

26 Absolem H. Blackburn, *A Brief Account of the Rise, Progress, Doctrines, and Practices of the People Usually Denominated Shakers* (Flemingsburg, KY: A. Crookshanks, 1824; reprint, Ashfield, MA: Huntstown Press, 1996), 21–22. See also Christian Goodwillie, *Writings of Shaker Apostates and Anti-Shakers, 1782–1850*, 3 vols. (London: Pickering & Chatto, 2013; London: Routledge, 2016), 2:242.

27 Henry C. Blinn, "Notes by the way, while on journey to the state of Kentucky in the year 1873," 8 May 1873, Canterbury Shaker Village, Archives, 9779 Bl, ID #1956 (photocopy at HSV,MillerLib, call #9758, B648, ID 6436). (Another version of Blinn's travel account is in OldChatKingLib, 12,791.) Another transcription, based on a manuscript in OldChatKingLib, appears in Theodore E. Johnson, "A Journey to Kentucky in the Year 1873 by Elder Henry C. Blinn," pts. 1–9, *Shaker Quarterly* 5, no.1 (1965): 3–19; no. 2 (1965): 38–55; no. 3 (1965); 69–79; no. 4 (1965): 107–33; 6, no. 1 (1966): 22–30; no. 2 (1966): 53–72; no. 3 (1966): 793–102; no. 4 (1966), 135–44; 7, no. 1 (1967): 13–22. For the quote from 8 May 1873, see 5, no. 1 (1965): 17.

28 Hervey Elkins, *Fifteen Years in the Senior Order of Shakers: A Narration of Facts, Concerning that Singular People* (Hanover, NH: Dartmouth Press, August 1853), 80.

29 For early dry accounts of travel, see "Journal of trips made by Elder Ebenezer and others from Mt. Lebanon to other communities," 1802–1804, WRHS,ShakerMSS, Series V, A-6; Western Reserve Historical Society, Shaker Manuscripts, "Journal kept by (Nathan Tiffany?) of a trip from Mt. Lebanon to Wheeling," 1806, WRHS,ShakerMSS, Series V, A-7; and WRHS,ShakerMSS, Series V, A-1, "From Mt. Lebanon to Hancock, etc." Nathan Tiffany, Jr. (1765–1840), lived at Enfield, Connecticut.

30 For widespread interest in Niagara Falls in the nineteenth century, see Elizabeth McKinsey, *Niagara Falls: Icon of the American Sublime* (Cambridge, UK: Cambridge University Press, 1985); and the essays in Jeremy Elwell Adamson, *Niagara: Two Centuries of Changing Attitudes, 1697–1901* (Washington, D.C.: Corcoran Gallery of Art, 1985).

31 Library of Congress, Shaker Collection, Item 169, "Journal kept by Naomi Ligier, 1840–1844," Union Village, Ohio, mid-June 1842. For information on her life, see Peter H. Van Demark, *The Journals of New Lebanon Shaker Elder Rufus Bishop*, vol. 2, *1840–1852* (Clinton, NY: Richard W. Couper Press, 2018), 465.

32 Amos Stewart, "Journal kept by A. S. of a visit to the western communities which he began on June 7 [1852]," 9 June 1852, 6, WRHS,ShakerMSS, Series V, B-150. This

is the same trip as recorded by Daniel Boler (1804–92), in Series V, B-152–156. For the biography of Stewart, see Jerry V. Grant and Douglas R. Allen, *Shaker Furniture Makers* (Hanover, NH: University Press of New England, published for Hancock Shaker Village, Pittsfield, MA, 1989), 56–63.

33 Isaac N. Youngs, "Tour thro the states of Ohio and Kentucky, 1834," vol. 1, 13 June 1834, 17, 24 June 1834, 35, OldChatKingLib, 12,751 (vol. 1) and 12,752 (vol. 2).

34 Seth Youngs Wells, "Journal of a Tour in the summer of 1832 to Sodus and Port Bay," 13 June 1832, 3–4, WRHS,ShakerMSS, Series V, B-103. (A less florid description of the same sight appears in Series V, B-101, a variant manuscript recording the same trip.)

35 *Oxford English Dictionary*, s.v. "sublime," adj. and noun; definitions 1b–c and 2.

36 Edmund Burke, *A Philosophical Enquiry into the Origin of Our Ideas of the Sublime and Beautiful* (London: Printed for R. and J. Dodsley, 1757); and a second edition, *A Philosophical Enquiry into the Origin of Our Ideas of the Sublime and Beautiful. With an Introductory Discourse concerning Taste, and several other Additions. A New Edition* (London: Printed for J. Dodsley, 1759).

37 William Gilpin, *Three Essays: On Picturesque Beauty; On Picturesque Travel; and On Sketching Landscape: to which is Added a Poem, On Landscape Painting* (London: printed for R. Blamire, 1792); Richard Payne Knight, *An Analytical Inquiry in the Principles of Taste* (London: printed for T. Payne and J. White, 1805); and Sir Uvedale Price, *An Essay on the Picturesque as Compared with the Sublime and the Beautiful* (London: J. Robson, 1796).

38 See, for example, Andrew Wilton and Tim Barringer, *American Sublime: Landscape Painting in the United States, 1820–1880* (Princeton, NJ: Princeton University Press, 2002), 152–54, for early praise of the representation of flowing water in Church's imagery of Niagara Falls.

39 Freegift Wells, "Freegift Wells set out on a journey to New Gloucester, by way of New Enfield—Canterbury–Alfred &c," 19 November 1851, 2–3, WRHS,ShakerMSS, Series V, B-337. (According to *The Oxford English Dictionary*, one definition of "season" is "a particular time or period during which something happens.")

40 Herman Melville, *Moby-Dick*, ed. Harrison Hayford and Hershel Parker (New York: W. W. Norton, 1967), 12.

41 E. L. Magoon, "Scenery and Mind," in *The Home Book of the Picturesque: Or American Scenery, Art, and Literature. Comprising a Series of Essays by Washington Irving, W. C. Bryant, Fenimore Cooper, Miss Cooper, N. P. Willis, [et al.].* (New York: G. P. Putnam, 1852), 27.

42 "Journal of a visit by the ministers of Union Village [Ohio] and South Union [Kentucky] to eastern communities." Early part written by William Reynolds of Union Village, Ohio, and the later part by Nancy E. Moore, of South Union, Kentucky, 27 September 1854, 94–95, WRHS,ShakerMSS, Series V, B-250. (The demarcation line of authorship is not clear. The manuscript is written by one hand, and it is likely that either Moore or Reynolds took the notes that the other had written and wrote them cleanly at a later time and made one account of it all.)

43 Deborah Robinson (likely author), "A Short Sketch of our Journey to the East.

1850," 5 September 1854, 28, Winterthur Library, Edward Deming Andrews Memorial Shaker Collection (hereafter WintAndrewsShakColl), ASC 829.

44 Sarah Ann Lewis (called in some documents Susan Ann Lewis), "A Small Memorandum Kept while on a Journey to the East" [recording a trip from New Lebanon to seven Shaker communities], 30 and 31 August 1849, 34–35, OldChatKingLib, 10,483.

45 Rufus Bishop, "A Daily Journal of Passing Events; begun January the 1st, 1830. By Rufus Bishop, in the 56th year of his age" (in 3 vols.; vol. 3 covers from 2 January 1850 until Bishop's death in August 1852, then continued by other hands until 19 October 1859), vol. 3, 10 June 1852, 74, NYPL,ShakerMSColl, #3. For the identification of Amos Stewart as the author this entry, see Demark, *Journals of Rufus Bishop*, 2:361nn35, 40.

46 Freegift Wells, "Ministry journal from Aug. 22, 1836 to May 1, 1837 including trips to Pleasant Hill & South Union, Ky. and North Union, Watervliet & Whitewater, O.[hio]," 26 August 1836, WRHS,ShakerMSS, Series V, B-239.

47 Benjamin Seth Youngs, "A journey to the Indians[,] Miami[,] near Lebanon, Ohio, 3d [third] month, 1807," about 24 March, 1807, 10, described as near the fort where Americans made peace with Indians, WintAndrewsShakColl, ASC 860.

48 William Leonard, "Autobiography of William Leonard," 69, WRHS,ShakerMSS, Series VI, B-5. For a discussion of Leonard and his travels, see Diane Sasson, *The Shaker Spiritual Narrative* (Knoxville: University of Tennessee Press, 1983), 116–32. See also Diane Sasson, "Not Such a Simple Life: The Case of William Leonard," *Shaker Quarterly* 20, no. 2 (1992): 37–51.

49 William Leonard, "Autobiography of William Leonard," 95, 97, WRHS,ShakerMSS, Series VI, B-5.

50 "Journal of a visit to five societies of believers viz Enfield, Conn.[,] Tyringham and Hancock Mass.[,] New Lebanon and Waterviliet [*sic*] New York" by a company from Harvard, including Thomas Hammond Jr., Daniel Myrick, Lucy Mackintosh (or McIntosh; or Sarah), Rosalana (Roxalana) Grosvenor, Olive Hatch Sr., and Leonora Blanchard, 22 September 1846, 23; 23 September 1846, 28; 24 September 1846, 31, WilliamsCollLib 21, J82 ("Anonymous journal of a visit by a company from Harvard to five societies of believers: Enfield, Tyringham, Hancock, New Lebanon and Watervliet, 1846").

51 Seth Youngs Wells, "Record of a journey from Alfred to Harvard to visit the schools," 19 August 1822, WRHS,ShakerMSS, Series V, B-1.

52 For accounts of views of the valley by the world's people, see David Schuyler, *Sanctified Landscape: Writers, Artists, and the Hudson River Valley, 1820–1909* (Ithaca, NY: Cornell University Press, 2012). See also Raymond J. O'Brien, *American Sublime: Landscape and Scenery of the Lower Hudson Valley* (New York: Columbia University Press, 1981).

53 "Items of a Journey to Harvard, Shirley, Lynn, New York, etc.," trip taken by Aaron Bells, George Curtis, and Abigail Crossman, journal likely written by Abigail Crossman, 24 August 1846, WRHS,ShakerMSS, Series V, B-140.

54 "Items of a Journey to Harvard, Shirley, Lynn, New York, etc.," trip taken by Aaron

Bells, George Curtis, and Abigail Crossman, journal likely written by Abigail Crossman, 24 August 1846, WRHS,ShakerMSS, Series V, B-140.

55 Thomas Hammond Jr., "Journal," 22 September 1846, 47, WRHS,ShakerMSS, Series V, B-36. Hammond's journal records events from 1839 to 1853, especially of a journey in 1846. A parallel diary of the 1846 trip, unsigned but written by one of Hammond's traveling companions, can be found at Williams College Library, Archives & Special Collections, Shaker Collection 21, J82, "Journal of a visit to five societies of believers viz Enfield, Conn.[,] Tyringham and Hancock Mass.[,] New Lebanon and Waterviliet [sic] New York" by a company from Harvard, including Thomas Hammond Jr., Daniel Myrick, Lucy Mackintosh (or McIntosh; or Sarah), Rosalana (Roxalana) Grosvenor, Olive Hatch Sr., and Leonora Blanchard, titled "Anonymous journal of a visit by a company from Harvard to five societies of believers: Enfield, Tyringham, Hancock, New Lebanon and Watervliet, 1846" at Williams College, and is cited in various places here. For the biography of Hammond, see Grant and Allen, *Shaker Furniture Makers*, 66–67.

56 "Diary of a journey by the ministry of Pleasant Hill and South Union, Kentucky, to visit the eastern Shakers, 1869," 28 June 1869, LofC,ShakColl, Item 35. Travelers included ministry leaders from Kentucky Harvey (or Hervey) Lauderdale Eads (or Eades) (1807–92), Eldress Betsy Smith (1813–97) (the probable author of the account), and Elder James Rankin (1792–1884) as well as New Lebanon Shaker Paulina (or Paolina) Bates, who moved to Watervliet in 1870. (Photocopy available at HSV,MillerLib, call no. 9758 S527, ID #4378. "Travel Journal of the Ministry from Pleasant Hill for Mt. Lebanon and the other Eastern Societies.") The trip extended from June to August 1869.

57 "Diary of a journey by the ministry of Pleasant Hill and South Union, Kentucky, to visit the eastern Shakers, 1869," 2 July 1869, LofC,ShakColl, Item 35.

58 Ibid., 21 July 1869.

59 Library of Congress, Shaker Collection, Item 35, "Diary of a journey by the ministry of Pleasant Hill and South Union, Kentucky, to visit the eastern Shakers, 1869," 10–11 June 1869.

60 "Diary of a journey by the ministry of Pleasant Hill and South Union, Kentucky, to visit the eastern Shakers, 1869," 11 June 1869, LofC,ShakColl, Item 35.

61 Ibid., 14 June 1869.

62 Giles B. Avery, "Journal or Diary of A Tour made by the Ministry of New Lebanon to the Shaker Societies in the Western States, Written by Elder Giles B. Avery," and Shaker travelers' names listed as Daniel Boler, Giles B. Avery, Betsy Bates, and A. Taylor, 19 June 1862, WRHS,ShakerMSS, Series V, B-163.

63 "Journal of a visit by the ministers of Union Village [Ohio] and South Union [Kentucky] to eastern communities." Early part written by William Reynolds of Union Village, Ohio, and the later part by Nancy E. Moore, of South Union, Kentucky, 28 September 1854, 109, WRHS,ShakerMSS, Series V, B-250.

64 "Items of a Journey to Harvard, Shirley, Lynn, New York, etc.," trip taken by Aaron Bells, George Curtis, and Abigail Crossman, journal likely written by Abigail Crossman, 14 August 1846, WRHS,ShakerMSS, Series V, B-140.

65 Benjamin Seth Youngs, "A journey to the Indians[,] Miami[,] near Lebanon, Ohio,

3d [third] month, 1807," about 17 March 1807, 2–3, WintAndrewsShakColl, ASC 860.

66 Isaac N. Youngs, "Tour thro the states of Ohio and Kentucky, 1834," vol. 1, 5 June 1834, 6, and 6 June 1834, 7, OldChatKingLib, 12,751 (vol. 1) and 12,752 (vol. 2).

67 Freegift Wells, "Journal of Freegift Wells kept on a visit to Marshall, Michigan, in June, 1855," [exact date uncertain] September 1855, WRHS,ShakerMSS, Series V, B-342.

68 Prudence Morrell, "This little Book contains an account of a journey taken by Prudence Morrell & Eliza Sharp, to the West, in the year 1847," 13 August 1847, WRHS,ShakerMSS, Series V, B-141.

69 Freegift Wells, "Ministry journal from Aug. 22, 1836 to May 1, 1837 including trips to Pleasant Hill & South Union, Ky. and North Union, Watervliet & Whitewater, O.[hio]," 29 August 1836, WRHS,ShakerMSS, Series V, B-239.

70 Isaac N. Youngs, "Tour thro the states of Ohio and Kentucky, 1834," Vol. 2, 8 September 1834, 33, OldChatKingLib, 12,751 (vol. 1) and 12,752 (vol. 2).

71 "Journal of William[']s Travel To the State of Ohio, 1 and 2 August 1810, 13–14, WintAndrewsShakColl, ASC 818. (A copy of the journal can be found at the Western Reserve Historical Society, Shaker Manuscripts, Series V, B-78, "Journal of William Demming's travels to Ohio and Kentucky including his visits to Union and South Union." Even ASC 818 at Winterthur is, according to a library record, possibly only a "fair copy" of Deming's original.)

72 "Journal of William[']s Travel To the State of Ohio, 4 August 1810, 15, WintAndrewsShakColl, ASC 818.

73 Isaac N. Youngs, "Tour thro the states of Ohio and Kentucky, 1834," vol. 1, 11 June 1834, 13, OldChatKingLib, 12,751 (vol. 1) and 12,752 (vol. 2). For the short-lived community of the Shakers at Sodus, see Herbert A. Wisbey Jr., *The Sodus Shaker Community* (Lyons, NY: Wayne County Historical Society, 1982). For the Shakers of Sodus and Groveland, see Fran Kramer, *Simply Shaker: Groveland and the New York Communities* (Rochester, NY: Rochester Museum and Science Center, 1991).

74 Freegift Wells, "Journal by Freegift Wells of a trip to Sodus and back to Watervliet in June [1834]," 23 June 1834, 26, WRHS,ShakerMSS, Series V, B-317.

75 William Deming, "Journal of William[']s Travel To the State of Ohio," 9 September 1818 (no pagination at this point in the journal), section called "An account of a Remarkable Tree Growing in the State of Ohio taken from a Cincinnati Almanack of this Year," WintAndrewsShakColl, ASC 818. (A copy of the journal can be found at the Western Reserve Historical Society, Shaker Manuscripts, Series V, B-78, "Journal of William Demming's travels to Ohio and Kentucky including his visits to Union and South Union." Even ASC 818 at Winterthur is, according to a library record, possibly a "fair copy" of Deming's original.)

76 Ibid., 7 August 1810, 16.

77 The verses were later set to music, and the popularity of the poem is suggested by one instance in which a Shaker sent a transcription of it as a gift to another believer. See WRHS,ShakerMSS, Series V, B-354, "Account of a journey to Busro," a present from Lovinia G. to Elizabeth Youngs at Watervliet, no date (and see another copy of the poem at B-355 in the same series).

78 For the life of Bates, see Carol Medlicott, *Issachar Bates: A Shaker's Journey* (Hanover, NH: University Press of New England, 2013). See also Paterwic, *Historical Dictionary of the Shakers*, also published as *The A to Z of the Shakers*, 14–16.

79 For the context of the trip by Bates and Youngs, see Medlicott, *Issachar Bates*, 130–36. The short-lived Shaker community of West Union at Busro, Indiana, founded in 1807, was abandoned in 1827. Traveling with Bates and Youngs on the perilous sixteen-day journey was Richard McNemar Sr. (1770–1839). For an early account of the spread of Shakerism to the West, see Richard McNemar, *The Kentucky Revival; or A Short History of the Late Extraordinary Outpouring of the Spirit of God in the Western States of America* (New York: Edward O. Jenkins, 1846; reprint: New York, AMS Press, 1974), 79–115. For information on McNemar, see Mary L. Richmond, *Shaker Literature: A Bibliography*, 2 vols. (Hancock, MA: Shaker Community; Hanover, NH: distributed by the University Press of New England, 1977), 1:122–23. See also Grant and Allen, *Shaker Furniture Makers*, 70–71. An early notice of the Shakers at Busro is in David Thomas, *Travels through the Western Country in the Summer of 1816* (Auburn, NY: David Mumsey, 1819), 149–50.

80 "Journey of Issachar Bates and Benjamin Youngs from Ohio to Busserow [Busro] 1808," written in stanzas, WRHS,ShakerMSS, Series V, A-8. The traditional music adopted by Bates is related to what became known as the spiritual "Wayfaring Stranger" and must have been favored by the Shakers, for multiple versions of it, with slight variations, appear in manuscripts from more than one community. See a variant of the text by Bates and the musical score in Daniel W. Patterson, "A Ballad by Elder Issachar Bates," *Shaker Quarterly* 2, no. 1 (1962): 60–66. See also text and score in Daniel W. Patterson, *The Shaker Spiritual* (Princeton, NJ: Princeton University Press, 1979), 142–44.

81 Benjamin S. Youngs, "Diary of Three Brethren Going South" [John Meacham, Issachar Bates, Sr., and Benjamin S. Youngs, going from New Lebanon to the southeast, beginning 1 January 1805], 25 February 1805, 28, OldChatKingLib, 15,220.

82 Cited from Benjamin Seth Youngs, "Diary," [exact date uncertain] January 1805, 16, WintAndrewsShakColl, ASC 859. (Copy of manuscript 15,220 in the Emma B. King Research Library, Old Chatham; see note preceding.)

83 Giles Bushnell Avery, "Journal of a Trip to the Eastern Societies," 4 May 1843, 45, OldChatKingLib, 12,744.

84 Prudence Morrell, "This little Book contains an account of a journey taken by Prudence Morrell & Eliza Sharp, to the West, in the year 1847," 17 August 1847 and 19 August 1847, WRHS,ShakerMSS, Series V, B-141.

85 "Items of a Journey to Harvard, Shirley, Lynn, New York, etc.," party consisting of New Lebanon Shakers Aaron Bells, George Curtis, and Abigail Crossman, 5 August 1846, 4, WRHS,ShakerMSS, Series V, B-140.

86 William Deming, "Journal of William[']s Travel To the State of Ohio," 24 July 1810, 12, WintAndrewsShakColl, ASC 818.

87 Calvin Green, "Journal Kept by Calvin Green on a trip to Philadelphia and vicinity," 13 May 1828, WRHS,ShakerMSS, Series V, B-98. (Manuscript difficult to read; cited here from the typescript prepared by the WRHS, B-98A.)

88 "Journal kept by Daniel Mosely on his return from Ohio to Mt. Lebanon," 30 April 1812, first page (ms. unpaginated), and 23 May 1812, WRHS,ShakerMSS, Series V, B-82. He was in company with Peter Pease and two Shaker sisters.

89 Rhoda Blake, "Sketch of the life and experiences of Rhoda Blake, begun in 1864, completed in 1892," 19, WRHS,ShakerMSS, Series VI, B-33.

90 Thomas Hammond, "Journal," 9 June 1851, 150, WRHS,ShakerMSS, Series V, B-36.

91 Charles Hodgdon, *Just Published, Hodgdon's Life and Manner of Living among the Shakers, Founded on Truth* (Concord, NH: published by the author, 1838), cited in Goodwillie, *Writings of Shaker Apostates and Anti-Shakers*, 3:77.

92 Henry C. Blinn, "Notes by the way, while on journey to the state of Kentucky in the year 1873," 6 May 1873, Canterbury Shaker Village, Archives, 9779 Bl, ID #1956 (photocopy at HSV,MillerLib, call #9758, B648, ID 6436). (Another version of Blinn's travel account is in OldChatKingLib, 12,791.) Another transcription appears in Johnson, "Journey to Kentucky," 5, no. 1 (1965): 8.

93 Freegift Wells, "Narrative of a journey made to Southold, Long Island, September 5–21,1853, by Freegift Wells," 9 September 1853, WRHS,ShakerMSS, Series V, B-339. Cutchogue is a hamlet in the town of Southold, New York.

94 Freegift Wells, "Diary of a trip from Watervliet, N.Y. to Cutchogue, Long Island" [journal entries from 1861 and 1863], 12 September 1861, 57, WRHS,ShakerMSS, Series V, B-344.

95 Isaac N. Youngs, "Tour thro the states of Ohio and Kentucky, 1834," vol. 1, 5 June 1834, 4, OldChatKingLib, 12,751 (vol. 1) and 12,752 (vol. 2).

96 James Fenimore Cooper, "American and European Scenery Compared," in *The Home Book of the Picturesque: Or American Scenery, Art, and Literature. Comprising a Series of Essays by Washington Irving, W. C. Bryant, Fenimore Cooper, Miss Cooper, N. P. Willis, [et al.]* (New York: G. P. Putnam, 1852), 65. For contemporary painted views of the region, see Patricia Anderson, *The Course of Empire: The Erie Canal and the New York Landscape, 1825–1875* (Rochester, NY: Memorial Art Gallery of the University of Rochester, 1984), and see 81–83 there for descriptions written ca. 1825–75 of travels and views along the Erie Canal.

97 Isaac N. Youngs, "Tour thro the states of Ohio and Kentucky, 1834," vol. 1, 6 June 1834, 6, OldChatKingLib, 12,751 (vol. 1) and 12,752 (vol. 2).

98 Seth Youngs Wells, "Journal kept by Seth Y. Wells of a visit to Port Bay (Sodus)," 25 June 1832, 6, WRHS,ShakerMSS, Series V, B-102. (The same journey is recounted in three variant manuscripts by Wells: B-101, B-102, and B-103.)

99 Hannah Agnew, "Journal of a Memorable Journey from White Water, Ohio. to New Lebanon. N.Y. Taken by Hannah R. Agnew when 16 years of age. In the Year 1836," 10 May 1836, 9, LofC,ShakColl, Item 50.

100 Prudence Morrell, "This little Book contains an account of a journey taken by Prudence Morrell & Eliza Sharp, to the West, in the year 1847", 1 October 1847, WRHS,ShakerMSS, Series V, B-141.

101 Joanna Mitchell, "Daily Journal," or "A Journey from New Lebanon, New York to Union Village, Ohio, kept by Joanna Mitchell," 7 August 1835, WRHS,ShakerMSS, Series V, B-238.

102 "Journal containing [an account] by unidentified Shakers [from Harvard, Massa-

chusetts] to Watervliet, New York, August 1845," 12 (?) August 1845, WRHS,ShakerMSS, Series V, B-51.

103 "Travel Journal of the Ministry from Pleasant Hill for Mt. Lebanon and the other Eastern Societies." Total June 1869-August 1869, 18 June 1869, 9, and 21 June 1869, 14, HSV,MillerLib, call no. 9758 S527.

104 Hannah Agnew, "Journal of a Memorable Journey from White Water, Ohio. to New Lebanon. N.Y. Taken by Hannah R. Agnew when 16 years of age. In the Year 1836," 14 May 1836, 13, LofC,ShakColl, Item 50.

105 "A Journey and Visit by the [Watervliet] ministry to the Society at Groveland," 8 and 13 May 1851, WRHS,ShakerMSS, Series V, B-336.

106 Thomas Damon, "Journal of a trip from Enfield, Connecticut to Shaker communities in Maine, New Hampshire, and Massachusetts. 1850," 14 September 1850, WintAndrewsShakColl, ASC 833.

107 Anna White, "An indeffinite account of <u>our</u> Eastern journey. M. P. & A. W.," 14 July 1873, (in Anna White's handwriting, with M. P. referred to in the third person), NYPL,ShakerMSColl, #11.

108 "Wm Trip" (William Trip's Journal, New Lebanon, 1820–1824), 25 August 1821, 17, OldChatKingLib, 13,316. (Photocopy at HSV,MillerLib, 9758.N5, ID #2157.) The date of his apostasy as 18 June 1827 is found in Magda Gabor-Hotchkiss, *Guide to Bound Shaker Manuscripts in the Library Collection of Hancock Shaker Village* (Pittsfield, MA: Hancock Shaker Village, 2001), 1:27.

109 Milton Robinson, "Journal, 1830–1831" (described on a title page as "Written by Milton, of South Union, KY, was declining with consumption—took a sea voyage for the improvement of his health, & past Spirit Land Oct. 19, 1832, aged 25, here in New Lebanon. The rest of the story he relates himself"), 17 June 1831, LofC,ShakColl, Item 37.

110 "Millennial Laws, or Gospel Statutes and Ordinances," October 1845 (revised from the laws of August 1821), Section VIII, nos. 1 and 2 ("Concerning the Order of the Natural Creation"), 203, LofC,ShakColl, Item 100. See also a transcription in Edward Deming Andrews, *The People Called Shakers: A Search for the Perfect Society* (New York: Oxford University Press, 1953; reprint, New York: Dover, 1963), 284–85.

111 Sister Marcia [Bullard], "Shaker Industries," *Good Housekeeping*, July 1906, 37. See also Joan M. Jensen, *With These Hands: Women Working on the Land* (Old Westbury, NY: Feminist Press, 1981), 56; and Amy Stechler Burns, *The Shakers: Hands to Work, Hearts to God: The History and Visions of the United Society of Believers in Christ's Second Appearing from 1774 to the Present*, photographs by Ken Burns, Langdon Clay, and Jerome Liebling (New York: Aperture Foundation, 1987), 78.

112 Elkins, *Fifteen Years in the Senior Order of Shakers*, 19, 105.

113 "Testimony of Elisha Pote," to "good believing young people and children," Alfred, Maine, 1843 (n.p.), WRHS,ShakerMSS, Series VI, A-1.

114 "Diary of a journey by the ministry of Pleasant Hill and South Union, Kentucky, to visit the eastern Shakers, 1869, 15 June 1869, LofC,ShakColl, Item 35.

115 Blackburn, *Brief Account*, 30–31. See also Goodwillie, *Writings of Shaker Apostates and Anti-Shakers*, 2:249. For a study of another Shaker village in Ohio, see Caroline B. Piercy, *The Valley of God's Pleasure: A Saga of The North Union Shaker Community* (New York: Stratford House, 1951).

116 "Journal of a trip to western societies by Hiram Rude and Hanna[h] Ann Agnew, May 28-July 3," 27 (?) June 1856, 94, WRHS,ShakerMSS, Series V, B-161. It is not clear from the manuscript exactly which date it is for some entries. The end date of the journey does not correspond to the title of the manuscript, as the trip went later than 3 July. Hannah Agnew is referred to in some documents as Hannah R. Agnew.

Useful for illustration and discussion of Shakers sites in Ohio and Kentucky is Martha Boice, Dale Covington, and Richard Spence, *Maps of the Shaker West: A Journey of Discovery* (Dayton, OH: Knot Garden Press, 1997), with 85–90 for White Water.

117 Elkins, *Fifteen Years in the Senior Order of Shakers*, 12.

118 Deborah Robinson (likely author), "A Short Sketch of our Journey to the East." 28 August 1850, 11 and 12, WintAndrewsShakColl, ASC 829.

119 Sarah Ann Lewis (called in some documents Susan Ann Lewis), "A Small Memorandum Kept while on a Journey to the East" (recording a trip from New Lebanon to seven Shaker communities), 12, 15, and 20 September 1849, 60, 62, and 74, OldChatKingLib, 10,483.

120 Elkins, *Fifteen Years in the Senior Order of Shakers*, 80.

121 "Millennial Laws, or Gospel Statutes and ordinances, adapted to the day of Christ's second Appea[r]ing. Given & established in the Church, for the protection thereof: By the Ministry & Elders. New Lebanon, August 7[th]: 1821, chap. 2, no. 6, 14, WRHS,ShakerMSS, Series I, B-37. (A similar text appears in a slightly later Shaker copy kept at the Shaker Library at Sabbathday Lake, 14-Cl-035, "Order and Rules the Church at New-Lebanon, August 7th, 1821," also called "Millenial Laws or Gospel Statutes, Adapted to the Day of Christ's Second Appearing; Given and established in the Church, for the protection of Believers Thereof. By the Ministry and Elders, New-Lebanon August 7th 1821" ["November 22nd 1829, A true copy from the Harvard coppy of Sep[t]. 19th 1829 by J. C."]). Another transcription of the 1821 rules can be found in Theodore E. Johnson, "The 'Millenial Laws' of 1821," *Shaker Quarterly* 7, no. 2 (1967): 35–58. See also the transcription in John T. Kirk, *The Shaker World: Art, Life, Belief* (New York: Harry N. Abrams, 1997), 261–64.

122 Giles Bushnell Avery, "Journal of a Trip to the Eastern Societies," 15 and 21 May 1843, 70 and 76, OldChatKingLib, 12,744.

123 Seth Young Wells, "Journal of Seth Wells' tour among eastern believers to organize their schools," 18 August 1823, WRHS,ShakerMSS, Series V, B-3.

124 Thomas Damon, "Journal of a trip from Enfield, Connecticut to Shaker communities in Maine, New Hampshire, and Massachusetts. 1850," 20 September 1850, WintAndrewsShakColl, ASC 833.

125 Prudence Morrell, "This little Book contains an account of a journey taken by Prudence Morrell & Eliza Sharp, to the West, in the year 1847," 2 June 1847, WRHS,ShakerMSS, Series V, B-141.

126 Henry C. Blinn, "Diary of the Ministry's Journey to New Lebanon and Groveland," 10 July 1856, 24, OldChatKingLib, 12,792.

127 Hannah Agnew, "Joyful Meeting and Wonderful Expedition of the Five Churches, July 1856," 66 and 68, LofC,ShakColl, Item 50.

128 "Solemn and sacred Writings Written by Mother Ann. . . . Given to the Ministry

at New Lebanon," dated 25 February 1841, and copied at the Second Order, March 1–March 5, 13–15, NYPL,ShakerMSColl, #27.

129 Hannah R. Agnew, "Journal of a Memorable Journey from White Water, Ohio. to New Lebanon. N.Y. Taken by Hannah R. Agnew when 16 years of age. In the Year 1836," 30 May 1836, 29, LofC,ShakColl, Item 50. For the community at White Water, see J. P. MacLean, *Shakers of Ohio: Fugitive Papers Concerning the Shakers of Ohio, with Unpublished Manuscripts* (Philadelphia: Porcupine Press, 1975), 227–69; Marjorie Byrnside Burress, ed., *Whitewater, Ohio, Village of Shakers, 1824–1916: Its History and Its People* (Cincinnati: n.p., 1979); and James R. Innis Jr. and Thomas Sakmyster, eds., *The Shakers of White Water, Ohio, 1823–1916* (Clinton, NY: Richard W. Couper Press, 2014).

130 Hannah R. Agnew, "Innocent Recreation," following the "Journal of a Memorable Journey from White Water, Ohio. to New Lebanon. N.Y. Taken by Hannah R. Agnew when 16 years of age. In the Year 1836," 18 June 1856, 36, LofC,ShakColl, Item 50.

131 Thomas Hammond Jr., "Journal," 22 September 1846, 48, WRHS,ShakerMSS, Series V, B-36. For other information about the community and site, see Stephen J. Paterwic, *Tyringham Shakers* (Clinton, NY: Richard W. Couper Press, 2013).

132 Henry C. Blinn, "Diary of the Ministry's Journey to New Lebanon and Groveland," 8 July 1856, 13, OldChatKingLib, 12,792.

133 "Diaries of Ann Buckingham," 27 November 1843, New York State Library, Shaker Collection (hereafter cited as NYSL,ShakColl), Series I, Box 5, Volume/Folder 1. The diarist was also known as Phebe Ann (see Demark, *Journals of Rufus Bishop*, 409).

134 Philemon Stewart, "A Daily Journal kept by Philemon Stewart," (New Lebanon), 1834–36, for 16 April 1834, 15, WRHS,ShakerMSS, Series V, B-130.

135 "Spring," possibly written in Union Village, Ohio, undated, but probably ca. 1849–51, LofC,ShakColl, Item 51.

136 Sally Bushnell, "A journal commenced January 1ˢᵗ, 1848," and goes through 1858, vol. 1, 4 May 1848, 16, OldChatKingLib, 10,347 (in 3 vols.: vol. 1, 10,347; vol. 2, 10,347-A; and vol. 3, 10,347-B).

137 Anna White, "Diary Kept by Sister Anna White, 1855–1873," 1 January 1871, NYPL,ShakerMSColl, #11.

138 Rufus Bishop, "A Daily Journal of Passing Events; begun January the 1st, 1830. By Rufus Bishop, in the 56th year of his age" (in 3 vols.; vol. 1 covers 1 January 1830 to 18 May 1839), vol. 1, 19 March 1833, NYPL,ShakerMSColl, #1.

139 Ibid. (vol. 2 covers from 19 May 1839 until 1 January 1850), vol. 2, 21 July 1843, 199, and 26 July 1843, 199, NYPL,ShakerMSColl, #2.

140 "Journal kept by Eunice E. Bennet," 1844–1848, 26 June 1844, WRHS,ShakerMSS, Series V, B-328. Her name is spelled "Bennett" in some documents.

141 Anonymous, "Daily Journal," (Harvard, MA), 17 September 1847, WRHS,ShakerMSS, Series V, B-53.

142 Daniel Miller, "A journal of 8 years or from the 1st of Jan[.] 1848 until the 31 of December 1855," 7 June 1849, LofC,ShakColl, Item 238.

143 "Diaries of Ann Buckingham," 12 April 1840, NYSL,ShakColl, Series I, Box 5, Volume/Folder 1.

144 Rufus Bishop, "A Daily Journal of Passing Events; begun January the 1st, 1830. By Rufus Bishop, in the 56th year of his age," vol. 2, 22 June 1840, 87, NYPL,ShakerMSColl, #2.

145 Ibid., 21 January 1841, 117.

146 Ibid., vol. 1, 15 October 1836, 28 May 1837, and 23 October 1833, NYPL,ShakerMSColl, #1.

147 Sally Bushnell, "A journal commenced January 1st, 1848," and goes through 1858, vol. 1, 21 February 1848, 6, OldChatKingLib, 10,347.

148 "Items of a Journey to Harvard, Shirley, Lynn, New York, etc.," party consisting of New Lebanon Shakers Aaron Bells, George Curtis, and Abigail Crossman, 5 August 1846, 8, WRHS,ShakerMSS, Series V, B-140.

149 Thomas Damon, "Journal of a trip from Enfield, Connecticut to Shaker communities in Maine, New Hampshire, and Massachusetts. 1850," 17 September 1850, WintAndrewShakColl, ASC 833.

150 Cited here from Rebecca Cox Jackson, copied by Alonzo Hollister, "Autobiography,"18 February 1850, 110, WRHS,ShakerMSS, Series VI, B-39. A transcription appears in Jean McMahon Humez, ed., *Gifts of Power: The Writings of Rebecca Jackson, Black Visionary, Shaker Eldress* (Amherst: University of Massachusetts Press, 1981), 220.

151 "Union Village, Ohio: Journal Kept by an Unidentified Shaker," 1853–1863 (n.d., n.p.), WRHS,ShakerMSS, Series V, B-249.

152 Quoted here from the copy at the NYSL,ShakColl, "Sketch of the Life and Experience of Issacher Bates," 2. See also South Union Shaker Library, "Sketch of the Life and Experiences of Issachar Bates [January 29, 1758–March 17, 1837]," written ca. 1833 of events from before the American Revolution, 2; original manuscript in Western Kentucky University, Champliss Collection, Bowling Green. Version published in Theodore E. Johnson, "A Sketch of the Life and Experience of Issachar Bates," *Shaker Quarterly* 1, no. 3 (1961): 101. Robinson published the text from the Shaker Library at Sabbathday Lake, Maine.

153 Rufus Bishop, "A Daily Journal of Passing Events; begun January the 1st, 1830. By Rufus Bishop, in the 56th year of his age," vol. 1, 24 December 1833, NYPL,ShakerMSColl, #1.

154 Ibid., vol. 2, 21 March 1843, 192, NYPL,ShakerMSColl, #2.

155 Ibid., 6 May 1844, 222.

156 Ibid., vol. 1, 24 December 1836. NYPL,ShakerMSColl, #1.

157 "Diaries of Ann Buckingham," 25 January 1837, NYSL,ShakColl, Series I, Box 5, Volume/Folder 1.

158 Seth Youngs Wells, "Journal of Seth Wells' tour among eastern believers to organize the schools," 22 July and 13 August 1823, WRHS,ShakerMSS, Series V, B-3.

159 Deborah Robinson (likely author), "A Short Sketch of our Journey to the East. 1850," 2 September 1850, 24, WintAndrewsShakColl, ASC 829.

160 Thomas Damon, "Journal of a trip from Enfield, Connecticut to Shaker communities

in Maine, New Hampshire, and Massachusetts. 1850," 3 September 1850, WintAndrewsShakColl, ASC 833.

161 Deborah Robinson (likely author), "A Short Sketch of our Journey to the East. 1850," 2 and 18 September 1850, 26, 35, and 45–46, WintAndrewsShakColl, ASC 829.

162 Thomas Damon, "Journal of a trip from Enfield, Connecticut to Shaker communities in Maine, New Hampshire, and Massachusetts. 1850," 18 September 1850, WintAndrewsShakColl, ASC 833.

163 "A Journal, or an Account of a load of Brethren & Sisters at Second Family, Watervliet, N. York Visiting Harvard & Shirley, Mass. June 1847," 7 June 1847 (date of 8 June incorrectly given by journal writer), WRHS,ShakerMSS, Series V, B-332. The names of the travelers are listed as David Train Jr., Joel Smith, Eleanor Vedder, Polly Bacon, Thankful Copley, and Lucinda Harwood, as written on the initial page of the (unpaginated) manuscript.

164 "Journal kept by Seth Y. Wells of a visit to Port Bay (Sodus)", 7 July 1832, 10, WRHS,ShakerMSS, Series V, B-102.

165 Freegift Wells, "Narrative of a journey made to Southold, Long Island, September 5–21, 1853, by Freegift Wells," 6 September 1853, WRHS,ShakerMSS, Series V, B-339.

166 Freegift Wells, "Diary of a trip from Watervliet, N.Y. to Cutchogue, Long Island" [journal entries from 1861 and 1863], 7 and 10 July 1861, 16 and 38, WRHS,ShakerMSS, Series V, B-344.

167 "Account of a journey in April [1836] to Union Village by Freegift Wells and Matthew Houston," mid-April 1836, WRHS,ShakerMSS, Series V, B-320.

168 Freegift Wells, "Journal by Freegift Wells of a trip to Sodus and back to Watervliet in June [1834]," 17 June 1834, 15, WRHS,ShakerMSS, Series V, B-317.

169 "Journey" to Mount Lebanon, Watervliet, Hancock, & Tyringham, from Enfield, Connecticut, by Philip Burlingame, et al., 24 June 1856, WRHS,ShakerMSS, Series V, B-19. For Bates, see Medlicott, *Issachar Bates.*

170 Thomas Damon, "Journal of a trip from Enfield, Connecticut to Shaker communities in Maine, New Hampshire, and Massachusetts. 1850," 28 August 1850, WintAndrewsShakColl, ASC 833.

171 Giles B. Avery, "Journal or Diary of A Tour made by the Ministry of New Lebanon to the Shaker Societies in the Western States, Written by Elder Giles B. Avery," and Shaker travelers' names listed as Daniel Boler, Giles B. Avery, Betsy Bates, and A. Taylor, 31 July 1862, WRHS,ShakerMSS, Series V, B-163.

172 *The Testimony of Christ's Second Appearing*, Published by Order of the Ministry (Albany, NY: E. and E. Hosford, 1810 [2nd ed., corrected and improved]), 5.

173 Seth Youngs Wells, "Journal of a Tour in the summer of 1832 to Sodus and Port Bay," 25 June 1832, 20, WRHS,ShakerMSS, Series V, B-103.

174 "Journal kept by Seth Y. Wells of a visit to Port Bay (Sodus)," 25 June 1832, 6, WRHS,ShakerMSS, Series V, B-102.

175 "Items of a Journey to Harvard, Shirley, Lynn, New York, etc.," trip taken by Aaron Bells, George Curtis, and Abigail Crossman, journal likely written by Abigail Crossman, 11–12 August 1846, WRHS,ShakerMSS, Series V, B-140.

176 Cole, "Essay on American Scenery," 3, 5, 3, 12. Cole was quoting from John Wilson's

poem "Nature Outraged." See *The Poetical Works of Professor Wilson* (Edinburgh: William Black and Sons, 1858), 388.

177 For various suggestions of God's hand in the American landscape, see Schuyler, *Sanctified Landscape.*

178 Magoon, "Scenery and Mind," 5, 7.

179 Giles B. Avery, "Journal or Diary of A Tour made by the Ministry of New Lebanon to the Shaker Societies in the Western States, Written by Elder Giles B. Avery," and Shaker travelers' names listed as Daniel Boler, Giles B. Avery, Betsy Bates, and A. Taylor, 9 July 1862, WRHS,ShakerMSS, Series V, B-163.

180 Susan C. Liddell, "Journal kept by Susan C. Liddil on a visit to Clinton Valley [Ohio], October 31 to November 2 [1857]," 2 November 1857, WRHS,ShakerMSS, Series V, B-253.

181 John M. Brown, "Notes by the Way," written in 1866–71, the passage here written 5 August 1866, recording events from 18–21 July 1866, 19, WRHS,ShakerMSS, Series VII, B-127.

182 "Journal of a trip to western societies by Hiram Rude and Hanna[h] Ann Agnew, May 28-July 3" June 1856, 50, WRHS,ShakerMSS, Series V, B-161.

183 Sally Bushnell, "A journal commenced January 1st, 1848," and goes through 1858, vol. 2, 2 November 1851, 84, OldChatKingLib, 10,347-A.

184 Calvin Green, "Journal Kept by Calvin Green on a trip to Philadelphia and vicinity," Saturday, 10 May 1828, WRHS,ShakerMSS, Series V, B-98. (Manuscript difficult to read; cited here from the typescript prepared by the WRHS, B-98A.)

185 Isaac N. Youngs, "Tour thro the states of Ohio and Kentucky, 1834," vol. 1, 18 July 1834, 53, OldChatKingLib, 1:12,751, and 2:12,752.

186 "Items of a Journey to Harvard, Shirley, Lynn, New York, etc.," trip taken by Aaron Bells, George Curtis, and Abigail Crossman, journal likely written by Abigail Crossman, about 20 August 1846, WRHS,ShakerMSS, Series V, B-140.

187 Rhoda Blake, "Sketch of the life and experiences of Rhoda Blake, begun in 1864, completed in 1892," 51, WRHS,ShakerMSS, Series VI, B-33.

188 Hannah R. Agnew, "Journal of a Memorable Journey from White Water, Ohio. to New Lebanon. N.Y. Taken by Hannah R. Agnew when 16 years of age. In the Year 1836," 17 May 1836, 16, 15, LofC,ShakColl, Item 50.

189 Seth Youngs Wells, "Record of a journey from Alfred to Harvard to visit the schools," 23 September 1822, WRHS,ShakerMSS, Series V, B-1.

190 Freegift Wells, "Diary of a trip from Watervliet, N.Y. to Cutchogue, Long Island" [journal entries from 1861 and 1863], 3 August 1863, 88–89, WRHS,ShakerMSS, Series V, B-344.

191 Mary Dempster, "Our Country," undated (according to a note in the library records it was written in the early 1860s), Shakers, 1852–65, New-York Historical Society Museum & Library (hereafter cited as N-YHSML), Patricia D. Klingenstein Library, Shaker Collection, 1822–79.

192 "The Holy Word of the Lord God Almighty[,] The Holy One of Israel to His Chosen People, throughout Zion[']s Habitations[.] Given at Wisdom's Valley, and written by Inspiration, at the Holy Mount, March 5th 1843," 13, 15, and 27, NYPL,ShakerMSColl, #9.

193 For weather reported in a dry fashion throughout the diary, see, for example, an anonymous diary from the Hancock community, 1790–1800, OldChatKingLib, 10,804.

194 Anonymous, "Journal," 1843–68, from Pleasant Hill, Kentucky, October 1854 (month listed only), HSV,MillerLib call no. 9758 P724.

195 Henry C. Blinn, "Diary of the Ministry's Journey to New Lebanon and Groveland," 7 July 1856, 2, OldChatKingLib, 12,792.

196 "Diary Kept by Sister Anna White, 1855–1873," 13 January 1855, NYPL,ShakerMSColl, #11.

197 Jane D. Knight, "Journal," 1833–36, 1838 (New Lebanon), 20 April 1834, 30 and 31, OldChatKingLib, 10,362.

198 Ibid., mid-October 1834, 49.

199 Ibid., 22 February 1835, 64.

200 Ibid., 9 May 1835, 74.

201 Ibid., 31 May 1835, 77.

202 From the testimony of an early follower (Hannah Cogswell), we learn that Ann Lee, speaking to a large gathering at Watervliet, called for Shakers never to allow dogs into dwelling houses nor ever "give your feelings to beasts, any more than is necessary to make a good use of them." See Rufus Bishop and Seth Youngs Wells, *Testimonies of the Life, Character, Revelations and Doctrines of Our Ever Blessed Mother Ann Lee, and the Elders with Her* (Hancock, MA: printed by J. Tallcott & J. Deming, Junrs., 1816), 279–80.

203 "Millennial Laws, or Gospel Statutes and Ordinances," October 1845 (revised from the laws of August 1821), Part III, Section VII, no. 1, 199. See also a transcription in Andrews, *People Called Shakers*, 284, LofC,ShakColl, Item 100.

204 "Journal kept by Seth Y. Wells of a tour to the eastern Believers' schools," 2 July 1823, WRHS,ShakerMSS, Series V, B-302.

205 "Journal of a visit by the ministers of Union Village [Ohio] and South Union [Kentucky] to eastern communities." Early part written by William Reynolds of Union Village, Ohio, and the later part by Nancy E. Moore, of South Union, Kentucky, 28 September 1854, 111, WRHS,ShakerMSS, Series V, B-250.

206 Freegift Wells, "Narrative of a journey made to Southold, Long Island, September 5–21, 1853, by Freegift Wells," 6 September 1853, WRHS,ShakerMSS, Series V, B-339.

207 Henry C. Blinn, "Diary of the Ministry's Journey to New Lebanon and Groveland," 24 July 1856, 67, OldChatKingLib, 12,792.

208 Freegift Wells, "Narrative of a journey made to Southold, Long Island, September 5–21, 1853, by Freegift Wells," 16 September, 8 September, and 9 September 1853, WRHS,ShakerMSS, Series V, B-339.

209 Freegift Wells, "Diary of a trip from Watervliet, N.Y. to Cutchogue, Long Island" (journal entries from 1861 and 1863), 3 August 1863, 91, WRHS,ShakerMSS, Series V, B-344. Following Wells's account, the father of the wife of Ira Hull Tuthill was a sea captain. Wells was presumably referring to a collection of shells formed by Captain Barney Green, and inherited by his daughter (young Ira's wife), Mary Louise Green (1844–1917).

210 Freegift Wells, "Ministry journal from Aug. 22, 1836 to May 1, 1837 including trips to Pleasant Hill & South Union, Ky. and North Union, Watervliet & Whitewater, O.[hio]," 29 April 1837, WRHS,ShakerMSS, Series V, B-239.

211 William Deming, "Journal of William[']s Travel To the State of Ohio," 22 June 1810, 7, WintAndrewsShakColl, ASC 818. (A copy of the journal can be found at the Western Reserve Historical Society, Shaker Manuscripts, Series V, B-78, "Journal of William Demming's travels to Ohio and Kentucky including his visits to Union and South Union." An introduction to the manuscript and another transcription can be found at http://findingaid.winterthur.org/html/HTML_Finding_Aids/ASC0818.htm. Even ASC 818 at Winterthur is, according to a library catalog record, possibly a "fair copy" of Deming's original.)

212 Calvin Green, "Journal Kept by Calvin Green on a trip to Philadelphia and vicinity," 16 May 1828, WRHS,ShakerMSS, Series V, B-98. (Manuscript difficult to read; cited here from the typescript prepared by the WRHS, B-98A.) Cf. Green's "Biographic Memoir of the Life and Experience of Calvin Green" (1861), 226, WRHS,ShakerMSS, Series VI, B-28, transcribed in Wergland and Goodwillie, *Shaker Autobiographies, Biographies and Testimonies*, 2:227–28.

213 Benjamin Seth Youngs, "Diary," 2 November 1805, 250, WintAndrewsShakColl, ASC 859.

214 Henry C. Blinn, "Diary of the Ministry's Journey to New Lebanon and Groveland, " 9 July 1856, 16, OldChatKingLib, 12,792.

215 Prudence Morrell, "This little Book contains an account of a journey taken by Prudence Morrell & Eliza Sharp, to the West, in the year 1847," 18 June 1847, WRHS,ShakerMSS, Series V, B-141.

216 Deborah Robinson (likely author), "A Short Sketch of our Journey to the East. 1850," 30 September 1850, 78–79, WintAndrewsShakColl, ASC 829.

217 Writer unknown (female), "Commonplace," [Shaker Diary], 1878–79, 2–3, N-Y-HSML, Patricia D. Klingenstein Library, Shaker Collection, 1822–79.

CHAPTER 3: CRAFTING ZION

1 For broad studies of the material world of the Shakers and their production, see Edward Deming Andrews, *The Community Industries of the Shakers* (Albany, NY: State University of New York Press, 1932); Edward Deming Andrews, "Communal Architecture of the Shakers," *Magazine of Art* 30 (December 1937): 710–15; Edward Deming Andrews, *Shaker Art and Craftsmanship: An Exhibition at the Berkshire Museum, Pittsfield, Massachusetts; Opening July the 30th, 1940 /* (Pittsfield, MA: Berkshire Museum, 1940); John M. Anderson, "Force and Form: The Shaker Intuition of Simplicity," *Journal of Religion* 30 (October 1950): 256–60; Marian Klamkin, *Hands to Work: Shaker Folk Art and Industries* (New York: Dodd, Mead, 1972); Edward Deming Andrews and Faith Andrews, *Work and Worship Among the Shakers: Their Craftsmanship and Economic Order* (Greenwich, CT: New York Graphic Society, 1974) (also published as Edward Deming Andrews and Faith Andrews, *Work and Worship: The Economic Order of the Shakers* [Greenwich, CT: New York Graphic Society, 1974; New York: Dover Books, 1982]); Wend Fischer, "The Exhibition," introduction to *The*

Shakers: Life and Production of a Community in the Pioneering Days of America: An Exhibition by the "Neue Sammlung" Munich (Munich: Die Neue Sammlung, 1974) (also published as *Die Shaker: Leben und Produktion einer Commune in der Pionierzeit Amerikas* [Munich: Die Neue Sammlung, 1974]); Milton C. Rose and Emily Mason Rose, eds., *A Shaker Reader* (New York: Universe Books, 1977); A. D. Emerich and A. H. Benning, eds., *Community Industries of the Shakers: A New Look* (Albany, NY: Shaker Heritage Society, 1983); Charles A. Weyerhauser, foreword to *The Shakers: Pure of Spirit, Pure of Mind* (Duxbury, MA: Art Complex Museum, 1983); June Sprigg, *Inner Light: The Shaker Legacy*, photographs by Linda Butler (New York: Alfred A. Knopf, 1985); E. Richard McKinstry, *The Edward Deming Andrews Memorial Shaker Collection* (New York: Garland, 1987); June Sprigg and David Larkin, *Shaker: Life, Work, and Art*, photography by Michael Freeman (New York: Steward, Tabori & Chang, 1987; London: Cassell, 1987; republished, New York: Smithmark, 2000); Michael Horsham, *The Art of the Shakers* (Secaucus, NJ: Chartwell Books, 1989); Candace Ord Manroe, *Shaker Style: The Gift of Simplicity* (New York: Crescent Books, 1991); Timothy D. Rieman, *Shaker: The Art of Craftsmanship. The Mount Lebanon Collection* (Alexandria, VA: Art Services International, 1995); William C. Ketchum Jr., *Simple Beauty: The Shakers in America* (New York: Todtri, 1996; New York: Smithmark, 1996); Scott T. Swank, *Shaker Life, Art, and Architecture: Hands to Work, Hearts to God*, principal photography by Bill Finney (New York: Abbeville Press, 1999); Sharon Duane Koomler, *Shaker Style: Form, Function, and Furniture* (Philadelphia: Courage Books, 2000); M. Stephen Miller, *From Shaker Lands and Shaker Hands: A Survey of the Industries* (Hanover, NH: University Press of New England, 2007); Mario S. De Pillis and Christian Goodwillie, *Gather Up the Fragments: The Andrews Shaker Collection* (Hancock Shaker Village, MA, distributed New Haven, CT: Yale University Press, 2008); Michael S. Graham, curator, *The Human and the Eternal: Shaker Art in its Many Forms* (New Gloucester, ME: United Society of Shakers, Sabbathday Lake, 2009); M. Stephen Miller, *Inspired Innovations: A Celebration of Shaker Ingenuity* (Hanover, NH: University Press of New England, 2010); the essays in Michael Komanecky, ed., *The Shakers: From Mount Lebanon to the World* (New York: Skira Rizzoli, 2014); and Pamela M. Ambrose, introduction to *As it is in Heaven: The Legacy of Shaker Faith and Design* (Chicago: Loyola University Museum of Art, 2015). For studies focused on Shaker furniture, see notes 129 and 139 below.

2 Benjamin Seth Youngs and Seth Youngs Wells, *The Testimony of Christ's Second Appearing* (Albany, NY: printed by E. and E. Hosford, 1810; 2nd ed., "Corrected and Improved," "Published by Order of the Ministry in Union with the Church"), 153, 160, 193, 252.

3 "Millennial Laws, or Gospel Statutes and Ordinances," October 1845 (revised from the laws of August 1821), "Preface," 3, LofC, ShakColl, Item 100; see also a transcription in Edward Deming Andrews, *The People Called Shakers: A Search for the Perfect Society* (New York: Oxford University Press, 1953), 251.

4 Charles Hodgdon, *Just Published, Hodgdon's Life and Manner of Living Among the Shakers: Founded on Truth* (Concord, NH: published by the author, 1838), cited from Christian Goodwillie, *Writings of Shaker Apostates and Anti-Shakers, 1782–1850*, 3 vols. (London: Pickering & Chatto, 2013; London: Routledge, 2016), 3:77.

5 "Milenial Laws, or Gospel statutes and ordinances, adapted to the day of Christ's second Appea[r]ing. Given & established in the Church, for the protection thereof: By the Ministry & Elders. New Lebanon, August 7th: 1821," Chapter 7, no. 2, 49, Western Reserve Historical Society, Shaker Manuscripts (hereafter cited as WRHS,ShakerMSS), Series I, B-37. Another transcription of the 1821 rules can be found in Theodore E. Johnson, "The 'Millenial Laws' of 1821," *Shaker Quarterly* 7, no. 2 (1967): 35–58. See also the transcription in John T. Kirk, *The Shaker World: Art, Life, Belief* (New York: Harry N. Abrams, 1997), 261–64. For a consideration of regularity and order in Shaker town planning in the context of reform movements of the time, see Julie Nicoletta, "The Architecture of Control: Shaker Dwelling Houses and the Reform Movement in Early-Nineteenth-Century America," *Journal of the Society of Architectural Historians* 62, no. 3 (2003): 352–87.

6 "Journal of William Demming's travels to Ohio and Kentucky including his visits to Union and South Union," 25 June 1810, 7, WRHS,ShakerMSS, Series V, B-78.

7 See Edward Deming Andrews, *A Shaker Meeting House and its Builder* (Hancock, MA: Shaker Community, 1962); Marius B. Péladeau, "The Shaker Meetinghouses of Moses Johnson," *Magazine Antiques* 98, no. 4 (1970): 594–600; and Marius B. Péladeau, *Brother Moses Johnson, 1752–1842* (Augusta, ME: Maine Historic Preservation Commission, 1988).

8 Deborah Robinson (likely author), "A Short Sketch of our Journey to the East. 1850," 20 September and 24 September 1850, 48 and 57–58, Winterthur Library, Edward Deming Andrews Memorial Shaker Collection (hereafter cited as WintAndrews-ShakColl), ASC 829.

9 Freegift Wells, "Freegift Wells set out on a journey to New Gloucester, by way of New Enfield—Canterbury—Alfred &c," 3 December, 1851, 21, WRHS,ShakerMSS, Series V, B-337.

10 John Kaime, "A Journal of a Journey from Canterbury to Enfield, con. Between the 15th & 26th of February, 1847," journal copied by Isaac N. Youngs on 13 September 1847, no pages, stanza 47, WRHS,ShakerMSS, Series V, B-4.

11 Henry C. Blinn, "Diary of the Ministry's Journey to New Lebanon and Groveland," East Canterbury, NH, 7 July 1856, 1, Old Chatham, Emma B. King Research Library at the Shaker Museum/Mount Lebanon (hereafter cited as OldChatKingLib), 12,792.

12 "Journal of a visit by the ministers of Union Village [Ohio] and South Union [Kentucky] to eastern communities." Early part written by William Reynolds of Union Village, Ohio, and the later part by Nancy E. Moore, of South Union, Kentucky, 13 September 1854, 21 and 23, WRHS,ShakerMSS, Series V, B-250. (The demarcation line of authorship is not clear. The manuscript is written by one hand, and it is likely that either Moore or Reynolds took the notes that the other had written and wrote them cleanly at a later time and made one account of it all.)

13 "A Journal, or an Account of a load of Brethren & Sisters at Second Family, Watervliet, N. York Visiting Harvard & Shirley, Mass. June 1847," 31 May 1847, WRHS,ShakerMSS, Series V, B-332. The names of the travelers are listed as David Train Jr., Joel Smith, Eleanor Vedder, Polly Bacon, Thankful Copley, and Lucinda Harwood, as written on the initial page of the (unpaginated) manuscript. For the

sect at Watervliet, see Stephen Bowe, "Watervliet Shakerism" (master's thesis, University of Liverpool, 1994).

14 "The Word of the Holy & Eternal God of Heaven. Written by Inspiration[,] Second Family—Wisdom's Valley—September 8th 1844," New York Public Library, Shaker Manuscript Collection [NYPL,ShakerMSColl], #98.

15 "Counsel and instruction given by Mother Lucy, for the use and benefit of those who are called to bear temporal burthens, throughout Zion's habitations. Written by Inspiration, Wisdom's Valley—October 5th 1844," 3, NYPL,ShakerMSColl, #99.

16 "A General Statement of the Holy Laws of Zion[.] Introduction by Father James[.] New Lebanon Thursday morning May 7th 1840" ("written by the hand of God Himself, and given to his two Anointed Ones to establish on earth"), 55, NYPL,ShakerMSColl, #10.

17 Some definitions and applications of order in Shaker thought and societies are discussed in Sally M. Promey, *Spiritual Spectacles: Vision and Image in Mid-Nineteenth-Century Shakerism* (Bloomington: Indiana University Press, 1993), 68–70.

18 Rufus Bishop and Seth Youngs Wells, *Testimonies of the Life, Character, Revelations and Doctrines of Our Ever Blessed Mother Ann Lee, and the Elders with Her* (Hancock: MA: printed by J. Tallcott & J. Deming, Junrs., 1816), 332; testimony of Hannah Goodrich (1763–1820), later of the communities at New Lebanon and Canterbury.

19 "Milenial Laws, or Gospel statutes and ordinances, adapted to the day of Christ's second Appea[r]ing. Given & established in the Church, for the protection thereof: By the Ministry & Elders. New Lebanon, August 7th: 1821," Chapter 7, no. 4, 50, WRHS,ShakerMSS, Series I, B-37.

20 Ibid., no. 12, 52–53.

21 Ibid., Chapter 13, no. 10, 79.

22 John M. Brown, "Autobiography of John M. Brown" (title on first page of manuscript: "A Biographic Sketch & Religious Experience by John M. Brown . . . 1866"), written in 1866–71, in this quote remembering events of 22 September 1842, 50–51, WRHS,ShakerMSS, Series VI, B-35.

23 "Diary of a journey by the ministry of Pleasant Hill and South Union, Kentucky, to visit the eastern Shakers, 1869," 22 and 23 June 1869, LofC,ShakColl, Item 35.

24 Rufus Bishop, "A Daily Journal of Passing Events; begun January the 1st, 1830. By Rufus Bishop, in the 56th year of his age" (in 3 vols.; vol. 3 covers from 2 January 1850 until Bishop's death in August 1852, then continued by other hands until 19 October 1859), vol. 3, 3 July 1854, 159, NYPL,ShakerMSColl, #3. The "Porch" was a smaller building, the residence of the ministry near the south end of the meeting-house at New Lebanon. Bishop had died in 1852; the continuer of his journal at this point was probably Amos Stewart.

25 Lamson, *Two Years' Experience Among the Shakers*, 21.

26 David R. Lamson, *Two Years' Experience Among the Shakers* (West Boylston, MA: published by the author, 1848), 17, 21, 106.

27 Hodgdon, *Just Published, Hodgdon's Life and Manner of Living among the Shakers*; for information on Hodgon himself, see Goodwillie, *Writings of Shaker Apostates and Anti-Shakers*, 3:76 for quote and 73–74 for information on Hodgdon himself. For

Canterbury, which has been particularly well studied, see David R. Starbuck and Margaret Supplee Smith, *Historical Survey of Canterbury Shaker Village*, vol. 1 (Boston: Boston University, 1979); David R. Starbuck, ed., *Canterbury Shaker Village: An Historical Survey*, vol. 2 (Durham, NH: University of New Hampshire, 1981); Swank, *Shaker Life, Art, and Architecture*; and David R. Starbuck, *Neither Plain nor Simple: New Perspectives on the Canterbury Shakers* (Hanover, NH: University Press of New England, 2004). For Canterbury in the twentieth century, see June Sprigg, *Simple Gifts: A Memoir of a Shaker Village* (New York: Alfred A. Knopf, 1998).

28 Hyatt Howe Waggoner, *Hawthorne: A Critical Study* (Cambridge, MA: Belknap Press of Harvard University, 1963), 40. For the community, see also Allison E. Ledes, "The Canterbury Shakers," *Magazine Antiques* 143, no. 2 (1993): 32–34.

29 Hervey Elkins, *Fifteen Years in the Senior Order of Shakers: A Narration of Facts, Concerning that Singular People* (Hanover, NH: Dartmouth Press, [August] 1853), 56.

30 Benson John Lossing, "The Shakers," *Harper's New Monthly Magazine* 15, no. 86 (1857): 165. See also Don Gifford, ed., *An Early View of the Shakers: Benson John Lossing and the "Harper's" Article of July 1857. With Reproductions of the Original Sketches and Watercolors* (Hanover, NH: University Press of New England, 1989; published for Hancock Shaker Village), 30.

31 Elkins, *Fifteen Years in the Senior Order of Shakers*, 13.

32 Robert Emlen, *Shaker Village Views: Illustrated Maps and Landscape Drawings by Shaker Artists of the Nineteenth Century* (Hanover, NH: University Press of New England, 1987); Robert P. Emlen, "Canterbury Views: The Enduring Image of a Shaker Village," *Imprint: Journal of the American Historical Print Collectors Society* 28, no. 2 (2003): 17–28.

33 For Bussell, see Robert P. Emlen, "The Early Drawings of Elder Joshua Bussell," *Magazine Antiques* 113, no. 3 (1978): 632–37. Fig. 3.5 is accession number 2013.1.51.

34 For appreciation by the world's people of the order and design of the Shaker villages, see Robert P. Emlen, "Shaker Villages and the Landscape of 'Gospel Order,'" in *Shaker Design: Out of This World*, ed. Jean M. Burks (New Haven, CT: Yale University Press, published for the Bard Graduate Center for Studies in the Decorative Arts, Design, and Culture, New York and the Shelburne Museum, Shelburne, VT, 2008), 1–29. A good compendium of opinions about the Shakers by the world's people appears in Flo Morse, *The Shakers and the World's People* (Hanover, NH: University Press of New England, 1987; first published New York: Dodd, Mead, 1980).

35 Judith Ann Livingston, "Victorian Views: Stereographs of the Mt. Lebanon Shaker Community, 1865–1895" (master's thesis, University of Delaware, Winterthur Program in Early American Culture, 1999), viii–ix, 44, passim.

36 For some broader studies of Shaker building, see Edward Deming Andrews, "The Shaker Manner of Building," *Art in America* 48, no. 3 (1960): 38–45; William Lawrence Lassiter, *Shaker Architecture* (New York: Bonanza Books, 1966); Horsham, *The Art of the Shakers*, 64–86; John Poppeliers, ed., *Shaker Built: A Catalog of Shaker Architectural Records from the Historic American Buildings Survey* (Washington, D.C.: Historic American Buildings Survey, 1974); Herbert Schiffer, *Shaker Architecture* (Exton, PA: Schiffer, 1979); A. Donald Emerich, "American Monaster;

or, The Meaning of Shaker Architecture," *Nineteenth Century* 11, nos. 3–4 (1992): 3–11; Paul Rocheleau and June Sprigg, *Shaker Built: The Form and Function of Shaker Architecture* (New York: Monacelli Press, 1994); Julie Nicoletta, *The Architecture of the Shakers*, photographs by Bret Morgan (Woodstock, VT: Countryman Press, 1995); and Henry Plummer, *Stillness and Light: The Silent Eloquence of Shaker Architecture* (Bloomington: Indiana University Press, 2009).

37 Thomas Jefferson, *Notes on the State of Virginia*, ed. William Peden (Chapel Hill: University of North Carolina Press, 1982), 153.

38 Calvin Green, "Biographic Memoir of Mother Lucy Wright by Calvin Green [1861], as copied by Alonzo Hollister," 80, WRHS,ShakerMSS, Series VI, B-27.

39 Deborah Robinson (likely author), "A Short Sketch of our Journey to the East. 1850," 27 August and 7 October 1850, 4 and 110, WintAndrewsShakColl, ASC 829.

40 "A journal of the Ministrys Eastern Visit," commenced 19 June 1850, visit on 26 July 1850, 47, WRHS,ShakerMSS, Series V, B-147.

41 Deborah Robinson (likely author), "A Short Sketch of our Journey to the East. 1850," 20 September 1850, 49, WintAndrewsShakColl, ASC 829.

42 "Journal of a visit to five societies of believers viz Enfield, Conn.[,] Tyringham and Hancock Mass.[,] New Lebanon and Waterviliet [*sic*] New York" by a company from Harvard, including Thomas Hammond Jr., Daniel Myrick, Lucy Mackintosh (or McIntosh; or Sarah), Rosalana (Roxalana) Grosvenor, Olive Hatch Sr., and Leonora Blanchard, 28 September 1846, 40, Williams College Library, Shaker Collection (hereafter cited as WilliamsCollLib), 21, J82 ("Anonymous journal of a visit by a company from Harvard to five societies of believers: Enfield, Tyringham, Hancock, New Lebanon and Watervliet, 1846"). On the Shaker barns of the nineteenth century, including the ones at New Lebanon and Hancock (see note below), see Lauren A. Stiles, *Shaker "Great Barns" 1820s–1880s: Evolution of Shaker Dairy Barn Design and its Relation to the Agricultural Press* (Clinton, NY: Richard W. Couper Press, 2013). A parallel journal of the same trip was written by Thomas Hammond Jr. and is cited in various places in this text; see Thomas Hammond Jr., "Journal," WRHS,ShakerMSS, Series V, B-36.

43 Henry C. Blinn, "Diary of a Journey from Canterbury, N. H. to Enfield & on to New Lebanon, N.Y. and to Hancock, Mass. in a Carriage," 4 July 1853, 110, OldChatKingLib, 12,792. The barn had a conical roof until a fire in 1864. The yellow coloring applied in 1864 on the exterior of the new wooden upper section was restored in 2009. For the barn's history, see Christian Goodwillie and John Harlow Ott, *Hancock Shaker Village: A Guidebook and History* (Pittsfield, MA: Hancock Shaker Village, 2011), 96–101. For the Hancock community in general, see John Harlow Ott, *Hancock Shaker Village: A Guidebook and History* (Hancock, MA: Shaker Community, 1976); Amy Bess Miller, *Hancock Shaker Village/The City of Peace: An Effort to Restore a Vision, 1960–1985* (Hancock, MA: Hancock Shaker Village, 1984); and Deborah E. Burns, *Shaker Cities of Peace, Love, and Union: A History of the Hancock Bishopric* (Hanover, NH: University Press of New England, 1993); and Goodwillie and Ott, *Hancock Shaker Village*, 10–59.

44 Rufus Bishop, "A Daily Journal of Passing Events; begun January the 1st, 1830. By Rufus Bishop, in the 56th year of his age," vol. 3, 18 July 1859, 369, NYPL,ShakerM-

SColl, #3. Bishop died in 1852; the continuer of his journal at this point (369) signed himself as "D.B.," Daniel Boler, a member of the ministry of the society.

45 "Journal of a visit by the ministers of Union Village [Ohio] and South Union [Kentucky] to eastern communities." Early part written by William Reynolds of Union Village, Ohio, and the later part by Nancy E. Moore, of South Union, Kentucky, 20 September 1854, 56–59, WRHS,ShakerMSS, Series V, B-250. The building has been ascribed to the design of young Ammi Burnham Young. A significant study of his output is under way as part of the dissertation by Katherine Miller, "The Office of the Supervising Architect in the Antebellum Era: Transforming Architectural Practice, 1852–1862" (University of Virginia, McIntire Department of Art). I have benefited from discussions with Miller, especially her information that she has found no evidence at all that Young, despite frequent claims in the literature, was the architect of or in any way involved with building the granite Shaker dwelling house in Enfield, New Hampshire. For the building, see also Robert P. Emlen, "The Great Stone Dwelling of the Enfield, New Hampshire Shakers," *Old-time New England: The Bulletin of the Society for the Preservation of New England Antiquities* 69, nos. 3–4 (1979): 69–85.

46 Giles Bushnell Avery, "Journal of a Trip to the Eastern Societies," 3 May 1843, 43, OldChatKingLib, 12,744.

47 Sarah Ann Lewis (called in some documents Susan Ann Lewis), "A Small Memorandum Kept while on a Journey to the East" (recording a trip from New Lebanon to seven Shaker communities), 21 September 1849, 76, OldChatKingLib, 10,483.

48 Thomas Damon, "Journal of a trip from Enfield, Connecticut to Shaker communities in Maine, New Hampshire, and Massachusetts, 1850," 25 September 1850, WintAndrewsShakColl, ASC 833.

49 "Diary of a journey by the ministry of Pleasant Hill and South Union, Kentucky, to visit the eastern Shakers, 1869," 7 July 1869, LofC,ShakColl, Item 35. For other architecture at Enfield, see Robert P. Emlen, "Raised, Razed, and Raised Again: The Shaker Meetinghouse at Enfield, New Hampshire, 1793–1902," *Historic New Hampshire* 30, no. 3 (1975): 133–46; and Elaine Piraino-Holevoet, "The Three Meetinghouses of the Enfield, Connecticut, Shakers" (master's thesis, University of Connecticut, 1978). Insight into life in the community in the middle and later nineteenth century appears also in the collected articles and essays in Mary Ann Haagen, *The Collected Writings of Henry Cumings (1834–1913): Enfield, N.H., Shaker (1844–1881)[,] Citizen of the Town of Enfield, N.H. (1890–1913)* (Clinton, NY: Richard W. Couper Press, 2012).

50 William C. Brackett, "Journal kept by William C. Brackett on a tour of the eastern communities from May to July [1862], 30 May 1862, WRHS,ShakerMSS, Series V, B-345.

51 "A journal of the Ministrys Eastern Visit," commenced 19 June 1850, visit on 5 July 1850, 17, WRHS,ShakerMSS, Series V, B-147.

52 Elkins, *Fifteen Years in the Senior Order of Shakers*, 105. The letter is written in Hervey's characteristic style and is likely by him and not a friend.

53 Ibid., 38–39, 98.

54 Henry C. Blinn, "Diary of a Journey from Canterbury, N.H. to Enfield & on to New

Lebanon, N.Y. & to Hancock, Mass. in a Carriage," 1 July 1853, 101–2, OldChatKing-Lib, 12,792. For this structure, see Jerry V. Grant, *Noble but Plain: The Shaker Meeting-house at Mount Lebanon* (Old Chatham, NY: Shaker Museum and Library, 1994).

55 "A Journey and D . . . [to] the Eastern Societies of Believers, by the Ministry of the Holy Mount. Commenced June 19th 1850," 26 July 1850, WRHS, ShakerMSS, Series V, B-148. For more on the community production there, see Theodore E. Johnson, *Hands to Work and Hearts to God: The Shaker Tradition in Maine*, photography by John McKee (Brunswick, ME: Bowdoin College Museum of Art, 1969); and Sister Mildred R. Barker, *The Sabbathday Lake Shakers—An Introduction to the Shaker Heritage* (Sabbathday Lake, ME: Shaker Press, 1985).

56 Henry C. Blinn, "Diary of the Ministry's Journey to New Lebanon and Groveland," 8 July 1856, 14, OldChatKingLib, 12,792.

57 "Correspondence dated 1832, 1851, and 1881, of William Deming, Benjamin S. Youngs, and others, from Pittsfield, Mass., and Enfield, Conn.," 8 January 1832, LofC, ShakColl, Item 5, the missive being a "Copy of a Letter [by William Deming] for Elder Benjamin S. Youngs, Pittsfield[,] Mass.[,] 8th January 1832." See also the transcription also in Goodwillie and Ott, *Hancock Shaker Village*, 75. Deming's letter offers a detailed description of the building, the foundation for which he noted was laid on 15 April 1862.

58 Henry C. Blinn, "Diary of a Journey from Canterbury, N.H. to Enfield & on to New Lebanon, N.Y. & to Hancock, Mass. in a Carriage," 4 July 1853, 111–12, OldChatKing-Lib, 12,792.

59 Henry C. Blinn, "Notes by the way, while on journey to the state of Kentucky in the year 1873," 10 May 1873, Canterbury Shaker Village, Archives, 9779 Bl, ID #1956 (photocopy at Hancock Shaker Village, the Amy Bess and Lawrence K. Miller Library [hereafter cited as HSV, MillerLib], call #9758, B648, ID #6436). (Another version of Blinn's travel account is in OldChatKingLib, 12,791.) Another transcription of the record for that date appears in Theodore E. Johnson, "A Journey to Kentucky in the Year 1873 by Elder Henry C. Blinn," *Shaker Quarterly* 5, no. 2 (1965): 38.

60 Henry C. Blinn, "Notes by the way, while on journey to the state of Kentucky in the year 1873," 14 May 1873, Canterbury Shaker Village, Archives, 9779 Bl, ID #1956 (photocopy at HSV, MillerLib, call #9758, B648, ID 6436). (Another version of Blinn's travel account is in OldChatKingLib, 12,791.)

61 "Correspondence dated 1832, 1851, and 1881, of William Deming, Benjamin S. Youngs, and others, from Pittsfield, Mass., and Enfield, Conn.," 8 January 1832, LofC, ShakColl, Item 5, the missive being a "Copy of a Letter [by William Deming] for Elder Benjamin S. Youngs, Pittsfield[,] Mass.[,] 8th January 1832." See also the transcription in Goodwillie and Ott, *Hancock Shaker Village*. For the building, see Goodwillie and Ott, *Hancock Shaker Village*, 72–79, 73–75, for a transcription of Deming's letter. See also observations in Paul Oliver, *Built to Meet Needs: Cultural Issues in Vernacular Architecture* (Amsterdam: Elsevier, 2006), 371.

62 Lamson, *Two Years' Experience among the Shakers*, 16.

63 Prudence Morrell, "This little Book contains an account of a journey taken by Prudence Morrell & Eliza Sharp, to the West, in the year 1847," 11 August 1847, WRHS, ShakerMSS, Series V, B-141.

64 "Journal of a trip to western societies by Hiram Rude and Hanna[h] Ann Agnew, May 28-July 3," June 1856, 16, WRHS,ShakerMSS, Series V, B-161.

65 Quoted from Starbuck and Smith, *Historical Survey of Canterbury Shaker Village,* 1:75n28. See also Sister Marcia [Bullard], "Shaker Industries," *Good Housekeeping,* July 1906, 36.

66 Thomas Damon, "Journal of a trip from Enfield, Connecticut to Shaker communities in Maine, New Hampshire, and Massachusetts, 1850," 27 September 1850, WintAndrewsShakColl, ASC 833.

67 Prudence Morrell, "This little Book contains an account of a journey taken by Prudence Morrell & Eliza Sharp, to the West, in the year 1847," 26 May 1847, WRHS,ShakerMSS, Series V, B-141.

68 "A Journey and D . . . [to] the Eastern Societies of Believers, by the Ministry of the Holy Mount. Commenced June 19^{th} 1850," 9 July 1850, WRHS,ShakerMSS, Series V, B-148.

69 "Journal of a visit to five societies of believers viz Enfield, Conn.[,] Tyringham and Hancock Mass.[,] New Lebanon and Waterviliet [*sic*] New York" by a company from Harvard, including Thomas Hammond Jr., Daniel Myrick, Lucy Mackintosh (or McIntosh; or Sarah), Rosalana (Roxalana) Grosvenor, Olive Hatch Sr., and Leonora Blanchard, 18 September 1846, 9, WilliamsCollLib 21, J82 ("Anonymous journal of a visit by a company from Harvard to five societies of believers: Enfield, Tyringham, Hancock, New Lebanon and Watervliet, 1846").

70 Elkins, *Fifteen Years in the Senior Order of Shakers,* 29.

71 Henry C. Blinn, "Diary of a Journey from Canterbury, N.H. to Enfield & on to New Lebanon, N.Y. & to Hancock, Mass. in a Carriage," 4 July 1853, 112–13, OldChatKingLib, 12,792.

72 Henry C. Blinn, "Notes by the way, while on journey to the state of Kentucky in the year 1873," 10 May 1873. Canterbury Shaker Village, Archives, 9779 Bl, ID #1956 (photocopy at HSV,MillerLib, call #9758, B648, ID #6436). (Another version of Blinn's travel account is in OldChatKingLib, 12,791.) For another transcription of Blinn's text for the same date, see Johnson, "Journey to Kentucky," 5, no. 2 (1965): 38. After the demolition in 1938 of the altered original meetinghouse of Moses Johnson, another Johnson meetinghouse (1792–93) was moved to Hancock from Shirley, Massachusetts, in 1962 and forms part of the current Hancock Shaker Village. See Andrews, *A Shaker Meeting House and its Builder.* For the meetinghouses and alterations at Hancock over the years, see also Goodwillie and Ott, *Hancock Shaker Village,* 142–45. For architecture in Hancock more generally, see Jeffrey D. Crocker, *Understanding Shaker Architecture at Hancock Shaker Village: An Interpretive Guidebook* (Pittsfield, MA: Hancock Shaker Village, 1987).

73 Henry C. Blinn, "Notes by the way, while on journey to the state of Kentucky in the year 1873," 10 May 1873, Canterbury Shaker Village, Archives, 9779 Bl, ID #1956 (photocopy at HSV,MillerLib, call #9758, B648, ID #6436). (Another version of Blinn's travel account is in OldChatKingLib, 12,791.) For another transcription of Blinn's text for the same date, see Johnson, "Journey to Kentucky," 5, no. 2 (1965): 39.

74 Barnabas Hinckley, "Diary," 20 September 1836, 11, WintAndrewsShakColl, ASC 831.

75 Sarah Ann Lewis (called in some documents Susan Ann Lewis), "A Small Memorandum Kept while on a Journey to the East" (recording a trip from New Lebanon to seven Shaker communities), 22 and 24 September 1849, 78 and 84–85, OldChatKingLib, 10,483.

76 "Journey" to Mount Lebanon, Watervliet, Hancock, & Tyringham, from Enfield, Connecticut, by Philip Burlingame et al., 29 June 1856, WRHS,ShakerMSS, Series V, B-19.

77 Rufus Bishop, "A Daily Journal of Passing Events; begun January the 1st, 1830. By Rufus Bishop, in the 56th year of his age," vol. 3, 3 August 1846, 46, NYPL,ShakerMSColl, #3.

78 Elsa Parsons (b. 1800), "Testimony of Elsa Parson," 19 December 1843, WRHS,ShakerMSS, Series VI, A-2.

79 Thomas Damon, "Journal of a trip from Enfield, Connecticut to Shaker communities in Maine, New Hampshire, and Massachusetts, 1850," 26 September 1850, WintAndrewsShakColl, ASC 833.

80 "Journal of a visit by the ministers of Union Village [Ohio] and South Union [Kentucky] to eastern communities." Early part written by William Reynolds of Union Village, Ohio, and the later part by Nancy E. Moore, of South Union, Kentucky, 14 September 1854, 28, WRHS,ShakerMSS, Series V, B-250.

81 Elkins, *Fifteen Years in the Senior Order of Shakers*, 118.

82 Giles Bushnell Avery, "Journal of a Trip to the Eastern Societies," April 1843, 25–26, OldChatKingLib, 12,744. For the communities at Harvard and Shirley, see Edward R. Horgan, *The Shaker Holy Land: A Community Portrait* (Harvard, MA: Harvard Common Press, 1982); and Suzanne R. Thurman, *"O Sisters Ain't You Happy?": Gender, Family, and Community among the Harvard and Shirley Shakers, 1781–1918* (Syracuse, NY: Syracuse University Press, 2002).

83 Giles Bushnell Avery, "Journal of a Trip to the Eastern Societies," April 1843, 27, OldChatKingLib, 12,744.

84 Thomas Hammond Jr., "Journal," 14 June 1851, 161, WRHS,ShakerMSS, Series V, B-36.

85 Isaac Newton Youngs, "A Concise View of the Church of God and of Christ On Earth[.] Having its foundation In the faith of Christ's first and Second Appearing[.] New Lebanon 1856," 339 and 345, WintAndrewsShakColl, ASC 861b; transcribed also by Christian Goodwillie in Glendyne R. Wergland and Christian Goodwillie, eds., *History of the Shakers at New Lebanon by Isaac Newton Youngs, 1780–1861* (Clinton, NY: Richard W. Couper Press, 2017), 122, 124.

86 "Journal of a visit by the ministers of Union Village [Ohio] and South Union [Kentucky] to eastern communities." Early part written by William Reynolds of Union Village, Ohio, and the later part by Nancy E. Moore, of South Union, Kentucky, 20 September 1854, 60, WRHS,ShakerMSS, Series V, B-250.

87 Giles Bushnell Avery, "Journal of a Trip to the Eastern Societies," April 1843, 55, OldChatKingLib, 12,744.

88 "Shaker Diary," Friday, 2 March 1877, described in the N-YHS catalogue as the diary of "1877, kept by a woman of the Shirley colony, recording her daily chores, activities, and life in the colony," New-York Historical Society Museum and Library [N-YHSML], Patricia D. Klingenstein Library, Shaker Collection, 1822–79.

89 Deborah Robinson (likely author), "A Short Sketch of our Journey to the East. 1850," 28 September 1850, 72, WintAndrewsShakColl, ASC 829.

90 Rufus Bishop, "A Daily Journal of Passing Events; begun January the 1st, 1830. By Rufus Bishop, in the 56th year of his age" (in 3 vols.; vol. 1 covers 1 January 1830 to 18 May 1839), vol. 1, 25 September 1833, NYPL,ShakerMSColl, #1.

91 See Goodwillie, *Writings of Shaker Apostates and Anti-Shakers*, 3:60; John McBride, undated experience, published by him in *An Account of the Doctrines, Government, Manners and Customs of the Shakers* (Cincinnati, 1834). For the Shakers at Pleasant Hill, see Daniel Mac-Hir Hutton, *Old Shakertown and the Shakers: A Brief History of the Rise of the United Society of Believers in Christ's Second Coming, the Establishment of the Pleasant Hill Colony, Their Beliefs, Customs and Pathetic End* (Harrodsburg, KY: Harrodsburg Herald Press, 1936); Marywebb Gibson [Mary Webb Gibson], *Shakerism in Kentucky: Founded in America by Ann Lee* (Cynthiana, KY: Hobson Press, 1942) (also published as Marywebb Gibson Robb, *Shakerism in Kentucky: Founded in America by Ann Lee* [Lexington, KY: Hurst, 1942]); Gerald F. Ham, "Pleasant Hill: A Century of Kentucky Shakerism, 1805–1910" (master's thesis, University of Kentucky, 1955); and Thomas D. Clark and F. Gerald Ham, *Pleasant Hill and its Shakers* (Pleasant Hill, KY: Shakertown Press, 1968). See also Julia Neal, *The Kentucky Shakers* (Lexington: University Press of Kentucky, 1977); and Thomas Parrish, *Restoring Shakertown: The Struggle to Save the Historic Shaker Village of Pleasant Hill* (Lexington: University Press of Kentucky, 2005).

92 Elkins, *Fifteen Years in the Senior Order of Shakers*, 77.

93 Ibid., 39–40.

94 Ibid., 23.

95 Prudence Morrell, "This little Book contains an account of a journey taken by Prudence Morrell & Eliza Sharp, to the West, in the year 1847," 10 August 1847, WRHS,ShakerMSS, Series V, B-141.

96 "Diary of a journey by the ministry of Pleasant Hill and South Union, Kentucky, to visit the eastern Shakers, 1869," 22 June 1869, LofC,ShakColl, Item 35.

97 Elkins, *Fifteen Years in the Senior Order of Shakers*, 51.

98 Ibid., 51–52.

99 "Diary of a journey by the ministry of Pleasant Hill and South Union, Kentucky, to visit the eastern Shakers, 1869," 24 June 1869, LofC,ShakColl, Item 35.

100 Henry C. Blinn, "Notes by the way, while on journey to the state of Kentucky in the year 1873," 10 May 1873, Canterbury Shaker Village, Archives, 9779 Bl, ID #1956 (photocopy at HSV,MillerLib, call #9758, B648, ID 6436). (Another version of Blinn's travel account is in OldChatKingLib, 12,791.) For another transcription of Blinn's text for the same date, see Johnson, "Journey to Kentucky," 5, no. 2 (1965): 41.

101 Henry C. Blinn, "Notes by the way, while on journey to the state of Kentucky in the year 1873," 8 May 1873, Canterbury Shaker Village, Archives, 9779 Bl, ID #1956 (photocopy at HSV,MillerLib, call #9758, B648, ID 6436). (Another version of Blinn's travel account is in OldChatKingLib, 12,791.) For another transcription of Blinn's text for the same date, see Johnson, "Journey to Kentucky," 5, no. 1 (1965): 18–19.

102 Isaac Newton Youngs, "A Concise View of the Church of God and of Christ On Earth[.] Having its foundation In the faith of Christ's first and Second Appearing[.]

New Lebanon 1856," 152, WintAndrewsShakColl, ASC 861b; transcribed also by Goodwillie in Wergland and Goodwillie, *History of the Shakers*, 63.

103 For Holy Mounts, see Robert F. W. Meader, "Zion Patetica," *Shaker Quarterly* 2, no. 1 (1962): 5–17. A description of the site: "Each 'feast ground' followed pretty much the same pattern. From half to three-quarters of an acre of ground was leveled off, cleared of trees, stumps and rocks, seeded down to grass, and a tall marble slab, called the Fountain Stone, erected near one end of it, surrounded by a low cedar fence. . . . At one end of the cleared Feast Ground was usually a small one-storey house, for shelter against the sudden storms which might sweep the hilltop. . . . The whole area was surrounded by a white wooden rail fence" (5).

104 Giles Bushnell Avery, "Journal of a Trip to the Eastern Societies," 21 April 1843, 7, OldChatKingLib, 12,744.

105 Prudence Morrell, "This little Book contains an account of a journey taken by Prudence Morrell & Eliza Sharp, to the West, in the year 1847," 1 June 1847, WRHS,ShakerMSS, Series V, B-141.

106 Prudence Morrell, "This little Book contains an account of a journey taken by Prudence Morrell & Eliza Sharp, to the West, in the year 1847," 10 August 1847, WRHS,ShakerMSS, Series V, B-141. For structures there and designs by Micajah Burnett (1791–1879), see James C. Thomas, "Micajah Burnett and the Buildings at Pleasant Hill," *Magazine Antiques* 98, no. 4 (1970): 600–605.

107 "A journal of the Ministrys Eastern Visit," commenced 19 June 1850, visit on 23 July 1850, 43,WRHS,ShakerMSS, Series V, B-147.

108 Deborah Robinson (likely author), "A Short Sketch of our Journey to the East. 1850," 31 August 1850, WintAndrewsShakColl, ASC 829.

109 "Journal of a visit by the ministers of Union Village [Ohio] and South Union [Kentucky] to eastern communities." Early part written by William Reynolds of Union Village, Ohio, and the later part by Nancy E. Moore, of South Union, Kentucky, 18 September 1854, 43–44, WRHS,ShakerMSS, Series V, B-250.

110 "A Journal, or an Account of a load of Brethren & Sisters at Second Family, Watervliet, N. York Visiting Harvard & Shirley, Mass. June 1847," 5 June 1847, WRHS,ShakerMSS, Series V, B-332. The names of the travelers are listed as David Train Jr., Joel Smith, Eleanor Vedder, Polly Bacon, Thankful Copley, and Lucinda Harwood, as written on the initial page of the (unpaginated) manuscript.

111 WintAndrewsShakColl, SA 1294. The words are fragmentary. On one side, it says, "[F]avor. [Pe]ople. Fountain.this," on the other "LO[VE]," and, below that "JE[SUS]."

112 "Journal of Mary Dryer," 13 and 18 May 1843, WRHS,ShakerMSS, Series V, B-24 and B-25.

113 Sarah Ann Lewis (called in some documents Susan Ann Lewis), "A Small Memorandum Kept while on a Journey to the East" (recording a trip from New Lebanon to seven Shaker communities), 3 September 1849, 41, OldChatKingLib, 10,483.

114 Isaac Newton Youngs, "A Concise View of the Church of God and of Christ On Earth[.] Having its foundation In the faith of Christ's first and Second Appearing[.] New Lebanon 1856," 156, WintAndrewsShakColl, ASC 861b; transcribed also by Christian Goodwillie in Wergland and Goodwillie, *History of the Shakers*, 66.

115 For example, for the periodic maintenance and preparation of a Holy Mount, and mention of the erection of the stone on 7 October 1843, see WRHS,ShakerMSS, Series V, B-13, Enfield, Connecticut, "Journal, Enfield, Conn., probably kept by Eldress Anna Granger [1808–92]," includes early history of Enfield, dates buildings were constructed, copies of memorials and letters, record of visitors, biography of Erastus Webster, and a record of deaths, 1842–85.

116 Lamson, *Two Years' Experience among the Shakers*, 57, 58, 60. Sandra A. Soule offers a good summary of Holy Mount meeting in May 1843 at Hancock, Massachusetts, where the world's people came and stood outside the boundary fence and watched, despite "Shakers efforts to keep the meeting secret." See Sandra A. Soule, *Seeking Robert White: Quaker, Shaker Husband, Father* (Clinton, NY: Richard W. Couper Press, 2016), 66.

117 Lamson, *Two Years' Experience among the Shakers*, 71.

118 "A Journey and D . . . [to] the Eastern Societies of Believers, by the Ministry of the Holy Mount. Commenced June 19^th^ 1850," 9 July 1850, WRHS,ShakerMSS, Series V, B-148.

119 Elkins, *Fifteen Years in the Senior Order of Shakers*, 100.

120 Timothy D. Rieman and Jean M. Burks, *The Shaker Furniture Handbook* (Atglen, PA: Schiffer, 2005), 32.

121 See "Simplicity should have a place in thy heart and soul: this beautifies the child of God." In Section V, No. 27, in *Youth's Guide in Zion, and Holy Mother's Promises. Given by Inspiration at New Lebanon, N.Y[,] January 5, 1842* (Canterbury, NH: n.p., 1842).

122 Any similarity between plain Quaker and Shaker aesthetics is largely from parallel development and not necessarily based on influence or, to be sure, shared religious thought. See Karie Diethorn, "What's Real? Quaker Material Culture and Eighteenth-Century Historic Site Interpretation," in *Quaker Aesthetics: Reflections on a Quaker Ethic in American Design and Consumption*, ed. Emma Jones Lapsanky and Anne A. Verplanck (Philadelphia: University of Pennsylvania Press, 2003), 289.

123 John Bigelow, ed., *Autobiography of Benjamin Franklin* (Philadelphia: J. B. Lippincott, 1868), 210.

124 Christian Becksvoort, *The Shaker Legacy: Perspectives on an Enduring Furniture Style*, Photographs by John Sheldon (Newtown, CT: Taunton Press, 1998), notes that Shaker pieces were "strongly influenced by the prevailing tastes of the surrounding world" and often just simplified or removed some of the ornament (67–68). See also Becksvoort's useful comparison of a Shaker ladderback chair and a similar one by a non-Shaker (74). See also the introduction to *Shaker Design*, ed. Burks, where she notes the "importance of plainness" in early American design, including American Federal period furniture, a taste that stood as a forerunner and parallel to the Shaker desire for "plain and functional furniture" (xx–xxi).

125 See Sumpter Priddy, "Plain Shakers, Fancy World," in *Shaker Design*, ed. Burks, 151–84.

126 See Patricia E. Kane, "Samuel Gragg: His Bentwood Fancy Chairs," *Yale University Art Gallery Bulletin* 33 (1971): 27–37.

127 For parallels between Shaker and Japanese furniture in the nineteenth century, see Becksvoort, *The Shaker Legacy*, 17–19.

128 "Items of a Journey to Harvard, Shirley, Lynn, New York, etc.," trip taken by Aaron Bells, George Curtis, and Abigail Crossman, journal doubtless written by Abigail Crossman, 21 August 1846, WRHS,ShakerMSS, Series V, B-140.

129 Jerry V. Grant and Douglas R. Allen, *Shaker Furniture Makers* (Hanover, NH: University Press of New England, for Hancock Shaker Village, Pittsfield, MA, 1989). Their useful study focused on the work of twenty-seven different Shaker furniture craftsmen. For notices of individual known makers, see also Rieman and Burks, *The Shaker Furniture Handbook* and their *Encyclopedia of Shaker Furniture*; and June Sprigg, "Marked Shaker Furniture," *Magazine Antiques* 115, no. 5 (1979): 1048–58.

130 "Millennial Laws, or Gospel Statutes and Ordinances," October 1845 (revised from the laws of August 1821), Part II, Section XII, no. 4, 137, LofC,ShakColl, Item 100. See also a transcription in Andrews, *People Called Shakers*, 274.

131 Timothy D. Rieman, *Shaker Furniture: A Craftsman's Journal* (Atglen, PA: Schiffer, 2006), 102. For Shaker colors, see also June Sprigg, *Shaker: Original Paints & Patinas* (Muhlenberg, PA: Muhlenberg College, Center for the Arts, Allentown, PA, 1987).

132 Rieman, *Shaker Furniture*, 104.

133 For illustrations and discussions of other vividly colored Shaker case pieces, see Rieman and Burks, *The Shaker Furniture Handbook*, 78, 89. For an overview of color and varnish in Shaker design, see Kirk, *The Shaker World*, 124–55.

134 Discussed in Rieman and Burks, *The Shaker Furniture Handbook*, 72.

135 Results are discussed in extensive wall text (Study Room 16) in the Brick Dwelling; it is likely that other rooms also had moldings and doors painted forcible colors. Analysis did reveal that the flooring throughout in the same building was once painted a strong yellow. The laws of 1845 and 1860 suggested the dwelling house floors, if they were to be stained, should be painted a "reddish yellow." See Library of Congress, Shaker Collection, Item 100, "Millennial Laws, or Gospel Statutes and Ordinances," October 1845 (revised from the laws of August 1821), Part III, Section IX, no. 4, 206; and LofC,ShakColl, Item 105, "Rules and Orders. for the Church of Christ's Second Appearing, Established By the Ministry and Elders of the Church. Revised and Reestablished by the Same. New-Lebanon. N.Y. May 1860," Part III, Section V, "Counsels," no. 2, 51.

136 "Correspondence dated 1832, 1851, and 1881, of William Deming, Benjamin S. Youngs, and others, from Pittsfield, Mass., and Enfield, Conn.," 8 January 1832, LofC,ShakColl, Item 5, the missive being a "Copy of a Letter [by William Deming] for Elder Benjamin S. Youngs, Pittsfield[,] Mass.[,] 8th January 1832." See also the transcription in Goodwillie and Ott, *Hancock Shaker Village*, 75.

137 Susan L. Buck, "Shaker Painted Furniture: Provocative Insights into Shaker Paints and Painting Techniques," in *Painted Wood: History and Conservation*, ed. Valerie Dorge and F. Carey Howlett (Los Angeles: Getty Conservation Institute, 1998), 143–54. See also Susan L. Buck, "Interpreting Paint and Finish Evidence on the Mount Lebanon Shaker Collection," in *Shaker: The Art of Craftsmanship*, by Rieman, 46–57.

138 For discussion of some of the subtle ways that Shaker furniture achieved a kind of

sophistication, see Robert W. Wilkins, "The Shaker Aesthetic Reconsidered," *Magazine Antiques* 173, no. 1 (2008): 194–201.

139 There are a number of well-illustrated and useful publications on Shaker furniture design, in addition to the literature on broader Shaker material culture (see also note 1 in this chapter), including Edward Deming Andrews, *The Furniture of Shaker Dwellings and Shops* (Pittsfield, MA: Berkshire Museum, 1932); Edward Deming Andrews and Faith Andrews, *Shaker Furniture: The Craftsmanship of an American Communal Sect*, photographs by William F. Winter (New Haven, CT: Yale University Press, 1937; London, H. Milford, Oxford University Press, 1937; reprint, New York: Dover, 1950); Edward Deming Andrews and Faith Andrews, *Religion in Wood: A Book of Shaker Furniture* (Bloomington: Indiana University Press, 1966), reprinted as *Masterpieces of Shaker Furniture* (Mineola, NY: Dover, 1999); Julia Neal, "Regional Characteristics of Western Shaker Furniture," *Magazine Antiques* 98, no. 4 (1970): 611–17; John G. Shea, *The American Shakers and their Furniture, with Measured Drawings of Museum Classics* (New York: Van Nostrand Reinhold, 1971); James W. Gibbs and Robert W. Meader, *Shaker Clockmakers* (Columbia, PA: National Association of Watch and Clock Collectors, 1972); A. D. Emerich and A. H. Benning, *Shaker: Furniture and Objects from the Faith and Edward Deming Andrews Collections* (Washington, D.C.: Smithsonian Institution Press, published for the Renwick Gallery of the National Collections of Fine Arts, 1973); Mary Lyn Ray, introduction to *True Gospel Simplicity: Shaker Furniture in New Hampshire* (Concord, MA: New Hampshire Historical Society, 1974); June Sprigg, *By Shaker Hands* (New York: Alfred A. Knopf, 1975; 2nd ed., Hanover, NH: University Press of New England, 1990); John Kassay, *The Book of Shaker Furniture, With Measured Drawings by the Author* (Amherst: University of Massachusetts Press, 1980); June Sprigg, *Shaker: Masterworks of Utilitarian Design Created between 1800 and 1875* (Katonah, NY: Katonah Gallery, 1983); David Serette, *Shaker Smalls* (Sebasco, ME: Cardigan Press, 1983); Charles R. Muller and Timothy D. Rieman, *The Shaker Chair* (Winchester, OH: Canal Press, 1984); June Sprigg, *Shaker Design* (New York: Whitney Museum of American Art, 1986); Charles L. Flint, *Mount Lebanon Shaker Collection*, photographs by Paul Rocheleau (New Lebanon, NY: Mount Lebanon Shaker Village, 1987); Jean M. Burks, *Documented Furniture: An Introduction to the Collections* [Canterbury Shaker Village] (Canterbury, NH: Shaker Village, 1989); Grant and Allen, *Shaker Furniture Makers*; John T. Kirk and Jerry V. Grant, "Forty Untouched Masterpieces of Shaker Design," *Magazine Antiques* 135, no. 5 (1989): 1226–37; Edward E. Nickels, "The Shaker Furniture of Pleasant Hill, Kentucky," *Magazine Antiques* 137, no. 5 (1990): 1178–89; Paul Oliver, "'Perfect and Plain': Shakers Approaches to Design," in *Locating the Shakers: Cultural Origins and Legacies of an American Religious Movement*, ed. Mick Gidley and Kate Bowles (Exeter: University of Exeter Press, 1990), 63–70; June Sprigg and Jim Johnson, *Shaker Woodenware: A Field Guide*, photographs by Paul Rocheleau, 2 vols. (Great Barrington, MA: Berkshire House, 1991–92); Timothy D. Rieman and Jean M. Burks, *The Complete Book of Shaker Furniture* (New York: Harry N. Abrams, 1993); Jean M. Burks, "The Evolution in Design in Shaker Furniture," *Magazine Antiques* 145, no. 5 (1994): 732–41; Kirk, *The Shaker World*, 52–155; Becksvoort, *The*

Shaker Legacy; Timothy D. Rieman and Jean M. Burks, *Encyclopedia of Shaker Furniture* (Atglen, PA: Schiffer, 2003); Rieman and Burks, *The Shaker Furniture Handbook*; Rieman, *Shaker Furniture*; Jean M. Burks, "Faith, Form, and Finish: Shaker Furniture in Context," in *Shaker Design*, ed. Burks, 31–60; De Pillis and Goodwillie, *Gather Up the Fragments*, 101–219; and Jerry V. Grant, "On Shaker Furniture," in *Shaker: Function—Purity—Perfection*, introduction by Terence Conran (New York: Assouline, 2014), 18–31.

140 Stephen Bowe and Peter Richmond, *Selling Shaker: The Commodification of Shaker Design in the Twentieth Century* (Liverpool: Liverpool University Press, 2007), 7–67, discuss the early establishment of the aesthetics of Shakerism, the focus on furniture, and the relationship with the art market and the role of Edward Deming Andrews and his wife, Faith Andrews. Before then, Stephen Stein, in considering the "selling of the Shakers," had pointed out the problematic aspects of modern scholarship on the Shakers when carried out by those with a commercial and personal interest in the subject. See his *The Shaker Experience in America: A History of the United Society of Believers* (New Haven, CT: Yale University Press, 1992), 394–409. For a more positive view of Edward and Faith Andrews and their preserving of Shaker culture, see De Pillis and Goodwillie, *Gather Up the Fragments*, esp. 1–99. For modern interest in Shaker material culture, see also Brian L. Bixby, "Seeking Shakers: Two Centuries of Visitors to Shaker Villages" (Ph.D. diss., University of Massachusetts–Amherst, 2010), 152–208.

141 Grant and Allen, *Shaker Furniture Makers*, 3; from the New Lebanon Ministry, "Letter to David Darrow, Elder John Meacham, and Eldress Ruth Farrington at Union Village, Ohio," 2 March 1807, WRHS,ShakerMSS, Series IV, A-31.

142 Rieman and Burks, *The Shaker Furniture Handbook* and their *Encyclopedia of Shaker Furniture*.

143 "Journal of a trip to western societies by Hiram Rude and Hanna[h] Ann Agnew, May 28–July 3," June, 1856, 44, WRHS,ShakerMSS, Series V, B-161.

144 Henry C. Blinn, "Diary of a Journey from Canterbury, N.H. to Enfield & on to New Lebanon, N.Y. & to Hancock, Mass. in a Carriage," 7 July 1853, 121, OldChatKingLib, 12,792.

145 "Journal of a visit by the ministers of Union Village [Ohio] and South Union [Kentucky] to eastern communities." Early part written by William Reynolds of Union Village, Ohio, and the later part by Nancy E. Moore, of South Union, Kentucky, 14 September 1854, 28, WRHS,ShakerMSS, Series V, B-250.

146 Writer unknown (female), "Shaker Diary," 4 May 1875, N-YHSML, Patricia D. Klingenstein Library Museum & Library, Shaker Collection, 1822–79.

147 Benjamin S. Youngs, "Diary of Three Brethren Going South" (John Meacham, Issachar Bates, Sr., and Benjamin S. Youngs, going from New Lebanon to the southeast, beginning 1 January 1805), 29 January 1805, 14, OldChatKingLib, 15,220. The journal lists the place as Edmonson.

148 "Journal of a visit by the ministers of Union Village [Ohio] and South Union [Kentucky] to eastern communities." Early part written by William Reynolds of Union Village, Ohio, and the later part by Nancy E. Moore, of South Union, Kentucky, 24 September 1854, 27–28, WRHS,ShakerMSS, Series V, B-250.

149 Ibid., [written in Cincinnati on] 11 October 1854, 148–49. On page 143, the section is called "Curtis Cramer's plan for making Pea Fowl brushes."

150 Elkins, *Fifteen Years in the Senior Order of Shakers*, 77.

151 Rufus Bishop, "A Daily Journal of Passing Events; begun January the 1st, 1830. By Rufus Bishop, in the 56th year of his age," vol. 1, 2 September 1830, NYPL,ShakerM-SColl, #1.

152 Stephen J. Stein, ed., *Letters from a Young Shaker: William S. Byrd at Pleasant Hill* (Lexington: University Press of Kentucky, 1985), letter dated 28 November 1826, 56–57.

153 Elkins, *Fifteen Years in the Senior Order of Shakers*, 77.

154 *Centennial Illustrated Catalogue and Price List of the Shakers' Chairs, Foot Benches, Floor Mats, etc.* no author listed, but noting "Manufactured and sold by the Shakers at Mt. Lebanon Columbia Co., N.Y." (Boston: Henry A. Turner [publisher]; Albany, NY: Weed, Parsons [printers], 1876), 13. See also the *Illustrated Catalogue and Price List of the Shakers' Chairs* (New York: R. M. Wagan and Co., 1874); and the *An Illustrated Catalogue and Price List of the Shakers' Chairs, Foot Benches, Floor Mats, etc. Manufactured and Sold by the Shakers, At Mt. Lebanon, Columbia Co., N.Y.* (Lebanon Springs, NY: B. F. Reynolds, Book, Card, and Job Printer, 1875).

155 *Centennial Illustrated Catalogue and Price List of the Shakers' Chairs, Foot Benches, Floor Mats, etc.*, [1876], 9–14, 11, 27.

156 "Millennial Laws, or Gospel Statutes and Ordinances," October 1845 (revised from the laws of August 1821), Part III, Section IX, nos. 1–7, 205–6, LofC,ShakColl, Item 100; see also a transcription in Andrews, *People Called Shakers*, 285–86.

157 "Millennial Laws, or Gospel Statutes and Ordinances," October 1845 (revised from the laws of August 1821), Part III, Section VI, no. 5, 196, and no. 4, 195–96, LofC,ShakColl, Item 100; see also a transcription in Andrews, *People Called Shakers*, 283.

158 "Milenial Laws, or Gospel statutes and ordinances, adapted to the day of Christ's second Appea[r]ing. Given & established in the Church, for the protection thereof: By the Ministry & Elders. New Lebanon, August 7th: 1821," Chapter 7, no. 2, 49. WRHS,ShakerMSS, Series I, B-37. Another transcription of the 1821 rules can be found in Theodore E. Johnson, "The 'Millenial Laws' of 1821," *Shaker Quarterly* 7, no. 2 (1967): 35–58. See also the transcription in Kirk, *The Shaker World*, 261–64.

159 For porches in America, see Jay Edwards, "The Complex Origins of the American Domestic Piazza-Veranda-Gallery," *Material Culture* 2, no. 2 (1989): 2–58; Joseph Manca, "On the Origins of the American Porch: Architectural Persistence in Hudson Valley Dutch Settlements," *Winterthur Portfolio: A Journal of American Material Culture* 40, nos. 2–3 (2005): 91–132; and Thomas Durant Visser, *Porches of North America* (Hanover, NH: University Press of New England, 2012).

160 Cited from Henry D. Thoreau, *The Maine Woods* (Boston: Houghton Mifflin, 1892), 121.

161 Isaac Newton Youngs, "A Concise View of the Church of God and of Christ On Earth[.] Having its foundation In the faith of Christ's first and Second Appearing[.] New Lebanon 1856," 344, WintAndrewsShakColl, ASC 861b; transcribed also by Goodwillie in Wergland and Goodwillie, *History of the Shakers*, 124.

162 Thomas Cole, "Essay on American Scenery," *American Monthly Magazine* 1 (January 1836): 2.

163 Elkins, *Fifteen Years in the Senior Order of Shakers*, 25.

164 "Milenial Laws, or Gospel statutes and ordinances, adapted to the day of Christ's second Appea[r]ing. Given & established in the Church, for the protection thereof: By the Ministry & Elders. New Lebanon, August 7[th]: 1821," appended with an asterisk to Chapter 5, no. 9, 31, WRHS,ShakerMSS, Series I, B-37. The placement in Chapter 5, no. 9, appears also in the version in the Shaker Library, Sabbathday Lake, Maine, 14-Cl-035, "Orders and Rules of the Church at New-Lebanon, August 7th 1821," also called "Millenial Laws or Gospel Statutes, Adapted to the Day of Christ's Second Appearing; Given and established in the Church, for the protection of Believers Thereof. By the Ministry and Elders, New-Lebanon August 7th 1821" ("November 22nd 1829, A true copy from the Harvard coppy of Sep[t]. 19th 1829 by J. C.").

165 Elkins, *Fifteen Years in the Senior Order of Shakers*, 29.

166 Library of Congress, Shaker Collection, Item 100, "Millennial Laws, or Gospel Statutes and Ordinances," October 1845 (revised from the laws of August 1821), Part II, Section X, nos. 1–10, 125–29. See also a transcription in Andrews, *People Called Shakers*, 271–72. The omitted part of the transcription here largely concerns the kinds of secular books and newspapers not permitted in the dwelling rooms.

167 "An Extract from The Holy Orders of the Church: Written by Father Joseph, To the Elders of the Church At New Lebanon, and copied agreeable to Father Joseph's word: February 18th 1841," 49–50, WintAndrewsShakColl, ASC 791.

168 Elkins, *Fifteen Years in the Senior Order of Shakers*, 25–26.

169 "A Journal or Day Book Containing some of the most important transactions of the Church [Family] of Harvard" and kept by the Sisters by order of the Ministry and Elders, 1840 (no particular date given), 1, WRHS,ShakerMSS, Series V, B-50.

170 Thomas Damon, "Memoranda, &c. mostly of Events and Things which have transpired since the first of Jan. 1846," (the journal actually begins 3 November 1845), 11 January 1854, 141, OldChatKingLib, 13,357 (photocopy available at HSV,MillerLib, call no. 9758, Da #342).

171 Rufus Bishop, "A Daily Journal of Passing Events; begun January the 1st, 1830. By Rufus Bishop, in the 56th year of his age," vol. 1, 24 December 1830, NYPL,ShakerMSColl, #1.

172 Henry C. Blinn, "Notes by the way, while on journey to the state of Kentucky in the year 1873," 4 June 1873, Canterbury Shaker Village, Archives, 9779 Bl, ID #1956 (photocopy at HSV,MillerLib, call #9758, B648, ID 6436). (Another version of Blinn's travel account is in OldChatKingLib, 12,791.) For another transcription of Blinn's text for the same date, see Johnson, "Journey to Kentucky," 5, no. 4 (1965): 131.

173 Mary Lyn Ray, "A Reappraisal of Shaker Furniture and Society," *Winterthur Portfolio* 8 (1973): 107–32, calls attention to the more ornate quality of furniture produced by the Shakers after 1850 that seemed to violate the earlier Shaker insistence on "gospel simplicity" (124), and she attributes the change in style to a weakening of Shaker self-identity and religious orthodoxy. On the other hand, Beverly Gordon, "Victorian Fancy Goods: Another Reappraisal of Shaker Material Culture," *Winterthur Portfolio: A Journal of American Material Culture* 25, nos. 2–3 (1990): 111–

30, argues against the idea that Shakers had lost their sense of separateness and identity after the Civil War, and she posits instead that they continued some of the simplicity and precision of earlier decades. See also Beverly Gordon, "Shaker Fancy Goods: Women's Work and Presentation of Self in the Community Context in the Victorian Era," in *Women in Spiritual and Communitarian Societies in the United States*, ed. Wendy E. Chmielewski, Louis J. Kern, and Marlyn Klee-Hartzell (Syracuse, NY: Syracuse University Press, 1993), 89–103.

174 Elkins, *Fifteen Years in the Senior Order of Shakers*, 26.

175 "An Extract from The Holy Orders of the Church: Written by Father Joseph, To the Elders of the Church At New Lebanon, and copied agreeable to Father Joseph's word: February 18th 1841," 52, 66, WintAndrewsShakColl, ASC 791.

176 "Millennial Laws, or Gospel Statutes and Ordinances," October 1845 (revised from the laws of August 1821), Part II, Section XVI, ("Concerning Literary Education, and the Schooling of Children,") no. 7, 158, LofC,ShakColl, Item 100. See also a transcription in Andrews, *People Called Shakers*, 277.

177 "Millennial Laws, or Gospel Statutes and Ordinances," October 1845 (revised from the laws of August 1821), Part II, Section XII, ("Concerning marking tools and conveniences"), nos. 2 and 3, 137, LofC,ShakColl, Item 100. See also a transcription in Andrews, *People Called Shakers*, 273–74.

178 "Millennial Laws, or Gospel Statutes and Ordinances," October 1845 (revised from the laws of August 1821), Part II, Section XII, nos. 6–7, 138, LofC,ShakColl, Item 100. See also a transcription in Andrews, *People Called Shakers*, 274.

179 "Millennial Laws, or Gospel Statutes and Ordinances," October 1845 (revised from the laws of August 1821), Part III, Section IX, nos. 8, 9, and 10, 207–8, LofC,ShakColl, Item 100. See also a transcription in Andrews, *People Called Shakers*, 285–86.

180 "Millennial Laws, or Gospel Statutes and Ordinances," October 1845 (revised from the laws of August 1821), Part II, Section XVIII, no. 14, LofC,ShakColl, Item 100. See also a transcription in Andrews, *The People Called Shakers*, 279.

181 "Millennial Laws, or Gospel Statutes and Ordinances," October 1845 (revised from the laws of August 1821), Part III, Section IV ("Concerning Superfluities which are not owned"), nos. 1–5, 187–90, LofC,ShakColl, Item 100. See also a transcription in Andrews, *People Called Shakers*, 282–83.

182 "Millennial Laws, or Gospel Statutes and Ordinances," October 1845 (revised from the laws of August 1821), Part I, Section IV, no. 22, 7, LofC,ShakColl, Item 100. See also a transcription in Andrews, *People Called Shakers*, 259.

183 "Rules and Orders. for the Church of Christ's Second Appearing. Established By the Ministry and Elders of the Church. Revised and Reestablished by the Same. New-Lebanon. N. Y. May 1860," Part II, Section VII, nos. 1 and 2, and, still within Section VII, "Counsels," no. 1, and Section VIII, no. 1, 29–31, LofC,ShakColl, Item 105. Another copy of the laws of 1860, with a similar title and with better spelling ("Daguerreotypes," for example), is in the N-YHSML, Shaker Collection, 1822–79. A transcription of the rules of 1860 is also published in Theodore E. Johnson, ed., "Rules and Orders for the Church of Christ's Second Appearing[,] Established by the Ministry and Elders of the Church[,] Revised and Reestablished by the Same[,] New Lebanon, New York[,] May 1860," *Shaker Quarterly* 11, no. 4 (1971): 139–65.

184 Author unknown, "A Card of love and notice from the Holy Saviour, to Philemon Stewart," dated 25 January 1843, pen and ink on paper, WRHS,ShakerMSS, Series VIII, C-5.

185 Signed "Ollive Spencer," statement dated 26 April 1840, following a list of "Wearing apparel for females" that is given on page 1; quote here from page 5, WintAndrewsShakColl, ASC 797.

186 "A Record of Inspired Writings, Given in the North, or Gathering Family, through Different Instruments. New Lebanon [1840-]1842," in a "A Short Roll from Mother Ann and Father William," 13 March 1841, 10, NYPL,ShakerMSColl, #23.

187 Shaker Library, Sabbathday Lake (New Gloucester), Maine, "A General Statement of the Holy Laws of Zion," cat. no. 10-CL-020, New Lebanon, 7 May 1840, 31, 46.

188 Ibid., 83.

189 "A General Statement of the Holy Laws of Zion. Introduction by Father James. New Lebanon Thursday morning May 7th 1840" ("written by the hand of God Himself, and given to his two Anointed Ones to establish on earth"), and in the section "Supplement to the Holy Laws of Zion. . . . Written by the Holy Angel Vikalen. . . . May 21st 1840," 117, 118, NYPL,ShakerMSColl, #10. (The manuscript is similar to the one given in the previous note, 10-CL-020 at Sabbathday Lake.)

190 Shaker Library, Sabbathday Lake (New Gloucester), Maine, cat. no. 10-CL-050, "The Solemn and Sacred Word or Holy and Eternal Law of God Almighty, even the Great I am . . . A Book Containing a Certain Part of the Sacred Word of God selected by God Himself for his Book of Holy Laws . . . read unto the Writer line by line and sentence to sentence by the Chosen Angel Koral Ven Jah and the Holy Apostle John"), commenced 20 February 1841, 48.

191 Ibid., 48–50.

192 Ibid., 52–54. The edicts are also called there "The Solemn and Sacred Word or Holy and Eternal Law of God Almighty, even the Great I Am unto for the Order of His Holy Anointed on Earth."

193 Ibid., 89.

194 Thomas Brown, *An Account of the People called Shakers* (Troy, NY: printed by Parker and Bliss, 1812), 220.

195 Elkins, *Fifteen Years in the Senior Order of Shakers*, 26.

196 Stein, *The Shaker Experience in America*, 63.

197 "Copies of messages and extracts of messages from Mother Ann, through Philemon Stewart," 1838, 8, WRHS,ShakerMSS, Series VIII, B-112. See also Promey, *Spiritual Spectacles*, 36, and a broader discussion, 32–43, about the banning or destruction of images.

198 "A true Record of Sacred Communications; Written by Divine Inspiration, By the mortal hand of Chosen Instruments; in the Church at New Lebanon," vol. II, from 4 August 1839 to 20 June 1840, "New Lebanon March 12th: 1840," 51–52, WRHS,ShakerMSS, Series VIII, B-117. See also Promey, *Spiritual Spectacles*, 36.

199 For a good compendium of photographs of Shakers and Shaker sites, see Elmer R. Pearson and Julia Neal, *The Shaker Image* (Boston: New York Graphic Society; Hancock, MA: Shaker Community, 1974 [1994, for the 2nd and annotated ed.]).

200 "Circular Concerning Photographs, Daugerreotypes, Ferrotypes, &c.," dated 1

November 1873, Church Family, Mount Lebanon, OldChatKingLib. See also Livingston, "Victorian Views," 65–69.

201 Thomas Damon, "Memoranda, &c. mostly of Events and Things which have transpired since the first of Jan. 1846" (the journal actually begins 3 November 1845), 11 August 1854, 149, OldChatKingLib, 13,357 (photocopy available at HSV,MillerLib, call no. 9758, Da #342).

CHAPTER 4: JOURNEYS TO THE OUTSIDE

1 "Millenial Laws, or Gospel Statutes and ordinances, adapted to the day of Christ's second Appea[r]ing. Given & established in the Church, for the protection thereof: By the Ministry & Elders. New Lebanon, August 7th: 1821," Chapter V, no. 6, 35 ("Rules to be observed in going abroad, & in our intercourse with the world of mankind"). Another transcription of the 1821 rules can be found in Theodore E. Johnson, "The 'Millenial Laws' of 1821," *Shaker Quarterly* 7, no. 2 (1967): 35–58. See also the transcription in John T. Kirk, *The Shaker World: Art, Life, Belief* (New York: Harry N. Abrams, 1997), 261–64.

2 "Millennial Laws, or Gospel Statutes and Ordinances," October 1845 (revised from the laws of August 1821), Part II, Section XV ("Orders concerning going abroad, and Intercourse with the World"), no. 11, 149, LofC,ShakColl, Item 100. See also a transcription in Edward Deming Andrews, *The People Called Shakers: A Search for the Perfect Society* (New York: Oxford University Press, 1953), 249–89 (275–76 for Part II, Section XV). Such restrictions on tourism were continued in the rules and orders of 1860 that revised the laws of 1845, although such places as ships and jails were no longer off limits. LofC,ShakColl, Item 105, "Rules and Orders. for the Church of Christ's Second Appearing, Established By the Ministry and Elders of the Church. Revised and Reestablished by the Same. New-Lebanon. N.Y. May 1860," 1860, Part II, Section IX, no. 3, 34–35: "It is not allowable for Believers, to go into Museums, Theatres, or to attend, Caravans, or shows, to gratify curiosity." A transcription of the rules of 1860 is also published in Theodore E. Johnson, ed., "Rules and Orders for the Church of Christ's Second Appearing[,] Established by the Ministry and Elders of the Church[,] Revised and Reestablished by the Same[,] New Lebanon, New York[,] May 1860," *Shaker Quarterly* 11, no. 4 (1971): 139–65.

3 "An Extract from The Holy Orders of the Church: Written by Father Joseph, To the Elders of the Church At New Lebanon, and copied agreeable to Father Joseph's word: February 18th 1841," 23, Winterthur Library, Edward Deming Andrews Memorial Shaker Collection (hereafter cited as WintAndrewsShakColl), ASC 791. See also WintAndrewsShakColl, ASC 792, "The Holy Orders of the Church. Written by Father Joseph. To the Elder of the Church at New Lebanon: And copied agreeable to Father Joseph's Word[.] February 18th 1841." Another manuscript version is LofC,ShakColl, Item 94, Section 4, number 4, 11, dated 18 February 1841, New Lebanon, called "The Holy Orders of God for his People," part of "An Extract from the Holy Orders of the Church, written by Father Joseph," both dated 18 February 1841.

4 John M. Brown, "Notes by the Way," written in 1866–71, the passage here written

5 August 1866, recording events from 18–21 July 1866, 13, 26, WRHS,ShakerMSS, Series VII, B-127.

5 Cited here from "Millennial Laws, or Gospel Statutes and Ordinances," October 1845 (revised from the laws of August 1821), Part II, Section XVI, no. 3, 156, LofC,ShakColl, Item 100. For similar advice for teachers, but with different wording from another manuscript of the 1845 laws, see Andrews, *People Called Shakers*, 276–77.

6 "Journal containing [an account] by unidentified Shakers [from Harvard, Massachusetts] to Watervliet, New York, August 1845," 12 (?) and 21 (?) August 1845, WRHS,ShakerMSS, Series V, B-51.

7 "Journal of a visit by the ministers of Union Village [Ohio] and South Union to eastern communities." Early part written by William Reynolds of Union Village, Ohio, and the later part by Nancy E. Moore, of South Union, Kentucky, 28 September 1854, 105–7, WRHS,ShakerMSS, Series V, B-250. (The demarcation line of authorship is not clear. The manuscript is written by one hand, and it is likely that either Moore or Reynolds took the notes that the other had written and wrote them cleanly at a later time and made one account of it all.)

8 "Journal of a trip to western societies by Hiram Rude and Hanna[h] Ann Agnew, May 28–July 3," 28 May and 29 May 1856, 1, 3, WRHS,ShakerMSS, Series V, B-161. Parts of the manuscript, clearly set off as a separate description, reflect Agnew's experiences in visiting White Water, Ohio.

9 "Items of a Journey to Harvard, Shirley, Lynn, New York, etc.," trip taken by Aaron Bells, George Curtis, and Abigail Crossman, journal likely written by Abigail Crossman, 22 and 25 August 1846, WRHS,ShakerMSS, Series V, B-140.

10 Calvin Green, "Journal Kept by Calvin Green on a trip to Philadelphia and vicinity," 29 May 1828, WRHS,ShakerMSS, Series V, B-98. (Manuscript difficult to read; cited here from the typescript prepared by the WRHS, B-98A.)

11 Joanna Mitchell, "Daily Journal," or "A Journey from New Lebanon, New York to Union Village, Ohio, kept by Joanna Mitchell," 10 August 1835, WRHS,ShakerMSS, Series V, B-238.

12 Freegift Wells, "Narrative of a journey made to Southold, Long Island, September 5–21, 1853, by Freegift Wells," 5 September and 6 September 1853, WRHS,ShakerMSS, Series V, B-339. For a view of Union Square, see John Bachmann, *Union Square, New-York* (1849), hand-colored lithograph by Sarony & Major, published by Williams & Stevens, New York. Metropolitan Museum of Art, Bequest of Susan Dwight Bliss, 1966 (67.630.142), http://metmuseum.org/art/collection/search/383286.

13 Cf. Spencer Trask, *Bowling Green*, Half Moon Series, vol. 2, no. 5 (New York: G. P. Putnam's Sons, 1898).

14 See *In Memoriam: Elder Henry C. Blinn, 1824–1905* (Concord, NH: Rumford Printing, 1905), including autobiographical notes by Blinn (8–38). Blinn himself noted (31–32) that he became an elder in March 1852 and entered the ministry in June 1852, the year before his travels to New York noted here.

15 Henry C. Blinn, "Diary of the Ministry's Journey to New Lebanon and Groveland," 24 July 1856, 69, Old Chatham, Emma B. King Research Library at the Shaker

Museum/Mount Lebanon Old Chatham, Emma B. King Research Library at the Shaker Museum/Mount Lebanon (hereafter cited as OldChatKingLib), 12,792.

16 For the appearance and function of the palace, see Dell Upton, "Inventing the Metropolis: Civilization and Urbanity in Antebellum New York," in *Art and the Empire City: New York, 1825–1861*, ed. Catherine Hoover Voorsanger and John K. Howat (New York: Metropolitan Museum of Art, New York; New Haven, CT: Yale University Press, 2000), 40–42, 467, and catalog nos. 141–42. For the architecture, see Georg Carstensen, *New York Crystal Palace: Illustrated Description of the Building. By Geo. Carstense & Chs. Gildemeister, Architects of the Building* (New York: Riker, Thorne & Co., 1854).

17 "Journal of a visit by the ministers of Union Village [Ohio] and South Union to eastern communities." Early part written by William Reynolds of Union Village, Ohio, and the later part by Nancy E. Moore, of South Union, Kentucky, 28 September 1854, 102, WRHS,ShakerMSS, Series V, B-250.

18 Henry C. Blinn, "Diary of the Ministry's Journey to New Lebanon and Groveland," 25 July 1856, 68, OldChatKingLib, 12,792.

19 Freegift Wells, "Narrative of a journey made to Southold, Long Island, September 5–21, 1853, by Freegift Wells," 18 September and 19 September 1853, WRHS,ShakerMSS, Series V, B-339.

20 "Diary of a journey by the ministry of Pleasant Hill and South Union, Kentucky, to visit the eastern Shakers, 1869," 13 June 1869, LofC,ShakColl, Item 35.

21 See Roy Rosenzweig and Elizabeth Blackmar, *The Park and the People: A History of Central Park* (Ithaca, NY: Cornell University Press, 1992). See also Upton, "Inventing the Metropolis," 42–45.

22 John M. Brown, "Notes by the Way," written in 1866–71, the passage here written 5 August 1866, recording events on 18–21 July 1866, 25–26, WRHS,ShakerMSS, Series VII, B-127.

23 Ibid., 25–27.

24 Calvin Green, "Journal Kept by Calvin Green on a trip to Philadelphia and vicinity," 7–29 May 1828, WRHS,ShakerMSS, Series V, B-98. (Manuscript difficult to read; cited here from the typescript prepared by the WRHS, B-98A.)

25 For a broader history of development of streets in Manhattan, see Paul E. Cohen and Robert T. Augustyn, *Manhattan in Maps, 1527–1995* (New York: Rizzoli, 1997). For the history of street plans in Lower Manhattan in the nineteenth century, see Upton, "Inventing the Metropolis," 4–11.

26 Calvin Green, "Journal Kept by Calvin Green on a trip to Philadelphia and vicinity," 28 May 1828, WRHS,ShakerMSS, Series V, B-98. (Manuscript difficult to read; cited here from the typescript prepared by the WRHS, B-98A.) For a recent account of the history of Philadelphia's street and park plan, see Elizabeth Milroy, *The Grid and the River: Philadelphia's Green Places, 1682–1876* (University Park: Pennsylvania University Press, 2016). For another statement of praise during this trip of the regular plan of Philadelphia, see Green's "Biographic Memoir of the Life and Experience of Calvin Green" (1861), 217, WRHS,ShakerMSS, Series VI, B-28, transcribed in Glendyne R. Wergland and Christian Goodwillie, eds., *Shaker Autobiographies,*

Biographies and Testimonies, 1806–1907, 3 vols. (London: Pickering & Chatto, 2014; London: Routledge, 2016), 2:219.

27 Milton Robinson, "Journal," 1830–33 ("Written by Milton Robinson of South Union, KY, was declining with consumption—took a sea voyage for the improvement of his health"), 13 May 1831, 84, LofC,ShakColl, Item 37. For the Second Bank of the United States, see Agnes Addison Gilchrist, *William Strickland: Architect and Engineer, 1788–1854* (Philadelphia: University of Pennsylvania Press, 1950; here cited from New York: Da Capo Press, 1969, enlarged ed.), 53–58; and Roger Moss, *Historic Landmarks of Philadelphia*, photographs by Tom Crane (Philadelphia: University of Pennsylvania Press, a Barra Foundation Book, 2008), 80–85.

28 "Journal of a trip to western societies by Hiram Rude and Hanna[h] Ann Agnew, May 28–July 3," June 1856, 44, WRHS,ShakerMSS, Series V, B-161.

29 Milton Robinson, "Journal," 1830–33 ("Written by Milton Robinson of South Union, KY, was declining with consumption—took a sea voyage for the improvement of his health"), 16 May 1831, 86, LofC,ShakColl, Item 37.

30 For the Naval Asylum, see Gilchrist, *William Strickland*, 73–76; and Moss, *Historic Landmarks of Philadelphia*, 100–105.

31 "Journal of a trip to western societies by Hiram Rude and Hanna[h] Ann Agnew, May 28–July 3," 30 May 1856, 5, WRHS,ShakerMSS, Series V, B-161. For the architecture of Girard College, see Bruce Laverty, Michael J. Lewis, and Michel Taillon Taylor, *Monument to Philanthropy: The Design and Building of Girard College, 1832–1848* (Philadelphia: Girard College, 1998); and see the text and photographs in Moss, *Historic Landmarks of Philadelphia*, 110–15.

32 "Journal of a trip to western societies by Hiram Rude and Hanna[h] Ann Agnew, May 28–July 3," 30 May 1856, 5. WRHS,ShakerMSS, Series V, B-161.

33 See Esther Klein, *Fairmount Park: A History and a Guidebook* (Bryn Mawr, PA: Harcum Junior College Press, 1974); and Tuomi Forrest, "Clean, Green, Machine: Philadelphia's Fairmount Water Works, 1800–1860" (master's thesis, University of Virginia, 1996).

34 Calvin Green, "Journal Kept by Calvin Green on a trip to Philadelphia and vicinity," 12 May 1828, WRHS,ShakerMSS, Series V, B-98. (Manuscript difficult to read; cited here from the typescript prepared by the WRHS, B-98A.)

35 For the statue, see Milroy, *The Grid and the River*, 189.

36 "Tour through the States of Ohio and Kentucky by Rufus Bishop and Isaac N. Youngs. In the summer of 1834[.] Copied from Isaac Young's Journal, Part II," 9 October 1834, 12–13, WRHS,ShakerMSS, Series V, B-129. The manuscript cited mentioned no month, but it was the month of October, as indicated in other versions or copies of the same travel. For another transcription of the trip, annotated by Carol Medlicott and titled "Br. Isaac Youngs' Journal[.] Tour with Br. Rufus Bishop, through the states of Ohio and Kentucky, in the Summer of 1834," see Peter H. Van Demark, *The Journals of New Lebanon Shaker Elder Rufus Bishop*, vol. 1, *1815–1839* (Clinton, NY: Richard W. Couper Press, 2018), 197–287, and page 285 for the Fairmount Water Works fountain. For the passage about the waterworks, see also the parallel text in Isaac N. Youngs, "Tour thro the states of Ohio and Kentucky, 1834," vol. 2, October 1834, 74–75, OldChatKingLib, 12,751 (vol. 1) and 12,752 (vol. 2).

37 Ibid., 13, 14. For the month of the trip, see note 36. See also the parallel text and date in OldChatKingLib, 12,751 (vol. 1) and 12,752 (vol. 2), Isaac N. Youngs, "Tour thro the states of Ohio and Kentucky, 1834," vol. 2.

38 "Journal of a visit by the ministers of Union Village [Ohio] and South Union [Kentucky] to eastern communities." Early part written by William Reynolds of South Union, Kentucky, and the later part by traveling companion Nancy E. Moore, also of South Union, Kentucky, 26 September 1854, 92, WRHS,ShakerMSS, Series V, B-250.

39 Ibid., 27 September 1854, 95–96.

40 Ibid., 97, 98. The "Greek" manner was not universally liked, and Young defended his style in a pamphlet, *The New Custom House: Strictures on an article in the "North American Review," for April, 1844* (Boston: W. D. Ticknor, 1844).

41 "Journal of a visit by the ministers of Union Village [Ohio] and South Union to eastern communities." Early part written by William Reynolds of Union Village, Ohio, and the later part by Nancy E. Moore, of South Union, Kentucky, 27 September 1854, 99, WRHS,ShakerMSS, Series V, B-250.

42 Thomas Damon, "Journal of a trip from Enfield, Connecticut to Shaker communities in Maine, New Hampshire, and Massachusetts. 1850," 2 September 1850, WintAndrewsShakColl, 833. He was guided, apparently, by Barnas Sears (1802–80), secretary of the Massachusetts Board of Education, replacing Horace Mann in that position.

43 Sarah Ann Lewis (called in some documents Susan Ann Lewis), "A Small Memorandum Kept while on a Journey to the East" (recording a trip from New Lebanon to seven Shaker communities), 29 August 1849, 31, OldChatKingLib, 10,483.

44 "A Journal, or an Account of a load of Brethren & Sisters at Second Family, Watervliet, N. York Visiting Harvard & Shirley, Mass. June 1847," 31 May 1847, WRHS,ShakerMSS, Series V, B-332. The names of the travelers are listed as David Train Jr., Joel Smith, Eleanor Vedder, Polly Bacon, Thankful Copley, and Lucinda Harwood, as written on the initial page of the (unpaginated) manuscript.

45 Ibid., 9 June 1847.

46 Sarah Ann Lewis (called in some documents Susan Ann Lewis), "A Small Memorandum Kept while on a Journey to the East" (recording a trip from New Lebanon to seven Shaker communities), 16 August 1849, 2, OldChatKingLib, 10,483.

47 Thomas Damon, "Journal of a trip from Enfield, Connecticut to Shaker communities in Maine, New Hampshire, and Massachusetts, 1850," 17 September 1850, WintAndrewsShakColl, ASC 833.

48 Seth Youngs Wells, "Journal by Freegift Wells of a trip to Sodus and back to Watervliet in June [17–28 June 1834]," 26 June 1834, 33, WRHS,ShakerMSS, Series V, B-317.

49 Prudence Morrell, "This little Book is an account of a journey taken by Prudence Morrell and Eliza Sharp, to the West, in the year 1847," 19 August 1847, WRHS,ShakerMSS, Series V, B-141.

50 "Journal of a trip to western societies by Hiram Rude and Hanna[h] Ann Agnew, May 28–July 3 [1856]," July 1856, 132, WRHS,ShakerMSS, Series V, B-161.

51 Henry C. Blinn, "Diary of a Journey from Canterbury, N.H. to Enfield & on to New Lebanon, N.Y. & to Hancock, Mass. in a Carriage," 13 July 1853, 130, OldChatKingLib, 12,792. He also noted on the next page, same day (131): "The Connecticut valley is a beautiful place."

52 Calvin Green, "Journal Kept by Calvin Green on a trip to Philadelphia and vicinity," 10 May 1828, WRHS,ShakerMSS, Series V, B-98. (Manuscript difficult to read; cited here from the typescript prepared by the WRHS, B-98A.)

53 Seth Youngs Wells, "Journal kept by Seth Y. Wells of a visit to Port Bay (Sodus),"12 June 1832, 8, WRHS,ShakerMSS, Series V, B-101.

54 Hannah R. Agnew, "Journal of a Memorable Journey from White Water, Ohio. to New Lebanon. N.Y. Taken by Hannah R. Agnew when 16 years of age. In the Year 1836," 29 May 1836, 24, LofC,ShakColl, Item 50.

55 Thomas Hammond, "Journal," 9 June 1851, 151, WRHS,ShakerMSS, Series V, B-36; and Deborah Robinson (likely author), "A Short Sketch of our Journey to the East. 1850," 24 September 1850, 56, WintAndrewsShakColl, ASC 829.

56 Prudence Morrell, "This little Book contains an account of a journey taken by Prudence Morrell & Eliza Sharp, to the West, in the year 1847," 24 September 1847, WRHS,ShakerMSS, Series V, B-141.

57 Henry C. Blinn, "Diary of the Ministry's Journey to New Lebanon and Groveland," 23 July 1856, 65, OldChatKingLib, 12,792. For typical and widespread criticism of early Hudson Valley Dutch buildings by non-Dutch viewers in the eighteenth and nineteenth centuries, see Joseph Manca, "Erasing the Dutch: The Critical Reception of Hudson Valley Dutch Architecture, 1670–1840," chap. 2 in *Going Dutch: The Dutch Presence in America, 1609–2009*, ed. Joyce D. Goodfriend, Benjamin Schmidt, and Annette Stott (Leiden and Boston: Brill, 2008), 59–84.

58 Seth Youngs Wells, "Record of a journey from Alfred to Harvard to visit the schools," 20 August and 30 September 1822, WRHS,ShakerMSS, Series V, B-1.

59 "Journal of a trip to western societies by Hiram Rude and Hanna[h] Ann Agnew, May 28–July 3," June 1856 and early July (?), and 10 July 1856, 40, 72–73, 118, WRHS,ShakerMSS, Series V, B-161. For the development of early Cleveland and its street plans, see Edmund H. Chapman, *Cleveland: Village to Metropolis. A Case Study of Problems of Urban Development in Nineteenth-Century America* (Cleveland, OH: Western Reserve Historical Society, 1979).

60 "Journal of a trip to western societies by Hiram Rude and Hanna[h] Ann Agnew, May 28–July 3," 10 July, 1856, 118, WRHS,ShakerMSS, Series V, B-161.

61 Freegift Wells, "Ministry journal from Aug. 22, 1836 to May 1, 1837 including trips to Pleasant Hill & South Union, Ky. and North Union, Watervliet & Whitewater, O.[hio]," 3 May 1837, WRHS,ShakerMSS, Series V, B-239.

62 See the text and illustrations in Patricia Anderson, *The Course of Empire: The Erie Canal and the New York Landscape, 1825–1875* (Rochester, NY: Memorial Art Gallery of the University of Rochester, 1984), 81–83 for descriptions written ca. 1825–75 of travels along the Erie Canal, the body of literature to which Wells's account relates.

63 See ibid., 32; and online catalog entry at http://www.albanyinstitute.org/details/items/before-the-days-of-rapid-transit.html.

64 "Journal by Freegift Wells of a trip to Sodus and back to Watervliet in June [17–28 June 1834]," 1–38 for the full account of his trip and back, and 6–7 for 17 June 1834 for the section of the trip cited here, WRHS,ShakerMSS, Series V, B-317. For the connection between panorama painting and American painting in general in the mid-nineteenth century, see Barbara Novak, *Nature and Culture: American Land-*

scape and Painting, 1825–1875 (New York: Oxford University Press, 1980), 18–28. For a seminal study of time-based, moving panoramas in America, see John Francis McDermott, *The Lost Panoramas of the Mississippi* (Chicago: University of Chicago Press, 1958). See also Erkki Huhtamo, *Illusions in Motion: Media Archaeology of the Moving Panorama and Related Spectacles* (Cambridge, MA: MIT Press, 2013), esp. 169–261 for what Huhtamo calls the "craze" for moving panoramas in an international context.

65 "Account of a journey in April [1836] to Union Village by Freegift Wells and Matthew Houston," 23 April 1836, WRHS,ShakerMSS, Series V, B-320.

66 Giles B. Avery, "Journal or Diary of A Tour made by the Ministry of New Lebanon to the Shaker Societies in the Western States, Written by Elder Giles B. Avery," and Shaker travelers' names listed as Daniel Boler, Giles B. Avery, Betsy Bates, and A. Taylor, 20 June 1862, WRHS,ShakerMSS, Series V, B-163.

67 Willard Glazier, *Peculiarities of American Cities* (Philadelphia: Hubbard Brothers, 1886), 334.

68 Henry C. Blinn, "Notes by the way, while on journey to the state of Kentucky in the year 1873," 23 May 1873, Canterbury Shaker Village, Archives, 9779 Bl, ID #1956 (photocopy at Hancock Shaker Village, the Amy Bess and Lawrence K. Miller Library [hereafter cited as HSV,MillerLib], call #9758, B648, ID 6436). (Another version of Blinn's travel account is in OldChatKingLib, 12,791.)

69 Seth Youngs Wells, "Journal kept by Seth Y. Wells of a tour to the eastern Believers' schools," 26 June 1823, WRHS,ShakerMSS, Series V, B-302.

70 Thomas Hammond Jr., "Journal," 14 September 1839, 2, WRHS,ShakerMSS, Series V, B-36.

71 For the Portland Merchants' Exchange, see http://www.loc.gov/pictures/resource/hhh.me0027.photos.087833p/.

72 Thomas Hammond Jr., "Journal," 16 September 1846, 29, WRHS,ShakerMSS, Series V, B-36.

73 Caleb A. Wall, *Reminiscences of Worcester from the Earliest Period, Historical and Genealogical* (Worcester, MA: printed by Tyler and Seagrave, 1877), 222–25, for the courthouses of Worcester. For the alterations to Young's building, see http://mass.historicbuildingsct.com/?p=6556.

74 Thomas Hammond Jr., "Journal," 22 September 1846, 47, WRHS,ShakerMSS, Series V, B-36.

75 Rhoda Blake, "Sketch of the life and experiences of Rhoda Blake, begun in 1864, completed in 1892," 20 May 1854, 44, WRHS,ShakerMSS, Series VI, B-33.

76 For the text of Longfellow's poem, see Henry Wadsworth Longfellow, *Poems*, 2 vols. (Boston Ticknor and Fields, 1862), 1:241–42. See also https://www.nps.gov/spar/learn/historyculture/arsenal-at-springfield.htm.

77 Henry C. Blinn, "Notes by the way, while on journey to the state of Kentucky in the year 1873," 7 May 1873, Canterbury Shaker Village, Archives, 9779 Bl, ID #1956 (photocopy at HSV,MillerLib, call #9758, B648, ID 6436). (Another version of Blinn's travel account is in OldChatKingLib, 12,791.) For another transcription of Blinn's text for the same date, see Johnson, "Journey to Kentucky," 5, no. 1 (1965): 12–14.

78 Henry C. Blinn, "Notes by the way, while on journey to the state of Kentucky in

the year 1873," 7 May 1873, Canterbury Shaker Village, Archives, 9779 Bl, ID #1956 (photocopy at HSV,MillerLib, call #9758, B648, ID 6436). (Another version of Blinn's travel account is in OldChatKingLib, 12,791.) For another transcription of Blinn's text for the same date, see Johnson, "Journey to Kentucky," 5, no. 1 (1965): 15.

79 Deborah Robinson (likely author), "A Short Sketch of our Journey to the East. 1850," 5 September 1850, 28–29, WintAndrewsShakColl, ASC 829.

80 Thomas Damon, "Journal of a trip from Enfield, Connecticut to Shaker communities in Maine, New Hampshire, and Massachusetts, 1850," 5 September 1850, WintAndrewsShakColl, ASC 833.

81 This is a broad subject of study, as mounds are scattered across much of the Midwest and South and produced by different cultures. Useful for the region where the Shakers traveled in Ohio and Kentucky is Susan L. Woodward and Jerry McDonald, *Indian Mounds of the Middle Ohio Valley: A Guide to Mounds and Earthworks of the Adena, Hopewell, Cole, and Fort Ancient People* (Newark, OH: McDonald & Woodward, 1986).

82 Benjamin Seth Youngs, "A journey to the Indians[,] Miami[,] near Lebanon, Ohio, 3d [third] month, 1807," about 18 March 1807, 3, WintAndrewsShakColl, ASC 860.

83 William Deming, "Journal of William's travel to the state of Ohio, 1810," 4 August and 7 August 1810, 14 and 16, WintAndrewsShakColl, ASC 818. (A copy of the journal can be found at the Western Reserve Historical Society, Shaker Manuscripts, Series V, B-78, "Journal of William Demming's travels to Ohio and Kentucky including his visits to Union and South Union." Even ASC 818 at Winterthur is possibly a fair copy of Deming's original.)

84 Freegift Wells, "Ministry journal from Aug. 22, 1836 to May 1, 1837 including trips to Pleasant Hill & South Union, Ky. and North Union, Watervliet & Whitewater, O.[hio]," 28 April 1837, WRHS,ShakerMSS, Series V, B-239.

85 Benjamin Seth Youngs, "A journey to the Indians[,] Miami[,] near Lebanon, Ohio, 3d [third] month, 1807," about 23 March 1807, 40–41, WintAndrewsShakColl, ASC 860. For Darrow, McNemar, and the early Shakers in Ohio, see Hazel Spencer Phillips, *Shaker Architecture: Warren County Ohio* (Oxford, OH: Typo Print, 1971), 3–5.

86 Benjamin Seth Youngs, "A journey to the Indians[,] Miami[,] near Lebanon, Ohio, 3d [third] month, 1807, " about 25 March 1807, 53–55, WintAndrewsShakColl, ASC 860. For the trip, see also Edward Deming Andrews, "The Shaker Mission to the Shawnee Indians," ed. Ian M. G. Quimby, *Winterthur Portfolio* 7 (1972): 113–28.

87 James Fenimore Cooper, "American and European Scenery Compared," in *The Home Book of the Picturesque: Or American Scenery, Art, and Literature. Comprising a Series of Essays by Washington Irving, W. C. Bryant, Fenimore Cooper, Miss Cooper, N. P. Willis, [et al.].* (New York: G. P. Putnam, 1852), 66.

88 Daniel Boler, "A Journal or Memorandum," 8 June 1852, WRHS,ShakerMSS, Series V, B-154. The journal, B-152, Daniel Boler, "Journal kept by Daniel Boler that commenced on June 7th [1852]," was copied several times early on (B-153, B-154, B-155, and B-156). I am using here the more legible but slightly variant early transcription, B-154. In 1852 Boler, already an elder, became a member of the ministry. See Peter H. Van Demark, *The Journals of New Lebanon Shaker Elder Rufus Bishop*, vol. 2, *1840–1852* (Clinton, NY: Richard W. Couper Press, 2018), 404.

89 Hiram Rude, "Journal of a trip to western societies by Hiram Rude and Hanna[h] Ann Agnew, May 28–July 3," 28 May 1856, 2, WRHS,ShakerMSS, Series V, B-161.

90 "Journals des Minors," 1845–46, kept by Oliver Hampton (life dates unknown), 3 October 1845, 2–3, LofC,ShakColl, Item 181. Hampton was likely confused or mistaken about the name of the railroad line; in production at the time was a Columbus and Xenia Railroad, chartered in 1844.

91 Hiram Rude, "Journal of a trip to western societies by Hiram Rude and Hanna[h] Ann Agnew, May 28–July 3," July 1856, 133–35 (135 for the drawing of the bridge), WRHS,ShakerMSS, Series V, B-161. For two other artworks of the bridge from ca. 1856, with viewpoints similar to Rude's, see Elizabeth McKinsey, *Niagara Falls: Icon of the American Sublime* (Cambridge: Cambridge University Press, 1985), 255.

92 See David P. Billington, *The Tower and the Bridge: The New Art of Structural Engineering* (Princeton, NJ: Princeton University Press, 1983), 72–83. See also S. Buonopane, *The Roeblings and the Stayed Suspension Bridge: Its Development and Propagation in 19th Century America*, 2006, https://www.arct.cam.ac.uk/Downloads/ichs/vol-1–441–460-buonopane.pdf; Hiram Rude, "Journal of a trip to western societies by Hiram Rude and Hanna[h] Ann Agnew, May 28–July 3," July 1856, 134–35, WRHS,ShakerMSS, Series V, B-161.

93 Freegift Wells, "Freegift Wells set out on a journey to New Gloucester, by way of New Enfield—Canterbury—Alfred &c," 19 November 1851, 4, WRHS,ShakerMSS, Series V, B-337.

94 Freegift Wells, "Account of a journey in April [1836] to Union Village by Freegift Wells and Matthew Houston," 19 and 26 April 1836, WRHS,ShakerMSS, Series V, B-320.

95 Daniel Boler, "Journal or Memorandum," 9 June 1852, WRHS,ShakerMSS, Series V, B-154.

96 "Journal of a visit by the ministers of Union Village [Ohio] and South Union [Kentucky] to eastern communities." Early part written by William Reynolds of South Union, Kentucky, and the later part by Nancy E. Moore also of South Union, Kentucky, 21 September 1854, WRHS,ShakerMSS, Series V, B-250.

97 Prudence Morrell, "This little Book is an account of a journey taken by Prudence Morrell and Eliza Sharp, to the West, in the year 1847," 12 August 1847, WRHS,ShakerMSS, Series V, B-141. (Copies of the journal can be found at HSV,MillerLib, "A journey to the West in the year 1847," 1847, Call #9779, ID #2024; and WintAndrewsShakColl, ASC 836, "Copy of a journal of a visit to The Western Societies by Prudence Morrell in 1847.")

98 "Journal kept by Naomi Ligier, 1840–1844," mid-June 1842, LofC,ShakColl, Item 169.

99 "Items of a Journey to Harvard, Shirley, Lynn, New York, etc.," trip taken by Aaron Bells, George Curtis, and Abigail Crossman, journal likely written by Abigail Crossman, mid-August 1846, WRHS,ShakerMSS, Series V, B-140.

100 "Journal by Freegift Wells of a trip to Sodus and back to Watervliet in June [17–28 June 1834]," 20 June 1834, 20, WRHS,ShakerMSS, Series V, B-317.

101 Milton Robinson, "Journal, 1830–1831" (described on a title page as "Written by Milton, of South Union, KY, was declining with consumption—took a sea voyage

for the improvement of his health, & past Spirit Land Oct. 19, 1832, aged 25, here in New Lebanon. The rest of the story he relates himself"), 14 March 1831, LofC, Shak-Coll, Item 37.

102 Freegift Wells, "Freegift Wells set out on a journey to New Gloucester, by way of New Enfield—Canterbury—Alfred &c," 5 December, 1851, 22, WRHS, ShakerMSS, Series V, B-337.

103 "Journal of a visit by the ministers of Union Village [Ohio] and South Union to eastern communities." Early part written by William Reynolds of Union Village, Ohio, and the later part by Nancy E. Moore, of South Union, Kentucky, entry probably by Moore, 27 September 1854, 96, 98, WRHS, ShakerMSS, Series V, B-250.

104 Freegift Wells, "Journal" (trip to Marshall, Michigan), 3 July 1855, 342–43, WRHS, ShakerMSS, Series V, B-343.

105 "Items of a Journey to Harvard, Shirley, Lynn, New York, etc.," trip taken by Aaron Bells, George Curtis, and Abigail Crossman, journal likely written by Abigail Crossman, mid-August 1846, WRHS, ShakerMSS, Series V, B-140.

106 Thomas Hammond Jr., "Journal," 151, 9 June 1851, WRHS, ShakerMSS, Series V, B-36.

107 "Journal of a visit to five societies of believers viz Enfield, Conn.[,] Tyringham and Hancock Mass.[,] New Lebanon and Watervliet [sic] New York" by a company from Harvard, including Thomas Hammond Jr., Daniel Myrick, Lucy Mackintosh (or McIntosh; or Sarah), Rosalana (Roxalana) Grosvenor, Olive Hatch Sr., and Leonora Blanchard, 16 and 17 September 1846, 4–5, Williams College Library, Archives & Special Collections, Shaker Collection (hereafter cited as WilliamsCollLib), 21, J82 ("Anonymous journal of a visit by a company from Harvard to five societies of believers: Enfield, Tyringham, Hancock, New Lebanon and Watervliet, 1846").

108 John Kaime, "A Journal of a Journey from Canterbury to Enfield, con. Between the 15th & 26th of February, 1847," journal copied by Isaac N. Youngs on 13 September 1847, no pages, stanza 3, WRHS, ShakerMSS, Series V, B-4.

109 Seth Youngs Wells, "Record of a journey from Alfred to Harvard to visit the schools," 21 August 1822, WRHS, ShakerMSS, Series V, B-1. For discussion and illustrations of Lowell's buildings, including workers' dwellings, see John Coolidge, *Mill and Mansion: A Study of Architecture and Society in Lowell, Massachusetts, 1820–1865* (New York: Columbia University Press, 1942), 28–43.

110 "Journal of a visit to five societies of believers viz Enfield, Conn.[,] Tyringham and Hancock Mass.[,] New Lebanon and Watervliet [sic] New York" by a company from Harvard, including Thomas Hammond Jr., Daniel Myrick, Lucy Mackintosh (or McIntosh; or Sarah), Rosalana (Roxalana) Grosvenor, Olive Hatch Sr., and Leonora Blanchard, 21 September 1846, 22, WilliamsCollLib 21, J82 ("Anonymous journal of a visit by a company from Harvard to five societies of believers: Enfield, Tyringham, Hancock, New Lebanon and Watervliet, 1846").

111 Calvin Green, "Journal Kept by Calvin Green on a trip to Philadelphia and vicinity," 13 May 1828, WRHS, ShakerMSS, Series V, B-98. (Manuscript difficult to read; cited here from the typescript prepared by the WRHS, B-98A.) For a similar notice of this pebbledash in Green's "Biographic Memoir of the Life and Experience of

Calvin Green" (1861), 221, WRHS,ShakerMSS), Series VI, B-28; see the transcription in Wergland and Goodwillie, *Shaker Autobiographies, Biographies and Testimonies*, 2:223.

112 Levi Shaw, "Journal" (Canaan, NY), 2 and 4 November 1841, LofC,ShakColl, Item 41. James Wilson was born in 1794; trustee John Sidle was born in 1792.

113 "Items of a Journey to Harvard, Shirley, Lynn, New York, etc.," trip taken by Aaron Bells, George Curtis, and Abigail Crossman, journal likely written by Abigail Crossman, 24 August 1846, WRHS,ShakerMSS, Series V, B-140.

114 Thomas Damon, "Memoranda, &c. mostly of Events and Things which have transpired since the first of Jan. 1846" (the journal actually begins 3 November 1845), 9 June 1847, 31, OldChatKingLib, 13,357. (Photocopy available at HSV,MillerLib, call no. 9758, Da #342.)

115 "Diary of a journey by the ministry of Pleasant Hill and South Union, Kentucky, to visit the eastern Shakers, 1869," 12 June 1869, LofC,ShakColl, Item 35.

116 Freegift Wells, "Diary of a trip from Watervliet, N.Y. to Cutchogue, Long Island" (journal entries from 1861 and 1863), 3 August 1863, 92, WRHS,ShakerMSS, Series V, B-344.

117 "A Journal, or an Account of a load of Brethren & Sisters at Second Family, Watervliet, N. York Visiting Harvard & Shirley, Mass. June 1847," 12 June 1847, WRHS,ShakerMSS, Series V, B-332. The names of the travelers are listed as David Train Jr., Joel Smith, Eleanor Vedder, Polly Bacon, Thankful Copley, and Lucinda Harwood, as written on the initial page of the (unpaginated) manuscript.

118 Rufus Bishop, "A Daily Journal of Passing Events; begun January the 1st, 1830. By Rufus Bishop, in the 56th year of his age" (in 3 vols.; vol. 1 covers 1 January 1830 to 18 May 1839), vol. 1, 2 September 1830, New York Public Library, Shaker Manuscript Collection #1.

119 Hervey Elkins, *Fifteen Years in the Senior Order of Shakers: A Narration of Facts, Concerning that Singular People* (Hanover, NH: Dartmouth Press, [August] 1853), 77.

120 Freegift Wells, "Narrative of a journey made to Southold, Long Island, September 5–21, 1853, by Freegift Wells," at the home of Capt. Benjamin Wells, 15 September 1853, WRHS,ShakerMSS, Series V, B-339.

121 Freegift Wells, "Diary of a trip from Watervliet, N.Y. to Cutchogue, Long Island" (journal entries from 1861 and 1863), 6 September 1861, 14, WRHS,ShakerMSS, Series V, B-344.

122 For parallels between Shaker and Japanese furniture in the nineteenth century, see Chris Becksvoort, *The Shaker Legacy: Perspectives on an Enduring Furniture Style* (Newtown, CT: Taunton Press, 1998), 17–19. In a broader view, Becksvoort noted that Shaker pieces were "strongly influenced by the prevailing tastes of the surrounding world" (67–68).

123 "Items of a Journey to Harvard, Shirley, Lynn, New York, etc.," trip taken by Aaron Bells, George Curtis, and Abigail Crossman, journal likely written by Abigail Crossman, 21 August 1846, WRHS,ShakerMSS, Series V, B-140. For trade between the United States and China during this time, including discussion of the importation of Chinese decorative arts and textiles, see the essays in Patricia Johnston and Caroline Frank, eds., *Global Trade and Visual Arts in Federal New England* (Durham,

NH: University of New Hampshire Press; Hanover, NH: University Press of New England, 2014).

124 Thomas Hammond Jr., "Journal," 9 October 1846, 116, WRHS,ShakerMSS, Series V, B-36. For Shaker baskets themselves, see Gerrie Kennedy, Galen Beale, and Jim Johnson, *Shakers Baskets & Poplarware*, photographs by Paul Rocheleau (Stockbridge, MA: Berkshire House, 1992).

125 Henry C. Blinn, "Diary of a Journey from Canterbury, N.H. to Enfield & on to New Lebanon, N.Y. & to Hancock, Mass. in a Carriage," 30 June 1853, 95, OldChatKingLib, 12,792.

126 Daniel Boler, "Journal or Memorandum," 9 June 1852, WRHS,ShakerMSS, Series V, B-154.

127 Daniel Boler, "Journal or Memorandum," 17 June 1852, WRHS,ShakerMSS, Series V, B-154.

128 Isaac N. Youngs, "Tour thro the states of Ohio and Kentucky, 1834," vol. 2, 23 August 1834, 12, OldChatKingLib, 12,751 (vol. 1) and 12,752 (vol. 2); moral criticism of Louisville is found in that same manuscript, vol. 2, 14 September 1834, 47.

129 Rufus Bishop and Seth Youngs Wells, *Testimonies of the Life, Character, Revelations and Doctrines of Our Ever Blessed Mother Ann Lee, and the Elders with Her* (Hancock, MA: Printed by J. Tallcott & J. Deming, Junrs., 1816), 386.

130 Benjamin Seth Youngs, "Diary," 5 January 1805 ("plain, but civil, house," near Philadelphia), WintAndrewsShakColl, ASC 859, and reference to the meal in Edmonson in Benjamin S. Youngs, "Diary of Three Brethren Going South" (John Meacham, Issachar Bates Sr., and Benjamin S. Youngs, going from New Lebanon to the Southeast, beginning 1 January 1805), 29 January 1805, 14, OldChatKingLib, 15,220.

131 "Diary of a journey by the ministry of Pleasant Hill and South Union, Kentucky to visit the eastern Shakers; 1869," 14 June 1869, LofC,ShakColl, Item 35.

132 Elkins, *Fifteen Years in the Senior Order of Shakers*, 133.

133 Elkins, *Fifteen Years in the Senior Order of Shakers*, 136, 134.

134 Ibid., 134–35.

135 Ibid., 135.

136 "Diary of a journey by the ministry of Pleasant Hill and South Union, Kentucky to visit the eastern Shakers; 1869," 13 June 1869, LofC,ShakColl, Item 35.

137 Calvin Green, "Journal Kept by Calvin Green on a trip to Philadelphia and vicinity," 8 May and 10 May 1828, WRHS,ShakerMSS, Series V, B-98. (Manuscript difficult to read; cited here from the typescript prepared by the WRHS, B-98A.)

138 http://nycnuts.net/genealogy/church/wpa_roman_catholic/45.jpg; no. 3 in the entries. See also http://new-york-city.yodelout.com/new-york-city-christ-church-in-ann-street/.

139 Calvin Green, "Journal Kept by Calvin Green on a trip to Philadelphia and vicinity," 25 May 1828, WRHS,ShakerMSS. Series V, B-98. (Manuscript difficult to read; cited here from the typescript prepared by the WRHS, B-98A.)

140 Ibid.

141 Ibid., 26 May and 28 May 1828.

142 Freegift Wells, "Narrative of a journey made to Southold, Long Island, September 5–21, 1853, by Freegift Wells," 18 September 1853, WRHS,ShakerMSS, Series V, B-339.

143 Elkins, *Fifteen Years in the Senior Order of Shakers*, 94.

144 Ibid., 91, 135.

145 Freegift Wells, "Narrative of a journey made to Southold, Long Island, September 5–21, 1853, by Freegift Wells," 11 September 1853, WRHS,ShakerMSS, Series V, B-339.

146 For a Presbyterian missionary publication near this time decrying worship of Juggernaut, see "The Foreign Missionary Chronicle. April, 1842. Illustrations of Idolatry. Processions and Worship of Juggernaut," in *The Missionary Chronicle* (New York: Mission House, 23 Centre-Street; Philadelphia: Mission Rooms, 29, Sansom-Street, 1842), 10:97–102.

147 Giles B. Avery, "Journal or Diary of A Tour made by the Ministry of New Lebanon to the Shaker Societies in the Western States, Written by Elder Giles B. Avery," and Shaker travelers' names listed as Daniel Boler, Giles B. Avery, Betsy Bates, and A. Taylor, 21 June 1862, WRHS,ShakerMSS, Series V, B-163. For the sculpture, see Michael Lewis, *City of Refuge: Separatists and Utopian Town Planning* (Princeton, NJ: Princeton University Press, 2016).

148 Susan C. Liddell, "Journal kept by Susan C. Liddil on a visit to Clinton Valley [Ohio], October 31 to November 2 [1857]," 2 November 1857, WRHS,ShakerMSS, Series V, B-253.

149 Elkins, *Fifteen Years in the Senior Order of Shakers*, 135.

150 John M. Brown, "Notes by the Way," written in 1866–71, the passage here written 5 August 1866, recording events from 18–21 July 1866, 28, 36, 48, WRHS,ShakerMSS, Series VII, B-127.

CHAPTER 5: VISIONS, VOICES, AND ART

1 *OED*, s.v. "vision," n., 1a, 2a.

2 For a contextualization of Shaker visionary experience in the larger Anglo-American context, see Clarke Garrett, *Spirit Possession and Popular Religion: From the Camisards to the Shakers* (Baltimore: Johns Hopkins University Press, 1987), 140–59.

3 Ibid., 154–55.

4 Ann Kirschner, "At the Gate of Heaven: Early Shaker Dreams and Visions," in *Heavenly Visions: Shaker Gift Drawings and Gift Songs*, ed. France Morin (New York: Drawing Center; Los Angeles: UCLA Hammer Museum; Minneapolis: University of Minnesota Press, 2001), 169–78; cf. esp. Rufus Bishop and Seth Youngs Wells, *Testimonies of the Life, Character, Revelations and Doctrines of Our Ever Blessed Mother Ann Lee, and the Elders with Her* (Hancock, MA: printed by J. Tallcott & J. Deming, Junrs., 1816); and Seth Youngs Wells and Calvin Green, *Testimonies Concerning the Character and Ministry of Mother Ann Lee and the First Witnesses of the Gospel of Christ's Second Appearing* (Albany, NY: printed by Packard & Van Benthuysen, 1827).

5 Isaac Newton Youngs, "A Concise View of the Church of God and of Christ On Earth[.] Having its foundation In the faith of Christ's first and Second Appearing[.] New Lebanon 1856," 68, Winterthur Library, Edward Deming Andrews Memorial Shaker Collection (hereafter cited as WintAndrewsShakColl), ASC 861b; transcribed also by Christian Goodwillie in Glendyne R. Wergland and Christian

Goodwillie, eds., *History of the Shakers at New Lebanon by Isaac Newton Youngs, 1780–1861* (Clinton, NY: Richard W. Couper Press, 2017), 48.

6 Isaac Newton Youngs, "A Concise View of the Church of God and of Christ On Earth[.] Having its foundation In the faith of Christ's first and Second Appearing[.] New Lebanon 1856," 97–108, WintAndrewsShakColl, ASC 861b; transcribed also by Goodwillie in Wergland and Goodwillie, *History of the Shakers*, 54–56.

7 For an early study of the phenomenon of the spirit drawings, see Edward Deming Andrews, "Shaker Inspirational Drawings," *Magazine Antiques* 48, no. 6 (1945): 338–41. See also notes below, especially note 103. For an overview of the era and early images and texts related to it, see Robert P. Emlen, *Picturing the Shakers in the Era of Manifestations* (Clinton, NY: Richard W. Couper Press, 2015).

8 Henry C. Blinn, *The Manifestation of Spiritualism among the Shakers, 1837–1847* (East Canterbury, NH: n.p., 1899), 15–16.

9 Isaac Newton Youngs, "A Concise View of the Church of God and of Christ On Earth[.] Having its foundation In the faith of Christ's first and Second Appearing[.] New Lebanon 1856," 97–100, WintAndrewsShakColl, ASC 861b; transcribed also by Goodwillie in Wergland and Goodwillie, *History of the Shakers*, 54.

10 Deborah E. Burns, *Shaker Cities of Peace, Love, and Union: A History of the Hancock Bishopric* (Hanover, NH: University Press of New England, 1993), 90.

11 Sally M. Promey, *Spiritual Spectacles: Vision and Image in Mid-Nineteenth-Century Shakerism* (Bloomington: Indiana University Press, 1993), 59, from "copies of letters, Begun 1833," by "Representative of New Lebanon Community to New Lebanon Ministry at Enfield, New Hampshire," 8 November 1837, 218, Western Reserve Historical Society, Shaker Manuscripts (hereafter cited as WRHS,ShakerMSS),WRHS, Series IV, B-8.

12 Promey, *Spiritual Spectacles*, 59. Quoted from a letter by the New Lebanon Ministry to Sodus Elders, in "Mt. Lebanon, New York: copies of letters sent by the ministry to various communities, 1833–1839," 233, WRHS,ShakerMSS, Series IV, B-8. For verbal Shaker visions, see also Diane Sasson, *The Shaker Spiritual Narrative* (Knoxville: University of Tennessee Press, 1983), 44–66.

13 Hervey Elkins, *Fifteen Years in the Senior Order of Shakers: A Narration of Facts, Concerning that Singular People* (Hanover, NH: Dartmouth Press, [August] 1853), 44–45.

14 David R. Lamson, *Two Years' Experience Among the Shakers* (West Boylston, MA: published by the author, 1848), 51, 70.

15 Elkins, *Fifteen Years in the Senior Order of Shakers*, 42.

16 Printed material, viewed at OldChatKingLib, 12,027, *Part I. A Closing Roll, from Holy and Eternal Wisdom, Mother Ann, Father William and Father James, to the Children of Zion. Part II. A Sacred Covenant of our Heavenly Parents* (Canterbury, NH: Shaker Community, 1843), 23. See also Promey, *Spiritual Spectacles*, 39.

17 Cf. the argument in Promey, *Spiritual Spectacles*, 149.

18 Isaac Newton Youngs, "A Concise View of the Church of God and of Christ On Earth[.] Having its foundation In the faith of Christ's first and Second Appearing[.] New Lebanon 1856," 118–19, WintAndrewsShakColl, ASC 861b; transcribed also by Goodwillie in Wergland and Goodwillie, *History of the Shakers*, 57.

19 Written ca. 1849, by "witness Calvin Green" and titled "Book of Visions;

Revelations—And Prophecies; Received at various time[s]." See his "Vision of the Night," 1829, in which he was in "visionary sleep or in a real trance" ("A Vision of the Parentage of the Newcreation[,] and the <u>regeneration</u>," written "about the commencement of summer 1829"), 13, Hancock Shaker Village, Amy Bess and Lawrence K. Miller Library (hereafter cited as HSV,MillerLib), 9758 G795, #3661.

20 Witness Calvin Green, written ca. 1849, "Book of Visions; Revelations—And Prophecies; Received at various time[s]." See "A Vision of the Parentage of the Newcreation, and the <u>regeneration</u>," written "about the commencement of summer 1829," 14, HSV,MillerLib, call no. 9758 G795, #3661.

21 Isaac Newton Youngs, "Visions Seen by Elleyett Gibbs & Ann Mariah Goff," 1 December 1837, 130, OldChatKingLib, 3270. See also a transcription in Promey, *Spiritual Spectacles*, 10.

22 The "instrument," or medium, is listed as Miranda Barber, "The Following is a Vision of the Writer. On the Sabbath of October 12th 1851, while in afternoon meeting. <u>Also on the evening of the same day</u>," 110, WRHS,ShakerMSS, Series VIII, C-1.

23 "Millennial Laws, or Gospel Statutes and Ordinances," October 1845 (revised from the laws of August 1821), "Mother Lucy's Sayings," 240, LofC,ShakColl, Item 100. See also a transcription in Edward Deming Andrews, *The People Called Shakers: A Search for the Perfect Society* (New York: Oxford University Press, 1953), 289.

24 Jean McMahon Humez, ed., *Gifts of Power: The Writings of Rebecca Jackson, Black Visionary, Shaker Eldress* (Amherst: University of Massachusetts Press, 1981), 168.

25 Ibid., 171–72.

26 Rufus Bishop, "A Daily Journal of Passing Events; begun January the 1st, 1830. By Rufus Bishop, in the 56th year of his age" (in 3 vols.; vol. 1 covers 1 January 1830 to 18 May 1839), vol. 1, 8 September 1830, New York Public Library, Shaker Manuscript Collection (hereafter cited as NYPL,ShakerMSColl), #1.

27 Ibid. (in 3 vols.; vol. 2 covers from 19 May 1839 until 1 January 1850), vol. 2, 8 February 1840, 66, NYPL,ShakerMSColl, #2.

28 Elvira Curtis Hulett, "Spirit Messages," the first beginning: "A message from Mother Ann, brought by Elderes[s] Molley Goodrich to the West Family and placed upon the Alter, Satturday Evening, Dec. 21, 1842 and copied by mortal hand Sabath evening Jan. 1. 1843," 5, WintAndrewsShakColl, ASC 779.

29 Ibid., 6.

30 Ibid., 15, 28.

31 "Copy of a Word Spoken by Father William and Father James[,] February 6th and 7th 1847, 20, WRHS,ShakerMSS, Series VIII, C-1.

32 "A Golden Roll or holy Gift from holy <u>Mother Wisdom</u> to the <u>Ministry</u>," copied 4 November 1847, NYPL,ShakerMSColl, #33.

33 Robey Bennet, "<u>My Clear and Holy Jasper</u>," 9 January 1842, 196, WRHS,ShakerMSS, Series IX, B-183.

34 "Beautiful Gem," Holy Mount [New Lebanon], October 1843, Shaker Songs, 1843–46, New-York Historical Society Museum & Library (N-YHSML), Patricia D. Klingenstein Library, Shaker Collection, 1822–79.

35 "Church meeting journal kept by request of the elders," 1844–46, 18 August 1845, 262, WRHS,ShakerMSS, Series V, B-327.

36 "A Book of Rolls, Letters, Messages, & Communications to the Ministry and Elders, and individual members, Given by Divine Inspiration at New Lebanon, Not Recorded in Public Record Transcribed 1842," OldChatKingLib, 12,306; see "Mother's Section, April 19th 1840," 28–29, and see also "Mother's own Words, Written by Father James and Read by Inspiration, June 22nd, 1839," stating that "In your right hand I will put a beautiful Lamp," 2, and, "Words from Mother Ann" dated 17 August 1840, 53, where it reads: "Behold . . . this pretty robe . . . O see! See those diamonds those shining stars."

37 "Items of a Journey to Harvard, Shirley, Lynn, New York, etc.," trip taken by Aaron Bells, George Curtis, and Abigail Crossman, journal likely written by Abigail Crossman, mid-August 1846, WRHS,ShakerMSS, Series V, B-140.

38 Isaac Newton Youngs, "A Concise View of the Church of God and of Christ On Earth[.] Having its foundation In the faith of Christ's first and Second Appearing[.] New Lebanon 1856," 282–302, WintAndrewsShakColl, ASC 861b; transcribed also by Goodwillie in Wergland and Goodwillie, *History of the Shakers*, 110–12.

39 "A pretty present of Encouragement," ca. 1840–42, OldChatKingLib, 157–56. James Goodwin Jr. (1821–88) lived at New Lebanon beginning in 1833.

40 "Songs; [and] spiritual communications . . . 1827–65 and undated" (Enfield, Connecticut), quoted from "A Letter from Lovicy Carey to Elder Br. Amaziah Clark. It was copied by an inspired Instrument March 30[,] 1843"), LofC,ShakColl, Item 13. In March 1782, Mother Ann Lee visited the home of Amaziah Clark in Granby, Massachusetts; see Bishop and Wells, *Testimonies* (1816), 106; and Andrews, *People Called Shakers*, 37.

41 See Mario S. De Pillis and Christian Goodwillie, *Gather Up the Fragments: The Andrews Shaker Collection* (Hancock Shaker Village, MA, distributed New Haven, CT: Yale University Press, 2008), 241. For the artist, see also R. Wolfe, "Hannah Cohoon," in *American Folk Painters of Three Centuries*, ed. J. Lipman and T. Armstrong (New York: Hudson Hills Press, 1980), 58–65; and Sharon Duane Koomler, *Seen and Received: The Shakers' Private Art* (Pittsfield, MA: Hancock Shaker Village, 2000). The name also appears in some documents as Cahoon.

42 Isaac Newton Youngs, "A Concise View of the Church of God and of Christ On Earth[.] Having its foundation In the faith of Christ's first and Second Appearing[.] New Lebanon 1856," 119–20, WintAndrewsShakColl, ASC 861b; transcribed also by Goodwillie in Wergland and Goodwillie, *History of the Shakers*, 57.

43 Grove B. Blanchard, "Daily Journal" (Harvard, Massachusetts), 1 March 1843, 181, WRHS,ShakerMSS, Series V, B-46.

44 "A Book Containing a General Statement of the Gifts and Spiritual Presents . . . Received by Eunice Bathrick . . . Commencing in the year 1839," 20 May 1841, 5, New York State Library, Shaker Collection, Box 30, Volume/Folder 1.

45 "A Communication from the Savior, Spoke at the Meeting House, Sabbath Afternoon[,] April 24th 1842," 1, WRHS,ShakerMSS, Series VIII, C-1.

46 Amy Reed (New Lebanon), "Diary," 27 March 1841, 8, OldChatKingLib, 10,465. The document refers to Olive Spencer of New Lebanon, who was deceased at the time of the writing.

47 Prudence Morrell, "This little Book is an account of a journey taken by Prudence

Morrell and Eliza Sharp, to the West, in the year 1847," 28 June and 14 July 1847, WRHS,ShakerMSS, Series V, B-141.

48 "A Short Word of Notice from Father William to Jane Blanchard," 1 January 1841, 113, OldChatKingLib, 12,113. See also a related transcription in Promey, *Spiritual Spectacles*, 27.

49 Bishop and Wells, *Testimonies* (1816), 304; testimony of Mehitabel Farrington (1758–1848).

50 Christian Goodwillie, *Writings of Shaker Apostates and Anti-Shakers, 1782–1850*, 3 vols. (London: Pickering & Chatto, 2013; London: Routledge, 2016), 3:212, from an anonymous *Extract from an Unpublished Manuscript on Shaker History* (Boston: E. K Allen, 1850), which, according to Goodwillie, was written "by an anonymous female member of the South Family of the Harvard, Massachusetts, Shaker community" (189).

51 For discussion and illustration of the work, see De Pillis and Goodwillie, *Gather Up the Fragments*, 248–49.

52 Philemon Stewart, *A Holy, Sacred and Divine Roll Book; From The Lord God of Heaven, to The Inhabitants of Earth* (Canterbury, NH: United Society, 1843) (printed); from Part II, "Testimonial Evidence, Given by Divine Revelation, and Witnessed by Harriet Goodwin [1823–1903] at New Lebanon, Columbia County, New York," 10 July 1842, 283, WintAndrewsShakColl, ASC 416.

53 Alonzo Hollister, "Copies of songs and anthems, many of which were given through inspiration," 1838–48, with additions, 231–32, WRHS,ShakerMSS, Series VIII, B-115. See also Promey, *Spiritual Spectacles*, 18.

54 Bishop and Wells, *Testimonies* (1816), 341, 233.

55 "Sayings of Mother Ann, and The First Elders, Gathered from Different Individuals, at Harvard & Shirley. . . . at Different times, & in Various Places," in the section "The following is Mostly what some of the Old Believers at New Lebanon remembered of hearing our First Parents say while living with them. . . . Testimony of Mother Sarah Kendall [Harvard Shaker, sister of Hannah Kendall]," 203, NYPL,ShakerMSColl, #105.

56 "A Record of Inspired Writings, Given in the North, or Gathering Family, through Different Instruments. New Lebanon [1840–]1842," in "A Roll from Elder Sister Olive to all under the age of Thirty five Years written Saturday March 6th 1840," 4, NYPL,ShakerMSColl, #23.

57 "A Record of Inspired Writings, Given in the North, or Gathering Family, through Different Instruments. New Lebanon [1840–]1842," in "Words of Father Joseph[,] 23 March 1840," 6, NYPL,ShakerMSColl, #23.

58 "The Holy Word of the Lord God Almighty[,] The Holy One of Israel to His Chosen People, throughout Zion[']s Habitations[.] Given at Wisdom's Valley, and written by Inspiration, at the Holy Mount, March 5th 1843, 39, NYPL,ShakerMSColl, #9.

59 "A Short Communication from Sister Lucy Prescott to Eldress Betty," 6 March 1846, WRHS,ShakerMSS, Series VIII, B-104.

60 "Diary Kept by Sister Anna White, 1855–1873," 20 December 1857, NYPL,ShakerMSColl, #11.

61 Rufus Bishop, "A Daily Journal of Passing Events; begun January the 1st, 1830.

By Rufus Bishop, in the 56th year of his age," vol. 1, 24 September 1837, NYPL, ShakerMSColl, #1.

62 "A Farewell Visit to the Spiritual World, May 30th 1841," by Harriet Bullard (manuscript is not clearly paginated), NYPL,ShakerMSColl, #30.

63 Rufus Bishop, "A Daily Journal of Passing Events; begun January the 1st, 1830. By Rufus Bishop, in the 56th year of his age," vol. 1, 12 August and 24 December 1837, NYPL,ShakerMSColl, #1.

64 "A Vision seen by Ann Mariah Goff—Second Family, Watervliet, September 16th, 1837," WRHS,ShakerMSS, Series VIII, B-223. See also Ann Kirschner, "God Visited My Slumber: The Intersection of Dreams, Religion, and Society in America, 1740–1830" (Ph.D. diss., University of Delaware, 2004), 169.

65 "Extracts from the meeting journal, 2nd order, Mt. Lebanon," January–November, 1842, 7 May 1842, WRHS,ShakerMSS, Series V, A-12. (The document is a typescript copy, with punctuation added in pen at an unknown date.)

66 Stewart, *A Holy, Sacred and Divine Roll Book*, from Part II, "A Holy and Divine Roll Written by the Holy Prophet Elisha, Before the Altar of Wisdom and Love, December 14, 1842, Revealed at Canterbury, New Hampshire, June 28, 1843," 227, WintAndrewsShakColl, ASC 416.

67 Rufus Bishop, "A Daily Journal of Passing Events; begun January the 1st, 1830. By Rufus Bishop, in the 56th year of his age," vol. 1, 1 February 1832, NYPL,ShakerMSColl, , #1.

68 Lamson, *Two Years' Experience Among the Shakers*, 149–50.

69 "Words written by the hand of the Lord, upon a beautiful little Ball of brightness . . . March 1st 1842," NYPL,ShakerMSColl, #40.

70 Sabbathday Lake, Maine, Shaker Library, Eldress Harriett Coolbroth, of Alfred, Maine, "Sketch of the Life of Annie S. Colley." See also the discussion in Sasson, *The Shaker Spiritual Narrative*, 24–25.

71 William Deming, "A Vision Seen the 24th of January.43," or "A short and interesting account of a beautiful Temple and glorified spirits in heaven: Seen in Vision. Tuesday evening January 24th and written the 28th 1843," 16, WintAndrewsShakColl, ASC 765.

72 "Testimonies" (New Lebanon), 1843, WRHS,ShakerMSS, Series VI, A-6. For Wilson's life and visions in the context of Shaker writings, see Sasson, *The Shaker Spiritual Narrative*, 69–83.

73 Isaac Youngs, "Personal diary, 1837–1859," 31 August 1837, 25–26, OldChatKingLib, 10,509.

74 Bishop and Wells, *Testimonies* (1816), 243.

75 "For the Ministry of the City of Peace [Hancock, MA] . . . A Little Book containing a short word from Holy Mother Wisdom, concerning the Robes and Dresses that are prepared for all such as go up to the feast of the Lord, or attend to her Holy Passover, Copied July 20th, 1842," no pages, LofC,ShakColl, Item 140. Another manuscript copy of the "Little Book," LofC,ShakColl, Item 141, also dated 20 July 1842, is signed A. C., J. J., C. P., and M. R.

76 From the "Holy Mother's Angel of Peace," Second Family, Harvard (Massachusetts): "A Roll from the Angel of Peace" to Sister Mary Grosvenor, copied "by Inspi-

ration, May 23rd 1842," Shaker Songs and Roles, 1841–45, N-YHSML, Patricia D. Klingenstein Library, Shaker Collection, 1822–79.

77 "Extracts from the meeting journal, 2nd order, Mt. Lebanon," January-November, 1842, 20 November 1842, WRHS,ShakerMSS, Series V, A-12. (The document is a typescript copy, with punctuation added in pen at an unknown date.)

78 "A journal of the Ministrys Eastern Visit," journal commenced 19 June 1850, visit on 16 July 1850, 35, WRHS,ShakerMSS, Series V, B-147.

79 For example, curious interactions between a Shaker visionist and "Great Men of Past Ages" are recounted in an anonymous book, *Extract from an Unpublished Manuscript on Shaker History*, transcribed by Goodwillie, *Writings of Shaker Apostates and Anti-Shakers*, 3:201–5.

80 See the discussion of Washington in Promey, *Spiritual Spectacles*, 124–25.

81 Rufus Bishop, "A Daily Journal of Passing Events; begun January the 1st, 1830. By Rufus Bishop, in the 56th year of his age," vol. 1, 20 November 1834, NYPL,ShakerMSColl, #1.

82 For more positive Shaker views of the American republic, attitudes reflecting the belief that the new nation harbored the sect, see Promey, *Spiritual Spectacles*, 121–28.

83 Elkins, *Fifteen Years in the Senior Order of Shakers*, 51.

84 Ibid., 55.

85 Ibid., 114.

86 Giles Bushnell Avery, "Journal of a Trip to the Eastern Societies," 26 April 1843, 18–19, OldChatKingLib, 12,744.

87 Bishop and Wells, *Testimonies* (1816), 66; reported by Eliphalet Comstock, later a member and elder at the Shaker village at Enfield, Connecticut.

88 "Words written by the hand of the Lord, upon a beautiful little Ball of brightness . . . March 1st 1842," NYPL,ShakerMSColl, #40.

89 "Mother's Pretty Garden," 1840–44, 124, WRHS,ShakerMSS, Series IX, B-181.

90 "Journal of a trip to western societies by Hiram Rude and Hanna[h] Ann Agnew, May 28–July 3," comprising "The Visitants Farewell [at White-Water]," 66, perhaps dating to July 1856, WRHS,ShakerMSS, Series V, B-161.

91 Stewart, *A Holy, Sacred and Divine Roll Book*, from Part II, "A Holy and Divine Roll Written by the Holy Prophet Elisha, Before the Altar of Wisdom and Love, December 14, 1842, Revealed at Canterbury, New Hampshire, June 28, 1843," 226, WintAndrewsShakColl, ASC 416.

92 "A Roll from Eldress Anna Vines of English Ministry to beloved Eldress Betty. Given June 10th 1842[.] Shirl[e]y Church," 2–3, NYPL,ShakerMSColl, #32. (The Anna Vines claims in the manuscript to be from Manchester, England, born of "wealthy and respectable parents" and to have died at the age of thirty.)

93 Hannah Agnew, "Innocent Recreation," following the "Journal of a Memorable Journey from White Water, Ohio. to New Lebanon. N.Y. Taken by Hannah R. Agnew when 16 years of age. In the Year 1836," 39–44, 18 June 1856, LofC,ShakColl, Item 50.

94 Ibid., 51.

95 "The Churchyard (of Lebanon)," 79 ("written from reflections in the year 1836," but

dated "New Lebanon 1846[,] Written by request, for a friend in Ohio"), LofC,Shak-Coll, Item 50.

96 Shakers, as far as we know, never made sculpture. Perhaps sculpture was thought to be too real or tangible and too much of a biblically forbidden graven image.

97 For inspired drawings by the Shakers, see Edward Deming Andrews and Faith Andrews, *Visions of the Heavenly Sphere: A Study in Shaker Religious Art* (Charlottesville: University Press of Virginia, published for the Henry Francis du Pont Winterthur Museum, 1969); Daniel W. Patterson, *Gift Drawing and Gift Song: A Study of Two Forms of Shaker Inspiration* (Sabbathday Lake, ME: United Society of Shakers, 1983); Koomler, *Seen and Received*; the essays in *Heavenly Visions*, ed. Morin, including John Kirk, "Contextualizing the Gift Drawings," 101–34; Gerard C. Wertkin, "'Given by Inspiration': Visionary Expressions in Shaker Life and Art (1837 to 1859)," in *Shaker Design: Out of This World*, ed. Jean M. Burks (New Haven, CT: Yale University Press, published for the Bard Graduate Center for Studies in the Decorative Arts, Design, and Culture, New York and the Shelburne Museum, Shelburne, VT, 2008), 121–48; and Jane F. Crostwaite, *The Shaker Spiritual and Notices of Eleanor Potter* (Clinton, NY: Richard W. Couper Press, 2013). For a focused study of one kind of inspired Shaker drawing, see Sandra A. Soule, *Shaker Cut-and-Fold Booklets: Unfolding the Gift Drawings of Emily Babock* (Clinton, NY: Richard W. Couper Press, 2014). For the larger "gift" culture of the Shakers, including a consideration of inspired drawings, see Janet Sarbanes, "The Shaker 'Gift' Economy: Charisma, Aesthetic Practice and Utopian Communalism," *Utopian Studies* 20, no. 1 (2009): 121–39.

98 Andrews and Andrews, *Visions of the Heavenly Sphere*, 4.

99 Promey, *Spiritual Spectacles*, 66–67.

100 Andrews and Andrews, *Visions of the Heavenly Sphere*, 4.

101 France Morin, "Simple Gifts," in *Heavenly Visions*, ed. Morin, 52–53.

102 Andrews and Andrews, *Visions of the Heavenly Sphere*, 4–5.

103 Some Shaker works are illustrated in a larger context of folk art in Stacy Hollander, *American Radiance: The Ralph Esmerian Gift to the American Folk Art Museum* (New York: American Folk Art Museum, New York, in association with Harry N. Abrams, 2001), 309–20, and accompanying catalog entries (no. 164b is close in style to Shaker works). For Shaker religious art in a large context of the nineteenth century, see also C. Kurt Dewhurst, Betty MacDowell, and Marsha MacDowell, *Religious Folk Art in America: Reflections of Faith* (New York: E. P. Dutton, in association with the Museum of American Folk Art, 1983), 32–83. For painted tin, see Gina Martin and Lois Tucker, *American Painted Tinware: A Guide to Its Identification*, 3 vols. (New York: Historical Society of Early American Decoration, 1997, 2001, and 2007). Many Shakers' depicted flowers recall freely painted flowers found on American tinware of the times (cf. 2:30–33). See also fig. 5.16 here for a work redolent of floral tinware decoration in America.

104 See, for example, Ted Campbell, *The Religion of the Heart: A Study of European Religious Life in the Seventeenth and Eighteenth Centuries* (Columbia: University of South Carolina Press, 1991).

105 Cf. Morin, *Heavenly Visions*, catalog nos. 16 and 17 (cf. catalog nos. 18–20, heart-shaped cutouts also by Polly Jane Reed).

106 See note 97 above in this chapter.

107 Transcription in Andrews and Andrews, *Visions of the Heavenly Sphere*, 16. For subject matter and context of Shaker drawings, see also Sally L. Kitch, "As a Sign That All May Understand: Shaker Gift Drawings and Female Spiritual Power," *Winterthur Portfolio: A Journal of American Material Culture* 24, no. 1 (1989): 1–28.

108 "A Dish of Fruit from The Native Spirits. With their kind love," 1848, signed on the left "Joanna Mitchell," WRHS,ShakerMSS, Series VIII: C-7.

109 Miranda Barber, "The Following is copied from a book of prophetic signs written by the Prophet Isaiah[,] June 1843," 36–37, WRHS,ShakerMSS, Series VIII, C-1.

110 Elvira Hulett, "Spirit Messages," at the "City of Peace," 7 January 1844, WintAndrewsShakColl, ASC 780.

111 See full transcription in Andrews and Andrews, *Visions of the Heavenly Sphere*, 94–95.

112 For Shaker hymns touching on nature, see Daniel W. Patterson, *The Shaker Spiritual* (Princeton, NJ: Princeton University Press, 1979), 338–53 and passim.

113 Carol Medlicott, *"Partake a Little Morsel": Popular Shaker Hymns of the Nineteenth Century* (Clinton, NY: Richard W. Couper Press 2011), 68–73.

114 Patterson, *The Shaker Spiritual*, 339, 142–44.

115 Ibid., 276–77. Words "received" by Polly Lawrence, of New Lebanon and Sodus, New York.

116 "Comfort from Mother," 27 July 1845, Shaker Songs, N-YHSML, Patricia D. Klingenstein Library, Shaker Collection, 1822–79.

117 Patterson, *The Shaker Spiritual*, 373–74.

118 Ibid., 341, words spiritually received in 1849.

119 By 1851, and said to come from Hancock. See ibid., 342–45.

120 Ibid., 349, words received at Gloucester, Maine, in 1846.

121 "Pleasant Path," undated, said to be from Mother Ann to a believer, Shaker Songs, 1843–46, N-YHSML, Patricia D. Klingenstein Library, Shaker Collection, 1822–79.

122 Edward Deming Andrews, *The Gift to be Simple: Songs, Dances and Rituals of the American Shakers* (New York: J. J. Augustin, 1940), 69 (song undated).

123 Patterson, *The Shaker Spiritual*, 339–40, 370–71.

124 Robert C. Opdahl and Viola E. Woodruff Opdahl, *A Shaker Musical Legacy* (Hanover, NH: University Press of New England, 2004), 73.

125 Patterson, *The Shaker Spiritual*, "My Vineyard," 411–12. According to Patterson, the song was possibly by David Austin Buckingham (1803–85) of Watervliet.

BIBLIOGRAPHY

Adamson, Jeremy Elwell. *Niagara: Two Centuries of Changing Attitudes, 1697–1901*. Washington, DC: Corcoran Gallery of Art, 1985.

Ambrose, Pamela M. Introduction to *As it is in Heaven: The Legacy of Shaker Faith and Design*. Chicago: Loyola University Museum of Art, 2015.

Anderson, John M. "Force and Form: The Shaker Intuition of Simplicity." *Journal of Religion* 30 (October 1950): 256–60.

Anderson, Patricia. *The Course of Empire: The Erie Canal and the New York Landscape, 1825–1875*. Rochester, NY: Memorial Art Gallery of the University of Rochester, 1984.

Andrews, Edward Deming. "Communal Architecture of the Shakers." *Magazine of Art* 30 (December 1937): 710–15.

———. *The Community Industries of the Shakers*. Albany: State University of New York Press, 1932.

———. *The Furniture of Shaker Dwellings and Shops*. Pittsfield, MA: Berkshire Museum, 1932.

———. *The Gift to be Simple: Songs, Dances and Rituals of the American Shakers*. New York: J. J. Augustin, 1940.

———. *The People Called Shakers: A Search for the Perfect Society*. New York: Oxford University Press, 1953. Reprint, New York: Dover, 1963.

———. *Shaker Art and Craftsmanship: An Exhibition at the Berkshire Museum, Pittsfield, Massachusetts; Opening July the 30th, 1940*. Pittsfield, MA: Berkshire Museum, 1940.

———. "Shaker Inspirational Drawings." *Magazine Antiques* 48, no. 6 (1945): 338–41.

———. "The Shaker Manner of Building." *Art in America* 48, no. 3 (1960): 38–45.

———. *A Shaker Meeting House and its Builder*. Hancock, MA: Shaker Community, 1962.

———. "The Shaker Mission to the Shawnee Indians." Edited by Ian M. G. Quimby. *Winterthur Portfolio* 7 (1972): 113–28.

Andrews, Edward Deming, and Faith Andrews. *Religion in Wood: A Book of Shaker Furniture*. Bloomington: Indiana University Press, 1966. Reprinted as *Masterpieces of Shaker Furniture*. Mineola, NY: Dover, 1999.

———. *Shaker Furniture: The Craftsmanship of an American Communal Sect*. Photographs by William F. Winter. New Haven, CT: Yale University Press, 1937; London: H. Milford, Oxford University Press, 1937. Reprint, New York: Dover, 1950.

———. *Visions of the Heavenly Sphere: A Study in Shaker Religious Art*. Charlottesville: University Press of Virginia, published for the Henry Francis du Pont Winterthur Museum, 1969.

———. *Work and Worship Among the Shakers: Their Craftsmanship and Economic Order*. Greenwich, CT: New York Graphic Society, 1974. Also published as *Work and Worship: The Economic Order of the Shakers*. Greenwich, CT: New York Graphic Society, 1974. Reprint, New York: Dover Books, 1982.

Arndt, Karl J. R. *George Rapp's Harmony Society, 1785–1847*. Philadelphia: University of Pennsylvania Press, 1965.

Barker, Sister Mildred R. *The Sabbathday Lake Shakers—An Introduction to the Shaker Heritage*. Sabbathday Lake, ME: The Shaker Press, 1985.

Becksvoort, Christian. *The Shaker Legacy: Perspectives on an Enduring Furniture Style*. Photographs by John Sheldon. Newtown, CT: Taunton Press, 1998.

Bigelow, John, ed. *Autobiography of Benjamin Franklin*. Philadelphia: J. B. Lippincott, 1868.

Billington, David P. *The Tower and the Bridge: The New Art of Structural Engineering*. Princeton, NJ: Princeton University Press, 1983.

Bishop, Rufus, and Seth Y. Wells. *Testimonies of the Life, Character, Revelations and Doctrines of Our Ever Blessed Mother Ann Lee, and the Elders with Her*. Hancock, MA: printed by J. Tallcott & J. Deming, Junrs., 1816.

Bishop, Rufus, Seth Youngs Wells, and Giles Bushnell Avery. *Testimonies of the Life, Character, Revelations and Doctrines of Mother Ann Lee, and the Elders with Her*. 2nd ed. Albany, NY: Weed, Parsons, 1888.

Bixby, Brian L. "Seeking Shakers: Two Centuries of Visitors to Shaker Villages." Ph.D. diss., University of Massachusetts–Amherst, 2010.

Blackburn, Absolem H. *A Brief Account of the Rise, Progress, Doctrines, and Practices of the People Usually Denominated Shakers*. Flemingsburg, KY: A. Crookshanks, 1824; reprint, Ashfield, MA: Huntstown Press, 1996.

Blinn, Henry C. *The Manifestation of Spiritualism among the Shakers, 1837–1847*. East Canterbury, NH: n.p., 1899.

Boice, Martha, Dale Covington, and Richard Spence. *Maps of the Shaker West: A Journey of Discovery*. Dayton, OH: Knot Garden Press, 1997.

Bowe, Stephen. "Watervliet Shakerism." Master's thesis, University of Liverpool, 1994.

Bowe, Stephen, and Peter Richmond. *Selling Shaker: The Commodification of Shaker Design in the Twentieth Century*. Liverpool: Liverpool University Press, 2007.

Brewer, Priscilla J. "The Demographic Features of Shaker Decline, 1787–1900." *Journal of Interdisciplinary History* 15, no. 1 (1984): 31–52.

———. *Shaker Communities, Shaker Lives*. Hanover, NH: University Press of New England, 1986.

———. "The Shakers of Mother Ann Lee." In *America's Communal Utopias*, edited by Donald E. Pitzer, 37–56. Chapel Hill: University of North Carolina Press, 1997.

———. "'Tho' of the Weaker Sex': A Reassessment of Gender Equality among the Shakers." In *Women in Spiritual and Communitarian Societies in the United States*, edited by Wendy E. Chmielewski, Louis J. Kern, and Marlyn Klee-Hartzell, 133–49. Syracuse, NY: Syracuse University Press, 1993.

Brown, John. *Estimate of the Manners and Principles of the Times*. London: printed for L. Davis and C. Reymers, 1757.

Brown, Thomas. *An Account of the People called Shakers*. Troy, NY: printed by Parker and Bliss, 1812.

Bruhn, T. P., ed. *Simple Gifts—Hands to Work and Hearts to God*. Exhibition catalog, William Benton Museum of Art, University of Connecticut–Storrs, 1978.

Buck, Susan L. "Shaker Painted Furniture: Provocative Insights into Shaker Paints and Painting Techniques." In *Painted Wood: History and Conservation*, edited by Valerie Dorge and F. Carey Howlett, 143–54. Los Angeles: Getty Conservation Institute, 1998.

[Bullard], Sister Marcia. "Shaker Industries." *Good Housekeeping*, July 1906, 33–37.

Burke, Edmund. *A Philosophical Enquiry into the Origin of Our Ideas of the Sublime and Beautiful*. London: Printed for R. and J. Dodsley, 1757.

———. *A Philosophical Enquiry into the Origin of Our Ideas of the Sublime and Beautiful. With an Introductory Discourse concerning Taste, and several other Additions. A New Edition*. London: Printed for J. Dodsley, 1759.

Burks, Jean M. *Documented Furniture: An Introduction to the Collections* [Canterbury Shaker Village]. Canterbury, NH: Shaker Village, 1989.

———. "The Evolution in Design in Shaker Furniture." *Magazine Antiques* 145, no. 5 (1994): 732–41.

———, ed. *Shaker Design: Out of This World*. New Haven, CT: Yale University Press, published for the Bard Graduate Center for Studies in the Decorative Arts, Design, and Culture, New York, and the Shelburne Museum, Shelburne, VT, 2008.

Burns, Amy Stechler. *The Shakers: Hands to Work, Hearts to God; The History and Visions of the United Society of Believers in Christ's Second Appearing from 1774 to the Present*. Photographs by Ken Burns, Langdon Clay, and Jerome Liebling. New York: Aperture Foundation, 1987; New York: Portland House, 1990.

Burns, Deborah E. *Shaker Cities of Peace, Love, and Union: A History of the Hancock Bishopric*. Hanover, NH: University Press of New England, 1993.

Burress, Marjorie Byrnside, ed. *Whitewater, Ohio, Village of Shakers, 1824–1916: Its History and Its People*. Cincinnati: n.p., 1979.

Campbell, Ted. *The Religion of the Heart: A Study of European Religious Life in the Seventeenth and Eighteenth Centuries*. Columbia: University of South Carolina Press, 1991.

Campion, Nardi Reeder. *Ann the Word: The Life of Mother Ann Lee, Founder of the Shakers*. Boston: Little, Brown, 1976.

Carstensen, Georg. *New York Crystal Palace: Illustrated Description of the Building. By Geo. Carstense & Chs. Gildemeister, Architects of the Building*. New York: Riker, Thorne, 1854.

Centennial Illustrated Catalogue and Price List of the Shakers' Chairs, Foot Benches, Floor

Mats, etc. No author listed, but noting "Manufactured and sold by the Shakers at Mt. Lebanon, Columbia Co., N.Y." Boston: Henry A. Turner [publisher]; Albany, NY: Weed, Parsons [printers], 1876.

Chase, Eugene Parker, ed. and trans. *Our Revolutionary Forefathers: The Letters of François, Marquis de Barbé-Marbois during his Residence in the United States as Secretary of the French Legation, 1779–1785.* New York: Duffield, 1929.

Clark, Thomas D., and F. Gerald Ham. *Pleasant Hill and its Shakers* (Pleasant Hill, KY: Shakertown Press, 1968; second printing, Pleasant Hill, KY: Pleasant Hill Press, 1987.

Cohen, Paul E., and Robert T. Augustyn. *Manhattan in Maps, 1527–1995.* New York: Rizzoli, 1997.

Cole, Thomas. "Essay on American Scenery." *American Monthly Magazine* 1 (January 1836).

Conlin, Mary Lou. "A Tour of the Western Societies and Museums." *Shaker Quarterly* 2, no. 1 (1962): 67–76.

Conran, Terence. Introduction to *Shaker: Function—Purity—Perfection.* New York: Assouline, 2014.

Coolidge, John. *Mill and Mansion: A Study of Architecture and Society in Lowell, Massachusetts, 1820–1865.* New York: Columbia University Press, 1942.

Cooper, James Fenimore. "American and European Scenery Compared." In *The Home Book of the Picturesque: Or American Scenery, Art, and Literature. Comprising a Series of Essays by Washington Irving, W. C. Bryant, Fenimore Cooper, Miss Cooper, N. P. Willis, [et al.],* 51–69. New York: G. P. Putnam, 1852.

Crocker, Jeffrey D. *Understanding Shaker Architecture at Hancock Shaker Village: An Interpretive Guidebook.* Pittsfield, MA: Hancock Shaker Village, 1987.

Crostwaite, Jane F. *The Shaker Spiritual and Notices of Eleanor Potter.* Clinton, NY: Richard W. Couper Press, 2013.

Deignan, Kathleen. *Christ Spirit: The Eschatology of Shaker Christianity.* Metuchen, NJ: American Theological Library Association and Scarecrow Press, 1992.

De Pillis, Mario S., and Christian Goodwillie. *Gather Up the Fragments: The Andrews Shaker Collection.* Hancock Shaker Village, MA, distributed New Haven, CT: Yale University Press, 2008.

Desroche, Henri. *The American Shakers: From Neo-Christianity to Presocialism.* Translated from the French and edited by John K. Savacool. Amherst: University of Massachusetts Press, 1971. Originally published as *Les Shakers américains: D'un néo-Christianisme a un pre-socialisme?* Paris: Éditions de Minuit, 1955.

Dewhurst, C. Kurt, Betty MacDowell, and Marsha MacDowell. *Religious Folk Art in America: Reflections of Faith.* New York: E. P. Dutton, in association with the Museum of American Folk Art, 1983.

De Wolfe, Elizabeth A. *Shaking the Faith: Women, Family, and Mary Marshall Dyer's Anti-Shaker Campaign, 1815–1867.* New York: Palgrave Macmillan, 2004.

Dickens, Charles. *American Notes.* 2 vols. London: Chapman and Hall, 1842.

Diethorn, Karie. "What's Real? Quaker Material Culture and Eighteenth-Century Historic Site Interpretation." In *Quaker Aesthetics: Reflections on a Quaker Ethic in American Design and Consumption,* ed. Emma Jones Lapsanky and Anne A. Verplanck. Philadelphia: University of Pennsylvania Press, 2003.

Duffield, Holley Gene. *Historical Dictionary of the Shakers*. Lanham, MD: Scarecrow Press, 2000.

Dyer, Mary [Marshall]. *A Portraiture of Shakerism*. N.p.: printed for the author, 1822.

Eastman, John R. *History of the Town of Andover, New Hampshire, 1751–1906*. Concord, NH: Rumford, 1910.

Edwards, Jay. "The Complex Origins of the American Domestic Piazza-Veranda-Gallery." *Material Culture* 2, no. 2 (1989): 2–58.

Elkins, Hervey. *Fifteen Years in the Senior Order of Shakers: A Narration of Facts, Concerning that Singular People*. Hanover, NH: Dartmouth Press, [August] 1853.

Emerich, A. Donald. "American Monaster; or, The Meaning of Shaker Architecture." *Nineteenth Century* 11, nos. 3–4 (1992): 3–11.

Emerich, A. D., and A. H. Benning, eds. *Community Industries of the Shakers: A New Look*. Albany, NY: Shaker Heritage Society at Watervliet, 1983.

———. *Shaker: Furniture and Objects from the Faith and Edward Deming Andrews Collections*. Washington, D.C.: Smithsonian Institution Press, published for the Renwick Gallery of the National Collection of Fine Arts, 1973.

Emlen, Robert P. "Canterbury Views." *Journal of the American Historical Prints Collectors Society* 28, no. 2 (2003).

———. "The Early Drawings of Elder Joshua Bussell." *Magazine Antiques* 113, no. 3 (1978): 632–37.

———. "The Great Stone Dwelling of the Enfield, New Hampshire Shakers." *Old-time New England: The Bulletin of the Society for the Preservation of New England Antiquities* 69, nos. 3–4 (1979): 69–85.

———. *Picturing the Shakers in the Era of Manifestations*. Clinton, NY: Richard W. Couper Press, 2015.

———. "Picturing the Shakers in the Popular Illustrated Press: Daily Life at Mount Lebanon in the Winter of 1869–70." *Winterthur Portfolio: A Journal of American Material Culture* 50, no. 4 (2016): 249–87.

———. "Raised, Razed, and Raised Again: The Shaker Meetinghouse at Enfield, New Hampshire, 1793–1902." *Historic New Hampshire* 30, no. 3 (1975): 133–46.

———. "The Shaker Dance Prints." *Imprint: Journal of the American Historical Print Collectors Society* 17, no. 2 (1992): 14–26.

———. *Shaker Village Views: Illustrated Maps and Landscape Drawings by Shaker Artists of the Nineteenth Century*. Hanover, NH: University Press of New England, 1987.

Evans, Frederick W. *Autobiography of a Shaker; and, Revelation of the Apocalypse; with an Appendix*. New York: American News, 1869.

———. *Shakers: Compendium of the Origin, History, Principles, Rules and Regulations, Government, and Doctrines of the United Society of Believers in Christ's Second Appearing*. New York: D. Appleton and Co., 1859; reprint, New York: Lenox Hill, 1972.

———. *Who is Ann Lee? What Evidence is There That She is the Second Messiah?* Mt. Lebanon, Columbia Co., NY: n.p., 1889.

Faber, Doris. *The Perfect Life: The Shakers in America*. New York: Farrar, Straus and Giroux, 1974.

Filley, Dorothy M. *Recapturing Wisdom's Valley: The Watervliet Shaker Heritage, 1775–1975*. Edited by Mary L. Richmond. Albany, NY: Albany Institute of History and Art, 1975.

Fischer, Wend. "The Exhibition." Introduction to *The Shakers: Life and Production of a Community in the Pioneering Days of America: An Exhibition by the "Neue Sammlung" Munich*. Munich: Die Neue Sammlung, 1974. Also published as *Die Shaker: Leben und Produktion einer Commune in der Pionierzeit Amerikas*. Munich: Die Neue Sammlung, 1974.

Flint, Charles L. *Mount Lebanon Shaker Collection*. Photographs by Paul Rocheleau. New Lebanon, NY: Mount Lebanon Shaker Village, 1987.

Forrest, Tuomi. "Clean, Green, Machine: Philadelphia's Fairmount Water Works, 1800–1860." Master's thesis, University of Virginia, 1996.

Foster, Lawrence. *Religion and Sexuality: Three American Communal Experiments of the Nineteenth Century*. New York: Oxford University Press, 1981.

Francis, Richard. *Ann the Word: The Story of Ann Lee, Female Messiah, Mother of the Shakers, the Woman Clothed with the Sun*. London: Fourth Estate, 2001.

Gabor-Hotchkiss, Magda, comp. *Guide to Bound Shaker Manuscripts in the Library Collection of Hancock Shaker Village*. Vol. 1. Pittsfield, MA: Hancock Shaker Village, 2001.

———, comp. *Guide to Printed Shaker Works in the Library Collection of Hancock Shaker Village*. Pittsfield, MA: Hancock Shaker Village, 2001.

———, comp. *Guide to Unbound Shaker Manuscripts in the Library Collection of Hancock Shaker Village*. Pittsfield, MA: Hancock Shaker Village, 2001.

———. *Shaker Community Industries: Guide to Printed Shaker Ephemera in the Library Collections of Hancock Shaker Village*. Pittsfield, MA: Hancock Shaker Village, 2001.

Garrett, Clarke. *Spirit Possession and Popular Religion: From the Camisards to the Shakers*. Baltimore: Johns Hopkins University Press, 1987.

Gibbs, James W., and Robert W. Meader. *Shaker Clockmakers*. Columbia, PA: National Association of Watch and Clock Collectors, 1972.

Gibson, Marywebb. *Shakerism in Kentucky: Founded in America by Ann Lee*. Cynthiana, KY: Hobson Press, 1942. *See also* Marywebb Gibson Robb.

Gidley, Mick, and Kate Bowles, eds. *Locating the Shakers: Cultural Origins and Legacies of an American Religious Movement*. Exeter: University of Exeter Press, 1990.

Gifford, Don, ed. *An Early View of the Shakers: Benson John Lossing and the "Harper's" Article of July 1857. With Reproductions of the Original Sketches and Watercolors*. Hanover, NH: University Press of New England, 1989; published for Hancock Shaker Village.

Gilchrist, Agnes Addison. *William Strickland: Architect and Engineer, 1788–1854*. Philadelphia: University of Pennsylvania Press, 1950; New York: Da Capo Press, 1969, enlarged ed.

Gilpin, William. *Three Essays: On Picturesque Beauty; On Picturesque Travel; and On Sketching Landscape: to which is Added a Poem, On Landscape Painting*. London: printed for R. Blamire, 1792.

Glazier, Willard. *Peculiarities of American Cities*. Philadelphia: Hubbard Brothers, 1886.

Gohl-Völker, Ulla. *Die Kleidung der Shakerschwestern im 19. Jahrhundert: Die Repräsentanz kategorialer Ordnungsbegriffe*. Münster: Waxmann, 2002.

Gollin, Gillian Lindt. *Moravians in Two Worlds*. New York: Columbia University Press, 1967.

Goodfriend, Joyce D., Benjamin Schmidt, and Annette Stott, eds. *Going Dutch: The Dutch Presence in America, 1609–2009.* Leiden and Boston: Brill, 2008.

Goodwillie, Christian. *Writings of Shaker Apostates and Anti-Shakers, 1782–1850.* 3 vols. London: Pickering & Chatto, 2013; London: Routledge, 2016.

Goodwillie, Christian, and John Harlow Ott. *Hancock Shaker Village: A Guidebook and History.* Pittsfield, MA: Hancock Shaker Village, 2011.

Gordon, Beverly. "Shaker Fancy Goods: Women's Work and Presentation of Self in the Community Context in the Victorian Era." In *Women in Spiritual and Communitarian Societies in the United States,* edited by Wendy E. Chmielewski, Louis J. Kern, and Marlyn Klee-Hartzell, 89–103. Syracuse, NY: Syracuse University Press, 1993.

———. *Shaker Textile Arts.* Hanover, NH: University Press of New England, with the cooperation of the Museum of American Textile History and Shaker Community, 1980.

———. "Victorian Fancy Goods: Another Reappraisal of Shaker Material Culture." *Winterthur Portfolio: A Journal of American Material Culture* 25, nos. 2–3 (1990): 111–30.

Graham, Michael S., curator. *The Human and the Eternal: Shaker Art in its Many Forms.* New Gloucester, ME: United Society of Shakers, Sabbathday Lake, 2009.

Grant, Jerry V. *Noble but Plain: The Shaker Meetinghouse at Mount Lebanon.* Old Chatham, NY: Shaker Museum and Library, 1994.

Grant, Jerry V., and Douglas R. Allen. *Shaker Furniture Makers.* Hanover, NH: University Press of New England, published for Hancock Shaker Village, Pittsfield, MA, 1989.

Greeley, Horace. "A Sabbath with the Shakers." *Knickerbocker; or New York Monthly Magazine* 11, no. 6 (1838): 532–37.

Green, Benjamin. *The True Believers Vademecum, or Shakerism Exposed.* Concord, NH: printed for the author, 1831.

Haagen, Mary Ann. *The Collected Writings of Henry Cumings (1834–1913): Enfield, N.H., Shaker (1844–1881)[,] Citizen of the Town of Enfield, N.H. (1890–1913).* Clinton, NY: Richard W. Couper Press, 2012.

Ham, Gerald F. "Pleasant Hill: A Century of Kentucky Shakerism, 1805–1910." Master's thesis, University of Kentucky, 1955.

Haskett, William. *Shakerism Unmasked, or, The History of the Shakers.* Pittsfield, MA: printed by the author, 1828.

Hawthorne, Nathaniel. *The American Notebooks by Nathaniel Hawthorne.* Edited by Randall Stewart. New Haven, CT: Yale University Press, 1932.

Hodgdon, Charles. *Just Published, Hodgdon's Life and Manner of Living among the Shakers: Founded on Truth.* Concord, NH: published by the author, 1838.

Hollander, Stacy. *American Radiance: The Ralph Esmerian Gift to the American Folk Art Museum.* New York: American Folk Art Museum, New York, in association with Harry N. Abrams, 2001.

Holloway, Mark. *Heavens on Earth: Utopian Communities in America, 1680–1880.* New York: Dover, 1966.

Home, Henry. *Sketches of the History of Man.* 4 vols. Dublin: printed for James Williams, 1774–75.

Horgan, Edward R. *The Shaker Holy Land: A Community Portrait.* Harvard, MA: Harvard Common Press, 1982.

Horsham, Michael. *The Art of the Shakers*. Secaucus, NJ: Chartwell Books, 1989.

Huhtamo, Erkki. *Illusions in Motion: Media Archaeology of the Moving Panorama and Related Spectacles*. Cambridge, MA: MIT Press, 2013.

Humez, Jean McMahon, ed. *Gifts of Power: The Writings of Rebecca Jackson, Black Visionary, Shaker Eldress*. Amherst: University of Massachusetts Press, 1981.

———, ed. *Mother's First-Born Daughters: Early Shaker Writings on Women and Religion*. Bloomington: Indiana University Press, 1993.

Hutton, Daniel Mac-Hir. *Old Shakertown and the Shakers: A Brief History of the Rise of the United Society of Believers in Christ's Second Coming, the Establishment of the Pleasant Hill Colony, Their Beliefs, Customs and Pathetic End*. Harrodsburg, KY: Harrodsburg Herald Press, 1936.

Illustrated Catalogue and Price List of the Shakers' Chairs. New York: R. M. Wagan, 1874.

An Illustrated Catalogue and Price List of the Shakers' Chairs, Foot Benches, Floor Mats, etc. "Manufactured and Sold by the Shakers, At Mt. Lebanon, Columbia Co., N.Y." Lebanon Springs, NY: B. F. Reynolds, Book, Card, and Job Printer, 1875.

Innis, James R., Jr., and Thomas Sakmyster, eds. *The Shakers of White Water, Ohio, 1823–1916*. Clinton, NY: Richard W. Couper Press, 2014.

Jefferson, Thomas. *Notes on the State of Virginia*. Edited by William Peden. Chapel Hill: University of North Carolina Press, 1982.

Jensen, Joan M. *With These Hands: Women Working on the Land*. Old Westbury, NY: Feminist Press, 1981.

Johnson, Theodore E. *Hands to Work and Hearts to God: The Shaker Tradition in Maine*. Photographs by John McKee. Brunswick, ME: Bowdoin College Museum of Art, 1969.

———. "A Journey to Kentucky in the Year 1873 by Elder Henry C. Blinn." Pts. 1–9. *Shaker Quarterly* 5, no. 1 (1965): 3–19; no. 2 (1965): 38–55; no. 3 (1965): 69–79; no. 4 (1965): 107–33; 6, no. 1 (1966): 22–30; no. 2 (1966): 53–72; no. 3 (1966): 93–102; no. 4 (1966): 135–44; 7, no. 1 (1967): 13–22.

———. "The 'Millenial Laws' of 1821." *Shaker Quarterly* 7, no. 2 (1967): 35–58.

———. "Prudence Morrell's Account of a Journey to the West in the Year 1847." Pts. 1–2. *Shaker Quarterly* 8, no. 2 (1968): 37–60; no. 3 (1968): 82–96.

———, ed. "Rules and Orders for the Church of Christ's Second Appearing[,] Established by the Ministry and Elders of the Church[,] Revised and Reestablished by the Same[,] New Lebanon, New York[,] May 1860." *Shaker Quarterly* 11, no. 4 (1971): 139–65.

———. "A Sketch of the Life and Experience of Issachar Bates." Pts. 1–3. *Shaker Quarterly* 1, no. 3 (1961): 98–118; no. 4 (1961): 145–63; 2, no. 1 (1962): 18–35.

Johnston, Patricia, and Caroline Frank, eds. *Global Trade and Visual Arts in Federal New England*. Durham: University of New Hampshire Press; Hanover, NH: University Press of New England, 2014.

Jortner, Adam. *Blood from the Sky: Miracle and Politics in the Early American Republic*. Charlottesville: University Press of Virginia, 2017.

Joy, Arthur F. *The Queen of the Shakers*. Minneapolis: T. S. Denison, 1960.

Kane, Patricia E. "Samuel Gragg: His Bentwood Fancy Chairs." *Yale University Art Gallery Bulletin* 33 (1971): 27–37.

Kassay, John. *The Book of Shaker Furniture, With Measured Drawings by the Author.* Amherst: University of Massachusetts Press, 1980.

Kennedy, Gerrie, Galen Beale, and Jim Johnson. *Shakers Baskets & Poplarware.* Photographs by Paul Rocheleau. Stockbridge, MA: Berkshire House, 1992.

Kern, Louis. *An Ordered Love: Sex Roles and Sexuality in Victorian Utopias: The Shakers, the Mormons, and the Oneida Community.* Chapel Hill: University of North Carolina Press, 1981.

Ketchum, William C., Jr. *Simple Beauty: The Shakers in America.* New York: Todtri, 1996; New York: Smithmark, 1996.

Kirk, John T. *American Furniture and the British Tradition to 1830.* New York: Alfred Knopf, 1982.

———. "Contextualizing the Gift Drawings." In *Heavenly Visions: Shaker Gift Drawings and Gift Songs*, edited by France Morin, 101–34. New York: Drawing Center; Los Angeles: UCLA Hammer Museum; Minneapolis: University of Minnesota Press, 2001.

———. *The Shaker World: Art, Life, Belief.* New York: Harry N. Abrams, 1997.

Kirk, John T., and Jerry V. Grant. "Forty Untouched Masterpieces of Shaker Design." *Magazine Antiques* 135, no. 5 (1989): 1226–37.

Kirschner, Ann. "At the Gate of Heaven: Early Shaker Dreams and Visions." In *Heavenly Visions: Shaker Gift Drawings and Gift Songs*, edited by France Morin, 169–78. New York: Drawing Center; Los Angeles: UCLA Hammer Museum; Minneapolis: University of Minnesota Press, 2001.

———. "God Visited My Slumber: The Intersection of Dreams, Religion, and Society in America, 1740–1830." Ph.D. diss., University of Delaware, 2004.

Kitch, Sally L. "As a Sign That all May Understand: Shaker Gift Drawings and Female Spiritual Power." *Winterthur Portfolio: A Journal of American Material Culture* 24, no. 1 (1989): 1–28.

Klamkin, Marian. *Hands to Work: Shaker Folk Art and Industries.* New York: Dodd, Mead, 1972. Identical text published in the same year and by the same publisher with the full title only as *Shaker Folk Art and Industries.*

Klaw, Spencer. *Without Sin: The Life and Death of the Oneida Community.* New York: Allen Lane, 1993.

Klein, Esther. *Fairmount Park: A History and a Guidebook.* Bryn Mawr, PA: Harcum Junior College Press, 1974.

Knight, Richard Payne. *An Analytical Inquiry in the Principles of Taste.* London: printed for T. Payne and J. White, 1805.

Komanecky, Michael, ed. *The Shakers: From Mount Lebanon to the World.* New York: Skira Rizzoli, 2014.

Koomler, Sharon Duane. *Seen and Received: The Shakers' Private Art.* Pittsfield, MA: Hancock Shaker Village, 2000.

———. *Shaker Style: Form, Function, and Furniture.* Philadelphia: Courage Books, 2000.

Kramer, Fran. *Simply Shaker: Groveland and the New York Communities.* Rochester, NY: Rochester Museum and Science Center, 1991.

Lamson, David R. *Two Years' Experience Among the Shakers.* West Boylston, MA: published by the author, 1848.

Lapsansky, Emma Jones, and Anne A. Verplanck, eds. *Quaker Aesthetics: Reflections on a Quaker Ethic in American Design and Consumption*. Philadelphia: University of Pennsylvania Press, 2003.

Laskovski, P. D. *The Shaker Chair: Strength, Sprightliness and Modest Beauty*. Old Chatham, NY: Shaker Museum, 1982.

Lassiter, William Lawrence. *Shaker Architecture*. New York: Bonanza Books, 1966.

Laverty, Bruce, Michael J. Lewis, and Michel Taillon Taylor. *Monument to Philanthropy: The Design and Building of Girard College, 1832–1848*. Philadelphia: Girard College, 1998.

Ledes, Allison E. "The Canterbury Shakers." *Magazine Antiques* 143, no. 2 (1993): 32–34.

Lewis, Michael. *City of Refuge: Separatists and Utopian Town Planning*. Princeton, NJ: Princeton University Press, 2016.

Livingston, Judith Ann. "Victorian Views: Stereographs of the Mt. Lebanon Shaker Community, 1865–1895." Master's thesis, University of Delaware, the Winterthur Program in Early American Culture, 1999.

Lossing, Benson John. "The Shakers." *Harper's New Monthly Magazine* 15, no. 86 (1857): 164–77.

MacLean, J. P. *A Bibliography of Shaker Literature*. Columbus, OH: Fred. J. Heer, 1905; reprint, New York, B. Franklin, 1971.

———. *Shakers of Ohio: Fugitive Papers Concerning the Shakers of Ohio, with Unpublished Manuscripts*. Philadelphia: Porcupine Press, 1975.

Madden, Etta M. *Bodies of Life: Shaker Literature and Literacies*. Westport, CT: Greenwood Press, 1998.

Magoon, E. L. "Scenery and Mind." In *The Home Book of the Picturesque: Or American Scenery, Art, and Literature. Comprising a Series of Essays by Washington Irving, W. C. Bryant, Fenimore Cooper, Miss Cooper, N. P. Willis, [et al.]*, 1–48. New York: G. P. Putnam, 1852.

Manca, Joseph. *George Washington's Eye: Landscape, Design, and Architecture at Mount Vernon*. Baltimore: Johns Hopkins University Press, 2012.

———. "On the Origins of the American Porch: Architectural Persistence in Hudson Valley Dutch Settlements." *Winterthur Portfolio: A Journal of American Material Culture* 40, nos. 2–3 (2005): 91–132.

Manroe, Candace Ord. *Shaker Style: The Gift of Simplicity*. New York: Crescent Books, 1991.

Martin, Gina, and Lois Tucker. *American Painted Tinware: A Guide to Its Identification*. 3 vols. New York: Historical Society of Early American Decoration, 1997, 2001, and 2007.

McBride, John. *An Account of the Doctrines, Government, Manners and Customs of the Shakers*. Cincinnati: published by the author, 1834.

McDermott, John Francis. *The Lost Panoramas of the Mississippi*. Chicago: University of Chicago Press, 1958.

McKinsey, Elizabeth. *Niagara Falls: Icon of the American Sublime*. Cambridge: Cambridge University Press, 1985.

McKinstry, E. Richard. *The Edward Deming Andrews Memorial Shaker Collection*. New York: Garland, 1987.

———, trans. *The Shakers through French Eyes: Essays on the Shaker Religious Sect, 1799–1912*. Clinton, NY: Richard Couper Press, 2011.

McNemar, Richard. *The Kentucky Revival; or A Short History of the Late Extraordinary Outpouring of the Spirit of God in the Western States of America.* New York: Edward O. Jenkins, 1846; reprint: New York, AMS Press, 1974.

Meader, Robert F. W. *Illustrated Guide to Shaker Furniture.* New York: Dover, 1972.

———. "Zion Patetica." *Shaker Quarterly* 2, no. 1 (1962): 5–17.

Medlicott, Carol. *Issachar Bates: A Shaker's Journey.* Hanover, NH: University Press of New England, 2013.

———. *"Partake a Little Morsel": Popular Shaker Hymns of the Nineteenth Century.* Clinton, NY: Richard W. Couper Press, 2011.

Melcher, Marguerite Fellows. *The Shaker Adventure.* Princeton, NJ: Princeton University Press, 1941; Cleveland, OH: Press of Western Reserve University, 1960.

Melville, Herman. *Moby-Dick.* Edited by Harrison Hayford and Hershel Parker. New York: W. W. Norton, 1967.

Mercadante, Linda A. *Gender, Doctrine, and God: The Shakers and Contemporary Theology.* Nashville: Abingdon Press, 1990.

Miller, Amy Bess. *Hancock Shaker Village/The City of Peace: An Effort to Restore a Vision, 1960–1985.* Hancock, MA: Hancock Shaker Village, 1984.

Miller, M. Stephen. *From Shaker Lands and Shaker Hands: A Survey of the Industries.* Hanover, NH: University Press of New England, 2007.

———. *Inspired Innovations: A Celebration of Shaker Ingenuity.* Hanover, NH: University Press of New England, 2010.

Milroy, Elizabeth. *The Grid and the River: Philadelphia's Green Places, 1682–1876.* University Park: Pennsylvania State University Press, 2016.

Morin, France, ed. *Heavenly Visions: Shaker Gift Drawings and Gift Songs.* New York: Drawing Center; Los Angeles: UCLA Hammer Museum; Minneapolis: University of Minnesota Press, 2001.

Morse, Flo. *The Shakers and the World's People.* Hanover, NH: University Press of New England, 1987; first published New York: Dodd, Mead, 1980.

———. *The Story of the Shakers.* Woodstock, VT: Countryman Press, 1986.

Moss, Roger. *Historic Landmarks of Philadelphia.* Photographs by Tom Crane. Philadelphia: University of Pennsylvania Press, a Barra Foundation Book, 2008.

Muller, Charles R., and Timothy D. Rieman. *The Shaker Chair.* Winchester, OH: Canal Press, 1984.

Neal, Julia. *The Kentucky Shakers.* Lexington: University Press of Kentucky, 1977.

———. "Regional Characteristics of Western Shaker Furniture." *Magazine Antiques* 98, no. 4 (1970): 611–17.

Nickels, Edward E. "The Shaker Furniture of Pleasant Hill, Kentucky." *Magazine Antiques* 137, no. 5 (1990): 1178–89.

Nicoletta, Julie. "The Architecture of Control: Shaker Dwelling Houses and the Reform Movement in Early-Nineteenth-Century America." *Journal of the Society of Architectural Historians* 62, no. 3 (2003): 352–87.

———. *The Architecture of the Shakers.* Photographs by Bret Morgan. Woodstock, VT: Countryman Press, 1995.

Nordhoff, Charles. *The Communistic Societies of the United States; From Personal Visit and Observation.* New York: Harper & Brothers, 1875.

Novak, Barbara. *Nature and Culture: American Landscape and Painting, 1825–1875*. New York: Oxford University Press, 1980.

O'Brien, Raymond J. *American Sublime: Landscape and Scenery of the Lower Hudson Valley*. New York: Columbia University Press, 1981.

Oliver, Paul. *Built to Meet Needs: Cultural Issues in Vernacular Architecture*. Amsterdam: Elsevier, 2006.

Opdahl, Robert C., and Viola E. Woodruff Opdahl. *A Shaker Musical Legacy*. Hanover, NH: University Press of New England, 2004.

Ott, John Harlow. *Hancock Shaker Village: A Guidebook and History*. Hancock, MA: Shaker Community, 1976.

Parrish, Thomas. *Restoring Shakertown: The Struggle to Save the Historic Shaker Village of Pleasant Hill*. Lexington: University Press of Kentucky, 2005.

Paterwic, Stephen J. *Historical Dictionary of the Shakers*. Lanham, MD: Scarecrow Press, 2008; also published as *The A to Z of the Shakers*. Lanham, MD: Scarecrow Press, 2009.

———. *Tyringham Shakers*. Clinton, NY: Richard W. Couper Press, 2013.

Patterson, Daniel W. "A Ballad by Elder Issachar Bates." *Shaker Quarterly* 2, no. 1 (1962): 60–66.

———. *Gift Drawing and Gift Song: A Study of Two Forms of Shaker Inspiration*. Sabbathday Lake, ME: United Society of Shakers, 1983.

———. *The Shaker Spiritual*. Princeton, NJ: Princeton University Press, 1979.

Pearson, Elmer R., and Julia Neal. *The Shaker Image*. Boston: New York Graphic Society; Hancock, MA: Shaker Community, 1974 (1994 for the 2nd and annotated ed.).

Peculiarities of the Shakers Described in a Series of Letters from Lebanon Springs, in the Year 1832 . . . by a Visiter. New York: J. K. Porter, 1832.

Péladeau, Marius B. *Brother Moses Johnson, 1752–1842*. Augusta, ME: Maine Historic Preservation Commission, 1988.

———. "The Shaker Meetinghouses of Moses Johnson." *Magazine Antiques* 98, no. 4 (1970): 594–99.

Phillips, Hazel Spencer. *Shaker Architecture: Warren County, Ohio*. Oxford, OH: Typo Print, 1971.

Piercy, Caroline B. *The Valley of God's Pleasure: A Saga of The North Union Shaker Community*. New York: Stratford House, 1951.

Pike, Kermit. *A Guide to Shaker Manuscripts in The Library of The Western Reserve Historical Society*. Cleveland, OH: Western Reserve Historical Society, 1974.

Piraino-Holevoet, Elaine. "The Three Meetinghouses of the Enfield, Connecticut, Shakers." Master's thesis, University of Connecticut, 1978.

Plummer, Henry. *Stillness and Light: The Silent Eloquence of Shaker Architecture*. Bloomington: Indiana University Press, 2009.

Pointon, Marcia. "Quakerism and Visual Culture, 1650–1800." *Art History* 20, no. 3 (1997): 397–431.

Poppeliers, John, ed. *Shaker Built: A Catalog of Shaker Architectural Records from the Historic American Buildings Survey*. Washington, D.C.: Historic American Buildings Survey, 1974.

Price, Sir Uvedale. *An Essay on the Picturesque as Compared with the Sublime and the Beautiful*. London: J. Robson, 1796.

Procter-Smith, Marjorie. *Shakerism and Feminism: Reflections on Women's Religion and the Early Shakers.* Old Chatham, NY: Shaker Museum and Library, 1991.

———. *Women in Shaker Community and Worship: A Feminist Analysis of the Uses of Religious Symbolism.* Lewiston, NY: Edwin Mellen Press, 1985.

Promey, Sally M. *Spiritual Spectacles: Vision and Image in Mid-Nineteenth-Century Shakerism.* Bloomington: Indiana University Press, 1993.

Rapp, George. *Thoughts on the Destiny of Man, Particularly with Reference to the Present Times.* New Harmony, IN: Harmony Society, printed by Johann Christoph Müller, 1824 (actually printed in 1825).

Rathbun, Daniel. *A Letter from Daniel Rathbun of Richmond in the County of Berkshire, to James Whittacor.* Springfield, MA, 1785.

Rathbun, Valentine. *An Account of the Matter, Form and Manner of a New and Strange Religion, Taught and Propagated by a Number of Europeans living in a Place called Nisqueunia in the State of New-York.* Providence, RI: printed by Bennett Wheeler, 1781.

———. *A Brief Account of a Religious Scheme.* Worcester, MA: n.p., 1782.

———. *Some Brief Hints of a Religious Scheme, Taught and Propagated, by a Number of Europeans Living in a Place Called Nisqueunia in the State of New York.* Norwich, CT: John Trumbull, 1781; several later editions published in Boston, Salem, and New York in 1782–83.

Ray, Mary Lyn. Introduction to *True Gospel Simplicity: Shaker Furniture in New Hampshire.* Concord, MA: New Hampshire Historical Society, 1974.

———. "A Reappraisal of Shaker Furniture and Society." *Winterthur Portfolio* 8 (1973): 107–32.

Richmond, Mary L. *Shaker Literature: A Bibliography.* 2 vols. Hancock, MA: Shaker Community; Hanover, NH: distributed by the University Press of New England, 1977.

Rieman, Timothy D. *Shaker: The Art of Craftsmanship. The Mount Lebanon Collection.* Alexandria, VA: Art Services International, 1995.

———. *Shaker Furniture: A Craftsman's Journal.* Atglen, PA: Schiffer, 2006.

Rieman, Timothy D., and Jean M. Burks. *The Complete Book of Shaker Furniture.* New York: Harry N. Abrams, 1993.

———. *Encyclopedia of Shaker Furniture.* Atglen, PA: Schiffer, 2003.

———. *The Shaker Furniture Handbook.* Atglen, PA: Schiffer, 2005.

Robb, Marywebb Gibson [Mary Webb Gibson]. *Shakerism in Kentucky: Founded in America by Ann Lee.* Lexington, KY: Hurst, 1942. *See also* Marywebb Gibson.

Robinson, Charles Edson. *A Concise History of the United Society Believers, Called Shakers.* East Canterbury, NH: Robinson, 1893.

Rocheleau, Paul, and June Sprigg. *Shaker Built: The Form and Function of Shaker Architecture.* New York: Monacelli Press, 1994.

Rose, Milton C., and Emily Mason Rose, eds. *A Shaker Reader.* New York: Universe Books, 1977.

Rosenzweig, Roy, and Elizabeth Blackmar. *The Park and the People: A History of Central Park.* Ithaca, NY: Cornell University Press, 1992.

Royall, Anne Newport. *The Black Book; or, A Continuation of Travels in the United States.* 2 vols. Washington, D.C.: printed for the author, 1828.

Sanchez, Anita. *Mr. Lincoln's Chair: The Shakers and their Quest for Peace.* Granville, OH: McDonald & Woodward, 2009.

Sarbanes, Janet. "The Shaker 'Gift' Economy: Charisma, Aesthetic Practice and Utopian Communalism." *Utopian Studies* 20, no. 1 (2009): 121–39.

Sasson, Diane. "Not Such a Simple Life: The Case of William Leonard." *Shaker Quarterly* 20, no. 2 (1992): 37–51.

———. *The Shaker Spiritual Narrative.* Knoxville: University of Tennessee Press, 1983.

Schiffer, Herbert. *Shaker Architecture.* Exton, PA: Schiffer, 1979.

Schuyler, David. *Sanctified Landscape: Writers, Artists, and the Hudson River Valley, 1820–1909.* Ithaca, NY: Cornell University Press, 2012.

Sears, John F. *Sacred Places: American Tourist Attractions in the Nineteenth Century.* New York: Oxford University Press, 1989.

Serette, David. *Shaker Smalls.* Sebasco, ME: Cardigan Press, 1983.

Shea, John G. *The American Shakers and their Furniture, with Measured Drawings of Museum Classics.* New York: Van Nostrand Reinhold, 1971.

Smith, James. *Shakerism Detected.* Paris, KY: J. R. Lyle, 1810.

Smith, William Loughton. "Journal of William Loughton Smith, 1790–1791." *Proceedings of the Massachusetts Historical Society* 51 (October 1917): 20–88.

Soule, Sandra A. *Robert White Jr.: "Spreading the Light of the Gospel."* Clinton, NY: Richard W. Couper Press, 2009.

———. *Seeking Robert White: Quaker, Shaker Husband, Father.* Clinton, NY: Richard W. Couper Press, 2016.

———. *Shaker Cut-and-Fold Booklets: Unfolding the Gift Drawings of Emily Babock.* Clinton, NY: Richard W. Couper Press, 2014.

Spadafora, David. *Idea of Progress in Eighteenth-Century Britain.* New Haven, CT: Yale University Press, 1990.

Sprigg, June. *By Shaker Hands.* New York: Alfred A. Knopf, 1975; 2nd ed., Hanover, NH: University Press of New England, 1990.

———. *Inner Light: The Shaker Legacy.* Photographs by Linda Butler. New York: Alfred A. Knopf, 1985.

———. "Marked Shaker Furniture." *Magazine Antiques* 115, no. 5 (1979): 1048–58.

———. *Shaker: Masterworks of Utilitarian Design Created between 1800 and 1875.* Katonah, NY: Katonah Gallery, 1983.

———. *Shaker: Original Paints & Patinas.* Muhlenberg, PA, Muhlenberg College, Center for the Arts, Allentown, PA, 1987.

———. *Shaker Design.* New York: Whitney Museum of American Art, 1986.

———. *Simple Gifts: A Memoir of a Shaker Village.* New York: Alfred A. Knopf, 1998.

Sprigg, June, and Jim Johnson. *Shaker Woodenware: A Field Guide.* Photographs by Paul Rocheleau. 2 vols. Great Barrington, MA: Berkshire House, 1991–92.

Sprigg, June, and David Larkin. *Shaker: Life, Work, and Art.* Photographs by Michael Freeman New York: Steward, Tabori & Chang, 1987; London: Cassell, 1987; republished, New York: Smithmark, 2000.

Starbuck, David R., ed. *Canterbury Shaker Village: An Historical Survey.* Vol. 2. Durham, NH: University of New Hampshire, 1981.

———. *Neither Plain nor Simple: New Perspectives on the Canterbury Shakers.* Hanover, NH: University Press of New England, 2004.

Starbuck, David R., and Margaret Supplee Smith. *Historical Survey of Canterbury Shaker Village.* Vol. 1. Boston: Boston University, 1979.

Stein, Stephen J., ed., *Letters from a Young Shaker: William S. Byrd at Pleasant Hill.* Lexington: University Press of Kentucky, 1985.

———. *The Shaker Experience in America: A History of the United Society of Believers.* New Haven, CT: Yale University Press, 1992.

Stewart, Philemon. *A Holy, Sacred and Divine Roll Book; From The Lord God of Heaven, to The Inhabitants of Earth.* Canterbury, NH: United Society, 1843.

Stiles, Lauren A. *Shaker "Great Barns" 1820s–1880s: Evolution of Shaker Dairy Barn Design and its Relation to the Agricultural Press.* Clinton, NY: Richard W. Couper Press, 2013.

Straub, Carl Benton. *An Honorable Harvest: Shakers and the Natural World.* New Gloucester, ME: United Society of Shakers, 2009.

Sutton, Robert P. *Communal Utopias and the American Experience: Religious Communities, 1732–2000.* Westport, CT: Praeger, 2003.

———. *Heartland Utopias.* DeKalb: Northern Illinois University Press, 2009.

Swank, Scott T. *Shaker Life, Art, and Architecture: Hands to Work, Hearts to God.* Principal photography by Bill Finney. New York: Abbeville Press, 1999.

Swem, Earl Gregg, ed. *Letters on the Condition of Kentucky in 1825.* New York: Charles F. Heartman, 1916.

Symonds, John. *Thomas Brown and the Angels: A Study in Enthusiasm.* London: Hutchinson, 1961.

Taylor, Amos. *A Narrative of the Strange Principles, Conduct and Character of the People Known by the Name of Shakers.* Worcester, MA: printed [by Isaiah Thomas] for the author, 1782.

Taylor, Anne. *Visions of Harmony: A Study of Nineteenth-Century Millenarianism.* Oxford: Clarendon Press, 1987.

Taysom, Stephen C. *Shakers, Mormons, and the Religious Worlds: Conflicting Visions, Contested Boundaries.* Bloomington: Indiana University Press, 2011.

Thacher, James. *A Military Journal during the American Revolutionary War, from 1775 to 1783.* Boston: Richardson and Lord, 1823.

Thomas, David. *Travels through the Western Country in the Summer of 1816.* Auburn, NY: David Mumsey, 1819.

Thomas, James C. "Micajah Burnett and the Buildings at Pleasant Hill." *Magazine Antiques* 98, no. 4 (1970): 600–605.

Thomas, Robert David. *The Man Who Would Be Perfect: John Humphrey Noyes and the Utopian Impulse.* Philadelphia: University of Pennsylvania Press, 1977.

Thoreau, Henry D. *The Maine Woods.* Boston: Houghton Mifflin, 1892.

———. *Walden; or, Life in the Woods.* Boston: Ticknor and Fields, 1854.

Thurman, Suzanne R. *"O Sisters Ain't You Happy?": Gender, Family, and Community among the Harvard and Shirley Shakers, 1781–1918.* Syracuse, NY: Syracuse University Press, 2002.

Upton, Dell. "Inventing the Metropolis: Civilization and Urbanity in Antebellum New York." In *Art and the Empire City: New York, 1825–1861,* edited by Catherine Hoover

Voorsanger and John K. Howat. New York: Metropolitan Museum of Art, New York; New Haven, CT: Yale University Press, 2000.

Van Demark, Peter H., ed. *The Journals of New Lebanon Shaker Elder Rufus Bishop*. 2 vols. Vol. 1, *1815–1839*. Vol. 2, *1840–1852*. Clinton, NY: Richard W. Couper Press, 2018.

Visser, Thomas Durant. *Porches of North America*. Hanover, NH: University Press of New England, 2012.

Waggoner, Hyatt Howe. *Hawthorne: A Critical Study*. Cambridge, MA: Belknap Press of Harvard University, 1963.

Wall, Caleb A. *Reminiscences of Worcester from the Earliest Period, Historical and Genealogical*. Worcester, MA: printed by Tyler and Seagrave, 1877.

Wells, Samuel R. "Mother Ann Lee, The Shaker." In *Annual of Phrenology and Physiognomy for 1872*, published as part of Samuel R. Wells, *The Illustrated Annuals of Phrenology and Physiognomy for the Years 1865–6–7–8–9–70–1–2 &3*, 38–41. New York: Samuel R. Wells, 1872.

Wells, Seth Youngs, and Calvin Green. *A Summary View of the Millennial Church, or United Society of Believers, (commonly called Shakers)*. Albany, NY: printed by Packard and Van Benthuysen, 1823.

———. *Testimonies Concerning the Character and Ministry of Mother Ann Lee and the First Witnesses of the Gospel of Christ's Second Appearing*. Albany, NY: printed by Packard & Van Benthuysen, 1827.

Wergland, Glendyne R. *One Shaker Life: Isaac Newton Youngs, 1793–1865*. Amherst: University of Massachusetts Press, 2006.

———. *Sisters in the Faith: Shaker Women and Equality of the Sexes*. Amherst: University of Massachusetts Press, 2011.

———, ed. *Visiting the Shakers: Watervliet, Hancock, Tyringham, New Lebanon, 1778–1849*. Clinton, NY: Richard W. Couper Press, 2007.

Wergland, Glendyne R., and Christian Goodwillie, eds. *History of the Shakers at New Lebanon by Isaac Newton Youngs, 1780–1861*. Clinton, NY: Richard W. Couper Press, 2017.

———, eds. *Shaker Autobiographies, Biographies and Testimonies, 1806–1907*. 3 vols. London: Pickering & Chatto, 2014; London: Routledge, 2016.

Wertkin, Gerald. *The Four Seasons of Shaker Life: An Intimate Portrait of the Community at Sabbathday Lake*. New York: Simon and Schuster, 1986.

Wetherbee, Martha, and Nathan Taylor. *Shaker Baskets*. Edited by Mary Lyn Ray. Sanbornton, NH: Martha Wetherbee Basket Shop, 1988.

Weyerhauser, Charles A. Foreword to *The Shakers: Pure of Spirit, Pure of Mind*. Duxbury, MA: Art Complex Museum, 1983.

Whitby, John. *Beauties of Priestcraft or Short Account of Shakerism*. New-Harmony, IN: n.p., 1826.

Whitson, Robley Edward, ed. *The Shakers: Two Centuries of Spiritual Reflection*. New York: Paulist Press, 1983.

Wilkins, Robert W. "The Shaker Aesthetic Reconsidered." *Magazine Antiques* 173, no. 1 (2008): 194–201.

Williams, Richard E. *Called and Chosen: The Story of Mother Rebecca Jackson and the*

Philadelphia Shakers. Edited by Cheryl Dorschner. Metuchen, NJ: Scarecrow Press and American Theological Library Association, 1981.

Wilson, John. *The Poetical Works of Professor Wilson.* Edinburgh: William Black and Sons, 1858.

Wilton, Andrew, and Tim Barringer. *American Sublime: Landscape Painting in the United States, 1820–1880.* Princeton, NJ: Princeton University Press, 2002.

Wisbey, Herbert A., Jr. *The Sodus Shaker Community.* Lyons, NY: Wayne County Historical Society, 1982.

Whitworth, John McKelvie. *God's Blueprints: A Sociological Study of Three Utopian Sects.* London: Routledge & Kegan Paul, 1975.

Wolfe, R. "Hannah Cohoon." In *American Folk Painters of Three Centuries,* edited by J. Lipman and T. Armstrong, 58–65. New York: Hudson Hills Press, 1980.

Woodward, Susan L., and Jerry McDonald. *Indian Mounds of the Middle Ohio Valley: A Guide to Mounds and Earthworks of the Adena, Hopewell, Cole, and Fort Ancient People.* Newark, OH: McDonald & Woodward, 1986.

Youngs, Benjamin Seth. *The Testimony of Christ's Second Appearing Containing a General Statement of all Things Pertaining to the Faith and Practice of the Church of God in this Latter-Day.* Lebanon, OH: from the Press of John M'Clean, Office of the Western Star, 1808). *See also* Benjamin Seth Youngs and Seth Youngs Wells 1810.

Youngs, Benjamin Seth, Calvin Green, John Meacham, and David Darrow. *Testimonies of Christ's Second Appearing, Exemplified by the Principles and Practice of the True Church of Christ.* 4th ed. Albany, NY: published by the United Society, called Shakers, 1856.

Youngs, Benjamin Seth, and Seth Youngs Wells. *The Testimony of Christ's Second Appearing.* Albany, NY: printed by E. and E. Hosford, 1810; 2nd ed., "Corrected and Improved," "Published by Order of the Ministry in Union with the Church." *See also* Benjamin Seth Youngs 1808. Page numbers in the notes refer to the 1810 edition.

Youth's Guide in Zion, and Holy Mother's Promises. Given by Inspiration at New Lebanon, N.Y[,] January 5, 1842. Canterbury, NH: n.p., 1842.

INDEX

JOSEPH MANCA was born in Sleepy Hollow and raised in nearby Tarrytown, New York. He earned his B.A. at the University of Rochester, and received an M.A., M.Phil., and Ph.D. (1986) in art history from Columbia University. After working as a researcher at the National Gallery of Art in Washington, D.C., he joined the faculty at Rice University in 1989, and serves as professor of art history and the Nina J. Cullinan Professor of Art and Art History. He has published widely in the areas of early American art and architecture as well as Italian Renaissance painting. His seven books include *George Washington's Eye: Landscape, Architecture, and Design at Mount Vernon* (Johns Hopkins, 2012), for which he received the John Brinckerhoff Jackson Book Prize in 2014 (Foundation for Landscape Studies).